CAI GUO-QIANG 蔡國強

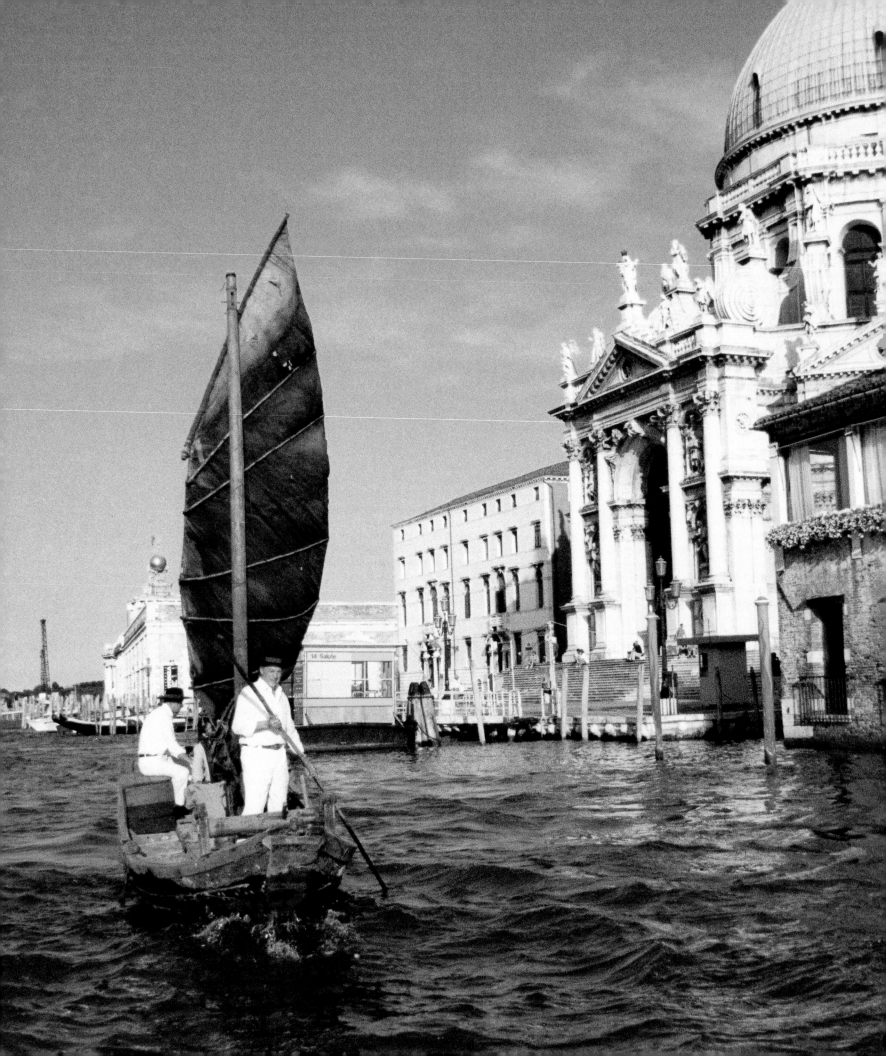

CAI GUO-QIANG: I WANT TO BELIEVE

THOMAS KRENS and ALEXANDRA MUNROE

GuggenheimMUSEUM

Published on the occasion of the exhibition
Cai Guo-Qiang: I Want to Believe

Organized by Thomas Krens and Alexandra Munroe

Solomon R. Guggenheim Museum, New York
February 22, 2008–May 28, 2008

National Art Museum of China, Beijing
August 18, 2008–September 20, 2008

Guggenheim Museum Bilbao
March 2009–September 2009

ISBN: 978-0-89207-371-9 (hardcover)
ISBN: 978-0-89207-372-6 (softcover)

Guggenheim Museum Publications
1071 Fifth Avenue
New York, New York 10128

Available through
D.A.P./Distributed Art Publishers
155 Sixth Avenue, 2nd Floor
New York, New York 10013
Tel.: (212) 627-1999; fax: (212) 627-9484

Distributed outside the United States and Canada by
Thames & Hudson, Ltd.
181A High Holborn Road
London WC1V 7QX, United Kingdom

Design: Miko McGinty and Rita Jules
Typesetting: Tina Henderson
Production: Melissa Secondino, Jonathan Bowen
Editorial: Edward Weisberger

Printed in Germany by GZD

Cover: Drawing by Cai Guo-Qiang on photo of
model for installation of *Inopportune: Stage One*
at Solomon R. Guggenheim Museum, New York,
in 2008 (see cat. no. 45)
Back cover: *The Earth Has Its Black Hole Too:
Project for Extraterrestrials No. 16* (1994, cat.
no. 24)
Frontispiece: *Bringing to Venice What Marco Polo
Forgot* (1995, cat. no. 48)

CONTENTS

CAI GUO-QIANG: I WANT TO BELIEVE 20
ALEXANDRA MUNROE

THE DIALECTICS OF ART AND THE EVENT 42
WANG HUI

IMAGE EXPLOSION: GLOBAL READYMADES 50
DAVID JOSELIT

THE ART OF EXPENDITURE 62
MIWON KWON

CATALOGUE 77
 EARLY WORKS 78
 GUNPOWDER DRAWINGS 88
 EXPLOSION EVENTS 128
 INSTALLATIONS 188
 SOCIAL PROJECTS 230

ANTHOLOGY 262

CHRONOLOGY 284

SELECTED EXHIBITION HISTORY 300

SELECTED BIBLIOGRAPHY 306

Lead Sponsor 何 鴻 毅 家 族 基 金
THE ROBERT H. N. HO FAMILY FOUNDATION

Media Partner Thirteen/WNET

This exhibition is funded in part by the National Endowment for the Arts,
and with the generous support of additional individuals and foundations.

SPONSOR'S STATEMENT

The Robert H. N. Ho Family Foundation, together with the Solomon R. Guggenheim Museum, is delighted to present an unprecedented retrospective of one of the most celebrated contemporary artists from China. Titled *Cai Guo-Qiang: I Want to Believe*, the exhibition features the thought-provoking work of Cai, who is also a true citizen of the world.

The foundation was established in Hong Kong with a mission to foster and promote understanding of Chinese arts and culture, in particular arts education and Buddhist philosophy. It shares Cai's vision of using art for social commentary, as well as his desire to provide creative opportunities for everyone.

By bringing the exhibition to an international audience, the foundation wishes to highlight the impact of using art to comment on social issues. We firmly believe in the importance of seeking harmony and coexistence amid differences and contradictions. We admire the way Cai expresses this theme by exploring the relationship between the individual and society and by probing and pondering the social landscape. He also creates space, both inside and outside the art world, to encourage dialogue and foster creativity within different communities.

The foundation is convinced that education should encompass the whole person and facilitate the cultivation of empathy and mutual understanding. We believe that healthy growth of the individual and society ultimately brings about positive change in the world. The creation of art, together with personal inquiry and expression, are the means to these purposes, as it liberates potential, encourages openness, and stimulates new perspectives. By supporting this exhibition, the foundation hopes to demonstrate its commitment to the promotion of cross-cultural understanding, arts education, and the opening up of the arts to broader participation.

The exhibition will also feature educational programs and a Chinese New Year family event. We hope that the audience will find these special events, as well as the exhibition and the catalogue, as fascinating, challenging, and thoroughly enjoyable as we do.

Cai's creations from the 1980s to the present manifest his vision and efforts to discover the connection between self and society. They highlight his unique and forward-looking worldview. We hope the messages in his work will help inspire deeper reflection on ourselves and the world around us.

Robert H. N. Ho
Chairman
The Robert H. N. Ho Family Foundation

何 鴻 毅 家 族 基 金
THE ROBERT H. N. HO FAMILY FOUNDATION

LENDERS TO THE EXHIBITION

Cai Studio, New York
The Cleveland Museum of Art
Miyatsu Daisuke, Japan
Deutsche Bank Collection, Germany
Eslite Gallery, Taiwan
Fondation Cartier pour l'art contemporain, Paris
Fukuoka Asian Art Museum, Japan
Harvard University Art Museums, Fogg Art Museum, Cambridge, Massachusetts
Hirshhorn Museum and Sculpture Garden, Smithsonian Institution, Washington, D.C.
The Miyake Issey Foundation, Tokyo
Collection of Miani Johnson, New York
Collection of Angela and Massimo Lauro, Naples, Italy
Museum of Contemporary Art, Tokyo
Museum Ludwig, Cologne
The Museum of Modern Art, New York
National Gallery of Canada, Ottawa
San Diego Museum of Art
Caspar H. Schübbe Collection, Switzerland
Seattle Art Museum
Setagaya Art Museum, Tokyo
Solomon R. Guggenheim Museum, New York
Collection of Leo Shih, Taiwan
Collection of Sardjana Sumichan, Singapore
Private collection
Courtesy private collection and Albion, London
Collection of Wijono Tanoko, Indonesia
Collection of Guy & Myriam Ullens Foundation, Switzerland
Yageo Foundation Collection, Taiwan

As of November 1, 2007

THE SOLOMON R. GUGGENHEIM FOUNDATION

PREFACE

Perhaps the two unique features in the history of art of the late twentieth and early twenty-first centuries are the sheer depth and breadth of art making invention and change that apparently took place within such a short span of time; and the degree to which the actions and manifestations of art making have been subject to analysis, scrutiny, and systematic deconstruction from every possible conceptual angle and historical methodology. In this context, the concept of artistic genius remains an open question. Is art making an intensely precise intellectual exercise? Do the most successful artists analyze the prevailing forms and paradigms and visualize the outcome of their creative energies more or less fully formed in advance? Or is the point of departure for the creation of their work of art more deeply buried in the subconscious, triggered, perhaps, by innate, intuitive and almost biological tendencies to transcend the prevailing norms or models, to create something unique, fresh, and never before seen.

As powerful as are the transgressive forces in any creative activity, there has been an equally powerful, if even more subtle, tendency to operate within the boundaries of the rules of formation that govern the expression of any given time in all of its forms. Artists have always tended to push the boundaries of their activity looking for new forms and directions, but rarely, very rarely, has the prevailing paradigm been thrown out altogether. The art history of the West can describe a lengthy series of incremental steps from the Renaissance to Minimalism, but the direct jump from the one to the other appeared to be virtually impossible. It is almost a cliché to say, then, that the richness of human culture has been lubricated by the tension between the new and the established. The dialectical evolution of forms and the pervasive impact of "influence" and "style" seem to be built into the process. The additional element that has particularly distinguished art making in the past one hundred fifty years or so has been a gradual, almost philosophical and historical self-awareness on the part of artists. The practical, dialectical, and analytical forces that drove the quasi-scientific, materialist, and formalist inquiry in the visual arts was virtually complete by the late twentieth century. The found object, the elemental shape, the all white canvas, and conceptual art signaled an end to almost five hundred years of a gradual and largely linear evolution.

Within the last forty years, however, artists appear to have clearly broken through whatever barriers were implied by the culmination of Western formalism and tapped into the hugely rich vein of personal experience and political, social, and geographic reference. Spontaneous association, memories, personal histories, political histories, obsessions, and neuroses were all material and inspiration for a unique and individual perspective that defied and even ignored an incremental approach. Joseph Beuys, in particular, stood out as an artist who created his own internally consistent universe, with a unique and almost shamanistic vocabulary. In this context, potential artistic narratives have proved to be virtually infinite, limited only by the individual persona and experience of any given artist. Nevertheless, and vis-à-vis any given artist's work, perhaps the more intriguing question—and certainly the key to reading, understanding, and fully appreciating Cai Guo-Qiang, the subject of our exhibition—is the degree to which art making is understood to be a fully self-conscious and historically self-aware act or the degree to which it is a mysterious, personal, and intuitively evocative act. Does the eventual shape of the art object gradually emerge through an iterative progression of intuitive decisions whose source remains both illusive and pure, or does logic, precise and pure, predominate? In essence, is it mathematics or is it magic or some combination of both?

Cai came to the attention of the emerging global art world in the 1990s as the artist who made gunpowder drawings and explosion events. Immersed in both calligraphy and traditional Chinese ink painting during his childhood and adolescence, he gravitated toward the more Western mediums of painting, drawing, and sculpture and then to stage design during the dying days of state-mandated propaganda art in China. It was in China in 1984 that Cai began to experiment with fuses and gunpowder, readily available materials in Quanzhou, Fujian Province, where he was born and raised. After graduating from the Shanghai Drama Institute, he immigrated to Japan in 1986 and immediately tapped into a rich vein of international twentieth-century art.

It was in Japan that Cai first attracted attention for a body of work that was increasingly and simultaneously bold, irreverent, conceptual, time specific, ephemeral, memorable, and site specific—in short, performance art with a literal explosive impact. Behind his developing dramatic power as an artist was a unique aesthetic iconography that drew freely from ancient mythology, military history, Taoist cosmology, extraterrestrial observations, Maoist revolutionary tactics, Buddhist philosophy, pyrotechnic technology, Chinese medicine, and methods of terrorist violence, among other areas. It was only after steady production of a variety of complex works, culminating perhaps with two seminal installations—*Venice's Rent Collection Courtyard*, which was installed at the 1999 Venice Biennale, and *Reflection—A Gift from*

Iwaki, a work first realized in 2004 at the Arthur M. Sackler Gallery, Washington, D.C., in which the wrecked hulk of a wooden schooner looks as if it is beached on a sand bar of porcelain statuettes of the popular Buddhist deity Guanyin—that an international awareness of his unique and complex oeuvre began to emerge.

Cai is now widely acclaimed as a bold originator of new art forms that continue to expand the whole notion of a cultural experience. His work is hugely intuitive and conscientiously analytical. His large-scale gunpowder drawings and site-specific explosion events demonstrate a spectacular fusion of the science and art of transformation and propose the processes of destruction and change as radical conditions for reality, and hence creativity.

Since the mid-1990s, Cai has expanded his range to focus on interactive installations that frequently recuperate signs and symbols of Chinese culture and brilliantly expose the dialectics of local history and globalization. Most recently, his experiments with social projects, whereby he engages communities to produce art events in remote, nonart sites like military bunkers, reveal the artist's critical fascination with a socialist utopianism that arises from his experience as a child of Mao Zedong's Cultural Revolution. The retrospective exhibition *Cai Guo-Qiang: I Want to Believe* examines the full spectrum of the artist's protean, multimedia practice and the conceptual complexity of his unique artistic methodologies. Cai is an artist of uncommon power and originality who arrived on the scene with full maturity. His work is likely to command our attention for decades to come. He is the living embodiment of both the magician and the mathematician.

It was at the dinner in North Adams to celebrate the opening of the exhibition *Cai Guo-Qiang: Inoppotune* at the Massachusetts Museum of Contemporary Art (MASS MoCA) in late 2004 that I first raised the possibility of a retrospective at the Guggenheim. I had just seen Cai's installation of three major new works at MASS MoCA: *Inopportune: Stage One*, in which white Ford automobiles were suspended in midair in a 15,000-square-foot gallery, each car sprouting numerous colored fiber-optic rods referencing with sly and self-deprecating allusion his explosion events; *Illusion*, a double-sided, multiscreen video projection of a white car maneuvering through Times Square while numerous explosions pour from its windows—the burnt-out hulk of the vehicle shared the gallery's darkened space; and *Inopportune: Stage Two*, which filled one room with nine amazingly lifelike but artificial tigers, each laced with scores of arrows, while a second, adjacent, smaller room contained *Painting of One Hundred Tigers* (1993), a monumental handscroll by the artist's father, Cai Ruiqin.

The combination of Cai's three works in one exhibition had for me the force of an epiphany. Indeed, I had followed his work and his growth as an artist for more than a decade with gathering interest and admiration. In 1996, he was selected as a finalist for the Guggenheim's inaugural Hugo Boss Prize, and thanks to the generosity of Peter Littman, then Chairman and CEO of Hugo Boss, we were able to acquire one of Cai's major installations, *Cry Dragon/Cry Wolf: The Ark of Genghis Khan*. This extraordinary piece from 1996—with its more than one hundred sheepskin bags lashed to a trellis of interwoven tree branches, seemingly powered into space by three Toyota engines—is among the highlights of the museum's contemporary art collection.

Later, with his major new works at MASS MoCA, it was clear to me that Cai had arrived at a special place in the art world. He could not be categorized simply as a Chinese artist of uncommon interest; he was, in fact, an international artist of unique and extraordinary power who had established an authentic presence in the global discourse at the highest levels. It occurred to me that if ever there was an artist on the contemporary scene whose work suggested a serious and comprehensive examination, it was abundantly obvious that Cai was just that artist.

I immediately asked a colleague, Min Jung Kim—who came to the Guggenheim from the curatorial department of the Ho-Am Museum in Seoul and has, for the past few years, held the title of Director of Strategic Development, Asia—to initiate discussions with Cai to see if a major exhibition project could be organized. Min Jung's counterpart in Cai's studio, Jennifer Wen Ma—an artist in her own right and, for several years, Studio Director and collaborator with Cai—proved to be the perfect interlocutor. Numerous discussions with Cai, Jennifer, and Min Jung followed: at the Guggenheim; in Cai's studio to look at plans for current projects and new work; and in Beijing where Cai was beginning to collaborate on the plans for the opening and closing ceremonies of the Beijing 2008 Olympic Games.

Perhaps the only impediment to the planning was Cai's insistence that I be the curator of his exhibition. My reluctance was hardly a function of the degree of my commitment to his work, and more a question of whether I could take the time from other Guggenheim activities to devote what would be required to realize such an ambitious and consuming enterprise. Fortuitously, Alexandra Munroe had joined the Guggenheim curatorial staff as Senior Curator for Asian Art, and graciously agreed to participate as co-curator. Coming from the Japan Society and with

considerable experience in Asian and contemporary art, Alexandra took charge of the practical curatorial organization for the Cai retrospective and played an important role in the final selection of the work in the exhibition. Her boundless enthusiasm is balanced by a conceptual rigor, ensuring that the exhibition and the accompanying catalogue elucidate the artist's historical contribution and boldly explicate new directions and implications in the work. Her scholarship, which balances Asian art and intellectual histories with modern and postmodern art critical discourse, offers a model for a new generation of curatorial practice. I am profoundly grateful to Jennifer, Min Jung, and Alexandra.

As the work on the exhibition unfolded, key representatives from the Cai Studio—especially Hong Hong Wu, Michelle Yun, Lesley Ma, and Mariluz Hoyos—have worked tirelessly to realize every aspect of this ambitious project, and I offer them my most profound thanks. With such capable professionals involved, I particularly enjoyed the luxury of my many meetings with Cai and Alexandra to discuss which works should be included in the exhibition and how they would be placed within the complexity of Frank Lloyd Wright's masterpiece building.

Of course, an exhibition of this ambition and magnitude would not have been possible without the generous support of our sponsors. I am deeply grateful to The Robert H. N. Ho Family Foundation for its most generous leadership grant, which has been essential in helping the Guggenheim to realize this project. In particular, I would like to acknowledge Robert H. N. Ho and his wife Greta for their extraordinary mission to foster and support Chinese arts and culture throughout the world and promote inspired arts education programming. Their enlightened support has been a great source of encouragement to our efforts. My good friend Silas Chou and his delightful wife Celia have shared a fascination with Cai's work for many years, and they have made an important financial contribution to this project.

Caroline Pfohl-Ho, President of the Ho Foundation, was an early champion of this project and I am deeply indebted to her for her guidance. I would also like to acknowledge Lillian C. K. Hau, Executive Director of the Ho Foundation, for her cheerful and efficient management of the numerous details of this sponsorship.

I offer my thanks as well to Thirteen/ WNET for joining this project as media partner. Thirteen/WNET has been a longtime supporter of the Guggenheim and I am grateful for their continued dedication to promoting our exhibitions to broader audiences. The National Endowment for the Arts also awarded an important grant in support of this exhibition.

The ambitious realization of *Cai Guo-Qiang: I Want to Believe* was made possible in part by the Guggenheim Museum's Asian Art Advisory Board, whose chairs, Jack and Susy Wadsworth, have provided inspired leadership, sage council, and extraordinary generosity. For their contributions toward this exhibition, we are also grateful to Christophe Mao and Chambers Fine Art and to Jack and Susy Wadsworth. The Leadership Committee for *Cai Guo-Qiang: I Want to Believe* is also gratefully acknowledged, as is Wendi Deng Murdoch for her important guidance and belief in Cai's art. From the Guggenheim, John L. Wielk, Executive Director of Corporate and Institutional Development, and Helen Warwick, Director of Individual Development, have presided over assembling sponsorship resources for this project, and their steadfast determination and focus have been an inspiration to us all.

Finally, and above all, I am grateful to Cai Guo-Qiang for generously sharing with us his time and creative energy, as well as his vision, which so brilliantly connects art to the ever-changing trajectories of culture, history, and society.

Thomas Krens
Director
Solomon R. Guggenheim Foundation

ACKNOWLEDGMENTS

Cai Guo-Qiang: I Want to Believe presents the most comprehensive survey to date of the inventive and provocative work of Cai Guo-Qiang and represents the Guggenheim Museum's first solo exhibition devoted to a Chinese-born artist. Initiated by Thomas Krens in 2004, this project was conceived as a collaboration with the artist and has benefited at every stage and on every dimension from the artist's expansive vision, unrelenting ambition, and extraordinary generosity. I joined the project as co-curator in 2006, and Cai's protean spirit and continuously evolving art have been a constant source of inspiration in guiding the exhibition and catalogue to fruition. Cai is no stranger to the complexities of staging large-scale events—indeed events are essential to his methodology. Naturally, his sustained support of the exhibition planning process was as constructive as it was empathetic. On behalf of the Guggenheim Museum's Project Team, I would like to express the sense of privilege that we have all felt in becoming part of Cai's world, where tolerance for big ideas and the aspiration for excellence are boundless. Cai's wife, Hong Hong Wu, has contributed in myriad ways to every facet of the exhibition's conception, development, and realization. We thank her for sharing her thoughts, recollections, and insights on Cai's life and art, and for imparting throughout a generous wisdom that has benefited what Cai would call the positive "energy flow" of the entire project.

Cai Guo-Qiang: I Want to Believe owes much to the prodigious and exacting input of Cai Studio. We offer enormous gratitude to Cai and Hong Hong Wu for opening their resources to the point where the studio became a direct extension of the Guggenheim's curatorial apparatus. First, I would like to thank artist Jennifer Wen Ma, Cai's former Studio Director, whose contributions helped shape the early conception of this project, and whose ongoing advice has been invaluable. Michelle Yun, Project Director, supervised every facet of the project's organization and implementation with extreme care and responded to each new proposal with a demand for clarity that broadened and stimulated our thinking. Lesley Ma, Project Manager, tirelessly supported our object research, outreach to lenders, and translation requests and guided us in dealing with the exact nature of Cai's fundamentally ephemeral art. Mariluz Hoyos, Head of Archives and Research, provided much of the visual and textual materials that formed the foundation of our research, and cheerfully prepared nearly every image of Cai's art that appears in this publication. Finally, Technical Director Tatsumi Masatoshi, who has worked with Cai since his early years in Japan, was instrumental in designing and implementing Cai's enormously complex installations at the Guggenheim Museum, and reimagining them for each of the exhibition venues. Cai operates essentially as a conceptual artist, and it is moving to observe how instinctively Tatsumi-san works as the artist's direct hand. The process of working together on the exhibition, catalogue, and public programs has been a deepening partnership with all of the gifted individuals of the Cai Studio staff, who are each acknowledged on the Project Team listing. Takahisa Araki's and Hiro Ihara's documentary materials have served as an excellent resource for the organization of the exhibition and publication.

Collaboration with local communities is one of the basic tenets of Cai's practice. For some key installations featured in the Guggenheim retrospective, we have invited the original members who worked on specific installations to re-create the works at each exhibition venue. The excavated boat that is the central element of *Reflection—A Gift from Iwaki* (2004) has been reassembled by a group of craftsmen who have traveled from the city of Iwaki in northeastern Japan. We would like to thank the following individuals from Iwaki for bringing their traditional Japanese carpentry and maritime crafts to the realization of Cai's visionary art: Shiga Tadashige, Fujita Chuhei, Kanno Yoshio, Maki Takashige, Nawa Makoto, Ono Kazuo, and Shiga Takemi. The restaging of Cai's *Venice Rent Collection Courtyard* (1999) ensemble of life-size clay sculptures, which are constructed on-site, has been supervised by Long Xu Li, one of the original artists of the Sichuan Fine Arts Institute who worked on the 1965 sculpture, and Long Shu. We are also grateful to Cai Guo-Sheng, President of the Quanzhou Xinwen Craft Company, who fabricated the river for *An Arbitrary History: River* (2001). For their helpful interpretation for our visiting installation team members, we acknowledge Ikuyo Nakagawa, Eric C. Shiner, and Aso Shinsuke.

One of the joys of working as a curator at the Guggenheim Museum is the institution's support of extraordinary projects that reflect the artist's vision. Cai Guo-Qiang designed the exhibition as a spectacular site-specific installation within Frank Lloyd Wright's celebrated rotunda that called for suspending real cars from the central atrium for a new version of *Inopportune: Stage One* (2004), building fifty life-size clay sculptures on-site for *Venice's Rent Collection Courtyard*, and constructing a riverbed of bamboo and resin to hold several tons of water for *An Arbitrary History: River*. The exhibition includes a myriad of works that demanded special care, not only during the installation and deinstallation but also throughout the course of the exhibition. All of this and more were expertly realized by our installation and

technical staff whose undaunted embrace of each new challenge energized the entire project. I would like to acknowledge Jessica Ludwig, Director of Exhibition Planning and Implementation; Melanie Taylor, Senior Exhibition Design Coordinator; Peter B. Read, Manager of Fabrications; Christopher George, Chief Fabricator: Paul Kuranko, Multimedia Specialist; Meryl Cohen, Director of Registration and Art Services; Laura Graziano, Assistant Registrar; David Bufano, Chief Preparator; Barry Hylton, Senior Exhibition Technician; Michael Sarff, Exhibition Construction Manager; Mary Ann Hoag, Lighting Designer; Carol Stringari, Chief Conservator; Julie Barten, Conservator for Collections and Exhibitions; Nathan Otterson, Sculpture Conservator; Jeffrey Warda, Assistant Paper Conservator; Marcia Fardella, Chief Graphic Designer; Steve Ursell, Director of Security; and Boris Keselman, Chief Engineer. I am also grateful to Gilsanz, Murray and Steficek LLP, Structural Engineers and Building Envelope Consultants for their assistance with this ambitious installation.

This project was a total and seamless team effort, and I wish to acknowledge Mónica Ramírez-Montagut, Assistant Curator of Architecture and Design, for expertly managing the complexity of loans from individuals and institutions located across the globe. Mónica's insights into Cai's practice as it relates to architecture and spatial concepts contributed to the exhibition design, and her introductory essay on Cai's installations enriches this catalogue. Sandhini Poddar, Assistant Curator of Asian Art, ably managed every aspect of the catalogue preparation and contributed the introductory essay on social projects that expounds on Cai's utopian and communitarian strategies. Sandhini also compiled the Chronology, which features illuminating excerpts from an extensive interview that I conducted with the artist in May 2007. I am especially indebted to Mónica and Sandhini for their spirited dedication to the project, thorough attention to detail, and close relations with the Cai Studio and every member of the Project Team.

Director of Education Kim Kanatani and her staff, Christina Yang, Senior Education Manager, Public Programs, and Sharon Vatsky, Senior Education Manager, School Programs, brought tremendous experience to the public programs that explore the far-reaching impact of Cai's diverse practice. The Sackler Education Center was responsible for working with Cai to realize a new iteration of the *Everything Is Museum* series, which features museum proposals and art installations by Norman Foster, Thomas Krens, Tan Dun, Jennifer Wen Ma, and Kiki Smith. Bringing the richness of this exhibition program to the wide public has been spearheaded by Eleanor R. Goldhar, Deputy Director for External Affairs, supported by Betsy Ennis, Director of Public Affairs, Laura Miller, Director of Marketing, and Maria Celi, Director of Visitor Services. Their enthusiasm for the magnitude of Cai's vision and his relevance for contemporary culture has helped ensure this project's lasting impact. Min Jung Kim, Director of Strategic Development, Asia, was instrumental in the early stages of this project and has offered support and advice at critical junctures of the New York presentation and international tour. The Legal Department, including Sarah Austrian, General Counsel, Sara Geelan, Assistant General Counsel, and Dana Wallach, Assistant General Counsel, provided expert advice for the particular challenges that arise out of Cai's ambitious work. From early on, our finance department, specifically Christina Kallergis, Budget Manager for Programs and Operations, and Sari Sharaby, Senior Financial Analyst, helped us to estimate and manage an extremely complicated project budget. In sum, each Guggenheim department contributed towards making this exhibition a landmark experience, and I am grateful to the dedication and creativity of all those listed in the Project Team credit page.

This accompanying catalogue also reflects Cai's direct creative engagement. Our goal has been to construct an illuminating, interpretive survey of Cai's art in all mediums over two decades of creative production; to provide a critical framework for appreciating the originality of his methodology; and through our study, to contribute to the emerging theoretical and art-historical discourse of contemporary Chinese art and its global context. In this regard, I would like to thank our catalogue authors for their original and insightful contributions. David Joselit, Chair, Department of Art History, Yale University, examines Cai Guo-Qiang's use of "cultural readymades" as an index of the diffusion of national cultures in a globalized world, what he calls their "diasporic formations," thereby positioning Cai's work as the postmodern iteration of a key Duchampian idea. Miwon Kwon, Associate Professor of Art History, University of California, Los Angeles, analyzes Cai's strategic choice of gunpowder within the context of Cai's underlying interest in the interface of art and war, and relates Cai's recent views of "destruction as expenditure" to the theoretical writings of Georges Bataille. Wang Hui, Research Professor of Tsinghua University, Beijing, and former editor-in-chief of *Dushu*, one of China's leading intellectual journals, explores Cai's art of spectacle and event as deeply related to the dialectics of revolution in modern Chinese history, especially the forces of civilization and savagery. We are grateful to Rebecca

Karl, Associate Professor, New York University, and a leading scholar of modern Chinese intellectual history, for the translation of Wang Hui's essay. Since Cai emerged on the international stage, his work has stimulated a significant body of critical writings that represents a range of contemporary art discourses, from those who see his work within an Asian lineage to those who promote his work as representative of the culture of globalization. Beijing-based critic and author Philip Tinari has compiled the Anthology, a selection of writings by and about Cai that charts this critical history. Consulting Scholar Reiko Tomii has contributed to the conceptual organization of data that comprises the catalogue sections, which present the most comprehensive documentation ever published on Cai's work across five areas: Early Works, Gunpowder Drawings, Explosion Events, Installations, and Social Projects. Reiko also selected and translated the Japanese texts for the Anthology, and compiled the entries for the social projects. Michelle Yun and Mariluz Hoyos of Cai Studio are the main compilers and authors of the catalogue entries and data, as well as the Bibliography and Exhibition History; their meticulous research helps establish this book as the definitive study to date on Cai's work. We are grateful to all of our authors and contributors for their research and writing that ensures this publication's lasting relevance for future scholarship. The design of the book, too, was a collaboration with the artist, and I am grateful to designer Miko McGinty for giving Cai's intention graphic brilliance. Miko has given elegant clarity to a large amount of textual and visual material, and we thank her and Rita Jules for their tireless work at every stage of conception, development, and production.

I commend the talents of the Publications Department in supporting the curatorial vision for this catalogue and for dealing with the complex editorial process that entailed coordination among an international team of scholars and translators. Elizabeth Levy, Director of Publications, expertly oversaw every aspect of the catalogue; Elizabeth Franzen, Managing Editor, and Edward Weisberger, Senior Editor, advised and supervised content with great acumen and Edward along with Helena Winston, Associate Editor, and Stephen Hoban, Assistant Managing Editor, worked carefully with each author to refine their texts; Melissa Secondino, Production Manager, and Jonathan Bowen, Associate Production Manager, meticulously managed all production details. David M. Heald, Director of Photographic Services and Chief Photographer, contributed photographs of Cai's work. I am grateful to each of these superb professionals for allowing us to realize every dream that we harbored for this book.

This exhibition would not have been possible without the support of the many institutions and individuals in Asia, America, and Europe who generously lent works of art. In this context, I would like to thank Hong Hong Wu, Michelle Yun, Lesley Ma, and Mariluz Hoyos of Cai Studio for facilitating several important loans from the artist's collection. We specially acknowledge the generous cooperation of Eric Chang and Ingrid Dudek, Asian Contemporary Art, Christie's, who helped to secure several key loans from private collections. I am also grateful to Jeffrey Deitch, Deitch Projects; Michael Hue Williams, Albion; Christophe Mao, Chambers Fine Art; and Xiaoming Zhang, Contemporary Asian Art, Sotheby's for their keen advice and encouragement. We are grateful to the following individuals for believing in the relevance of this project and supporting it with important loans to one or more of the international exhibition tour venues: Alia Al-Senussi, Albion, London; Timothy Rub, Gretchen Shie Miller of the Cleveland Museum of Art; Miyatsu Daisuke, Japan; Friedhelm Hütte, Christina Maerz, Sara Bernshausen, Carmen Schaefer of Deutsche Bank, Germany; Robert C. Y. Wu, Emily Chao, Chang Hai-ping of Eslite Gallery, Taiwan; Thomas Lentz, Helen Molesworth, Anne Driesse Erin Hayde, Francine Flynn, Maureen Donovan, Craigen Bowen of the Harvard University Art Museums, Fogg Art Museum, Cambridge; Hervé Chandès, Grazia Quaroni, Corinne Bocquet, Alanna-Minta Jordan of Fondation Cartier pour l'art contemporain, Paris; Ishimatsu Noriko, Ishida Takehisa of the Fukuoka Asian Art Museum, Japan; Olga Viso, Kerry Brougher, Keri Towler, Amy Snyder of the Hirshhorn Museum and Sculpture Garden, Smithsonian Institution, Washington, D.C.; Issey Miyake, Kanai Jun, Omori Masako of Issey Miyake Design Studio, Tokyo and New York; Miani Johnson, New York; Anne Sofie Kries, Switzerland; Angela and Massimo Lauro, Naples, Italy; Kaspar König, Ulrich Wilmes, Museum Ludwig, Cologne; Hasegawa Yūko, Aki Fujii of the Museum of Contemporary Art, Tokyo; Glenn Lowry, Cora Rosevear, Lynda Zycherman, Jerry Neuner, Sydney Briggs, Stefanii Ruta of the Museum of Modern Art, New York; Pierre Théberge, Caroline Cotê of National Gallery of Canada, Ottawa; Derrick Cartwright, Betti-Sue Hertz, Tammie Bennett of the San Diego Museum of Art; Caspar H. Schübbe, Switzerland; Mimi Gardner Gates, Lauren Mellon, Lauren Tucker of the Seattle Art Museum; Sakai Tadayasu, Noda Naotoshi of Setagaya Art Museum, Tokyo; Leo Shih, Taiwan; Sardjana Sumichan, Aiko W. Sumichan, Singapore; Wijono Tanoko, Indonesia; Guy and Myriam Ullens, Guy & Myriam Ullens Foundation, Switzerland; and the Yageo Foundation Collection, Taiwan.

An exhibition of this magnitude requires significant funding. On behalf of the entire Cai exhibition team, I offer my gratitude and admiration to the Development Department for its dedicated efforts to support this exhibition, its catalogue, and related educational programs. John L. Wielk, Executive Director of Corporate and Institutional Development, has led the planning and implementation of our outreach, and supported by Stacy Dieter, Director of Corporate Development; Renée Schacht, Associate Director of Institutional Development; and Lisa Brown, Manager of Corporate Sponsorship, his team has excelled in gathering major gifts from international corporate and foundation sources, as well as from the U.S. Government. Helen Warwick, Director of Individual Development, Ben Whine, Associate Director of Individual Development, and Abigail Lawler, Associate Manager for Individual Development, have worked their inimitable magic to gather support for this project and the Guggenheim's overall Asian art initiative, and I thank each for their essential

contribution to our success. Adrienne Hines, Executive Director of Major Gifts, has guided funding of special projects related to the exhibition, and we thank her for her spirited support.

In 2006, the Guggenheim became the first international modern and contemporary art museum in the West to establish a curatorial position for Asian art. *Cai Guo-Qiang: I Want to Believe* is the first exhibition organized by the Guggenheim Museum's Asian art program, and I offer my sincerest appreciation to Thomas Krens for his inspired and energizing leadership that has endowed this initiative with a most timely mandate. The personal and professional support of former Guggenheim Museum Director Lisa Dennison has been absolutely critical to the realization of the Asian art initiative and this inaugural exhibition, and I offer her my deepest gratitude. I also thank Marc Steglitz, Interim Director of the Guggenheim Museum, and Chief Curator Nancy Spector, who have lent constant encouragement at every stage of this program's development. Assistant Curator of Asian Art Sandhini Poddar, whose expertise in South Asian art complements my own East Asian background, is a vital administrative steward of all facets of our Asian art initiative and offers a lively source of intellectual companionship.

Cai Guo-Qiang: I Want to Believe is supported by the W. L. S. Spencer Foundation, the Starr Foundation, and the Asian Cultural Council. The Guggenheim is privileged to work with these foundations whose dedication to deepening the reception for Asian art in America has had far-reaching impact. The Asian art initiative is supported by the Guggenheim Museum's Asian Art Advisory Board, which was established in 2007. The board is chaired by Jack and Susy Wadsworth, whose extraordinary philanthropic focus on contemporary Asian art has been instrumental in shaping the field over the last fifteen years. I am grateful to Jack and Susy for their partnership in this cultural, curatorial, and institutional enterprise, and I offer my thanks to the Asian Art Advisory Board members whose generosity has contributed to the realization of this exhibition: Jane deBevoise and Paul Calello; J. Christopher Flowers and Mary White; Barbara Hemmerle Gollust and Keith Gollust; Kenneth Miller and Lybess Sweezy; and Honorary Member, Jennifer Blei Stockman, President of the Solomon R. Guggenheim Foundation, whose keen enthusiasm has further galvanized our activities. Central to the Guggenheim's Asian art activities is the formation of the Asian Art Council, a group of scholars, curators, and artists who serve as our curatorial think tank to map the intellectual course of modern and contemporary Asian art and to debate key issues pertinent to its curatorial practice. I would like to acknowledge the members of this council, which convened for its inaugural annual meeting in September 2007: Arjun Appadurai, Senior Advisor for Global Initiatives at The New School University; Homi K. Bhabha, Anne F. Rothenberg Professor of English and American Literature, Harvard University; Vishakha N. Desai, President, Asia Society; Layla S. Diba, independent curator; David Elliott, independent curator and writer, Istanbul; Fan Di'an, Director, National Art Museum of China, Beijing; Doug Hall, former museum director, Queensland Art Gallery; Hasegawa Yūko, Chief Curator, Museum of Contemporary Art, Tokyo; Hou Hanru, independent curator and writer, Director of Exhibitions and Public Programs, Chair of Exhibition and Museum Studies, San Francisco Art Institute; RaYoung Hong, Deputy Director, Leeum Samsung Museum of Art, Seoul; David Joselit, Chair, Department of the History of Art, Yale University; Geeta Kapur, critic and curator, New Delhi; Hongnam Kim, Director, National Museum of Korea, Seoul; Victoria Lu, Director, Moon River Museum of Contemporary Art, Beijing, and Creative Director, Shanghai eARTS Festival, Shanghai; Pan Gongkai, President, Central Academy of Fine Arts, Beijing; Apinan Poshyananda, Director-General of the Office of Contemporary Art and Culture at the Ministry of Culture, Thailand, Chair and Acting Director of the Office of Knowledge Management and Development under the Prime Minster's Office, Thailand; Uli Sigg, collector; Shahzia Sikander, artist; Andrew Solomon, author and cultural critic; Wang Hui, intellectual historian, Tsinghua University, Beijing; and Xu Bing, artist.

In addition to the Asian Art Council members, I would like to acknowledge the following colleagues for lending their insights to this exhibition project: Geremie Barmé, Australian National University; Johnson Tzong-Zung Chang; Gao Shiming, China Art Academy; Wu Hung, University of Chicago; Robert Mowry, Harvard University Art Museums; Nanjō Fumio, Mori Art Museum; Philip Tinari; and Reiko Tomii.

On a personal note, I wish to thank Cai Guo-Qiang for expanding the parameters and thinking of my own curatorial practice. For Cai, an exhibition is far more than a fixed assembly of objects; it is a live event that exists as a constantly evolving process in time and space. Objects activate social interactions and propel astonishing flashes of insight; they are never static things but rather interconnected agents for invigoration. Every aspect of the show's preparation, installation, public programs, catalogue, and tour thus reveals itself as one piece or stage of a larger ecosystem—Cai's ecosystem. It has been a remarkable experience to operate within this particular culture, whose teachings I will carry forward.

Alexandra Munroe
Senior Curator of Asian Art
Solomon R. Guggenheim Museum

PROJECT TEAM

SOLOMON R. GUGGENHEIM MUSEUM

ADMINISTRATION
Marc Steglitz, Interim Director and
 Chief Operating Officer
Brendan Connell, Director and Counsel
 for Administration
Boris Keselman, Chief Engineer
 of Facilities

ART SERVICES AND PREPARATIONS
David Bufano, Chief Preparator
Barry Hylton, Senior Exhibition Technician
Paul Bridge, Art Handler
Derek Deluco, Technical Specialist
Elisabeth L. Jaff, Associate Preparator
 for Paper
Jeffrey Clemens, Associate Preparator

CONSERVATION
Carol Stringari, Chief Conservator
Julie Barten, Conservator for Collection
 and Exhibitions
Nathan Otterson, Sculpture Conservator
Jeffrey Warda, Assistant Paper Conservator
Esther Chao, Project Assistant Conservator

CONSTRUCTION
Michael Sarff, Exhibition Construction
 Manager

CURATORIAL
Thomas Krens, Director, Solomon R.
 Guggenheim Foundation
Alexandra Munroe, Senior Curator of
 Asian Art
Mónica Ramírez-Montagut, Assistant
 Curator of Architecture and Design
Sandhini Poddar, Assistant Curator of
 Asian Art

CURATORIAL INTERNS
Ting-Chi Wang
Hanyu Zhang
Yao Wu
Jieun Kim
Daisy Wong

DEVELOPMENT
Adrienne Hines, Executive Director
 of Major Gifts
John L. Wielk, Executive Director of
 Corporate and Institutional Development
Stacy Dieter, Director of Corporate
 Development
Helen Warwick, Director of Individual
 Development
Stephen Diefenderfer, Associate Director
 of Museum Events
Bronwyn Keenan, Associate Director of
 Special Events
Renée Schacht, Associate Director of
 Institutional Development
Ben Whine, Associate Director of Individual
 Development
Brady Allen, Associate Director of
 Development Operations
Jenny Parsons, Manager of Corporate
 Membership
Lisa Brown, Manager of Corporate
 Sponsorship
Julia Brown, Manager of Membership
Abigail Lawler, Associate Manager for
 Individual Development

EDUCATION
Kim Kanatani, Director of Education
Christina Yang, Senior Education Manager,
 Public Programs
Sharon Vatsky, Senior Education Manager,
 School Programs

EXHIBITION DESIGN
Ana Luisa Leite, Manager of Exhibition
 Design
Melanie Taylor, Senior Exhibition Design
 Coordinator
Shraddha Aryal, Exhibition Designer

EXHIBITION DESIGN INTERNS
James Way
Jitendra Arora
Natalia Canas

EXHIBITION MANAGEMENT
Jessica Ludwig, Director of Exhibition
 Planning and Implementation,
 New York

FABRICATION
Peter B. Read, Manager Exhibition
 Fabrication and Design
Christopher George, Chief Fabricator
Richard Avery, Chief Cabinetmaker
David Johnson, Chief Framemaker
Doug Hollingsworth, Cabinetmaker
Peter Mallo, Cabinetmaker

FINANCE
Amy West, Director of Finance
Christina Kallergis, Budget Manager for
 Programs and Operations
Sari Sharaby, Senior Financial Analyst
Yoni Yahalom, Senior Financial Analyst

GRAPHIC DESIGN
Marcia Fardella, Chief Graphic Designer
Concetta Pereira, Production Supervisor
Janice Lee, Senior Graphic Designer

LEGAL
Sarah Austrian, General Counsel
Sara Geelan, Associate General Counsel
Dana Wallach, Assistant General Counsel

CAI GUO-QIANG: I WANT TO BELIEVE

ALEXANDRA MUNROE

Artists have a way of filling their work spaces with images and artifacts that have talismanic power, and Cai Guo-Qiang is no exception. A Chinese stone lion guards the entrance way to his large, garden studio in Manhattan's East Village. A full-page newspaper advertisement reproducing a majestic El Greco painting is taped to a door, and a multipanel gunpowder drawing of an eagle with wings fully spread—Cai's *Man, Eagle, and Eye in the Sky: The Age of the Eagle* (2004, fig. 80)—occupies a place of honor, watching over and blessing the studio's activities. The most unexpected and arresting icon, however, is a poster depicting a UFO hovering in the sky above a bucolic landscape printed over with the words "I Want To Believe."

Cai's largest series of artworks to date is called *Projects for Extraterrestrials*. For the artist, imagining the existence of alien intelligence compels a contemplation of alternative, coexisting, or multiple realities that is akin to the function of art. The perception of art is an experience of believing in something that does not actually exist, or rather, exists as another reality. Along with the supernatural and UFOs, Cai's work freely cites historical legends and folk myths, apocalyptic imagery and healing powers, the big bang and terrorist acts—all utilized in different ways to suspend, provoke, and challenge our habits of mind. The slogan "I Want to Believe"—which unbeknownst to the artist was popularized by the television

series *The X-Files*, captures the brilliant ambiguities at the core of Cai's protean artistic practice.

Cai is best known for his use of gunpowder. Invented by the Chinese and called fire-medicine (*huoyao*), gunpowder is arguably China's single technological advance of the last millennium that has had truly global consequences. Cai mines this material's charged associations and has used it to create a radical new form and methodology of art. Explosives are central to his signature gunpowder drawings, which are made by laying gunpowder and fuses on fibrous paper and igniting them in a blast that creates charred residue of the original matter. Gunpowder is also the essential material for Cai's spectacular explosion events, which are site-specific pyrotechnic displays, often on a monumental scale. Although his practice can be related to Conceptual art, performance, and Land art, Cai extends each art form toward a new matrix by operating outside conventional parameters. Where artists like John Cage, Chen Zhen, and Yves Klein have used fire, smoke, or burned matter to make objects of art, Cai uses explosives to directly manifest the pure force of energy, not to induce art but as an art form itself. While the intention of modernism and the avant-garde was the destruction of boundaries between art and life, his strategy to embody destruction itself shifts the conceptual framework to the blurring of boundaries between art and

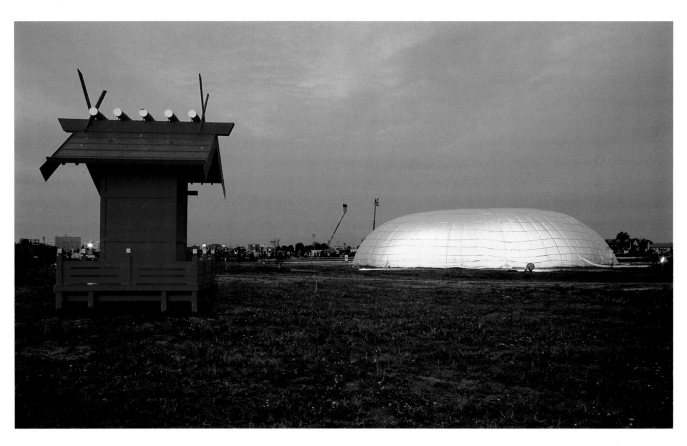

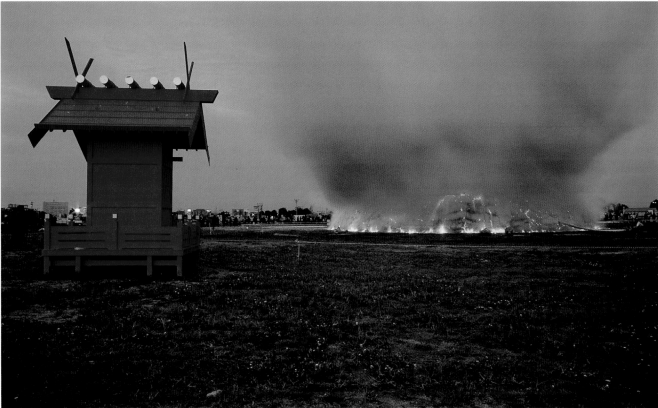

FIGS. 1 AND 2. *SKYBOUND UFO AND SHRINE*, REALIZED AT OBIHIRO RACETRACK, HOKKAIDŌ, AUGUST 11, 2002, 6:30 PM, APPROXIMATELY 20 SECONDS. BLIMP, GUNPOWDER FUSE, AND SHRINE. COMMISSIONED BY P3 ART AND ENVIRONMENT FOR *TOKACHI INTERNATIONAL CONTEMPORARY ART EXHIBITION: DEMETER*

FIG. 3. CAI STUDIO, NEW YORK, 2007

war. "I make explosions, " Cai has remarked, "so I pay attention to explosions."[1]

Inherent throughout Cai's art are unstable structures of process and transition, doubt and ambivalence. For him, matter and energy are equally materialized and dematerialized. The transformations from one state to another are both the method and the meaning of his art. All states of a work's creation, including its destruction, coexist in the work itself. This complete freedom from fixed form shapes a body of work that has evolved from studio paintings to interactive installations to visual extravaganzas for vast audiences. Cai's subject matter ranges from Buddhist metaphysics to cosmological science, from ancient healing systems to contemporary car bombings, and what underpins his diverse practice is the core ideal that art link—if *you* want to believe—the seen and unseen worlds.

The ideal of belief also generates the political dimension of Cai's art. A socialist utopianism pervades his artistic strategies, and has led to using the term "social projects" to describe a range of work for which the allure of socialist memory and the idea of absolute faith in communitarian forces of historical progress—another kind of unseen world—are key to the artist's process, imagination, and narrative. An ongoing aspect of this approach is Cai's working method for producing explosion events and installations that requires dozens, even hundreds, of collaborators, including professional project teams, art-world volunteers, and local residents. More specifically, his social projects comprise the *Everything Is Museum* series for which he has produced MoCAs (museums of contemporary art; see cat. nos. 50–52) in remote sites, appropriating nonart structures such as military bunkers and old kilns. He assumes the role of curator and invites the participation of artists and the local public alike to install work and participate in his "museum" events. Cai's infiltration of nonart spaces and local communities involves extraordinary logistical negotiations, relies on his considerable charisma and mobilization skills, including fund-raising, and is infused with an idealistic socialism that aspires to claim the public realm as a site for art of democratic empowerment. Critic and curator Hou Hanru has commented on similar ideals that have shaped artists who were born and raised in the early decades of Mao Zedong's China:

> My generation of Chinese has been fighting for more fundamental issues of humanity. For us, the first necessity of art is never to return to the enclosure of the self. The second thing is to see how modernity rewrites the process of social transformation in different conditions, and then how it is visualized.[2]

Cai's exploration of the relationship between the individual and the collective society is best understood in the context of China's cultural and political memory, including its modern revolutionary history—a context that sets his collaborative practice apart

from his contemporaries in the West. Cai's 2006 participation in the *Long March: A Visual Walking Display* exemplifies how he has become increasingly interested in interrogating and reimagining the history and social idealism of early Chinese communism.[3] Initiated by Lu Jie and Qiu Zhijie in 2002, this Long March project was a curatorial experiment that utilized selected sites along the Red Army's mythologized 1934–35 Long March route. Cai's contribution took place in Yan'an, the terminus of the historic Long March, where Mao established his base and, in 1943, delivered his "Talks at the Yan'an Conference on Literature and Art." Cai prepared and discussed a curriculum of art education that critically engaged with Mao's radical Yan'an call to "make art for the people." The artist described his pedagogical method: "The program aims to endow students with the power of self-discovery, the ability to understand the past, present, and future of contemporary art more fully. . . . This will allow them to create based on problems and questions, and to carry out self-examination and self-criticism."[4] Cai's belief system, which is "earnest without being pious," reflects the aftermath of modern Chinese revolutionary thought.[5]

Ironically, it is precisely Cai's social optimism recalled from revolutionary history that is now in the service of China's postrevolutionary state. The opening and closing ceremonies he is collaborating on for the Beijing 2008 Olympic Games will be spectacles of unprecedented mass outreach, with an estimated audience of four billion television viewers. His faith in the global language of art to provoke critical wonder among the broadest populations adds another level of idealistic meaning to the words on the poster, "I Want To Believe." Critic Philip Tinari has commented, "In a way, his elevation to such a public role was only possible because his kind of belief is somehow palatable to this group of leaders and the way they want their national project to be seen."[6]

Taped to another wall of Cai's studio is a front-page article from the arts section of the *New York Times* in which critic Holland Cotter discusses *Light Cycle: Explosion Project for Central Park* (2003, cat. no. 32):

This is the stuff of a visionary, but unmystical art; complex in ideas, but tailored to a universal citizenry. In a world where politics, culture and nature are all unstable compounds, and everyone lives tensed in expectation of the next Big Bang, such art, like a throw of the I Ching, comes across as a judicious but exhilarating act of the faith in the benignity of the unknown. [7]

CRITICAL HISTORIES

The question of whether Cai is a global artist first and a Chinese artist second, or vice versa, has generated considerable confusion among art critics. He has consistently challenged this binary. By complicating, dodging, and deftly deflating the facile categorization of his work, Cai has contributed to this question's waning critical relevance in contemporary global art discourse. He was born in China in 1957 but has lived and worked outside the country since 1986. Until recently, he was associated with the phenomenon of overseas Chinese artists and was relatively unconnected to Mainland China. Cai was peripheral to the 1980s avant-garde movements, such as the Stars group, '85 New Wave, or Xiamen Dada, and did not participate in the historic *China/Avant-Garde* exhibition at the National Art Museum of China in 1989.[8] Indeed, most critics agree that he first made history within China only in 1999, when his installation at the Venice Biennale, *Venice's Rent Collection Courtyard* (cat. no. 42)—a re-creation of an iconic socialist-realist sculptural ensemble from 1965 (fig. 5)—became a national controversy.[9]

Cai's rise to international prominence following his move to Japan in 1986 and later to New York in 1995 is unparalleled in contemporary Chinese art. His high-profile participation in biennales and other international art events, his many solo museum exhibitions, and his Olympics collaboration—which is without doubt the most visible and important project within the Chinese art establishment today—lend Cai a unique status. As historian Geremie R. Barmé remarked, "Cai's international fame, which parallels and reflects the rise of China as a world power, stimulated the surge of interest in

contemporary Chinese art in the west. He will always be remembered as the first Chinese artist to become a house-hold name."[10] While it seems ironic that an unofficial artist will represent the Chinese state at the largest public ceremony in modern Chinese history, the fact that Cai's rise to fame has coincided with China's epic economic transformation during the years of reform has earned him his place in that history.

Cai's position within the Mainland Chinese avant-garde is a recent achievement, but he has long been a central figure among the émigré Chinese artists. Many artists of his generation were the first to leave their homeland after travel restrictions were lifted following the post-Mao reforms of 1979; others left after the military suppression of the Tian'anmen Square protests in 1989. The perpetuation of the Chinese government's antagonistic stance toward experimental art (*shiyan yishu*), which often led to terminations of art exhibitions and banning of artworks, the reluctance of state-run art galleries and schools to support installation art, video art, and performance, and the perceived insularity of the Chinese art world were among the factors that caused a significant exodus of artists through the early 1990s. This wave of immigration to the United States, Europe, Japan, and Australia included several artists who became China's most prominent in the international arena, including Chen Zhen, Gu Wenda, Huang Yong Ping, and Xu Bing.[11] The international awareness of contemporary Chinese art that advanced so dramatically during the late 1980s and the 1990s was largely due to the activities of these so-called "overseas artists" with transnational identities, including Cai, rather than those residing within China, Hong Kong, or Taiwan. Related to this phenomenon was the simultaneous emigration of a coterie of art critics and curators who would play an important role in introducing Chinese experimental art to the West, including Fei Dawei, Gao Minglu, Hou Hanru, and Wu Hung. In short order, their exhibitions and publications created the canon of contemporary art from China. Cai has been featured in most of the large surveys of Chinese art that these influential critic-curators have produced in the

West,[12] beginning with *Chine demain pour hier*, Fei's landmark 1990 exhibition in Pourrières, Aix-en-Provence, where the artist's *45.5 Meteorite Craters Made by Humans on Their 45.5 Hundred Million Year Old Planet: Project for Extraterrestrials No. 3* (cat. no. 19) introduced his explosion events to an international audience.

Cai's importance within this parallel history of Chinese contemporary art is critical, for he was among the first to contribute through the originality of his artistic strategies to discussions of Chinese art, however geographically dispersed, as a viable intellectual narrative with its own historical context and theoretical framework. Gao Minglu, curator of such important exhibitions as *Fragmented Memory: The Chinese Avant-Garde in Exile* (1993), *Inside Out: New Chinese Art* (1998), and *The Wall* (2006),[13] has proposed three requisites for this new art-historical inquiry: an artist must search for the principles of art making within specific Chinese cultural mechanisms; must learn from specific traditional philosophical concepts, aesthetic values, and techniques; and must develop experimental approaches to making art.[14] Cai not only satisfies these conditions; he helped to create them. What theorist Wang Hui wrote of modern Chinese thought applies equally well to Chinese art, and locates Cai's creative innovation:

> The teleology of modernization that has dominated Chinese thinking for the past century must now be challenged. We must reconsider our old familiar patterns of thought. Even though there is no one theory that can explain the complex and often mutually contradictory problems we now face, it nevertheless behooves Chinese intellectuals to break their dependence on time-honored binary paradigms, such as China/West and tradition/modernity, and to reconsider China's search for modernity and its historical conditions by placing these questions in the context of globalization. This is an urgent theoretical problem. . . . [It] may prove for Chinese intellectuals to be a historical opportunity for theoretical and institutional innovation.[15]

However valid it may otherwise be, this "Chinese art" framework poses limitations for an interpretation of Cai's work because of his association with Japan, where he lived from 1986 to 1995. It was in Japan that his work first achieved art-critical recognition, and he was championed within the emerging critical discourse of contemporary Asian art. For this discourse as it evolved in Japan, national identity was less significant than cultural identity—that is, East Asia—as defined by a spectrum of "Asian" aesthetics and philosophical sources. The artist-critic Lee Ufan, who first came to prominence in the late 1960s, was among those who drew on post-structuralism to posit the legitimacy of non-Western modernisms and argue for alternative referents for contemporary Asian artistic expression, including Taoism and Zen. The political, cultural, and philosophical foundations of modern Asia came to challenge, if not displace, the authority of the Eurocentric philosophy of modern art. This direction and the construction of "Asia" were informed by a sophisticated discourse about Japan, China, and modernity that dates back to Okakura Kakuzō, whose classic *Ideals of the East* (1903) advocated the recovery of traditional aesthetics to create an authentic, modern Pan-Asian culture that was not simply a crude imitation of Western models. This debate from the pre–World War II period culminated in a symposium on "overcoming the modern" (*kindai no chōkoku*) organized by the Literary Society (Bungakkai) in Kyoto in 1942. Although coopted in part by the state's Pan-Asian expansionist agenda, the purpose was to rethink Japan's course of modernization in terms of refuting westernization and articulating an autonomous, nativist, and spiritual vision of the future. Among its participants was the critic Kobayashi Hideo, who believed that Japan was already modern but dangerously close to becoming a mere replica of the West. Rejecting the rational, progressive view of history, Kobayashi proposed that the timeless "essence" of tradition, as found in art and objects of beauty, could save Japan by offering a source of "renewal, creative inspiration, and identity in a world insisting on the sameness of the modern."[16] After the war, the debates about modernity and

Asia led by such influential intellectuals as Takeuchi Yoshimi further argued for Japan's urgent need to resist the West's objectification of itself and to willfully pursue global equality before being subsumed by Western homogeneity. In Takeuchi's essay "Asia as Method" from 1961, he posed the question, "Shouldn't Japan rather stop pursuing the West and ground itself on Asian principles?"[17] Japan's gradual reconciliation from the late 1970s with its former colonies and occupied territories stimulated new iterations and elaborations of its Asian imaginary.

In Japan, Cai's explosion events, gunpowder drawings, and installations came to emblemize the successful recuperation of Asian culture within the contemporary language of international art. A leading institution for the research, collection, and exhibition of contemporary Asian art is the Fukuoka Art Museum, located at the historical crossroads of East Asia in southern Japan. In 1979 this museum began a series of Asian art exhibitions, making it the first forum in Japan to regularly show contemporary art from across Asia. Its continuing program has aimed to create new criteria for Asian art's distinctive aesthetics independent of the framework of fine art derived from the West.[18] Curator Kuroda Raiji reflected that "it is not an overstatement that the notion of 'Asian contemporary art' was born in me when I witnessed the successful realization of Cai Guo-Qiang's explosion event [*I Am an Extraterrestrial, Project for Meeting with Tenjin (Heavenly Gods): Project for Extraterrestrials No. 4* (1990, fig. 47)]."[19] Kuroda also remarked:

> Cai's projects constitute communication with the whole of humankind, the whole of history, no, the whole universe, through the use of the medium of gunpowder, a Chinese invention. His art is completely new; it starts from zero and transcends such stale issues as East versus West, tradition versus modernity, and high culture versus popular culture. . . . [He] presented work that effortlessly satisfied the Euro-American critical standard of "originality" . . . and completely changed my idea of Asian art.[20]

Cai's goal—to challenge, disrupt, and imbalance the center of modern and contemporary art—is perhaps itself an "explosion" aimed at the entrenched status quo, as he himself stated:

Previously, [there were often two reasons that] art coming from Eastern Europe, the Soviet Union, and other non-Western areas was appreciated in the West: first, it was seen as criticism of the artist's own culture or national system; second, it was seen as proving that the artist was studying diligently, seeking to catch up with contemporary Western artistic expression. But these modalities, which have become ingrained in the West, are starting to change. After the Cold War, enthusiasm for non-Western cultures and multiculturalism has made it more difficult for the West to enact its whims, leading to a truly non-Western, multi-polar contemporary culture. Perhaps we are still in some ways the spring rolls at the banquet, but if the spring rolls carry bacteria, they can ruin the entire party.[21]

Cai's association with the Chinese émigré avant-garde and his importance within the Asian modernity discourse has prompted most Western critics and curators to rely on a predictable inventory of Chinese tropes to construct interpretations of his work. Taoism is frequently cited, for example, as Cai's primary philosophic source for such thematic content as qi (cosmic energy) and yin and yang (interdependent opposites). This tendency is partly the result of Cai's conspicuous appropriations of national symbols like dragons, feng shui (literally "wind-water"), acupuncture, and gunpowder. Too often, however, the critical perception of such imagery has led to a facile orientalist interpretation. Cai's deliberate self-exoticizing strategies have also tended to reinforce the familiar East-West binary, which has sometimes separated him from the international art world by identifying him too stridently as a Chinese artist.

A more interesting reading recognizes the political critique and inversion at the heart of Cai's Asian imagery and rhetoric. His installation Cry Dragon/Cry Wolf: The Ark of Genghis Khan (cat. no. 39), first realized at the Guggenheim Museum SoHo in competition for the Hugo Boss Prize 1996, utilizes seemingly stereotypical imagery: traditional sheepskin rafts are installed to look like the spine of a dragon, and the work's title cites Asia's most famous warrior, whose invasions reached as far as Eastern Europe. Cai inserted into this mythologic symbolization three running Toyota car engines, which augment Genghis Khan's historic military threat with functioning products of East Asia's current economic threat. Cai's installation is more than a spectacular reinvigoration of Chinese cultural devices; it critiques the West for its staid imagery of China while inferring the undercurrent of conflict characterizing U.S.-Asia relations in the era of globalization.

Indeed, it is finally as an artist of the global art system that Cai's work has come to be appreciated. Though the specific Chinese content of his work is apparent and intentional, and while Cai's socialist methodologies are grounded in the specifics of his childhood during the Cultural Revolution, his art operates in a framework of contemporary-art lineage that links Joseph Beuys and Yves Klein to Arte Povera in Italy and Mono-ha in Japan and to younger artists like Matthew Barney—an artist he exhibited with when both were short listed for the Hugo Boss Prize 1996, which Barney won. As critic Barry Schwabsky argued in a seminal 1997 essay on Cai in Artforum:

There is by now a multigenerational international vernacular of installation art that combines showmanship with elusiveness and synthesizes the collective familiarity of the readymade with the suggestively idiosyncratic "atmosphere" of bricolage. That Cai partakes of the international lingua franca does not make him an epigone—it simply identifies the idiom within which he works. From an aesthetic viewpoint, Cai must be counted among its most fluent practitioners.[22]

Cai, like many of today's most-widely exhibited artists, is an art-world nomad, always on the go, for whom fragmented existence is the norm. Rather than critique such peripatetic conditions, he embeds them in his art. History, geography, and culture are mutable, imagined signs that he feels free to mix up and free to assign with his own brand of universalism. Cai's early notions of chaos (hundun) based in Taoist cosmology and popular science have evolved into a belief in chaos as the ultimate postmodern condition of globalization—the collapse of linear time and spatial boundaries. "I am bringing chaos to time, to context, and to culture," he remarks. "I ignore the boundaries between different cultural heritages and freely navigate between Chinese, Eastern, and Western, or whatever world culture there is. I can take one out of context and put it into another, ignoring all boundaries and socially constructed constraints."[23]

Cai has been a central figure in the new art that has emerged since the late 1980s, namely, art that links the global and the peripheral, the transnational and the local. His work, largely realized through commissions from museums, international art events, and government agencies around the world, responds to and signifies the expanded parameters of art making and cultural identity in a global era. He recalls:

One time, someone gave me a form to fill out. The questions on this form were, 'What is a Chinese artist? What is an Asian artist? What is an international artist? What is a contemporary artist? And what is a traditional artist?' And for all of these answers, I wrote: 'It's me. This is what I am.' Our times have given us the opportunity to be able to say that we belong to every category. We are free to be whatever we want.

Eclectic, ahistorical, and essentially ephemeral, Cai's work draws on themes, ideas, and materials that pick up and also refute precedent. Arising from the epic geopolitical shifts of the post-Cold War, his work transgresses cultural boundaries as the ultimate creative force of our borderless age.

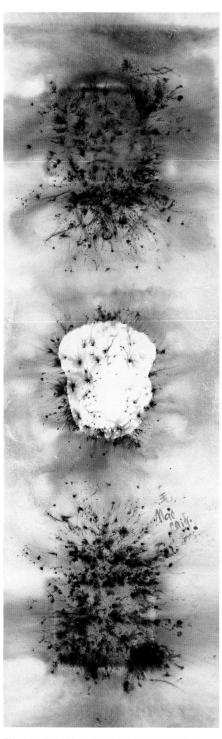

FIG. 4. *MAO*, 2005. GUNPOWDER ON PAPER, 235 X 77 CM. PRIVATE COLLECTION

HOMETOWN: NO DESTRUCTION, NO CONSTRUCTION

Cai was born in 1957 in the southeastern province of Fujian in Quanzhou, a coastal city characterized by a cultural openness to the outside world. Until recently, the majority of overseas Chinese who settled across Asia, the Americas, and Europe emigrated from Fujian and neighboring Guangdong Province. Émigrés maintained vital channels of communication and information with Quanzhou that fostered the city's remarkable cosmopolitanism. Quanzhou also has a long tradition of religious diversity— with Islam, Nestorian Christianity, and Manicheanism practiced alongside Buddhism, Taoism, and Confucianism—and is famous as the site, then one of the largest ports in the world, from which Marco Polo departed in 1292 for his return journey to Venice. The city's rich history has been an essential source of inspiration for Cai's work, prompting him to claim, "More than [all of] China, my hometown has informed my work. I am interested in mining the microcosm of my culture for symbols that can be universally understood."[24]

During the decades of Mao's regime, Quanzhou was politically marginal enough that various customs banned elsewhere survived. According to Cai, Buddhist and Taoist temples continued to hold festivals and a covert local culture of superstition, ghost stories, and myths stimulated his childhood imagination. The concepts and practice of traditional Chinese medicine based on acupuncture, as well as an understanding of the geomantic principles of feng shui, which tap into the energy currents of the land to promote auspicious environments, were natural belief-systems for Cai as he was growing up, and he attributes his fascination with the supernatural world of "unseen forces" to this early exposure. For his debut at an international arts exhibition, at the *46th Venice Biennale* in 1995, the artist created the social project *Bringing to Venice What Marco Polo Forgot* (cat. no. 48). Cai responded to this biennale's theme of "transculture" with a spectacular act of historical inversion that marked the seven-hundredth anniversary of Marco Polo's arrival back in Venice by sailing a Quanzhou junk filled with Chinese medicinal herbs along the Grand Canal. Cai's work brought to the West what the Italian explorer forgot: the spiritual teachings of the East.

Another anomaly of Cai's childhood in Mao's China was his family's relatively undisturbed social and political status. His father, Cai Ruiqin, is a member of the Chinese Communist Pary and worked in a state-run bookstore. He is also an amateur ink-painter and calligrapher (see fig. 24). According to Cai, he grew up in a milieu where the classical ideals of Chinese literati culture were still discussed. The elite scholar-artists (*wenren*, literally "men of literary culture") whose thinking shaped the critical tradition of Chinese art positioned themselves as independent from or even adversarial to the ruling imperial court, and held painting, calligraphy, and poetry as lofty pursuits of the individual mind and art appreciation as a direct engagement with the philosophical spirit of great sages of the past. "[My] family was always talking about the grandeur and accomplishment of Chinese art and civilization," Cai has commented. "But the huge discrepancy between the greatness of the art and the dissatisfaction in Chinese society created a natural rebelliousness in me. I wanted to follow Western tradition in oil painting and sculpture, and be influenced by Western thought. Now, looking back, I see I've inherited some of my father's scholarly thinking; Chinese cultural tradition has already unconsciously become part of me."[25]

While millions severely suffered in the decades following the establishment of the People's Republic of China in 1949, Cai is a *product* much more than a *victim* of his time. His precise trajectory, combined with his self-described instinctual wisdom (*wuxing*) and knack for taking advantage of opportunities, has allowed him to productively draw from Maoist revolutionary ideology, culture, and practice in ways that are inconceivable for artists born a generation earlier. From the age of nine, Cai was directly affected by the tumult of the government's Great Proletarian Cultural Revolution of 1966–76. Schools were shut down, and he participated as a young performer in various propaganda programs. Typically, parades and

celebrations in the streets involved beating drums and singing revolutionary songs while holding aloft portraits of Chairman Mao and banners proclaiming, "We are the critics of the old world; we are the builders of the new world." Cai's family was spared the terrors of authoritarian rule by which vast numbers of artists, academics, and intellectuals were denounced, jailed, or sent into exile. For him and his generation, Mao was and has remained the transcendent master of a vast revolutionary enterprise:

> To us, Mao Zedong is the most influential person in the latter half of the twentieth century. He is the idol, God-like. His artistic talent, calligraphy, poetry, military strategies, philosophy, essays, and revolution movements deeply influenced my generation, despite the fact that later on we all started to question his ideologies.

The perception of Mao and the era of modern China that he shaped as a source of conceptual identity and creative methodology for artists of Cai's generation is a topic of recent revisionist discussion in China.[26] The appropriation of Cultural Revolution imagery and narratives by artists like the Luo Brothers, Wang Guangyi, and Yu Youhan exemplify this phenomenon. In Cai's case, the argument that certain of his artistic strategies—in addition to iconography—are derived from his idealized memory of Maoist revolutionary culture is both persuasive and illuminating. Mao's slogan "No construction, no destruction" (*bu po bu li*) is central to Cai's practice, for example. Revolution, transformation, and idealism are born from radical elimination, and the foundation of new culture must lie in the demolition or reconfiguration of the past.[27] For an artist whose main material is gunpowder, such dialectics are theoretically and scientifically pertinent: Cai must literally

destroy in order to create. But beyond the methodology of art making, he takes from his memory of revolutionary praxis a deeper commitment to the critique of cultural constructs. Cai explains the ease with which he appropriates, dismisses, and layers multiple "translations" of Chinese culture in his own work, in order to arrive at a new iteration and provocation of culture itself, in terms of this deconstructive strategy:

> The Cultural Revolution began as a political movement that was basically an effort to overthrow traditional Chinese culture and heritage, to examine its failings and consider alternative directions for the future of Chinese culture. It was, fundamentally, a *cultural* revolution. It allowed people to reexamine the lineage of Chinese culture and education, and so produced a reflection, a way of looking at China. It was a large, societal way of

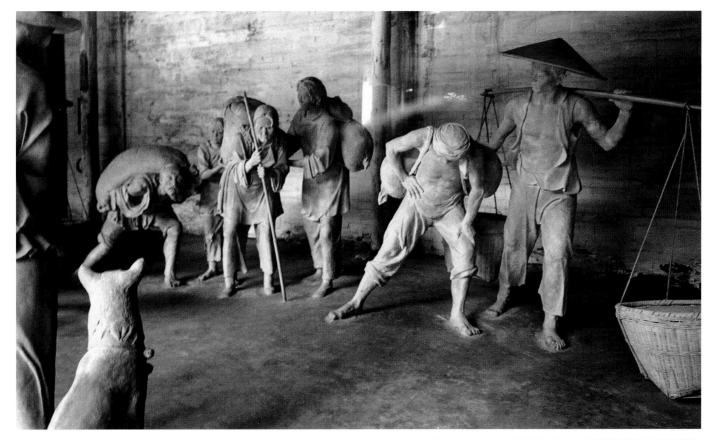

FIG. 5. PROFESSIONAL AND AMATEUR SCULPTORS OF SICHUAN PROVINCE, *RENT COLLECTION COURTYARD*, 1965 (DETAIL). 114 LIFE-SIZE FIGURAL SCULPTURES IN CLAY PLASTER, ARRANGED IN SIX SCENES. ON PERMANENT DISPLAY AT THE FORMER MANSION OF LANDLORD LIU WENCAI IN DAYI, SICHUAN PROVINCE

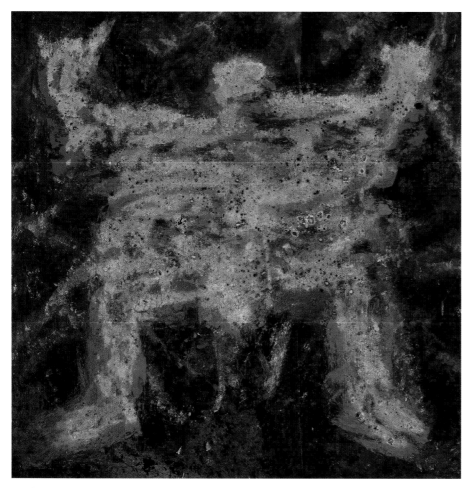

FIG. 7. CHEN ZHEN, *QI FLOTTANT*, 1985. OIL ON CANVAS, 221 X 118 CM. PRIVATE COLLECTION, PARIS

FIG. 6. *CHU BA WANG*, 1985. GUNPOWDER, OIL, AND INK ON CANVAS, 155 X 150 CM. COLLECTION OF THE ARTIST

reformatting and reforming culture itself. At that revolutionary time, the entire society participated in this movement of searching for the core of culture.

Cai's most significant engagement with the legacy of the Cultural Revolution is his 1999 installation *Venice's Rent Collection Courtyard*. It had been the wish of curator Harald Szeemann, director of the *48th Venice Biennale*, to exhibit the *Rent Collection Courtyard* in the West since he first proposed it for *Documenta 5* in 1972. This 1965 sculptural work—depicting the misery of peasants at the hands of an exploitative landlord under the prerevolutionary Guomintang government—epitomized the propagandistic zeal of socialist-realist art during the Cultural Revolution. Comprised of 114 life-size clay sculptures arranged in narrative scenes

depicting class struggle, *Rent Collection Courtyard* was hailed as an artwork of unprecedented mass appeal that "can serve the workers, peasants, and soldiers and socialism."[28] For a decade, it was reproduced and erected in cities throughout China, where it was the most emotionally charged and ubiquitous political image after Mao's portrait. At Szeemann's invitation, Cai organized the re-creation of the ensemble at the Venice Biennale by inviting ten Chinese artisans, including Long Xu Li, who had worked on the original, to reenact the making of the work on site. Cai's intention in showing a socialist-realist work of such emotional power was to subvert contemporary Western notions of art by revealing its own stylistic constraints and fundamental *lack* of creative freedom.[29] "Today we regularly hold biennales and the like, but why do we do this?" Cai asks. "Are

we constrained by something? Are we really free to create what we want? This is something that we must always ask ourselves. I do not know whether it is the artists of the Cultural Revolution or us who hold the strongest attachment to art, but the people of that time believed in a new society and an ideal for mankind."[30]

In Venice, he was praised for his postmodernist appropriation of the historic icon and won the Golden Lion award. In China, however, the Sichuan Fine Arts Institute in Chongqing, where the original work was created, planned to sue Cai for plagiarism and violation of spiritual property, but its case was dismissed.[31] Martina Köppel-Yang placed these differences in the context of Cai's interpretation of the revolutionary slogan "Revolt is reasonable" (*zaofan youli*):

For the international art world, to award this prize [the Golden Lion] to Cai and his *Venice's Rent Collection Courtyard* was another move in the process of globalization. For the [Sichuan Fine Arts Institute] and the growing nationalist tendencies in China, the fact that this prize—one of the most prestigious in the Western art world—was given to a non-authorized copy of a masterwork of Chinese socialist art was simply an act of Western colonialism. *Rent Collection Courtyard* not only proves Cai's sense of witty strategy but also the disrespectful and subversive attitude of a Red Guard, who is convinced that a critique of, and the revolt against, institutionalized thought and practice are reasonable.[32]

Other aspects of Cai's artistic strategies can be attributed to what he called the formative influences of Mao that "consciously and unconsciously seeped into my mentality"[33] and relate to the artist's use of spectacle, such as explosion events, to engage a mass public. Revolutionary culture was agitprop culture, made for the moment and immediately expendable. Cai also credits Maoist ideology

for inspiring his residency in the Japanese coastal city of Iwaki from November 1993 to March 1994. He "integrated"[34] himself among the local workers in Iwaki and mobilized their help for the realization in 1994 of two installations, *San Jō Tower* (cat. no. 38) and *Kaikō—The Keel (Returning Light—The Dragon Bone)*, and an explosion event, *The Horizon from the Pan-Pacific: Project for Extraterrestrials No. 14* (cat. no. 22). Cai would again work with Iwaki residents a decade later to realize *Reflection—A Gift from Iwaki* (2004, cat. no. 44); whenever this installation is exhibited, it is accompanied by a video documenting the social process of art making that included volunteers excavating a large fishing vessel. Through this process, Cai demonstrated how the utopian aspects of the Cultural Revolution with its total aesthetization of politics, society, and everyday life can be interpreted and recuperated as an overall "social sculpture," in the sense of Joseph Beuys. Cai's methodology as a cultural producer, whereby art serves an eternal revolutionary present through the agency of society, thus arises from both his memory and interrogation of modern art in China during the era of Mao.

CHINA/JAPAN: TOWARD METHODOLOGY

Cai moved to Shanghai in 1981 to attend the Shanghai Drama Institute (also known as Shanghai Theatre Academy), where he majored in the department of stage design for four years. In the aftermath of the Cultural Revolution and Deng Xiaoping's historic "Open Door" reforms of 1979, younger artists and intellectuals returning from the countryside, where many had been assigned to manual labor, were hopeful for the promise of a new era of openness in the arts. Travel abroad and a flood of information from the West stimulated burgeoning movements of avant-garde art (*qianwei* or *xianfeng*) and experimental art (*shiyan yishu*) and promoted previously suppressed ideas about modernism, individualism, and freedom of expression. Writings and artworks by a range of Westerners such as Joseph Beuys, John Cage, Dadaists, Marcel Duchamp, Michel Foucault, Gabriel García Márquez, Andy Warhol, and Ludwig Wittgenstein, among others, introduced a new ontology for these post-Cultural Revolution artists, who relished transgression, deconstruction, and speed.

Cai's choice of studying stage design was a fortunate one for his artistic development.

FIG. 8. CHEN ZHEN, *EMPTY FIELD*, 1993. ASHES OF NEWSPAPERS AND WOOD, 240 X 810 X 655 CM. PRIVATE COLLECTION, PARIS

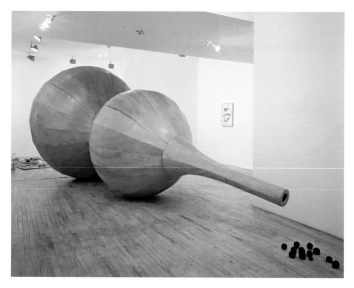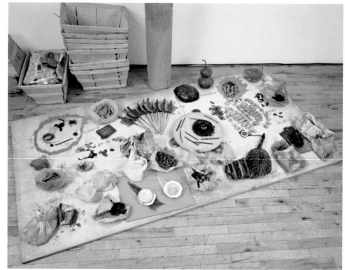

FIGS. 9 AND 10. HUANG YONG PING, *THE PHARMACY*, 1995–97. MIXED MEDIA,
255.9 X 645.2 X 261.1 CM. SIGG COLLECTION

Although he entered the Shanghai Drama Institute as a realist oil painter, the realm of theater production exposed him to greater possibilities for new aesthetic thinking. "At that time there were no schools that trained students in contemporary art," Cai has stated. "But theatre school is different because your concerns are more conceptual. . . . Theatre is based on time: how your work is revealed in time, how it develops and proceeds, how the audience is engaged. These ideas laid the foundation of my art practice."[35] Through studying theater with Zhou Benyi, Cai grasped the notion of artworks as conceptual totalities, multivalent narratives crafted from a variety of approaches, not just single images, that expressed big ideas about humanity.

Among his colleagues in Shanghai was the artist Chen Zhen, who, while only two years older than Cai, taught in the department of stage design.[36] Their ensuing friendship was possibly influential for Cai's early experimental work. Where most artists were looking eagerly to the West, Chen Zhen was among the first Chinese artist of his generation to delve into the rich inventory of East Asian spiritual and material culture to find an alternative aesthetic and discursive framework for the production of avant-garde art. His rigorous exploration of an independent system of thinking represented a radical resistance to both Chinese socialist and Western

liberal ideologies. From around 1983, when he visited Tibet to study prayer as a means for curing himself of a degenerative illness, Chen became seriously interested in Taoist cosmology and Buddhist metaphysics. "The key to an artist's identity is not his nationality," Chen believed, "but his profound understanding and his critical ideas about his own culture, and also his openness to the world and to diversity."[37] His 1985 series of abstract paintings, entitled *Qi Flottant* (1985, fig. 7), aimed to make art the practice for his "silent prayer and mental reflection"[38] and, citing the ancient Taoist sages, a reinvented channel for cosmic primary energy (*yuan qi*).

Like Chen Zhen, Cai became interested early on in reclaiming signs and systems of ancient Chinese culture to critique, and as cures for, the ills of contemporary society. During the summers of 1982 and 1984, Cai visited the Tibetan plateau and the remote regions of Xinjiang, Dunhuang, and the Yellow River Valley "to create myself by placing myself in Mother Nature and ancient cultures."[39] An early work that resulted from his trips is *Chu Ba Wang* (1985, fig. 6), a pictograph-like painting of the general who lived 231–202 B.C.E. and is famous for committing suicide when his troops were overwhelmed. Cai's paintings of this period relate to Chen's contemporaneous works with highly textured surfaces, through which

that artist aimed to express "a primitive vitality."[40] Although Chen was satisfied to enact the Taoist concept of yuan qi through abstract form and color on canvas, Cai pursued ways to collect and expend energy itself as a work of art.

Cai began experimenting with igniting gunpowder on canvas in such early works as *Self-Portrait: A Subjugated Soul* (1985/89, cat. no. 2) and *Shadow: Pray for Protection* (1985–86, cat. no. 3). These acts of what he called "unpredictable splendor" combined his evolving interests in war and Dada, hazard and chance, spectacle and performance. Significantly, Cai couched his artistic breakthrough in an eclectic rhetoric of Taoism and a humanism that differed from that of the West: "Through my work, I explore my inherited culture and induce transformations into it."[41] Elaborating on the significance of his gunpowder drawings, he stated:

> I developed a concept of the universe based on the fundamental and primitive relationships between humans and nature, such as "borrowing the power of nature," "the unity of man-art-nature," and "the co-existing and simultaneously opposing principles of yin and yang

elements." In other words, the true nature of gunpowder corresponds to the power and spirit that humans have possessed since the beginnings of evolution. These concepts also correspond to characteristics of the universe itself. By producing work inspired by such spiritual correspondence, the meaning of the use of gunpowder went beyond being simply a means of production.[42]

Cai has also been discussed in the context of Huang Yong Ping, Xu Bing, and Gu Wenda, three Chinese artists often grouped together because of their critical and creative use of the Three Teachings (*Sanjiao*) of ancient China: Taoism, Buddhism, and Confucianism. Like Cai and Chen Zhen, these artists were born in the 1950s and left China in the 1980s. Their dual outsider status as expatriates sharpened their sense of identity as difference, while their stance as avant-gardists encouraged them to question the self and Other as a dynamic process of confrontation, exchange, negotiation, and regeneration. Breaking out of a revolutionary environment and totalitarian regime where Western liberalism did not exist—or rather, where its manifestations were suppressed—

these artists were free to critique the orthodoxy and institutionalization of contemporary Western culture because its systems were never a given. For all these artists, site-specific installations and events became an important means of subverting the hegemony of art-historical modernism to arrive at a third space beyond the East-West paradigm. Huang Yong Ping's *The Pharmacy* (1995–97, figs. 9 and 10) presents a gourd, the receptacle for traditional Chinese medicine and an iconographic motif of Taoist immortals. An actual apothecary of snake and lizard skins spills from this enlarged "object of magical power," offering a provocative metaphor for alternative and coexisting systems of truth.[43] Huang's use of Chinese medicine parallels Cai's, which incorporates traditional Chinese remedies that viewers are invited to drink, inhale, or soak in, as in such works as *Cultural Melting Bath: Project for the 20th Century* (1997, cat. no. 40) where museumgoers are invited to bathe in a tub of water treated with Chinese herbs, and *Calendar of Life* (1994, fig. 11), an interactive installation whose contents are traditional cures.

For Cai, as for Huang Yong Ping and Chen Zhen, Taoism provided the most productive

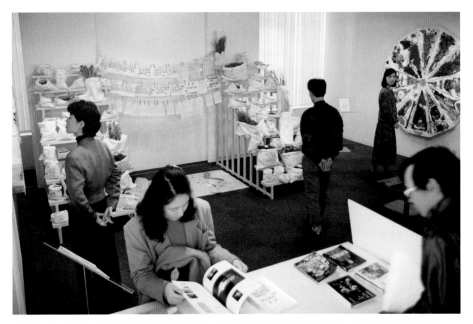

FIG. 11. *CALENDAR OF LIFE*, 1994. CHINESE HERBS, CLOCK, COTTON, AND PLEXIGLAS, DIMENSIONS VARIABLE. GALLERY APA COLLECTION, NAGOYA. INSTALLATION VIEW AT GALLERY APA, 1994

source for their critical engagement with "Asia as method," to borrow Takeuchi's words. Taoist concepts, combined with postmodern deconstructive philosophies current in the 1990s, informed the archaic look and essentially ephemeral, chance-determined and process-oriented installations that Cai, Huang, and Chen (fig. 8) staged to critical acclaim at venues around the world. Tao, often translated as "the Way," is conceived as the void out of which all reality emerges, the structure of being that underlies the universe. In the Taoist vision of cosmogenesis, primal energy, or yuan qi, emerged from the origin of Tao, which was empty and still, and swirled for eons in a state of chaos known as *hundun*. The Tao then generated the complementary forces of yin and yang, which organized the primal energy into patterns of movement and transformation. According to Taoism, all things are made up of qi, which is vital energy or breath. Matter and energy are interchangeable, and transformation and change are constant. These ideas are found in the famous treatise *Tao-te-ching* (Classic of the Way), traditionally attributed to the sage Lao-tzu, who is believed to have lived in the sixth century B.C.E. The concept of qi also lies at the heart of Chinese medicine, which views illness as caused by internal imbalances of yin and yang. Acupuncture and other traditional remedies are designed to restore the proper movement of vital energy, thereby restoring health. The same principles apply to feng shui, which is a geomantic system to promote auspicious environments by activating the proper flow of qi.[44]

Cai has appropriated Taoist concepts and even used feng shui masters to prepare sites for his explosion events and installation works, as part of his idea that art is a method for healing the larger ecosystem of today's society. With the explosion event *Fetus Movement II: Project for Extraterrestrials No. 9* (1992, cat. no. 20), for example, which was staged at a German military base. Cai diverted water from a nearby river in accordance with feng shui principles to expel and transform the accumulation of war's negative energy. Each time he exhibits his installation *An Arbitrary History: River*

(2001, cat. no. 43), the artist manipulates the given space rather than the objects themselves. Instead of fixity, the works and their viewers are subjected to a potential for vitalization. In this way, Cai's notions of qi inform the conditions of constant change, interconnectivity, and transformation that characterize his practice.

Cai's methodology advanced dramatically after his move to Japan in 1986. While living and working with his wife, Hong Hong Wu, in and around Tokyo for nine years, he learned the Japanese language and became established as a professional artist of increasing national and international reputation. Cai arrived at a time when China, newly emergent on the world stage, repeatedly called for Japan's apology and reparations for atrocities committed during the prolonged period that began with the invasion of Manchuria in 1931 and continued with the Sino-Japanese War of 1937–45. The long-taboo subject of Japan's role as a perpetrator of imperialist militarism throughout East Asia was brought to the forefront of public debate, and further inflamed, with the death of Emperor Hirohito in 1989. The leftist media and art world in Japan, which, like the rest of the Left, had opposed the nation's war machine and the emperor system that enabled it, were quick to embrace the latest generation of Chinese students, artists, and intellectuals as heroes and comrades.

Cai also arrived in Japan at the height of revisionist debates concerning Mono-ha (literally "School of Things"), a movement that had changed the course of Japanese art in the late 1960s by accepting Asia as a center, rather than periphery, of contemporary artistic practice and discourse. Korean-born Lee Ufan, the architect of Mono-ha theory, drew upon the phenomenology of Martin Heidegger and the religious philosophy of Nishida Kitarō to challenge modern Western aesthetics and theories of ontology. For Mono-ha, the function of art was to produce a "structure" that elicits an "encounter" with "being." Unity is realized through one's intuitive, concrete grasp of the total "site," an elusive term connoting a ceremonial terrain of place. Writing on the influential *Relatum* series that he began in 1968 (fig. 12), Lee articulated a

philosophy that would have clear resonance with Cai's. Lee stated:

My work involves the displacement of a double meaning: trying to make things which are visible invisible, and to make the world which is invisible visible. The point of contact between the visible and the invisible is the thing which brings crucial immediacy to a work of art. As we get near to it, it has the appearance of matter. As we go away, it appears as a system of ideas. The mystery of art rests in the dynamics of distance.[45]

Cai, who befriended Lee and studied at Tsukuba University with post-Mono-ha conceptualist sculptor Kawaguchi Tatsuo,[46] recalls, "This is the lesson I learned from Japan and from the Mono-ha artists' experience: the search for one's own method and an individual expression."

During Cai's early years in Japan, his generation of post-Mono-ha artists were developing interest in the allegoric and iconic—what curator Howard N. Fox termed "a primal spirit."[47] One of the most active artists of the 1980s was Endō Toshikatsu. He subjected his massive, minimalist forms of pitch-black wood or trenches filled with oil to a process of fire in outdoor sites. Set into the earth, his monuments were set aflame until their surfaces were utterly carbonized and charred (figs. 13 and 14). Endō believed that "it is within [the] cosmological relation—where human life becomes linked with fire, earth, water, air, sun, and other physical elements of the universe—that the material imagination can become manifest and bring meaning."[48] Fire does not destroy; it transforms.

Cai's gunpowder drawings and explosion events were originally seen in Japan within the context of post-Mono-ha art and discourses. Although this dominant art world was conducive to an enthusiastic critical reception for Cai's work in the late 1980s and early 1990s, Cai considered their theoretical terms to be too organized around East-West oppositions: "They [artists and critics] wanted to achieve an internationalism and modernism. But in the end, they found that this too was a form of Westernization. The

FIG. 12. LEE UFAN, *RELATUM*, 1968. STONE, IRON, AND EARTH, 30 X 250 X 350 CM, INCLUDING GROUND AROUND IRON PLATES AND STONES. ARTWORK NOT EXTANT

Japanese problem became my problem. That is how the series *Project for Extraterrestrials* came about. I was thinking, 'Would there be a way to go beyond the very narrow Eastern and Western comparison? Was there an even larger context or a larger approach?'"

Cai's research to create an independent method and expression culminated with the spectacular *Project to Extend the Great Wall of China by 10,000 Meters: Project for Extraterrestrials No. 10* (fig. 15) in 1993. This explosion event, the largest Cai had yet produced, originated as a commission from Serizawa Takashi. A passionate supporter of Cai's vision, Serizawa was the founder of an

alternative Tokyo art space, P3 art and environment, which had exhibited *Primeval Fireball: The Project for Projects* (cat. no. 37), the artist's installation composed of gunpowder drawings mounted as folding screens, in 1991. The Great Wall, constructed of mud and stone between the fifth and sixteenth centuries, is the world's largest single structure and China's greatest national monument, stretching 6,400 kilometers along the country's northern border. For centuries, over successive dynasties, it was the actual and symbolic fortification that identified "China" to the outside world, but was left to ruin for much of the twentieth century.

In the aftermath of Deng Xiaoping's economic reforms, the Great Wall became a resurgent symbol of a reconstructed Chinese nationalism with the slogan, "Let's love our country and restore the Great Wall." Once again, it became a national signifier of enduring empire, terrestrial magnitude, and cultural pride. Cai reworked these tropes for a complex investigation of the mutable meaning of borders in the post-Cold War world—particularly after the fall of the Berlin Wall in 1989—and borrowed the powers of historical myth, in the same way that he had referred to "borrowing the power of nature," to radically disrupt the historical present.

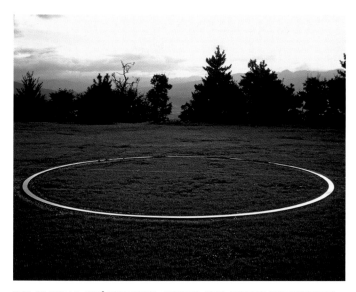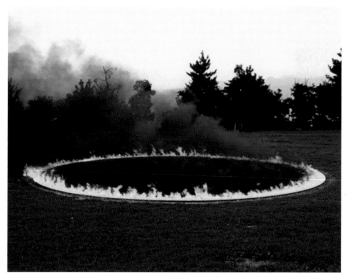

FIGS. 13 AND 14. ENDŌ TOSHIKATSU, *UNTITLED*, 1987. REALIZED FOR *SHIBUKAWA TRIENNALE EXHIBITION OF CONTEMPORARY SCULPTURE '87.* FIRE, IRON, EARTH, AIR, AND SUN, DIAMETER 800 CM.

Cai conceived of *Project to Extend the Great Wall of China by 10,000 Meters* as an interactive performance involving hundreds of volunteers and a local audience of approximately 40,000 people. Before leaving Japan, his assistants drank Chinese herbal remedies to purify and fortify themselves for their labor. Cai chose a location in Gansu Province, at the wall's western-most point in Jiayuguan, at the edge of the Gobi Desert. At dusk, he "extended" the Great Wall by detonating 10,000 meters of gunpowder fuse, which had been laid in a snaking line along the ridges of the dunes. The explosion of the fuse, which lasted fifteen minutes, was meant to evoke the form of a flying dragon of fire against the sky. The dragon, a Taoist mythological symbol of the yang forces of the universe and an icon of the Chinese emperor, has been a ubiquitous image in Chinese art for millennia. Cai's allusion to such famous compositions as Chen Rong's thirteenth-century *Nine Dragons* (fig. 16) is intentional, as he aspired with this project to both represent and be represented by mainstream Chinese culture. The richness of such conceptual provocations is only part of Cai's overall strategy for explosion events as an art form. What he most wants to achieve happens in the moment before ignition, just before violence rips matter into energy. At that instant, Cai's mind goes "blank" at the

thought of losing all control over to the nature of chaos. "This momentary flash contains eternity," he says. "Its impact is both physical and spiritual."

Cai's intent is not to preserve the past so much as to revivify it, and the inventory of Chinese cultural heritage—whether Taoism, Buddhism, or signifiers such as the Great Wall and the dragon—is not to be revered so much as redistributed. For him, the past is a constructed imaginary. The importance of Cai's work lies in his notion of cultural transgression, whereby a present that is psychological as well as the social and political is revealed to be a state of perpetual chance and transformation.

BEING GLOBAL: THE POLITICS OF RELATIVISM

When Cai Guo-Qiang moved to New York in 1995, he arrived from Japan on a grant from the Asian Cultural Council for a residency at the P.S.1 Studio Program in Long Island City. He and his family have been residents of New York ever since. For Cai, this relocation was not simply a move to a new country; rather, it signaled a shift toward the peripatetic lifestyle of global artists at the turn of the twenty-first century. That Cai has never become conversant in English—his studio assistants interpret for him—reinforces his ongoing status as a migrant within the global art system.

Since establishing New York as his base of operations, Cai has continued to produce explosion events, gunpowder drawings, installations, and social projects and participate in biennials, group exhibitions, and solo exhibitions in cities around the world. His work as a member of the creative team collaborting on the opening and closing ceremonies being planned for the Beijing 2008 Olympic Games led Cai to set up an additional home and studio in Beijing. His embrace of these mobile creative conditions—new localities, new environments, new production teams—comes naturally to him; indeed, they have become part of his methodology. Cai embodies what globalization theorist Arjun Appadurai called "a world of flows," a borderless and fluid space of floating populations, transnational politics, mobile configurations of technology and expertise, and a globalization of knowledge. According to Cai:

> We should explore the possibilities of how to understand the world, how to contemplate the world, and how to express the world. The more we get to know these possibilities, the more we can approach the essence of everything. We should be more open-minded to adjust to the constant change in the world in order to get to the core of what

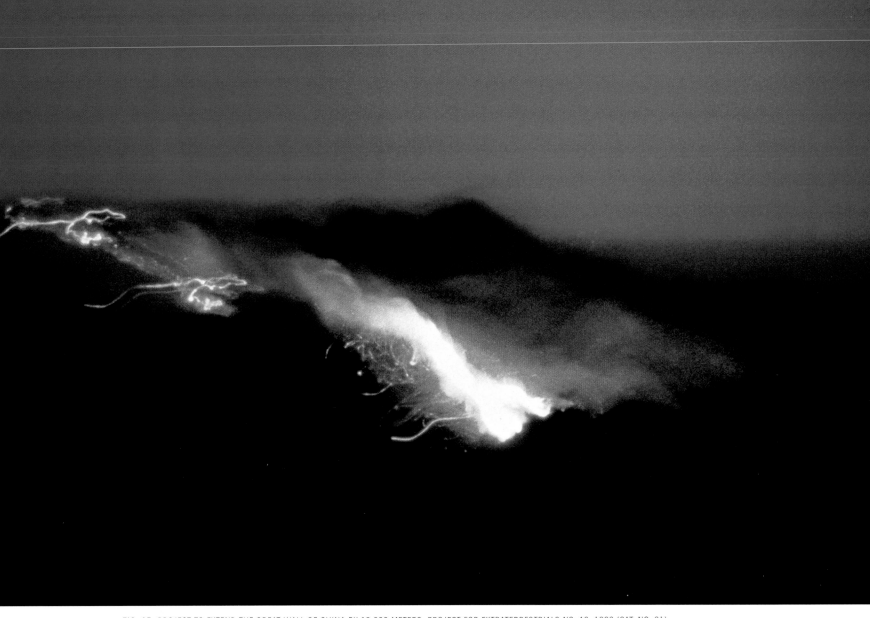

FIG. 15. *PROJECT TO EXTEND THE GREAT WALL OF CHINA BY 10,000 METERS: PROJECT FOR EXTRATERRESTRIALS NO. 10*, 1993 (CAT. NO. 21)

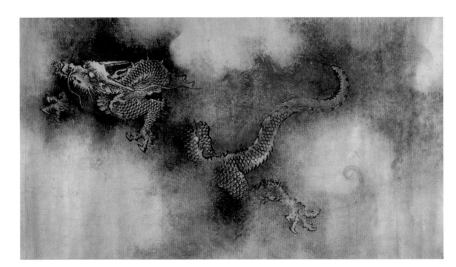

FIG. 16. CHEN RONG, *NINE DRAGONS*, DATED TO 1244 (DETAIL). SOUTHERN SONG DYNASTY (1127–1279). INK AND COLOR ON PAPER, 46.3 X 1,096.4 CM. MUSEUM OF FINE ARTS, BOSTON, FRANCIS GARDNER CURTIS FUND, 17.1697

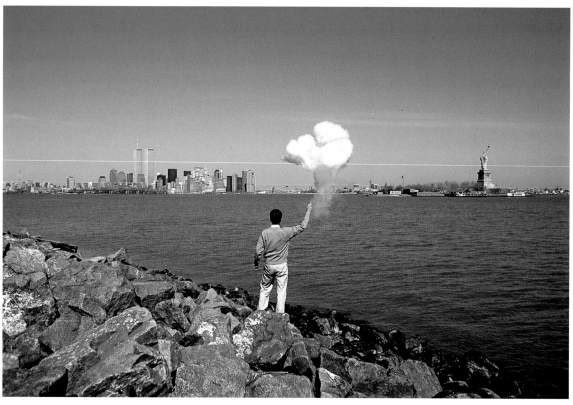

FIG. 17. *THE CENTURY WITH MUSHROOM CLOUDS: PROJECT FOR THE 20TH CENTURY*, 1996 (CAT. NO. 26). LOOKING TOWARD MANHATTAN AND THE STATUE OF LIBERTY, APRIL 20, 1996

our environment is, and then find a more direct way of depicting our realizations and our response.

The work Cai had made while living in Japan demonstrates a preoccupation with poetic metaphysics, cosmology, and ideas of cultural conflict. His conceptual approach to art making changed dramatically, however, in New York, and the underlying theme of conflict that had long concerned the artist moved front and center in his practice. Images of chaos and violence have come to dominate Cai's increasingly diverse installations and social projects as well as larger and more complex gunpowder drawings and explosion events. Seemingly informed by nimble wit and an indifference to ideological stance, his recent works are unabashed provocations to consider the global human condition of incessant conflict. The 9/11 terrorist attacks in the United States, the Madrid train bombings of March 11, 2004, the London subway bombings of July 7, 2005,

and the proliferation of suicide bombings in Iraq and elsewhere have directly impacted Cai's work. He has overcome community reluctance to stage large-scale explosion events in New York and Valencia, Spain, in the wake of recent attacks by persuading authorities of the "healing" effects of his blasts. It was his conviction that these aestheticized productions of violence would alleviate the trauma of recent terrorist attacks and stimulate the mental transformation of society at large. "My work *Transient Rainbow* showed people how to have courage and hope in the face of calamity," he said of his spectacular 2002 explosion event commissioned by the Museum of Modern Art, New York (cat. no. 30).

Cai's belief in the power of art to affect social change links his work to Joseph Beuys's concept of art as a generative "social sculpture." Beuys began his *7000 Oaks* (fig. 18) in 1982 at *Documenta 7* in Kassel, Germany, as the first stage in a proposal to plant trees paired with basalt markers at sites

throughout the world—a project that exemplifies his mission to effect environmental and social change. The Dia Art Foundation, for example, planted five pairings of trees and markers in New York in 1988 as a continuation of the project. In various locales, *7000 Oaks* was a method of urban renewal and involved citizen and community council participation.

Similarly, Cai's first projects in the United States, in 1996—*The Century with Mushroom Clouds: Project for the 20th Century* (cat. no. 26) and the related *Crab House* (cat. no. 49)—continued his implementation of healing and can also be understood as partaking of a Beuysian mission. *The Century with Mushroom Clouds* is a series of explosions that Cai initiated at the Nevada Test Site. There, he detonated small mushroom-cloud explosions from a homemade, handheld device: a simple cardboard tube filled with gunpowder. Cai also made explosions for this series at two iconic Land art sites, chosen because of their relative

proximity to, and arguable conceptual negation of, the nuclear-testing area: Michael Heizer's *Double Negative* (1969), in Nevada, and Robert Smithson's *Spiral Jetty* (1970, fig. 44) on the Great Salt Lake in Utah. Cai extended his series to a sequence of explosions for which select Manhattan landmarks like the Twin Towers and the Statue of Liberty acted as backdrops (fig. 17); for him, it was particularly significant that early research for the atomic bomb was done in Manhattan and that the first headquarters for the Manhattan Project was in the borough as well.

While *The Century with Mushroom Clouds* can be interpreted as Cai's direct engagement with Land art, in whose critical lineage he perhaps belongs, it can also be seen as the artist's reimagining of history's greatest weapon of mass destruction *as art*. "The mushroom cloud constitutes a beautiful, monumental image," in his words. "It is the visual creation that symbolizes the twentieth century, overwhelming all other artistic creations of its time. It will continue to have a powerful effect in the centuries to come."[49] In an act of conceptual inversion, Cai upends the permanent monumentality of Land art with the ephemeral but infinitely more powerful creation of explosions. For *Crab House*, he transformed a storefront in Manhattan into a tea house that ostensibly promoted "nuclear tourism" as the ruins of our contemporary age. A variety of nuclear-explosion imagery was displayed, including postcards that could be purchased. Visitors were invited to look through copies of an artist's book containing photographs of nuclear mushroom clouds while sipping a Chinese medicinal infusion made from the lingzhi mushroom, whose form evokes the mushroom cloud. Within the tea house, 160 live crabs scuttled about the floor—a metaphor for evolutionary survival and radiation-induced cancer.

It appears that Cai has appropriated the mushroom cloud to deftly transmute pejorative nuclear tropes into "art" and "culture." He is avidly nonideological and follows what he calls "the laws of tolerance," declaring that an artist's task is not to say whether something is good or bad, but simply to show reality in a new way. This relativism culminated in Cai's vision for his largest installation to date, *Inopportune: Stage One* (2004, cat. no. 45), which presents nine real cars in a cinematic progression that simulates a car bombing. In an interview with Jennifer Wen Ma, he remarked:

> My work begins with things I observe and am interested in; this, then, gradually becomes the desire to produce a work. For example, I make explosions, so I pay attention to explosions. I can imagine the methods used and the mental state of the suicide bombers. . . . Before igniting an artwork, I am sometimes nervous, yet terrorists face death unflinchingly. Along with the sympathy we hold for the victims I also have compassion for the young men and women who commit the act. Artists can

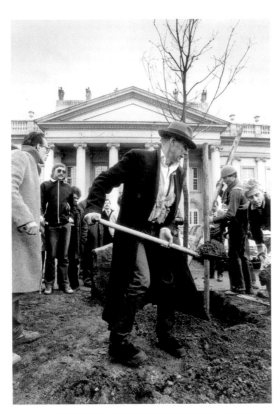

FIG. 18. JOSEPH BEUYS, *7000 EICHEN* (*7000 OAKS*), 1982–87. PERFORMANCE VIEW AT *DOCUMENTA 7*, KASSEL, 1982

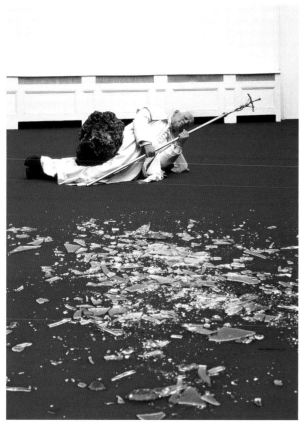

FIG. 19. MAURIZIO CATTELAN, *LA NONA ORA*, 1999. POLYESTER RESIN, NATURAL HAIRS, ACCESSORIES, STONE, AND MOQUETTE, DIMENSIONS VARIABLE. PRIVATE COLLECTION

sympathize with the other possibility, present issues from someone else's point of view. The work of art comes into being because our society has this predicament. Artists do not pronounce it good or bad.[50]

In part, Cai's use of violent but typical images drawn from our modern world is a form of appropriation art whereby an atomic explosion or a suicide bombing is a kind of cultural readymade.[51] His reinvention of *Rent Collection Courtyard* by virtue of its placement in the context of a contemporary international art exhibition became a model for reassigning the spectacle of everyday news from vivid terror to deconstructed subject of art. Through his methodology, Cai couples the Dadaist battle cry to destroy the boundaries of art and everyday life with Mao's famous dictum to make "revolutionary art that is the

result of the human mind reflecting and processing popular life."[52] His use of what can be called the "readymade explosion" underscores his overall strategy of art as a tool of cultural provocation aimed at subverting and challenging contemporary systems of order. Here, Cai's interest in the work of artist Maurizio Cattelan offers insight into his own practice. Where Cai uses the readymade atomic or car explosion, Cattelan uses effigies of Adolf Hitler and Pope John Paul II to create scenes that border on the unbearable (fig. 19).[53] His purpose, like Cattelan's, is to disrupt banality with provocative contemplations, as Cai explains: "When most people approach the subject of suicide bombings, their ideas are very fixated and very stubborn. Everybody has the same, almost uniform reaction. What is 'inopportune' about this work is not the event itself, but rather the presentation of another voice."

At first, the apparent neutrality of Cai's stance with regard to victims and perpetrators of mass destruction can be perplexing. But upon deeper reflection, the violent transformations with which he is concerned reveal themselves as turning points in human history. The invention of gunpowder, the development of nuclear weaponry, and the current ubiquity of suicide bombings each identify paradigm shifts within the history of civilization. For Cai, the forces of destruction are in a dialectical process of creation, and the only constant is change itself. The wisdom that art can impart to those living in turbulent times may be just this perspective. If *you* want to believe, Cai's creations unite us, for a brilliant flash, with the mind of benign and terrifying eternity.

NOTES

1. Cai Guo-Qiang, "I Wish It Never Happened," interview with Jennifer Wen Ma in *Cai Guo-Qiang: Innoportune* (North Adams: Mass MoCA, 2005), p. 60.

2. Hou Hanru, interview in Carolee Thea, *Foci Interviews with Ten International Curators* (New York: Apex Art, 2001), p. 30.

3. Initiated by curator Lu Jie in 1999, the Long March Project has invited Chinese and international artists to travel to selected sites along the historic Long March route to produce artworks that interrogate Chinese visual culture and revolutionary memory. The ongoing project uses the historical event as a discursive framework for reexamining and reengaging in China's cultural and artistic past through exhibitions, performances, symposia, and the creation of new work in public sites with historical, political, or cultural significance. For more about this curatorial project, see www.longmarchspace.com.

4. Cai Guo-Qiang, "Master's Program in Contemporary Art Curriculum (Proposal)" (Mar. 2002), *Yishu: Journal of Contemporary Chinese Art* 5, no. 3 (Sept. 2006), pp. 73–74.

5. "This 20th-century Chinese substrain of belief seems to be earnest without being pious, differentiating it from Judeo-Christian understandings of faith." Philip Tinari, e-mail to author, Oct. 30, 2007. I am grateful to Tinari for his comments on my discussion of Cai's relationship to modern Chinese revolutionary belief.

6. Ibid.

7. Holland Cotter, "Public Art: Both Violent and Gorgeous," *New York Times*, Sept. 14, 2003, Arts & Leisure, section 2, p. 33.

8. *China/Avant-Garde* was China's first national exhibition of avant-garde art. It opened at the National Art Museum of China, Beijing, in February 1989 and featured 293 paintings, sculptures, videos, and installations by 186 artists. According to Cai, who was living in Japan at the time, he was invited to exhibit a work but declined. For resources in English on the Chinese avant-garde of the 1980s, see Thomas J. Berghuis, *Performance Art in China* (Beijing:

Timezone 8, 2006); Johnson Tsongzung Chang, *New Art from China: Post-1989* (London: Marlborough Fine Art, 1994); Fei Dawei, *'85 New Wave: The Birth of Chinese Contemporary Art* (Beijing: Ullens Center of Contemporary Art, 2007); Gao Minglu, *The Wall: Reshaping Contemporary Chinese Art* (Buffalo: Albright-Knox Art Gallery, 2005); Martina Köppel-Yang, *Semiotic Warfare: A Semiotic Analysis of the Chinese Avant-Garde, 1979–1989* (Hong Kong: Timezone 8, 2003); Jochen Noth, Pöhlmann Wolfger, and Reschke Kai, *China Avant-Garde: Counter-Currents in Art and Culture* (Hong Kong: Oxford University Press, 1994); Karen Smith, *Nine Lives: The Birth of Avant-Garde Art in New China* (Zurich: Scalo, 2006); Wu Hung, ed., *Chinese Art at the Crossroads: Between Past and Future, Between East and West* (Hong Kong: New Art Media, 2001); and Zhu Qi, "Putting On and Taking Off: How the Mao Suit Became Art," in Wu, *Chinese Art at the Crossroads*.

9. Lu Jie, interview with the author, New York, Aug. 15, 2007.

10. Geremie R. Barmé, interview with the author, Sydney, Dec. 5, 2006.

11. Among the artists born in the 1950s and 1960s who settled outside China, Ai Weiwei, Gu Wenda, Lin Tianmao, Wang Gongxin, Xu Bing, and Zhang Huan moved to New York; Chen Zhen, Huang Yongping, Shen Yuan, and Yang Jiechang to Paris; Wu Shanzhuan to Hamburg; and Qin Yufen and Zhu Jinshi to Berlin. For studies of contemporary overseas Chinese artists, see Julia F. Andrews and Gao Minglu, *Fragmented Memory: The Chinese Avant-Garde in Exile* (Columbus: Ohio State University, Wexner Center for the Arts, 1993); and Melissa Chiu, *Breakout: Chinese Art Outside China* (Milan: Charta, 2006).

12. The following listing indicates by curator the group and solo exhibitions in which Cai participated that were curated or cocurated by the leading émigré Chinese critics and curators—Fei Dawei: *Art Chinoise 1990: Chine demain pour hier*, Pourrières, Aix-en-Provence, 1990, and *Cai Guo-Qiang,* Fondation Cartier pour l'art contemporain, Paris, 2000; Hou Hanru:

Cities on the Move, which opened at Secession, Exhibition Hall for Contemporary Art, Vienna, 1997–98, and traveled to Bordeaux, New York, Helsinki, Humlebaek, and London; Gao Minglu: *Inside Out: New Chinese Art*, which opened at P.S.1 Contemporary Art Center and Asia Society, 1998–99, and traveled to San Francisco, Monterrey, Tacoma, Seattle, and Canberra, and *The Wall: Reshaping Contemporary Chinese Art*, which opened at the Millennium Monument Art Museum, Beijing, 2005, and traveled to Buffalo; and Wu Hung: *The First Guangzhou Triennial. Reinterpretation: A Decade of Experimental Chinese Art*, Guangdong Museum of Art, Guangzhou, 2002–03.

13. See Andrews and Gao, *Fragmented Memory*; Gao Minglu, ed., *Inside Out: New Chinese Art* (Berkeley: University of California Press, 1998); Gao Minglu, *The Wall: Reshaping Contemporary Chinese Art* (Buffalo: Albright-Knox Art Gallery, 2005).

14. See Christina Yu, "Curating Chinese Art in the Twenty-First Century: An Interview with Gao Minglu," in *Yishu: Journal of Contemporary Chinese Art* (Mar. 2006), p. 21.

15. Wang Hui, "Contemporary Chinese Thought and the Question of Modernity," trans. Rebecca Karl, *Social Text*, no. 55, *Intellectual Politics in Post-Tiananmen China* (Summer 1998), p. 37.

16. See H. D. Harootunian, "Visible Discourses/Invisible Ideologies," in Masao Miyoshi and H. D. Harootunian, eds., *Postmodernism and Japan* (Durham: Duke University Press, 1989), pp. 67–81; Harry Harootunian, *Overcome by Modernity: History, Culture, and Community in Interwar Japan* (Princeton: Princeton University Press, 2000); and Alexandra Munroe, *Japanese Art After 1945: Scream Against the Sky* (New York: Harry N. Abrams, 1994).

17. Takeuchi Yoshimi, *What is Modernity? Writings of Takeuchi Yoshimi*, ed. and trans. Richard F. Calichman (New York: Columbia University Press, 2004), p. 165. The essay "Asia as Method" was originally adapted from a lecture and published in 1961.

18. For the mission statement and collecting policy of the Fukuoka Art Museum and its affiliate the Fukuoka

Asian Art Museum founded in 1999, see the institutional Web sites www.fukuoka-artmuseum.jp and http://faam.city.fukuoka.jp.

19. Kuroda Raiji, "Ten Years of MCP (Museum City Project)," in *Museum City Project 1990–2003* (Fukuoka: Museum City Project Publishing, 2003), pp. 6–8.

20. Kuroda Raiji, "The Future of Presenting 'Asian Art': Thoughts on Asian Contemporary Art," *The Shin Bijutsu Shinbun* (Japan), no. 608, July 1, 1991. Originally published in Japanese, translated by Reiko Tomii.

21. Cai Guo-Qiang, "Traces of Gunpowder Explosions," interview with Gao Minglu, *Dushu* (China) 9 (1999), pp. 87–93. Originally published in Chinese, translated by Philip Tinari. In the quotation, Cai refers to curator and critic Li Xianting's notion of Chinese art as dispensable "spring rolls" at the banquet of the international art world.

22. Barry Schwabsky, "Tao and Physics," *Artforum International* (Summer 1997), p. 121.

23. Unless otherwise noted, Cai Guo-Qiang quotations are from interviews with the author, New York, May 2007.

24. Quoted in Carol Lutfy, "Flame and Fortune," *Artnews* 96, no. 11 (Dec. 1997), p. 146.

25. Cai Guo-Qiang, interview with Octavio Zaya, in Dana Friis-Hansen, Octavio Zaya, and Serizawa Takashi, *Cai Guo-Qiang* (London: Phaidon Press Limited, 2002), p. 10.

26. For resources on the impact of the Cultural Revolution on the development of contemporary art and culture in China, see Geremie R. Barmé, *Shades of Mao* (London: An East Gate Book, 1996); Francesca del Lago, "Personal Mao: Reshaping an Icon in Contemporary Chinese Art," *Art Journal* 58, no. 2 (Summer 1999); Hou Hanru, "Towards an 'Un-Unofficial Art': De-ideologization of China's Contemporary Art in the 1990s," *Third Text* 34 (Spring 1996), p. 41; Jiang Jiehong, ed., *Burden or Legacy: From the Chinese Cultural Revolution to Contemporary Art* (Hong Kong: Hong Kong University Press, 2007); Martina Köppek-Yang, "Zaofan Youli/Revolt Is Reasonable: Remanifestations of the Cultural Revolution in Chinese Contemporary Art of the 1980s and 1990s," *Yishu: Journal of Contemporary Chinese Art* (Aug. 2002).

27. "Destruction means criticism and repudiation; it means revolution. It involves reasoning things out, which is construction. Put destruction first, and in the process you have construction." "Circular of the Central Committee of the Chinese Communist Party," May 16, 1966. For an excellent educational Web site on the Cultural Revolution, see www.morningsun.org.

28. *Rent Collection Courtyard—Sculptures of Oppression and Revolt* (Beijing: Foreign Languages Press, 1968). See www.morningsun.org. The 1968 text explains:

This grand exhibition of life-size clay figures takes its setting from the former rent collection courtyard of Liu Wen-tsai, a tyrannical landlord of Tayi County, Szechuan Province in southwestern China. It recreates a profound, vivid and truthful picture of the raging class struggle in old China's countryside.

Before liberation the people of Tayi suffered untold misery through the brutalities of the local despots and the oppressive taxes levied by the Kuomintang reactionary government. . . .

Under the leadership of the Chinese Communist Party headed by the great leader Chairman Mao Tse-tung, the Chinese people in 1949 completely threw off the rule of imperialism, feudalism and bureaucrat-capitalism and established the People's Republic of China. Since then the people of Tayi, like those in other parts of China, have been liberated, they have set out on the socialist road and have marched bravely forward in the socialist revolution and in socialist construction.

The more than a hundred sculptured figures portraying the story of rent collection are the work of a group of revolutionary Chinese art workers who, following a path lit by the invincible thought of Mao Tse-tung, creatively studied and applied Chairman Mao's works, completely immersed themselves in the lives of the workers, peasants and soldiers, and gave full play to their collective efforts.

. . . Rent Collection Courtyard offers a striking example of how sculpture can serve the workers, peasants and soldiers as well as socialism. It is a brilliant achievement of the great proletarian cultural revolution and a victory for the great thought of Mao Tse-tung. [Chinese transliteration given in original Wade-Giles system.]

29. Cai has commented, "During the Cultural Revolution, people were very moved by the 'Rent Collection Courtyard.' Naturally, I was moved myself. I believe it is wrong to simply comment on the limitations of artists from the past, at the time they were being used politically, but they still pushed to the limit of the restrictions set upon them when carrying out their work." Quoted in Kumagai Isako, "Chinese Artists in New York," *Bulletin of Museum of Contemporary Art, Tokyo* (Mar. 2004). In Japanese; unpublished translation by Gavin Frew.

30. Ibid.

31. See Martina Köppek-Yang, "Zaofan Youli/Revolt Is Reasonable: Remanifestations of the Cultural Revolution in Chinese Contemporary Art of the 1980s and 1990s," *Yishu: Journal of Contemporary Chinese Art* (Aug. 2002), pp. 66–75.

32. Ibid., p. 74.

33. Cai remarked in his interview with the author, "All of Mao's influences and movements happened during my formative years, my elementary school and adolescent period. So Mao's concepts do subconsciously and consciously seep into my mentality."

34. Mao Zedong wrote in "The May 4th Movement" (May 1939), "The intellectuals will accomplish nothing if they fail to integrate themselves with the workers and peasants. In the final analysis, the dividing line between revolutionary intellectuals and non-revolutionary or counter-revolutionary intellectuals is whether or not they are willing to integrate themselves

with the workers and peasants and actually do so."
See www.morningsun.org.

35. Cai, interview with Octavio Zaya, p. 11.

36. Chen Zhen studied stage design at the Shanghai
Drama Institute from 1978 to 1982, and taught there
from 1982 to 1986, when he moved to Paris. I am
grateful to Xu Min, the artist's widow, for sharing reflec-
tions on Chen's friendship with Cai through an inter-
view with the author, Paris, Mar. 29, 2007. For Chen's
life and work, see David Rosenberg and Xu Min, *Chen
Zhen: Invocation of Washing Fire* (Prato-Siena, Italy:
Gli Ori, 2003); and www.chenzhen.org.

37. Chen Zhen, quoted in Rosenberg and Xu, *Chen
Zhen*, p. 19.

38. Ibid.

39. Cai Guo-Qiang, "Cai Guo-Qiang + P3," in *Cai
Guo-Qiang. Primeval Fireball: The Project for Projects*
(Tokyo: P3 art and environment, 1991), unpaginated.
In Japanese; translation mine.

40. Chen Zhen, quoted in Rosenberg and Xu, *Chen
Zhen*.

41. Cai, *Primeval Fireball*.

42. Ibid.

43. Huang Yong Ping, cited in Fei Dawai, Hou Hanru,
and Phillippe Vergne, *House of Oracles: A Huang Yong
Ping Retrospective* (Minneapolis: Walker Art Center,
2005), p. 42.

44. For an excellent study on Taoism in premodern
Chinese culture, see Stephen Little with Shawn
Eichman, *Taoism and the Arts of China* (Chicago: Art
Institute of Chicago, 2000).

45. Lee U Fan [Ufan], quoted in *Lee U Fan* (Tokyo:
Bijutsu Shuppan-sha, 1986), p. 138.

46. For a history of the Mono-ha and post-Mono-ha
movements, see Munroe, *Japanese Art After 1945*.

47. See Howard N. Fox, *A Primal Spirit: Ten
Contemporary Japanese Sculptors* (Los Angeles:
Los Angeles County Museum of Art, 1990).

48. Endō Toshikatsu, "Hi ni tsuite/On Fire," in *Endō
Toshikatsu/Toshikatsu Endō*, trans. Stanley N. Anderson
et al. (Tokyo: Touko Museum of Contemporary Art,
1991), p. 42.

49. Cai Guo-Qiang, "Other Fire Projects," in Fei Dawai,

ed., *Cai Guo-Qiang* (London: Thames and Hudson;
Paris: Fondation Cartier pour l'art contemporain,
2000), p. 146.

50. See Cai, "I Wish It Never Happened,"
pp. 54–69.

51. I am grateful to Sandhini Poddar for helping me
arrive at the concept of news items as "readymades."

52. Mao Zedong, "Talks at the Yan'an Conference on
Literature and Art," in Bonnie S. McDugall, *Mao
Zedong's "Talks at the Yan'an Conference on Literature
and Art": A Translation of the 1943 Text with
Commentary* (Ann Arbor: Center for Chinese Studies,
University of Michigan, 1980), p. 69.

53. Jennifer Wen Ma, interview with the author,
New York, July 26, 2007.

THE DIALECTICS OF ART AND THE EVENT

WANG HUI

THE EVENT AND HISTORY

Cai Guo-Qiang is an artist who has thought about history in a powerfully individual holistic manner. The intensity, anguish, and intelligence inherent in the artistic subjects of his works are revealed through a meticulously designed procedure; an aesthetic distance specially created through a poetics of humor; a measured tension between a proceduralized and deconstructed ritual and the subject that transforms this ritual. His art simultaneously preserves an overall fluency, beauty, and humor. Even when Cai deals with violence, terror, and isolation, he does so without sacrificing grace. His sequential explosions in Asia, Europe, and the United States reveal a genuinely unique approach, which allows spectators to repeatedly experience the abandon, the uninhibited sense, of an artistic event.

There is no doubt that Cai is an artist overflowing with ideas, an artist who, relying upon his own sense of art and his own capabilities, is able to create astonishing things. Yet, is he a profound person? Does his art offer a unique perspective on the world in which we live? This Chinese artist, who has resided in Japan and the United States, put all his abilities on display for the Asia-Pacific Economic Cooperation conference in Shanghai in 2001 (fig. 20), and is slated to do so again for the Beijing 2008 Olympic Games—why would this distinctively individual artist participate in state-sponsored rituals and ceremonies, does he lose himself in these rituals and ceremonies or does he use his creative participation to produce a transformed significance for them?

Cai's intention is to reveal the multivalent significances of history through the simulation, repetition, subversion, transformation, and creation of "the event," which is a prominent feature of his art. Rather than events simply emerging from the inevitability of history, history flows through them and their extensions. Just as people are one motivator for the formation of events, they also give impetus to the events' extensions. To cite a maxim Cai likes to use, the constitution of an event requires an auspicious time, an opportune place, and popular support. If any of these is lacking, there is no event. An event marks the sudden transformation, turning, or new continuation of a predetermined route or accumulation process. Before a new event arrives, all changes can be seen as extensions of the previous event. For this reason, not all of those things that have already happened or are happening can be considered as an event. An event forms only at a particular time, under particular circumstances, and with particular impulses. It is always unique and always happens under specific historical conditions.

Of all the Chinese artists whose work I have seen, Cai is the only one to continually use art to express an attachment to the event. His work pursues events and invents them. It strives to create a correspondence between

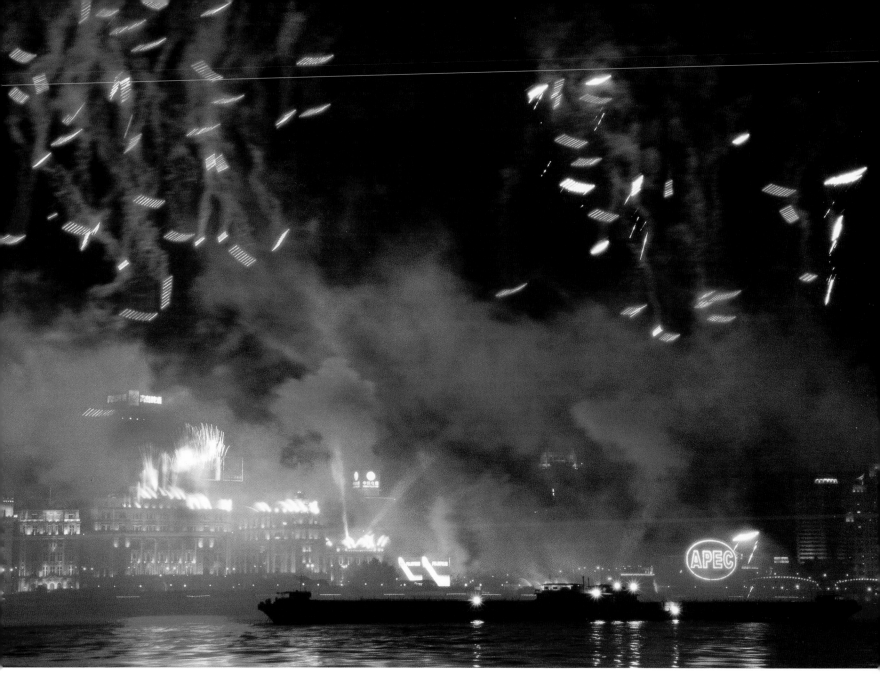

FIG. 20. *ASIA-PACIFIC ECONOMIC COOPERATION CITYSCAPE FIREWORKS*, 2001 (SEE CAT. NOS. 15.1–.14)

artistic events and historical events. Although many contemporary artists place their own expression at the center of *their art*, Cai's uniqueness resides in the fact that he places his self-expression at the center of the unfolding of *an event*. For many of his works we can roughly specify two sequences of determinative events and their extensions: the first is the explosion of the atomic bomb and its symbolic inauguration of the Cold War era; the second is 9/11 and China's rise as a world power as symbols of the arrival of a new era. Gunpowder, explosions, ferocious animals, lethal arrows, and transparent walls are among the methods and manifestations of presenting these two sequences. Cai uses various ways to demonstrate the multivocality of an event, thereby challenging any simple grasp of it. By tracking and articulating momentous historical events, he embeds his own art within history. This does not mean that Cai's art is subordinated to history, but rather that he uses artistic methods to reveal the not-easily perceived relations behind events, to transform the significance of the occurrence.

THE MUSHROOM CLOUD CENTURY AND THE RITUALIZATION OF VIOLENCE

In 1986, after graduating from the set design department at Shanghai Drama Institute (also known as Shanghai Theatre Academy), Cai moved to Japan, where he would live until relocating to New York in 1995. In 1996 he created *The Century with Mushroom Clouds: Project for the 20th Century* (cat. no. 26), a series of small explosion events in Nevada, Utah, and New York. Two years prior to this, in Hiroshima, Cai had completed *The Earth Has Its Black Hole Too: Project for Extraterrestrials No. 16* (cat. no. 24), an enormous outdoor project for which he detonated an upside-down mushroom cloud, a black hole—thereby using the explosion event as a method of presenting the subjects of rebirth and putting ghosts to rest. As an extension of that 1994 project, *The Century with Mushroom Clouds* events were realizations of mushroom clouds in America as if in re-creation and remembrance of life and history on the Asian side of the Pacific.

While his work on the subject of the mushroom cloud won him international recognition, an even more profound commentary on the Cold War era emerges from Cai's contemporaneous explication of Chinese politics.

At the 1999 Venice Biennale, he was awarded the Golden Lion for *Venice's Rent Collection Courtyard* (cat. no. 42), an installation that existed only for the duration of the Biennale. During the Cultural Revolution that began in 1966, the socialist-realist sculpture *Rent Collection Courtyard* (1965, fig. 5), created by members of the Sichuan Fine Arts Institute, was duplicated as a propaganda tool for the cultural and political movement that swept over all of China, especially the urban areas. That sculpture, which is itself a denunciation of prerevolutionary landlords, clearly exemplifies how historical and class consciousness was shaped by "speak bitterness" meetings. For his appropriation of this work at the Venice Biennale, Cai used a precise method to recover the process of molding the clay figures—a deployment that deconstructed the culture and politics of the Cultural Revolution. Given the reemergence in contemporary Chinese society of divisive social relations, did Cai's work also signify a revision of historical memory through deconstruction?

China's class politics were intimately related to imperialist wars and the Cold War. This relationship renders Cai's suspension of a mushroom cloud over Hiroshima not exclusionary but a depiction of the politics of an

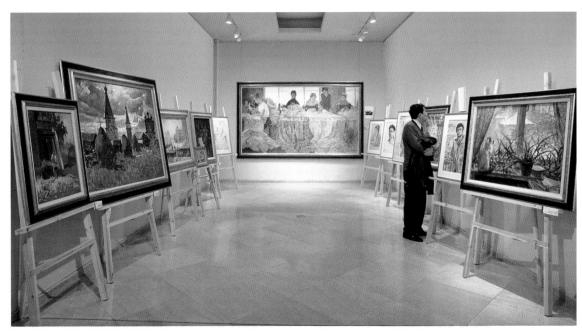

FIG. 21. INSTALLATION VIEW OF THE EXHIBITION *CAI GUO-QIANG'S MAKSIMOV COLLECTION*, CENTRAL ACADEMY OF FINE ARTS, BEIJING, 2002

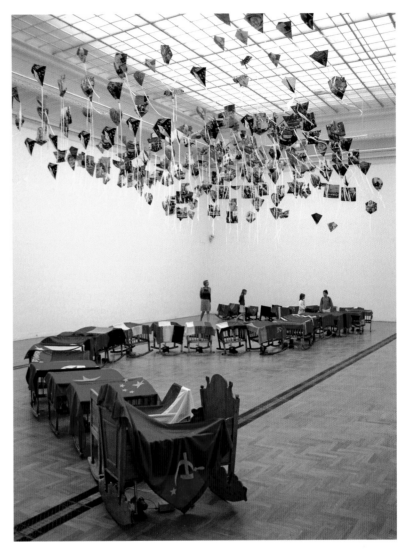

FIG. 22. *PARADISE*, 2005. 200 HANDMADE KITES, 29 ROCKING CRADLES, 29 FLAGS, 29 MOTORS, AND FOUR FANS, DIMENSIONS VARIABLE; CRADLES APPROXIMATELY 80 X 60 X 90 CM EACH. COLLECTION OF THE ARTIST. INSTALLATION VIEW AT ZACHETA NATIONAL GALLERY OF ART, WARSAW, 2005

era. At the Venice Biennale, the mimesis of *Rent Collection Courtyard* used deconstruction to express the artist's complex attitude toward socialist China and its cultural politics during the Cold War. In 2002 in Shanghai, Cai exhibited his collection of works by Soviet artist Konstantin Maksimov (fig. 21), who had come to China in the 1950s to teach art. Cai intended to reconstruct the art history of socialist China from within a sequence originating in the 1950s. The specter of Maksimov was thus thrust to center stage from backstage oblivion—just as former, as well as current, communist nations are the subject of *Paradise* (2005, fig. 22)—and his

own era's perspectives were deployed to observe the current era of hectic motion. Cai often borrows such ghostly eyes to illumine the world in which he lives.

On September 11, 2004, the third anniversary of 9/11, Cai's *BMoCA (Bunker Museum of Contemporary Art): Everything Is Museum No. 3* (cat. no. 52), a permanent museum located on Kinmen—a small island located offshore Fujian Province—was inaugurated with *18 Solo Exhibitions*, which primarily included works by artists from China, Taiwan, and the Chinese diaspora. For Cai, who was born in the Fujian port city of Quanzhou, the way in which Kinmen (also known as

Quemoy) became famous because of its 1958 bombardment by Mainland China presented a particularly profound exposition of the Cold War era. It should not be forgotten that in general his direct motivation is to use art to substitute for weapons, infinite exhibitions to substitute for infinite war. However, I am more concerned with how he understands war and what the relationship between war, violence, and art might be for him from this singular circumstance. BMoCA, with its B standing for "bunker," fictionalizes and transforms war and violence, but did not the attack on Kinmen in 1958 already do this? At that time, on one side was "retake the

communist mainland," and on the other was "liberate Taiwan." The actual bombardment was the violent expression of these two mutually opposed pursuits. Yet the constraining of violence was also inherent in this manifestation of violence. The specter of large-scale war and the danger of nuclear war gradually retreated as violence achieved an ambivalent peace. This is ritualized war and the ritualization of war—a type of conflation of real violence with virtual violence, a type of procedure to announce the special relationship between the two sides, a type of dialectical politics that embodies the mutual transformation of war and peace. This is another aspect of infinite war, and it suggests to Cai the logic of infinite exhibitions.

POST-9/11 AND INFINITE EXHIBITIONS

Cai's main artistic topics of subversion and transformation unfold in his centering of the event. What he is subverting with BMoCA, and subverted with *18 Solo Exhibitions*, are dichotomies: retake China and liberate Taiwan, violence and peace, terrorism and antiterrorism, flourishing and decline, reality and art. What are transformed are mutual relations between chasms and exchange, death and life, fear and happiness, solitude and companionship. And what often seeps

through Cai's work is a playfulness produced by his distinctive overview of the mutual transformations. The Kinmen "infinite exhibition" not only explores the topic of the Cold War and the constraints on violence that resulted from China's 1958 attack, it also directly echoes the post-Cold War pattern of violence announced by 9/11.

Even as people blanch at the mere mention of "infinite war," Cai has discovered another possibility. In recent years, 9/11 is a topic Cai has explored often: *Light Cycle: Explosion Project for Central Park* (cat. no. 32) in 2003; BMoCA and *Inopportune: Stage One* (cat. no. 45) in 2004; the exhibitions *Head On*, *Transparent Monument*, and *Long Scroll* in 2006—all are direct contemplations of this event. Yet, his post-9/11 works really began with a huge, seemingly unrelated ritual.

One month after 9/11, the thirteenth meeting of the Asia-Pacific Economic Cooperation (APEC) assembled in Shanghai. A creation of the post-Cold War world, APEC is a direct expression of moving the center of the global economy toward the Asia Pacific region, particularly the East Asian rim. The gathering in Shanghai took place at a special moment. On the one hand, the environment was one of terror and sadness, following the

opening act in the war on terror; on the other hand, the economic vista was one of global cooperation. Various agreements were passed, including the Shanghai Accord. The envelopment of the world economy by the shadow of 9/11 was counteracted with a shot of adrenaline from China and other Asian nations. In Cai's works, the meaning of "post-9/11"—as with the meaning of the Cold War era—is explained through a number of different perspectives.

At 9 PM on October 20, 2001, Cai's *Asia-Pacific Economic Cooperation Cityscape Fireworks* was realized for the closing ceremonies of the APEC conference. Ten barges and eighteen yachts on the Huangpu River and twenty-three buildings on the Bund in the Puxi district were firing points for the display. There were also a 1.8-kilometer-long firework waterfall and mines on the Puxi side and three circular jets of comet fireworks from the three orbs of the Oriental Pearl TV Tower. This made for a stereoscopic water, land, building, and air performance, using many types and large quantities of pyrotechnic effects. The scope was unprecedented not only in China but globally—another instance of "infinite exhibition."

APEC was a crucial step along Cai's path toward collaborating on the opening and

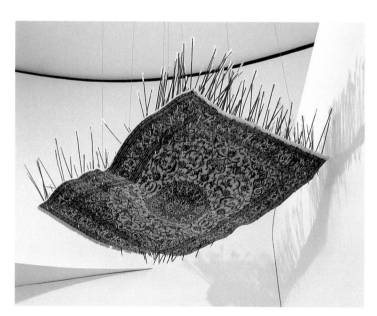

FIG. 23. *FLYING CARPET*, 2005. CARPET, RESIN, AND 500 ARROWS; CARPET 250 X 150 CM.
MARTA HERFORD COLLECTION

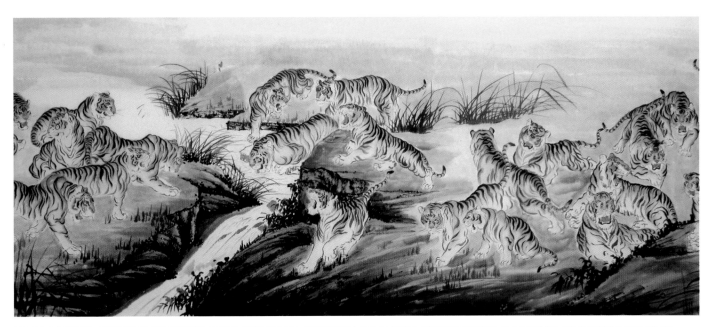

FIG. 24. CAI RUIQIN, *PAINTING OF ONE HUNDRED TIGERS*, 1993 (DETAIL). HANDSCROLL, INK ON PAPER, MOUNTED ON SILK, 45.6 X 670 CM. CAI GUO-QIANG COLLECTION

closing ceremonies for the Beijing 2008 Olympic Games. "Auspicious time," "opportune place," and "popular support" converge, and yet such rituals present conceptual and logistical challenges for Cai. If creating an artistic event is merely a question of fixing a controlled procedure, if the point of the APEC fireworks was merely to gain an entry in the record books as the largest display of its kind, then what, after all, is the significance of his pursuit of the correspondence between artistic and historical events? Cai's attention to the event once again was predominant. For him, what more attractive event could there possibly have been than this one symbolizing the transformed global order? In his view, ritual is always contained within a procedurally controlled system. However, there is no system that can completely affect control. What the indeterminateness and instability of ritual offers precisely is the possibility of the creation of art. Here, there is a type of ancient dialectical law: rituals are ordered, yet their plenitude and tendencies depend upon the dynamic initiatives of the participants. What the participatory initiative offers is the pursuit of the opposite of control, and it is precisely this anticontrol pursuit that endows rituals with life and animation. In the view of Chinese Confucians, the practice

of *liyue* (rites and music), is unlike *liyi* (the rigid ritual form). The former is completed naturally through the actions of the subject, while the latter is entirely dependent upon the compulsory control of procedure.

Confucius critiqued his own era for *libeng yuehuai* (the collapse of rites and the destruction of music), and although his times witnessed wars without end, nevertheless, the implementation of rites for enjoyment continued to flourish. What then did Confucius mean by his criticism? In my view, he was emphasizing that when rituals are made into a question of mere formality, then ritual disintegrates. Ritual is interdependent with people's initiative, dynamism, and freedom.

Cai strives to inject his own explanation for an historical event into the requirements of the procedure of ritual. For APEC, he not only used a magnificent fireworks display as a manifestation of the dynamism of China, a country with a long history, but he also, with the three circular explosions on the Oriental Pearl TV Tower, again created an upside-down mushroom cloud that continually dispersed on all sides. The bustle of the post-9/11 era is haunted by lurking shadows. What type of annotation is more able to precisely explain the plenitude and implication of this event?

CHINA AS METHOD

Gunpowder is one of China's four major ancient discoveries, the others being the compass, papermaking, and printing. In the course of the time period Eric Hobsbawn defined as the "long nineteenth century," China was ridiculed as a civilization that discovered gunpowder but then only used it to produce fireworks, discovered the compass merely to enhance leisure travel. From the moment he chose gunpowder as the main material for his creations, Cai was investigating the meaning of tradition in contemporary art. In his hands, gunpowder becomes a method of describing, displaying, and experiencing the world. It can refer to the mushroom cloud of the nuclear test site and at the same time present the gaiety of celebratory rituals, symbolizing reanimation and rebirth. When Cai detonates different explosion events specifically conceived for different sites and subjects around the world, gunpowder no longer serves as a symbol of Chinese civilization and even less as a decorative feature of an exotic land.

So-called orientalism is a method developed to display the "East" from the perspective of an internalized "West," but, here, with Cai, "China" or "Asia" is no longer an object of "Western" eyes. Many contemporary Asian

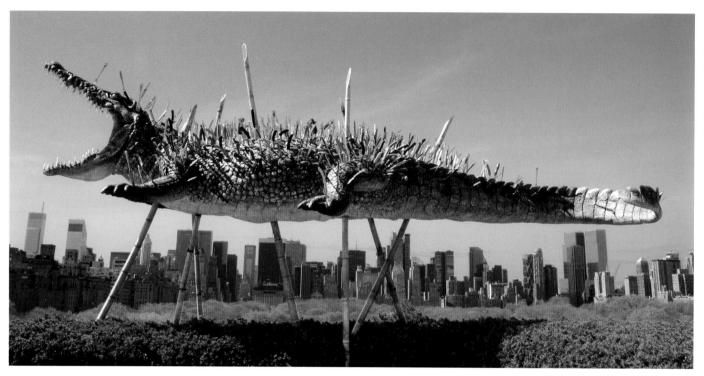

FIG. 25. *MOVE ALONG, NOTHING TO SEE HERE*, 2006 (DETAIL). PAINTED RESIN WITH SHARP OBJECTS CONFISCATED AT AIRPORT SECURITY CHECKPOINTS. DIMENSIONS VARIABLE; CROCODILES 241.3 X 132.1 X 406.4 CM AND 228.6 X 116.8 X 426.7 CM. COLLECTION OF THE ARTIST. INSTALLATION VIEW AT THE IRIS AND B. GERALD CANTOR ROOF GARDEN, THE METROPOLITAN MUSEUM OF ART, NEW YORK, 2006

artists, under the influence of this method, are transforming living traditions into artistic embellishments. Cai does not objectify his own experience and tradition, but rather methodologizes them in order to observe the world in which we exist. Precisely in striving to turn "China" and "Asia" into a method, what he derives from tradition is not limited to ancient symbols. In 1998, he chose to name a work *No Destruction, No Construction: Bombing the Taiwan Province Museum of Art* (cat. no. 28), a title that is a literal description of the event. "No destruction, no construction" was a popular slogan that was advocated by Mao Zedong during the Cultural Revolution. Indeed, Cai's art of explosions is deeply related to the dialectics of revolution in modern Chinese history.

Linked to the dialectical logic of "no destruction, no construction" is Cai's intensive research into the difference between civilization and savagery. From the use of gunpowder to create works that simulate traditional literati painting to the exhibition *Long Scroll*, in which he contextualized the literati-style painting *One Hundred Tigers* by his father, Cai Ruiqin (fig. 24), we can see that within the perspective of *wen* (civilization/culture/literature) is displayed its dialectical opposites: *wu* (military) and *ye* (savagery). Cai uses the artistic form of violence to reject violence, yet in the narrative of using "culture not weapons to struggle" (in the words of a Chinese saying), "struggle" is rescued from the rejection of violence. In *Inopportune: Stage Two* (2004, cat. no. 46), the tiger—symbolizing terrorism, wildness, and violence—is densely covered from head to toe with the counterviolence of arrows. This makes us think of another work filled with arrows, *Flying Carpet* (2005, fig. 23), which is a symbol of ancient civilizations that are considered "savage" from the perspective of modern "civilization." In 2006, Cai's exhibition on the roof of the Metropolitan Museum of Art in New York included a transparent glass monument (fig. 33), two crocodiles stabbed with knives and other sharp implements (fig. 25), a large stone relief documenting recent political and cultural events, and a daily explosion event (fig. 31). Dead birds placed at the foot of the glass monument were a deconstruction of the "transparent" as well as a metaphor for the "transnational," or "globalization"—a deconstruction of terms using "trans" as their prefix. This is the dialectic of isolation and transparency, civilization and savagery, culture and military. The strength of this type of dialectic can be felt in almost all of Cai's work. In this way, the tradition of Chinese literati painting and its associated concepts of *wen* (civilization), *wen wu zhi dao* (the way of civilization and military), and *wen ye zhi bian* (the difference between civilization and savagery) are affirmed as method.

Translated from the Chinese by Rebecca E. Karl

IMAGE EXPLOSION: GLOBAL READYMADES

DAVID JOSELIT

READYMADE DISLOCATIONS

Since its invention by Marcel Duchamp in the early twentieth century, the concept of the readymade has set limits and opened new fields for aesthetic practice. Readymades placed ordinary commodities in the position of art—causing a urinal, for instance, to migrate from the plumbing supply store to the exhibition hall. *Fountain* (1917) was the result of such a passage in which Duchamp recategorized a men's room fixture as sculpture. It is often forgotten, however, that *Fountain* was immediately lost after its rejection from the nominally unjuried exhibition of the New York Society of Independent Artists, and that its life as an artwork has depended exclusively on photographic, sculptural, and textual reproductions (fig. 26).[1] The continuing potency of the readymade legacy lies in precisely this displacement from a singular artwork to a network of representations inspired by it. As currently practiced, the readymade strategy demonstrates that an object's significance depends upon its circulation—on where and through what contexts it passes. In other words, the meaning of a readymade is dependent not on its objecthood, but on its *actions*.

Some eighty years after Duchamp's gesture, Cai Guo-Qiang began to produce what he has called "cultural readymades,"[2] which explore the political economy of image dissemination in a globalized world. For Duchamp, the dislocation of the readymade (its movement, for instance, from bathroom to gallery) was intended to question the category of the art object. For Cai, who would cite *Fountain* directly in a 2001 installation entitled *An Arbitrary History: Roller Coaster* (fig. 27), the migration of the readymade serves as an index of the diffusion of national cultures—one might say their diasporic formations. If Duchamp made us ask: "What does *an everyday object* mean here, in the context of the gallery," Cai begs the question: "What does it mean to be Chinese?"—not only in the West, but in Japan, for instance, or in China itself. Secondly, and more significantly, Cai has recognized that in our current moment the meaning of images is related not only to their mere dissemination, but to *the speed at which they circulate*. Part of his special contribution to the readymade tradition, I shall argue, lies in his visualization of different temporalities of image circulation—the fast, the medium, and the slow.

It was in his *Venice's Rent Collection Courtyard* (figs. 28–30), an installation for the 1999 Venice Biennale, that Cai demonstrated most forcefully what might be called his diasporic revision of the readymade. I use the term "diasporic" because at issue in this work was not only how an object's circulation determines its significance, but also how the artist's *position* as an ethnically Chinese person based abroad and exhibiting internationally was profoundly at stake in how a "cultural readymade" accrues meaning for

FIG. 26. R. MUTT (MARCEL DUCHAMP), *FOUNTAIN*, 1917. GELATIN-SILVER PRINT BY ALFRED STIEGLITZ, AS PUBLISHED IN *THE BLIND MAN*, NO. 1, APRIL 10, 1917. PHILADELPHIA MUSEUM OF ART, THE LOUISE AND WALTER ARENSBERG COLLECTION, 1950

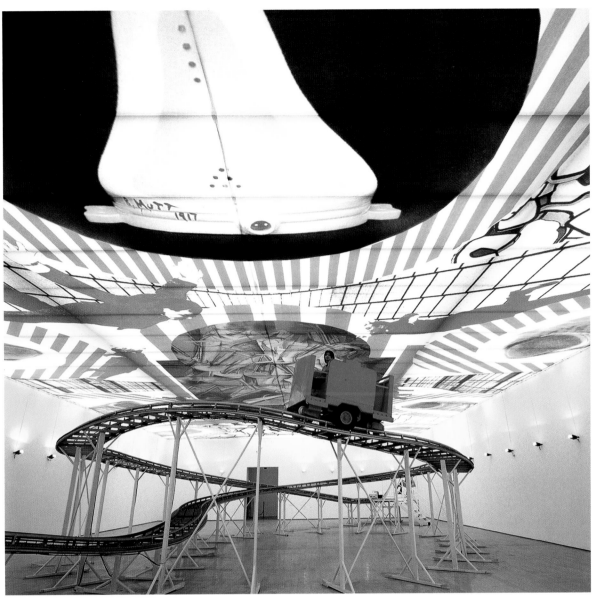

FIG. 27. *AN ARBITRARY HISTORY: ROLLER COASTER*, 2001 (SEE CAT. NO. 43)

different audiences. *Venice's Rent Collection Courtyard* was a partial reconstruction of *Rent Collection Courtyard* (1965, fig. 5), an eponymous 1960s monument from China's Cultural Revolution, originally commissioned by the government and composed of 114 clay sculptures dramatizing the exploitation of peasants by their landlords. Before Cai appropriated this work in his reconstruction, it had already had a long history. In its initial official manifestation, *Rent Collection Courtyard* was installed as a socialist-realist tableau in a former landowner's courtyard in Sichuan Province like the dream of a recently obliterated past. And yet arising out of this site-specificity was a double logic of the readymade: on the one hand the sculptures were distinguished by their incorporation of readymade elements, ranging from farm tools to furniture, but more interestingly the ensemble functioned as a readymade source for its own subsequent reproduction. It was copied in clay for installation in different sites around China, and later in fiberglass to facilitate touring domestically and abroad. Because the government made several versions of this work, each copy was a kind of readymade reiteration of the original. As Alexandra Munroe has commented, because the installations were reproduced at Mao's request and for the benefit of the masses they were, in a manner of speaking, *mass-produced* despite their construction from manual labor.[3] While the figures in *Rent Collection Courtyard* are drawn from the international style of socialist realism (rooted in Western aesthetic traditions), the logic of its replication and distribution is analogous to the site-specific strategies of post-Minimalism or institutional critique, with one major difference: its permutations were staged in the service of state ideology. In 1999 an

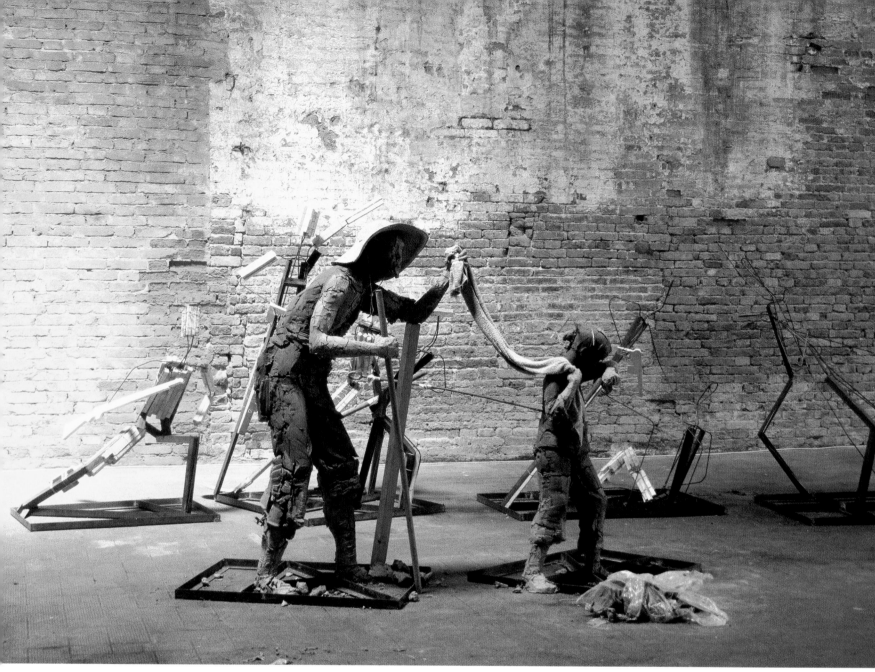

FIG. 28. *VENICE'S RENT COLLECTION COURTYARD*, 1999 (CAT. NO. 42)

individual artist—namely Cai Guo-Qiang—assumed the role erstwhile occupied by academic and official patronage: he self-authorized the reproduction of *Rent Collection Courtyard*, with the encouragement of curator Harald Szeemann, as his contribution to the Venice Biennale. Like the 1960s and '70s Chinese copies of the work, Cai took the ensemble as a readymade, using Chinese sculptors (one of whom, Long Xu Li, had worked on the original version) to reconstruct the work, in person, as a spectacle for visitors to the Venice exhibition.

Cai did no more than continue the tradition of reproduction and reinstallation that had characterized *Rent Collection Courtyard* from the start, but his gesture met with two very different consequences: a prize from the Biennale jury, and a threatened lawsuit for copyright infringement from the Sichuan Fine Arts Institute, where the work had originally been produced under the guidance of Wang Guan-yi. If Cai put himself in the place of academic and political authority by initiating a further iteration of *Rent Collection Courtyard*, he also shifted the question of labor—thematized in the work as exploitation of the peasantry by landed elites—to the asymmetrical relations between artist and worker in a global art world (which, one could

argue, mirror asymmetrical labor relations in many other precincts as well). Indeed, because the clay figures in Venice were not fired, and because the process of making them was explicitly part of the exhibition, Cai's *Venice's Rent Collection Courtyard* was fundamentally performative, and what it dramatized was the cultural displacement of artistic labor itself—Chinese artists and artisans remaking a monument of the Cultural Revolution for a European audience. In the resulting controversy, artists still working in a national academic tradition in China pitted themselves against a successful cosmopolitan artist who had lived abroad for many years, and who, like the Academy itself, could marshal the labor of other artists. While this contretemps has been viewed as the collision of "postmodern," Western aesthetic strategies with traditional social realist art, I think such a view is false, or at least is so reductive as to be virtually meaningless. After all, as I have tried to demonstrate, the "postmodern" tactics of appropriation and performative reinstallation of which Cai's work was accused were essential to the earlier Chinese career of *Rent Collection Courtyard*, which was remade over and over for new locations, just as American appropriation artists such as Richard Prince and Sherrie Levine (working in the late 1970s) reproduced existing commercial or fine art images in new contexts. In his account of the affair, critic and curator Zhu Qi suggests a productive interpretation linking the tactics of Duchamp to those of Cai:

> In the 1990s, Duchamp's games with art and non-art have been emptied of their critical power, and so now it is time for Easterners and Westerners to play games. As a young Shanghai artist has said, the more he paints to ridicule Western art critics, the more he gets invited to Western biennales or receives requests to collect his work.[4]

Indeed, Duchamp's "games" always functioned best when they forced unconscious social formations into the open, as when the summary rejection of his *Fountain* from the Independents' exhibition in New York caused the unconscious limits of an artwork in 1917 to flash into being. I agree with Zhu that by the 1990s, such questions of art versus nonart had been eclipsed by a more cosmopolitan dynamic of the readymade in which the category in crisis was not the artwork per se, but national identity—what Zhu calls games between "Easterners and Westerners" (to which we might add games between Southerners and Northerners, and games played by ethnic or gender minorities within particular nation-states). Despite any possible copyright infringement, the question begged by *Venice's Rent Collection Courtyard* is not what counts as *art*, but what counts as *Chinese*.

If Cai's appropriation of the *Rent Collection Courtyard* problematizes Chinese-ness, as is vividly demonstrated by the threatened lawsuit from China accompanied by ad hominem attacks on Cai's "authenticity" as a Chinese,[5] his work is no more about defining or representing Chinese identity than Duchamp's *Fountain* is about plumbing. Rather, as in earlier readymade tactics, Cai brings into focus the unspoken assumptions that regulate the codes—or ideologies—that underlie our sense of cultural identity in a global world. He is an artist whom Westerners see as Chinese and whom, as an expatriate, some

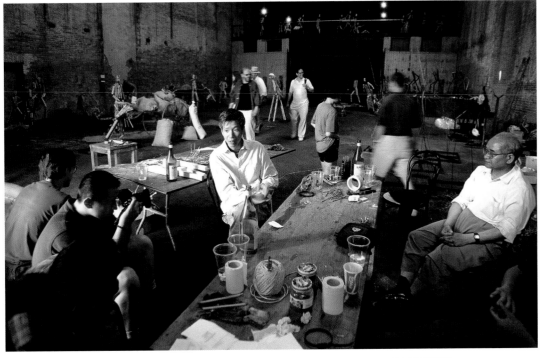

FIG. 29. CAI GUO-QIANG AND LONG XU LI DURING THE CONSTRUCTION OF *VENICE'S RENT COLLECTION COURTYARD*

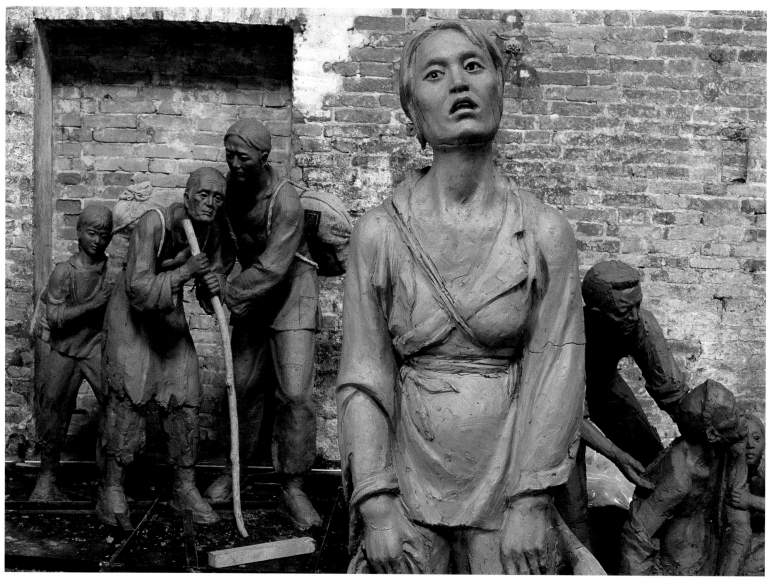

FIG. 30. *VENICE'S RENT COLLECTION COURTYARD*

Chinese regard as not Chinese enough. Since the 1970s feminists and practitioners of cultural studies have utilized the concept of difference to suggest that identity—whether based on gender, sexuality, or ethnicity—emerges not from some essential inner quality, but from a play of differences within a field of positions in which, for instance, femininity is produced in opposition to masculinity (or androgyny), or being Chinese in opposition being Japanese or being Western. *Venice's Rent Collection Courtyard* was an occasion for negotiating such a field of differences: the difference between the ensemble's initial and later copies; the difference between Chinese artists in China and Chinese artists living abroad; the difference between fabricating a work of art and presenting a finished product; and the difference between propaganda and avant-garde art. A major monument of public art in China, *Rent Collection Courtyard* could easily seem like socialist kitsch to the largely Western art world audiences that frequent the Venice Biennale. But the performative character of *Venice's Rent Collection Courtyard*, and more broadly, all of Cai's action-oriented artworks devoted to movement and motion, visualize what Stuart Hall has called the *negotiation* between such differences. Indeed, Cai's art seems to exist

inside difference, stabilizing as art the transition from one position to another. Ideologies of a fully homogenized global world are founded in the erasure of such distinctions—on the fantasy of a single undifferentiated world—but as Hall suggests, the situation is more complicated. Capital wishes to satisfy desire for difference without allowing its disruptive force to surge forth: "It is trying to constitute a world in which things are different. And that is the pleasure of it but the differences do not matter."[6] *Venice's Rent Collection Courtyard* provoked a demonstration of how differences *do* matter, and this is what places it firmly in the tradition of the readymade.

It seems apt that one of Cai's earliest and most enduring series of works is titled *Projects for Extraterrestrials,* which includes such pieces as *Project to Extend the Great Wall of China by 10,000 Meters: Project for Extraterrestrials No. 10* (1993, cat. no. 21). Despite what might appear a tongue-in-cheek designation, the absolute difference encoded in imagining an audience of aliens offers an important clue to the way Cai's cosmopolitan readymades visualize the great *distance* between cultural positions that finds its most extreme form in the figure of the extraterrestrial.[7] After all, not only did the artist make himself a kind of alien when he

moved to Japan in 1986 and later, in 1995, to New York, but the very power of *Venice's Rent Collection Courtyard* and its significant revision of the readymade tradition lies in rendering alien—in alienating—the assumptions of others about identical actions and objects. And yet extraterrestrials view the earth as a single entity—a globe—whose strange communications can only be received as signals without a code. It seems apt then, that in describing his role collaborating on the opening and closing ceremonies for the Beijing 2008 Olympic Games, whose slogan is "One World, One Dream," Cai speaks of the planned live broadcasts as reaching four billion viewers—an audience of global proportions. One of the fundamental paradoxes in his art lies in this double gesture toward the world as a single entity (in a kind of utopian gesture of unification, even healing), and an uncompromisingly alien vision (as an absolute inscription of difference). How can this distance, which is so productive in defamiliarizing assumptions and perhaps even in producing new platforms of mutuality, be reconciled with the cohesion of a global audience? Such a paradox is equally present in the dangerous beauty of Cai's explosion events, which sometimes misfire and always retain the possibility of actual destruction.

This doubling of the celebratory and the malignant is everywhere in Cai's work, from his domestication of the mushroom cloud in *The Century with Mushroom Clouds: Project for the 20th Century* (1996, cat. no. 26) to his spectacular and sinister *No Destruction, No Construction: Bombing the Taiwan Province Museum of Art* (1998, cat. no. 28) in which fireworks racing across the roof the eponymous museum resembled an act of war.

READYMADES IN MOTION

Thus far I have stressed Cai's establishment of cultural difference through his readymade practice: *Venice's Rent Collection Courtyard* alienates, in the sense that it literally *makes alien* for Chinese viewers a work that is very familiar to them, and for Western viewers, a form of figuration that they thought they understood. This cultural alienation is represented at its limits by Cai's utopian citation of the ultimate difference of the extraterrestrial—denizens of different planets. And yet, for me, the most theoretically significant accomplishment of Cai's work builds upon this basic articulation of difference to propose strategies for *negotiating* or crossing such differences and distances. It is here that he engages with that dimension of Duchamp's readymades

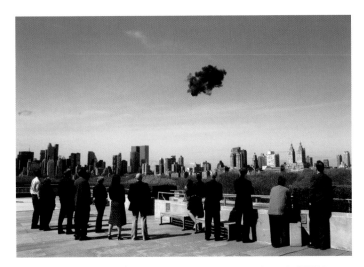

FIG. 31. *CLEAR SKY BLACK CLOUD*, 2006. REALIZED AT THE IRIS AND B. GERALD CANTOR ROOF GARDEN, THE METROPOLITAN MUSEUM OF ART, NEW YORK, DAILY AT NOON, TUESDAY–SUNDAY, APRIL 25–OCTOBER 29, APPROXIMATELY 5 TO 13 SECONDS. BLACK SMOKE SHELLS. COMMISSIONED BY THE METROPOLITAN MUSEUM OF ART FOR THE EXHIBITION *CAI GUO-QIANG ON THE ROOF: TRANSPARENT MONUMENT*

FIG. 32. *CLEAR SKY BLACK CLOUD*, 2005. INK ON PAPER, 33 X 48 CM. COLLECTION OF THE ARTIST

FIG. 33. *TRANSPARENT MONUMENT*, 2006. GLASS, PAPIER-MÂCHÉ, FIBERGLASS, PLASTIC, AND FEATHERS, 457.2 X 310 X 81.3 CM. COLLECTION OF THE ARTIST. INSTALLATION VIEW AT THE IRIS AND B. GERALD CANTOR ROOF GARDEN, THE METROPOLITAN MUSEUM OF ART, NEW YORK, 2006

that pertains not only to the physical dislocation of objects, but also their mobility through reproduction.[8] As I mentioned at the outset of this essay, *Fountain*, for instance, was known exclusively through the circulation of its reproductions—in photography, text, and reissued urinals. The power of that work was and remains a function of the extent and pace of its dissemination as a reproduction. Cai's "cultural readymades" place their emphasis on precisely the formal moment of image dissemination that corresponds in his various projects to three tempos: fast, medium,

and slow (or immobilized). Let me consider each in turn.

The pleasure of Cai's explosion events, beyond their dangerous flirtation with a violence that is never fully domesticated, is that they end too soon. In general, fireworks constitute a potlatch in which the expenditure and labor required to produce them, as well as the excited anticipation of their audiences, are extinguished in a flash. In *Project to Extend the Great Wall of China by 10,000 Meters: Project for Extraterrestrials No. 10*, which I, like most viewers, can only know

secondhand through documentation, the ponderous labor of building the wall goes gaily up in smoke in the seconds it takes to extend the structure through fire for 10,000 meters, leaving in its place only a searing aesthetic-historical afterimage. The accelerated tempo of fireworks is typically used by Cai either to mark occasions like the opening of museums, as in *Transient Rainbow* (2002, cat. no. 30) staged when the Museum of Modern Art moved temporarily from Manhattan to Queens, or to reenact traumatic events in a darkly spectacular key, as in *The*

Century with Mushroom Clouds: Project for the 20th Century, which replays the atomic holocaust in Hiroshima in miniature, or *Clear Sky Black Cloud* (2006, fig. 31) at the Metropolitan Museum of Art, which recalls the attacks of 9/11. These latter events dissolve disaster into showmanship to a degree that pain and voyeuristic pleasure are hard to discern. Under their spectacular surfaces they proffer a sharp ethical challenge: how can we bear negotiating our tragedies—or for that matter, our triumphs—by instantaneously consuming them as entertainment?

If the lines traced by Cai's explosion events move too fast, his other tempos—medium and slow—offer opportunities for contemplation, exploring possibilities that explosions foreclose through their rapidity. The medium tempo is tied to exhibitions, and its form is the itinerary. Cai's 2001 exhibition, *An Arbitrary History*, at the Musée d'Art Contemporain de Lyon, brilliantly superimposed what the artist calls "multiple time lines . . . within one artwork, one space."[9] On the lower floor was exhibited *An Arbitrary History: River* (2001, cat. no. 43), an installation in which viewers could navigate a meandering artificial river—a channel built from woven bamboo, resin, and fiberglass—in yak-skin boats that carried them through a floating retrospective of several of Cai's major sculptures suspended from the ceiling. On the floor above, *An Arbitrary History: Roller Coaster* (2001, fig. 27) accelerated the pace of the viewer's itinerary by shifting the mode of locomotion from that of the nature preserve to that of the amusement park. Visitors could ride a gentle roller coaster, accompanied by an audio recording of Gustav Holst's "Jupiter" from *The Planets*, beneath motifs from twentieth-century Western "masterpieces" like Duchamp's *Fountain* and his *Nude Descending a Staircase No. 2* (1912) collaged into a vast ceiling decoration. It is tempting to compare the river, as a "Chinese" itinerary, to the roller coaster as a "Western" path, and yet such rigid distinctions lead directly to the trap so skillfully laid by *Venice's Rent Collection Courtyard*. It is sufficient to say that in this superimposition, Cai remakes the sizzling line of fireworks as a more leisurely itinerary through a landscape of images.[10]

If the fast tempo of explosion events corresponds to the status of an event, and the medium tempo relates to exhibitions, the slow tempo (or the utter immobility of silence) corresponds to individual works of art or monuments. In so many of Cai's sculptures a line of movement is evoked by an arc of repeated elements describing a trajectory, as in *Cry Dragon/Cry Wolf: The Ark of Genghis Khan* (1996, cat. no. 39); or sequential motion sculptures reminiscent of stop-action photography, as in the exploding automobile in *Inopportune: Stage One* (2004, cat. no. 45); or a suddenly and cruelly arrested motion, as in *Transparent Monument* (2006, fig. 33), a pane of glass installed on the roof of the Metropolitan Museum of Art with stunned (artificial) birds fallen at its base. It is as though the explosive motion of the events has been frozen into a single moment offered for the viewer's extended contemplation. Taken together, Cai's three tempos function as alternate perspectives on the same aesthetic vector, regarded at different speeds. Whatever their iconographic significance, the three tempos establish a structural and formal potential for negotiation that is closely related to what Nicolas Bourriaud has called Relational Aesthetics. For Bourriaud: "One of the virtual properties of the image is its power of *linkage* (Fr. *reliance*),"[11] an explicitly social bond. Bourriaud's influential, if somewhat overly capacious program promotes artistic practices whose medium is social relations themselves, as in Pierre Huyghe's enactments of festivals (figs. 34 and 35) or Rirkrit Tiravanija's staging of meals in museums and galleries. Each of Cai's *tempos* traces a different social or relational vector—the line of fire, an itinerary, or a frozen action—but all actualize a moment of *linkage* by enacting the passage from one point to another. Each, in other words, is founded in mobility as the necessary ground for the negotiation of difference and the production of a community. The best description I know of such dynamic aesthetic objects comes from Huyghe, who declared in a 2004 interview: "I am interested in an object that is in fact a dynamic chain that passes through different formats. I am interested in a movement that goes through and between some of the fields

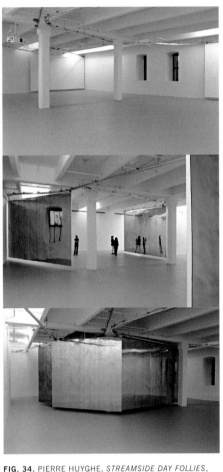

FIG. 34. PIERRE HUYGHE, *STREAMSIDE DAY FOLLIES*, 2003. DIGITAL VIDEO PROJECTION FROM FILM AND VIDEO TRANSFERS, COLOR, SOUND, 26 MINUTES; MOVING WALLS, FIVE COLORED PENCIL DRAWINGS. ELLIPSE FOUNDATION, CASCAIS, PORTUGAL. INSTALLATION VIEW AT DIA ART FOUNDATION, NEW YORK, 2003–04

[architecture, design, cinema, and music] that you mentioned."[12] Cai is also interested in "objects" that behave as dynamic chains, but rather than passing through different formats, they conversely function as the medium for different amplitudes of explosive motion.

READYMADE ETHICS

How do these object-chains function ethically? Cai's spectacular explosion events are often interpreted as performing a kind of healing, or homeopathic energetic balancing. The artist, as well as his critics, frequently cites the Chinese association of gunpowder with medicine. In a 2002 interview he stated:

> I saw gunpowder used in both good ways and bad, in destruction and reconstruction. Gunpowder was invented in China as a by-product of alchemy. It is still called 'fire medicine' because it was accidentally created during an attempt to produce a medicine.[13]

And yet Cai's aesthetics are not aimed at healing trauma once and for all, but rather at demonstrating how destructive and constructive forces (even with regard to such

events as terrorist attacks) are inextricably linked, as he suggests in an interview published three years later, in 2005:

> No matter how extraordinary an event is, it is also nothing extraordinary. No matter how transitory life is, it is also infinite. No matter how lacking in energy, there is still energy. Impossibility is still possibility. Because energy is infinite, no one is capable of using it up. Understanding this allows the self to be relaxed and free, at one with the universe.[14]

In Cai's art, modes of destruction and construction, in and through representation, are bound together in circuits of negotiation. This aesthetics of image generation is analogous to the broad contemporary fascination with cinematic reenactments among artists like Huyghe, in which documentary and fiction, original and copy, and acting versus being are inextricably folded together. One of the fundamental preoccupations of art in the 1990s and 2000s has been the wild and even exorbitant production of images from other images, whether in Catherine Sullivan's "derivative" character-types performing

delirious scores of fragmentary actions in the multi-screen projection *The Chittendens* (2005), or Mike Kelley's reenactments of extracurricular activities drawn from high school yearbooks and done in several media and formats ranging from photographs to videotapes and sculpture in *Day is Done* (2005). In these practices, the image undergoes a quasi-biological cycle of life and death—of circulation, dormancy, and recirculation— just as in Cai's works different tempos characterize image-events whose meaning is largely derived from the changes in state and the locations they traverse.

Cai's generation of images is, however, more closely tied to cycles of violence and their reversals (as entertainment or catharsis). In discussing the events of September 11, Jacques Derrida used the term "autoimmunitary" to suggest a form of image-event uncannily similar to Cai's explosive object-chains. Autoimmunitary images do not arise from outside the global system, but from within it as a reactive force:

> More than the destruction of the Twin Towers or the attack on the Pentagon, more than the killing of thousands of

FIG. 35. PIERRE HUYGHE, *STREAMSIDE DAY*, 2003. FILM AND VIDEO TRANSFERS, COLOR, SOUND; 26 MINUTES. VIDEO STILL. COLLECTION OF CONTEMPORARY ART FUNDACIÓ "LA CAIXA," BARCELONA, AND FONDATION LOUIS VUITTON POUR LA CRÉATION, PARIS

FIG. 36. NEW YORK, SEPTEMBER 11, 2001

people, the real "terror" consisted of and, in fact, began by exposing and exploiting, having exposed and exploited, the image of this terror by the target itself. This target (the United States, let's say, and anyone who supports or is allied with them in the world, and this knows almost no limits today) had it in its own *interest* (the *same* interest it shares with its sworn enemies) to expose its vulnerability, to give the greatest possible coverage to the aggression against which it wishes to protect itself. This is again the same autoimmunity perversion.[15]

Derrida refers here to how the image of terrorist destruction—the collapse of the Twin Towers, and the resulting media explosion—was compulsively fueled and amplified in the United States by expansive coverage on television, the Internet, and print media in order to build consensus for an aggressive "War Against Terror," and an ideologically related, if strategically irrelevant war against Saddam Hussein. In other words, the aggressors and victims in this attack made use of the same image-events: the former in order to terrify its opponents and rally its sympathizers, and the latter to claim moral high ground and consolidate support among its citizens and allies for retaliatory action. What Derrida insists upon is that the *circulation* of images is ethically complex and ultimately contradictory since the selfsame spectacle may be used in different contexts for absolutely opposed purposes. Cai's explosion events and his auxiliary aesthetic tempos of medium-speed exhibition itineraries and frozen sculptural vectors embody this complex autoimmunity logic. He makes images that produce their own reversals: China and the West, war and celebration, propaganda and entertainment all mutually generate one another. Indeed, even though film and video have not been his primary mediums, Cai's art may be regarded as enacting *media explosions* in that the negotiations he orchestrates have everything to do with facing the overwhelming pace at which we receive visual information, and the exhilarating and sometimes terrifying volatility with which images may be consumed (think for instance of the Abu Ghraib photographs exposed on cell phones and ultimately disseminated worldwide via the Internet). If, as I believe, the *circulation* of images is as important as their representational face value,[16] Cai has done a great service in presenting the *explosive image*, from several angles and at different speeds, as an ethically challenging model of meaning in an era where terror and media work hand in hand.

NOTES

The author would like to thank the Cai Studio and especially Michelle Yun for research assistance, and Helena Winston for her careful editorial response.

1. For an excellent account of the "career" of *Fountain* see William A. Camfield, *Marcel Duchamp: Fountain* (Houston: Menil Collection, Houston Fine Arts Press, 1989).

2. Cai Guo-Qiang, "On *Venice's Rent Collection Courtyard*," *Avant-Garde Today* (China: Tianjin Academy of Social Sciences Publishing House) 9 (2000), pp. 75–78. Translation by Philip Tinari.

3. Alexandra Munroe, e-mail message to David Joselit and Helena Winston, August 3, 2007.

4. Zhu Qi, "We Are All Too Sensitive When it Comes to Awards! Cai Guo-Qiang and the Copyright Infringement Problems Surrounding *Venice's Rent Collection Courtyard*," in *Chinese Art at the Crossroads: Between Past and Future, Between East and West*, ed. Wu Hung (Hong Kong: New Art Media Limited, in collaboration with the Institute of International Visual Arts, London, 2001), p. 65.

5. "Some Chinese critics and artists used harsher language, calling Cai Guo-Qiang a 'banana (yellow on the outside, white on the inside)—and a greencard (somebody with a Western passport)—artist.' They say that Cai Guo-Qiang and other Chinese artists living in the West use Chinese political and traditional images to pander to Western political ideology and Western fascination with the East, in order to gain entrance to international art exhibitions held in the West." Ibid., p. 58.

6. "In order to maintain its global position, capital has had to negotiate and by negotiate I mean it had to incorporate and partly reflect the differences it was trying to overcome. It had to try to get hold of, and neutralize, to some degree, the differences. It is trying to constitute a world in which things are different. And that is the pleasure of it but the differences do not matter." Stuart Hall, "The Local and the Global: Globalization and Ethnicity," in *Culture, Globalization and the World-System: Contemporary Conditions for the Representation of Identity*, ed. Anthony D. King (Minneapolis: University of Minnesota Press, 1997), p. 33.

7. In conversation with the author, Cai emphasized the importance of "distance" to him. Conversation on April 30, 2007.

8. See in this regard, T. J. Demos, *The Exiles of Marcel Duchamp* (Cambridge: MIT Press, 2007).

9. Jérôme Sans, interview with Cai Guo-Qiang, "Light Your Fire," in *Cai Guo-Qiang: An Arbitrary History* (Lyon: Musée d'Art Contemporain de Lyon; Milan: 5 Continents Editions srl, 2002), p. 56. Cai makes this comment with regard to *Venice's Rent Collection Courtyard*, but I think it is equally applicable to *An Arbitrary History*.

10. Curator Thierry Raspail makes a similar point when he writes that on account of their shared emphasis on duration, "the 'arbitrary history' and the Explosion are two facets of a single process." Thierry Raspail, "An Arbitrary History—A History *Now*," in *Cai Guo-Qiang*, p. 13. With regard to the model of the exhibition itinerary, it is important to note that Cai has initiated a number of working museums around the world including his very charged *BMoCA (Bunker Museum of Contemporary Art): Everything Is Museum No. 3* (cat. no. 52), initiated on September 11, 2004, which transformed various abandoned bunkers on Kinmen Island, a disputed territory between China and Taiwan during the Cold War, into exhibition spaces. Interestingly, the BMoCA was self-consciously intended to assist in efforts to make Kinmen Island a tourist destination, thus offering a different model of negotiation between alternate models of "Chinese-ness" from that of *Venice's Rent Collection Courtyard*. The historically charged opening date, on the third anniversary of 9/11, also makes clear Cai's ongoing engagement with terrorism. See Cai Guo-Qiang, *Bunker Museum of Contemporary Art, Kinmen Island: A Permanent Sanctuary for Arts in a Demilitarized Zone* (Milan: Charta, 2006).

11. Nicolas Bourriaud, *Relational Aesthetics*, trans. Simon Pleasance and Fronza Woods with the participation of Mathieu Copeland (Dijon: Les Presses du réel, 2002), p. 15.

12. George Baker, "An Interview with Pierre Huyghe," *October* 110 (Fall 2004), p. 90.

13. Octavio Zaya in Conversation with Cai Guo-Qiang, in Dana Friis-Hansen, Octavio Zaya, and Serizawa Takashi, *Cai Guo-Qiang* (London: Phaidon, 2002), p. 14.

14. Cai Guo-Qiang, interview with Jennifer Wen Ma, "I Wish It Never Happened," in *Cai Guo-Qiang: Inopportune* (North Adams: MASS MoCA, 2005), p. 68.

15. Giovanna Borradori, "Autoimmunity: Real and Symbolic Suicides: A Dialogue with Jacques Derrida," trans. Pascale-Anne Brault and Michael Naas, in *Philosophy in a Time of Terror: Dialogues with Jürgen Habermas and Jacques Derrida*, by Giovanna Borradori (Chicago: University of Chicago Press, 2003), pp. 108–9.

16. I make this argument in my book, *Feedback: Television Against Democracy* (Cambridge: MIT Press, 2007).

THE ART OF EXPENDITURE

MIWON KWON

DESTRUCTION AS CREATION

Cai Guo-Qiang's signature material is gunpowder. Throughout his artistic career, which has taken him from China (1957–86) to Japan (1986–95) to now the United States (1995–present), gunpowder has remained at the core of his multifarious practice, serving as the means to produce both grand and modest drawings, as well as to stage the spectacular pyrotechnic events for which he is probably best known. On the one hand, given that gunpowder is known to have been discovered by the Chinese in the ninth century, and continues to be omnipresent in the fabric of everyday Chinese life (marking every significant public and private occasion, from weddings, funerals, anniversaries, and birthdays, to political elections, public speeches, inaugurations, village festivals, etc.), Cai's long-standing commitment to the material can seem natural, reflecting perhaps an indigenous affinity. Indeed, the artist has often spoken about the presence of gunpowder in his childhood growing up in Quanzhou. Gunpowder is part of his formative memories and relates to both celebratory social events as well as the ominous military confrontations taking place between Mainland China and Taiwan.[1] On the other hand, precisely because gunpowder has associations with ancient China, Cai's choice seems strategic as well, conferring cultural authenticity and distinction on his work in the global art world. For some critics, Cai's ongoing employment of gunpowder, like his use of other stereotypically Chinese materials (herbal medicines and teas), imagery (dragons, pagoda towers), and concepts (feng shui, qi, geomancy, and Taoism) reflects the artist's canny ability to play the Chinese card.[2]

But, of course, gunpowder is not linked just to China anymore. It belongs to all countries, and while it is used to produce beautiful celebratory displays, like the ones we see in the United States on the Fourth of July, its capacity to cause injury, death, and destruction and to serve violence and war is by far the more current significance. However, when Cai first started experimenting with gunpowder in 1984 in China, it was in order to explore new ways of creating images and making paintings. Trying to incorporate the accidental into his process by "borrowing" energy from "nature," Cai's canvas-bound explosions were acts of rebellion against the entrenched Chinese tradition of highly controlled and premeditated executions of paintings.[3] Which is to say, he was initially drawn to gunpowder less for its cultural connotations and more for the possibilities it opened up for new processes of making artworks, or more precisely, how it allowed him to explore destroying as a means of making. In the artist's own words regarding his early experiments: "I wanted to investigate both the destructive and the constructive nature of gunpowder, and to look at how destruction can create something as well."[4]

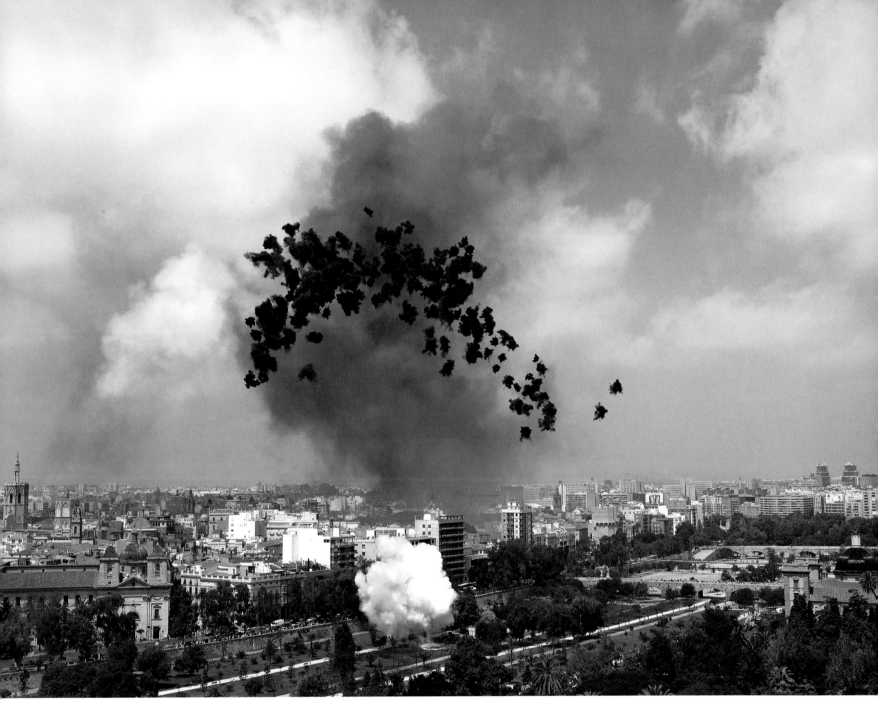

FIG. 37. *BLACK RAINBOW: EXPLOSION PROJECT FOR VALENCIA*, 2005 (CAT. NO. 34)

Cai's investigation of the dyadic, yin-and-yang unity of destruction and creation continues in his subsequent outdoor explosion projects that far exceed the bounds of painting and which have grown extraordinarily in size, scale, budget, and audience. However, Cai's approach to the use of gunpowder and explosions, and by extension the idea of destruction, has shifted in major ways during the past two decades, each shift coinciding with a move to a new country and concomitantly reflecting a major conceptual reorientation. The artist has even mapped distinct periods in his oeuvre of

explosion works. In a 2000 interview with curator and critic Fei Dawei, Cai identifies his "Chinese period" as manifesting a sociological viewpoint, stating that he "us[es] dynamite to avoid painting like a 'literati' and to oppose my spatio-temporal environment—to destroy it."[5] He defines his subsequent "Japanese period" as aesthetic and cosmological in orientation: "I did very pretty things; traces of explosions on paper and canvas were perfectly controlled."[6] But of his current "U.S. period" Cai says very little, cryptically remarking only that he decided to "try something new."[7]

What is this "something new"? Prior to arriving in the United States in 1995, Cai had already executed many impressive explosion projects, including *Human Abode: Project for Extraterrestrials No. 1* (1989, cat. no. 18), *The Immensity of Heaven and Earth: Project for Extraterrestrials No. 11* (1991), *Project to Extend the Great Wall of China by 10,000 Meters: Project for Extraterrestrials No. 10* (1993, cat. no. 21), *The Horizon from the Pan-Pacific: Project for Extraterrestrials No. 14* (1994, cat. no. 22), and *Project for Heiankyō 1,200th Anniversary: Celebration*

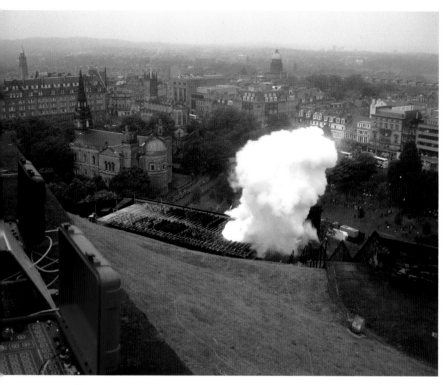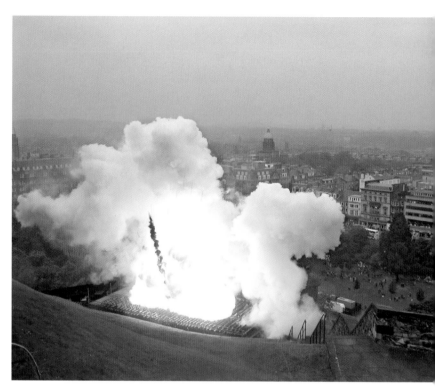

FIGS. 38 AND 39. LAUNCHING SITE FOR *BLACK RAINBOW: EXPLOSION PROJECT FOR EDINBURGH*, 2005 (SEE CAT. NO. 34)

from Chang'an (1994, cat. no. 23). In these projects, all produced while living in Japan and all involving outdoor locations and extensive explosions, the artist sought communication on a cosmological level, addressing his works to an audience in the celestial sphere, in galaxies far, far away (the subtitle for many of these works indicate as much: "Project for Extraterrestrials"). Even in works such as *The Earth Has Its Black Hole Too: Project for Extraterrestrials No. 16* (1994, cat. no. 24), which, due to its siting in Hiroshima, Japan, could not help but agitate the very real historical wounds of World War II and recall the cataclysmic destruction caused by the dropping of the atomic bomb upon the city in 1945, the artist still aspired toward a transcendent outcome.[8]

But whereas Cai's explosion projects of this period address the heavens as a metaphysical exploration of the destruction/creation principle, conjuring the Big Bang, the birth of stars, time tunnels, black holes, the origin of the universe, and the laws of the cosmos—the explosion works after 1995 generally shift their address to his fellow human beings and engage the dynamics of destruction/creation at an altogether different register. Take, for example, the relatively recent *Black Rainbow: Explosion Project for Valencia* (2005, fig. 37), the first in a series of explosion projects to be distinguished by the use of black smoke[9] and that produce a solemn, almost funerary mood quite antithetical to the giddy sense of danger and exhilaration that many of Cai's other explosions incite.

According to Cai, this brief event and the *Black Rainbow* series as a whole (see figs. 38–40) are "intended as a series of omens of widespread unease. While signaling alarm like ancient smoke signals, the ominous arc of smoke in *Black Rainbow* also serves as a somber and dreamlike salute and reminds us, despite our contemporary associations with explosive materials and warfare, that violence and its signifiers can possess ethereal and profound beauty."[10] Indeed, even in their mournful gravity, the *Black Rainbow* explosions are elegant and hauntingly beautiful works. So on the face of it, this new series seems to offer the same kind of metaphysical perspective of destruction that motivated Cai's earlier explosion projects. It also continues to encourage the appreciation of certain "destructive" and "violent" materials, like gunpowder, for their creative capacity, and in this case for their "ethereal and profound beauty." In doing so, Cai asserts once again an outlook that embraces opposed forces as inextricably connected if not unified at some metaphysical level, and proposes the work of art as a vehicle for embodying this connection or unity, transcending the limitations of worldly understanding.

But the three short acts of *Black Rainbow: Explosion Project for Valencia*, unlike many of his other explosion projects that remain abstract in reference, specifically commemorates the victims of the March 11, 2004, train bombings in Madrid, when 191 died and over 1,800 were wounded. In recalling an actual act of urban terrorism and public trauma of very recent memory, and in borrowing the ritual of gun salutes that honor fallen soldiers lost in battle, Cai explicitly foregrounds the very real militaristic uses of gunpowder in *Black Rainbow*. He directs our attention, in other words, to human rather

than cosmological causes of destruction and violence. Although Cai apparently refuses any position of judgment regarding such destruction and violence (one wonders: could he genuinely be beseeching his viewers to appreciate some kind of redeeming beauty in terrorist attacks and warfare? To forget their historical and political realities and to be enthralled by their aesthetic aspects instead?[11]), he locates his artistic investigations now in the human realm. He also presses the categories of art and war into closer aesthetic and conceptual proximity than ever before, bridging the two categories of human endeavor that are normally thought to be opposed to one another: art (creation) and war (destruction).

EXPENDITURE

We will return to the convergence of art and war in Cai's explosion projects, but first we need to realize that the most significant

change in Cai's conceptualization of destruction is not really located in the formal and material aspects of his explosions (the turn to black smoke, for instance), nor in how they might, as in the Valencia project, reference very specific political events and realities. Rather, it is in how the artist now views destruction in terms of expenditure. A clue to the artist's shift in thinking is found in the following exchange between Cai and curator David Rodríguez Caballero, published in the catalogue accompanying the *Black Rainbow: Explosion Project for Valencia*:

> D.R.: The ephemeral component is very much present in your events. The production of these events costs a great deal of money. In the society we live in, we consider art as a consumer good. It is hard to understand that such an expensive artistic product can be consumed in a few instants . . .

C.G.Q.: It is from this destructive nature of consuming such a great amount of money in a split second that the pleasure derives. The destructive implication to material life is the unimportant aspect of the work. It's a triumph of spiritual reality over material reality. Because money is a symbol of power, status, and privilege in our society. And exploding $200,000 worth in fifteen seconds is in itself a statement.[12]

But what kind of "statement" is exploding $200,000 in 15 seconds? And how are we to understand the meaning of such a "statement"? Perhaps it is a political statement, a critical stab at the rich and powerful. After all, Cai implies that in blowing up $200,000 in his explosion, he is challenging the overvaluation of money and the ways in which it determines and maintains hierarchical social divisions. But the statement could be a

FIG. 40. *BLACK RAINBOW: EXPLOSION PROJECT FOR EDINBURGH*

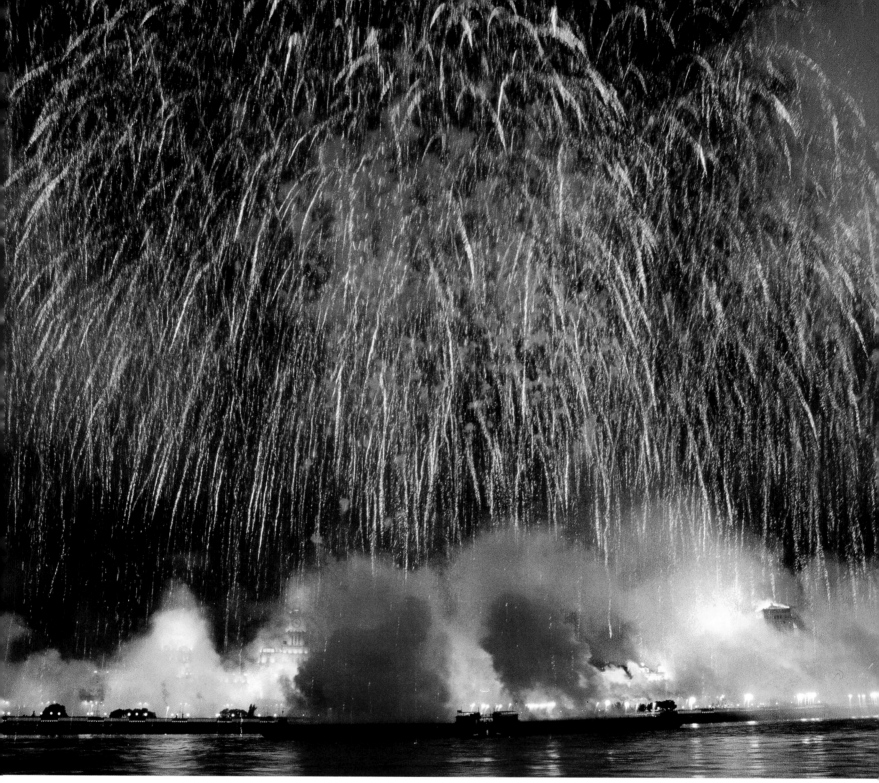

FIG. 41. *ASIA-PACIFIC ECONOMIC COOPERATION CITYSCAPE FIREWORKS*, 2001 (SEE CAT. NOS. 15.1–.14)

specifically artistic one, too, registering a resurgent allegiance to the dematerialization ethos in order to subvert the commodification of art as consumer goods. By professing a lack of interest in the making of any permanent physical object, Cai might be aligning himself here to the anti-commercial and anti-establishment attitudes that emerged in the 1960s in neo-avant-garde art circles in the West that sought to subvert economic materialism through the denial of physical materialism.[13] Then again, in prioritizing spirit over matter, sending $200,000 up in smoke in 15 seconds may be taken for an exaggerated and overly dramatic metaphysical statement.

Whatever the nature of the statement, one thing is clear: the primary source of the pleasure of the work for the artist comes from the consumption of a large sum of money in a short amount of time, used up in a "split second," with the implication that the larger the amount and faster the speed of its consumption, the greater the pleasure. Which is to say, Cai is no longer approaching the notion of destruction as a primordial and cosmological (creative) force but in relation to the economic notion of consumption. More specifically, Cai describes consumption here not as a mode of acquisition but instead as a willful loss, a calculated form of utter wasting where there is no gainful return, no accumulation of value. This will strike those inclined toward a pragmatic way of thinking as a misguided if not an outrageously wasteful enterprise. Couldn't the $200,000 be better spent for more useful purposes? To help the hungry and the poor, for instance, or to further a worthy humanitarian cause, rather than being wasted in this frivolous manner, satisfying a perverse whim of an artist? But it is precisely the extravagance of a purposeless, useless, and seemingly senseless kind of spending, a certain purity of consumption one could say, which seems to interest Cai here.

In fact, despite the artist's consistent reference to destruction as a key methodology of his practice, and despite its centrality in the critical reception of his works, one could argue that Cai's explosion projects are not (and have not been) about destruction. For even when a sequence of powerful explosions speed through a building, smoking it up as if it were under air attack or being demolished (*No Destruction, No Construction: Bombing the Taiwan Province Museum of Art*, 1998, cat. no. 28), or when fire bursts are set off on designer dresses (*Dragon: Explosion on Pleats Please Issey Miyake*, 1998, cat. no. 29), or when gunpowder is detonated on precious handmade paper, the result is never a true violation of the building or dress or paper. His explosions leave behind traces of ash that become the marks of an artistic presence, transforming the building, dress, and paper into highly valued works of art. Nothing is destroyed; objects are, in fact, vitalized. We never have to deal with ruins in Cai's projects. And as such, while they may connote or allude to destruction, his explosions cannot be viewed as themselves part of a destructive methodology. It would be more accurate to understand them as extravagant, highly theatrical performances of expenditure instead. There is, in the first instance, the expenditure of concentrated energy in a technical, material, and physical sense that comes from the speedy burning of gunpowder. But there is also the expenditure of time, effort, and energy of many people, as well as lots of money—all productive aspects of making "a work." And, of course, the loss of all this productive energy, with money as its most abstract representation, is performed quite literally in Cai's case: it is all burned up in a flash; it goes up in smoke.

The artist's own assertion that his explosion projects are acts of lavish spending, an extravagant consumption of wealth, puts them in the orbit of Georges Bataille's radical discourse on political economy. In his 1949 book *The Accursed Share*, a characteristically unclassifiable study in terms of genre or discipline, the French philosopher, writer, and cultural critic went against the conventional wisdom of economic science, insisting on the primacy of expenditure rather than production as the more crucial category of inquiry. Most significantly, Bataille sought an almost cosmologically encompassing theory of a "general economy" that could relate problems posed in calculable economic crises (i.e., overproduction, scarcity, utility, profit, etc.—concerns of what the author calls "restrictive economy") to the broader dynamics of production and consumption as they pertain to family rituals, cultural exchanges, and social interactions, as well to as natural processes involving all living matter (i.e., eating, death, and sexual reproduction). Hence, to Bataille "a human sacrifice, the construction of a church or the gift of a jewel were no less interesting than the sale of wheat,"[14] as they all instance forms of expenditure and serve as evidence of movements toward dissipating accumulated excess energy, which the author also called wealth.

Bataille's focus on expenditure is motivated by his belief that the fundamental problem of modern man is no longer how to fulfill necessities for the continuation of man's existence on earth (i.e., production) but rather what to do with the accumulation of surplus energy that far *exceeds* man's needs for survival (i.e., consumption). That is, how to deal with "luxury." In his words:

> The living organism, in a situation determined by the play of energy on the surface of the globe, ordinarily receives more energy than is necessary for maintaining life; the excess energy (wealth) can be used for the growth of a system (e.g., an organism); if the system can no longer grow, or if the excess cannot be completely absorbed in its growth, it must necessarily be lost without profit; it must be spent, willingly or not, gloriously or catastrophically.[15]

The system that is most immediately relevant to consider in relation to Cai's explosions as expenditure is, of course, the contemporary art system. In light of Bataille's words, we can understand those aspects associated with the "globalization of the art world" today (of which Cai is an active participant and subject)—the escalating size and scale of contemporary art production, the parallel spectacularization of new museum architecture, the countless expansions and franchising of art museums, the multiplication and increasing prominence of international biennials and art fairs, etc.—as either the ongoing growth of a system that has not yet reached

its maximum capacity, or, more likely, modes of dissipating all the surplus energy that cannot be absorbed by the actual needs of the system. That is, the current rate of growth of the art industry and its global expansion, exemplified best by the intensification of museum construction around the world, can be viewed as pure waste.

Cai's intuitive understanding of the need for "destructive" consumption as an appropriate, if not logical response to the ever-expanding conditions of the present art system was registered even earlier than his wasting $200,000 in 15 seconds in Valencia. The artist remembers this 1999 exchange with curator Jan Hoet in an interview with Fei Dawei:

> I have attended a good number of inaugurations of new museums, such as the S.M.A.K. [Stedelijk Museum voor Actuele Kunst] in Ghent. Jan Hoet wanted me to participate. I told him: "With all the money that you gave me to make work, I am going to buy some firecrackers to explode the money that is left over." He asked me: "What is the significance of such an act?" I answered: "It means that you wanted to build a museum and therefore spend money!" . . . I think we spend too much money on museums. This is what I wanted to express when I did a giant explosion at a museum in Taiwan.[16]

As the artist put it more succinctly in another interview: "For me, bombing or establishing a museum is the same thing."[17]

The system that Bataille had in mind when theorizing expenditure and the general economy was not limited to any specific field of activity like art, but rather, as mentioned earlier, encompassed all forces—natural, social, economic, political, religious, etc.—that act upon and move through the planetary dynamics of production and consumption. When there is no more room to grow, yet productive activities continue at a pace, the dissipation of excess energy or the adequate loss of accumulation accrued from too much and ever intensifying productivity becomes a crucial task for man's survival on earth. Bataille recommended that such energy, or wealth be spent lavishly (that is, without return) because, as he warned, "if we do not have the force to destroy the surplus energy ourselves, it cannot be used, and, like an unbroken animal that cannot be trained, it is this energy that destroys us; it is we who pay the price of the inevitable explosion."[18]

For Bataille, war is the "inevitable explosion" that follows the failure of lavish spending. In his view, modern industrial development and technological innovations that fueled various demographic expansions and the growth of productivity in advanced countries around the world from the late nineteenth through the twentieth century, having satisfied what was needed for maintaining life, reached moments when continuous expansion and growth became far too difficult to sustain. He asserted that both World War I and II could be understood as catastrophic but necessary consequences of mankind's need to utterly waste the immense accumulation of excess energy (human, natural, and technological); to spend it without a return in order to be able to go on. He goes on to say: "We can express the hope of avoiding a war that already threatens. But in order to do so we must divert the surplus production, either into the rational extension of a difficult industrial growth, or into unproductive works that will dissipate an energy that cannot be accumulated in any case."[19]

With the explosion projects at its core, Cai's artistic practice pushes toward pure loss and waste, toward "unproductive works" in Bataille's sense of the term. But given the art system's penchant for converting all types of lavish expenditure, including its own, into a form of production, rendering necessary wasting into unnecessary making, Cai's efforts at unproductive work—like burning up $200,000 in 15 seconds—can easily be recast as a "production" or "a work"—consolidated as a form of accumulation and gain all over again, rather than dissipated as an unrecoverable loss. This is due in part to the fact that, as Bataille noted, to devote oneself to expenditure "is to go against judgments that form the basis of a rational economy."[20] The "wisdom" of a rational economy, whose rules betray art's opportunities for necessary waste, converts what I would call critical consumptive expenditure into recuperative productive expenditure. And the artist inevitably partakes in the very processes that the latter type of expenditure supports: the spectacularization of culture and the structural conditions of the contemporary art system that promote its continued, if "difficult," growth and expansion.[21] So, for instance, while the "bombing" of the Taiwan Province Museum of Art in *No Destruction, No Construction* expresses the artist's stated critical view of overblown expansionist efforts of museums around the world,[22] it simultaneously functions to "rejuvenate" the museum, giving it "new and powerful energy."[23] The disturbance to the building, in fact, does little to interrupt the institution's business-as-usual activities as the burn-mark "designs" left by Cai's explosion sequence upon the pillars flanking the entrance to the museum are now part of its permanent collection.

LAND ART AS DISASTER
Putting aside such contradictions, a serious consideration of art as what Bataille identifies as "unproductive works," or what I am calling critical consumptive expenditure, leads to the issue of the relationship between art and war, that "inevitable explosion," which has not been far from Cai's mind over the past two decades. Indeed, his interest in destruction, the use of gunpowder, the consistent appearance of or reference to rifles, bombs, missiles, and other weapons, and the conjuring of the military and its rituals, all make plain the centrality of war in Cai's practice. But the

FIG. 42. *ASIA-PACIFIC ECONOMIC COOPERATION CITYSCAPE FIREWORKS*

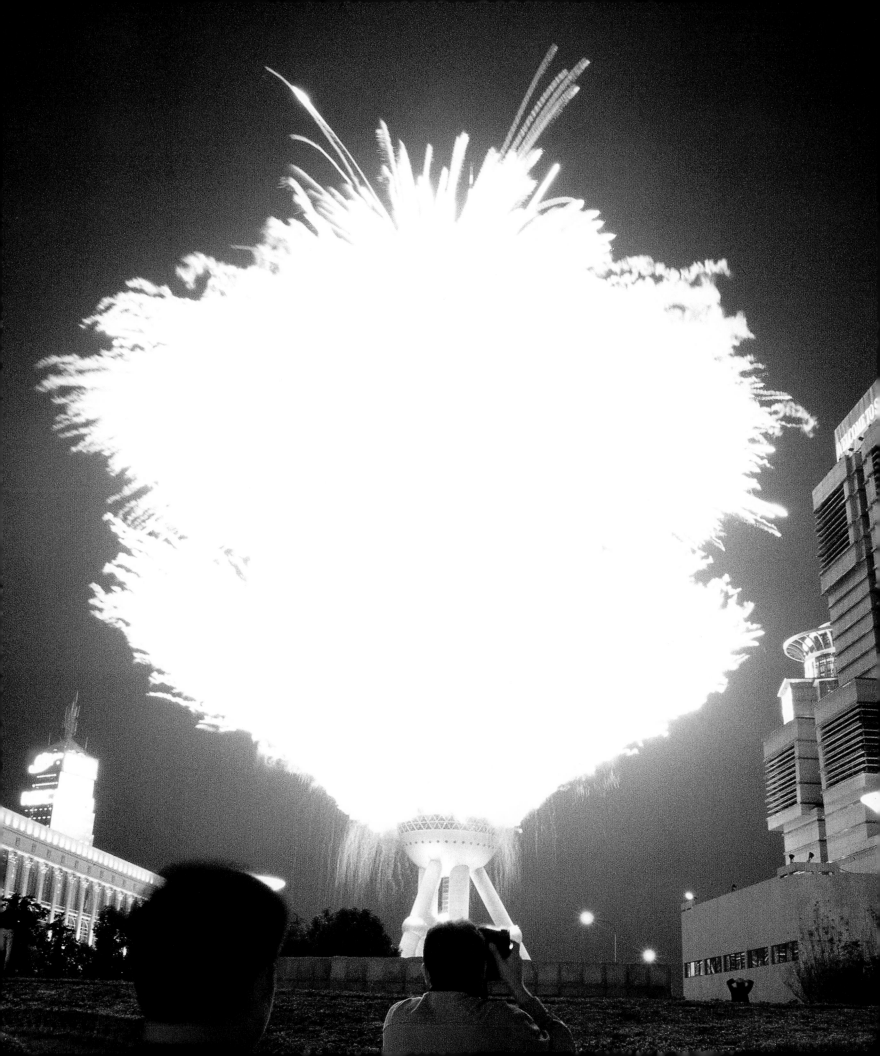

presence of war in the artist's imagination is not merely at the level of subject matter or image and material repertoire. His art is not just *about* war. Rather, art and war are conceived to be structurally one with the other (see figs. 41 and 42).

Explicitly, Cai did not choose an art historical, theoretical, cultural, or literary text for the feature in the "Artist's Choice" section of the 2002 monograph on the artist published by Phaidon Press, as so many other artists in the series have done. Rather, the reader finds there the table of contents from *Warfare Beyond Rules: Judgment of War and Methods of War in the Era of Globalization* by Qiao Liang and Wang Xianhui. Of this selection, the artist notes:

> If in the table of contents reprinted here you exchange the words 'war' (or 'warfare') with 'exhibition'; 'weapon' with 'artworks,' you will see that the theories laid out in *Warfare Beyond Rules* parallel the state of the artist and art world since the 1990s. For example, 'the war Defined by the Weapons vs. the War Dictating the Weapons Produced' becomes 'the Exhibition Defined by the Art Works vs. the Exhibition Dictating the Art Works Produced.'[24]

Here, war is not simply a metaphor for Cai; art and war are parallel operations. On other occasions, the artist has more bluntly referred to the art world itself as a militarized zone: "Art is like an industry over here [in the United States]. It's like the official army, whereas in China, art is like the underground guerrilla forces and in Japan it's more like the militia."[25]

Taking this lead from the artist, and with the help of Bataille's thinking on expenditure, we can perhaps better understand what the "something new" might be in Cai's explosion projects of his "U.S. period." We can turn to *The Century with Mushroom Clouds: Project for the 20th Century* (1996, cat. no. 26), Cai's very first project after arriving in the United States, to see the artist's keen sensitivity to the link between art and war more clearly. For this "private" and decidedly unspectacular performance and photographic series, conceived in part to explore America, the artist traveled to a set of specific locations around the United States, detonating at each site a home-made, handheld explosive. The puff of white smoke produced by the explosive is caught by the photographic image as if being released into the air by the artist, who stands alone in a vast urban or natural landscape. The small size of Cai's "mushroom cloud" is a meager yet forceful reminder of the real deal, however, which the artist has described as a "beautiful, monumental image. It is the visual creation that symbolizes the twentieth century, overwhelming all other artistic creations of its time."[26]

As if to make the point absolutely unambiguous, the artist chose two locations for the series that highlight canonic Land art pieces that are famous for their overwhelming scale and ambition—Michael Heizer's *Double Negative* (1969–70) in the Mormon Mesa in Nevada, and Robert Smithson's *Spiral Jetty* (1970, figs. 43 and 44) in the Great Salt Lake of Utah. These sites of monumental artistic creations are put in relation to a site of another kind of monumental and overwhelming undertaking that ultimately dwarfs the ambitions of the first two: the U.S. military nuclear Nevada Test Site. The triangulation of these three locations, which Bataille would likely recognize as sites of extraordinary expenditure, are further constellated with New York, ostensibly still the center of the art world and the seat of the undisputed might of American capitalism. Cai's small, almost delicate "mushroom cloud" against the skyline of lower Manhattan with the Statue of Liberty on one side and the Twin Towers of the World Trade Center still standing on the other side cannot help but be seen now as a harbinger of the explosive outflow of energy on September 11, 2001—a glorious event for few, a catastrophic one for most (fig. 17). Overall, *The Century with Mushroom Clouds* frames the literally groundbreaking, epic artistic efforts of Land art and the militaristic visual creation of a "beautiful and monumental image" as deeply connected along the lines of expenditure. And this

FIG. 43. ROBERT SMITHSON'S *SPIRAL JETTY* (1970) UNDER CONSTRUCTION

FIG. 44. ROBERT SMITHSON, *SPIRAL JETTY*, 1970, GREAT SALT LAKE, UTAH. BLACK ROCK, SALT CRYSTALS, EARTH, AND RED WATER (ALGAE), COIL: LENGTH 457 M; WIDTH 4.6 M. COLLECTION DIA ART FOUNDATION

FIG. 45. *THE CENTURY WITH MUSHROOM CLOUDS: PROJECT FOR THE 20TH CENTURY*, 1996 (CAT. NO. 26) AT ROBERT SMITHSON'S *SPIRAL JETTY*, FEBRUARY 15, 1996

connection between art and war continues to be embodied—not merely represented—in almost all of Cai's explosive art.

It is surprising that Cai did not make it to Quemado, New Mexico on his travel for *The Century with Mushroom Clouds*. Because there he would have found Walter De Maria's *The Lightning Field* (1977, fig. 46), a work that Cai has cited as among the most inspiring of contemporary art for its linking of sky and earth, and for its dependence on the electrical discharge of lightning flashes which "reveal communication with an unseen force."[27] But there is more to the affinity between Cai's and De Maria's art than the cosmic orientation that the former recognizes in the latter's work. The apparent similarity between a natural display of lightning and a cultural display of fireworks is also inadequate to understanding what is shared between the two artists. For before De Maria moved into the landscape to draw mile-long lines in the Mojave Desert; or took over entire gallery spaces in Munich, Darmstadt, and New York in order to fill them up with dirt; or dug a hole one kilometer long into the earth only to fill it up again with a metal rod of the same diameter and length,[28] he wrote a manifesto espousing a kind of art that would be purposeless, unproductive, and not add up to anything. In a short statement entitled "Meaningless Work" (1960), De Maria confidently declared:

> Meaningless work is obviously the most important and significant art form today. . . . By meaningless work I simply mean work which does not make you money or accomplish a conventional purpose. For instance putting wooden blocks from one box to another, then putting the blocks back to the original box, back and forth, back and forth etc., is a fine example of meaningless work. Or digging a hole, then covering it is another example.[29]

Meaningless work still requires effort ("like ordinary work, meaningless work can make you sweat if you do it long enough"), but it does not yield gains of any kind—not prizes, nor profit, nor even pleasure. In short, meaningless work, the most significant art form of his time in De Maria's view, is expenditure (of energy, resources, time, etc.) without a return. And this expenditure is not only that of the "sweat" of the artist but also the money of the patron: when De Maria drilled a hole and covered it up again in Kassel, Germany, for *Documenta 6*, producing a 19-ton sculpture buried in the earth, never to be seen, he spent $419,000 in 1977 U.S. dollars, a gesture that is arguably far more extravagant, more expensive, and thus more outrageous than Cai blowing $200,000 in 15 seconds.[30]

Although Cai has received many prizes, made substantial gains, and, one assumes, finds great pleasure in his work (even De Maria has suffered such "indignities," which is what he called such rewards in 1960), if the reader can be persuaded that the art of De Maria and Cai both entail expending, wasting, spending, burning, losing, or, as Bataille put it, "dissipat[ing] a substantial portion of energy produced [i.e., wealth], sending it up in smoke,"[31]—this last in metaphorical terms in De Maria's case, and literal in Cai's—then we potentially have an altogether different story to tell about Land art in general.[32] We can see, for instance, that what has been said of the heroic and monumental undertaking of Land art could be rethought as not merely post-Minimalism's expansion into the landscape, escaping the gallery system, embracing the ephemeral, etc., but as a new iteration of art as massive expenditure or destructive consumption.[33]

Land art, emerging during the era of the Vietnam War, can be reinterpreted in other words, as a critical investigation of lavish spending in the manner discussed by Bataille. Although this story of Land art cannot be pursued here, we can recognize the work of Cai Guo-Qiang as allowing a new access point to interrupt its conventionalized discourse.

Finally, one last thought. In 1960 De Maria wrote another tract entitled "On the Importance of Natural Disasters." He says there that a flood, forest fire, tornado, earthquake, typhoon, sand storm, and the breaking of ice jams may be "the highest form[s] of art possible to experience." He complained longingly: "If all of the people who go to museums could just feel an earthquake."[34] Cai came close to providing such an experience in 2005 with his *Tornado: Explosion Project for the Festival of China* (cat. no. 36) for the John F. Kennedy Center for the Performing Arts in Washington, D.C. Although not fully executed as conceived, this multipart, 7-minute fireworks spectacle on the Potomac River culminated with an awesome 100-foot-wide cone-shaped twister touching down on the water from 500 feet in the air, then rising up again from the water to that height. Other than war, there is perhaps no greater and more powerful a model for an art of the purposeless and meaningless wasting of wealth than a natural disaster. And one assumes Cai's lavish "statement" in this case blew up a far greater sum than $200,000.

NOTES

1. Octavio Zaya, "Interview: Octavio Zaya in conversation with Cai Guo-Qiang," in Dana Friis-Hansen, Octavio Zaya, and Serizawa Takashi, *Cai Guo-Qiang* (London: Phaidon Press Limited, 2002), p. 14.

2. Fei Dawei, "Amateur Recklessness: On the Work of Cai Guo-Qiang," in *Cai Guo-Qiang* (Paris: Fondation Cartier pour l'art contemporain; London: Thames & Hudson, 2000), p. 9.

3. In actuality, Cai did not use natural forces so much as industrial objects to aid in his painting techniques, like electric fans to move the paint across canvas, for instance. See his remarks in his interview with Octavio Zaya, p. 13.

4. Ibid.

5. Fei Dawei, "To Dare to Accomplish Nothing: Fei Dawei Interviews Cai Guo-Qiang," in *Cai Guo-Qiang* (Paris; London), p. 132.

6. Ibid.

7. Ibid.

8. Such aspirations are well reflected in Cai's description of the experiential dimension of these projects: "I think at the split second of the explosion, the viewer feels a connection with the energy of the universe, crossing the walls of time and space." And, "at the moment of explosion, all existences in the celestial bodies, earth and humans are entranced—time/space stops, or time/space goes back to its origin. They unite with the ether of the universe." See Jérôme Sans, interview with Cai Guo-Qiang, "Light Your Fire," in *Cai Guo-Qiang: An Arbitrary History* (Lyon: Musée d'Art Contemporain de Lyon; Milan: 5 Continents Editions srl, 2002), p. 54; and Dana Friis-Hansen, "Towards a New Methodology in Art," in *Cai Guo-Qiang* (London, 2002), p. 49, respectively.

9. Black smoke is composed of atomized charcoal that is nontoxic to the environment and is absorbed by the atmosphere. See *Cai Guo-Qiang: Transparent Monument* (Milan: Edition Charta, 2006), p. 52.

10. See the entry on *Black Rainbow: Explosion Project for Valencia* on the artist's Web site: www.caiguoqiang.com.

11. One is reminded of the controversy surrounding the remarks of German composer Karlheinz Stockhausen, who was misrepresented in the press as having said that the attacks on the World Trade Center buildings in 2001 were "works of art."

12. David Rodríguez Caballero, "East–West–East: Interview with Cai Guo-Qiang," in *Cai Guo-Qiang: On Black Fireworks* (Valencia: Institut Valencia d'Art Moderne, 2005), p. 123.

13. Lucy Lippard has been the most articulate in defining the parameters of an art of dematerialization. See her *Six Years: The Dematerialization of the Art Object from 1966 to 1972* (1973; Berkeley: University of California Press, 1997).

14. Georges Bataille, *The Accursed Share: An Essay on General Economy*, vol. 1, *Consumption*, trans. Robert Hurley (New York: Zone Books, 1988), p. 9. Published in France as *La Part maudite* (Paris: Les Éditions de minuit, 1967). This 1967 version is the well known version of Bataille's 1949 text and is the one on which the English translation is based.

15. Bataille, p. 21.

16. Dawei, "To Dare to Accomplish Nothing: Fei Dawei Interviews Cai Guo-Qiang," p. 127.

17. Sans, p. 57.

18. Bataille, p. 24.

19. Ibid., p. 25.

20. Ibid., p. 22.

21. The move to embrace, rather than resist the logic of the culture industry is one that has a longer history in postwar art. In reevaluating the legacy of the French artist Yves Klein, an artist who, like Cai, was devoted to fire, expenditure, and loss, Yve-Alain Bois has written that "in a world in which everything has become myth and spectacle, only the spectacularization of myth and spectacle can contain a parcel of truth: as their indictment." Yve-Alain Bois, "Klein's Relevance for Today," *October* 119 (Winter 2007), p. 86.

22. See the project description for *No Destruction, No Construction: Bombing the Taiwan Province Museum of Art* in *Cai Guo-Qiang* (Paris; London), p. 147: "This project is particularly meaningful when considered in the context of the current trend of building oversized museums throughout the world, while the present museum system is still full of many problems."

23. Dana Friis-Hansen, "Towards a New Methodology in Art," p. 83.

24. The selection is Jennnifer Wen Ma's translation of only the table of contents of the book, which was published in Beijing by The Chinese People's Liberation Army, Art and Culture in 1999. See *Cai Guo-Qiang* (London, 2002), p. 118.

25. Zaya, p. 22.

26. Quoted in Friis-Hansen, p. 70.

27. Ibid., p. 57. Given the difficulty of viewing *The Lightning Field* in situ, especially with Dia Art Foundation's intense control over access to it, it is ultimately not surprising that Cai did not visit the work. His impression of the work as a form of communication between sky and earth is in fact directed by the familiar photographic images of the piece, the distribution of which is also highly controlled. On this issue of control over access, see John Beardsley, "Art and Authoritarianism: Walter De Maria's *Lightning Field*," *October* 16 (Spring 1981), pp. 35–38.

28. The works referred to here by Walter De Maria are, in order: *Mile Long Drawing* in the Mojave Desert, California (1968); *Earth Room* in Munich (1968), Darmstadt (1974), and New York (1977, redone in 1980 as a permanent installation); and *Vertical Earth Kilometer* in Friedriensplatz plaza park in Kassel, Germany, made for *Documenta* 6 in 1977.

29. Walter De Maria, "Meaningless Work (March 1960)," in *An Anthology*, ed. La Monte Young (New York: La Monte Young and Jackson Mac Low, 1963). Reprinted in Kristine Stiles and Peter Selz, eds., *Theories and Documents of Contemporary Art: A Sourcebook of Artists' Writings* (Berkeley: University of California Press, 1996), p. 526.

30. The sponsoring institution footing the bill was the Dia Art Foundation. For a detailed history of De Maria's *Vertical Earth Kilometer*, see George Baker and Christian Philipp Müller, "A Balancing Act," *October* 82 (Fall 1997), pp. 95–118.

31. Bataille, p. 22.

32. Cai has been asked to comment on the relationship

between his projects and Land art on a regular basis over the past two decades. While a connection between Cai's work and those works by Michael Heizer, Robert Smithson, Walter De Maria, Dennis Oppenheim, or Nancy Holt (among others), may seem viable given their shared sense of scale and attraction to outdoor locations and ephemeral materials, Cai has denied any significant relationship between his work and Land art: "Well, it [Land art] came along before I did, so of course I draw on it. But more importantly, my work is based on my own cultural foundations, on the grand scale of Chinese history and inventions: the Great Wall, the terra-cotta warriors of the Qin dynasty, the great wave of Chairman Mao's Little Red Book during the Cultural Revolution, the relief carving of Mao's portrait on the side of the mountain—all these came to me before the encounter with contemporary western art." (Sans, p. 54.) This and other statements like it underscoring the importance of the artist's Chinese roots should give pause to any (Western) art historian set with the assignment of providing some explanation of Cai's projects in relation to Land art. To assert links based on superficial similarities is a denial of historical and cultural specificity, and to insinuate an artist's practice into an epistemic and methodological trajectory that is foreign, or at least new to the artist's frame of reference and development, would be an egregious act of imperialistic arrogance. But seeing the work of art as a direct and unmediated expression of the artist's identity, background, and self-stated claims is problematic as well. It would be irresponsible to insert Cai's work into Land art's lineage as much as it would be inaccurate to say that his work extends exclusively Chinese traditions. How then is one to approach the task of critical interpretive judgment that is conceptually rigorous and ethically sound, about works by artists whose frames of reference (aesthetic, cultural, sociological, political, historic, and economic) are not one's own familiar frames of reference or formation of discursive and historical understanding? This methodological predicament, with its deep ethical and political implications, constitutes the very unstable grounds of contemporary art discourse today and therefore conditions this essay. The very fact that Cai is asked to address his work in relation to Land art is in itself a manifestation of the uneven playing field of a supposed global art world. Would anyone ask Michael Heizer, for instance, to relate his works to the Great Wall of China or Mao's Cultural Revolution?

33. This is a speculation at this point, but if we follow certain postwar tendencies through the lens of expenditure, we can potentially map a very different genealogy of Land art than the one that currently dominates the discourse. For instance, the work of Yves Klein, Jean Tinguely, Niki de Saint Phalle, Arman, and other artists associated with Nouveau Réalisme were critically engaged with the problems of accumulation and expenditure in relation to the devastating destruction of Europe in World War II, and its aftermath. Arman, for instance, when commissioned for a work by a patron, requisitioned the patron's MG convertible, dynamited it, and returned the wreckage to the patron as the finished sculpture. See Benjamin Buchloh, "From Yves Klein's *Le Vide* to Arman's *Le Plein* (1998)," in *Neo-Avantgarde and Culture Industry: Essays on European and American Art from 1955 to 1975* (Cambridge: MIT Press, 2000), pp. 257–83. To think of Land art as linked to these practices and not merely as American Minimalism or Conceptual art reframes it radically. Thanks to George Baker for exchanges regarding this other genealogical possibility.

34. Walter De Maria, "On the Importance of Natural Disasters (May 1960)," in *An Anthology*. Reprinted in Kristine Stiles and Peter Selz, eds., *Theories and Documents of Contemporary Art: A Sourcebook of Artists' Writings*, p. 527. Thanks to Karen Dunbar for suggesting I consider this text in relation to Cai's work.

CATALOGUE

INTRODUCTIONS BY
ALEXANDRA MUNROE
MÓNICA RAMÍREZ MONTAGUT
SANDHINI PODDAR

ENTRY TEXTS BY
MICHELLE YUN (MY)
REIKO TOMII (RT)

DATA COMPILED BY
MARILUZ HOYOS

CONSULTING SCHOLAR
REIKO TOMII

NOTE TO THE READER

Artwork titles in English and Chinese have been assigned by Cai Guo-Qiang. For dimensions, height precedes width followed by depth. All installation dimensions are variable, but in some cases specific dimensions for one or more components are provided.

The execution data included for certain types of works is introduced by the terminology "Created" for works created before a live audience or made for a specific exhibition; "Realized" for time-based works such as explosion events; "First realized" for installations; and "Permanent museum" for works in the *Everything Is Museum* series. For these works the medium data may comprise select information about conceptually relevant materials and include quantities in parentheses.

The Exhibition History listings in the entries provide abbreviated data for exhibitions and major events in which the work featured in the entry has been presented; for complete details, consult the Selected Exhibition History in the back of this book. The Related Works listings cite selected works that are related conceptually to the featured work; "same title" indicates that a related work has the same title as the featured work.

EARLY WORKS

EARLY WORKS

Cai Guo-Qiang's early works represented in this section date from 1985, when he graduated from the Department of Stage Design at the Shanghai Drama Institute (also known as Shanghai Theatre Academy), through 1988, when he first made large works on Japanese paper using gunpowder and fuses. During this period of experimentation, Cai developed the basic methodology and process of his signature gunpowder drawings and explosions. Trained in academic oil painting, the artist was early to comprehend the possibilities for avant-garde art as introduced to China in the immediate post-Mao era. The early works selected here exhibit his progressive search for a practice of art making that is radically and profoundly experimental. Ultimately, he developed a method of directly harnessing the spontaneity of natural forces, which allowed the artist to relinquish control and resulted in compositions formed by the random marks of sparks and smoke.

Initially, in *Typhoon* (1985, cat. no. 1), Cai experimented with laying oil paint on canvas and blasting it with air blown from an electric fan that he held over the canvas's surface, shaping the movement of paint with the force of wind. The title of the work, its swirling imagery, and the process of its creation all represent his yearning to create art that does not just depict a natural phenomenon of energy, but is itself the direct trace or effect of that phenomenon—in this case, a wind storm.

From the start, Cai sought to connect what he called "the invisible world" to art, linking his practice to a metaphysical study of cosmic meridians of energy currents, primordial states of chaos, and the nature of formless matter. This quest led to his introduction, in 1984, of gunpowder ignited directly on his oil canvases. Cai placed gunpowder and fuses on the surface of the canvas, which he positioned horizontally on the floor. When lit, the fuse lines burned instantly,

igniting the gunpowder and creating loud bangs, flashes of fire, and then clouds of smoke. On a canvas like *Gunpowder Painting No. 8-10* (1988, cat. no. 4) the result is a textured surface that looks and feels like an explosion—the once-white acrylic paint on canvas is blackened, charred, and erupted, arrested in a state of being expended in a flash. After his move to Japan in 1986, Cai switched from igniting gunpowder on painted canvases to igniting it directly on sheets of paper.

Cai's early two-dimensional works on canvas and paper display key themes that would later come to define the artist's conceptual concerns. The first is his mining of Chinese folklore and mythology, wherein he appropriates popular traditional materials, images, and stories to specify the meaning of his work. Gunpowder, a famous Chinese invention that is charged with cultural nationalism, is the most obvious of Cai's tropes. In his painting *Chu Ba Wang* (1985, fig. 6), Cai references a tragic historical figure and uses a style of figural representation that conjures ancient Chinese pictographic script. Cai demonstrates his interest in atomic warfare, another focus of his work, in his remarkable painting *Shadow: Pray for Protection* (1985–86, cat. no. 3), which conveys the spectral horrors of Nagasaki. Finally, in *Self-Portrait: A Subjugated Soul* (1985/89, cat. no. 2), Cai represents his notion of humanity—a being on a quest, surrounded with radiating intelligence like an orb, suspended in a state between form and formlessness like pure energy. Throughout Cai's subsequent work in all mediums, the existential human condition in relationship to "the visible and invisible worlds" remains his central subject. As he later stated in relation to the installation *Primeval Fireball: The Project for Projects* (1991, cat. no. 37), "A quest for one's self is equal to a quest for the universe."

—ALEXANDRA MUNROE

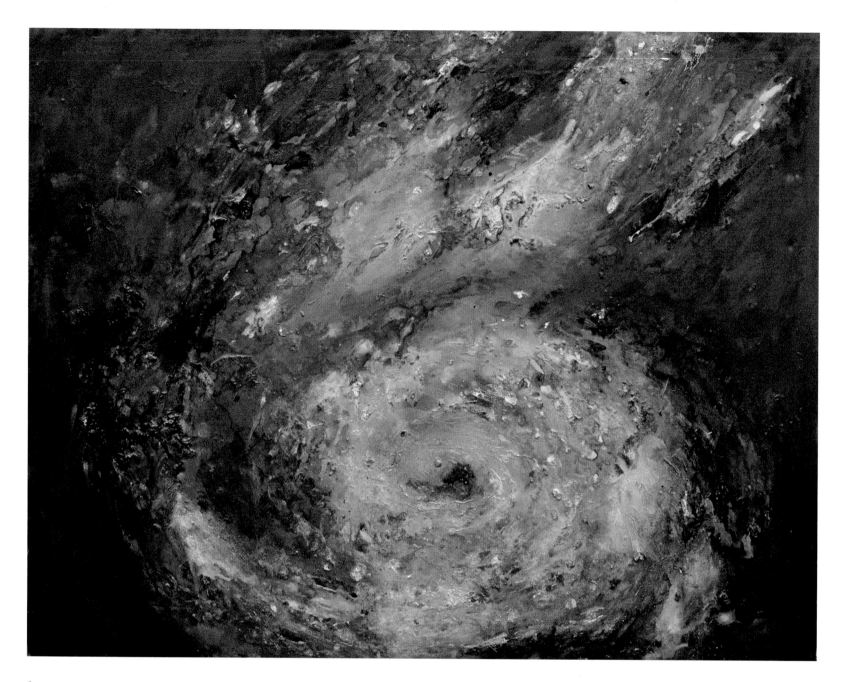

1

TYPHOON
台风
1985

OIL ON CANVAS, 78 X 100 CM. COLLECTION OF
THE ARTIST

To depict a typhoon, Cai harnessed the natural
energy of wind by using an electric fan to move
oil paint around the surface of the canvas.
Typhoons—many of which arise in the South
China Sea—frequently hit Cai's seaside hometown
of Quanzhou, Fujian Province, where this and a
related painting of the same title were executed.
The choice of subject is significant as it refers both
to the process of making these paintings and to
the artist's fascination with the unpredictable
forces of nature. In addition, the aerial perspective

anticipates Cai's later attempts to communicate
with extraterrestrial life forms through his *Projects
for Extraterrestrials* series in the 1990s. Exploring
the possibilities of chance through the use of non-
traditional materials and tools, the two *Typhoon*
paintings exemplify a new phase in the artist's
creative process that would lead him to introduce
gunpowder and explosions in the execution of sub-
sequent works. —MICHELLE YUN

EXHIBITION HISTORY
1985: *Cai Guo-Qiang and Hong Hong Wu: Paintings*,
Quanzhou Art Gallery

RELATED WORKS
1985: Painting, same title. Brick fragments and oil on
canvas, approximately 86 x 98 cm. Collection of the artist

2

SELF-PORTRAIT: A SUBJUGATED SOUL
自画像: 镇魂
1985/89

GUNPOWDER AND OIL ON CANVAS, 167 X 118 CM.
COLLECTION OF LEO SHIH

This gunpowder painting is a transitional work made during the end of Cai's time in China before he immigrated to Japan in 1986 and is reflective of the tumultuous emotions he experienced during this period. It was created in Quanzhou and portrays the silhouetted artist surrounded by a vibrant golden halo. Composed on an empty ground, the figure—suggesting a transcendence of time and space—is evocative of a pure and vital energy source. Cai took this work with him when he left China and reworked it after the events in Tian'anmen Square in 1989 prompted him to revisit the composition. At that time, the background was repainted and the subtitle *A Subjugated Soul* was added. The revised title superimposes new meaning on the painting by projecting the feelings of alienation and loneliness Cai experienced as an expatriate separated from his homeland during a dark time in its history.
—MY

EXHIBITION HISTORY

1987: *55th Memorial Exhibition of Dokuritsu Art Association*, Tokyo Metropolitan Art Museum
1994: *Cai Guo-Qiang: Concerning Flame*, Tokyo Gallery

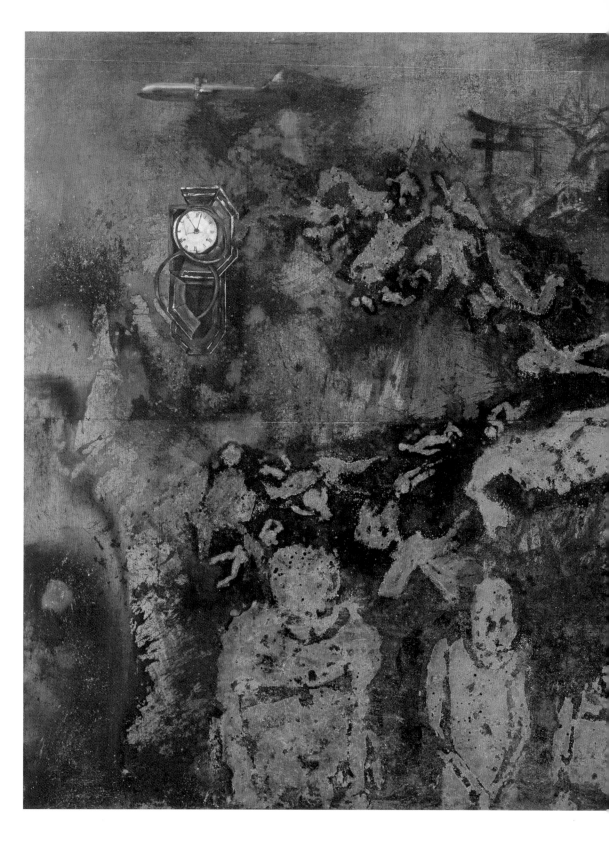

3

SHADOW: PRAY FOR PROTECTION
阴影: 祈佑
1985–86

GUNPOWDER, INK, CANDLE WAX, AND OIL ON CANVAS,
MOUNTED ON WOOD, 155 X 300 CM. COLLECTION OF
THE ARTIST

Made prior to Cai's move to Japan, this painting is a major early example of his incorporation of gunpowder as a medium. It is also the first instance in which the subject of the atomic bomb enters the artist's oeuvre—a topic that will intermittently surface throughout his work over the next fifteen years. The devastating aftermath of the detonation of an A-bomb over Nagasaki is depicted as a nightmarish dreamscape. The history of atomic bombing was well known in China, where it was taught to schoolchildren. Spectral figures shrouded by the shadow of the B-29 bomber represent the tragic aftermath of the attack. The time on the clock to the left is stopped at 11:02 AM, the moment at which the atomic blast occurred. To the right, the artist himself—half-shrouded in shadow—summons a dove of peace overhead. In what was for him an early implementation of

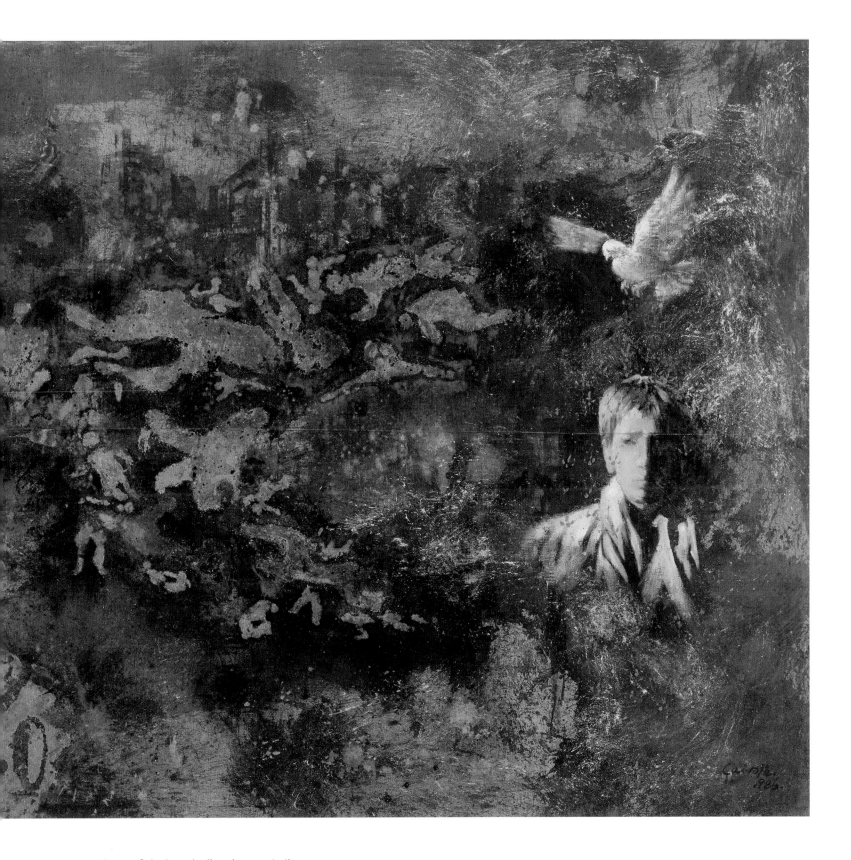

chance, Cai released a live pigeon onto the canvas
and allowed it to track paint on the composition.
Shadow: Pray for Protection is the largest work
Cai had created up to this date and exemplifies his
innovative use of materials. —MY

EXHIBITION HISTORY

1987: *Cai Guo-Qiang's Painting*, Office of the Foreign
Correspondents' Club of Japan, Tokyo

4

GUNPOWDER PAINTING NO. 8-10
火药画 NO. 8-10
1988

CREATED **MARCH 1988 AT IBARAKI FACTORY,**
MARUTAMAYA OGATSU FIREWORKS, FOR BROADCAST
BY NHK MORNING NEWS, TOKYO. GUNPOWDER,
ACRYLIC, AND PAPER PULP ON CANVAS, 227.3 X
181.8 CM. COLLECTION OF THE ARTIST

This gunpowder painting and two related works constitute the first important group of paintings created by Cai after moving to Japan in 1986. In *Gunpowder Painting No. 8-10*, the artist's liberal application of gunpowder to create an abstract composition indicates a willingness to improvise with the properties of the material. The heavily textured surface of the canvas was created using white acrylic paint and paper pulp, especially in the central areas of the composition. The range of color within the composition was generated exclusively by the smoke and fire from the explosion of gunpowder. Made during the early period of Cai's exploration of gunpowder as a primary medium, this rare series of nonfigurative works allowed the artist the freedom to focus on formal concerns while developing his new process. The production of the three paintings was commissioned and broadcast by the Tokyo bureau of NHK, Japan's public television network, and the occasion marked the beginning of a broader interest among the Japanese public in Cai's radical art making practice, including his unique choice of materials. —MY

EXHIBITION HISTORY

1990: *Cai Guo-Qiang: Works 1988/89*, Osaka Contemporary Art Center

RELATED WORKS

1988: *Gunpowder Painting No. 8-A5*. Gunpowder, acrylic, and paper pulp on canvas, 227.3 x 181.8 cm. Collection of the artist

1988: *Gunpowder Painting No. 8-11*. Gunpowder on canvas, 227.3 x 181.8 cm. Collection of the artist

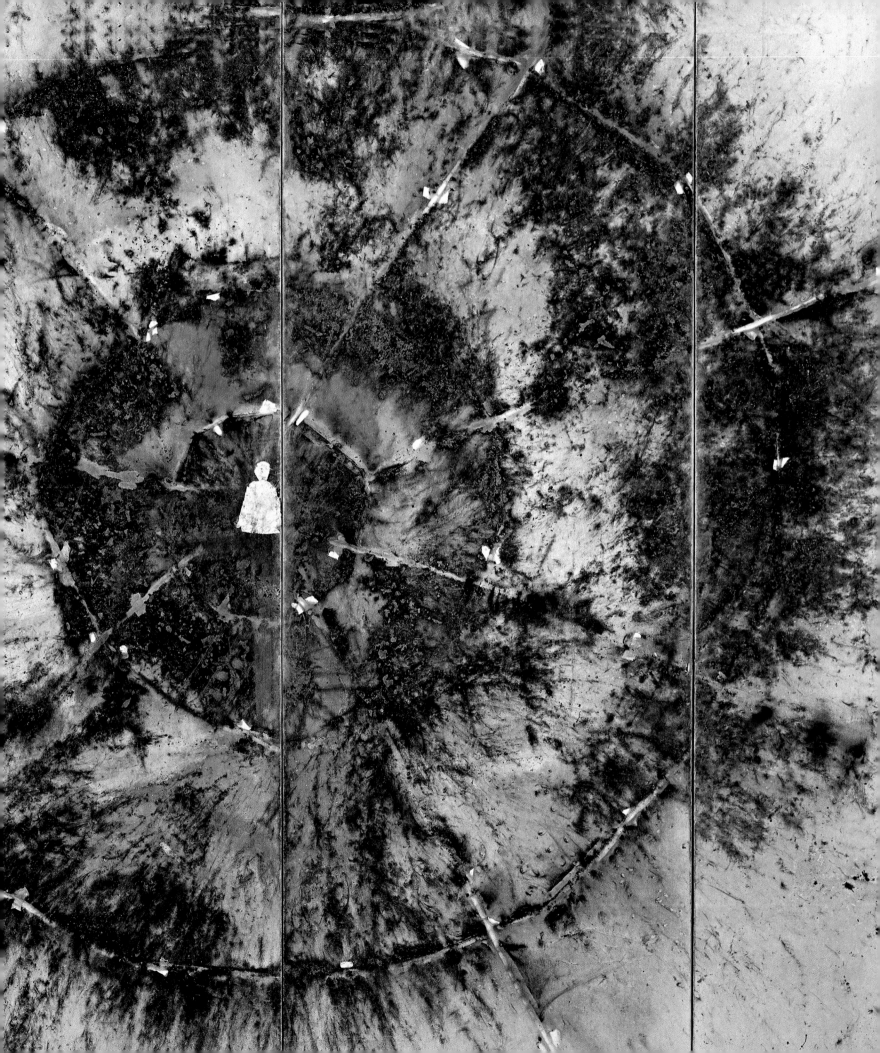

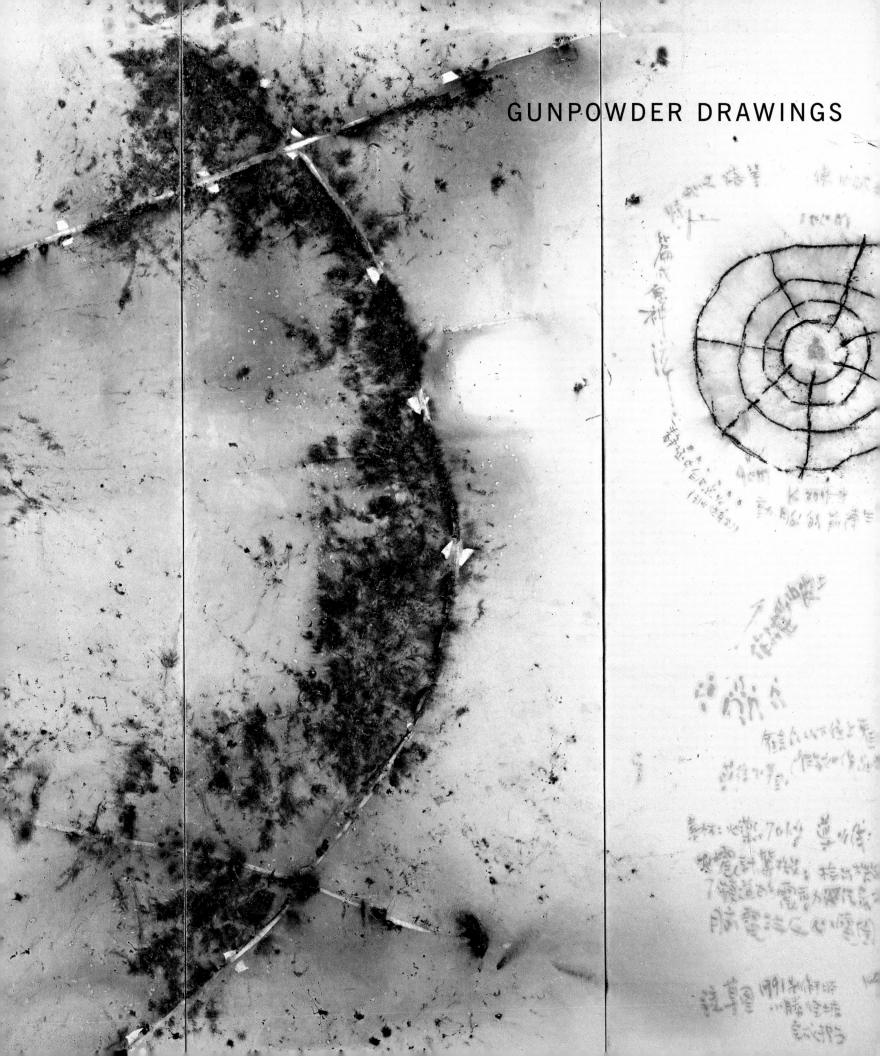

GUNPOWDER DRAWINGS

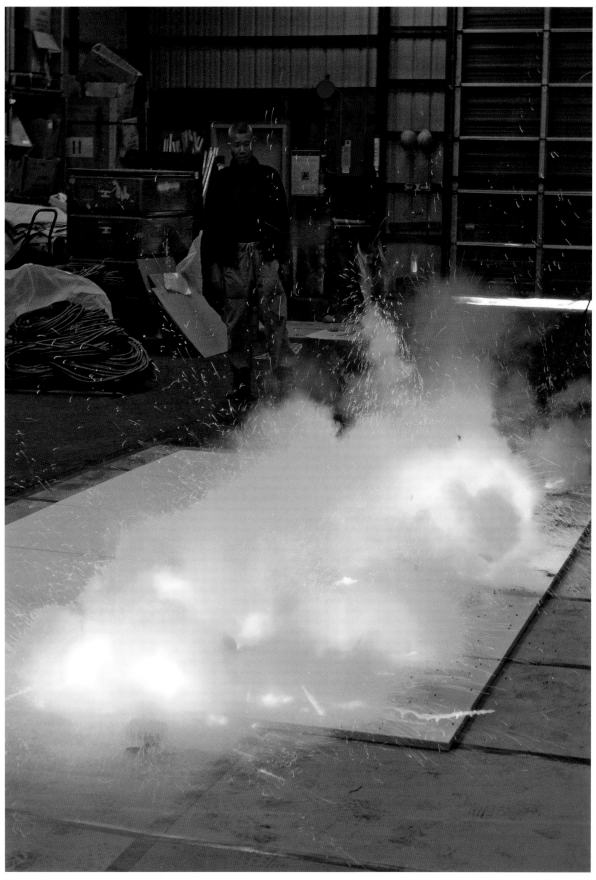

CAI GUO-QIANG CREATING GUNPOWDER DRAWING *BIRD OF LIGHT* (2004) AT FIREWORKS BY GRUCCI, BROOKHAVEN, NEW YORK, 2004

GUNPOWDER DRAWINGS

Cai Guo-Qiang's drawings made from igniting gunpowder explosives laid on paper constitute a new medium of contemporary artistic expression. For Cai, his choice of material and process is significant because it lies outside of the conventional categories of Eastern and Western art forms; his works are free from linear associations with any specific art historical traditions. Together with the explosion events to which they are conceptually linked, Cai's gunpowder drawings convey his central idea of mediating natural energy forces to create works that connect both the artist and the viewer with primordial and contemporary states of chaos, contained in the moment of explosion. They also demonstrate his central interest in the relationship of matter and energy; in these works, matter (gunpowder) explodes into energy and reverts to matter in another state (the charred drawing). In this way, they are charts of time, process, and transformation.

Cai's gunpowder drawing process has been likened to the practice of a shaman who invokes agents of a spirit world to cause a reaction in the material realm. For the drawings, Cai largely uses sheets of Japanese hemp paper whose manufacture he specially commissions; its fibrous structure withstands and absorbs the impact of the explosion and the incineration of the paper to beautiful effect. Placing these sheets on the floor, he arranges gunpowder fuses of varying potency, loose explosive powders, and cardboard stencils to create silhouetted forms over the paper's surface. Here and there, he lays wooden boards to effectively disperse the patterns resulting from smoke and the impact of the explosion. He then weights all these elements in place with rocks to intensify the explosion. Once the setup is completed, he ignites a fuse at one end of the work with a stick of burning incense. Then, with loud bangs, the ignited gunpowder rips across the surface of the paper, lighting the array of explosives according to its designated pattern and engaging artist and onlookers in a momentary encounter with the spectacular power of explosive destruction. A second or two later, the paper lies burning in clouds of acrid smoke. Assistants run to stamp out any embers with rags. Finally, the drawing is removed from the floor and hung up vertically for the artist's inspection.

Cai's drawing practice is a kind of performance where time and movement as well as shifts in the artist's psychological state—from creative intention to "a blank mind" that he experiences at the moment of ignition—are integral stages of the drawing's creation. He approaches the working space as a field of energy, similar to a stage set, where he acts as a conduit of unseen but ever-present celestial and geomantic currents that his art is designed to capture and erupt. In this sense, his drawings are relics recording the artist's personal rituals, but they also survive as objects of aestheticized violence. Their abstract marks—the traces of smoke and fire from the gunpowder ignition—create an intense atmospheric effect of ephemera and loss, expressing the material yet mysterious evidence of pure explosion.

Cai's production of gunpowder drawings can be organized into two periods: from his first drawings in 1989 to 1995, when he was living in Japan; and from 1995 through the present, while living in New York. During the Japan period, Cai produced two major series of gunpowder

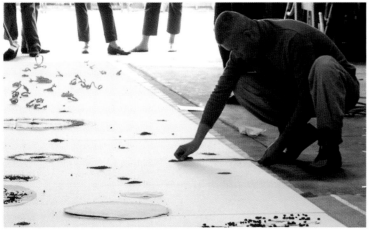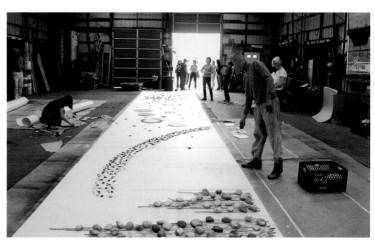

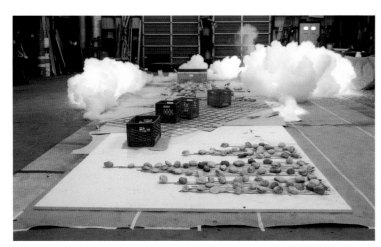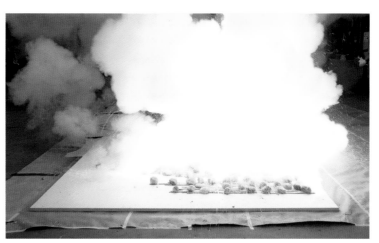

CREATION OF GUNPOWDER DRAWING *BLACK FIREWORKS: PROJECT FOR IVAM* (2005, SEE CAT. NO. 34) AT FIREWORKS BY GRUCCI, BROOKHAVEN, NEW YORK, 2005

drawings that were directly connected to the development of his explosion events. These are *Projects for Extraterrestrials* and *Projects for Humankind.* The majority of the gunpowder drawings—whether a multi-panel folding-screen or a single sheet of paper—were created as diagrams of Cai's conceptual ideas and proposed visual designs for specific explosions, what scholar Wu Hung refers to as Cai's "think pieces." That some projects were ultimately realized while several never were is insignificant in recognizing these drawings as stand-alone works of art. Often, Cai revisited the same theme or project in different formats, including accordion-style albums, many of which are illustrated here as "related works." These drawings were often inscribed with instructions that referred to the technical planning and poetic meaning of its related explosion event. In formal terms, the gunpowder drawings of this period evolved from images of pure abstraction, as in *The Immensity of Heaven and Earth: Project for Extraterrestrials No. 11* (1991, cat. no. 13), to more representational compositions that suggest physical structures, as in *Extension* (1994, cat. no. 14), which renders the Great Wall of China as a charred serpentine divider across a twelve-paneled screen. Cai's gunpowder drawings are created as both pre-event and post-event records, and are titled and dated accordingly.

Since his move to New York in 1995, Cai's mastery over his materials has resulted in gunpowder drawings that are increasingly complex as both technical and pictorial feats. Working with a wider range of fuse grades and explosive chemicals, some of which he has designed in collaboration with professional pyrotechnicians, and using more elaborate stencils and weights to outline forms and to control the explosions, Cai has further established gunpowder drawings as his primary artistic medium. For example, *Drawing for Asia-Pacific Economic Cooperation: Ode to Joy* (2002, cat. no. 15.14) illustrates in remarkable detail Cai's design for a historic fireworks display over Shanghai's landmark colonial-era Bund. Another recent development is the production of drawings that relate to Cai's installations. Works like *Tigers with Arrows* (2005, fig. 76), created in response to *Inopportune: Stage Two* (2004, cat. no. 46), display Cai's virtuoso use of gunpowder to create large-scale representational allegories. More recently, Cai has begun to develop gunpowder drawings that are unrelated to specific explosion events. These experiments reflect Cai's interest in connecting gunpowder drawing methodology with Chinese literati land-scape painting traditions.

Despite the radical originality of Cai's gunpowder drawings, they resonate with a tradition of performative and automatic drawing that was championed by the Surrealists, by Japan's postwar Gutai and Mono-ha groups, and by John Cage and his circle. Like Cai's explosion events, installations, and social projects, the gunpowder drawings evolve from a practice that seeks to conflate, collapse, and complicate distances—between the "seen and unseen worlds," between ancient and contemporary notions of time, and between human life and natural and man-made chaos.

—ALEXANDRA MUNROE

5

HUMAN ABODE: PROJECT FOR EXTRATERRESTRIALS NO. 1
人类的家：为外星人作的计划第一号
1989

GUNPOWDER ON PAPER, 212.8 X 154.3 CM.
COLLECTION OF THE ARTIST

This gunpowder drawing was created in conjunction with Cai's first explosion event, also entitled *Human Abode: Project for Extraterrestrials No. 1* (cat. no. 18), which was realized for the *89 Tama River Fussa Outdoor Art Exhibition* held in Fussa, a western suburb of Tokyo. The drawing is significant as one of the first times the artist used paper as support for a gunpowder work instead of using canvas. It also marks the beginning of his ongoing practice of exploring a singular idea through several mediums and is the earliest drawing in the *Projects for Extraterrestrials* series. Produced after the explosion event, this drawing serves as its visual documentation by depicting the point of ignition when a nomadic yurt was exploded as a metaphoric act to create a dialogue between the present and the origins of the universe. Meticulously inscribed instructions at once elaborate Cai's intentions and function as a compositional device. Early gunpowder drawings that correspond to explosion events generally serve as diagrams outlining the artist's concept, yet their conceptual rigor and aesthetic beauty elevate them to the status of independent works. This drawing was exhibited alongside the remnants of the exploded yurt in the Kumagawa shrine for one week, thus underscoring the direct relationship between drawing and explosion event. —MICHELLE YUN

EXHIBITION HISTORY

1990: *Cai Guo-Qiang: Works 1988/89*, Osaka Contemporary Art Center

RELATED WORKS

1989: Explosion event, same title (cat. no. 18)

6

ASCENDING DRAGON: PROJECT FOR EXTRATERRESTRIALS NO. 2
升龙：为外星人作的计划第二号
1989

GUNPOWDER AND INK ON PAPER, 240 X 300 CM.
COLLECTION OF LEO SHIH

Ascending Dragon: Project for Extraterrestrials No. 2 depicts the concept for an unrealized project for the 1990 exhibition *Chine demain pour hier* organized by Fei Dawei and held in Pourrières, Aix-en-Provence. Cai proposed to trace the journey of a dragon ascending the rocky terrain of Mont Sainte-Victoire at dusk by using 15 kilograms of gunpowder and 200 meters of fuse lines. The fuse would extend from the base of the mountain to its summit, tracing the dragon's path up into the heavens in a ten-second blaze of fire. Among the inscriptions on the drawing, the artist wrote: "Dragons have symbolized power of nature on earth and in the universe. They are also an incarnation of the dreams of humans to fly freely through the skies and oceans beyond physical limitations. Now the fire dragon ascends higher in the sky from the rock slope rising from the earth as an undulation of a dragon, carrying the hope of contact between humans and minds beyond the earth. In addition, it represents an action of the universal spirit of humans seeking a return to the embrace of the universe." Mont Sainte-Victoire is famous as a favorite subject of the painter Paul Cézanne, and Cai's wish to make his mark on the iconic mountain is a significant indication of his desire to create a dialogue with the French master and consequently with Western art history. However, the proposed explosion event was denied due to safety concerns because there had previously been a devastating fire on the mountain. —MY

EXHIBITION HISTORY
1990: *Cai Guo-Qiang: Works 1988/89*, Osaka Contemporary Art Center
1991: *Asian Wave: China*, Tokyo Gallery

RELATED WORKS
1989: Drawing, same title. Gunpowder and ink on paper, 66.5 x 72 cm. Collection of the artist

la montagne Sainte-Victoire
CAI 1990 AIX-EN-PROVENCE, FRANCE
PROJECT
FOR E.T.
清同聖維多克多山·創作草稿

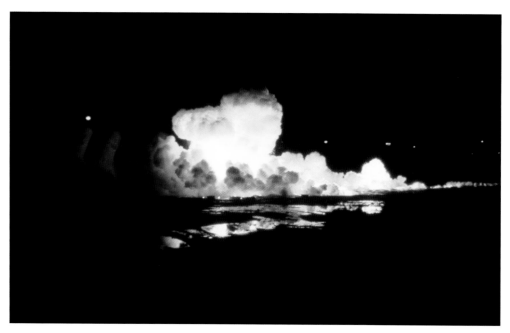

FIG. 47. *I AM AN EXTRATERRESTRIAL, PROJECT FOR MEETING WITH TENJIN (HEAVENLY GODS): PROJECT FOR EXTRATERRESTRIALS NO. 4*, 1990. REALIZED AT OPEN SPACE NEAR NAGAHAMA PORT, FUKUOKA, OCTOBER 6, 1990, 7:30 PM, 3 SECONDS. LAND AREA 85 X 30 M. GUNPOWDER (10 KG), FUSE (200 M), AND VINYL. COMMISSIONED BY MUSEUM CITY TENJIN, FUKUOKA, FOR THE EXHIBITION *MUSEUM CITY TENJIN '90: CIRCULATION OF SENSIBILITY—VISUAL CITY, FUNCTIONING ART*

7

I AM AN EXTRATERRESTRIAL, PROJECT FOR MEETING WITH TENJIN (HEAVENLY GODS): PROJECT FOR EXTRATERRESTRIALS NO. 4

我是外星人: 为外星人作的计划第四号

1990

CREATED **SEPTEMBER 1990 IN FUKUOKA** FOR THE EXHIBITION *MUSEUM CITY TENJIN '90: CIRCULATION OF SENSIBILITY—VISUAL CITY, FUNCTIONING ART.* GUNPOWDER AND INK ON PAPER, MOUNTED ON CANVAS, 227.4 X 182 CM. COLLECTION OF FUKUOKA ASIAN ART MUSEUM

This gunpowder drawing was created in preparation for the explosion event commissioned for Museum City Tenjin—the biannual exhibition staged in the streets of Fukuoka—and executed in an open field near the city's Nagahama Port in October 1990 (fig. 47). In this project, Cai for the first time explicitly referenced controversial evidence of the presence of extraterrestrials on earth, appropriating the imagery of a now-famous crop circle pattern that had only recently been discovered in Wiltshire, England, in July of that year. The drawing offers an aerial perspective that would be natural to extraterrestrials looking down onto the earth, as opposed to the frontal and earthbound perspective used in two previous drawings in the series, both from 1989: *Human Abode: Project for Extraterrestrials No. 1* (cat. no. 5) and *Ascending Dragon: Project for Extraterrestrials No. 2* (cat. no. 6). Cai's intention with *I Am an Extraterrestrial, Project for Meeting with Tenjin (Heavenly Gods): Project for Extraterrestrials No. 4* was to create a dialogue with celestial beings by using crop circles as a common language and exploding these symbols to momentarily unite humankind with the greater universe. —MY

EXHIBITION HISTORY

1990: *Museum City Tenjin '90: Circulation of Sensibility—Visual City, Functioning Art*, Fukuoka City Hall and Nagahama Port

2000: *Pioneers of Chinese Contemporary Art*, Fukuoka Asian Art Museum

RELATED WORKS

1990: Drawing, same title. Gunpowder and ink on paper, mounted on canvas, 227.4 x 364 cm. Collection of Fukuoka Asian Art Museum

1990: Explosion event, same title (fig. 47)

A CERTAIN LUNAR ECLIPSE: PROJECT FOR HUMANKIND NO. 2
月蚀：为人类作的计划第二号
1991

CREATED **JANUARY 1991 AT IBARAKI FACTORY, MARUTAMAYA OGATSU FIREWORKS,** FOR THE EXHIBITION *PRIMEVAL FIREBALL: THE PROJECT FOR PROJECTS.* GUNPOWDER AND INK ON PAPER, MOUNTED ON WOOD AS SEVEN-PANEL FOLDING SCREEN, 200 X 595 CM OVERALL. COLLECTION OF SARDJANA SUMICHAN

Developed concurrently with the *Projects for Extraterrestrials*, the series of gunpowder drawings entitled *Projects for Humankind* conversely envision explosion events to be created in outer space for humans to view from the earth. None

of the *Projects for Humankind* have been realized to date. *A Certain Lunar Eclipse: Project for Humankind No. 2* calls for a line of fuses to be detonated on the moon's surface during a lunar eclipse. The exploding line echoes the shape and length of the Great Wall of China—an important emblem in Cai's early works, prominently featured in *Project to Extend the Great Wall of China by 10,000 Meters: Project for Extraterrestrials No. 10* (1993, cat. no. 21) and *Extension* (1994, cat. no. 14). Mounting paper onto panels, which are then assembled as a folding screen, is a practice the artist has continued to employ for such large-scale drawings. *A Certain Lunar Eclipse* was exhibited as a component of the installation *Primeval Fireball: The Project for Projects* (1991, cat. no. 37). A folding album (1990, fig. 48) predates the drawing. Cai's albums often function

almost as journals, which he fills with sketches and inscriptions that are inspirations for the gunpowder drawings and explosion events related to them. Complete works in their own right, the albums are integral to the artist's working process.
—MY

EXHIBITION HISTORY

1991: *Primeval Fireball: The Project for Projects*, P3 art and environment, Tokyo

1993: *Cai Guo-Qiang*, Naoshima Contemporary Art Museum (now Benesse House)

2000: *Cai Guo-Qiang*, Fondation Cartier pour l'art contemporain, Paris

RELATED WORKS

1990: Folding album, same title (fig. 48)

1991: *Primeval Fireball: The Project for Projects* (cat. no. 37)

FIG. 48. *A CERTAIN LUNAR ECLIPSE: PROJECT FOR HUMANKIND NO. 2*, 1990. GUNPOWDER AND INK ON PAPER, 24-PAGE FOLDING ALBUM, 33.5 X 320 CM OPENED. COLLECTION OF LEO SHIH

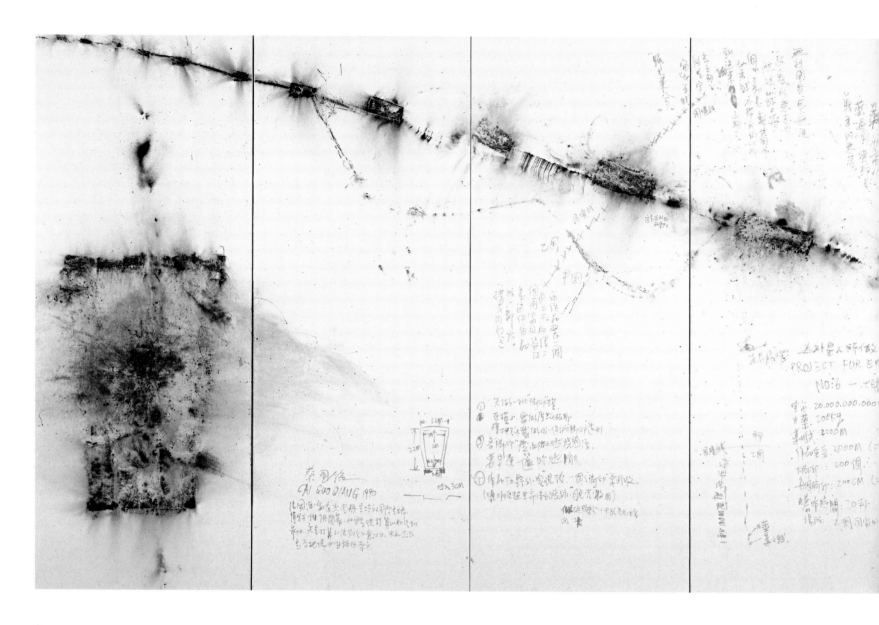

BIGFOOT'S FOOTPRINTS: PROJECT FOR EXTRATERRESTRIALS NO. 6
大脚印：为外星人作的计划第六号
1991

CREATED **JANUARY 1991 AT IBARAKI FACTORY, MARUTAMAYA OGATSU FIREWORKS,** FOR THE EXHIBITION *PRIMEVAL FIREBALL: THE PROJECT FOR PROJECTS.* GUNPOWDER AND INK ON PAPER, MOUNTED ON WOOD AS EIGHT-PANEL FOLDING SCREEN, 200 X 680 CM OVERALL. COLLECTION OF THE ARTIST

Made in preparation for an unrealized explosion event, this gunpowder drawing outlines Cai's poetic yet subversive idea to stomp out national borders with gunpowder—a material that other-wise enables war. The artist's sensitivity to the dangers of nationalistic hegemony was informed by his experience of living on the Fujian Front as a youth and witnessing the ongoing conflict between Mainland China and Taiwan, as well as by his awareness, as a Chinese citizen living in Tokyo, of historical tensions between his homeland and Japan. The facilitation of communication between nations, and humans with extraterrestrials for that matter, is a recurring idea in Cai's oeuvre. *Bigfoot's Footprints: Project for Extraterrestrials No. 6* summarizes a plan to create a 2-meter track of footprints embedded with two hundred explosives and straddling the border between two countries. Upon ignition, it would appear as if an invisible giant is leaving behind footprints as it races across the border during the explosion's 20-second duration. Obtaining visas and per-missions from the two nations hosting this project would be key elements of the work. According to Cai, just as extraterrestrials, in his idealization, do not recognize borders, humans should raise their sights in pursuit of the limitless boundaries of the universe. The drawing was first exhibited as a component of the installation *Primeval Fireball: The Project for Projects* (1991, cat. no. 37). —MY

EXHIBITION HISTORY

1991: *Primeval Fireball: The Project for Projects*, P3 art and environment, Tokyo

1993: *Cai Guo-Qiang*, Naoshima Contemporary Art Museum (now Benesse House)

2000: *Cai Guo-Qiang*, Fondation Cartier pour l'art contemporain, Paris

2004: *Cai Guo-Qiang: Traveler*, Arthur M. Sackler Gallery and Hirshhorn Museum and Sculpture Garden, Smithsonian Institution, Washington, D.C.

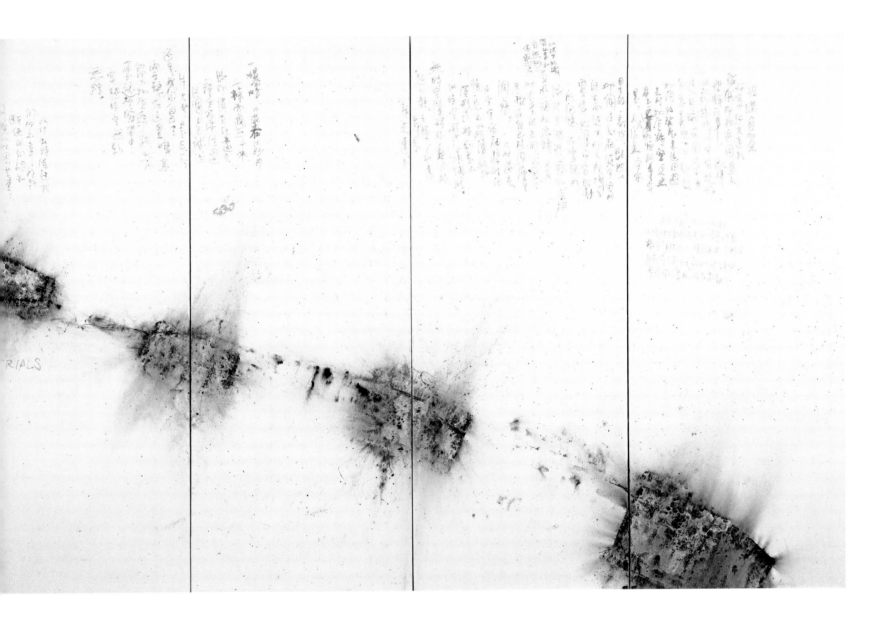

RELATED WORKS

1990: Folding album, same title (fig. 49)

1991: *Primeval Fireball: The Project for Projects* (cat. no. 37)

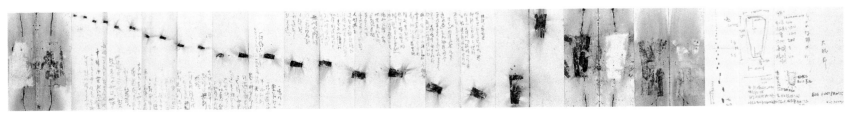

FIG. 49. *BIGFOOT'S FOOTPRINTS: PROJECT FOR EXTRATERRESTRIALS NO. 6*, 1990. GUNPOWDER AND INK ON PAPER, 24-PAGE FOLDING ALBUM, 33 X 318.5 CM OPENED. SAN DIEGO MUSEUM OF ART, MUSEUM PURCHASE 2002:14

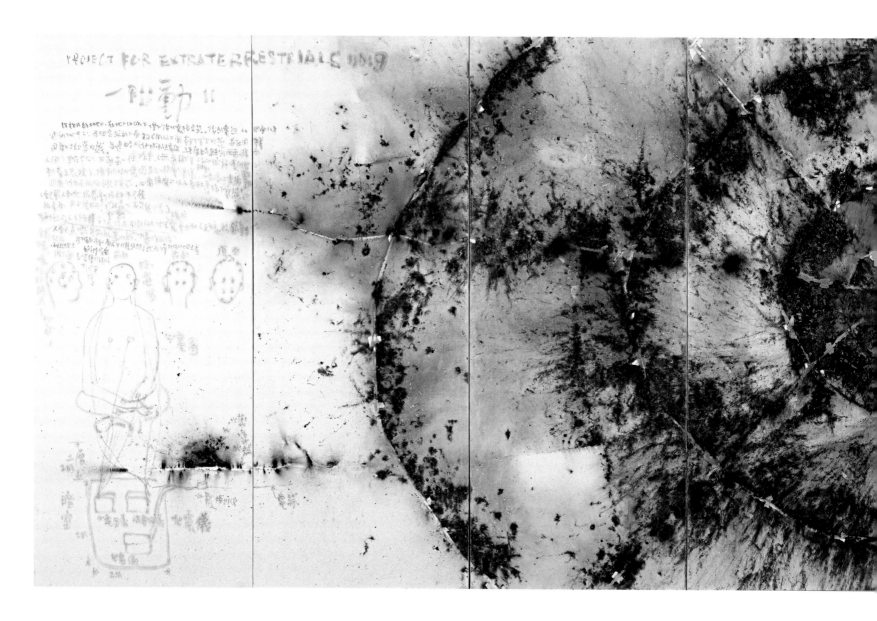

FETUS MOVEMENT II: PROJECT FOR EXTRATERRESTRIALS NO. 9
胎动二：为外星人作的计划第九号
1991

CREATED JANUARY 1991 AT IBARAKI FACTORY, MARUTAMAYA OGATSU FIREWORKS, FOR THE EXHIBITION *PRIMEVAL FIREBALL: THE PROJECT FOR PROJECTS*. GUNPOWDER AND INK ON PAPER, MOUNTED ON WOOD AS EIGHT-PANEL FOLDING SCREEN, 200 X 680 CM OVERALL. MUSEUM OF CONTEMPORARY ART, TOKYO

This gunpowder drawing was created in preparation for the explosion event, also entitled *Fetus Movement II: Project for Extraterrestrials No. 9*, executed in 1992 (cat. no. 20). It is dominated by a central circular image composed of three concentric circles and seven transverse lines, resembling the earth's lines of longitude and latitude. The artist, represented at the center in silhouette, is an integral part of the work, intended to track what may be called the "fetus movements" of earth, the heavens, and the human spirit at their big bang-like primal moment of origin. Instructions and sketches on the left of the composition, written in red ink, detail the procedure for monitoring the artist's heart rate and brainwaves and the earth's vibrations at the moment of ignition. The text inscribed on the right echoes the central image and provides the viewer with an overview of the project. The gunpowder drawing was first exhibited as a component of the installation *Primeval Fireball: The Project for Projects* (1991, cat. no. 37). —MY

EXHIBITION HISTORY

1991: *Primeval Fireball: The Project for Projects*, P3 art and environment, Tokyo
1993: *Cai Guo-Qiang*, Naoshima Contemporary Art Museum (now Benesse House)
2000: *Cai Guo-Qiang*, Fondation Cartier pour l'art contemporain, Paris

RELATED WORKS

1990: Folding album, same title (fig. 50)
1991: *Primeval Fireball: The Project for Projects* (cat. no. 37)
1992: Explosion event, same title (cat. no. 20)
1992: *Seismogram, Electroencephalogram, and Electrocardiogram from Fetus Movement II: Project for Extraterrestrials No. 9* (fig. 61)

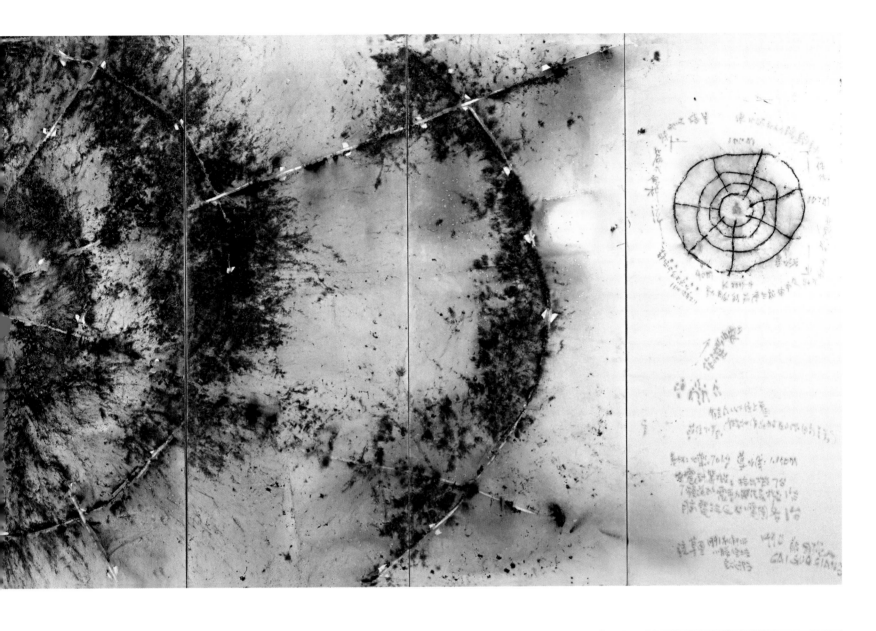

FIG. 50. *FETUS MOVEMENT II: PROJECT FOR EXTRATERRESTRIALS NO. 9*, 1990. GUNPOWDER AND INK ON PAPER, 24-PAGE FOLDING ALBUM, 33.5 X 320 CM OPENED. PRIVATE COLLECTION

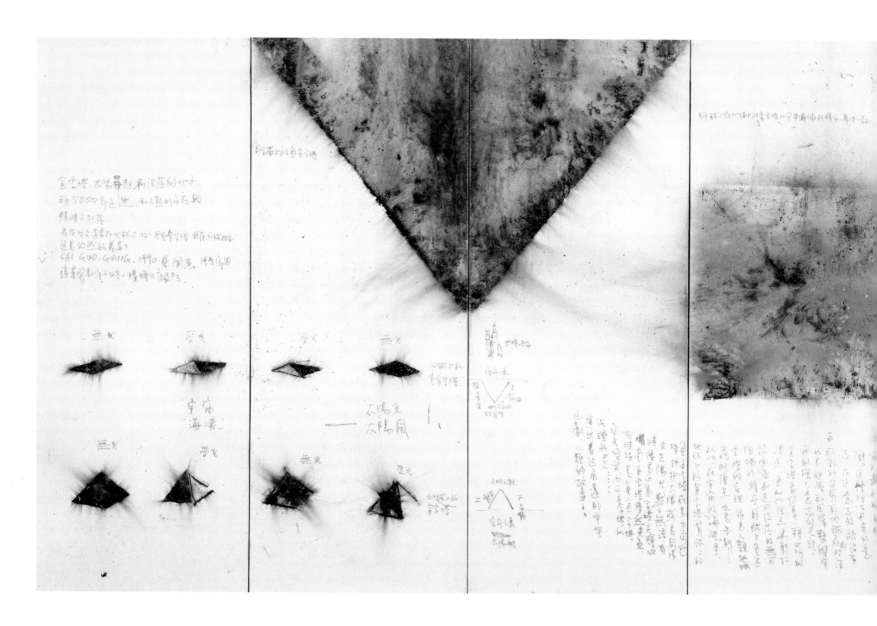

11

INVERTED PYRAMID ON THE MOON: PROJECT FOR HUMANKIND NO. 3
月球、负金字塔：为人类作的计划第三号
1991

CREATED JANUARY 1991 AT IBARAKI FACTORY, MARUTAMAYA OGATSU FIREWORKS, FOR THE EXHIBITION *PRIMEVAL FIREBALL: THE PROJECT FOR PROJECTS*. GUNPOWDER AND INK ON PAPER, MOUNTED ON WOOD AS EIGHT-PANEL FOLDING SCREEN, 200 X 680 CM OVERALL. COLLECTION OF THE ARTIST

Throughout history, mankind has been preoccupied with the passage between life and death. Among ancient civilizations, Egyptian pyramids served as portals for the departed to reach the heavens. *Inverted Pyramid on the Moon: Project for Humankind No. 3* uses these funerary forms to reconcile the divide between seen and unseen worlds, between earth and the larger universe and between the physical being and inner life of humankind. First exhibited as a component of the installation *Primeval Fireball: The Project for Projects* (1991, cat. no. 37), this drawing illustrates an unrealized explosion event in which inverted pyramids would be blasted into the surface of the moon by using explosives ignited by a solar device. These negative impressions would correlate with existing pyramids on the earth and be visible from earth depending on cycles of the moon and sun. According to Cai, "In the celestial straits between the earth and the moon, the two juxtaposed pyramids will both be lit by the sun, or both be in darkness; or perhaps only one pyramid will be lit brightly while the other is in darkness.

The endless interplay between humanity and the cosmos will never end." Cai utilized triangles within the composition, centering them on the folds between the panels to create the illusion that the pyramids are three-dimensional. —MY

EXHIBITION HISTORY

1991: *Primeval Fireball: The Project for Projects*, P3 art and environment, Tokyo

1993: *Cai Guo-Qiang*, Naoshima Contemporary Art Museum (now Benesse House)

2000: *Cai Guo-Qiang*, Fondation Cartier pour l'art contemporain, Paris

RELATED WORKS

1990: Folding album, same title (fig. 51)

1991: *Primeval Fireball: The Project for Projects* (cat. no. 37)

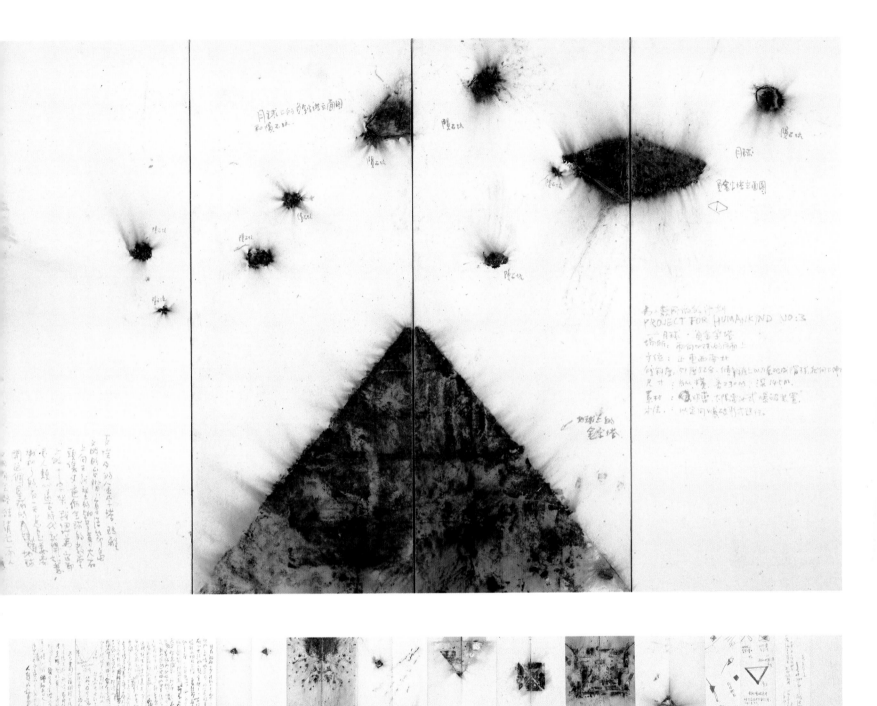

FIG. 51. *INVERTED PYRAMID ON THE MOON: PROJECT FOR HUMANKIND NO. 3,* 1990. GUNPOWDER AND INK ON PAPER, 24-PAGE FOLDING ALBUM, 33.5 X 320 CM OPENED.
COLLECTION OF LEO SHIH

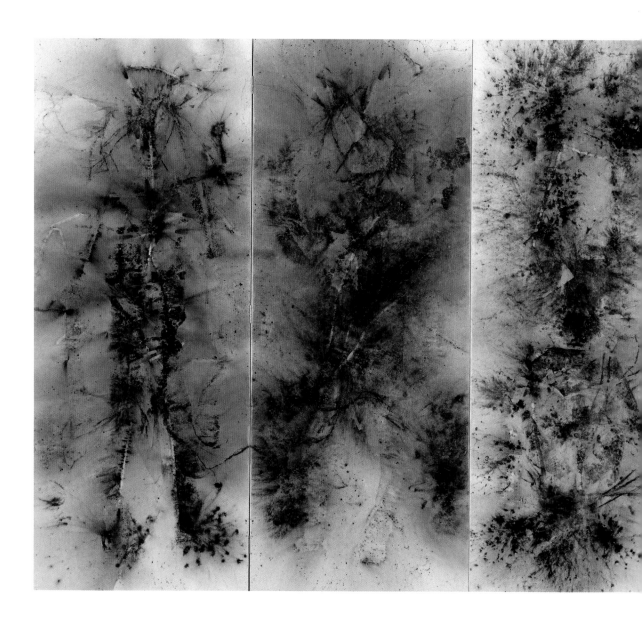

12

THE VAGUE BORDER AT THE EDGE OF TIME/SPACE PROJECT
时空模糊计划
1991

CREATED **JANUARY 1991 AT IBARAKI FACTORY, MARUTAMAYA OGATSU FIREWORKS,** FOR THE EXHIBITION *PRIMEVAL FIREBALL: THE PROJECT FOR PROJECTS.* GUNPOWDER ON PAPER, MOUNTED ON WOOD AS SEVEN-PANEL FOLDING SCREEN, 200 X 595 CM OVERALL. FONDATION CARTIER POUR L'ART CONTEMPORAIN, PARIS

In this gunpowder drawing, Cai attempts to elucidate the fluid relationship between seen and unseen worlds and, more specifically, to pinpoint "the vague border at the edge of time/space" where the two worlds meet. His quest for an understanding of this dichotomy within the universe and the indistinctness of the border at which these two realms intersect and overlap, giving rise to a world of ambiguity, is fundamental to his working practice and is a topic on which he focuses much energy. Unlike works in the *Projects for Extraterrestrials* and *Projects for Humankind* series, which serve as proposals for other projects, this drawing is self-reflective. The life-sized figures depicted on each of the seven panels were created by using daylight to project the artist's own shadow onto the paper and are reminiscent of the figure in Cai's earlier *Self-Portrait: A Subjugated Soul* (1985/89, cat no. 2). The drawing was first exhibited as a component of the installation *Primeval Fireball: The Project for Projects* (1991, cat. no. 37). —MY

EXHIBITION HISTORY

1991: *Primeval Fireball: The Project for Projects*, P3 art and environment, Tokyo

1993: *Cai Guo-Qiang*, Naoshima Contemporary Art Museum (now Benesse House)

2000: *Cai Guo-Qiang*, Fondation Cartier pour l'art contemporain, Paris

RELATED WORKS

1989: Folding album, same title (fig. 52)

1991: *Primeval Fireball: The Project for Projects* (cat. no. 37)

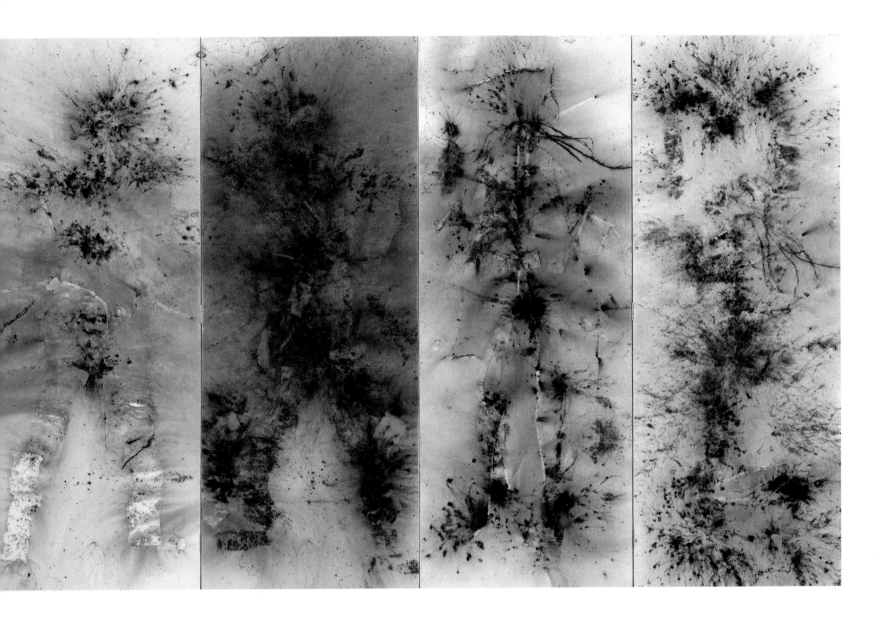

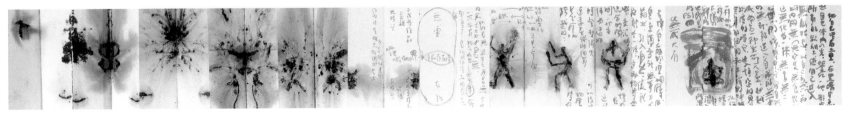

FIG. 52. *THE VAGUE BORDER AT THE EDGE OF TIME/SPACE PROJECT*, 1989. GUNPOWDER AND INK ON PAPER, 24-PAGE FOLDING ALBUM, 33.5 X 320 CM OPENED. COLLECTION OF LEO SHIH

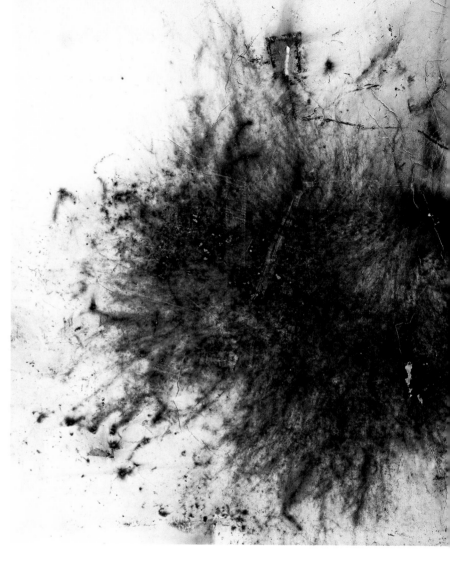

INSTALLATION VIEW AT MITSUBISHI JISHO ARTIUM, FUKUOKA, 1991

13

THE IMMENSITY OF HEAVEN AND EARTH: PROJECT FOR EXTRATERRESTRIALS NO. 11
天地悠悠： 为外星人作的计划第十一号
1991

CREATED **1991 IN FUKUOKA** FOR *EXCEPTIONAL PASSAGE: CHINESE AVANT-GARDE ARTISTS EXHIBITION.* GUNPOWDER ON PAPER, MOUNTED ON CANVAS; REFRIGERATOR CONTAINING SOIL AND ICE MADE OUT OF SEAWATER; DIMENSIONS VARIABLE; GUNPOWDER DRAWING 200 X 600 CM. COLLECTION OF FUKUOKA ASIAN ART MUSEUM

Cai's belief in the formidable relationship between the origins of life and the cosmos is reflected in the concept behind this gunpowder drawing and its installation components. This work and the explosion event conceptualized in the drawing were both created in 1991 for a landmark exhibition, *Exceptional Passage: Chinese Avant-Garde Artists Exhibition*, held in the Japanese port city of Fukuoka. According to the artist, "One day, humankind will leave this planet and take a part of their civilization with them. However, the majority of it will remain on earth in a state of ruin. Later, when the extraterrestrials, or human beings returning as extraterrestrials, visit the earth, the frozen block of seawater can be melted down, so that life might resume once again and give birth to an indigenous civilization." The explosion event—also entitled *The Immensity of Heaven and Earth: Project for Extraterrestrials No. 11*—occurred at dusk in a former train yard. At the peak of a small nearby mountain, Cai had first buried a 600-kilogram frozen block of seawater—a symbolic material for the creation of life—encased in a wooden coffin. Starting at the burial site, 150 meters of fuse were laid atop a track the artist had created with recycled materials alongside active train rails. Detonation was timed to coincide with a passing train, the flame of the ignited fuse racing against the speeding locomotive until it reached an awaiting kite, poised to propel the flame into the heavens. The drawing reveals the artist's intention to illustrate the shift in relative perspective between the stationary viewers on the ground and the moving passengers on the train. It was originally exhibited alongside a refrigerator containing soil and frozen seawater as relics of the explosion event. —MY

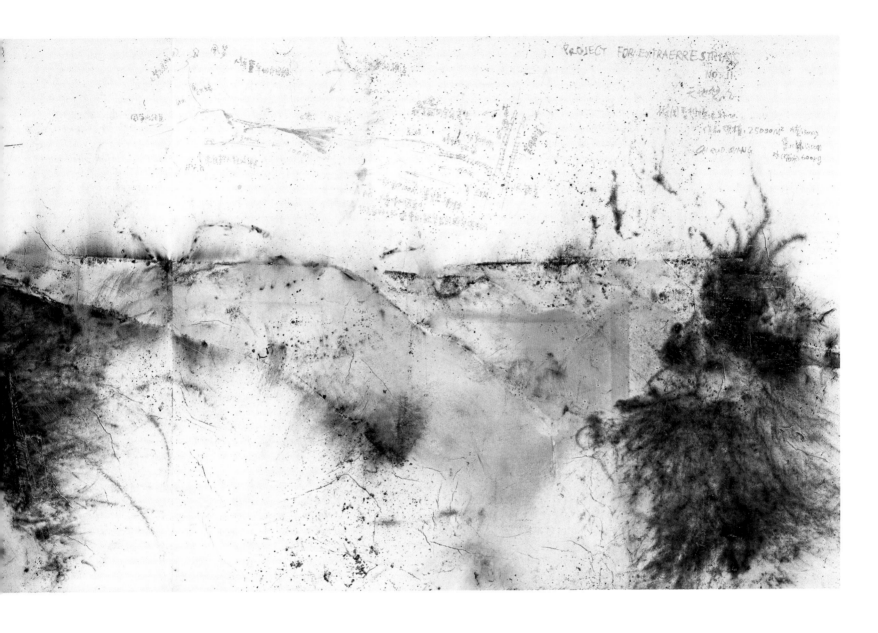

EXHIBITION HISTORY

1991: *Exceptional Passage: Chinese Avant-Garde Artists Exhibition*, Mitsubishi Jisho Artium and Kashii former train yard, Fukuoka

1992: *Looking for Tree of Life: A Journey to Asian Contemporary Art*, Museum of Modern Art, Saitama

2000: *Pioneers of Chinese Contemporary Art*, Fukuoka Asian Art Museum

RELATED WORKS

1991: Album, same title. Gunpowder and ink on paper, 24-page folding album, 33.5 x 320 cm opened. Private collection

1991: Explosion event, same title. Realized at Kashii former train yard, Fukuoka, September 15, 1991, 6:54 PM, 5 seconds. Land area approximately 25,000 sq. m. Gunpowder (30 kg), fuse (1,300 m), seawater (600 kg), ice (1,200 kg), railroad ties and rails, and kite. Commissioned by Museum City Project, Fukuoka, for *Exceptional Passage: Chinese Avant-Garde Artists Exhibition*

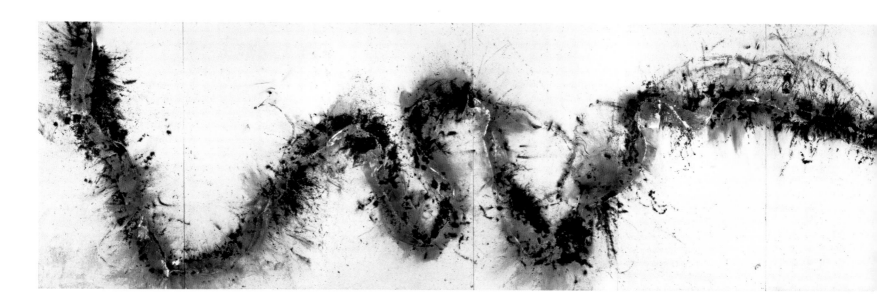

14
EXTENSION
延长
1994

CREATED **1994 AT KOYAMA FIREWORKS, NARA,** FOR
THE EXHIBITION *CHAOS: CAI GUO-QIANG.* GUNPOWDER
ON PAPER, MOUNTED ON WOOD AS 12-PANEL FOLDING
SCREEN, 236 X 1,560 CM OVERALL. COLLECTION OF
SETAGAYA ART MUSEUM, TOKYO

The Great Wall of China is a significant motif
found throughout Cai's body of work, and the gun-
powder drawing *Extension* was inspired by the
explosion event *Project to Extend the Great
Wall of China by 10,000 Meters: Project for
Extraterrestrials No. 10* (1993, fig. 54), for which
the artist traveled to the westernmost edge of the
wall. For the event he symbolically lengthened the

Great Wall by igniting gunpowder fuse that
extended 10,000 meters into the Gobi desert. The
drawing is mounted on twelve oversized panels,
and the viewer must physically walk along the
work's expansive length to fully experience it. The
panels of the folding screen are displayed in a
pattern that shifts the perspective of the drawing
in and out, mimicking the peaks and valleys of the
Great Wall, while also suggesting, as does the wall
itself, the undulating body of a dragon. This idea
was revisited in 2000 in a much larger gunpowder
drawing, which has the same title as the explosion
event. The two related folding albums (1990,
fig. 55, and 1993, fig. 56) further emphasize the
artist's practice of revisiting key ideas and aes-
thetic formal devices through a variety of formats.
—MY

EXHIBITION HISTORY

1994: *Chaos: Cai Guo-Qiang*, Setagaya Art Museum, Tokyo

RELATED WORKS

1990: *Project to Extend the Great Wall of China by 10,000
Meters: Project for Extraterrestrials No. 10* (fig. 55)
1993: *Drawing for Project to Extend the Great Wall of
China by 10,000 Meters: Project for Extraterrestrials
No. 10* (fig. 53)
1993: *Project to Extend the Great Wall of China by 10,000
Meters: Project for Extraterrestrials No. 10* (fig. 54)
1993: *Project to Extend the Great Wall of China by 10,000
Meters: Project for Extraterrestrials No. 10* (fig. 56)
2000: *Project to Extend the Great Wall of China by 10,000
Meters: Project for Extraterrestrials No. 10.* Gunpowder on
paper, 300 x 2000 cm. Glory Fine Arts Museum, Hsinchu

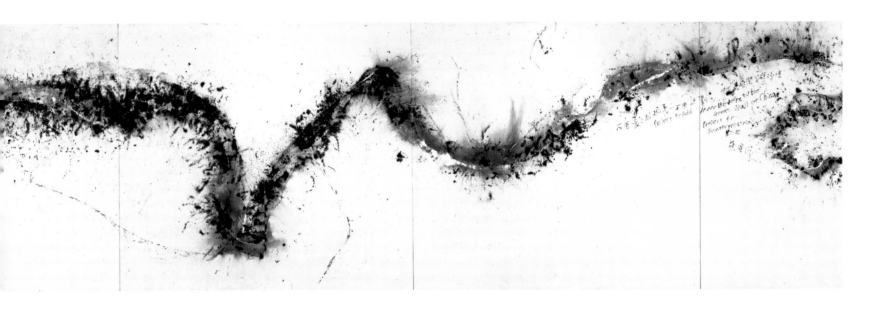

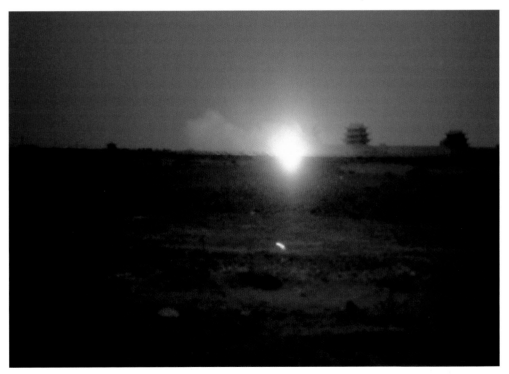

FIG. 53. *DRAWING FOR PROJECT TO EXTEND THE GREAT WALL OF CHINA BY 10,000 METERS: PROJECT FOR EXTRATERRESTRIALS NO. 10*, 1993. PEN AND CRAYON ON PAPER, APPROXIMATELY 29.5 X 22 CM. COLLECTION OF THE ARTIST

FIG. 54. *PROJECT TO EXTEND THE GREAT WALL OF CHINA BY 10,000 METERS: PROJECT FOR EXTRATERRESTRIALS NO. 10*, 1993 (CAT NO. 21)

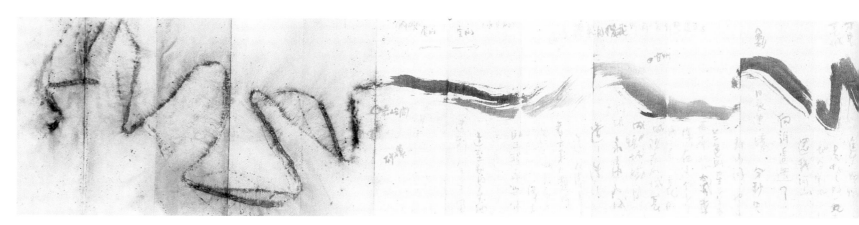

FIG. 55. *PROJECT TO EXTEND THE GREAT WALL OF CHINA BY 10,000 METERS: PROJECT FOR EXTRATERRESTRIALS NO. 10*, 1990. GUNPOWDER AND INK ON PAPER, 24-PAGE FOLDING ALBUM, 33.5 X 320 CM OPENED. PRIVATE COLLECTION, NEW YORK

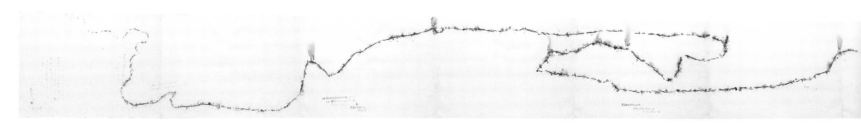

FIG. 56. *PROJECT TO EXTEND THE GREAT WALL OF CHINA BY 10,000 METERS: PROJECT FOR EXTRATERRESTRIALS NO. 10*, 1993. GUNPOWDER AND INK ON PAPER, 26-PAGE FOLDING ALBUM, 55.3 X 988 CM OPENED. COLLECTION OF THE ARTIST

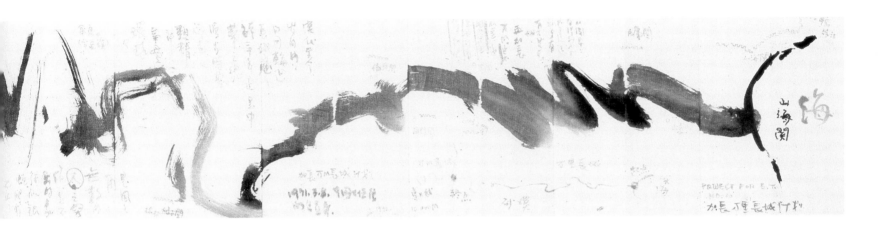

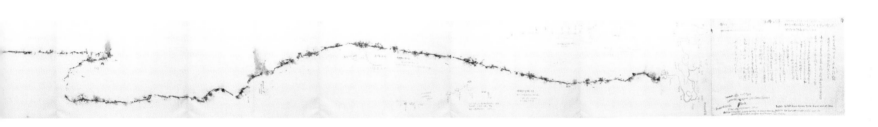

15.1–.14
**DRAWINGS FOR ASIA-PACIFIC
ECONOMIC COOPERATION**
APEC景观焰火表演草图
2002

CREATED **DECEMBER 2002 AT XINWEN CRAFT COMPANY,
QUANZHOU,** FOR THE EXHIBITION *CAI GUO-QIANG*,
SHANGHAI ART MUSEUM. GUNPOWDER ON PAPER.
COURTESY ESLITE GALLERY (CHERNG PIIN), TAIPEI

15.1

**Drawing for Asia-Pacific Economic Cooperation:
Imagining the Universe**
太阳系、银河系(APEC景观焰火表演草图)
300 X 400 CM

15.2

**Drawing for Asia-Pacific Economic Cooperation:
Dragon Boats**
百舸争流(APEC景观焰火表演草图)
300 X 400 CM

15.3

**Drawing for Asia-Pacific Economic Cooperation:
Red Carpet**
红地毯(APEC景观焰火表演草图)
300 X 400 CM

15.4

**Drawing for Asia-Pacific Economic Cooperation:
Oriental Pearl**
明珠耀东方(APEC景观焰火表演草图)
300 X 400 CM

15.5

**Drawing For Asia-Pacific Economic Cooperation:
Red, Yellow, Blue Peonies**
红、黄、蓝牡丹(APEC景观焰火表演草图)
300 X 400 CM

15.6

**Drawing for Asia-Pacific Economic Cooperation:
Fountain**
喷泉(APEC景观焰火表演草图)
300 X 200 CM

15.7

**Drawing for Asia-Pacific Economic Cooperation:
Golden Willow**
锦冠(APEC景观焰火表演草图)
300 X 200 CM

15.8

**Drawing for Asia-Pacific Economic Cooperation:
Salute from Heaven**
来自天上的贺礼(APEC景观焰火表演草图)
300 X 200 CM

15.9

**Drawing for Asia-Pacific Economic Cooperation:
Great Dragon**
飞龙在天(APEC景观焰火表演草图)
300 X 600 CM

15.10

**Drawing for Asia-Pacific Economic Cooperation:
Red Lanterns**
红灯笼(APEC景观焰火表演草图)
300 X 400 CM

15.11

**Drawing for Asia-Pacific Economic Cooperation:
UFO**
飞碟(APEC景观焰火表演草图)
300 X 400 CM

15.12

**Drawing for Asia-Pacific Economic Cooperation:
Heavenly Ladder**
天梯(APEC景观焰火表演草图)
300 X 200 CM

15.13

**Drawing for Asia-Pacific Economic Cooperation:
Missiles Rising**
火箭升空(APEC景观焰火表演草图)
300 X 200 CM

15.14

**Drawing for Asia-Pacific Economic Cooperation:
Ode to Joy**
欢乐颂(APEC景观焰火表演草图)
300 X 400 CM

This group of fourteen gunpowder drawings was inspired by Cai's historic presentation of the *Asia-Pacific Economic Cooperation Cityscape Fireworks* commissioned by APEC to celebrate the close of its 2001 conference, which was held in Shanghai. (The order in which the drawings are reproduced here does not match the cycle of the fireworks display.) The approximately 20-minute-long program—realized on the Huangpu River, above the cityscape of the embankment area known as the Bund, and at the Oriental Pearl TV Tower—is the only project within his oeuvre that the artist considers a true, full-scale fireworks display. It was divided into four sections incorporating iconic symbols from both traditional Chinese culture and Cai's personal vision of the cosmos, including dragons, boats, UFOs, planets, and lanterns. Created for inclusion in the artist's solo exhibition at the Shanghai Art Museum in 2002, the drawings commemorate the successful execution of the explosion event, and each reflects an individual idea expressed in the program of the fireworks display. Collectively, the drawings embody the sense

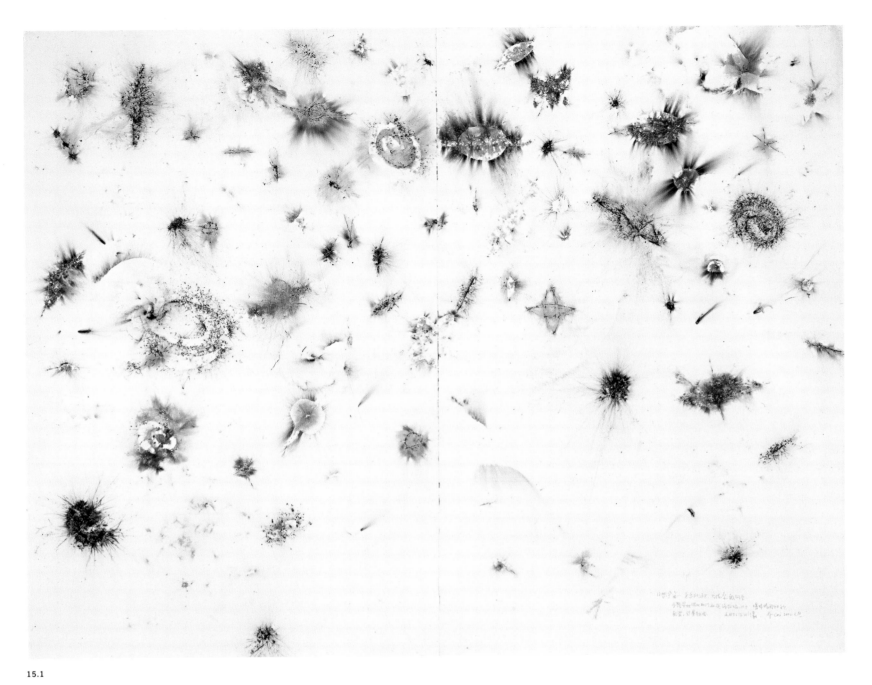

15.1

of experiencing these images exploding in isolation against the sky. The exception is *Ode To Joy* (cat. no. 15.14), which is the most figurative composition and offers a panoramic skyscape. —MY

EXHIBITION HISTORY

2002: *Cai Guo-Qiang*, Shanghai Art Museum

RELATED WORKS

2001: *Asia-Pacific Economic Cooperation Cityscape Fireworks* (figs. 57–59)

FIG. 57. *ASIA-PACIFIC ECONOMIC COOPERATION CITYSCAPE FIREWORKS*, 2001. REALIZED AT THE BUND, HUANGPU RIVER, AND ORIENTAL PEARL TV TOWER, SHANGHAI, OCTOBER 20, 2001, 9:00 PM, APPROXIMATELY 20 MINUTES. FIREWORKS (200,000 SHOTS OF EXPLOSIVE). COMMISSIONED BY ASIA-PACIFIC ECONOMIC COOPERATION FOR THE CLOSING CEREMONIES OF THE 2001 APEC CONFERENCE

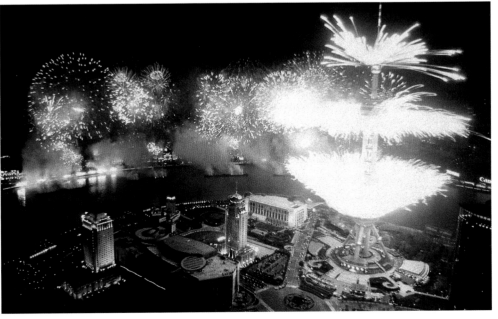

15.2

15.3

15.4

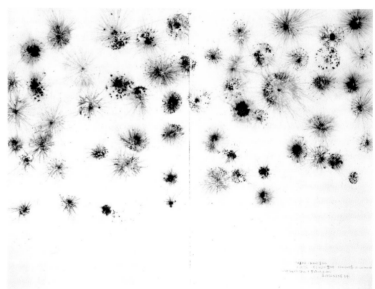

15.5

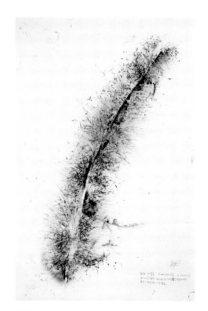

15.6

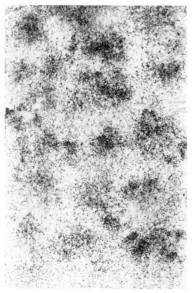

15.7

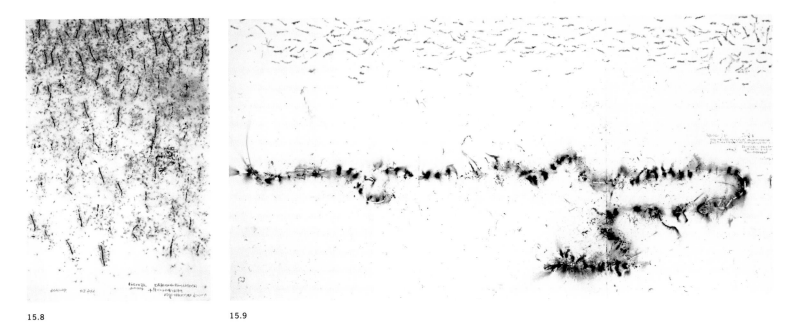

15.8

15.9

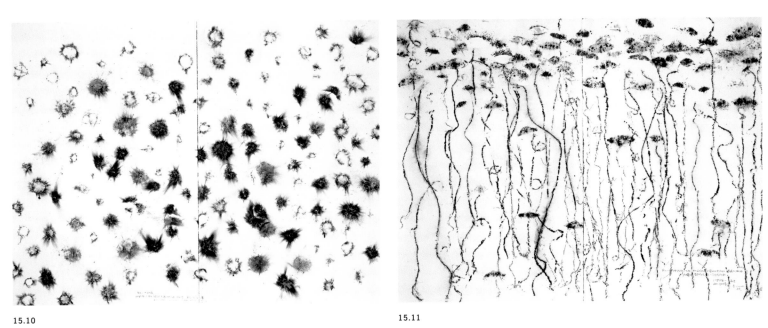

15.10

15.11

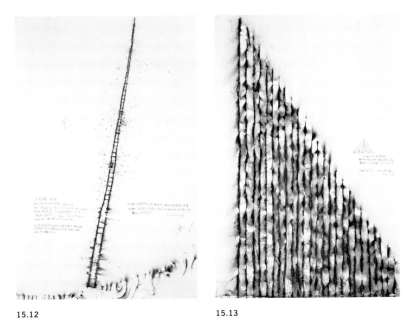

15.12

15.13

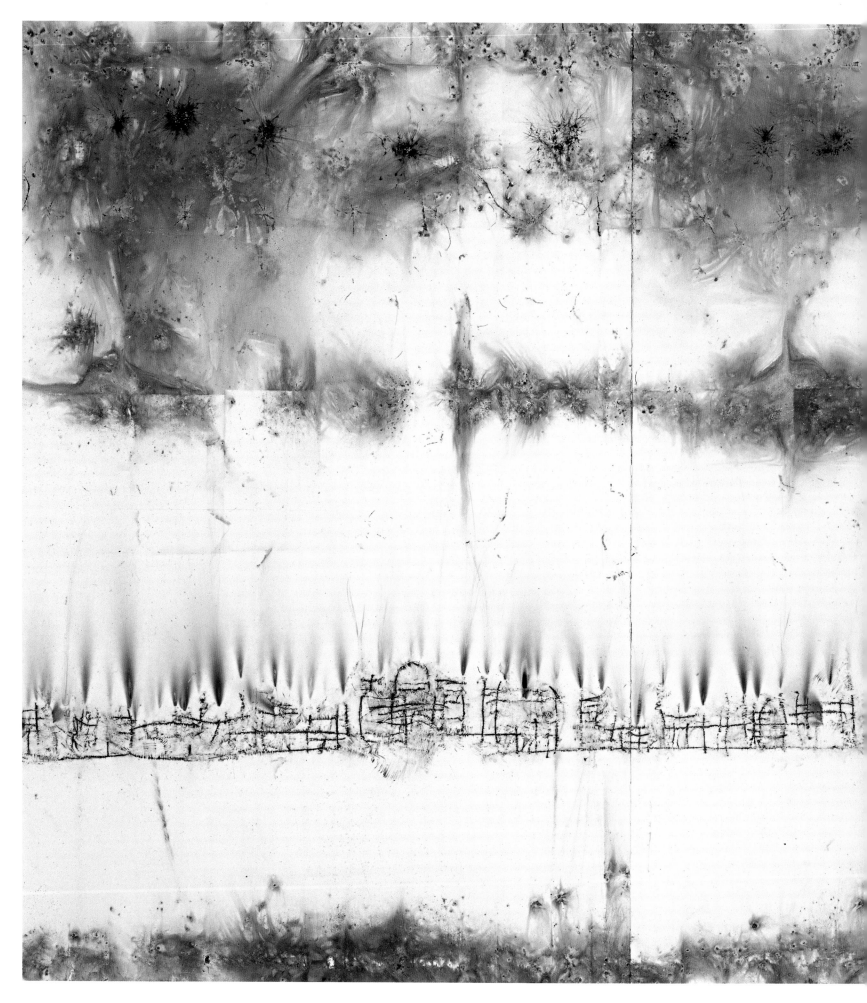

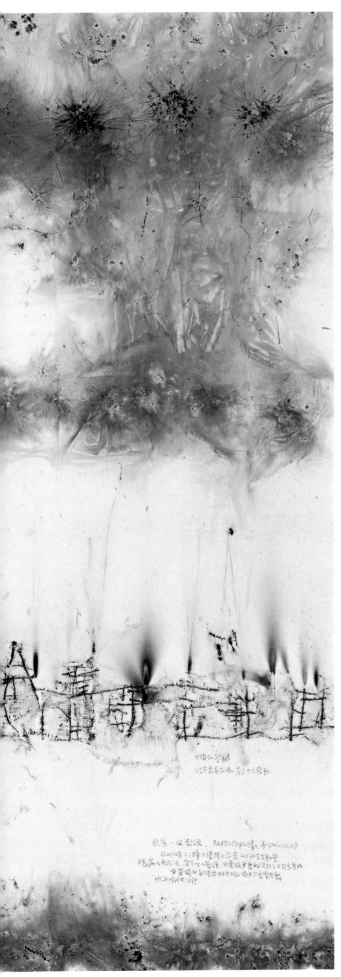

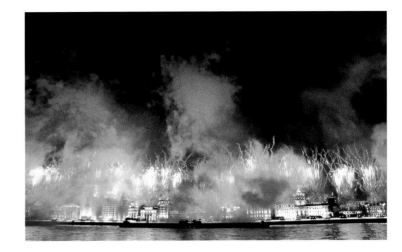

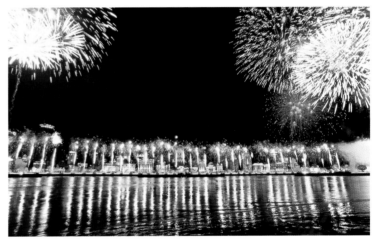

FIGS. 58 AND 59. *ASIA-PACIFIC ECONOMIC COOPERATION CITYSCAPE FIREWORKS*

15.14

16.1–.13

LIFE BENEATH THE SHADOW
为爱丁堡作的计划
2005

CREATED **JANUARY 2005 AT FIREWORKS BY GRUCCI,**
BROOKHAVEN, NEW YORK, FOR THE EXHIBITION
CAI GUO-QIANG: LIFE BENEATH THE SHADOW.
GUNPOWDER ON PAPER, 200 X 150 CM EACH

16.1

Life Beneath the Shadow: Michael Scott
为爱丁堡作的计划: 麦克 · 史卡特
COURTESY JENNIFER BLEI STOCKMAN

16.2

Life Beneath the Shadow: Aleister Crowley
为爱丁堡作的计划: 艾莱斯特 · 克劳利
ASTRUP FEARNLEY COLLECTION, OSLO

16.3

Life Beneath the Shadow: Arthur Conan Doyle
为爱丁堡作的计划: 阿瑟 · 柯南 · 道尔
PRIVATE COLLECTION, COURTESY ALBION, LONDON

16.4

Life Beneath the Shadow: Hugh Miller
为爱丁堡作的计划: 休 · 米勒
ASTRUP FEARNLEY COLLECTION, OSLO

16.5

Life Beneath the Shadow: James Hogg
为爱丁堡作的计划: 詹姆斯 · 哈哥
COLLECTION OF THE ARTIST

16.6

Life Beneath the Shadow: Little Annie
为爱丁堡作的计划: 小安妮
COLLECTION OF THE ARTIST

16.7

Life Beneath the Shadow: Robert Kirk
为爱丁堡作的计划: 罗伯特 · 卡尔特
PRIVATE COLLECTION, COURTESY ALBION, LONDON

16.8

Life Beneath the Shadow: Major Weir
为爱丁堡作的计划: 威尔少校
PRIVATE COLLECTION, COURTESY ALBION, LONDON

16.9

Life Beneath the Shadow: The Lady of Lawers
为爱丁堡作的计划: 洛尔斯女士
PRIVATE COLLECTION, COURTESY ALBION, LONDON

16.10

Life Beneath the Shadow: Bald Agnes
为爱丁堡作的计划: 光头艾格尼斯
COLLECTION OF THE ARTIST

16.11

Life Beneath the Shadow: Issobel Gowdie
为爱丁堡作的计划: 伊索贝尔 · 高蒂
PRIVATE COLLECTION, COURTESY ALBION, LONDON

16.12

Life Beneath the Shadow:
Judge Bluidy Mackenzie
为爱丁堡作的计划: 布拉迪 · 麦肯锡法官
ASTRUP FEARNLEY COLLECTION, OSLO

16.13

Life Beneath the Shadow: The Brahan Seer
为爱丁堡作的计划: 布拉罕 · 锡尔
PRIVATE COLLECTION, COURTESY ALBION, LONDON

In connection with Cai's exhibition at the
Fruitmarket Gallery, Edinburgh, in 2005—and
inspired by the rich heritage of spiritualism and

ghosts in that Scottish city—he created *Life
Beneath the Shadow*, a series of thirteen portraits.
The subjects include authors known for their
interest in the supernatural such as James Hogg
and Sir Arthur Conan Doyle, occultists such as
Bald Agnes and Aleister Crowley (the only figure
not from Scotland), seers, both real and legendary,
such as the Lady of Lawers and the Brahan Seer,
and others—even ghosts—culled from local folk-
lore and legend. Remarkably, many of the subjects
are known solely by the stories about them, and
Cai was thus given more latitude to create visual
personas derived exclusively from descriptions
compiled by the Scottish writer James Robertson
for the project. These gunpowder drawings are
representative of Cai's endeavors to give visual
forms to imaginations animated by mythologies.
Compositionally they range from traditional por-
traits to tableaux depicting defining moments in
the person's life or even the moment of death.
The series serves as an excellent opportunity to
study the artist's creative process and the rich
visual vocabulary he has been able to achieve
with his innovative gunpowder medium. The
broad range of marks was attained through a vari-
ety of gunpowder and fuse grades, which affected
the potency of the explosions, along with the use
of paper and cardboard stencils. Stones and
wooden panels served as weights to increase the
intensity of the marks. With these tools, Cai was
able to realize extremely different results, varying
from the subtle and ethereal portrait of Little Annie
(cat. no. 16.6) to the dark and deliberate visage
of Michael Scott (cat. no. 16.1). —MY

16.2

16.3

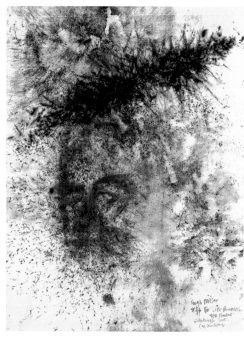

16.4

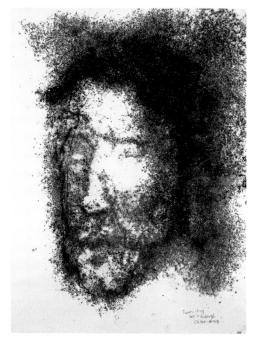

16.5

16.6

16.7

EXHIBITION HISTORY

2005: *Cai Guo-Qiang: Life Beneath the Shadow*, Fruitmarket Gallery, Edinburgh

RELATED WORKS

2005: *Life Beneath the Shadow*. Installation incorporating 11 gunpowder drawings, joss dolls, fishing wire, needles, and fire on wall, dimensions variable. Astrup Fearnley Collection, Oslo, private collections, and collection of the artist

2005: *Dark Night Edinburgh*. Installation incorporating two gunpowder drawings, 20 death masks, and black plants, dimensions variable. Drawings: Astrup Fearnley Collection, Oslo; death masks: Edinburgh Phrenological Society

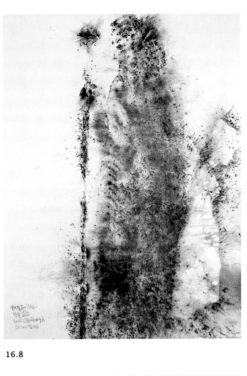

16.8

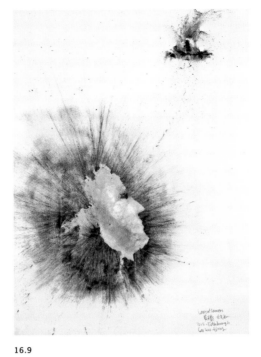

16.9

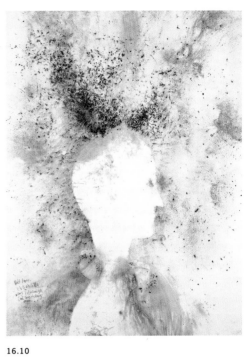

16.10

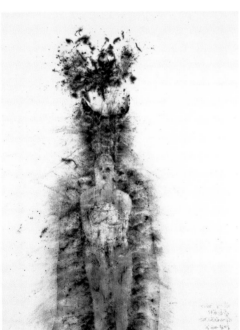

16.11

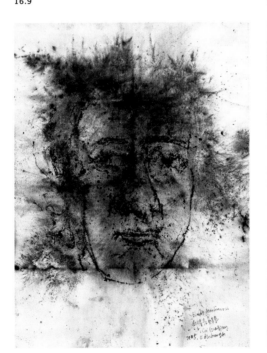

16.12

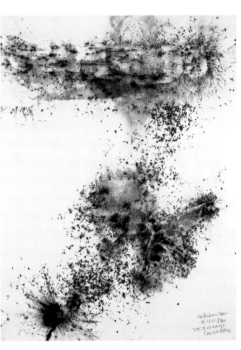

16.13

17

PINE FOREST AND WOLF: DRAWING EXPERIMENT FOR DEUTSCHE GUGGENHEIM
松林与狼
2005

GUNPOWDER ON PAPER, MOUNTED ON WOOD AS
FOUR-PANEL SCREEN, 230 X 308 CM OVERALL.
THE CLEVELAND MUSEUM OF ART, GIFT OF AGNES
GUND 2006.134A–D

The artist created a group of drawings in 2005–06 to explore ideas for the exhibition *Cai Guo-Qiang: Head On* at the Deutsche Guggenheim, Berlin, in 2006. Among them, *Pine Forest and Wolf: Drawing Experiment for Deutsche Guggenheim* is a prime example of Cai's implementation of traditional Chinese landscape painting principles in his more recent gunpowder drawings. Within the central area of the drawing is the shadowy outline of a solitary wolf, protected by a grove of pine trees. The composition's flattened and unfocused perspective is an adaptation of the atmospheric depth of traditional Chinese landscape painting. The depiction of the trees through the use of bold and graphic exploded lines to outline their structure is more in keeping with traditional

principles. In contrast, the subtlety of the wolf's figure illustrates the artist's high level of control over his gunpowder medium. After the attack on the World Trade Center on September 11, 2001, Cai returned to animal motifs in his work. He was deeply affected by 9/11 and chose animals that possess ferocious characteristics, such as wolves, lions, and tigers, as emblems of heroism. The wolf symbolizes strength and bravery in this drawing and was similarly portrayed in the installation *Head On* (2006, cat. no. 47), which was part of the Berlin exhibition. —MY

RELATED WORKS
2005: *Lion and Wolf: Drawing Experiment for Deutsche Guggenheim*. Gunpowder on paper, mounted on wood as four-panel screen, 230 x 310 cm overall. Collection of the artist
2005: *Wolf: Drawing Experiment for Deutsche Guggenheim*. Gunpowder on paper, 97 x 124 cm. Collection of the artist
2005: *Wolf and Earth: Drawing Experiment for Deutsche Guggenheim*. Gunpowder on paper, mounted on wood, 230 x 77.5 cm. Collection of the artist
2005: *Wolf and Lion: Drawing Experiment for Deutsche Guggenheim*. Gunpowder on paper, 202 x 305 cm. Agnes Gund Collection, New York
2005: *Wolf and Milky Way: Drawing Experiment for*

Deutsche Guggenheim. Gunpowder on paper, mounted on wood, 230 x 77.5 cm. Collection of the artist
2005: *Wolves of the Dark Night: Drawing Experiment for Deutsche Guggenheim*. Gunpowder on paper, 202 x 305 cm. Collection of the artist
2005–06: *Howling Wolf*. Gunpowder on paper, 150 x 200 cm. Private collection
2006: *Vortex*. Gunpowder on paper, 400 x 900 cm. Collection of the artist
2006: *Head On* (cat. no. 47)

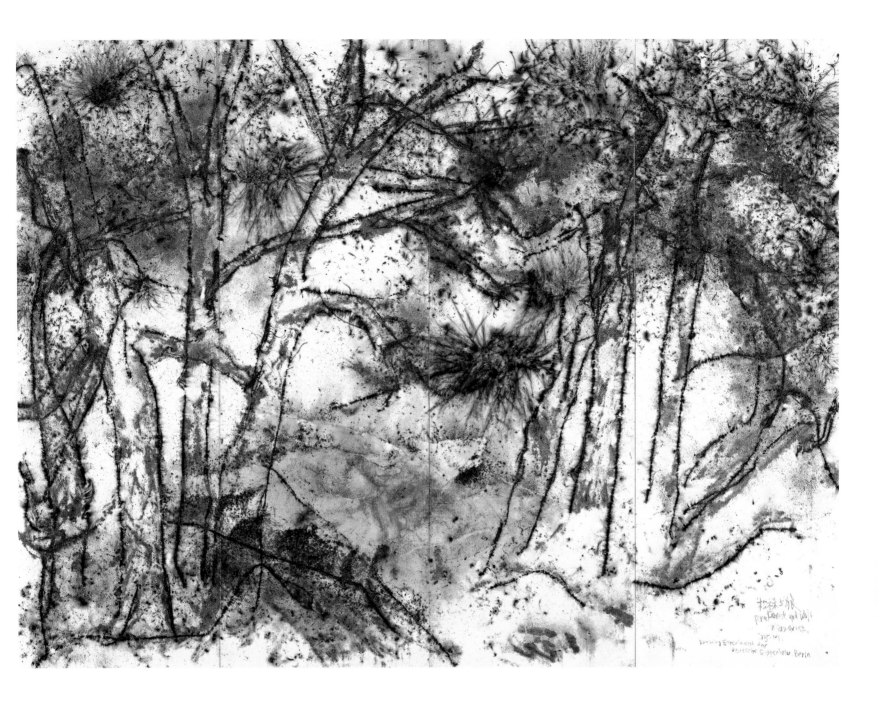

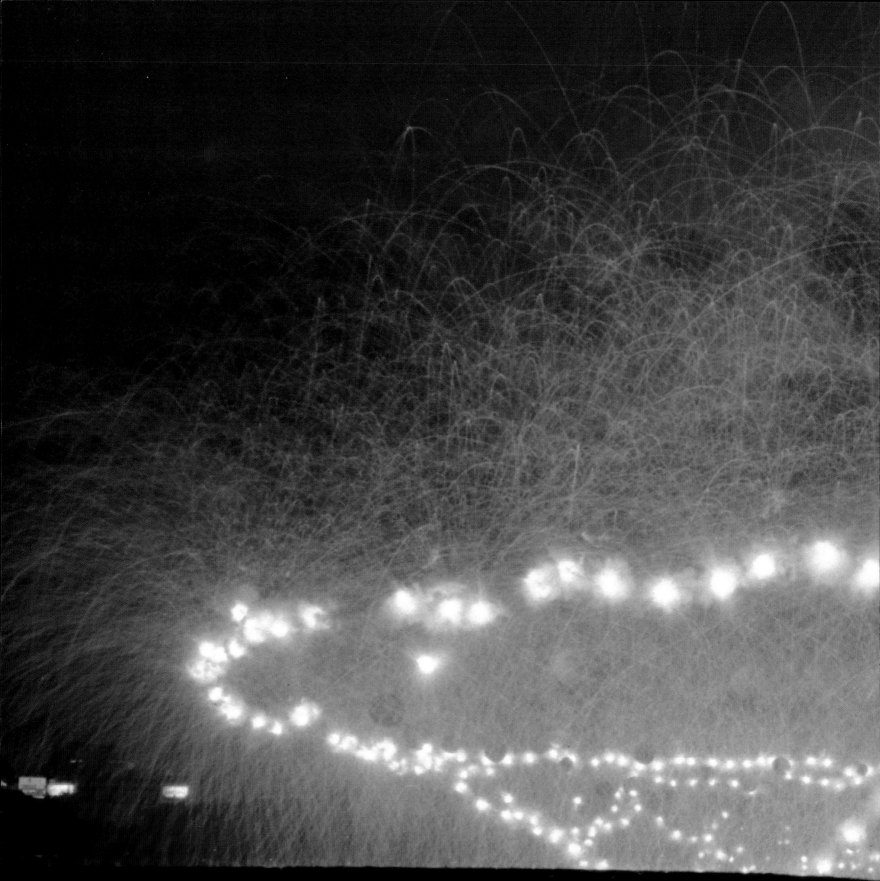

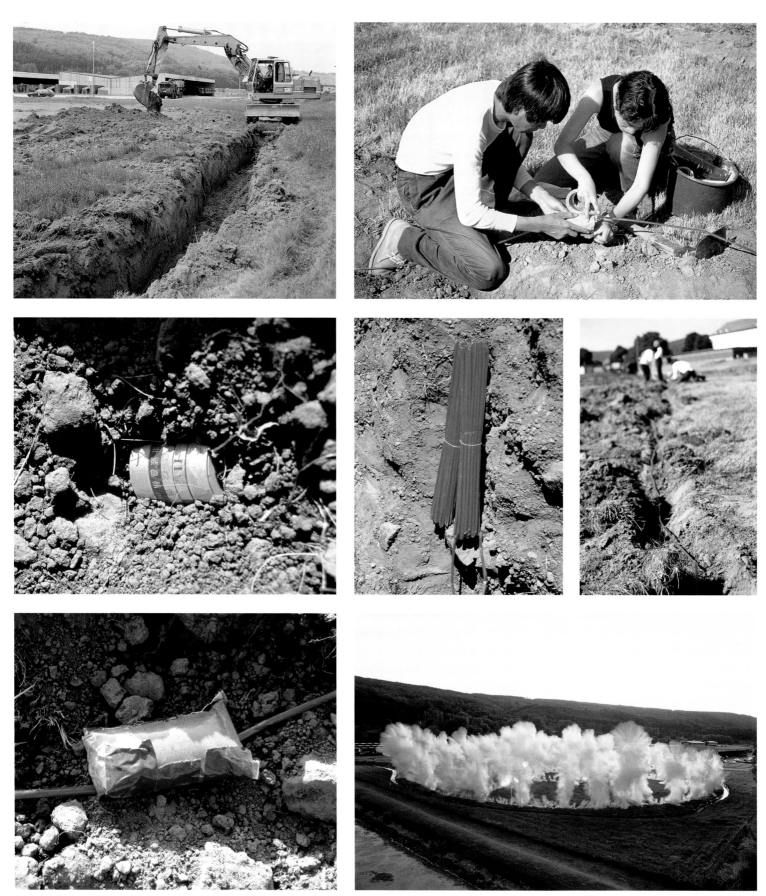

REALIZATION OF *FETUS MOVEMENT II: PROJECT FOR EXTRATERRESTRIALS NO. 9* (1992, CAT. NO. 20)

EXPLOSION EVENTS

Cai Guo-Qiang is best known for his explosion events. In 1989, he began using gunpowder and fuse lines to create outdoor explosions for public audiences using the ground and existing structures as a framework. These early works lasted between one and fifteen seconds. Since then, Cai's practice has evolved dramatically. He now produces aerial explosion events that are often developed with professional pyrotechnicians. Most recently the artist has harnessed computerized technology to create more elaborate explosion imagery, whose effects last as long as twenty minutes. The explosion events are usually realized through commissions by museums, art biennials, or national and international agencies like the Beijing 2008 Olympic Games, for which Cai is serving as a core member of the creative team and Art Director of Visual and Special Effects for the opening and closing ceremonies. Cai's explosion events are primarily created with gunpowder, while others are designed as celebratory spectacles in the tradition of fireworks displays (Cai derides this term). But they are also contemporary works of art whose conceptual, allegorical, and metaphorical narratives express the artist's critical interests.

Gunpowder, which is a mixture of saltpeter, charcoal, and sulfur, is China's most famous invention, literally meaning "fire medicine" in Chinese. It was originally discovered by Taoist alchemists in search of an imperial "elixir of immortality," and fireworks, a related invention, have long been used to mark auspicious occasions and frighten away evil spirits. Cai mines gunpowder's charged identification with China and simultaneously alludes to its original medicinal use and its ongoing equation with violence. *Fetus Movement II: Project for Extraterrestrials No. 9* (1992, cat. no. 20), staged at a German military base, uses the Chinese healing arts of feng shui (a system of geomancy) and the seismic waves produced by the ground explosion to metaphorically discharge the negative energy accumulated at the site. Like many of the explosion events, the underlying principle and essential experience of *Fetus Movement II* is transformation through conflict. Other projects, such as *The Horizon from the Pan-Pacific: Project for Extraterrestrials No. 14* (1994, cat. no. 22), focus on the context, culture, and interaction of the artist with the local community. Both the chemical process of explosion and the creation, destruction, and disappearance of the work itself are designed to produce a physical and conceptual catharsis.

Cai's explosion events are related in sheer scale to site-specific Land art projects, where art disrupts the land by employing it to radical aesthetic use. Cai extends this practice to take in the sky, which represents the ancient space of heavens and the contemporary arenas of war and terror. But whereas most Land art is static and semi-permanent, Cai's explosion events are spectacularly transient. *Project to Extend the Great Wall of China by 10,000 Meters: Project*

for Extraterrestrials No. 10 (1993, cat. no. 21) was a vast event that took place on a single night in the Gobi desert. It consisted of 10,000 meters of fuse lines and 60 kilograms of gunpowder that volunteers laid along the desert ridges extending from the westernmost ruins of the Great Wall. The gunpowder was ignited at dusk, creating a line of fire that cut across the vast expanse of desert, momentarily uniting the forty thousand local people who gathered to see this demonstration of public art. As time-based works created for live public audiences, Cai's explosion events also operate as performances, whose impact—thunderous bangs, fiery light, smoke, and floating debris—conjures both violent chaos and ritual celebration. For both the artist and his audience, the moment of explosion is severely and creatively disorienting: Time pauses and the mind goes blank in the face of such unpredictable force. "This disruption of banal consciousness," Cai explains, "is something that is worthy of use by an artist because it has the power to create a great experience." Finally, as with all ephemeral art, the explosion events become known only through their documentation—photographs, videos, and drawings.

Cai's explosion events are often titled by series, such as *Projects for Extraterrestrials*, of which there are at least thirty-three projects to date, including unrealized projects; *Projects for Humankind* of which there are at least five projects to date, including unrealized projects; and *Projects for the 20th Century*, among which there are at least three projects, including his critical work *The Century with Mushroom Clouds: Project for the 20th Century* (1996, cat. no. 26). The titles tell us something about the scale and perspective of Cai's thinking. The giant patterns of fire on earth signify a code, or the aspiration to communicate a code, to "extraterrestrials," by which Cai means realities or forces that are alien to our mundane existence. By harnessing fire as an ancient and constant element of geological formation, social ritual and religious purification, and life's destruction, Cai's explosion events express a profound interest in both ancient and modern cosmology and an expansive vision of art as a science of transformation. As spectacles of primal power, the explosion events produce an experience of temporal dislocation, a momentary trance when we feel ourselves to be at the beginning and the end of life on earth.

—ALEXANDRA MUNROE

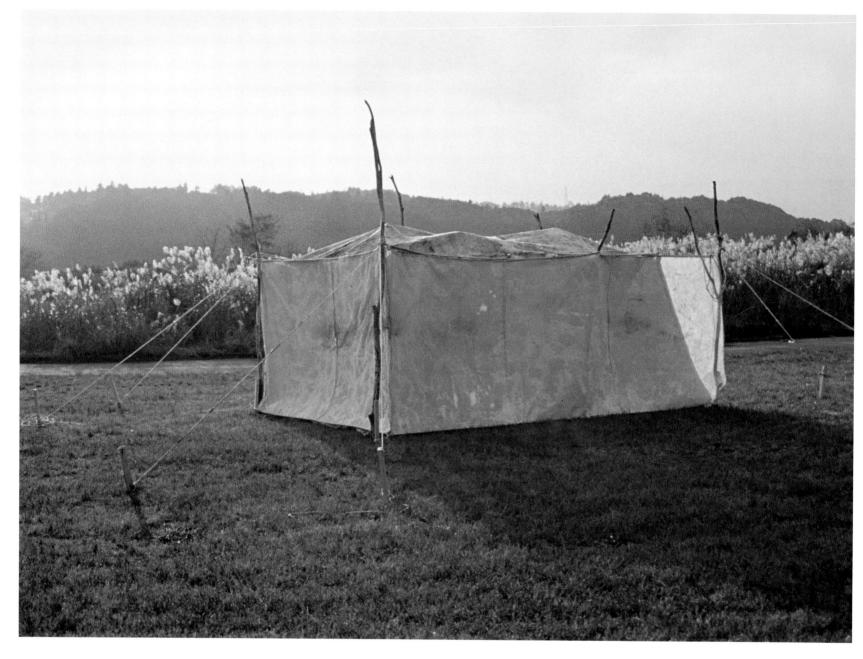

18

HUMAN ABODE: PROJECT FOR EXTRATERRESTRIALS NO. 1
人类的家：为外星人作的计划第一号
1989

REALIZED AT **FUSSA MINAMI PARK AND KUMAGAWA SHRINE, FUSSA, TOKYO, NOVEMBER 11, 1989, 2:40 PM, 2 SECONDS.** EXPLOSION AREA (SIZE OF YURT) 550 X 450 X 250 CM. GUNPOWDER (2 KG), FUSE (2 M), HEMP TENT CLOTH, WAX, TWIGS, FEATHERS, AND ROPE. COMMISSIONED BY *89 TAMA RIVER FUSSA OUTDOOR ART EXHIBITION*. REMNANTS OF YURT IN THE COLLECTION OF THE ARTIST

This was Cai's earliest explosion event and the first realized concept within the *Projects for Extraterrestrials* series. It marked Cai's first direct attempt at communication with extraterrestrials.

According to the artist, "The explosions of gunpowder that have taken place on earth have been mostly for war and environmental destruction under the name of development. How do extraterrestrials receive these acts? Humans now send out a different image of humans to the universe which is not related to war or killing." On the bank of the Tama River, a yurt—a transportable home used by Central Asian nomads—was constructed and exploded. The energy expended at detonation was meant to symbolize the big bang as the origin of life as well as the eternal cycle of regeneration. At sunset, remnants of the destroyed structure were installed in the nearby Kumagawa Shrine, which dates back to the late sixteenth century and is the oldest wooden structure in the city, and remained on view for one week. —MICHELLE YUN

EXHIBITION HISTORY

1989: *89 Tama River Fussa Outdoor Art Exhibition*, Fussa Minami Park and Kumagawa Shrine, Fussa, Tokyo

1990: Remnants of yurt displayed in *Cai Guo-Qiang: Works 1988/89*, Osaka Contemporary Art Center

RELATED WORKS

1989: Drawing, same title (cat. no. 5)

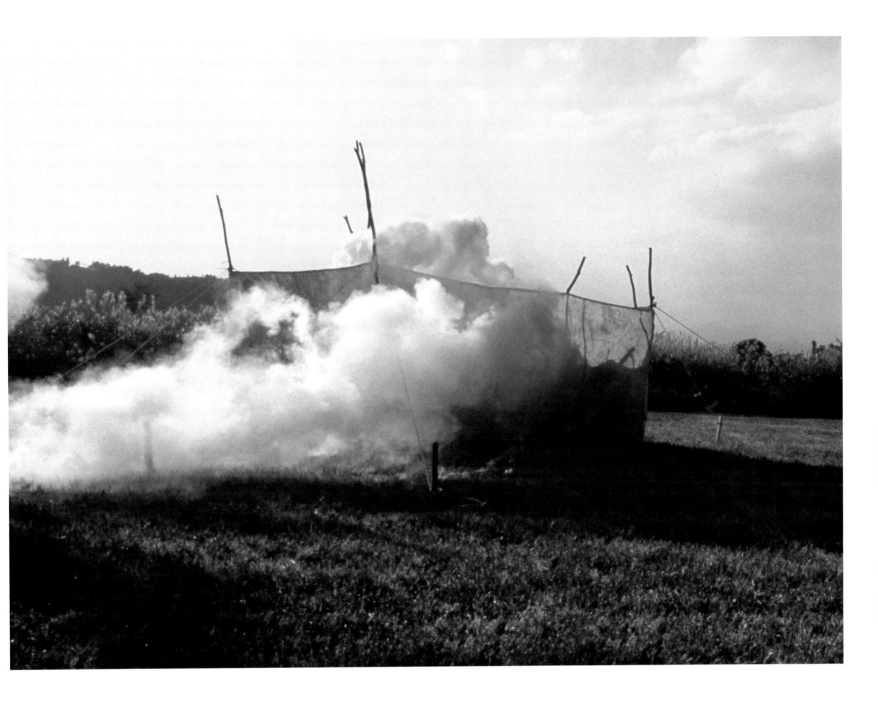

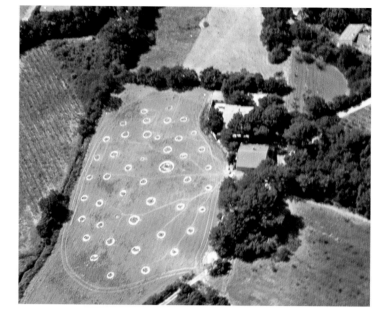

FIG. 60. *CRATER*, 1990. GUNPOWDER ON PAPIER-MÂCHÉ, 56 X 67 X 2.5 CM.
COLLECTION OF THE ARTIST

19

45.5 METEORITE CRATERS MADE BY HUMANS ON THEIR 45.5 HUNDRED MILLION YEAR OLD PLANET: PROJECT FOR EXTRATERRESTRIALS NO. 3
人类为他的四十五点五亿年的星球作的四十五个半陨石坑：为外星人作的计划第三号
1990

REALIZED AT **POURRIÈRES, AIX-EN-PROVENCE, JULY 7, 1990, 9:00 PM, APPROXIMATELY 3 SECONDS.** LAND AREA 10,000 SQ. M. GUNPOWDER (50 KG), FUSE (800 M), DRIED GRASS (600 KG), AND PAPER PULP (500 KG). COMMISSIONED BY LES DOMAINES DE L'ART FOR THE EXHIBITION *CHINE DEMAIN POUR HIER*

This explosion event was conceived as a transitory monument to the earth's history and a reminder of its finite existence, consequently alluding to humankind's own origins and mortality. Cai and a team of workers, later joined by volunteers, toiled for one month using manual labor to dig forty-five and a half craters in an open grass field, each void signifying one hundred million years of the earth's existence. After each depression was coated with a straw-and-newspaper paste, it was covered with gunpowder. All the craters were then connected together by 800 meters of fuse. Detonation occurred at dusk, so that the proliferation of fire and smoke was dramatically highlighted by the glow of the setting sun. Realized at Pourrières, Aix-en-Provence, it was the artist's first explosion event that took place outside of Asia. In preparation for the explosion, Cai fabricated *Crater* (1990, fig. 60) as a prototype out of paper pulp and gunpowder. —MY

EXHIBITION HISTORY

1990: *Chine demain pour hier*, Pourrières, Aix-en-Provence

RELATED WORKS

1989: *Crater*. Gunpowder, oil, and paper pulp on canvas, 61 x 73 x 3 cm. Collection of the artist
1990: *Crater* (fig. 60)
1990: Drawing, same title. Gunpowder and pen on paper, 66.3 x 50 cm. Collection of the artist
2001: *Impression Oil Drawing: Meteorite Crater*. Oil on canvas, 122 x 152 cm. Collection of the artist

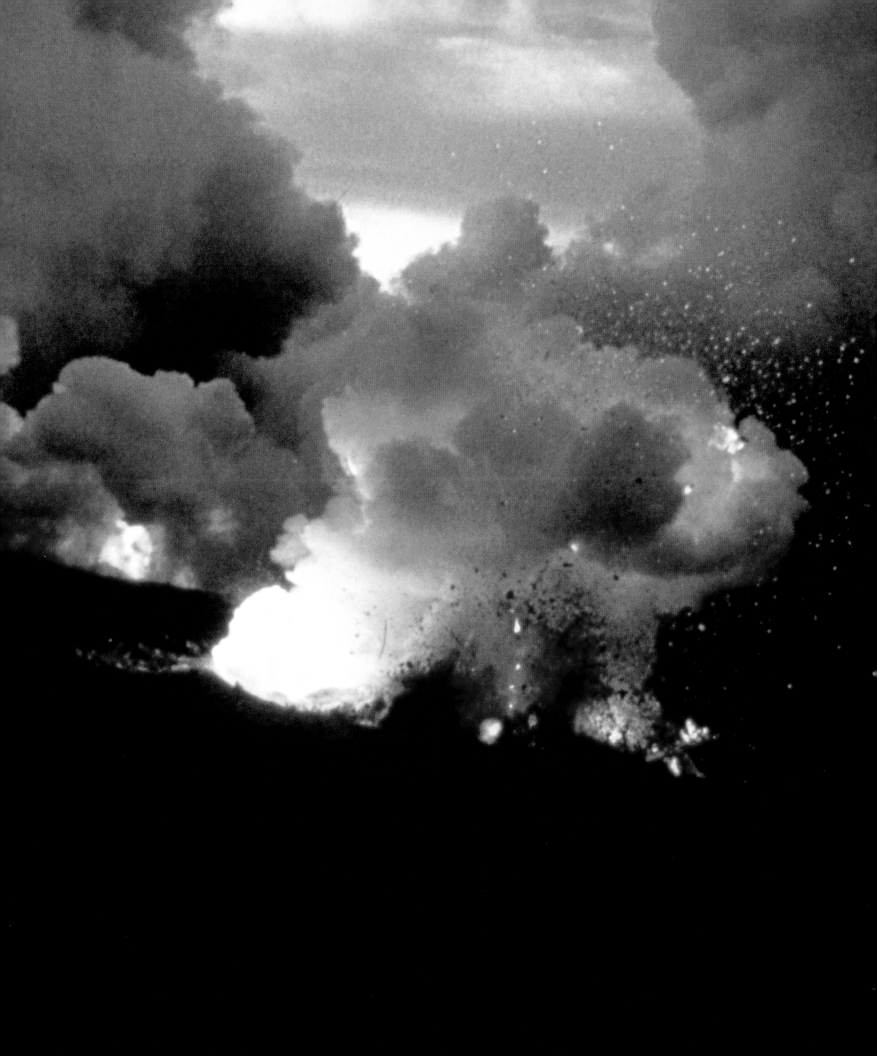

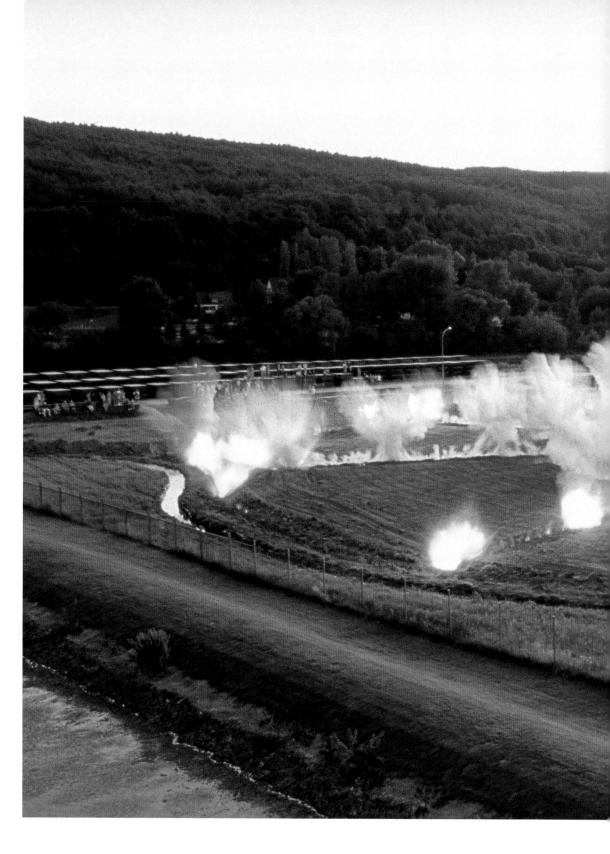

**FETUS MOVEMENT II: PROJECT FOR
EXTRATERRESTRIALS NO. 9**
胎动二：为外星人作的计划第九号
1992

REALIZED AT **BUNDESWEHR-WASSERÜBUNGSPLATZ
MILITARY BASE, HANNOVER-MÜNDEN, JUNE 27, 1992,
9:40 PM, 9 SECONDS.** LAND AREA 15,000 SQ. M.
GUNPOWDER (90 KG), FUSE (1,300 M), SEISMOGRAPH

WITH NINE SENSORS, ELECTROENCEPHALOGRAPH,
AND ELECTROCARDIOGRAPH. COMMISSIONED
BY THE KASSEL INTERNATIONAL ART EXHIBITION
FOR *ENCOUNTERING THE OTHERS: THE KASSEL
INTERNATIONAL ART EXHIBITION*

Cai presented the original idea for this explosion
event in his 1991 gunpowder drawing of the same
title (cat. no. 10), in which he envisioned uniting

"the fetus movement," or the primordial origins,
of "the earth and human spirit, and to feel the
origin of the fetus movement of the universe
itself, and all existence within it." The violent con-
notation of the site—a military base—prompted
him to add the healing practice of feng shui, an
element absent in the gunpowder drawing. At the
site, gunpowder fuse was arranged on the ground
in three concentric circles and eight transverse

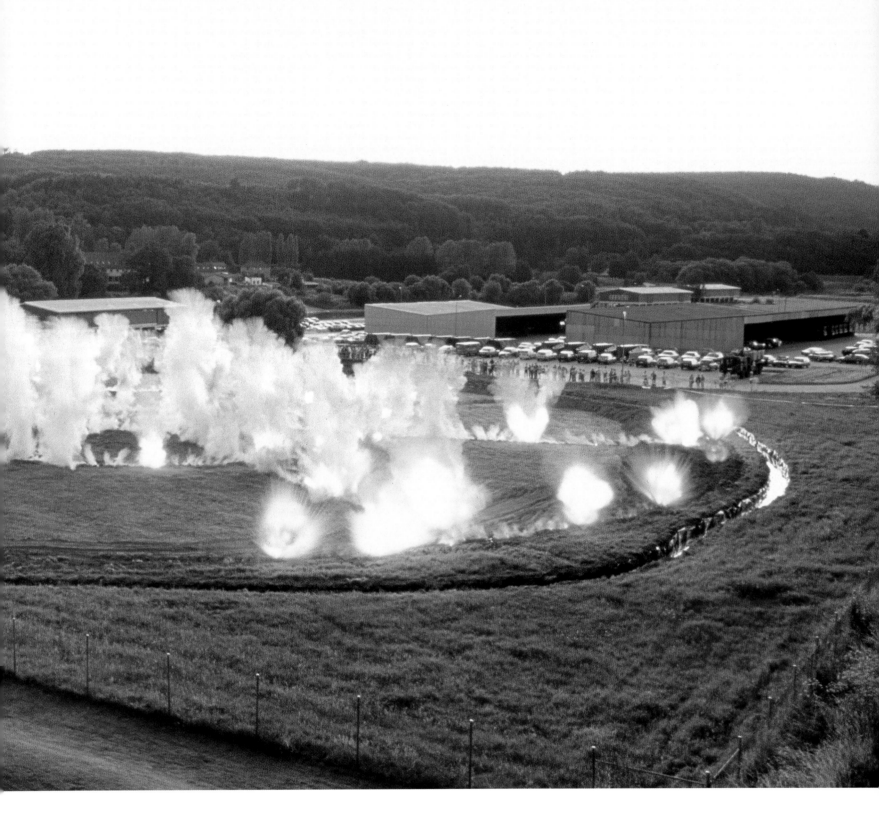

lines to resemble markings for latitude and longitude. To incorporate the feng shui principle that "running water does not rot"—in an attempt to return the military base back to its natural balance—water was diverted from a nearby river into a canal composing the outermost circle. Cai positioned himself in the middle on a tiny circular island surrounded by a second canal of river water. He was connected to an electrocardiograph and an electroencephalograph to monitor his heart and brainwaves during the explosion. Nine sensors were buried around the outside perimeter of the outer circle, each at a depth of 50 centimeters and attached to a seismograph on the island to simultaneously chart the movement of the earth. A composite print (fig. 61) documents the results taken from each instrument before, during, and after the explosion, quantifying the inextricable relationship between man, the earth, and the universe. —MY

EXHIBITION HISTORY

1992: *Encountering the Others: The Kassel International Art Exhibition*, various sites in Hannover-Münden and Kassel

RELATED WORKS

1990: Folding album, same title (fig. 50)

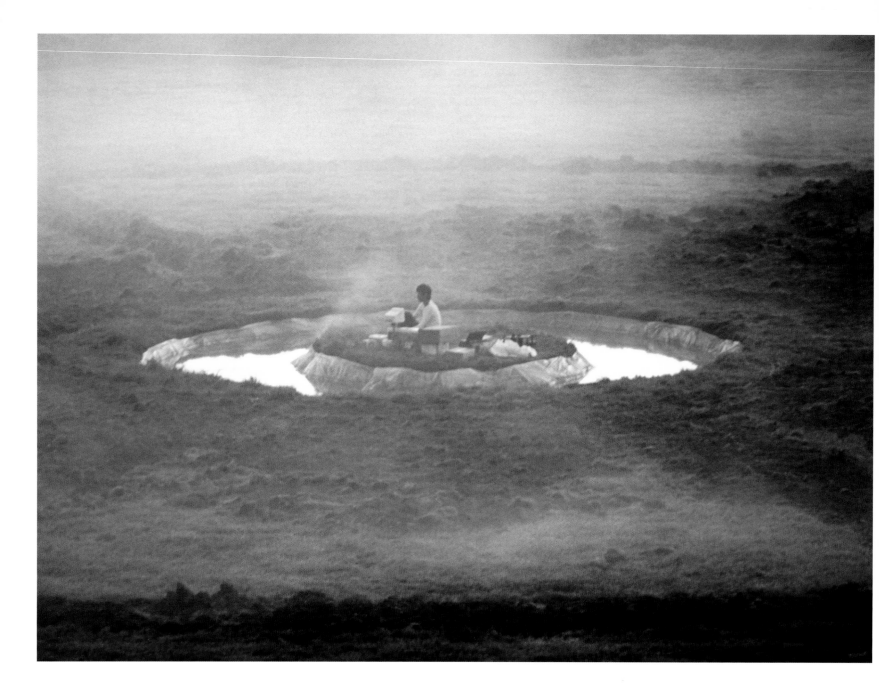

1990: *Fetus Movement: Project for Extraterrestrials No. 5*. Realized at Palace Plaza, Olive Mountain, Ushimado, Okayama, November 3, 1990, 5:30 PM, approximately 3 seconds. Land area 400 x 300 cm. Gunpowder (8 kg), fuse (1 m), and seismometer. Commissioned by Japan Ushimado International Art Festival for the *7th Japan Ushimado International Art Festival*

1991: Drawing, same title (cat. no. 10)

1992: *Seismogram, Electroencephalogram, and Electrocardiogram from Fetus Movement II: Project for Extraterrestrials No. 9* (fig. 61)

1992: Drawing, same title. Gunpowder on paper, 280 x 420 cm. Private collection

1992: *Drawing for Fetus Movement II: Project for Extraterrestrials No. 9*. Gunpowder and ink on paper, 66.5 x 48.5 cm. Collection of the artist

1992: *Drawing for Fetus Movement II: Project for Extraterrestrials No. 9*. Gunpowder and ink on paper,

mounted on board, 48 x 66.5 cm. Collection of the artist

1992: Edition, same title. Gunpowder drawing, two silkscreen prints documenting the explosion, and a recycled plastic bag originally used to hold gunpowder for the explosion event. Edition of 15. Private collections

FIG. 61. *SEISMOGRAM, ELECTROENCEPHALOGRAM, AND ELECTROCARDIOGRAM FROM FETUS MOVEMENT II: PROJECT FOR EXTRATERRESTRIALS NO. 9*, 1992. SILKSCREEN AND METALLIC MARKER ON PAPER, 56 X 76 CM. COLLECTION OF THE ARTIST

FIGS. **62** AND **63**. *SECRET RECIPE FOR JAPAN, FAN PU GUI ZHEN TANG AND ZENG SHOU NING SHEN TANG: PROJECT FOR HUMANKIND NO. 5, 1993.* REALIZED AT P3 ART AND ENVIRONMENT, TOKYO. MEDICINAL HERBS, WATER, KETTLES, AND CUPS. COMMISSIONED BY P3 ART AND ENVIRONMENT FOR THE EXHIBITION *LONG MAI—THE DRAGON MERIDIAN.* ARTWORK NOT EXTANT

21

PROJECT TO EXTEND THE GREAT WALL OF CHINA BY 10,000 METERS: PROJECT FOR EXTRATERRESTRIALS NO. 10

万里长城延长一万米: 为外星人作的计划第十号
1993

REALIZED AT **THE GOBI DESERT, WEST OF THE GREAT WALL, JIAYUGUAN, GANSU PROVINCE, FEBRUARY 27, 1993, 7:35 PM, 15 MINUTES.** EXPLOSION LENGTH 10,000 M. GUNPOWDER (600 KG) AND TWO FUSE LINES (10,000 M EACH). COMMISSIONED BY P3 ART AND ENVIRONMENT, TOKYO

Created during the period when Cai lived in Japan, this complex, multilayered explosion event is a key work in the *Projects for Extraterrestrials* series. This explosion event explored the primordial need to build walls and the relationship between humankind and the larger cosmos, while also embodying the artist's ongoing practice of realizing his ideas through collaboration. The project site began at Jiayuguan, the western-most section of the Great Wall of China in Gansu Province. To offset the costs of the project, Cai organized a tour group from Japan to attend the explosion event. More than one hundred tourists and local volunteers extended 10,000 meters of fuse from the end of the Great Wall into the Gobi Desert. At dusk the fuse was detonated and a line of fire evocative of a dragon glided across the plain. Momentary pulses of light were released by small charges placed every 3 meters and larger charges—signifying signal towers—placed every 1,000 meters. In this instance, Cai's attempt to communicate with extraterrestrials plays on the apocryphal claim that the Great Wall of China is

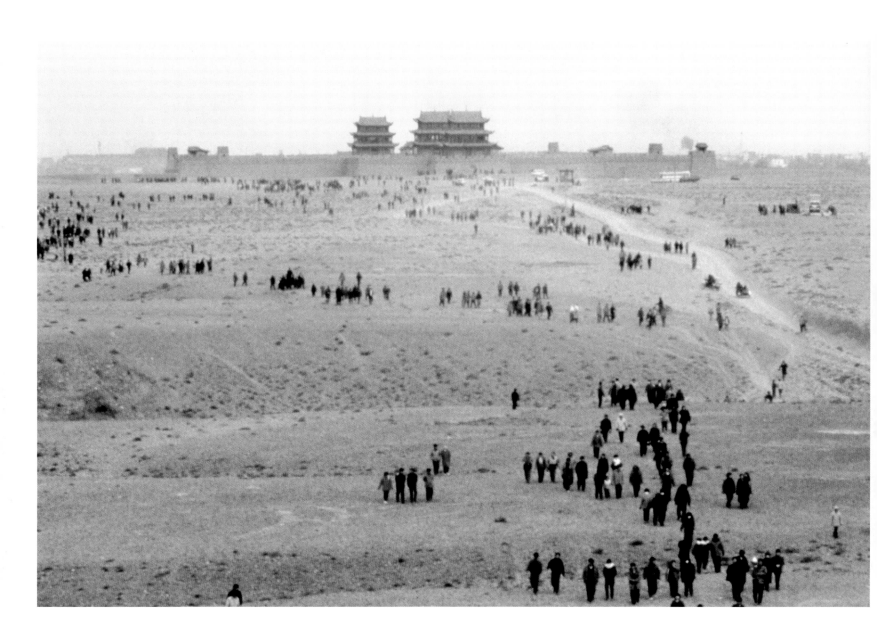

the only man-made structure visible from the moon. In accordance with feng shui principles, the explosion awakened the circulation of qi energy along the fabled "dragon meridian" of the site and released the energy into the universe. Maintaining inner equilibrium through the use of Chinese medicine within the microcosm of the body is equally important to Cai. A key aspect of the project was the preparation of herbal remedies by the artist for the participants to take before and after the explosion. A tonic was consumed to fortify the mind and body in preparation for the arduous trek into the desert and to render the mind open to the experience. Afterward, a soothing and calming elixir was consumed to balance the excitement generated by the event. —MY

EXHIBITION HISTORY

1993: Project introduction and preparation phase, *Long Mai—The Dragon Meridian*, P3 art and environment, Tokyo

1994: Three-channel video presentation, *Chaos: Cai Guo-Qiang*, Setagaya Art Museum, Tokyo

2005–06: One-channel video presentation, *The Wall: Reshaping Contemporary Chinese Art* (traveling exhibition)

RELATED WORKS

1990: Folding album, same title (fig. 55)

1992: Drawings, same title. Two drawings, gunpowder and ink on paper, 70 x 50 cm each. Private collections

1992–93: *Dragon II: Project to Extend the Great Wall of China by 10,000 Meters*. Two installations, each with gunpowder drawing and clay piece, dimensions variable; drawing: 400 x 150 cm. Private collection and collection of the artist

1993: Folding album (fig. 56)

1993: *Long Mai—The Dragon Meridian: Project for Humankind No. 5*. Chinese soil, armature, and fabric, length approximately 100 m. Artwork not extant

1993: *Secret Recipe for Japan, Fan Pu Gui Zhen Tang and Zeng Shou Ning Shen Tang: Project for Humankind No. 5* (figs. 62 and 63)

1994: *Extension* (cat. no. 14)

2000: Drawing, same title. Gunpowder on paper, 300 x 2,000 cm. Glory Fine Arts Museum, Hsinchu

2001: *Impression Oil Drawing: Extension*. Two works, oil on canvas, 183 x 120 cm; 40.5 x 51 cm. Collection of the artist

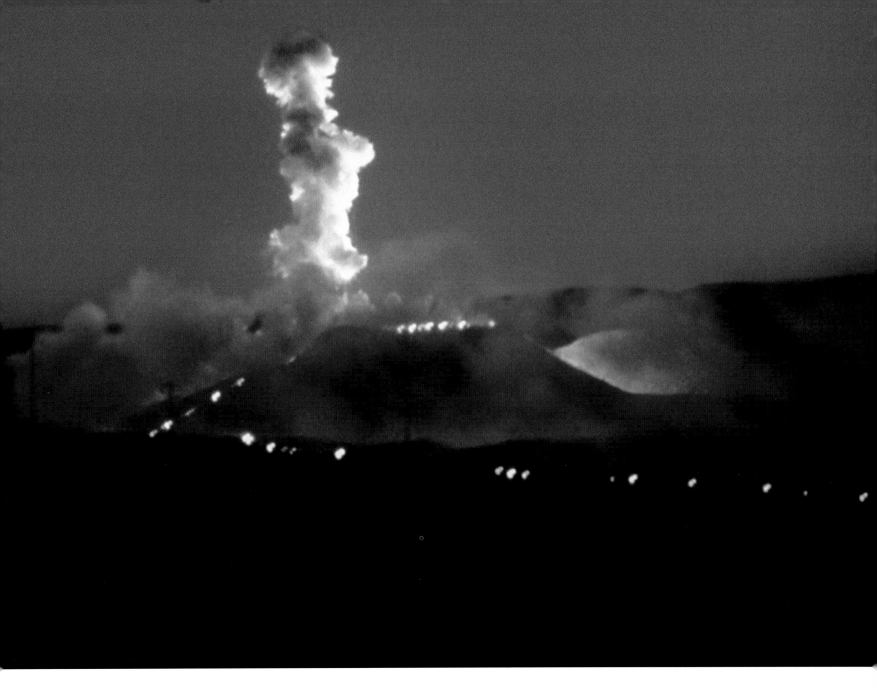

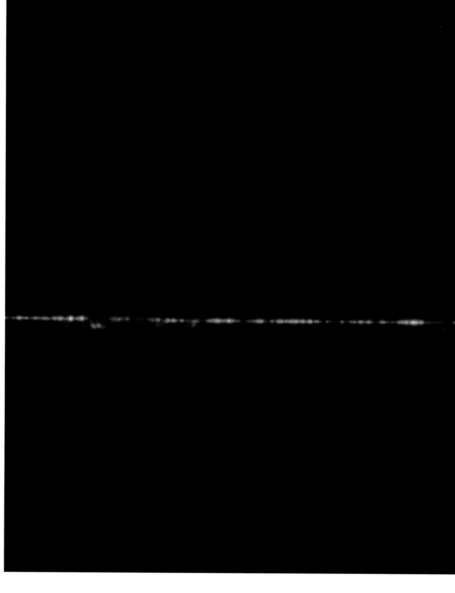

22

THE HORIZON FROM THE PAN-PACIFIC: PROJECT FOR EXTRATERRESTRIALS NO. 14
地平线：为外星人作的计划第十四号
1994

REALIZED ON **THE PACIFIC OCEAN, OFFSHORE FROM NUMANOUCHI TO YOTSUKURA BEACH, IWAKI, FUKUSHIMA, MARCH 7, 1994, 6:38 PM, 1 MINUTE 40 SECONDS.** EXPLOSION LENGTH 30,000 M. SIX GUNPOWDER FUSES (5,000 M EACH), ROPE, VINYL SHEETS, THREE BOATS, AND BASE SHIP. COMMISSIONED BY IWAKI CITY ART MUSEUM, FOR THE EXHIBITION *CAI GUO-QIANG: FROM THE PAN-PACIFIC*

The success of Cai's explosion events and site-specific projects relies on local community participation and support. His residency in Iwaki—a city located on the northeastern coast of Japan—from November 1993 to March 1994 exemplifies how these collaborations not only contribute to the realization of a project but are also integral to the artist's methodology. For this project, Cai articulated principles that would also inform future projects: "construct my works here, in this place, converse with outer space from here, and create a story of this era with the people here." During this time, consciously following Mao Zedong's approach toward mobilizing the public, he produced and distributed flyers to explain the project and to generate support for it. *The Horizon from the Pan-Pacific: Project for Extraterrestrials No. 14* involved laying a 30,000-meter length of waterproof fuse and gunpowder line across the bay from Numanouchi to Yotsukura Beach. Cai rallied a team of volunteers—many of whom had never set foot in a museum—to persuade local residents to each purchase 1 meter of fuse for the equivalent price of ten dollars. On the day of the explosion event, three barges manned by the coast guard and one base ship took control of the waters to prevent intruding ships from severing the fuse. Upon ignition, the line of fire shot along the water's surface and illuminated the horizon between the dark water and nighttime sky, using light to define the boundary between the earth and the rest of the universe. Residents who lived around the bay also participated by turning their lights off for the duration of the explosion, heightening the dramatic effect of the event and demonstrating the extraordinary local support Cai had secured. —MY

EXHIBITION HISTORY

1994: *Cai Guo-Qiang: From the Pan-Pacific*, Iwaki City
Art Museum, Fukushima

RELATED WORKS

1994: *Days*. Notes, instructions, and sketches on paper,
dimensions variable. Iwaki City Art Museum, Fukushima
1994: *Peaceful Earth*. Japanese rice paper, electricity,
satellite photo, and chair, dimensions variable. Collection
of the artist
1994: *Chrysanthemum Tea*. White chrysanthemums,
soil from chrysanthemum garden, trees, and charcoal,
dimensions variable. Collection of the artist

23

PROJECT FOR HEIANKYŌ 1,200TH ANNIVERSARY: CELEBRATION FROM CHANG'AN
平安建都一千二百年祭: 来自长安的祝贺
1994

REALIZED AT **KYOTO CITY HALL, MARCH 13, 1994, 6:30 PM, 60 MINUTES.** LAND AREA APPROXIMATELY 40 X 70 M. XIFENG WINE (1,200 KG). COMMISSIONED BY THE CITY OF KYOTO FOR THE EXHIBITION *MAKING NEW KYOTO '94*

This project was Cai's first explosion event commissioned for a celebratory occasion. He was invited by the Kyoto municipal government to memorialize the city's 1,200th anniversary and referenced Kyoto's history in a tribute of blue glowing flame. Kyoto, originally known as Heiankyō, was founded as Japan's capital city in 794 and modeled after the Tang Dynasty (618–907) capital of Chang'an (Xi'an) in what is now Shanxi Province in China. The artist literally inscribed his well wishes into the earth, digging trenches into the plaza in front of City Hall in the shape of auspicious Chinese emblems reminiscent of an ancient seal script symbol signifying "luck." Once the pattern was completed, Cai dripped 1,200 kilograms of Xifeng wine—produced in Shanxi Province and donated by the city of Xi'an—from one of the plaza's historic government buildings to fill the trenches. The wine was ignited, linking past, present, and future. For 60 minutes the blue flame of burning alcohol seared the emblems into the earth. The lingering smell intoxicated citizens and visitors, metaphorically granting them and the city luck for the future. —MY

EXHIBITION HISTORY
1994 *Making New Kyoto '94*, Kyoto City Hall

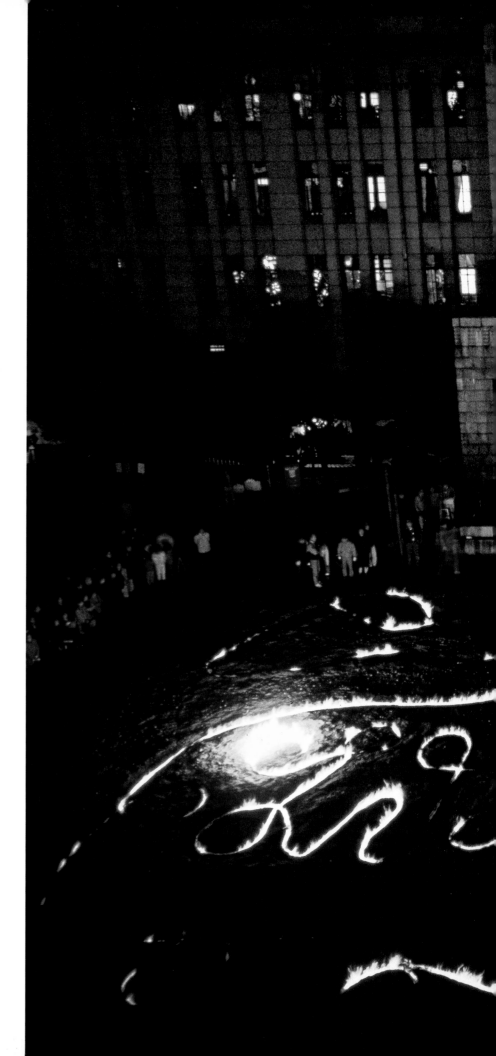

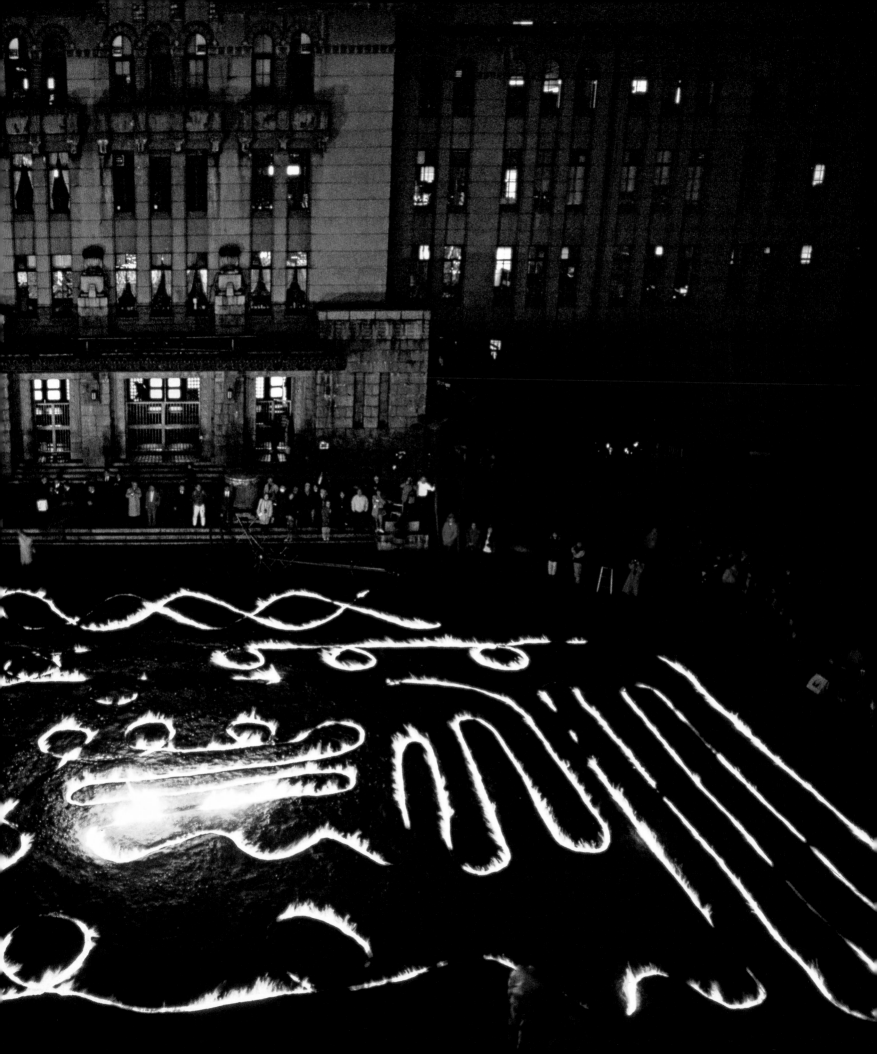

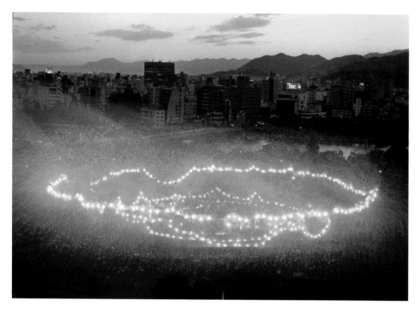

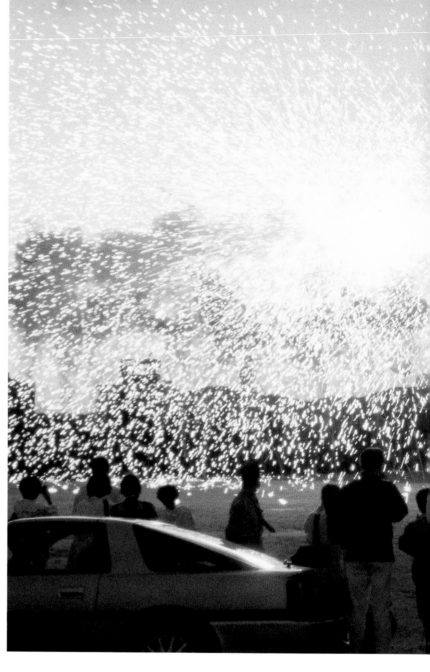

24

THE EARTH HAS ITS BLACK HOLE TOO: PROJECT FOR EXTRATERRESTRIALS NO. 16
地球也有黑洞：为外星人作的计划第十六号
1994

REALIZED AT **HIROSHIMA CENTRAL PARK NEAR THE A-BOMB DOME, HIROSHIMA, OCTOBER 1, 1994, 6:01 PM, 30 SECONDS.** EXPLOSION AREA: DIAMETER APPROXIMATELY 100 M; SPIRAL LENGTH 900 M. GUNPOWDER (3 KG), FUSE (2,000 M), AND 114 HELIUM BALLOONS. COMMISSIONED BY HIROSHIMA CITY MUSEUM OF CONTEMPORARY ART FOR THE EXHIBITION *CREATIVITY IN ASIAN ART NOW*

In 1994, Cai was commissioned to create an explosion event in conjunction with the 12th Asian Games, which were held in Hiroshima. His preoccupation with nuclear weapons as a subject began with *Shadow: Pray for Protection* (1985–86, cat no. 3) and extended into his series *The Century with Mushroom Clouds: Project for the 20th Century* (1996, cat. no. 26). Mindful of Hiroshima's tragic past as the target of the first atomic bombing on August 6, 1945, Cai first proposed *Torch Lighting*, for which an athlete in a helicopter hovering 600 meters above would have ignited a fuse extending to a torch at Hiroshima's ground zero. Although this idea was meant to suggest that fire descending from the sky may have the potential to initiate rebirth, as represented by the games, it was abandoned because survivors of the atomic bombing objected to it. Cai turned to another of his preoccupations, astrophysics, and proposed an alternative, *The Earth Has Its Black Hole Too: Project for Extraterrestrials No. 16*.

This explosion event was realized in Hiroshima Central Park at the site of a former Japanese military headquarters. The park is located near the A-Bomb Dome, the iconic ruin that is the centerpiece of the Hiroshima Peace Memorial Park. Helium balloons suspended in place at precise heights were used to hold the fuse and gunpowder aloft. At detonation, the explosion began at the highest outermost point and traveled in smaller concentric circles until it disappeared into a black hole dug into the ground. This downward spiral, bursting with heat and light, served as a metaphor for the irreversible gravity of a black hole, as well as to the implosion method used for nuclear weapons. It was Cai's intention to pointedly suggest that—by way of nuclear science—humankind had generated its own black holes on the earth echoing the celestial phenomena. —MY

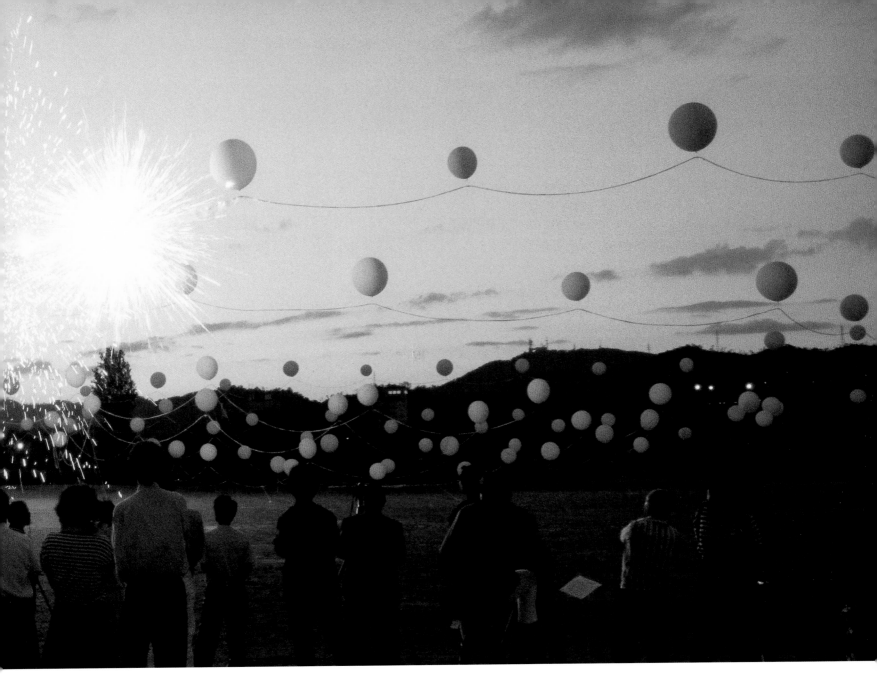

EXHIBITION HISTORY

1994: *Creativity in Asian Art Now*, Hiroshima City Museum
of Contemporary Art

RELATED WORKS

1993: Drawing, same title. Gunpowder on paper, 300 x
400 cm. Fondation Cartier pour l'art contemporain, Paris
1994: Drawing, same title. Gunpowder on paper, 400 x
600 cm. Private collection
1994: Drawing, same title. Gunpowder and ink on paper,
63.3 x 55 cm. Collection of the artist

RESTRAINED VIOLENCE—RAINBOW: PROJECT FOR EXTRATERRESTRIALS NO. 25
有限制的暴力 ——彩虹: 为外星人作的计划第二十五号
1995

REALIZED AT **TRIBUNE HALL, JOHANNESBURG POWER STATION, FEBRUARY 28, 1995, 6 PM, 5 SECONDS.** EXPLOSION AREA (BUILDING FACADE) APPROXIMATELY 25 X 150 M, GUNPOWDER (5 KG) AND FUSE (500 M). COMMISSIONED BY THE JOHANNESBURG BIENNALE FOR *THE EVER-CHANGING, DRIFTING HEAT: THE FIRST JOHANNESBURG BIENNALE*

This explosion event exemplifies Cai's sensitivity to local concerns in relation to his site-specific projects and his growing interest in political and social issues beginning in the mid-1990s. In 1995, Cai participated as a Japanese representative in the first Johannesburg Biennale, organized a year after the first free elections were held in South Africa after the end of apartheid. The project was inspired by Nelson Mandela, who in 1961 had become leader of Umkhonto we Sizwe (Spear of the Nation), an underground organization dedicated to the violent overthrow of South Africa's

apartheid regime; its tactics included sabotaging power plants. After his election to the nation's presidency in 1994, Mandela embraced the promotion of social change through economic means with the goal of building a harmonious Rainbow Nation. On the inaugural evening of the biennale, Cai's explosion event inscribed three bands of a rainbow across the exterior of a partially abandoned power plant, metaphorically acknowledging the violent history of the city while signaling a new era of peace. Prior to the event, the artist visited a local shaman to ask for her blessing over the project. Upon ignition of 500 meters of fuse and specially made gunpowder charges, flames raced across the structure leaving behind the shape of a rainbow in the shattered glass of the windows and red brick of the facade. —MY

EXHIBITION HISTORY
1995: *The Ever-Changing, Drifting Heat: The First Johannesburg Biennale*, Electric Workshop, Johannesburg

RELATED WORKS
1995: *Drawing for Restrained Violence—Rainbow: Project for Extraterrestrials No. 25*. Gunpowder fuse on wall, 11 x 18 m. Watari-um Museum of Contemporary Art, Tokyo

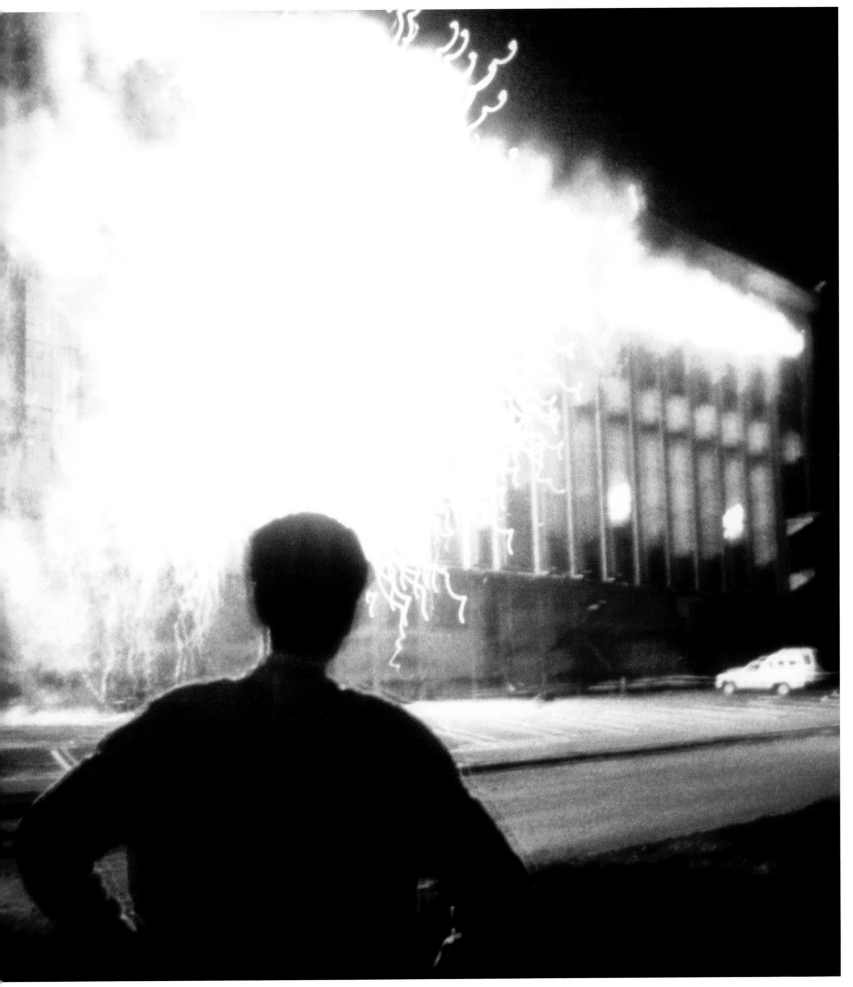

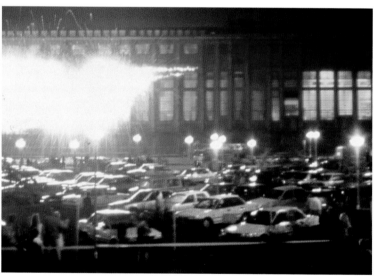

26

THE CENTURY WITH MUSHROOM CLOUDS: PROJECT FOR THE 20TH CENTURY
有蘑菇云的世纪：为二十世纪作的计划
1996

REALIZED AT **VARIOUS SITES IN THE UNITED STATES, FEBRUARY–APRIL, 1996, 1 SECOND EACH EXPLOSION.** GUNPOWDER (10G EACH) AND CARDBOARD TUBES

The iconic image of the mushroom cloud is arguably the most potent symbol of the twentieth century. Its image conjures the horrors of atomic warfare and the dangers of nuclear proliferation, as well as the advances of science and technology. According to Cai, "As a symbol of the progress and victory of science, the 'mushroom clouds,' with all their visual impact, have a tremendous material and spiritual influence on human society." In this project, he employed gunpowder to "depict the 'face' of the nuclear bomb that represents modern-day technology." *The Century with Mushroom Clouds: Project for the 20th Century* is a series of miniature "mushroom cloud" explosions realized at symbolic locations in the United States. Created during Cai's residency at the P.S.1 Studio Program, this project was the first body of work he created after moving to New York in 1995. It is indicative of the artist's increasing interest in political and social issues as subject matter at that time. Using gunpowder placed in small cardboard tubes, he detonated the explosions by hand at various locations, including the Nevada Test Site (used for explosive nuclear-weapons tests between 1951 and 1992), Michael Heizer's earthwork *Double Negative* (1969–70) also in Nevada, and Robert Smithson's earthwork *Spiral Jetty* (1970, fig. 44) on the Great Salt Lake in Utah—all chosen to emphasize their relative physical proximity to one another. Cai also detonated gunpowder with the familiar skyline of Manhattan in the background. Related drawings show him creating mushroom clouds at cities around the world because, in his words, "Various reactions toward the mushroom clouds by all races, individuals, and nations are anticipated, and these will also constitute symbolic phenomena of contemporary life." The explosions were documented through photographs and video footage, and through postcards that were sold in a related installation entitled *Crab House* (1996, cat no. 49). —MY

LOOKING TOWARD MANHATTAN, APRIL 20, 1996

EXHIBITION HISTORY

1996: Documentation display as a component of *Crab House* (cat. no. 49) installation for *In the Ruins of the Twentieth Century*, P.S.1 The Institute for Contemporary Art, off-site: 80 Lafayette Street, New York

RELATED WORKS

1995: *The Century with Mushroom Clouds, Paris: Project for the 20th Century*. Ink on paper, 47 x 29.5 cm. Collection of the artist

1995: *The Century with Mushroom Clouds, London: Project for the 20th Century*. Ink on paper, 29.5 x 47 cm. Collection of the artist

1995: *The Century with Mushroom Clouds, Moscow: Project for the 20th Century*. Ink on paper, 47 x 29.5 cm. Collection of the artist

1995: *The Century with Mushroom Clouds, India: Project for the 20th Century*. Ink on paper, 29.5 x 47 cm. Collection of the artist

1995–96: *Drawing for the Century with Mushroom Clouds: Project for the 20th Century* (fig. 78)

1996: *Drawing for the Century with Mushroom Clouds: Project for the 20th Century*. Two works, gunpowder on paper, 48 x 30.5 cm; 49 x 62 cm. Collection of the artist

1996: *The Century with Mushroom Clouds, Tian'anmen Square: Project for the 20th Century*. Gunpowder and ink on paper, 183 x 65 cm. Private collection

1996: *Crab House* (cat. no. 49)

1996: Drawing, same title (fig. 79)

2001: *Impression Oil Drawing: Mushroom Cloud*. Oil on canvas, 230 x 183 cm. Collection of the artist

AT MICHAEL HEIZER'S *DOUBLE NEGATIVE* (1969–70), MORMON MESA, OVERTON, FEBRUARY 14, 1996

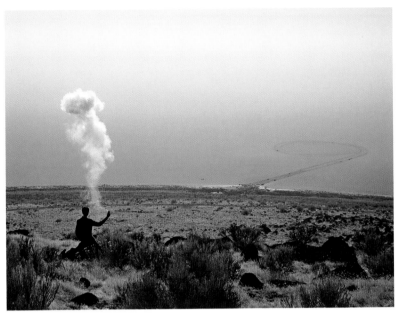

AT ROBERT SMITHSON'S *SPIRAL JETTY* (1970), GREAT SALT LAKE, FEBRUARY 15, 1996

AT NEVADA TEST SITE, FEBRUARY 13, 1996

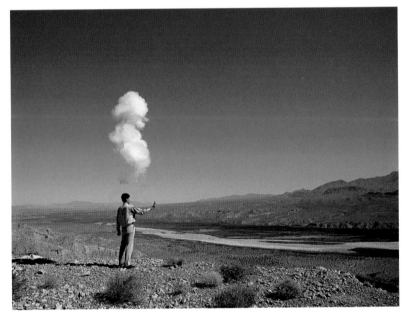

AT NEVADA TEST SITE, FEBRUARY 13, 1996

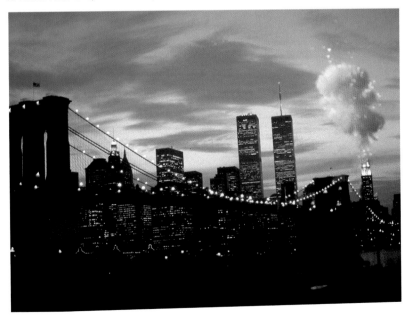

LOOKING TOWARD MANHATTAN, APRIL 20, 1996

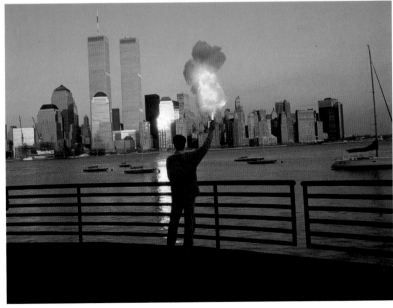

LOOKING TOWARD MANHATTAN, APRIL 21, 1996

27

GOLDEN MISSILE
金飞弹
1998

REALIZED AT **TAIPEI FINE ARTS MUSEUM, JUNE 13, 1998, 53 SECONDS.** EXPLOSION AREA: HEIGHT 150 M; DIAMETER 25 M. 200 MINIATURE GOLDEN MISSILES WITH PARACHUTES. COMMISSIONED BY TAIPEI FINE ARTS MUSEUM FOR *SITE OF DESIRE: 1998 TAIPEI BIENNIAL*

Cai is sensitive to the ongoing political tensions between Mainland China and Taiwan, having first experienced them as a youth in Quanzhou. *Golden Missile* addressed this mutual animosity head on and attempted reconciliation through humor and goodwill while also symbolizing Asia's burgeoning force as an economic power. The

explosion event involved launching 200 gold-painted missiles from a plaza adjacent to the Taipei Fine Arts Museum on the opening day of the 1998 Taipei Biennial. The discharged missiles were detonated at a height of 150 meters, releasing parachutes that then floated the missiles gently back to earth. The parachutes were imprinted with images of a traditional Chinese coin. Onlookers rushed forward to catch these falling objects as mementos of the event.
—MY

EXHIBITION HISTORY
1998: *Site of Desire: 1998 Taipei Biennial*, Taipei Fine Arts Museum

RELATED WORKS
1998: Drawing, same title. Gunpowder on paper, mounted on wood as six-panel screen, 218.5 x 450 cm overall. Private collection

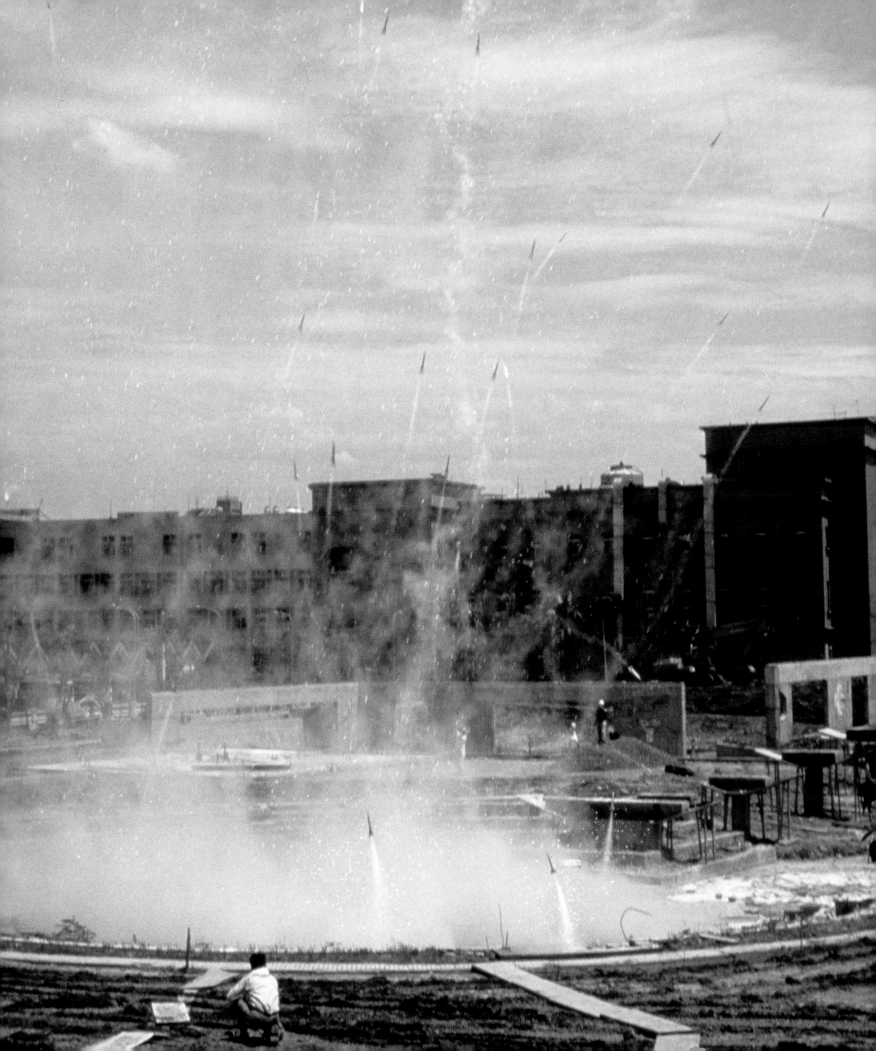

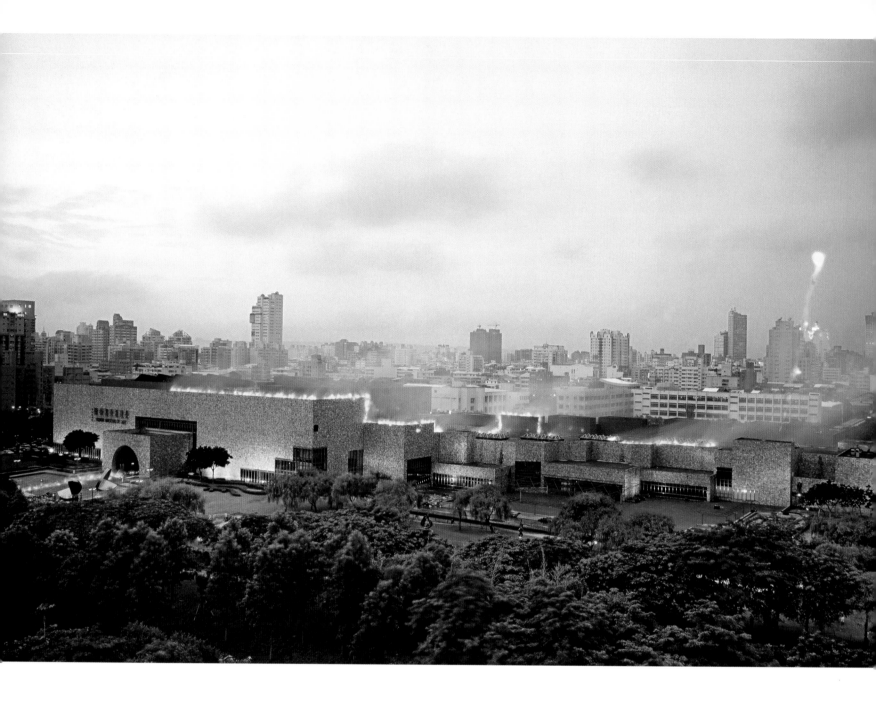

28

NO DESTRUCTION, NO CONSTRUCTION: BOMBING THE TAIWAN PROVINCE MUSEUM OF ART

不破不立: 引爆台湾省立美术馆
1998

REALIZED AT **TAIWAN PROVINCE MUSEUM OF ART**,
TAICHUNG, AUGUST 21, 1998, 6:35 PM,
APPROXIMATELY 1 MINUTE. GUNPOWDER BOMBS

(25 KG), FUSE (2,500 M), AND ONE HELIUM BALLOON.
COMMISSIONED BY TAIWAN PROVINCE MUSEUM OF ART

For this project, Cai ingeniously seized upon
the opportunity to utilize a museum under renova-
tion to celebrate the site's impending "rebirth."
Museological interventions are an ongoing
theme throughout the artist's practice, especially
in his later *Everything Is Museum* series (cat.

nos. 50–52). Ignited in mid-air through a fuse
suspended by a white helium balloon above the
building, the detonated fuse descended rapidly
onto the roof and then entered the building. The
explosion proceeded to weave in and out of the
structure seven times through a series of skylights,
the flame taking on the appearance of a dragon
cresting out of the structure from one place to
another. The sequence continued as two fire

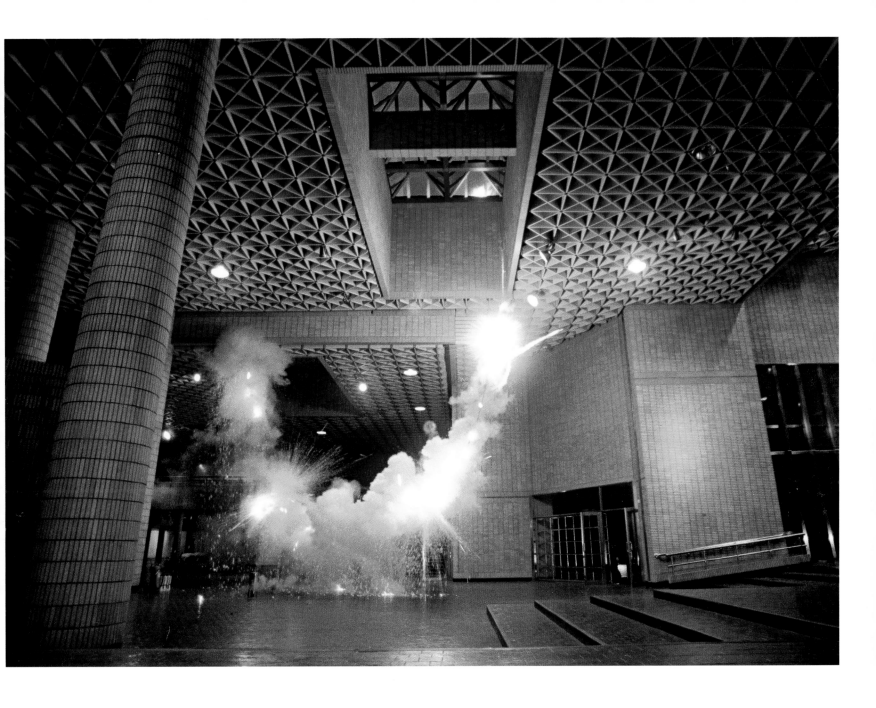

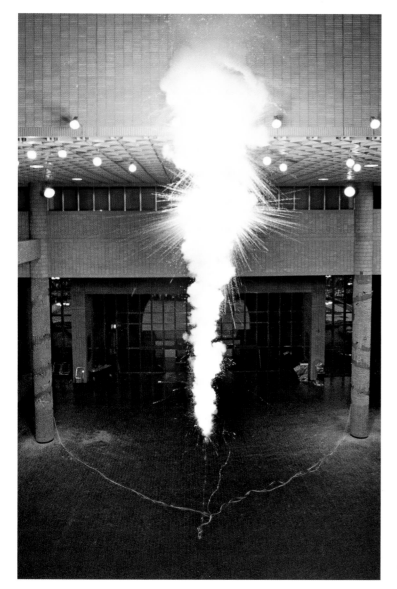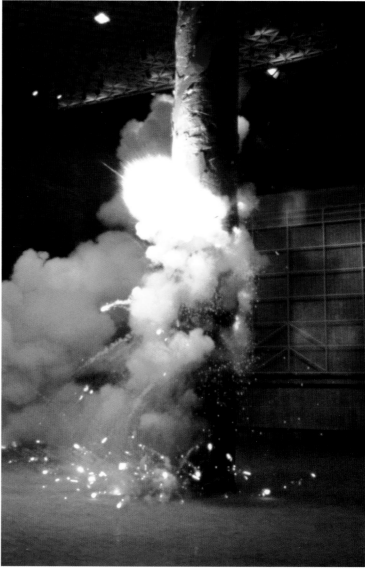

FIG. 64. *NO DESTRUCTION, NO CONSTRUCTION: BOMBING THE TAIWAN PROVINCE MUSEUM OF ART*, 1998. GUNPOWDER FUSE ON CONCRETE PILLARS. PERMANENT INSTALLATION AT NATIONAL TAIWAN MUSEUM OF FINE ARTS, TAICHUNG

dragons composed of fuse simultaneously inscribed circular burn marks as they spiraled up a pair of central concrete pillars in the building's interior. Finally, the explosion—and with it, the dynamic energy of the renovation—extended out the museum entrance onto the front plaza. As does *Golden Missile* (1998, cat no. 27), realized at the Taipei Fine Arts Museum, but more subliminally, *No Destruction, No Construction: Bombing the Taiwan Province Museum of Art* reflects Cai's engagement with the charged topic of relations between Taiwan and Mainland China. The controversy surrounding this collaboration with Ni Tsai-Chin, then the museum's director and curator of the project, contributed to Ni's eventual resignation from the museum. The Taiwan Province Museum of Art was later renamed the National Taiwan Museum of Fine Arts. —MY

RELATED ARTWORKS

1998: Drawing, same title (fig. 64)

1998: Drawing, same title. Gunpowder on paper, 400 x 500 cm. National Taiwan Museum of Fine Arts, Taichung

2001: *Impression Oil Drawing: Bombing the Taiwan Museum of Art.* Oil on canvas, 76 x 61 cm. Collection of the artist

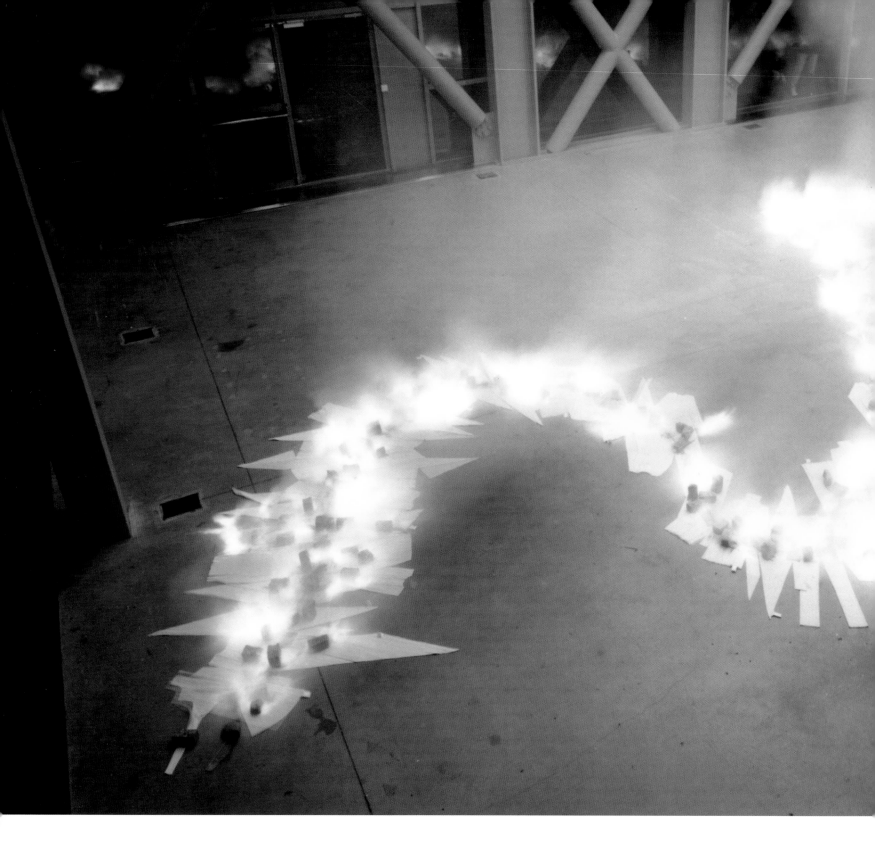

FIG. 65. *PLEATS PLEASE ISSEY MIYAKE GUEST ARTIST SERIES NO. 4: CAI GUO-QIANG ON PLEATS PLEASE*, 1998. THE MIYAKE ISSEY FOUNDATION

29

DRAGON: EXPLOSION ON PLEATS PLEASE ISSEY MIYAKE

龙柱: 炸三宅一生服装

1998

REALIZED AT **FONDATION CARTIER POUR L'ART CONTEMPORAIN**, PARIS, OCTOBER 5, 1998, 9 PM, **2 SECONDS.** GUNPOWDER ON PLEATS PLEASE GARMENTS. COMMISSIONED BY FONDATION CARTIER POUR L'ART CONTEMPORAIN FOR THE EXHIBITION *ISSEY MIYAKE MAKING THINGS*

Throughout his career, Cai has collaborated with artists from a range of disciplines, including architecture, music, the performing arts, and—for this event—fashion. In 1998, he was invited by the Japanese designer Issey Miyake to participate in the fourth installment of the *Guest Artist Series* of Pleats Please. The theme of their collaboration focused on fashion and energy. *Dragon: Explosion on Pleats Please Issey Miyake* was realized for the opening of the retrospective *Issey Miyake Making Things* at the Fondation Cartier pour l'art contemporain. Cai's idea drew from his ongoing use of dragon imagery and the flammable nature of Miyake's signature polyester fabric. He created an undulating dragon—composed of sixty-three Pleats Please garments—along the floor of one of the museum's galleries. Gunpowder was laid atop clothing, which was then held down by strategically placed rocks. Upon ignition, the flame raced across the fabric, and the scorched traces of the explosion creating dragon motifs on individual garments. The charred garments were reconfigured as an installation arranged on the floor for the duration of the exhibition, and the burnt patterns were

used as a template to mass produce the designs in ink on Pleats Please garments for Miyake's Spring/Summer 1999 collection. —MY

EXHIBITION HISTORY

1998–2000: Explosion event (first venue only) and installations with garments from explosion event, *Issey Miyake Making Things* (traveling exhibition)

1998–99: Garments from explosion event worn at press events for *Issey Miyake Spring/Summer 1999 Collection: Pleats Please Issey Miyake, America*, various venues

2001: Installation with garments from explosion event, Miyake Design Studio, Tokyo

RELATED WORKS

1997: *Drawing for Dragon: Explosion on Pleats Please Issey Miyake*. Two drawings, gunpowder on paper, 38.3 x 37.3 cm; 50.5 x 38.3 cm. Collection of the artist

1998: *Drawing for Dragon: Explosion on Pleats Please Issey Miyake*. Gunpowder on paper, 300 x 400 cm. Collection of the artist

1998: Installation, same title. Gunpowder on Pleats Please garments and rocks, dimensions variable. The Miyake Issey Foundation

2001: Installation, same title. Gunpowder on Pleats Please garments and Plexiglas column, approximately 250 x 150 x 150 cm. The Miyake Issey Foundation

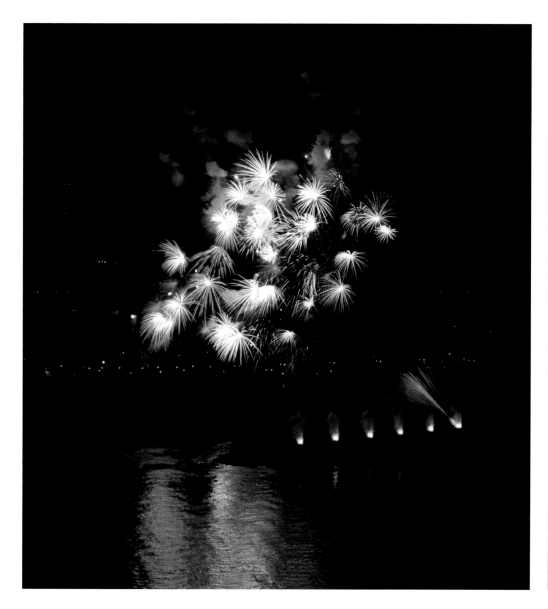

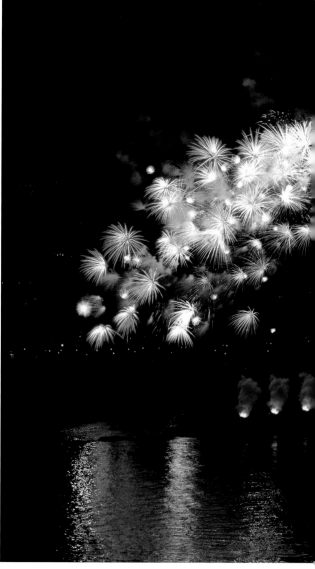

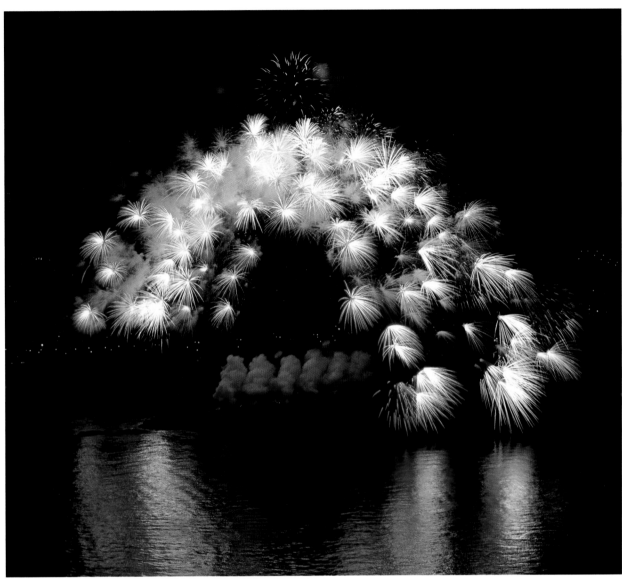

30

TRANSIENT RAINBOW
移动彩虹
2002

REALIZED OVER **THE EAST RIVER, FROM MANHATTAN TO QUEENS, NEW YORK, JUNE 29, 2002, 9:30 PM, 15 SECONDS.** EXPLOSION RADIUS APPROXIMATELY 200 M. 1,000 3-INCH MULTICOLOR PEONY FIREWORKS FITTED WITH COMPUTER CHIPS. COMMISSIONED BY THE MUSEUM OF MODERN ART, NEW YORK, FOR THE OPENING OF THE MUSEUM OF MODERN ART, QUEENS

Transient Rainbow was commissioned by the Museum of Modern Art in Manhattan to mark its temporary move to the borough of Queens in 2002. This project was the first pyrotechnic event allowed in New York after the terrorist attacks on the World Trade Center on September 11, 2001.

Sensitive to the magnitude of this occasion, the artist chose a rainbow motif to symbolize renewal and promise. In order to create the form of a rainbow, shells containing computer chips were specially designed by Fireworks by Grucci to control the precise height and timing of each detonation. The shells were fired off the southern tip of Roosevelt Island, and the form arched over the East River from Manhattan to Queens. The rainbow appeared twice, first sweeping across the sky in a progressive cadence, immediately followed by a simultaneous flash illuminating the night sky with a full rainbow. The vibrant arc of colors was reflected on the surface of the river, creating the illusion of a continuous ring of light. Working closely with curator Lilian Tone, Cai convinced government officials to approve his idea and overcame logistical obstacles. The spectacular result

unified viewers in a common celebration. Two related drawings (see fig. 66) were made in 2003 after the event and illustrate the artist's continual practice of working across mediums to realize and document his ideas. —MY

RELATED WORKS

2002: *Impression Oil Drawing: Transient Rainbow.* Four works, oil on canvas, 150 x 190 cm each. Collection of the artist

2002: *Impression Oil Drawing: Transient Rainbow.* Oil on canvas, three panels, 460 x 198 cm overall. Collection of the artist

2003: Drawing, same title (fig. 66)

2003: *Drawing for Transient Rainbow.* Gunpowder on paper, 454.7 x 405.1 cm. The Museum of Modern Art, New York

FIG. 66. *TRANSIENT RAINBOW*, 2003. GUNPOWDER ON PAPER, 300 X 400 CM. COLLECTION OF WIJONO TANOKO, INDONESIA

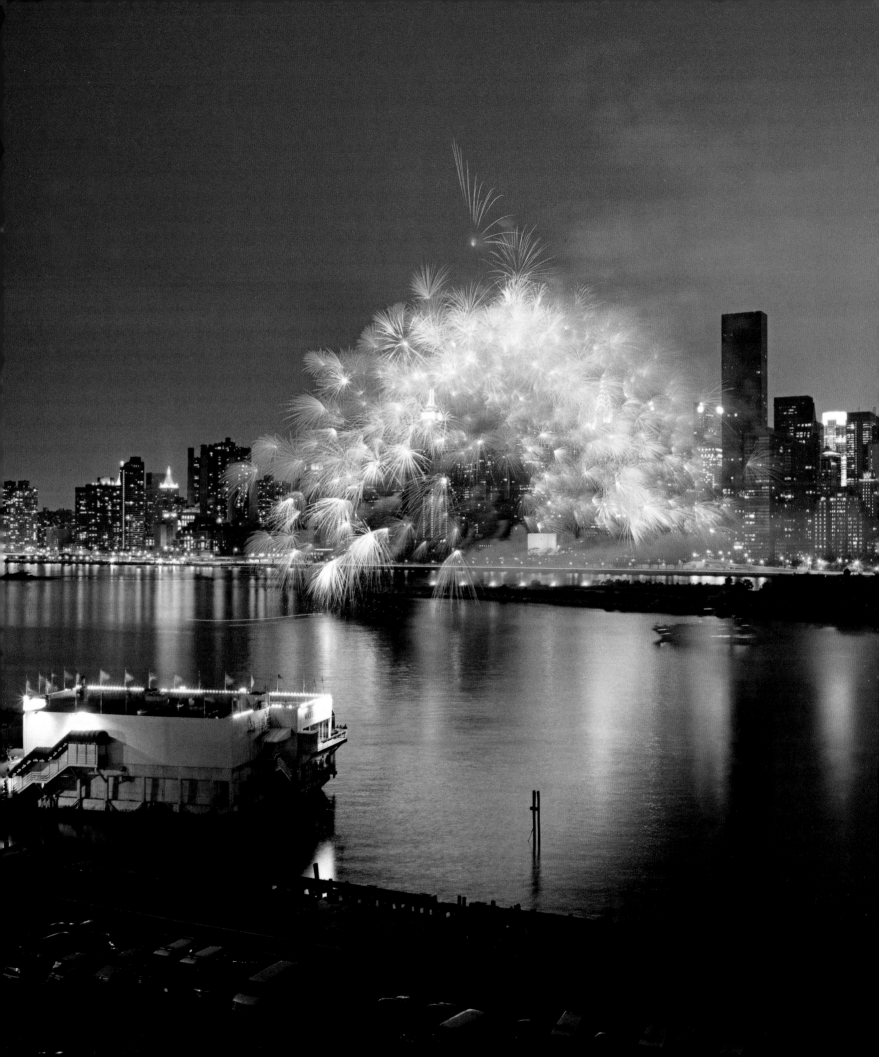

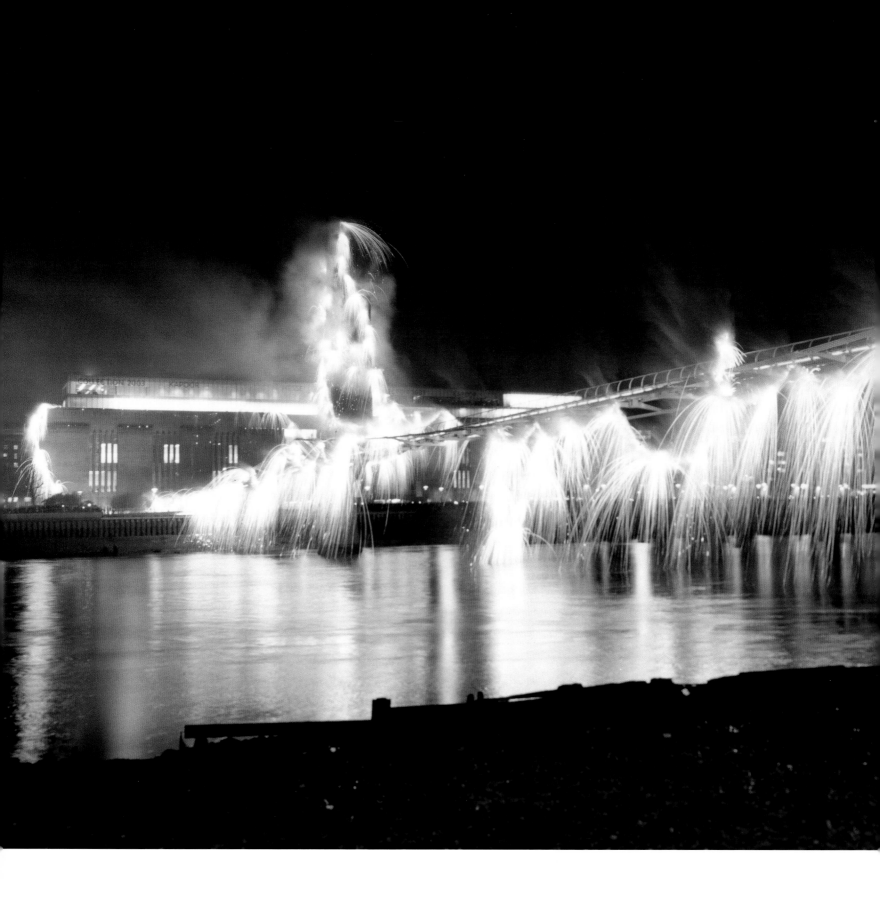

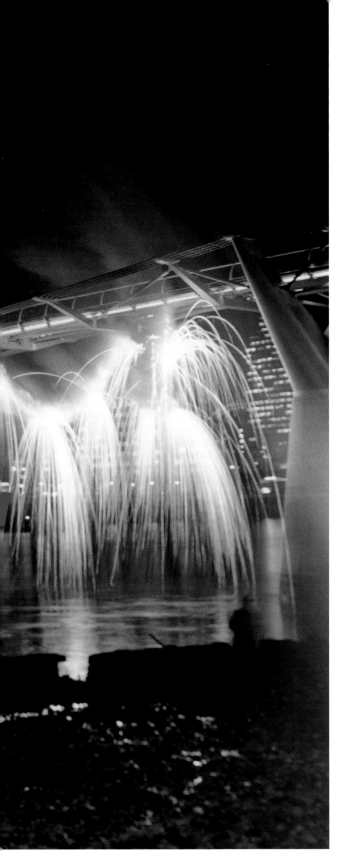

31

YE GONG HAO LONG (MR. YE WHO LOVES DRAGONS): EXPLOSION PROJECT FOR TATE MODERN
叶公好龙: 为泰德现代美术馆作的爆破计划
2003

REALIZED AT **MILLENIUM BRIDGE AND TATE MODERN, LONDON, JANUARY 31, 2003, 7 PM, 1 MINUTE.** TRIPLE FUSE LINES (6,000 M), BLACK GUNPOWDER (25 KG), AND METALLIC GUNPOWDER (25 KG). COMMISSIONED BY TATE GALLERY AS PART OF *TATE & EGG LIVE 2003*

As is apparent in many of the titles of his artworks, Cai has often culled his subject matter from traditional Chinese folklore. In many instances, humorous fables served as a basis for the visual imagery and are deftly intermixed with ideas pertaining to politics, cosmology, and philosophy. *Ye Gong Hao Long (Mr. Ye Who Loves Dragons)* refers to the story of a man enamored with the idea of dragons. However, when a living dragon appeared in his window, Mr. Ye was so frightened that he fled from the tangible manifestation of his beloved ideal. Cai's adaptation of this allegory allowed him to continue his ongoing appropriation of dragon imagery as a metaphor of China, and he used it to allude to the fluid economic and political relationship between modern China and the West. The explosion event coincided with the Chinese New Year and inaugurated *Tate & Egg Live*, a series of live arts events jointly sponsored by the Tate Gallery and the online bank Egg. Although the detonation was supposed to start on the north bank of the Thames, due to strong currents, the fuse spread out along the river, rendering it useless. Instead, the explosion began at the Millenium Bridge, raced across the span, and then up the north facade of the Tate Modern, like a dragon climbing upward. Falling sparks melted a plastic component of the glass windows on the facade, causing the Tate's internal fire alarm system to respond. The subsequent delay in disabling the alarm prevented the scheduled postexplosion reception—an outcome that serves as an example of the unpredictability and risk involved in Cai's explosion events. —MY

EXHIBITION HISTORY
2003: *Tate & Egg Live 2003*, Tate Modern, London, and Tate Britain, London

RELATED WORKS
2003: *Ye Gong Hao Long (Mr. Ye Who Loves Dragons)*. Gunpowder on paper, 400 x 1,500 cm. Tate Modern, London
2003: *Ye Gong Hao Long (Mr. Ye Who Loves Dragons)*. Gunpowder on paper, 300 x 400 cm. Tate Modern, London
2003: *Ye Gong Hao Long (Mr. Ye Who Loves Dragons)*. Gunpowder on paper, mounted on wood as six-panel screen, 220 x 450 cm overall. Private collection

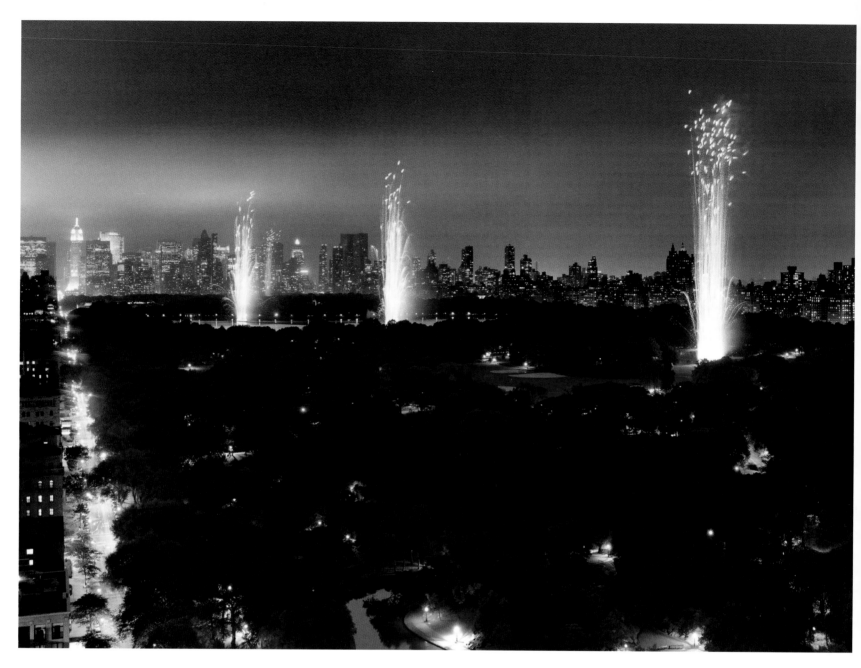

32

LIGHT CYCLE: EXPLOSION PROJECT FOR CENTRAL PARK
光轮：为中央公园作的爆破计划
2003

REALIZED AT **CENTRAL PARK, NEW YORK,**
SEPTEMBER 15, 2003, 7:45 PM, 4 MINUTES.
TIGER TAILS, TITANIUM SOLUTES FITTED WITH
COMPUTER CHIPS, AND SHELLS WITH DESCENDING
STARS. COMMISSIONED BY CREATIVE TIME IN
CONJUNCTION WITH THE CITY OF NEW YORK AND THE
CENTRAL PARK CONSERVANCY FOR THE 150TH
ANNIVERSARY OF THE CREATION OF CENTRAL PARK

This explosion event over New York's Central Park
was composed of three parts—*Signal Towers*,
Light Cycle, and *White Night*—to celebrate the
park's 150th anniversary. Beginning with *Signal*
Towers, five golden pillars of fire were detonated
for 30 seconds each at progressive intervals of
5 seconds traveling from the southern end of the
park northward. This was immediately followed by
Light Cycle, for which a sequence of three hori-
zontal golden rings were inscribed into the sky,
leading up to an enormous vertical ring detonated
above the Central Park reservoir in three consecu-
tive configurations: successive bursts of light;
progressive explosives forming a whole; and a
simultaneous brilliant flash. These halos of light
over the park served as talismans offered by the
artist to protect the city. The event closed with
White Night, for which a blanket of signal flares
were shot into the air, illuminating the park's
walkways. The related drawing (2003, fig. 67)
created after the event documents the three
realized parts of the explosion events as well as
two unrealized ideas—*Ancient Branding* and
Seasons—that Cai had originally proposed. It also
depicts iconography reflecting the artist's belief in
the primordial and everlasting relationship
between humankind and nature. —MY

RELATED WORKS

2003: Drawing, same title (fig. 67)

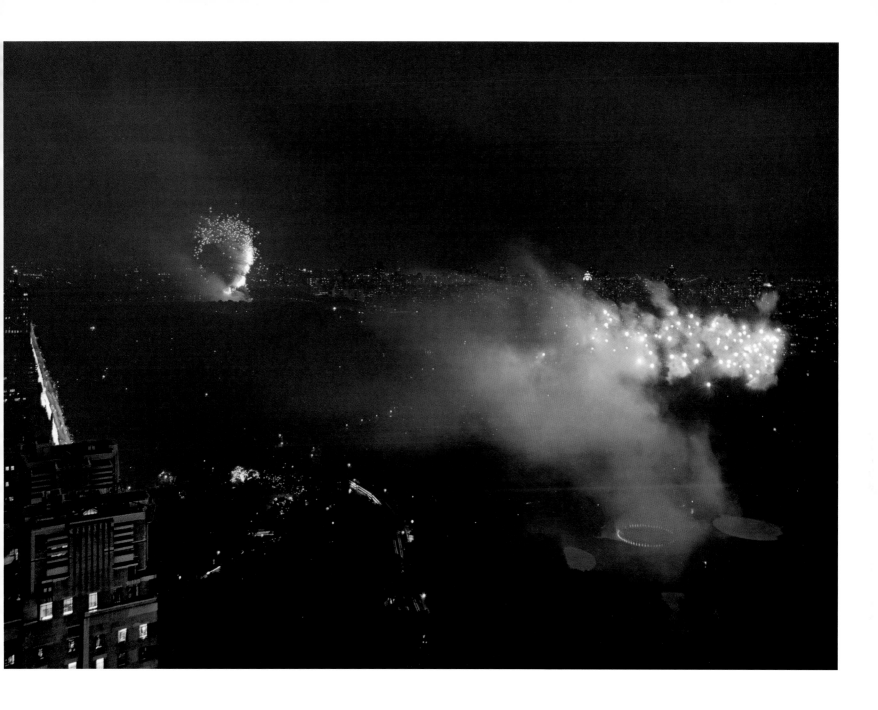

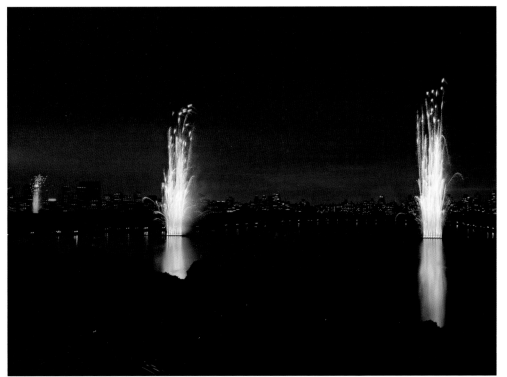

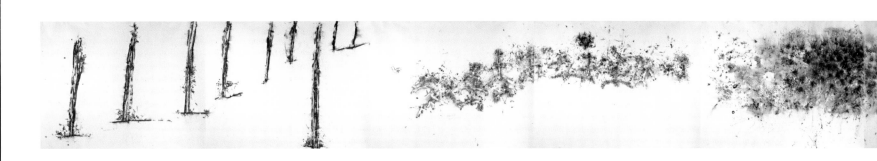

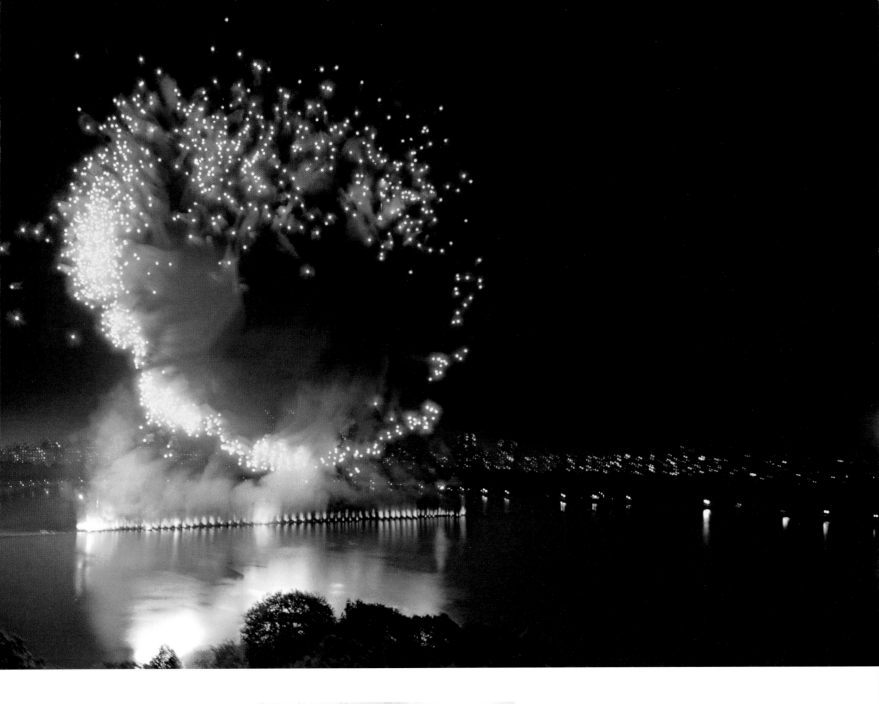

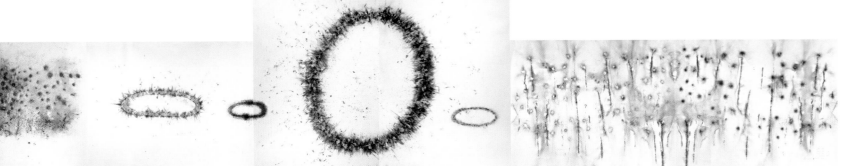

FIG. 67. *LIGHT CYCLE: EXPLOSION PROJECT FOR CENTRAL PARK*, 2003. FIVE-PART DRAWING, LEFT TO RIGHT: *SIGNAL TOWERS, ANCIENT BRANDING, SEASONS, LIGHT CYCLE,* AND *WHITE NIGHT*, GUNPOWDER ON PAPER, 4 X 42 M OVERALL. YAGEO FOUNDATION COLLECTION, TAIWAN

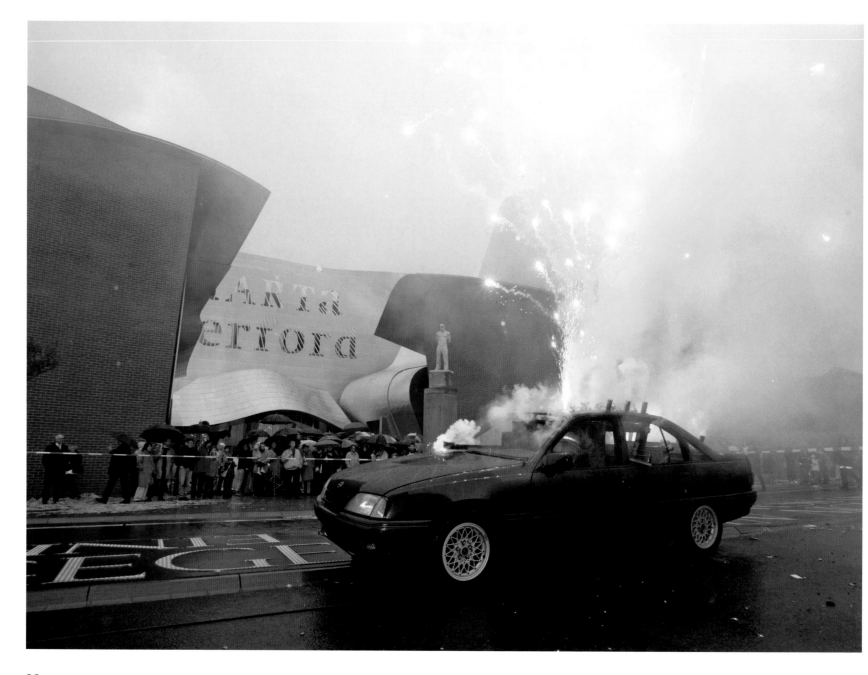

33

AUTO-DESTRUCT
自动销毁
2005

REALIZED ON **GOEBENSTRASSE, IN FRONT OF MARTA HERFORD, GERMANY, MAY 7, 2005, 4:30 PM, 1 MINUTE 30 SECONDS.** CAR AND FIREWORKS. COMMISSIONED BY MARTA HERFORD FOR THE EXHIBITION *(MY PRIVATE) HEROES*

Auto-Destruct succinctly conflates notions of celebration and spectacle with acts of terror, illuminating Cai's ability to deftly juxtapose disparate types of experience. The artist's focus on social issues, though always present, intensified upon his move to New York in 1995 and has progressively become more overt since the 9/11 terrorist attack on that city in 2001. The regular occurrence of car bombings in the news has signaled the proliferation of this type of warfare in the twenty-first century, and Cai has adopted the imagery of exploding automobiles as a recurring motif in recent work, beginning with *Inopportune: Stage One* (cat. no. 45) and *Illusion* (fig. 74), both from 2004. The play on words of the title *Auto-Destruct* evokes associations that range from the literal destruction of an automobile to what the artist sees as the politicized self-destructive behavior of suicide bombers. For this explosion event realized at the opening of the inaugural exhibition *(my private) Heroes*, curated by Cai's longtime collaborator Jan Hoet, a German-made car was pulled toward the entrance of the MARTa Herford museum as multicolored fireworks—including rockets, cakes, fountains, and mines—burst out of the opened roof, windshield, and windows.

This ominous display in front of the newly constructed Frank Gehry building, with its blurring of the distinction between terrorism and art, tempered the pleasure of the festivities with a sense of unease. —MY

EXHIBITION HISTORY

2005: *(my private) Heroes*, MARTa Herford

RELATED WORKS

2004: *Illusion* (fig. 74)
2004: *Inopportune: Stage One* (cat. no. 45)
2006: *Illusion II: Explosion Project* (fig. 77)
2006: *Illusion II*. Two-channel video installation, 8 minutes 48 seconds, loop, dimensions variable. Edition of 5. Deutsche Bank Collection and collection of the artist

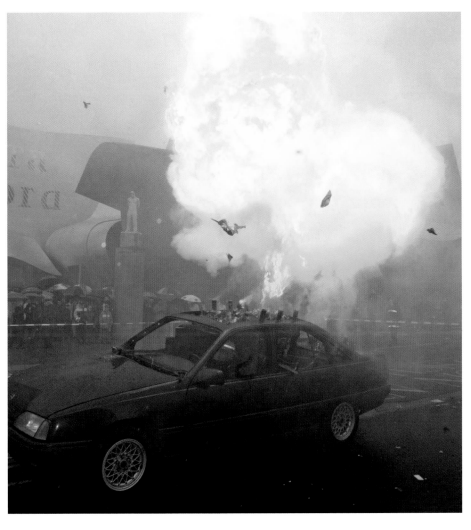
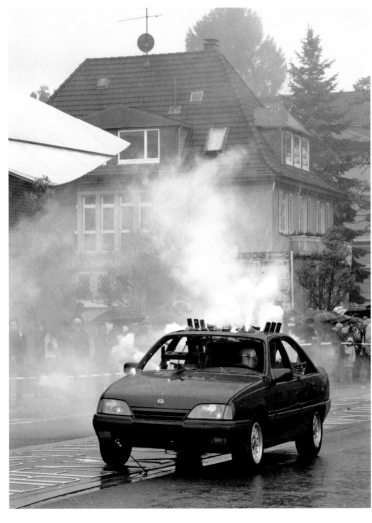

34

BLACK RAINBOW: EXPLOSION PROJECT FOR VALENCIA
黑彩虹: 瓦伦西亚爆破计划
2005

REALIZED AT **OLD TURIA RIVERBED PARK, BETWEEN ROYAL BRIDGE AND TRINIDAD BRIDGE, VALENCIA, MAY 22, 2005, 12:05 PM, APPROXIMATELY 1 MINUTE.** 1,400 3-INCH BLACK SMOKE SHELLS. COMMISSIONED BY INSTITUT VALENCIÀ D'ART MODERN FOR THE EXHIBITION *CAI GUO-QIANG: ON BLACK FIREWORKS*

In March 2004, Cai was invited to Valencia, a city famous for extravagant fireworks, to discuss a possible project for the Institut Valencià d'Art Modern (IVAM). The terrorist train bombings that occurred in Madrid on March 11, three days prior to his departure for Spain, prompted the artist to develop the concept for *Black Rainbow: Explosion Project for Valencia*. For this project, the black fireworks were specifically invented for the artist to explode in daylight. In this and subsequent related works, Cai inverted the brilliance of fireworks designed to explode against a dark night sky with black fireworks made to be explored during the day. This inversion serves as a symbol for our increased vulnerability at the hands of terrorism. *Black Rainbow* serves as a counterpoint to *Transient Rainbow* (2002, cat. no. 30), a post-9/11 work in which the rainbow was used for its traditional positive connotations. The Valencia project was realized over the city's River Park at midday, the explosion unfolding in three successive rounds. The first rainbow appeared in rapid progression, seeming to puncture black holes into the sky. The second iteration fanned open into a continuous arc, formed by growing plumes of smoke. And the third rainbow appeared in its entirety as a simultaneous flash, forming a viscous black cloud that slowly dissipated into blue sky in an eerie silence. Created after the event, the drawing *Black Fireworks: Project for IVAM* (2005, fig. 68) shifts from long views to details to capture the explosion's opaque density. A second version of this project, *Black Rainbow: Explosion Project for Edinburgh* (2005, fig. 69), was realized over Edinburgh Castle. —MY

EXHIBITION HISTORY
2005: *Cai Guo-Qiang: On Black Fireworks*, Institut Valencià d'Art Modern
2007: One-channel video presentation shown at *6 Billion Perps Held Hostage! Artists Address Global Warming*, Andy Warhol Museum, Pittsburgh

RELATED WORKS
2005: *Black Fireworks: Project for IVAM* (fig. 68)
2005: *Black Rainbow: Explosion Project for Edinburgh* (fig. 69)
2006: *Clear Sky Black Cloud* (fig. 31)

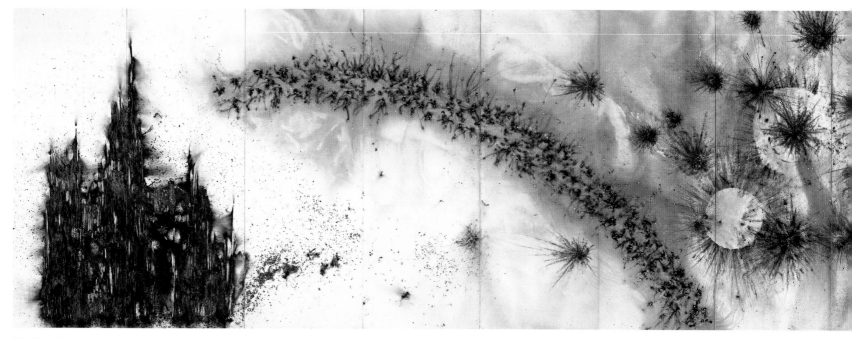

FIG. 68. *BLACK FIREWORKS: PROJECT FOR IVAM*, 2005. GUNPOWDER ON PAPER, MOUNTED ON WOOD AS 15-PANEL SCREEN, 240 X 1,342 CM OVERALL. COLLECTION OF THE ARTIST

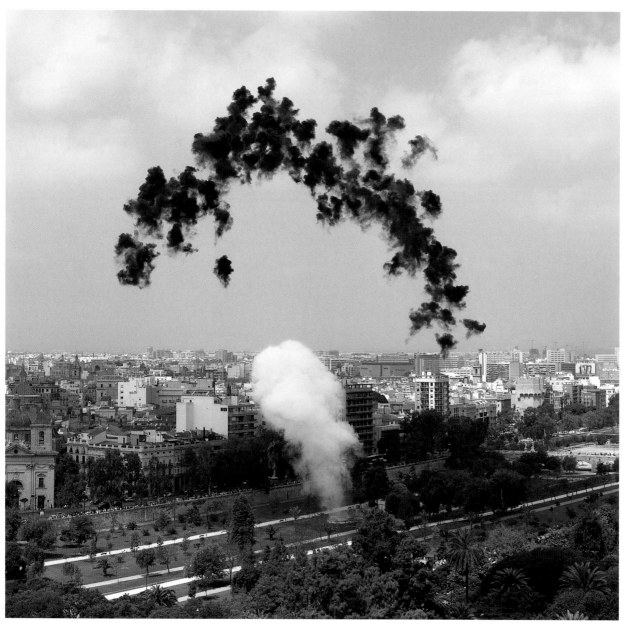

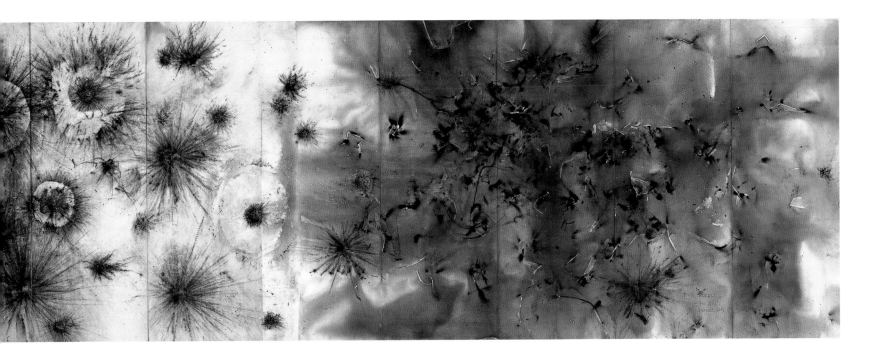

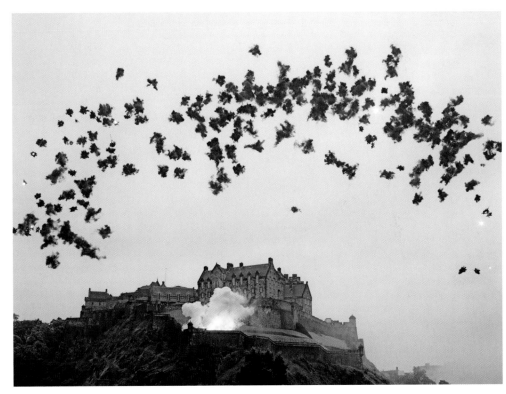

FIG. 69. *BLACK RAINBOW: EXPLOSION PROJECT FOR EDINBURGH*, 2005. REALIZED AT EDINBURGH CASTLE, JULY 29, 2005, 7 PM, 3 MINUTES. 1,400 3-INCH BLACK SMOKE SHELLS. COMMISSIONED BY THE FRUITMARKET GALLERY, EDINBURGH, FOR THE EXHIBITION *CAI GUO-QIANG: LIFE BENEATH THE SHADOW*

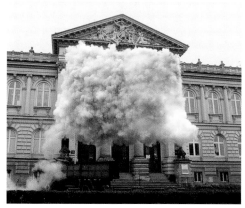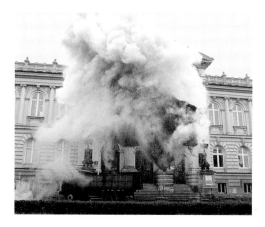

35

RED FLAG

红旗

2005

REALIZED AT **ZACHETA NATIONAL GALLERY OF ART,
WARSAW, JUNE 17, 2005, 7:15 PM, 2 SECONDS.**
EXPLOSION AREA (FLAG) 640 X 960 CM. GUNPOWDER
FUSE AND RED FLAG. COMMISSIONED BY ZACHETA
NATIONAL GALLERY OF ART FOR THE EXHIBITION *CAI
GUO-QIANG: PARADISE*

For this explosion event, Cai appropriated the uni-
versal symbol of flag burning to symbolize the end
of communist control over Eastern Europe. A large
red flag—made of interwoven red gunpowder
fuses backed with red cloth—was affixed to a flag-
pole mounted on a socialist-era truck parked in
front of the entrance to the Zacheta National

Gallery of Art, a location loaded with political sig-
nificance. It was the assassination site in 1922 of
the first president of Poland, Gabriel Narutowicz,
and served as an assembly point for numerous
protests against the communist regime in the
1980s. Upon ignition, the flame burst from the
lower left corner of the flag, fanned upward, and
instantaneously combusted the rest of the cloth
while leaving behind a white carpet of smoke.
This explosion event and the accompanying exhi-
bition, *Cai Guo-Qiang: Paradise*, were notable as
the first presentations of Cai's work in a commu-
nist country outside of China. —MY

EXHIBITION HISTORY

2005: *Cai Guo-Qiang: Paradise*, Zacheta National Gallery of
Art, Warsaw

RELATED WORKS

2005: Drawing, same title. Gunpowder on paper, 400 x
600 cm. Collection of the artist

2005: *Flag*. Gunpowder on paper, mounted on wood, two
panels, 154 x 230 cm overall. Private collection

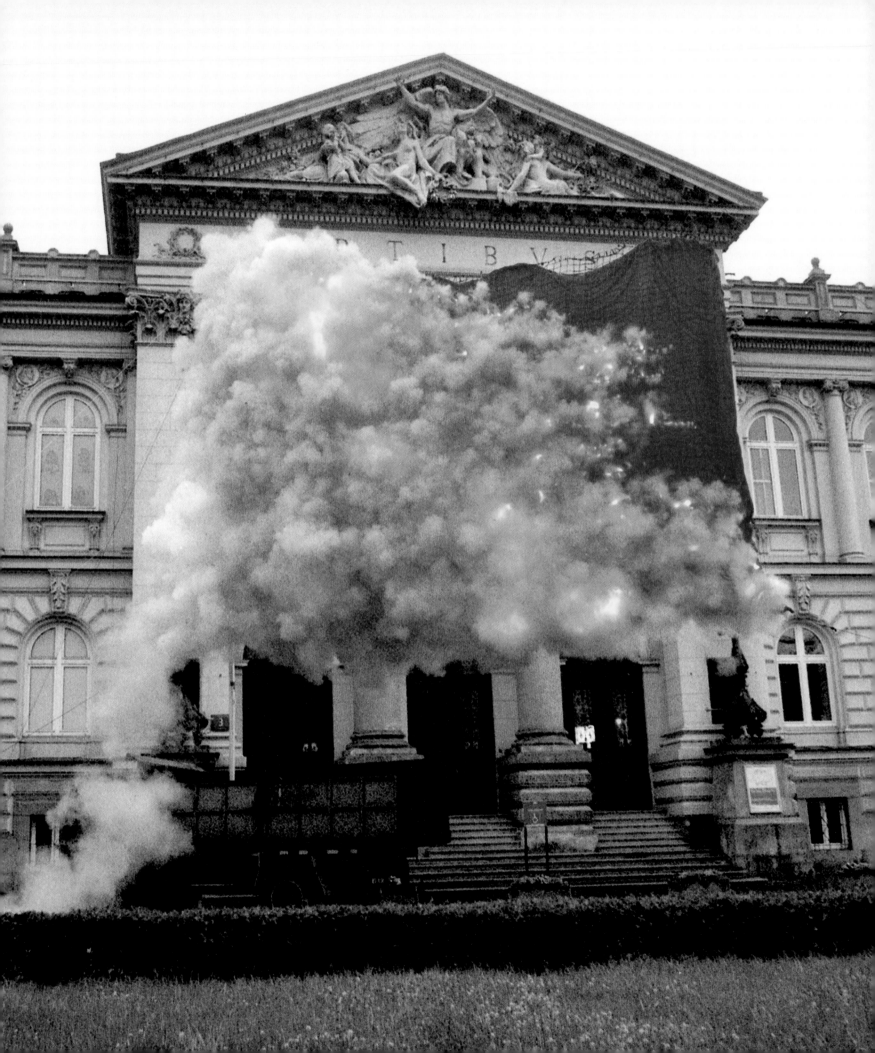

**TORNADO: EXPLOSION PROJECT FOR
THE FESTIVAL OF CHINA**
龙卷风: 为华盛顿中国文化节作的爆破计划
2005

REALIZED AT **POTOMAC RIVER, WASHINGTON, D.C.,
OCTOBER 1, 2005, 7 MINUTES.** *DANCING BOATS*:
NINE BOATS AND 30MM CAKE FIREWORKS; *TORNADO*:
2,030 3-INCH PIXELBURST SHELLS. COMMISSIONED BY
THE JOHN F. KENNEDY CENTER FOR THE PERFORMING
ARTS FOR *THE KENNEDY CENTER FESTIVAL OF CHINA*

Cai was commissioned to create this explosion
event to celebrate the first *Kennedy Center
Festival of China*, organized in conjunction with
China's Ministry of Culture to honor the country's
rich cultural history. The Chinese word for tornado,
longjuanfeng, literally means "dragon swirling
wind." The artist used the tornado-dragon analogy
as a metaphor for China's rapid rise as an eco-
nomic, political, and cultural power in the twenty-
first century. The dragon is a recurring motif in
Cai's oeuvre and serves as a multilayered emblem
within Chinese culture. Concomitant with China's
position as a major player on the world stage,
it can be interpreted as symbolizing national
power. The explosion event began with a prelude,

Dancing Boats, during which nine motorboats
executed a delicate choreography of movement
and multicolored pyrotechnics along the Potomac.
Tornado, which was the main part of the explosion
event, immediately followed and was composed
of three successive white tornado renderings over
the Potomac executed with precision through the
aid of computer microchips inserted into each
shell. The first iteration appeared as a rapid fire
drawing on the night sky, followed by two con-
secutive tornados illuminated in full, each spiral-
ing down to the river's surface. Residual smoke
from the shells echoed the illusion that a twister
was touching down on the earth. *Tornado*'s vibrant
silhouette was juxtaposed with the iconic form of
the Washington Monument in the background.
—MY

EXHIBITION HISTORY
2005: *The Kennedy Center Festival of China*, John F.
Kennedy Center for the Performing Arts, Washington, D.C.

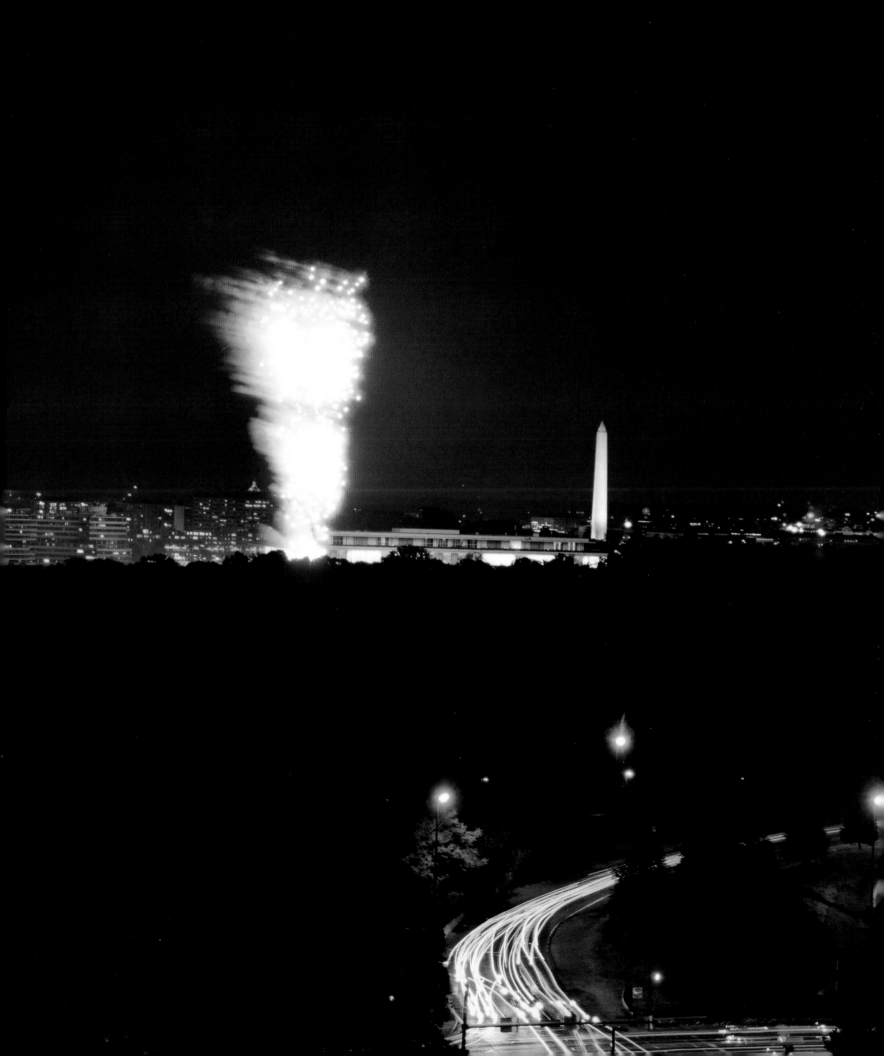

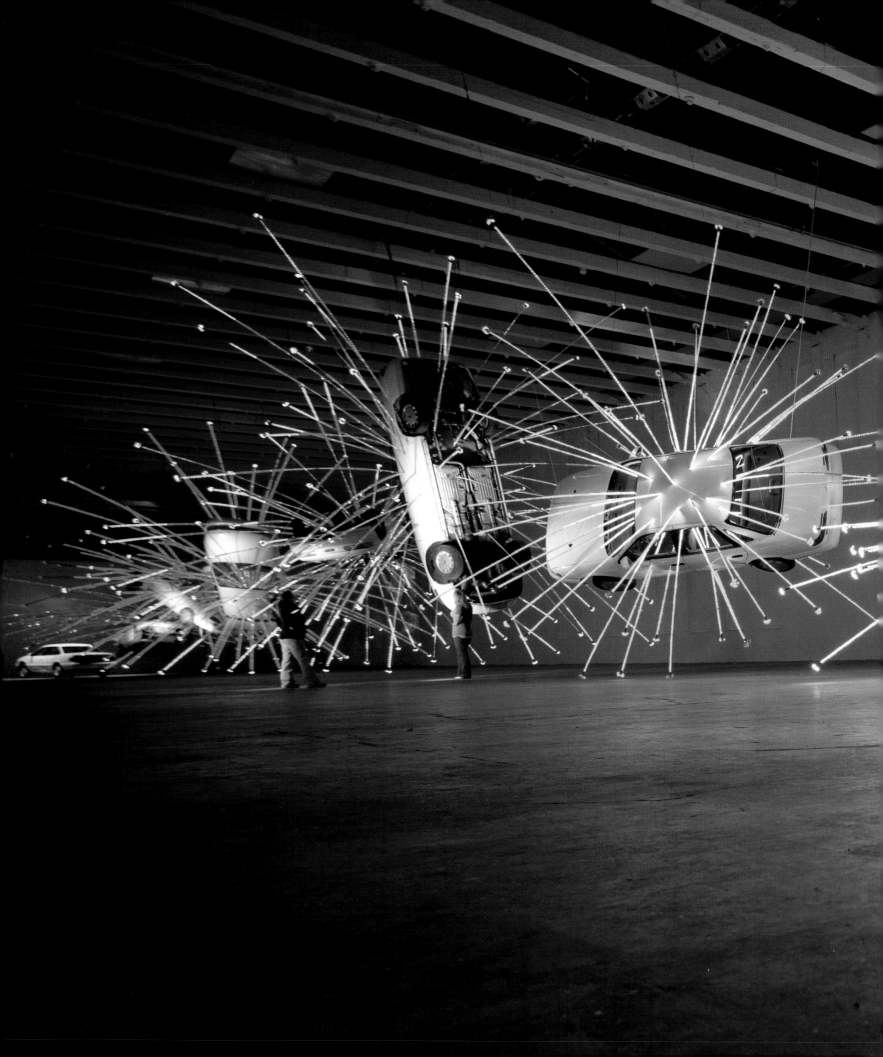

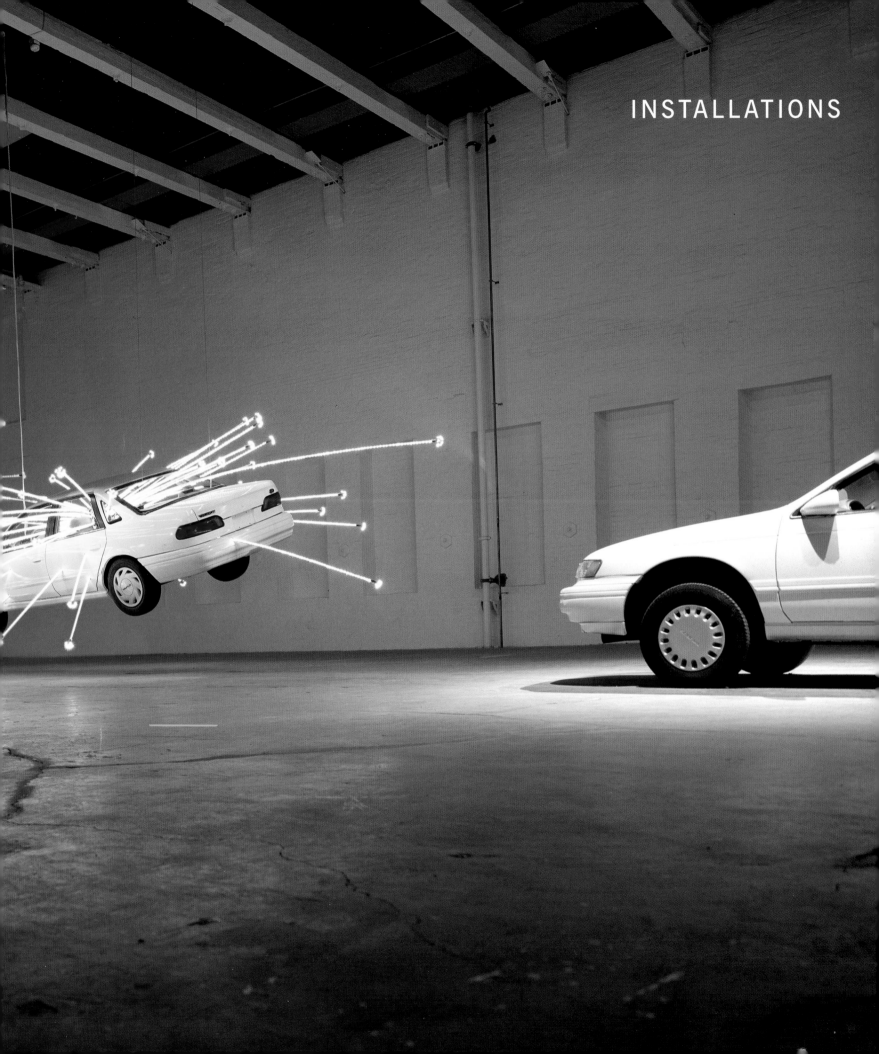

INSTALLATIONS

Cai Guo-Qiang's varied art arises directly from his multidisciplinary training. His early studies in stage design have influenced his approach to installations, instilling them with particular temporal and spatial dynamism and performance sensibility. As with stage sets, the installations present scenes temporarily inhabited by "performers" (the players in the scenes and also visitors) that are transformed by their journey through Cai's meticulously choreographed installations. The transformation is similar to that following certain rites of passage and cleansing, where a ceremonial performance marks a change in status. For Cai, these transformative events and processes are a basic condition of life.

With each installation, the artist responds to the conditions and significance of the given location. In some occasions, Cai applies the principles of feng shui to transform the site and uniquely arranges the composition of objects in space. Feng shui engages hidden energy flows among the features of a place, or the directional conditions of a given space, and through its practice Cai connects not only the different scenes to one another but also the whole installation back to the earth, achieving what he calls "a beneficial energy field."

Cai often collaborates with volunteers who operate outside the contemporary art world for the production and implementation of his artwork, thus bringing a dimension of social context into the realm of international art making. For *Reflection—A Gift from Iwaki* (2004, cat. no. 44), the local residents of Iwaki who originally excavated the sunken ship are the only authorized workers to install it. In *Venice's Rent Collection Courtyard* (1999, cat. no. 42), Chinese artists trained in official socialist-realist sculpture were invited to Venice to replicate the iconic Cultural Revolution sculptural tableau and fashion the clay sculptures on site during and after the exhibition's opening, allowing for visitors' interaction with the academic sculptors who had never been exposed to international contemporary art events.

Presenting scenes that are played by mythiclike characters, Cai's installations posit unresolved conflicts. Polemic approaches and politically charged issues, such as conjuring the now-destroyed Berlin Wall in *Head On* (2006, cat. no. 47), presenting the horrific explosion of a car

bomb through a spectacular play of light and color in *Inopportune: Stage One* (2004, cat. no. 45), or embellishing the killing of tigers in *Inopportune: Stage Two* (2004, cat. no. 46), are restaged so that their contradictions are made evident and open for public discussion and reflection.

If troubling social and political themes underpin the installations, the forms Cai gives the players in the scenes allow for flexible interpretations. His use of live animals, such as snakes, crabs, and fish, also symbolizes the universal condition of humanity's distancing from nature. Life-size replicas of tigers and wolves, excavated boats, paper lanterns, and sheepskin floats all have traditional associations in Chinese society, but in a contemporary art context they open up to western interpretations.

Cai's installations expand spatially and temporally simultaneously. Spatially, the display of elements floating in space gives a sense of antigravity and other-worldliness. Similar to unfolding Chinese handscroll paintings, the installations unfold as Cai composes a series of static scenes that imply movement when placed in a linear sequence, as in *Inopportune: Stage One* and *Inopportune: Stage Two*.

Temporally, while the visitor navigates the installations' apparent linear flow, elements of the journey trigger the intrusion of different times and memories of past experiences. For Cai, this experience of the coexistence of present and past replicates a comprehensive life experience. For example, in a journey through Cai's artistic life in *An Arbitrary History: River* (2001, cat. no. 43), the visitor is invited to board a vernacular Tibetan raft and float down a serpentine river while observing the artist's own retrospective freely suspended overhead. *An Arbitrary History: River* produces in the visitor a stir of primeval memories of the passage through life.

Cai's installations are a participatory space where the visitor is subjugated to a confluence of contradictory feelings. They attempt to connect the visitor with impulses (or struggles) of creation and destruction, to instability, through scenes of controlled violence. However, since energy cannot be created or destroyed, only transformed, the installations are ultimately manifestations of liberating transformations through the staging of violent beauty.

—MÓNICA RAMÍREZ-MONTAGUT

PRIMEVAL FIREBALL:
THE PROJECT FOR PROJECTS
原初火球: 为计划作的计划
1991

FIRST REALIZED **FEBRUARY 1991 AT P3 ART AND
ENVIRONMENT, TOKYO,** FOR THE EXHIBITION *PRIMEVAL
FIREBALL: THE PROJECT FOR PROJECTS.* INSTALLATION
INCORPORATING SEVEN GUNPOWDER DRAWINGS
(SEE LIST BELOW). VARIOUS COLLECTIONS (SEE LIST)

Primeval Fireball: The Project for Projects was
one of Cai's earliest installations. This work
emphasizes the direct physical and conceptual
correlation between the artist's gunpowder draw-
ings and his explosion events and installations. It
is also a significant example of Cai's unique prac-
tice of appropriating his own work as material for
subsequent projects and of his versatile use of
multidisciplinary ideas across mediums. Created
in close collaboration with Serizawa Takashi,
founding director of the Tokyo-based gallery P3 art
and environment, all of the seven folding-screen
gunpowder drawings that compose this installa-
tion were created in 1991. Six of them are culled
from the *Projects for Humankind* and *Projects
for Extraterrestrials* series: *A Certain Lunar
Eclipse: Project for Humankind No. 2* (cat.
no. 8), *Inverted Pyramid on the Moon: Project
for Humankind No. 3* (cat. no. 11), *Bigfoot's
Footprints: Project for Extraterrestrials No. 6*
(cat. no. 9), *Rebuilding the Berlin Wall:
Project for Extraterrestrials No. 7, Reviving the
Ancient Signal Towers: Project for Extraterrestrials
No. 8,* and *Fetus Movement II: Project for
Extraterrestrials No. 9* (cat. no. 10). The seventh
is *The Vague Border at the Edge of Time/Space
Project* (cat. no. 12). Each of these drawings was
primarily intended as a proposal to garner interest
and funding in order to realize an explosion event.
The artist thinks of such drawings, which often
include inscriptions in Chinese characters, as his
"big-character posters," alluding to a form of com-
munication and propaganda prevalent in China
that he would have particularly become aware of

during the Cultural Revolution. Each of the seven
folding screens is installed as if metaphorically
expanding and contracting from the epicenter of
an explosion. Conceptually the title's wording "pri-
meval fireball" refers to the big bang. "Project for
projects" signifies the unlimited potential of
the imagination. —MICHELLE YUN

WORKS PRESENTED AS INSTALLATION COMPONENTS
1991: *A Certain Lunar Eclipse: Project for Humankind
No. 2* (cat. no. 8)
1991: *Inverted Pyramid on the Moon: Project for
Humankind No. 3* (cat. no. 11)
1991: *Bigfoot's Footprints: Project for Extraterrestrials
No. 6* (cat. no. 9)
1991: *Rebuilding the Berlin Wall: Project for
Extraterrestrials No. 7.* Gunpowder on paper, mounted
on wood as seven-panel folding screen, 200 x 595 cm
overall. Collection of Angela and Massimo Lauro, Naples
1991: *Reviving the Ancient Signal Towers: Project for
Extraterrestrials No. 8.* Gunpowder and ink on paper,
mounted on wood as eight-panel folding screen, 200 x
680 cm overall. Museum of Contemporary Art, Tokyo
1991: *Fetus Movement II: Project for Extraterrestrials
No. 9* (cat. no. 10)
1991: *The Vague Border at the Edge of Time/Space
Project* (cat. no. 12)

EXHIBITION HISTORY
1991: *Primeval Fireball: The Project for Projects,* P3 art
and environment, Tokyo
1993: *Cai Guo-Qiang,* Naoshima Contemporary Art Museum
(now Benesse House)
2000: *Cai Guo-Qiang,* Fondation Cartier pour l'art
contemporain, Paris

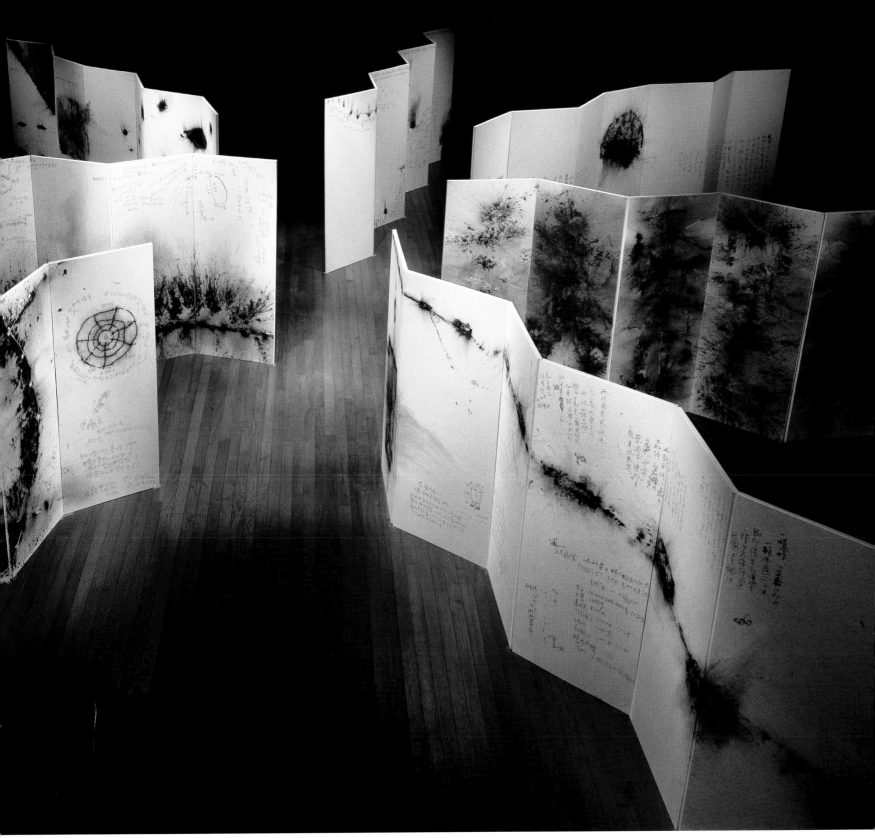

INSTALLATION VIEW AT P3 ART AND ENVIRONMENT, TOKYO, 1991

SAN JŌ TOWER
三丈塔
1994

REALIZED **MARCH 1994 AT IWAKI CITY ART MUSEUM,**
FUKUSHIMA, FOR THE EXHIBITION *CAI GUO-QIANG:*
FROM THE PAN-PACIFIC. SALVAGED WOOD FROM
SUNKEN BOAT, DIMENSIONS VARIABLE. THE DAKIS
JOANNOU COLLECTION, ATHENS

An early example of Cai's practice of appropriating
local found materials for his site-specific installa-
tions, this installation is one of the works he
created while living in the port city of Iwaki in
northeastern Japan. It is constructed of three sep-
arate tiers of a tower, or pagoda, structure. Each
tier is fabricated from refurbished wood from the
exterior of an excavated boat, dredged from an
Iwaki beach. The skeleton of this vessel was used
in *Kaikō—The Keel (Returning Light—The Dragon*
Bone), also created in 1994 for the exhibition
Cai Guo-Qiang: From the Pan-Pacific at the Iwaki
City Art Museum. The inspiration, building, and
initial installation of *San Jō Tower* were realized
with the assistance of Iwaki residents, beginning
a long-term collaborative endeavor that most
recently produced *Reflection—A Gift from Iwaki*

(2004, cat. no. 44). Cai implemented the tower
imagery as a protective amulet, alluding to the
city's historical need for a beacon to guide ships
coming into port. *San Jō Tower* is unique within
the artist's oeuvre in that it subsequently has
existed in two variations. The work was installed,
under the title *The Orient (San Jō Tower)*, at the
Museum of Contemporary Art, Tokyo, in 1995. In
this second configuration, the three tiers—formerly
placed separately on the ground—were stacked on
top of each other, and seismographic meters were
placed on all four sides of the tower to record the
frequent seismic vibrations in Tokyo. It was
installed at the 1997 Venice Biennale under yet
another name, *The Dragon Has Arrived!*, in a third
configuration. This time the tower was trans-
formed into a rocket by the addition of Mainland
Chinese flags, lights, and electric fans, symboli-
cally launching China into the future. —MY

RELATED WORKS (OTHER CONFIGURATIONS)

1995: *The Orient (San Jō Tower)*. Salvaged wood from a
sunken boat, seismographic meters, and soil. The Dakis
Joannou Collection, Athens
1997: *The Dragon Has Arrived!* Salvaged wood from a
sunken boat, Chinese flags, electric fan, and lights.
The Dakis Joannou Collection, Athens

EXHIBITION HISTORY

1994: *Cai Guo-Qiang: From the Pan-Pacific*, Iwaki City
Art Museum, Fukushima (as *San Jō Tower*)
1995: *Art in Japan Today 1985–1995*, Museum of
Contemporary Art, Tokyo (as *The Orient [San Jō Tower]*)
1997: *Future, Past, Present*, 47th Venice Biennale, Giardini
di Castelo, Arsenale, Venice (as *The Dragon Has Arrived!*)
1998: *Global Vision: New Art from the 90's Part II*, Deste
Foundation Centre for Contemporary Art, Athens (as *The
Dragon Has Arrived!*)
2000: *Outbound: Passages from the 90's*, Contemporary
Arts Museum, Houston (as *The Dragon Has Arrived!*)
2001–03: Installed as component of *An Arbitrary History:*
River (cat. no. 43) for *Cai Guo-Qiang: An Arbitrary History*
(traveling exhibition) (as *The Dragon Has Arrived!*)
2005: *Translation*, Palais de Tokyo, Paris (as *The Dragon*
Has Arrived!)

INSTALLATION VIEW AS *THE ORIENT (SAN JŌ TOWER)* AT
MUSEUM OF CONTEMPORARY ART, TOKYO, 1995

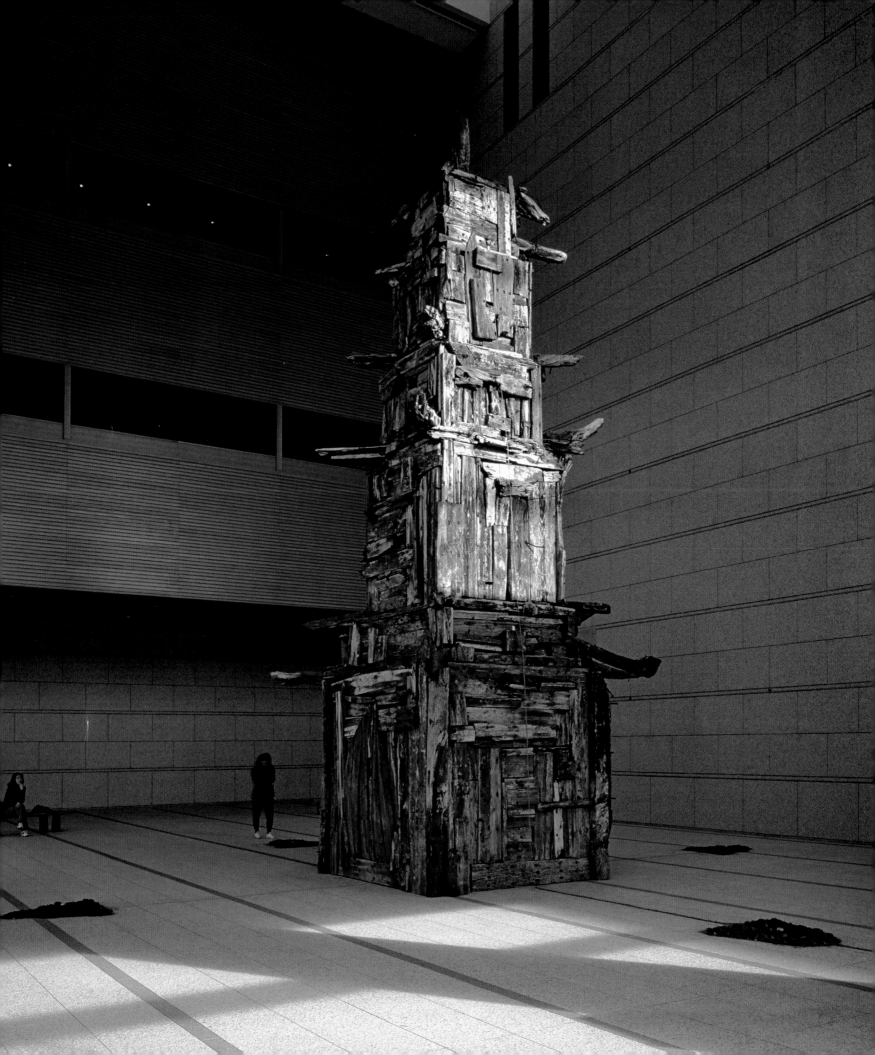

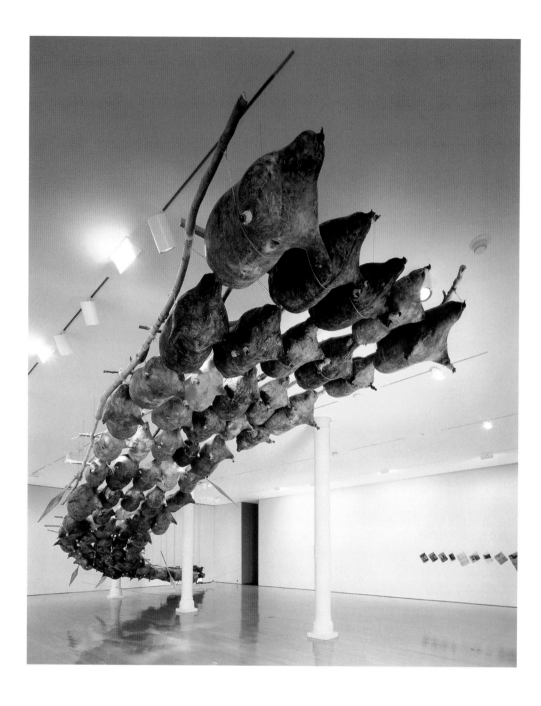

39

CRY DRAGON/CRY WOLF: THE ARK OF GENGHIS KHAN
龙来了！狼来了！成吉思汗的方舟
1996

FIRST REALIZED **NOVEMBER 1996 AT GUGGENHEIM MUSEUM SOHO, NEW YORK,** FOR THE EXHIBITION *HUGO BOSS PRIZE 1996.* 108 SHEEPSKIN BAGS, WOODEN BRANCHES, PADDLES, ROPE, THREE TOYOTA ENGINES, AND PHOTOCOPIES OF VARIOUS MAGAZINE COVERS AND ARTICLE CLIPPINGS, DIMENSIONS VARIABLE. SOLOMON R. GUGGENHEIM MUSEUM, NEW YORK, PURCHASED WITH FUNDS CONTRIBUTED BY THE INTERNATIONAL DIRECTOR'S COUNCIL AND EXECUTIVE COMMITTEE MEMBERS: ELI BROAD, ELAINE TERNER COOPER, BEAT CURTI, RONNIE HEYMAN, J. TOMILSON HILL, DAKIS JOANNOU, BARBARA LANE, ROBERT MNUCHIN, PETER NORTON, THOMAS WALTHER, AND GINNY WILLIAMS, WITH ADDITIONAL FUNDS CONTRIBUTED BY PETER LITTMANN 97.4523

When it was included in the inaugural Hugo Boss Prize exhibition in 1996, *Cry Dragon/Cry Wolf: The Ark of Genghis Khan* was the first major introduction of Cai's work to New York. The artist has often used allegory as a point of entry to raise larger issues for consideration, and for this installation, Genghis Khan's reputation as a skillful warrior and conqueror of Eurasia was adroitly appropriated alongside the cautionary tale of "The Boy Who Cried Wolf" to address Western fears of Asian dominance. Asia's expansionism—an actuality in terms of the region's growing economic power—is pointedly, and humorously, emphasized through the artist's choice of symbolically loaded materials. The installation descends from the ceiling in the form of a dragon, formed from large branches affixed with inflated sheepskin bags, which were traditionally used by ancient Mongol warriors alternately to hold drinking water and, when inflated, to use in constructing rafts for crossing rivers. At the lower end of the installation, three Toyota engines remain running, signifying the power of Japanese automobile companies to overtake United States automakers. An earlier version, *The Ark of Genghis Khan,* was realized in 1996 for a group exhibition that originated at the Nagoya City Art Museum, which is located near the city of Toyota, where the automaker has its headquarters. As part of the installation, the ephemera that line the gallery wall document the mutual dependence—characterized by attraction and repulsion—between East and West in the era

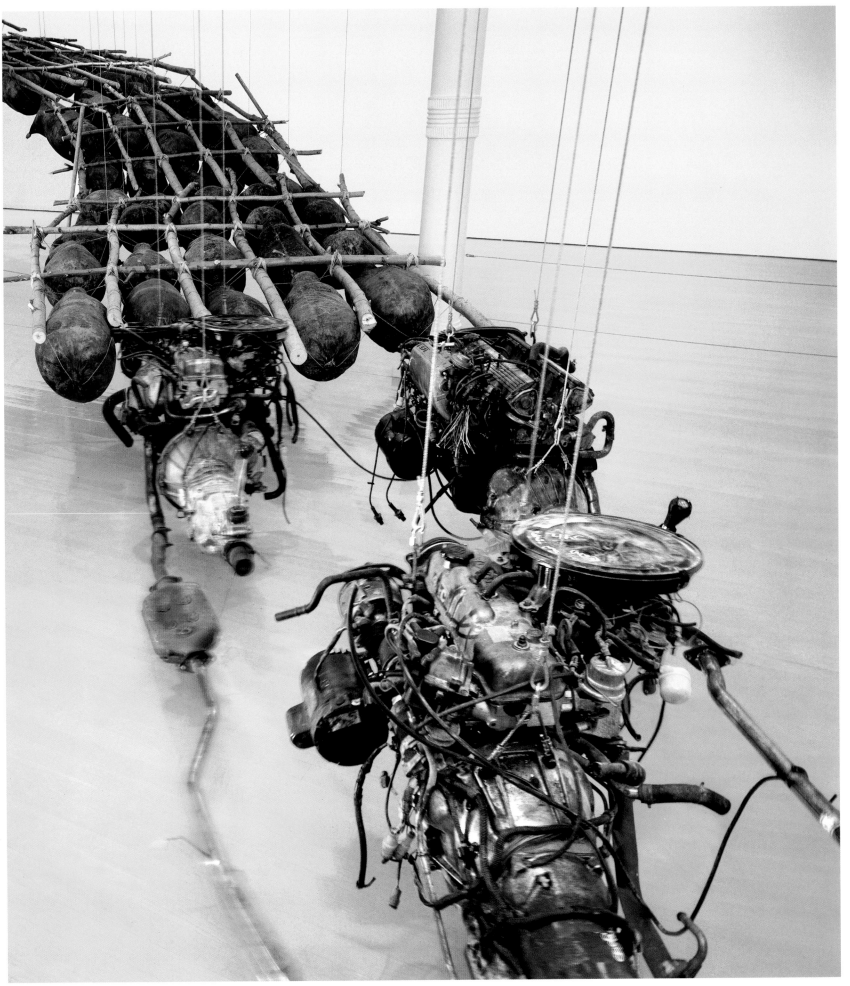

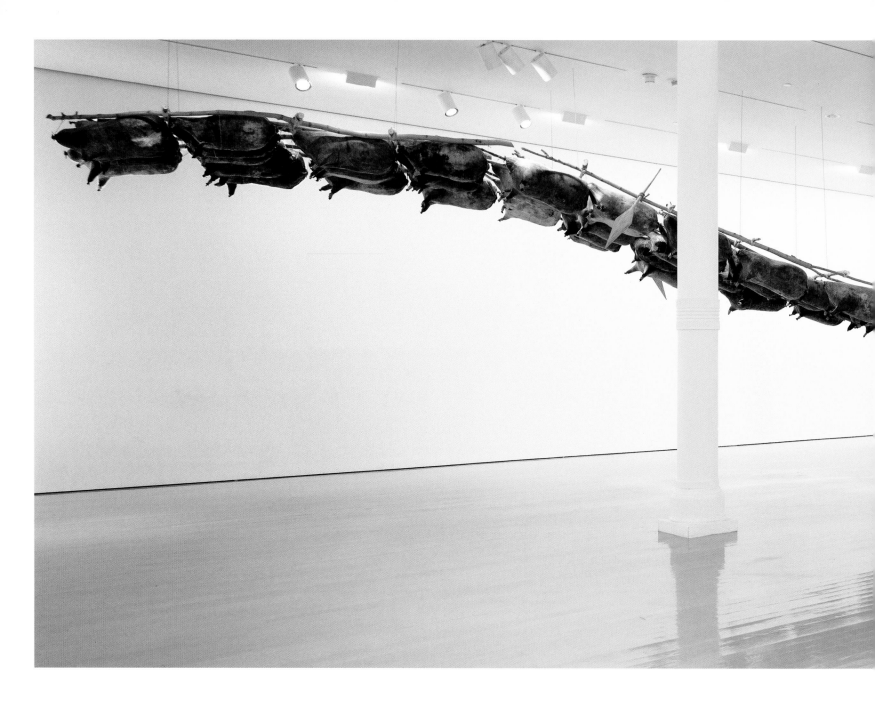

of globalization. The Guggenheim administered the Hugo Boss Prize and exhibited Cai and the other short-listed artists at the Guggenheim Museum SoHo, an occasion marked by the earliest of the artist's large-scale installations to be exhibited in a Western museum. —MY

EXHIBITION HISTORY

1996: *The Hugo Boss Prize 1996*, Guggenheim Museum SoHo, New York

1998: *Crossings*, National Gallery of Canada, Ottawa

1999: *International Currents in Contemporary Art*, Guggenheim Museum Bilbao

RELATED WORKS

1996: *The Ark of Genghis Khan*. Sheepskin bags, Toyota engines, gasoline, stainless steel, iron frame, and facsimiles of various magazine covers and article clippings,

dimensions variable. Commissioned for the exhibition *Between Earth and the Heavens: Aspects of Contemporary Japanese Art II* (traveling exhibition). Artwork not extant

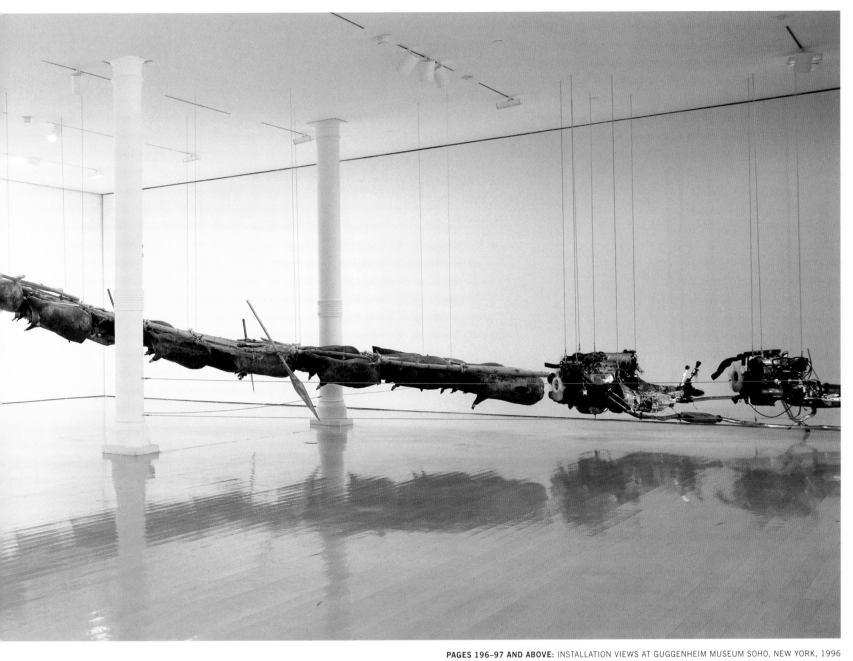

CULTURAL MELTING BATH: PROJECT FOR THE 20TH CENTURY
文化大混浴: 为二十世纪作的计划
1997

FIRST REALIZED **AUGUST 1997 AT QUEENS MUSEUM OF ART, NEW YORK,** FOR THE *EXHIBITION CAI GUO-QIANG: CULTURAL MELTING BATH: PROJECTS FOR THE 20TH CENTURY*. 18 TAIHU ROCKS, HOT TUB WITH HYDROTHERAPY JETS, BATHWATER INFUSED WITH HERBS, BANYAN TREE ROOT, TRANSLUCENT FABRIC, AND LIVE BIRDS, DIMENSIONS VARIABLE. COLLECTION DU MUSÉE D'ART CONTEMPORAIN DE LYON

The ritual of bathing is an ancient and universal custom for healing and purification. In East Asia, public bathing has remained an integral aspect of communal and social interaction. Cai evoked these cultural references by incorporating principles of Chinese medicine and feng shui through the strategic layout and interactivity of this participatory installation. Originally created for a New York audience at the Queens Museum of Art—as part of Cai's first solo exhibition in the United States—*Cultural Melting Bath: Project for the 20th Century* also re-creates a Chinese scholar's garden, a frequent subject of Chinese poetry and painting. A prominent aspect of such gardens is the presence of spirit stones (also known as scholar's rocks), limestone formations traditionally collected from Lake Tai, near Suzhou, Jiangsu Province. These fantastically shaped rocks reminiscent of animals or mystical creatures are deliberately placed according to feng shui principals to maximize the flow of qi (energy) throughout the garden. By transferring these features

INSTALLATION VIEW AT QUEENS MUSEUM OF ART, NEW YORK, 1997

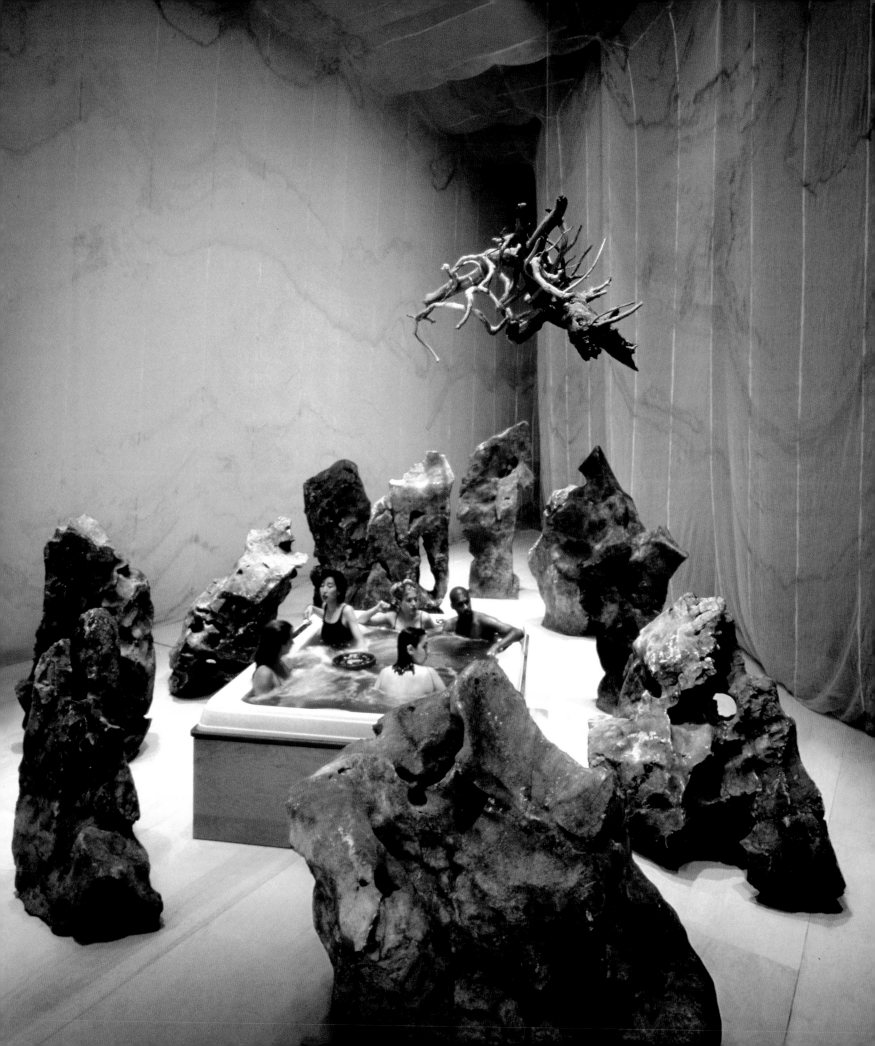

FIG. 70. HERBAL INFUSION USED FOR INSTALLATION OF *CULTURAL MELTING BATH: PROJECT FOR THE 20TH CENTURY* (1998) AT BENESSE HOUSE, NAOSHIMA

into the contemporary art arena, Cai conflated nature and culture, tradition and the avant-garde. For this installation, the artist arranged imported Taihu (Lake Tai) rocks in consultation with a feng shui master to promote the maximum flow of qi within the space. Visitors in Queens were invited to bathe in an American-made hot tub equipped with hydrotherapy jets. The bathwater was infused with a prescription of traditional Chinese medicinal herbs—prescribed by a doctor from the artist's hometown of Quanzhou—meant to promote skin health and relaxation. Live birds perched in the Banyan tree roots that were suspended overhead, and the entire installation was enclosed under translucent mosquito netting. The artist playfully borrowed the idea of New York as a cultural melting pot by literally inviting visitors to bathe together, and by providing a forum

for social interaction. This work was subsequently exhibited in other museums in the United States and France, where the first version is now in the collection of the Musée d'Art Contemporain de Lyon. A permanent version has been placed outdoors as a site-specific installation at Benesse House on the Japanese island of Naoshima, where it remains a popular bathing and meeting spot (figs. 70 and 71). —MY

EXHIBITION HISTORY

1997: Cai Guo Qiang: *Cultural Melting Bath: Projects for the 20th Century*, Queens Museum of Art, New York
2000: *Sharing Exoticisms. 5th Lyon Biennale d'Art Contemporain*, Musée d'Art Contemporain de Lyon
2003: *Somewhere Better Than This Place*, Contemporary Arts Center, Cincinnati

RELATED WORKS

1998: Permanent outdoor installation (figs. 70 and 71)

FIG. 71. *CULTURAL MELTING BATH: PROJECT FOR THE 20TH CENTURY*, 1998. 36 TAIHU ROCKS, HOT TUB WITH HYDROTHERAPY JETS, AND BATHWATER INFUSED WITH HERBS. PERMANENT OUTDOOR INSTALLATION AT BENESSE HOUSE (FORMERLY NAOSHIMA CONTEMPORARY ART MUSEUM), BENESSE ART SITE, NAOSHIMA. COLLECTION OF BENESSE CORPORATION

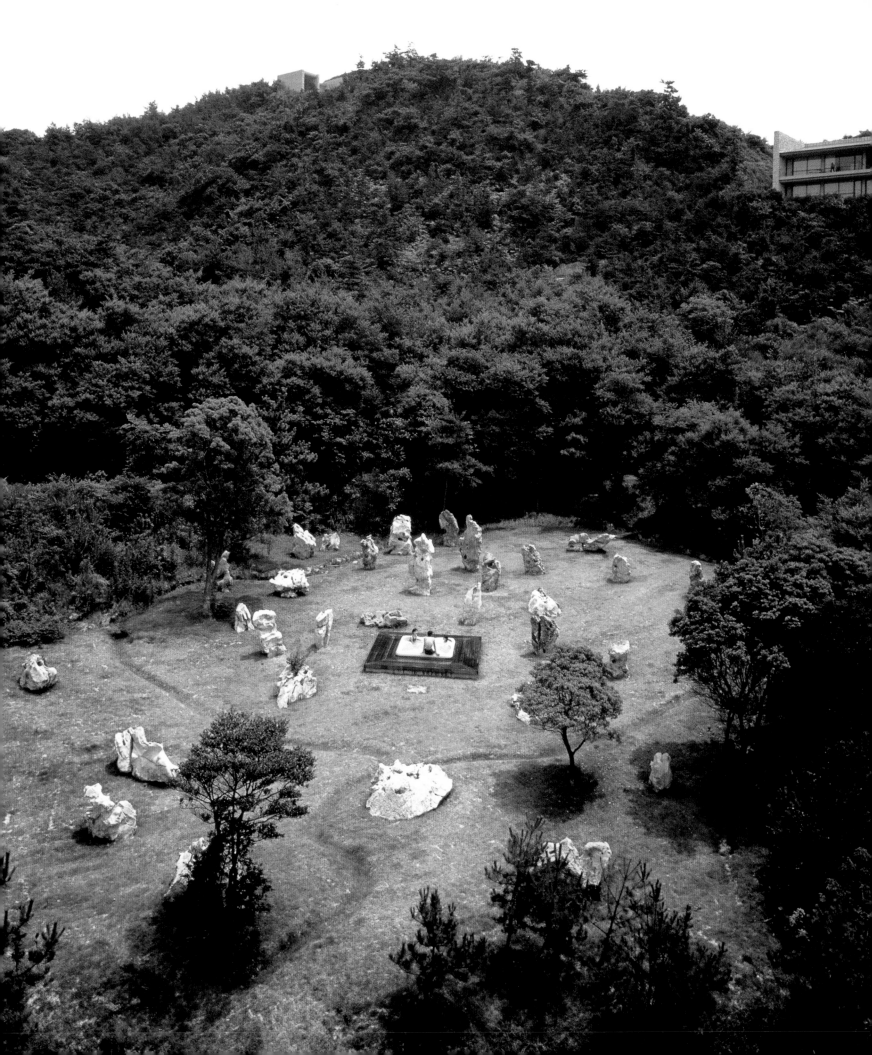

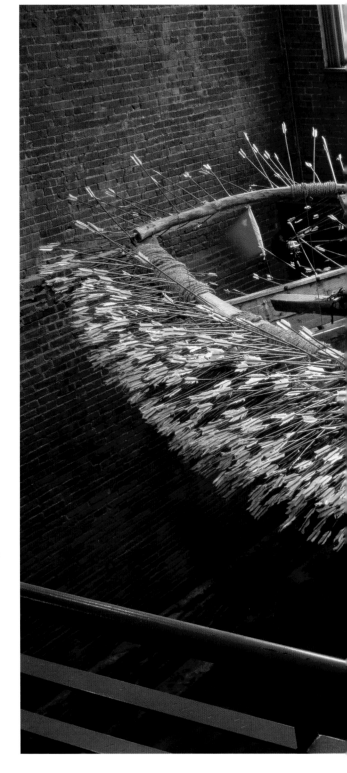

41
BORROWING YOUR ENEMY'S ARROWS
草船借箭
1998

FIRST REALIZED **SEPTEMBER 1998 AT P.S.1**
CONTEMPORARY ART CENTER, NEW YORK, FOR THE
EXHIBITION *INSIDE OUT: NEW CHINESE ART*. WOODEN
BOAT, CANVAS SAIL, ARROWS, METAL, ROPE, CHINESE
FLAG, AND ELECTRIC FAN, BOAT APPROXIMATELY
152.4 X 720 X 230 CM; ARROWS APPROXIMATELY 62 CM
EACH. THE MUSEUM OF MODERN ART, NEW YORK,
GIFT OF PATRICIA PHELPS DE CISNEROS IN HONOR OF
GLENN D. LOWRY (318.1999)

Borrowing Your Enemy's Arrows is composed of
an excavated fishing boat from Quanzhou. Its
outer surface is pierced with approximately 3,000
arrows. At the stern, a Chinese flag flutters in the
wind from an the electric fan mounted in front of
it. As the title *Borrowing Your Enemy's Arrows*
indicates, this work alludes to a legendary story
involving the Chinese general Zhuge Liang (181–
234)—a lesson on the importance of resourceful-
ness and strategy. For an impending battle, the
military strategist Zhou Yu challenged Zhuge to
produce 100,000 arrows in ten days or face capi-
tal punishment. Ingeniously, Zhuge took only three
days to meet the challenge. He ordered his men
to fill twenty boats with straw figures and just a
few soldiers hidden among them. The boats were
sent out in the darkness before dawn, so that the
enemy was unable to see what was actually going
on. Beating drums provided the noise of an attack,
and the enemy fired arrows that lodged in the
straw dummies, effectively giving Zhuge 100,000
"borrowed" arrows. Cai's installation examines
the dynamics of China's emergence as an interna-
tional leader in the late 1990s through what can
be seen as a tactical strategy of defeating its
opponents—the established world powers—with
their own strengths. The boat motif, which figures
frequently within the artist's visual iconography,
also references his childhood in the port city of
Quanzhou as well as his nomadic lifestyle as an
international artist. —MY

EXHIBITION HISTORY
1998–2000: *Inside Out: New Chinese Art* (traveling
exhibition)
2000: *Open Ends—MoMA 2000*, Museum of Modern Art,
New York
2003: *The Heroic Century: The Museum of Modern Art's
Masterpieces, 200 Paintings and Sculptures*, Museum of
Fine Arts, Houston

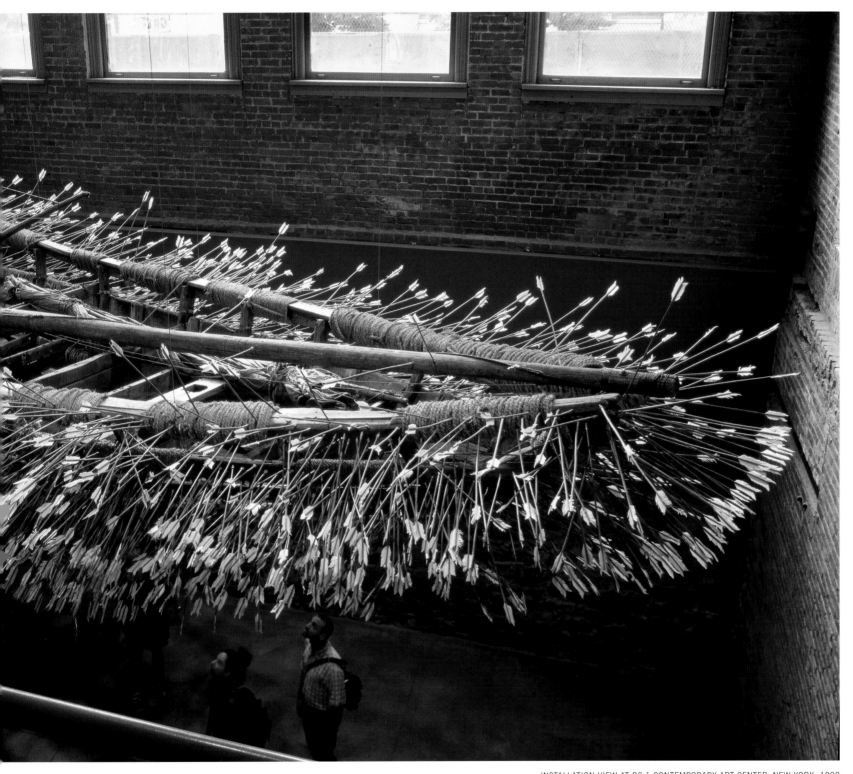

INSTALLATION VIEW AT P.S.1 CONTEMPORARY ART CENTER, NEW YORK, 1998

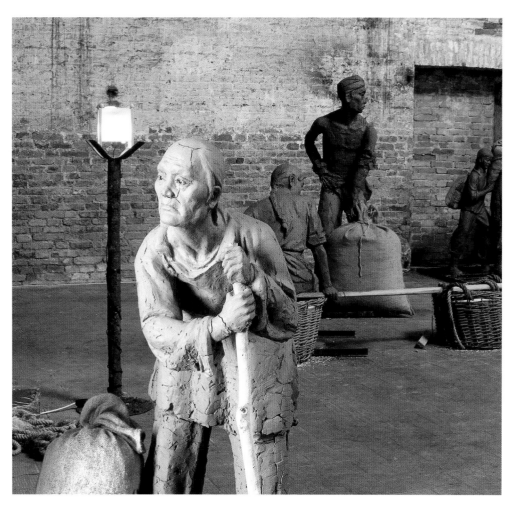

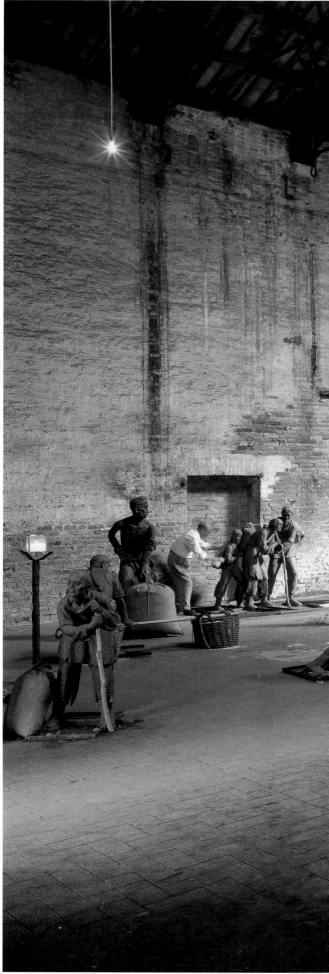

42

VENICE'S RENT COLLECTION
COURTYARD
威尼斯收租院
1999

REALIZED **JUNE 1999 AT DEPOSITO POLVERI,
ARSENALE, VENICE,** FOR *APERTO OVER ALL,
48TH VENICE BIENNALE.* 108 LIFE-SIZE SCULPTURES
CREATED ON SITE BY LONG XU LI AND NINE
GUEST ARTISAN SCULPTORS, 60 TONS OF CLAY, WIRE
AND WOOD ARMATURES, AND OTHER PROPS AND
TOOLS FOR SCULPTURE, FOUR SPINNING NIGHT
LAMPS, FACSIMILES PHOTOCOPIES OF DOCUMENTS
AND PHOTOGRAPHS RELATED TO *RENT COLLECTION
COURTYARD* (DATED 1965). ARTWORK NOT EXTANT.
COMMISSIONED BY VENICE BIENNALE

This installation only existed for the duration of
the *48th Venice Biennale*, for which it was
created. It was formally based on the iconic
socialist-realist sculpture *Rent Collection
Courtyard* (fig. 5), which had been created in
1965 by members of the Sichuan Fine Arts
Institute. The 1965 version, which still exists in
multiples located throughout China, is composed
of 114 life-size figures configured in a series of
tableaux depicting the mistreatment of peasants
at the hands of prerevolutionary landlords. In the
1960s, this sculpture was lauded by the central
government as a tribute to the great accomplish-
ments of Chinese communism. Actual copies
and photo reproductions detailing the sculpture
were distributed widely, and it became one of the
best-known propaganda works of the Cultural
Revolution. Cai appropriated this potent imagery

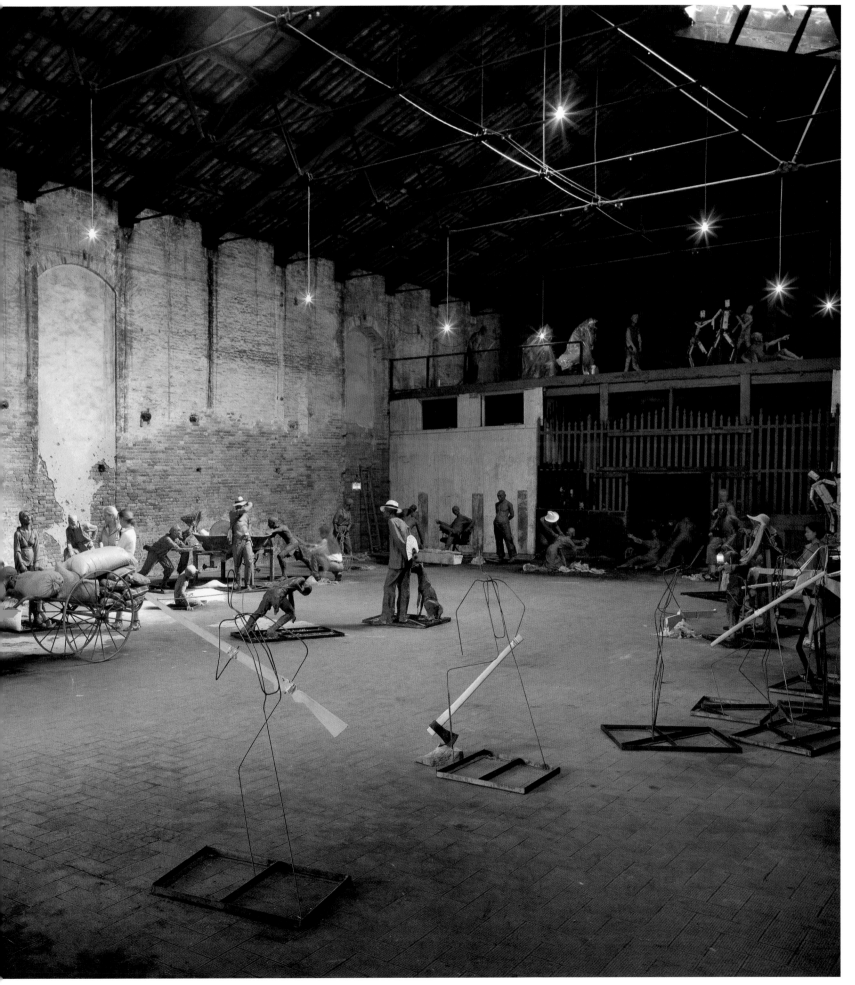

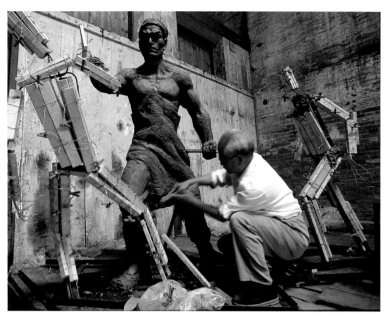

LONG XU LI WORKING ON SCULPTURE

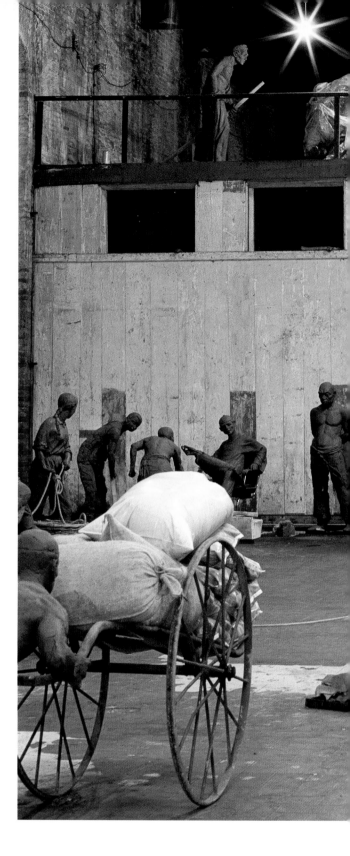

to illuminate the creative process and the inescapable effects of time. He also intended for his installation version to bring the tradition of figurative sculpture into the arena of contemporary art, while also commenting on the fate of art under the manipulation of political ideology. A crew of ten sculptors—including Long Xu Li, the only one to have worked on the original sculpture—re-created selected tableaux out of metal armatures, wood,

and clay. On the opening day of the biennale the installation in the Deposito Polveri of the Arsenale remained intentionally unfinished, and for the first week the artisans continued to work on the figures, in various states of completion, while visitors looked on. Unfired, the clay sculptures were left to slowly dry and disintegrate, and any remaining figures were destroyed after the close of the exhibition. Cai was awarded the biennale's Golden

Lion for this installation. The Chinese press subsequently raised the issue of appropriation and intellectual copyright and covered the political controversy raised by the widespread belief that Cai was attacking his homeland. A copyright infringement lawsuit against Cai and the Venice Biennale was filed in China by sculptors who participated in creating the original work, but the case was ultimately dismissed by the courts. —MY

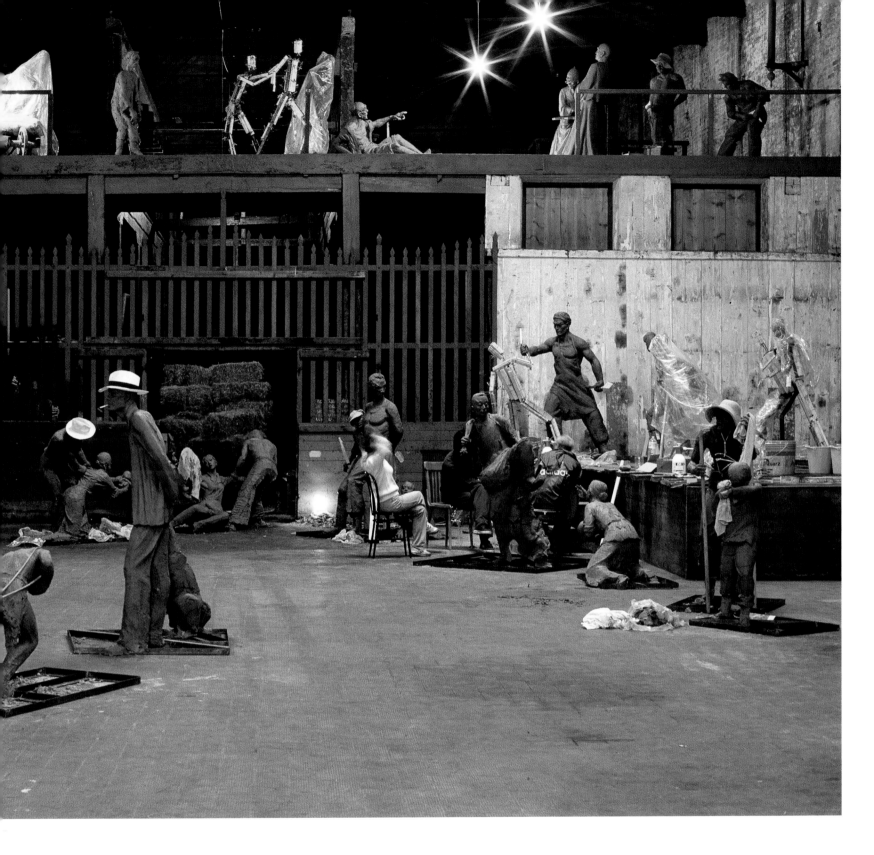

EXHIBITION HISTORY

1999: *Aperto Over All*, *48th Venice Biennale*, Arsenale, Venice

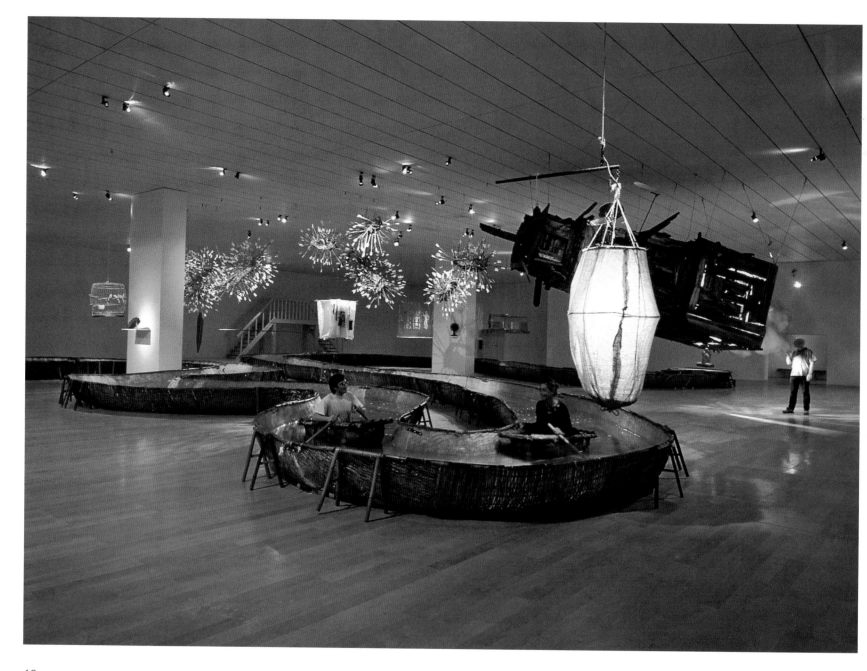

AN ARBITRARY HISTORY: RIVER
随意的历史: 河流
2001

FIRST REALIZED **OCTOBER 2001 AT MUSÉE D'ART CONTEMPORAIN DE LYON,** FOR THE EXHIBITION *CAI GUO-QIANG: AN ARBITRARY HISTORY*. INSTALLATION INCORPORATING RESIN AND BAMBOO RIVERBED, WATER, YAK SKIN, WOODEN BOATS, AND WORKS PRESENTED AS COMPONENTS (SEE LIST BELOW), DIMENSIONS VARIABLE. COLLECTION OF THE ARTIST (RIVERBED AND BOATS) AND VARIOUS COLLECTIONS (SEE LIST)

For this interactive installation Cai took on the role of curator, suspending a selection of past works from the ceiling above a resin and bamboo river-bed created to fit the specifications of a gallery space. Visitors were invited to view this whimsical "arbitrary history" by taking a boat ride on the river. Many of the reoccurring themes within the artist's oeuvre were highlighted within the preexisting works chosen to be components of *An Arbitrary History: River*. For example, both *Acupuncture for Venice* (1995) and *Moxacautery—For Africa* (1995) refer to the healing power of acupuncture to metaphorically cure social ills. In *The Age of Not Believing in God* (1999) wooden effigies of religious figures such as Jesus and the Avalokiteśvara (Guanyin) Bodhisattva are pierced with arrows, symbolizing the marginalization of world religions through modern society's preoccupations with science, materialism, and politics. Boats—important symbols in Cai's artistic vocabulary—are found in *Mao* (1997), a poetic rumination on his youthful romanticization of

Mao Zedong, and *The Dragon Has Arrived!* (1997), a dynamic transformation of a shipwreck into a rocket. When these and several other dispa-rate works were temporarily recontextualized within this installation, the relationship between them and the sites for which they were first made was questioned—especially given the continuing validity of the works in their new context. *An Arbitrary History: Roller Coaster* (2001, figs. 72 and 73) was a companion piece that addressed art history on a national level, with a mosaic of images culled from the host country's art history imprinted on a suspended fabric ceiling. A record-ing of Gustav Holst's "Jupiter, the Bringer of Jollity" was heard by visitors as they rode the roller coaster. —MY

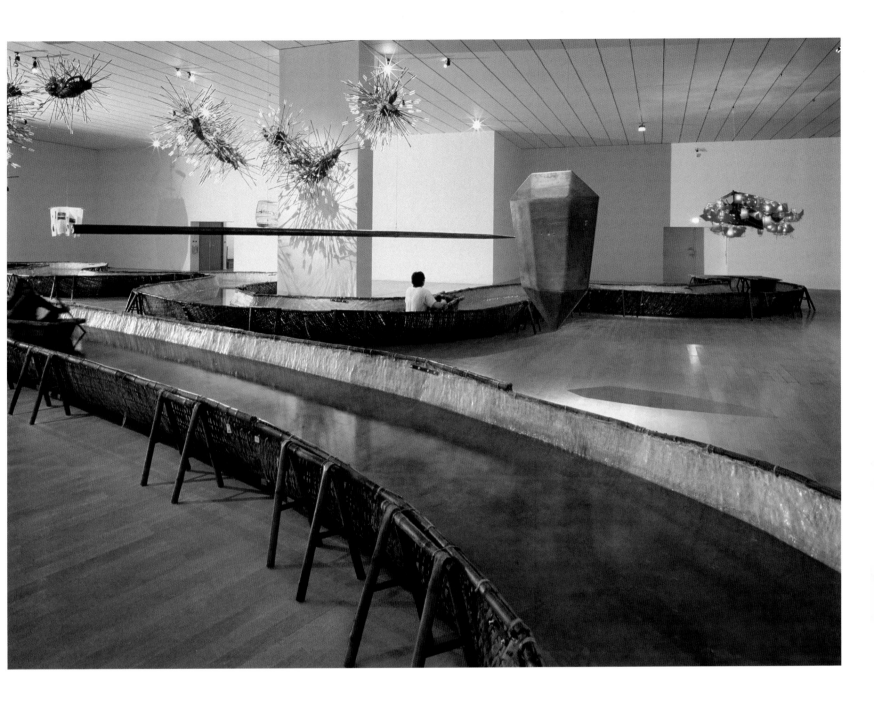

WORKS PRESENTED AS INSTALLATION COMPONENTS

1992: *Wailing Wall* (documentation). First realized October 1992 at IBM Kawasaki City Gallery for the exhibition *Cai Guo-Qiang: Wailing Wall—From the Engine of Four Hundred Cars*. Documentation images of *Wailing Wall— From the Engine of Four Hundred Cars* (1992), printed on cloth diapers, and hanging device, approximately 100 x 120 x 120 cm overall. Collection of the artist

1994: *Arms—Contradiction*. First realized in September 1994 at Hiroshima City Museum of Contemporary Art for the exhibition *Creativity in Asian Art Now*. Lead and wood, dimensions variable; wood approximately 361 x 4 cm; lead 152.4 x 99 x 6.3 cm. Collection of the artist

1995: *Acupuncture for Venice*. Plastic, decal, water, and acupuncture needles, dimensions variable; plastic 184.5 x 490.2 x 0.5 cm. Collection of Miani Johnson, New York

1995: *Moxacautery—For Africa*. First realized February 1995 at Electric Workshop, Johannesburg, for *The*

Ever-Changing, Drifting Heat: The First Johannesburg Biennale. Wooden sculptures, medicine, moxa, and statement of treatment, dimensions variable; sculptures length approximately 200 cm each. Collection of the artist

1995: *Snake Bag—Multiculture*. First realized February 1995 at Electric Workshop, Johannesburg, for *The Ever-Changing, Drifting Heat: The First Johannesburg Biennale*. Snakes, snakeskin, altered mirrors, light bulb, balance scale, photograph, hemp bag, and crane; approximately 150 x 100 cm overall. Collection of the artist

1997: *The Dragon Has Arrived!* (see cat. no. 38)

1997: *Mao*. First realized March 1997 at Louisiana Museum of Modern Art, Humlebaek, Denmark, for the exhibition *Cai Guo-Qiang: Flying Dragon in the Heavens*. Wooden boat, paper lanterns, stone dragons, electric lights, and poster of Andy Warhol's *Mao* (1972), dimensions variable. Collection of David Kowitz, London

1997: *Searching for Extraterrestrials*. First realized

March 1997 at Louisiana Museum of Modern Art, Humlebaek, for the exhibition *Cai Guo-Qiang: Flying Dragon in the Heavens*. Fan and kite, dimensions variable; fan diameter 40 cm; kite 45 x 40 cm irregular dimensions. Glory Fine Arts Museum, Hsinchu, Taiwan

1997: *Trap: Project for the 20th Century*. First realized August 1997 at Queens Museum of Art, New York, for the exhibition *Cai Guo-Qiang: Cultural Melting Bath, Projects for the 20th Century*. Wooden model of PT-109 boat, rattan bird cage, live birds, string, dimensions variable; model length 83.8 cm; cage 71.1 x 68.6 cm. Collection of Miyatsu Daisuke, Japan

1999: *The Age of Not Believing in God*. First realized November 1999 at Museum Ludwig Köln for the exhibition *Kunst-Welten im Dialog (Art-Worlds in Dialogue)*. Wooden sculptures and arrows (bronze heads, bamboo, and feather shaft), dimensions variable; sculptures: height 80–130 cm each. Museum Ludwig Köln

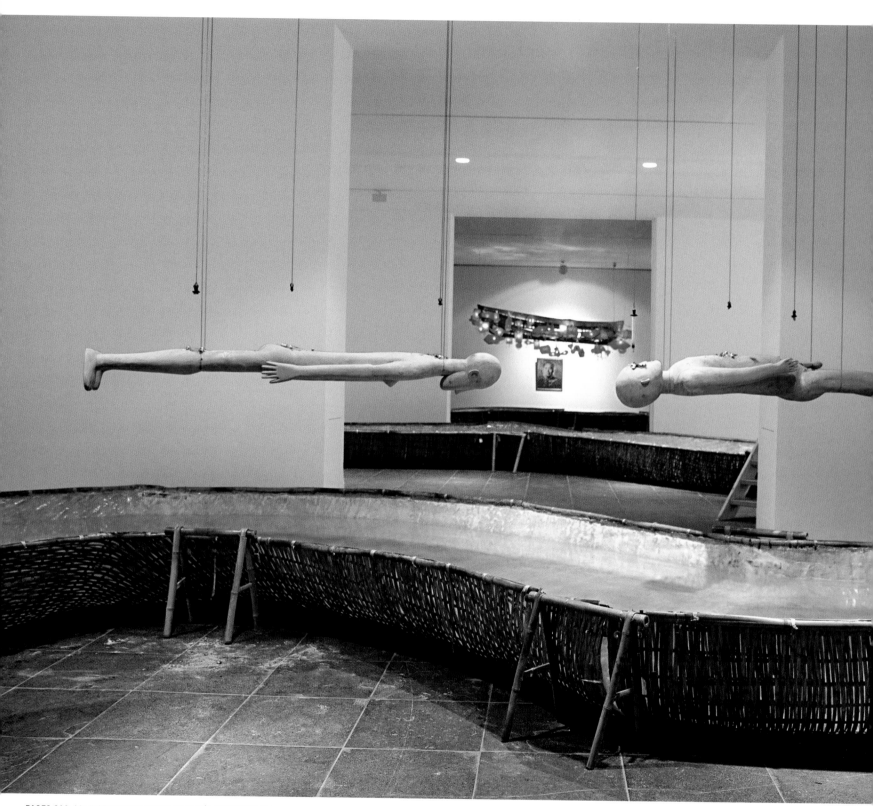

PAGES 210–11: INSTALLATION VIEWS AT MUSÉE D'ART CONTEMPORAIN DE LYON; **ABOVE:** INSTALLATION VIEW AT S.M.A.K.
(STEDELIJK MUSEUM VOOR ACTUELE KUNST), GHENT, 2003

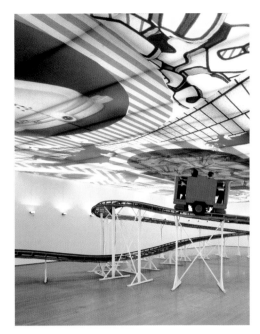

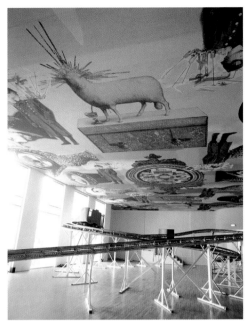

FIG. 72. *AN ARBITRARY HISTORY: ROLLER COASTER*, 2001. ROLLER COASTER, COUNTRY-SPECIFIC PRINTED-FABRIC CEILING, AND AUDIO RECORDING (GUSTAV HOLST, "JUPITER, THE BRINGER OF JOLLITY" FROM *THE PLANETS* [1914–16]), DIMENSIONS VARIABLE. COLLECTION DU MUSÉE D'ART CONTEMPORAIN DE LYON (ROLLER COASTER AND PRINTED FABRIC FOR FRANCE). INSTALLATION VIEW AT MUSÉE D'ART CONTEMPORAIN DE LYON, 2001

FIG. 73. *AN ARBITRARY HISTORY: ROLLER COASTER*, 2001. ROLLER COASTER, COUNTRY-SPECIFIC PRINTED-FABRIC CEILING, AND AUDIO RECORDING (GUSTAV HOLST, "JUPITER, THE BRINGER OF JOLLITY" FROM *THE PLANETS* [1914–16]), DIMENSIONS VARIABLE. COLLECTION DU MUSÉE D'ART CONTEMPORAIN DE LYON (ROLLER COASTER) AND COLLECTION OF THE ARTIST (PRINTED FABRIC FOR BELGIUM). INSTALLATION VIEW AT S.M.A.K., GHENT, 2003

2000: *Sky Bath*. First realized April 2000 at S.M.A.K. (Stedelijk Museum voor Actuele Kunst), Ghent, for the exhibition *Over the Edges*. Glass and stainless steel bathtub, water, fish, live model, and bamboo, 180 x 90 x 80 cm overall. Collection of the artist

EXHIBITION HISTORY

2001–03: *Cai Guo-Qiang: An Arbitrary History* (traveling exhibition)

RELATED WORKS

2001: *An Arbitrary History: Roller Coaster* (figs. 72 and 73)

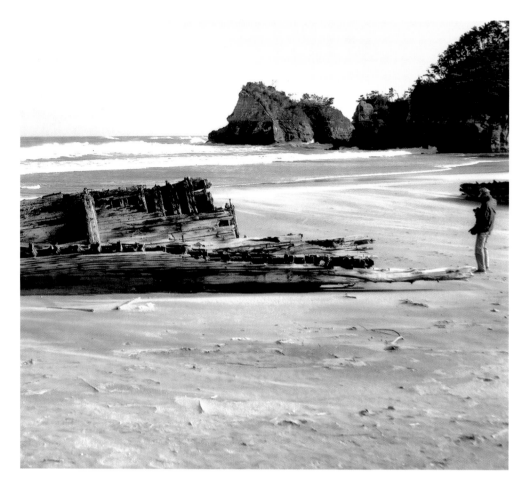

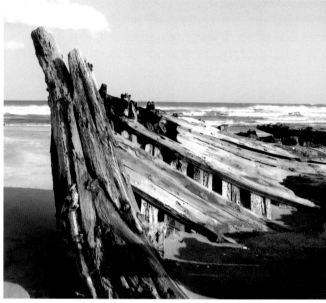

IWAKI EXCAVATION, 2004

REFLECTION—A GIFT FROM IWAKI
迴光——来自磐城的礼物
2004

FIRST REALIZED **OCTOBER 2004 AT ARTHUR M. SACKLER GALLERY, SMITHSONIAN INSTITUTION, WASHINGTON, D.C.,** FOR THE EXHIBITION *CAI GUO-QIANG: TRAVELER*. EXCAVATED WOODEN BOAT AND PORCELAIN, DIMENSIONS VARIABLE; BOAT 5 X 5.5 X 15 M. CASPAR H. SCHÜBBE COLLECTION

As its title suggests, *Reflection—A Gift from Iwaki* references Cai's ongoing collaborations with the residents of the Japanese seaport of Iwaki in Fukushima and is a testament to the possibility for rich cultural interactions across national and cultural boundaries. Cai, who grew up in the port city of Quanzhou, has frequently used boats as a metaphoric feature in his installation works. They figure prominently in two Iwaki projects from 1994, *Kaikō—The Keel (Returning Light—The Dragon Bone)* and *San Jō Tower* (cat. no. 38), both exhibited in that year at the Iwaki City Art Museum. *Reflection—A Gift from Iwaki* is a spare yet dramatic installation whose central feature is a 15 meter-long skeleton of a wrecked fishing vessel that Cai dredged from the beaches of Iwaki. A team of local volunteers was critical to this work from its inception to the final realization—a process documented in an accompanying video. For the installation, the boat's hull is filled with an enormous hoard of white porcelain statuettes of the popular Buddhist deity Avalokiteśvara (Guanyin), Bodhisattva of mercy. These figures were manufactured near Quanzhou in Dehua, a region famous for producing blanc-de-Chine porcelain for the Chinese export trade to Europe since the eighteenth century. The Avalokiteśvara Bodhisattva's likeness is objectified in the context of the history of cultural and commercial exchange between Asia and the West. The fact that many of the figures are broken also raises such issues as the commodification of spirituality. On another level, according to Cai, the installation represents historic ruins trapped under the sea—a silent sunken vessel containing broken porcelain—whose states of decomposition reflect the destructive power of time and the inherent beauty brought out by its passage. —MY

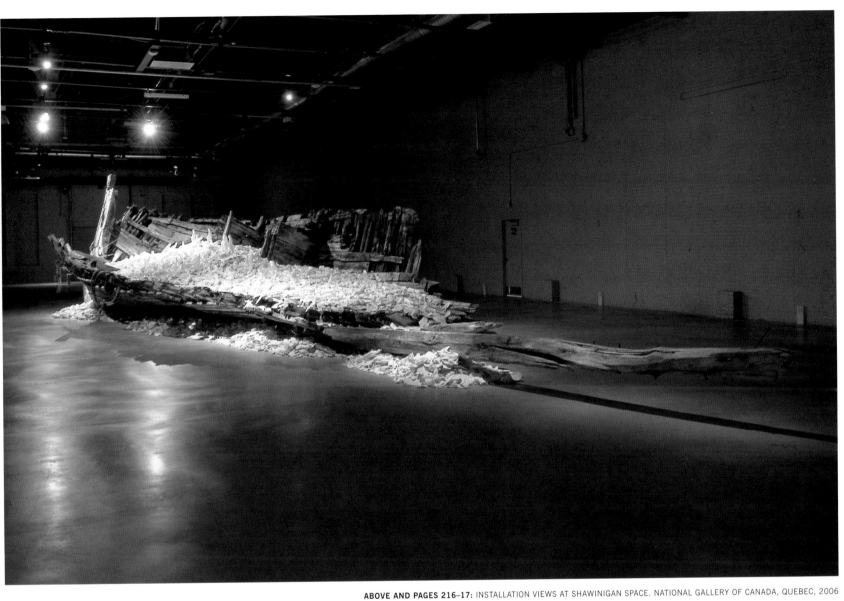

ABOVE AND PAGES 216–17: INSTALLATION VIEWS AT SHAWINIGAN SPACE. NATIONAL GALLERY OF CANADA, QUEBEC, 2006

EXHIBITION HISTORY

2004: *Cai Guo-Qiang: Traveler*, Arthur M. Sackler Gallery and Hirshhorn Museum and Sculpture Garden, Smithsonian Institution, Washington, D.C.

2006: *Cai Guo-Qiang: Long Scroll*, Shawinigan Space, National Gallery of Canada, Quebec

RELATED WORKS

1994: *Kaikō—The Keel (Returning Light—The Dragon Bone)*. Excavated fishing boat, salt (9 tons), plastic wrap, Styrofoam, and fish, dimensions variable; boat 5 x 5.5 x 13.5 m. Collection of the City of Iwaki

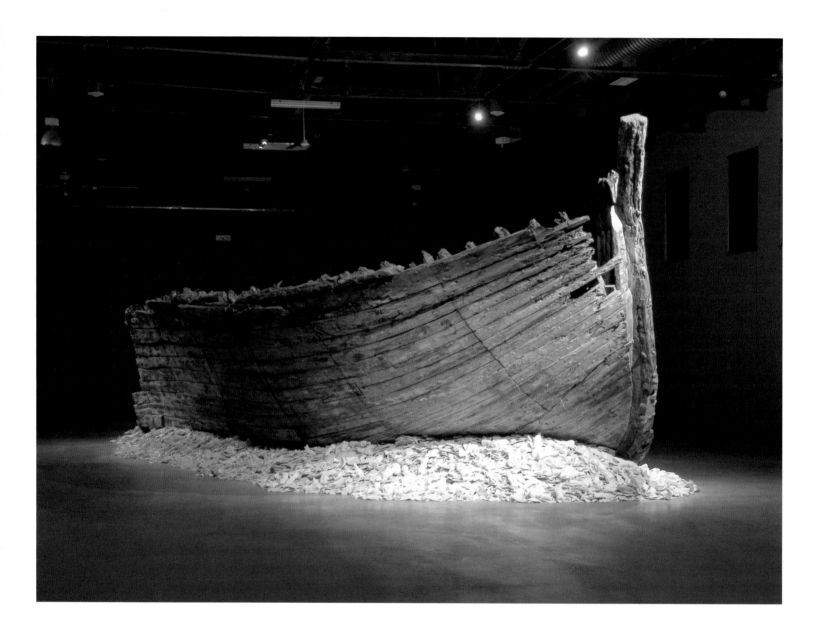

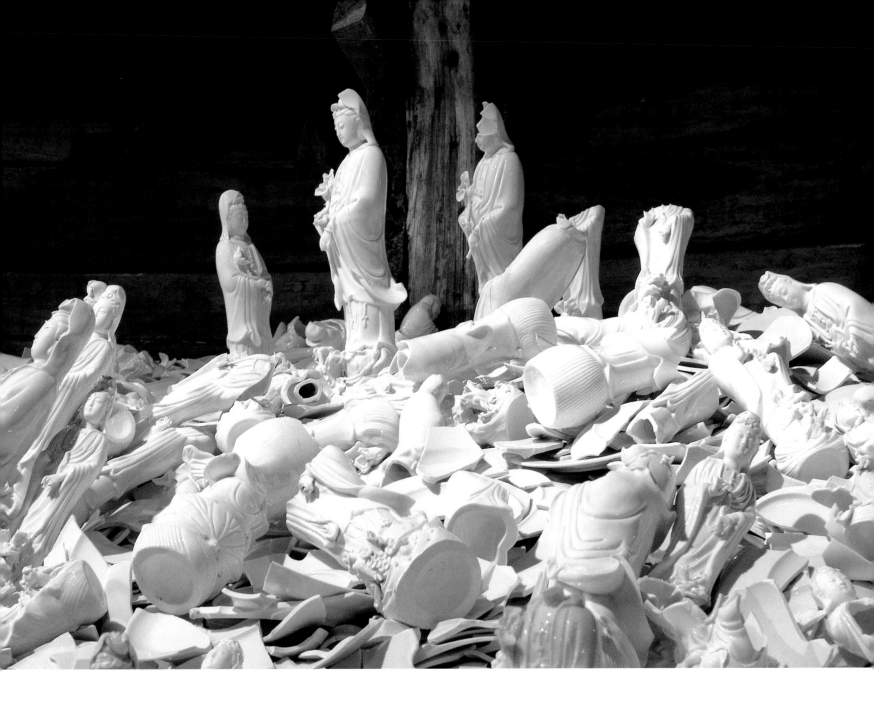

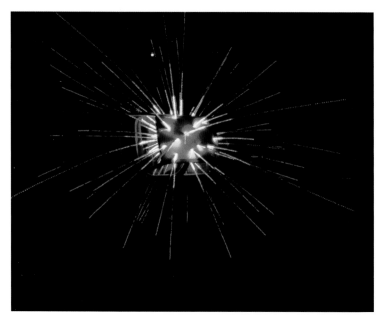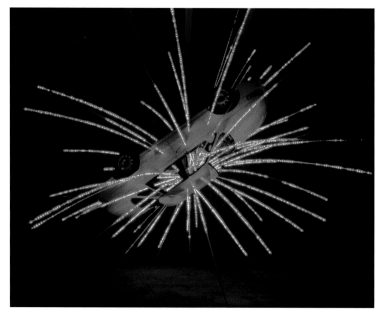

INSTALLATION VIEWS AT MASS MOCA, NORTH ADAMS, 2004

45

INOPPORTUNE: STAGE ONE
不合时宜: 舞台一
2004

FIRST REALIZED **DECEMBER 2004 AT MASSACHUSETTS
MUSEUM OF CONTEMPORARY ART (MASS MOCA),
NORTH ADAMS,** FOR THE EXHIBITION *CAI GUO-QIANG:
INOPPORTUNE.* CARS AND SEQUENCED MULTICHANNEL
LIGHT TUBES, DIMENSIONS VARIABLE. SEATTLE ART
MUSEUM, GIFT OF ROBERT M. ARNOLD, IN HONOR OF
THE 75TH ANNIVERSARY OF THE SEATTLE ART
MUSEUM (2006.1)

Cai's focus on sociopolitical issues, especially
relating to acts of terrorism, has become a central
feature of his work since 9/11. The most overt
example, *Inopportune: Stage One*, simulates the
trajectory of an exploding automobile tumbling
through space, offering up the contradiction
between a spectator's abhorrence of violence and
attraction to the abstract beauty of some violent
images. Nine white American-made cars are posi-
tioned in various stages of tumbling through the
air. The first car remains inert on the ground. As
each subsequent vehicle progresses through the
sequence in mid-air, electric light rods protruding
from their bodies emit blinding, flashing lights
that mimic exploding fireworks. The palette of the
light rods begins with a white, hot light, and
grows progressively warmer and more vibrant as
the angles of the cars rise and the "explosion"
progresses through time, then quiets down into
soft hues of purple and pink and at last a soft
blue. The last vehicle lands on the ground, absent
of any color, as if the car explosion never hap-
pened. The overall composition has the look of
stop-motion photography or a sequence of freeze
frames from a movie. According to the artist,
the expansive horizontal layout of the original
installation at MASS MoCA—which viewers had
to walk along and through to experience fully—
also referred to the temporal experience of
viewing Chinese hand scroll paintings, whose
narratives unfold horizontally. A related work,
Illusion (fig. 74), is a three-channel video installa-
tion that depicts an exploding car superimposed to
move through Times Square in Manhattan. The
pedestrians and surrounding traffic seem apathetic
or oblivious to the vehicle's violent demise. The
concept of *Inopportune: Stage One* has been
reconfigured as a vertical installation within the
rotunda of the Solomon R. Guggenheim Museum
as a central element of the artist's 2008 retro-
spective (fig. 75). —MY

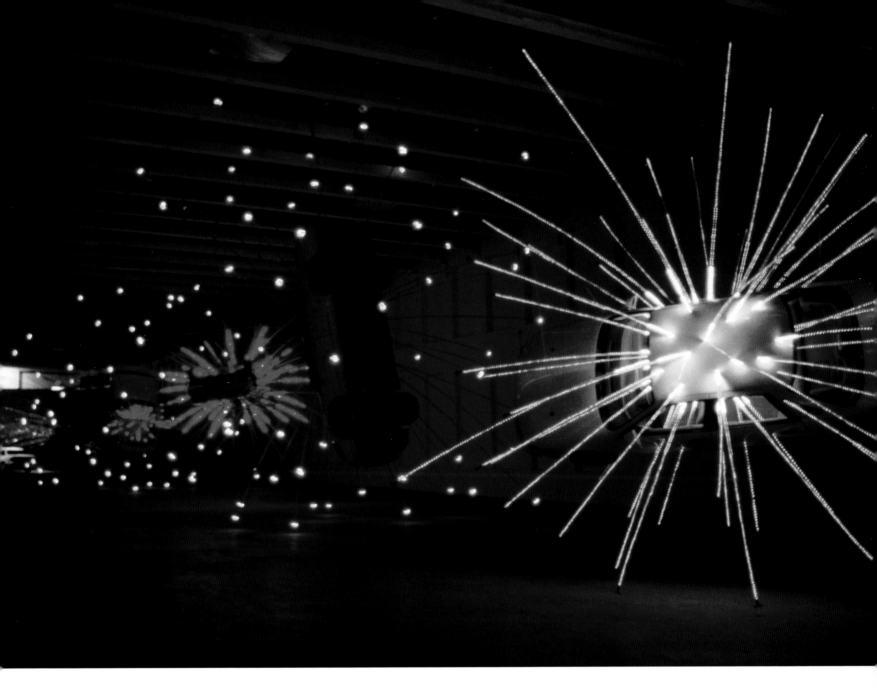

EXHIBITION HISTORY

2004: *Cai Guo-Qiang: Inopportune*, MASS MoCA,
North Adams
2006: *Cai Guo-Qiang: Long Scroll*, Shawinigan Space,
National Gallery of Canada, Quebec
2007: *Cai Guo-Qiang: Inopportune: Stage One*,
Seattle Art Museum

RELATED WORKS

2004: *Illusion* (fig. 74)
2004: *Illusion*, video edition. Three-channel video
transferred to DVD, 1 minute 37 seconds, loop. Videography
by John Borst, edited by Lauren Petty. Edition of 5. Seattle
Art Museum, National Gallery of Canada, and collection of
the artist
2004: *Inopportune: Stage One—Exploding Car No. 1*.
Gunpowder on paper, 240 x 75 cm. Collection of the artist
2004: *Inopportune: Stage One—Exploding Car No. 2*.
Gunpowder on paper, 240 x 75 cm. Collection of the artist
2004: *Inopportune: Stage One—Exploding Car No. 3*.
Gunpowder on paper, 75 x 240 cm. Collection of the artist
2004: *Nine Cars*. Gunpowder on paper, 400 x 600 cm.
Private collection, courtesy Albion, London
2005: *A Car*. Gunpowder on paper, mounted on wood as
nine-panel screen, 230 x 693 cm overall. Collection of
the artist

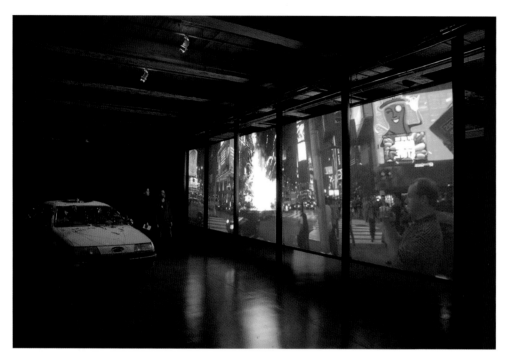

FIG. 74. *ILLUSION*, 2004. THREE-CHANNEL VIDEO (1 MINUTE 37 SECONDS, LOOP; VIDEOGRAPHY BY JOHN BORST, EDITED BY LAUREN PETTY; EDITION 1/5), CAR, AND SPENT FIREWORKS, DIMENSIONS VARIABLE. SEATTLE ART MUSEUM, GIFT OF ROBERT M. ARNOLD, IN HONOR OF THE 75TH ANNIVERSARY OF THE SEATTLE ART MUSEUM (2006.2). INSTALLATION VIEW AT MASS MOCA, NORTH ADAMS, 2004

FIG. 75. MODEL (2007) FOR INSTALLATION AT SOLOMON R. GUGGENHEIM MUSEUM, NEW YORK, IN 2008

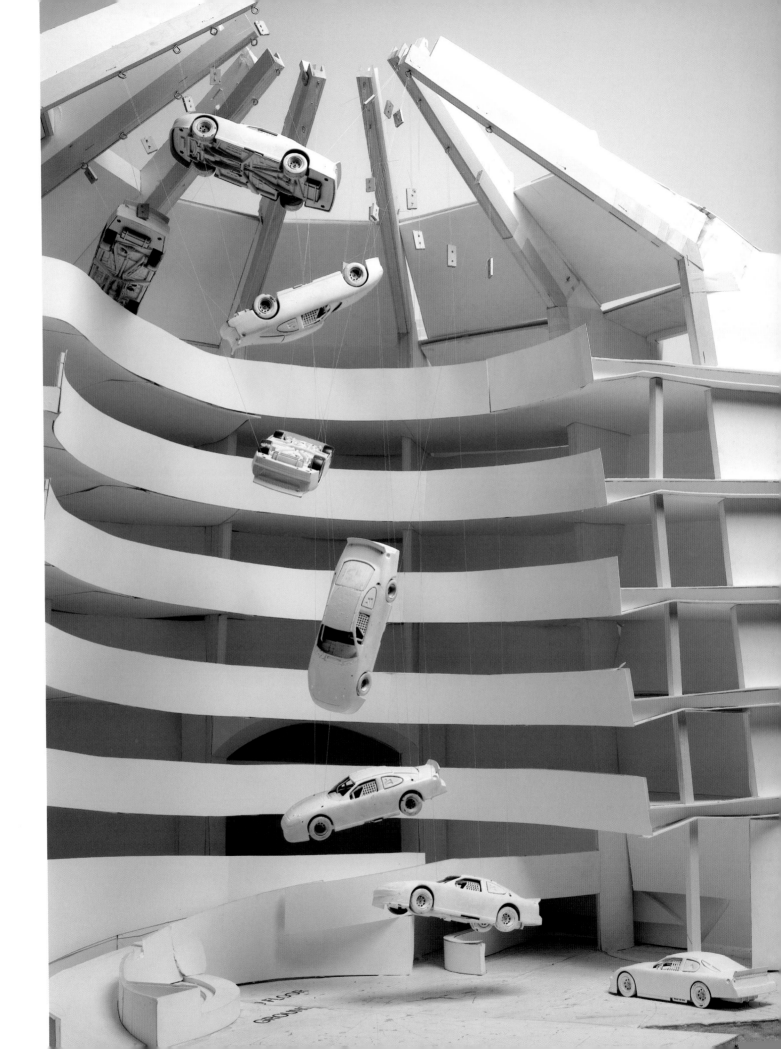

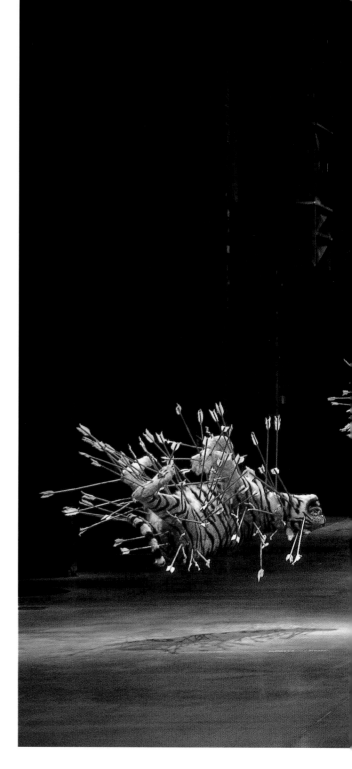

46
INOPPORTUNE: STAGE TWO
不合时宜：舞台二
2004

FIRST REALIZED **DECEMBER 2004 AT MASSACHUSETTS MUSEUM OF CONTEMPORARY ART (MASS MOCA), NORTH ADAMS,** FOR THE EXHIBITION *CAI GUO-QIANG: INOPPORTUNE*. NINE LIFE-SIZED TIGER REPLICAS, ARROWS, AND MOUNTAIN STAGE PROP. TIGERS: PAPIER-MÂCHÉ, PLASTER, FIBERGLASS, RESIN, AND PAINTED SHEEP HIDE; ARROWS: BRASS, THREADED BAMBOO SHAFT, AND FEATHERS; AND STAGE PROP: STYROFOAM, WOOD, CANVAS, AND ACRYLIC PAINT; DIMENSIONS VARIABLE. COLLECTION OF THE ARTIST

Loosely based on the twelfth-century Chinese folktale of Wu Song, a celebrated hero who once saved a village by vanquishing a man-eating tiger, *Inopportune: Stage Two* dramatically highlights Cai's background in stage design. Nine life-sized tigers are depicted under siege, leaping through space and writhing in pain from the onslaught of arrows shot by a phantom assailant. The artist orchestrated this illusory spectacle by using tiger replicas. And, when seen from behind, the imposing boulder is exposed as a stage prop—further confirming the complete artifice of this installation,

which reinterprets the folktale as a tragedy for the tigers, instead of as the celebration of a heroic feat. Although animal motifs have recurred throughout Cai's oeuvre, it was only after 9/11 that he began using ferocious animals as emblems of human nature, alternately alluding to violence, self-preservation, heroism, and bravery. As with *Inopportune: Stage One* (2004, cat. no. 45), this tableau is meant to evoke the experience of viewing traditional Chinese scroll paintings with visitors moving along a horizontal expanse. —MY

EXHIBITION HISTORY

2004: *Cai Guo-Qiang: Inopportune*, MASS MoCA, North Adams
2006: *Cai Guo-Qiang: Inopportune*, SITE Santa Fe
2006: *Cai Guo-Qiang: Long Scroll*, Shawinigan Space, National Gallery of Canada, Quebec

RELATED WORKS

1993: Cai Ruiqin, *Painting of One Hundred Tigers* (fig. 24)
2005: *Furious Tiger*. Gunpowder on paper, 77 x 230 cm. Private collection
2005: *Tigers with Arrows* (fig. 76)
2005: *Tiger with Arrows: Project for MASS MoCA*. Gunpowder on paper, 77.5 x 230 cm. Private collection

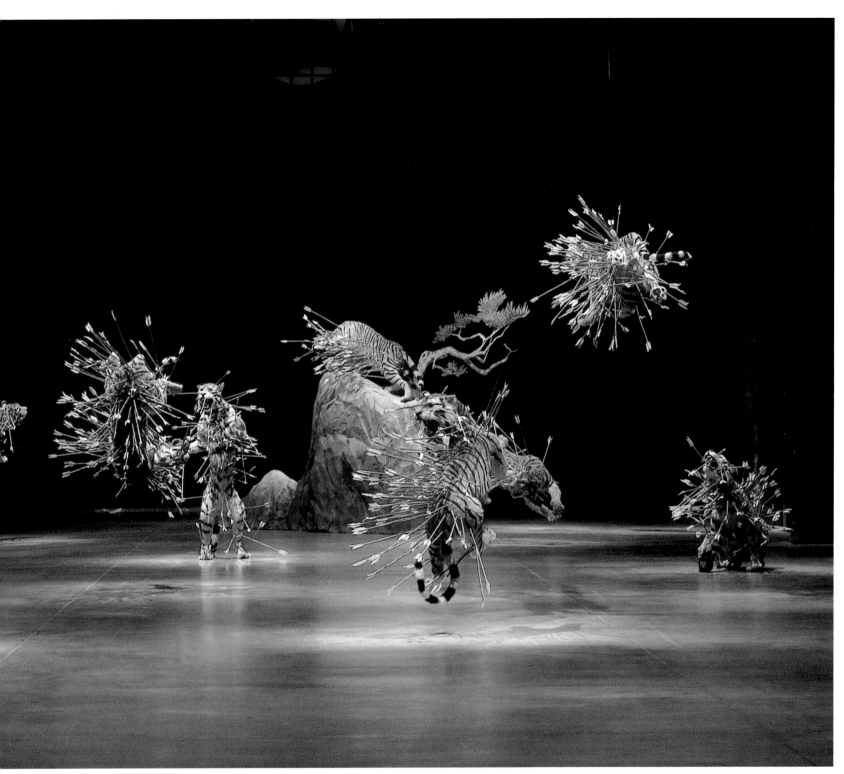

INSTALLATION VIEW AT SHAWINIGAN SPACE, NATIONAL GALLERY OF CANADA, QUEBEC, 2006

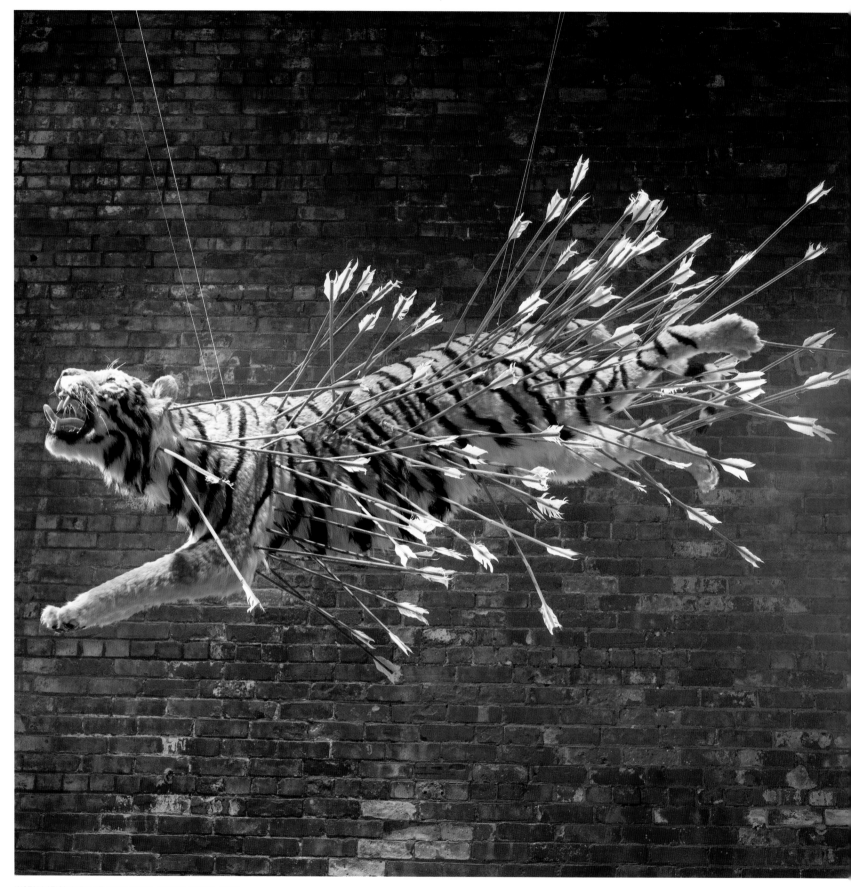

INSTALLATION VIEW AT MASS MOCA, NORTH ADAMS, 2004

FIG. 76. *TIGERS WITH ARROWS*, 2005. GUNPOWDER ON PAPER, MOUNTED ON WOOD AS NINE-PANEL SCREEN, 230.5 X 692.2 CM OVERALL. THE MUSEUM OF CONTEMPORARY ART, LOS ANGELES, THE EAST WEST BANK COLLECTION, PURCHASED AND PROMISED GIFT OF EAST WEST BANK (2006.181A-I)

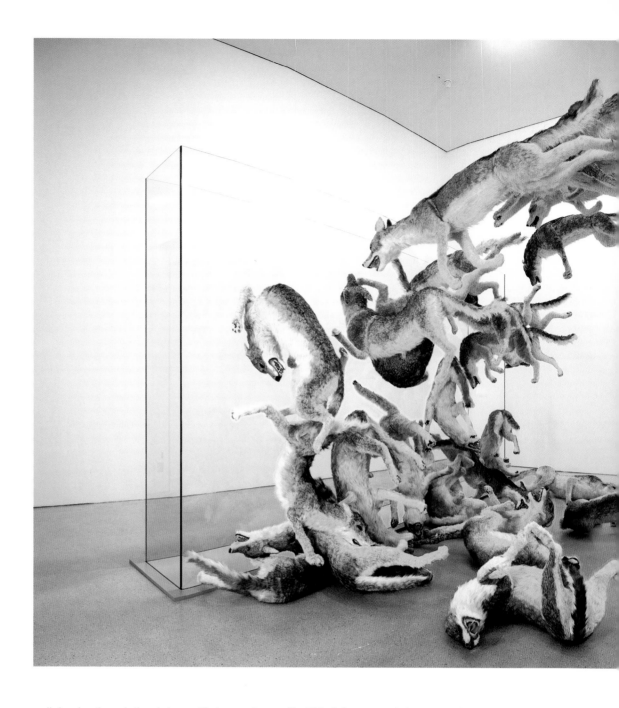

47
HEAD ON
撞墙
2006

FIRST REALIZED **AUGUST 2006 AT DEUTSCHE GUGGENHEIM, BERLIN,** FOR THE EXHIBITION *CAI GUO-QIANG: HEAD ON*. 99 LIFE-SIZED REPLICAS OF WOLVES AND GLASS WALL; WOLVES: PAPIER-MÂCHÉ, PLASTER, FIBERGLASS, RESIN, AND PAINTED HIDE; DIMENSIONS VARIABLE. DEUTSCHE BANK COLLECTION, COMMISSIONED BY DEUTSCHE BANK AG

Head On was created for Cai's eponymous solo exhibition at the Deutsche Guggenheim in Berlin and exemplifies how local history and culture play a central role within his working process. In this tableau, a pack of ninety-nine life-sized wolves gallops at full force toward a transparent glass wall, leaping through the air in a unified arc, only to collide head on into the unyielding barrier. The wall—first realized to the exact height and thickness of the Berlin Wall—represents society's tendency to search only for the obvious, missing instead what may not be immediately evident but ultimately more dangerous. In Cai's artistic iconography, wolves possess a ferocity and courageousness similar to tigers and achieve heroism through their collective unity. In this installation, however, their cohesiveness leads to their ultimate downfall. Here, through the emblematic imagery of wolves, Cai intends to address the human fallibility of following any collective ideology too blindly and humankind's fate to repeat mistakes unthinkingly. *Illusion II*—a two-channel video installation that was also included in the *Head On* exhibition—documents an explosion event of the same title (fig. 77). A German-style house was fabricated by Cai on a lot adjacent to the Anhalter Bahnhof, which was once Berlin's largest train station but almost completely destroyed during World War II. The video's documentation of the small house being decimated by explosives, with the station's ruins in the background, illustrates the artist's ongoing exploration of the contradictions involved in perceptions of beauty and violence. —MY

EXHIBITION HISTORY

2006: *Cai Guo-Qiang: Head On*, Deutsche Guggenheim, Berlin

RELATED WORKS

2005: *Lion and Wolf: Drawing Experiment for Deutsche Guggenheim*. Gunpowder on paper, mounted on wood as four-panel screen, 230 x 310 cm overall. Collection of the artist

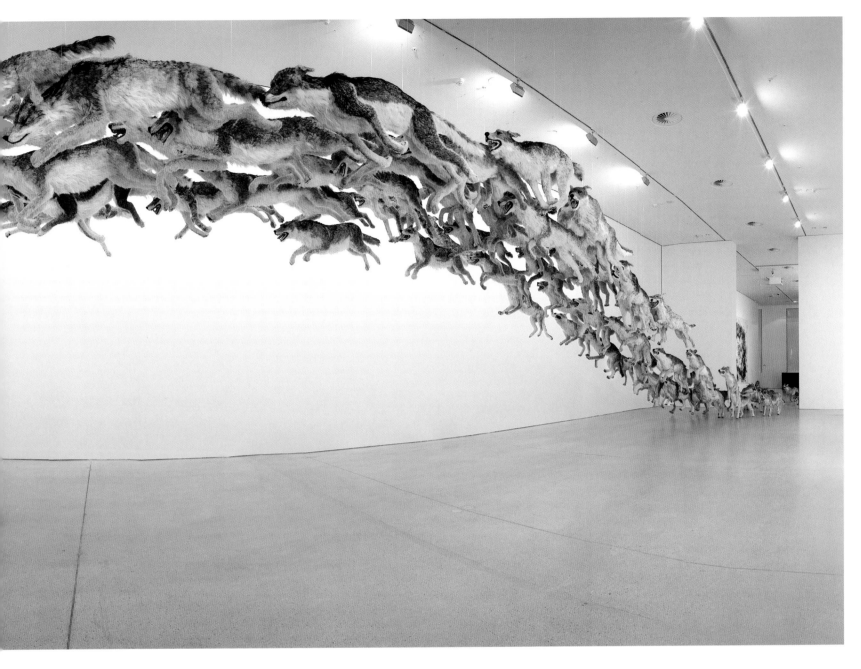

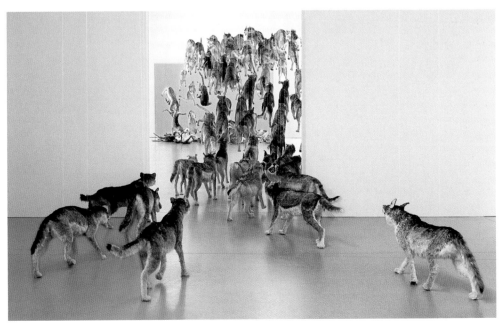

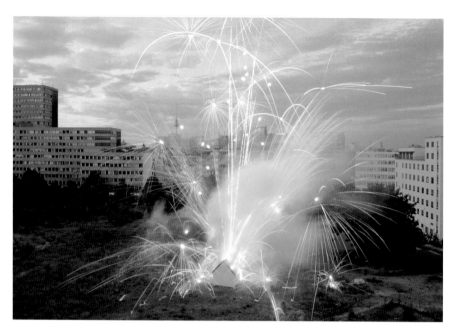

FIG. 77. *ILLUSION II: EXPLOSION PROJECT*, 2006. REALIZED AT MÖCKERNSTRASSE/STRESEMANNSTRASSE, BERLIN, JULY 11, 2006, 9:30 PM, 18 MINUTES. 2,000 ASSORTED FIREWORK SHELLS, PLASTER, WOOD, AND CARDBOARD. COMMISSIONED BY DEUTSCHE GUGGENHEIM FOR THE EXHIBITION *CAI GUO-QIANG: HEAD ON*

2005: *Pine Forest and Wolf: Drawing Experiment for Deutsche Guggenheim* (cat. no. 17)
2005: *Wolf and Lion: Drawing Experiment for Deutsche Guggenheim*. Gunpowder on paper, 202 x 305 cm. Agnes Gund Collection, New York
2005–06: *Howling Wolf*. Gunpowder on paper, 150 x 200 cm. Private collection
2006: *Vortex*. Gunpowder on paper, 400 x 900 cm. Collection of the artist
2006: *Study for a Wolf's Bodily Movements: For Head On*. Nine clay wolf figures, dimensions variable. Edition of 11 + 2 A.P. Private collections and collection of the artist
2006: *Illusion II: Explosion Project* (fig. 77)
2006: *Illusion II*. Two-channel video installation, 8 minutes 48 seconds, loop, dimensions variable. Edition of 5. Deutsche Bank Collection and collection of the artist

PAGES 226–27 AND 229: INSTALLATION VIEWS AT DEUTSCHE GUGGENHEIM, BERLIN, 2006

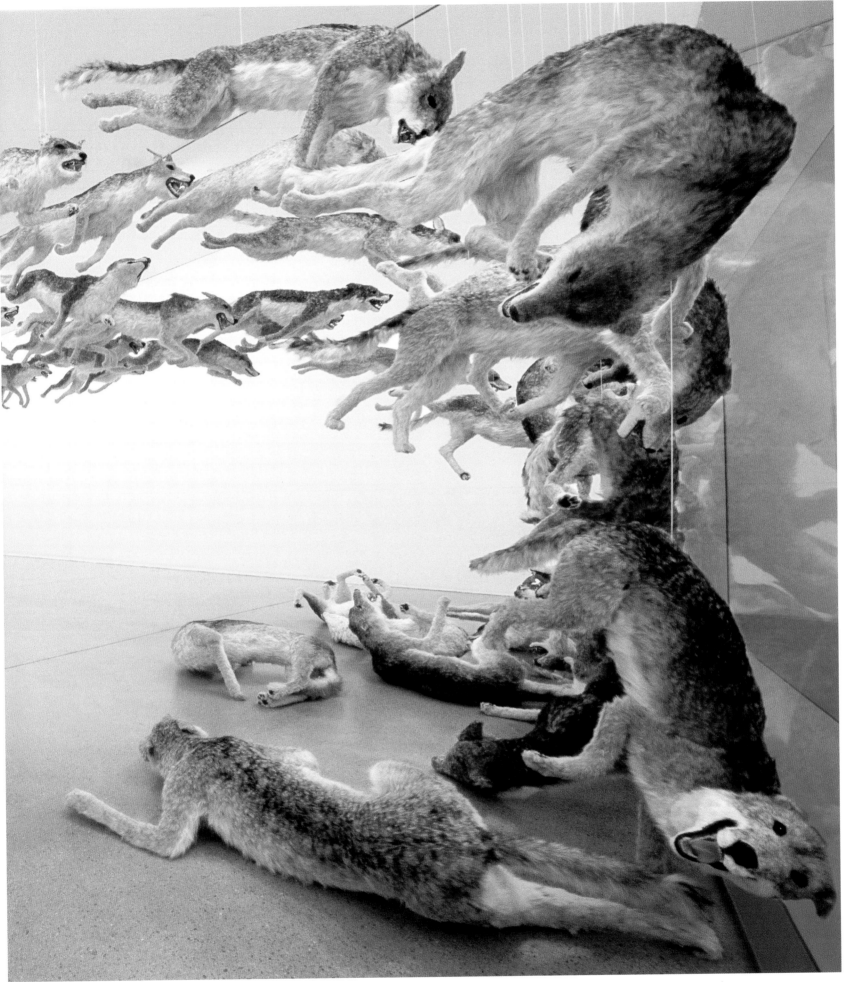

SOCIAL PROJECTS

Cai Guo-Qiang is a peripatetic, transnational artist whose work explores and challenges the function and meaning of art within a wider sociocultural context. Central to his practice is the contraction of extreme site-specificity with a conscious transcendence of cultural and temporal limitations. Responding to the conditions of each new location for a project, the artist approaches its place, patrimony, and indigenous practice with the sensibility of an archaeologist or historian. To assimilate contemporary art into the everyday life of communities and cities, he commenced what may be termed his "social projects" in the early 1990s. Assuming the role of a cultural activist, Cai began collaborations at nonart sites, creating opportunities for dialogue and debate. These ongoing experiments carry out the artist's utopian ideals of social engagement and mobilization, with a core belief in the transformational nature of art and culture in society. The social projects expand upon Cai's goal to not just make art, but to "create a culture," in his own words.

Referencing a Chinese proverb by late-Ming-period calligrapher and poet Dong Qichang (1555–1636), Cai has quoted, "Reading ten thousand books is not as fruitful as traveling ten thousand miles." The social projects, which operate across time and spot the globe, evince a consistent socialist idealism that informs his work across different mediums. Whether harnessing the force of one hundred volunteers to travel to the Gobi Desert to extend the Great Wall of China with explosives (*Project to Extend the Great Wall of China by 10,000 Meters: Project for Extraterrestrials No. 10*, 1993, cat. no. 21), or engaging Japanese laborers from Iwaki to reclaim their local heritage by resurrecting wooden boats for installations such as *Reflection—A Gift from Iwaki* (2004, cat. no. 44), Cai's uncanny, maverick projects encourage the participation of large, dynamic audiences utilizing a keen sense of diplomacy, negotiation, and cultural sensitivity. The artist's ongoing collaboration with the Iwaki residents is of particular importance, as it demonstrates his commitment to process and to working on multiple projects with specific communities and regional cultures over extended periods of time.

Cai's continued rebellion against established norms and traditions has led to a self-described need to oftentimes "exile" himself from the professional art world. As an alternative community-based, grass-roots strategy, Cai has developed his ongoing *Everything Is Museum* series. Beginning with *DMoCA (Dragon Museum of Contemporary Art): Everything Is Museum No. 1* in Niigata, Japan (2000, cat. no. 50), this series thus far includes three interventions into unusual, abandoned sites such as pottery kilns, old bridges, and military bunkers. Collaborating with government officials, artisans, volunteers, and contemporary artists, Cai exhibits extraordinary charisma and leadership to realize these complex large-scale living projects. As the architect, director, or curator of these interactive exhibition sites, the artist further subverts attributed roles of art world professionals, thus questioning authorship.

BMoCA (Bunker Museum of Contemporary Art): Everything Is Museum No. 3 (2004, cat. no. 52) on Kinmen Island brings attention to the ongoing tension of cross-strait relations between Mainland China and Taiwan. By inviting contemporary artists and local school children to create interactive projects in the island's ubiquitous bunkers, Cai has converted part of this demilitarized

zone into an "Eco-Museum." The *Everything Is Museum* series highlights Cai's interest in tourism, museology, and infrastructure building as sustainable methodologies in mass communication and the regeneration of cultural industry. These projects also attest to the artist's magnetic attraction toward unstable environments, and the temerity involved in manifesting this vision. *QMoCA (Quanzhou Museum of Contemporary Art): Everything Is Museum No. 4* (fig. 135), scheduled to open in Cai's hometown in 2009, marks a shift. Rather than appropriating, recycling, or transforming an old site, this new structure will be designed by Foster + Partners, and will function as an international museum, residency, and performance center.

In order to underline both the positive and negative aspect of any experience, Cai approaches political themes with a cultural diplomacy that de-emphasizes strident ideological content. *The Century with Mushroom Clouds: Project for the 20th Century* (1996, cat. no. 26) employed as its leitmotif what the artist considers as the most significant symbol of the twentieth century: the atomic bomb. Extending this investigation, Cai invited visitors into his installation of a makeshift café called *Crab House* (1996, cat. no. 49) to ingest a lingzhi medicinal drink as an allegory for social healing; the form of the lingzhi mushroom conjures the bomb's signature "mushroom cloud," but in Cai's hands it becomes a symbol for life rather than death. The concept of social healing is a key ingredient; grounded in Cai's understanding of twentieth-century trauma and his serious interest in Chinese medicine as a form of ancient Eastern wisdom. While working in Salvador, Bahia, for the Quiet in the Land residency in 1999–2000, Cai prompted juvenile delinquents to build their own cannons with local materials, which were fired as a way of "combating poison with poison" to transform violence.

More recently, Cai collaborated with Beijing's Long March Foundation in 2006. Referencing Mao Zedong's famous 1943 doctrinaire speech on the future development of Chinese art and culture, the artist initiated the Yan'an Forum on Contemporary Art Education to discuss the sociological basis of contemporary Chinese art education and proposed a two-year master's program for students of art. Long March is seminal as an ongoing site-specific, community-based project, which both critiques and propagates Maoist revolutionary ideas. Cai's involvement as a key participant demonstrates his commitment to education and intellectual debate, and to reinventing the role of the artist in society.

Bringing to Venice What Marco Polo Forgot (1995, cat. no. 48), part of the *46th Venice Biennale*'s *TransCulture* exhibition, can be read as a gestalt for Cai's social projects. Functioning as an emissary, the artist conceptually traversed binaries such as East and West, local and global, traditional and contemporary. When asked, "What is a Chinese artist? What is an Asian artist? What is an international artist? What is a contemporary artist? What is a traditional artist?" Cai recalls replying, "It is me. This is what I am." According to him, "Our times have given us the opportunity to belong to every category." In his art and in his life, Cai conflates, confounds, and complicates the distinctions between the individual and the collective, between local histories and national agendas, and between the violent and the beautiful, to create multivalent works that defy easy categorization and merit active, social participation. —SANDHINI PODDAR

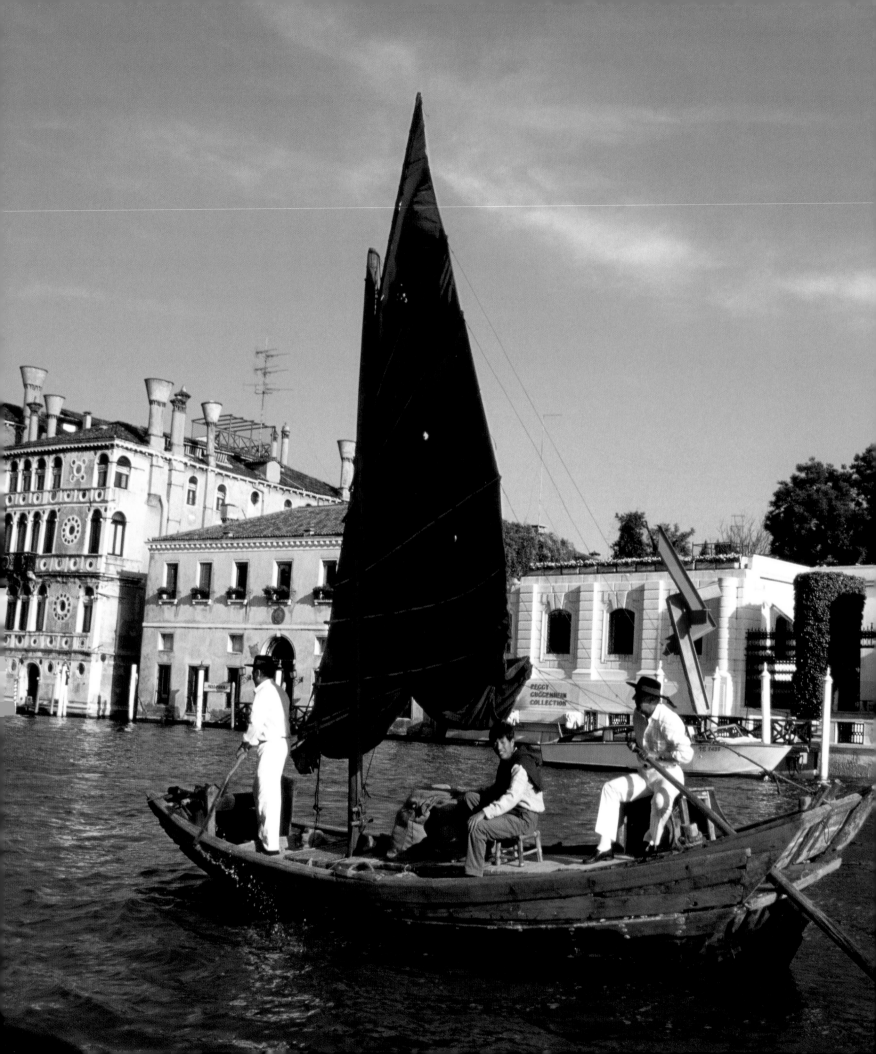

48

BRINGING TO VENICE WHAT MARCO POLO FORGOT
马可波罗遗忘的东西
1995

FIRST REALIZED **JUNE 1995 AT PALAZZO GIUSTINIAN LOLIN AND THE GRAND CANAL, VENICE,** FOR THE EXHIBITION *TRANSCULTURE, 46TH VENICE BIENNALE.* INSTALLATION INCORPORATING WOODEN FISHING BOAT FROM QUANZHOU, CHINESE HERBS, EARTHEN JARS, GINSENG BEVERAGES, BAMBOO LADLES AND PORCELAIN CUPS, GINSENG (100 KG) AND HANDCART, AND WORKS PRESENTED AS COMPONENTS (SEE LIST BELOW), DIMENSIONS VARIABLE; BOAT 700 X 950 X 180 CM. MUSEO NAVALE DI VENEZIA (BOAT) AND PRIVATE COLLECTIONS (SEE LIST)

The year 1995 marked the seven-hundredth anniversary of Marco Polo's return to Venice from China after a maritime journey that began in Quanzhou, Cai's hometown. The Chinese artist commemorated this historic transcultural event by bringing what the Italian explorer "forgot" to take home: the Eastern spirit. When this project was first realized, Cai symbolically transported that spirit—embodied by Chinese herbal medicine— from East to West by navigating an old-fashioned fishing junk (brought specifically from Quanzhou) along Venice's Grand Canal from Piazza San Marco to Palazzo Giustinian Lolin. Docked outside the palazzo, the boat functioned as a seating area where visitors could savor the medicinal tonics and potions offered inside. Within the palazzo, a modern vending machine was installed on one wall to dispense five varieties of bottled herbal tonics for 10,000 lira each. These drinks were

formulated according to the ancient Chinese principle of "five elements," wherein five elements of natural phenomena (wood, fire, earth, metal, water) correlate to five tastes (bitter, sweet, sour, spicy, salty) and five bodily organs (liver, heart, spleen, lung, kidney). The prescriptions posted on one wall enabled participants to select remedies suitable to their needs. Available along the opposite wall were traditional ginseng soup and ginseng liquor, each contained in a large earthen jar. Visitors used bamboo ladles to pour these potions—formulated to enhance bodily qi, or energy—into porcelain cups. To commemorate the one-hundredth anniversary of the Venice Biennale, one hundred kilo sacks of ginseng were displayed on a handcart placed near the ginseng service. The idea of healing was extended to the city and its canals, which Cai compared to a living organism and its energy flows. Just inside the palazzo's entrance he hung a plastic curtain covered with common acupuncture meridian charts and filled with canal water to which he symbolically applied acupuncture needles. —REIKO TOMII

WORKS PRESENTED AS INSTALLATION COMPONENTS
1995: *Water, Wood, Gold, Fire, Earth*. Chinese herbs, Chinese herbal medicines in bottles, and rented vending machine, dimensions variable. Collection of the artist
1995: *Acupuncture for Venice*. Plastic, decal, water, and acupuncture needles, dimensions variable; plastic 184.5 x 490.2 x 0.5 cm. Collection of Miani Johnson, New York

EXHIBITION HISTORY
1995: *TransCulture, 46th Venice Biennale*, Palazzo Giustinian Lolin

RELATED WORKS

1994: *Universal Design, Feng Shui Project for Mito: Chang Sheng*. Digital print of computer manipulated image of Mito City, ink drawings and small stone lions, wood and photographs, tombstones, stone, and pine tree, dimensions variable; print 360 x 900 cm. Art Tower Mito Contemporary Art Center (print, drawings, and stone lions) and collection of the artist (wood and photographs). Tombstones, stone, and pine tree not extant

1994: *Lion: Feng Shui Project for Mito: Chang Sheng*. Stone, 300 x 200 x 150 cm. Permanent installation, Mito Train Station

1994: *Internal and External Universe: Water, Wood, Metal, Fire, Earth*. Chinese herbs, rented vending machine, medicine bottles, steel cable, paper, table, and cloth, dimensions variable. Collection of the artist

1995: *Moxacautery—for Africa*. Wooden sculptures, medicine, moxa, and statement of treatment, dimensions

variable; sculptures: length approximately 200 cm each. Collection of the artist

1997: *A Cure When Ill, A Supplement When Healthy*. Gunpowder drawing, bed of stones set in resin, herbal medicines, and vending machine, dimensions variable; drawing 300 x 800 cm; bed of stones 90 x 1,200 cm. Collection of the artist

2000: *How Is Your Feng Shui? Year 2000 Project for Manhattan*. 99 stone lions, feng shui software, three

computer monitors, and photographs documenting feng
shui treatments at selected participants' residences, offices,
and corporate lobbies. Commissioned by the Whitney
Museum of American Art, New York. Collection of the artist,
corporate collections, and private collections

49
CRAB HOUSE
蟹蟹之家
1996

FIRST REALIZED **MAY 1996 AT P.S.1 THE INSTITUTE FOR CONTEMPORARY ART, OFF-SITE: 80 LAFAYETTE STREET, NEW YORK**, FOR THE EXHIBITION *IN THE RUINS OF THE TWENTIETH CENTURY*. INSTALLATION INCORPORATING 160 LIVE CRABS, SAND, FOUR TABLES, EIGHT CHAIRS, FOUR TEA MAKERS, FOUR PLASTIC STANDS WITH PRESCRIPTION, LINGZHI MUSHROOM TEA, DISPOSABLE CUPS, METAL POSTCARD STAND, AND WORKS PRESENTED AS COMPONENTS (SEE LIST BELOW), DIMENSIONS VARIABLE. HARVARD UNIVERSITY ART MUSEUMS, FOGG ART MUSEUM, CAMBRIDGE, AND COLLECTION OF THE ARTIST (SEE LIST)

Crab House was an interactive installation designed to function as a "tea house" open to the public. Inside, a mural-size gunpowder drawing presented a view from outer space, in which "more than 2,000 nuclear tests conducted on our planet must look like a field of mushrooms growing on the planet," according to the artist. The explosion event *The Century with Mushroom Clouds: Project for the 20th Century* (1996, cat. no. 26) was represented by a documentary video as well as by documentary postcards placed in a stand and sold for one dollar apiece. Framed photographs and drawings decorated the tea-house walls. The idea of nuclear tourism was the subject of photographs depicting the Nevada Test Site and taken as part of Cai's field research. Small concept drawings depicted his proposals for mushroom cloud explosions over London, Paris, and Moscow.

Cai's assertion that the twentieth century was the nuclear century, and that nuclear tests created mushroom clouds whose "monumental and beautiful" imagery "overwhelm[s] artistic creation," was backed up by copies of his artist's book featuring photographs of nuclear test explosions obtained from the U.S. Department of Energy and other sources. On the book's endpapers, the cautionary image of an ape holding up fire was intended as an allusion to humankind's reckless attitude toward what Cai has characterized as "the civilization of nuclear weaponry, which can easily destroy humankind and thus will continue to have a powerful influence in the coming centuries." Visitors were able to view the books while sipping lingzhi mushroom tea, which is used in Chinese medicine to detoxify and boost the immune system. The mushroom form of course conjures that

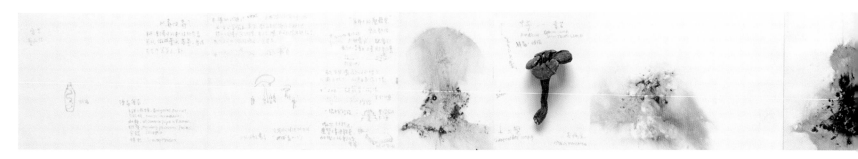

FIG. 78. *DRAWING FOR THE CENTURY WITH MUSHROOM CLOUDS: PROJECT FOR THE 20TH CENTURY*, 1995–96. GUNPOWDER, INK, AND DRIED LINGZHI MUSHROOM ON PAPER, 20-PAGE FOLDING ALBUM, 28 X 481.5 CM OPENED. SOLOMON R. GUGGENHEIM MUSEUM, NEW YORK, PARTIAL GIFT OF THE ARTIST AND PURCHASED WITH FUNDS CONTRIBUTED BY THE INTERNATIONAL DIRECTOR'S COUNCIL AND EXECUTIVE COMMITTEE MEMBERS: TIQUI ATENCIO DEMIRDJIAN, CHRISTINA BAKER, EDYTHE BROAD, JANA BULLOCK, RITA ROVELLI CALTAGIRONE, DIMITRIS DASKALOPOULOS, HARRY DAVID, CARYL ENGLANDER, SHIRLEY FITERMAN, LAURENCE GRAFF, NICKI HARRIS, DAKIS JOANNOU, RACHEL LEHMANN, LINDA MACKLOWE, PETER NORTON, TONINO PERNA, INGA RUBENSTEIN, SIMONETTA SERAGNOLI, CATHIE SHRIRO, GINNY WILLIAMS, AND ELLIOT WOLK, AND SUSTAINING MEMBERS: LINDA FISCHBACH, BEATRICE HABERMANN, AND CARGILL AND DONNA MACMILLAN 2007.52

of a mushroom cloud, and so symbolically suggests that whatever destroys can also heal. The title *Crab House* refers to the live crabs that roamed the installation's sand-filled floor, initiating a lively relationship with the visitors, who had to use caution to avoid stepping on or being nicked by them. The crab is the zodiac emblem for Cancer, and Cai's use of crabs was meant to signify the relationship between nuclear radiation and death, as well as the use of radiation to treat cancer. In the artist's view, the crabs' sideways movements offered an alternative to the linear progression of science and technology that produced the atomic bomb. —RT

WORKS PRESENTED AS INSTALLATION COMPONENTS

1996: *The Century with Mushroom Clouds: Project for the 20th Century* (fig. 79)

1996: *The Century with Mushroom Clouds: Project for the 20th Century*. Video documentation of explosion event (cat. no. 26)

1996: Site research for *The Century with Mushroom Clouds: Project for the 20th Century*. 14 framed photographs, 18.2 x 23.2 x 1.7 cm or 23.2 x 18.2 x 1.7 cm each. Collection of the artist

1996: *The Century with Mushroom Clouds: Project for the 20th Century*. Artist's book for *Crab House*, eight copies. Hardcover blank books, 19 or 20 pages with 11 or 12 facsimile clippings of mushroom cloud photographs and illustrated end papers, 21 x 15 x 2 cm each. Harvard University Art Museums, Fogg Art Museum, Cambridge (two books), and collection of the artist (six books)

1996: *The Century with Mushroom Clouds: Project for the 20th Century*. Postcards, open edition. Eight postcards documenting the explosion event (cat. no. 26),

10.5 x 15 cm each. Harvard University Art Museums, Fogg Art Museum, Cambridge, and private collections

1996: *Drawings for The Century with Mushroom Clouds: Project for the 20th Century*. Eight drawings, pen on paper, approximately 10.5 x 15 or 15 x 10.5 each. Collection of the artist

EXHIBITION HISTORY

1996: *In the Ruins of the Twentieth Century*, P.S.1 The Institute for Contemporary Art, off-site: 80 Lafayette Street, New York

RELATED WORKS

1995–96: *Drawing for The Century with Mushroom Clouds: Project for the 20th Century* (fig. 78)

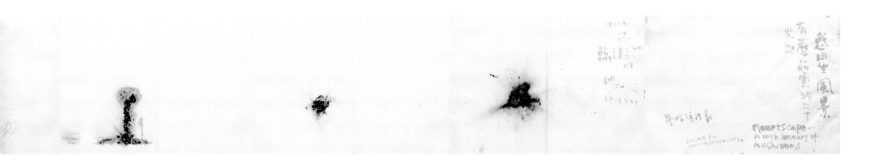

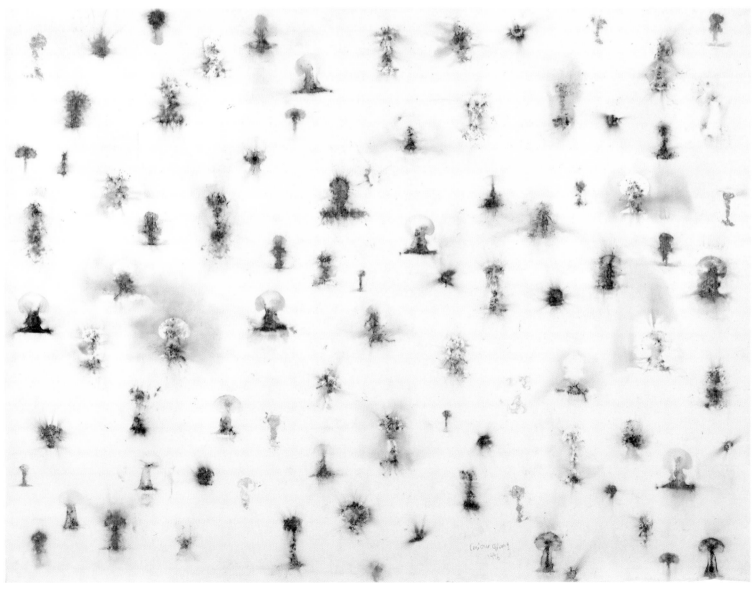

FIG. 79. *THE CENTURY WITH MUSHROOM CLOUDS: PROJECT FOR THE 20TH CENTURY*, 1996. GUNPOWDER ON PAPER, 301.2 X 403 CM. HARVARD UNIVERSITY ART MUSEUMS, FOGG ART MUSEUM, CAMBRIDGE, THE JORIE MARSHALL WATERMAN '96 AND GWENDOLYN DUNAWAY WATERMAN '92 FUND, 2000.60.1

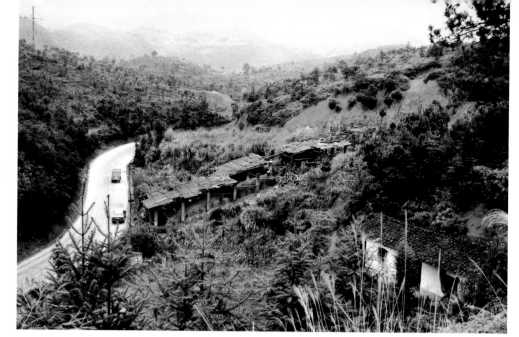

DISASSEMBLY OF DEHUA KILN AT QUANZHOU, JUNE 2000

50

DMOCA (DRAGON MUSEUM OF CONTEMPORARY ART): EVERYTHING IS MUSEUM NO. 1
龙当代美术馆：什么都是美术馆第一号
2000

PERMANENT MUSEUM BUILT IN **JUNE–JULY 2000**
AT TSUNAN MOUNTAIN PARK, NIIGATA PREFECTURE.
DEHUA KILN (DATED 1956) TRANSPORTED AND
RECONSTRUCTED ON SITE, 2.5 X 2.5 X 35 M.
COMMISSIONED FOR *ECHIGO-TSUMARI ART
TRIENNIAL 2000*

This permanent museum in Japan is the first in the *Everything Is Museum* series, which represents "a small rebellion against the current system of the generic MoMAs and MoCAs," enlightened institutions that have nonetheless become "detached from the public" in Cai's view. Located in the remote mountain village of Tsunan in Niigata Prefecture, DMoCA was created for the first Echigo-Tsumari Art Triennial in 2000. Supportive of the triennial's goal of revitalizing the depopulated and economically depressed region, Cai gave Tsunan this museum as a gift. To create DMoCA, he relocated a Dehua kiln—a so-called dragon kiln—from Quanzhou, his hometown in China. Common in southern China, and taking its name from a region of Fujian Province, the Dehua kiln has an elongated form, is sited on hillsides, and resembles an ascending dragon. The kiln Cai used, originally built in 1956, was carefully dismantled, transported with the local mud needed to create new bricks, and reassembled at Tsunan under the supervision of two Chinese master artisans. Made entirely of earthen bricks, DMoCA

uses no electricity, climate control, or security measures. The kiln's stoke holes on either side let in natural light. The terraced platforms inside were originally used for stacking clay vessels during the firing process. As part of the triennial, *DMoCA 2* in 2003 and *DMoCA 3* in 2006 were organized by Cai as the museum's director. *DMoCA 2* was in effect the museum's inaugural exhibition, curated by Cai himself, who offered Kiki Smith her first solo museum exhibition in Japan. Working with local residents and triennial volunteers, Smith created the installation *Pause*. *DMoCA 3* featured the exhibition of the Japanese artist Miyanaga Kōtarō, who fired recycled glass bottles to create a crystalline flow inside the kiln-museum. The people of Tsunan, who are responsible for the structure's maintenance, have also used it for various cultural programs. —RT

242

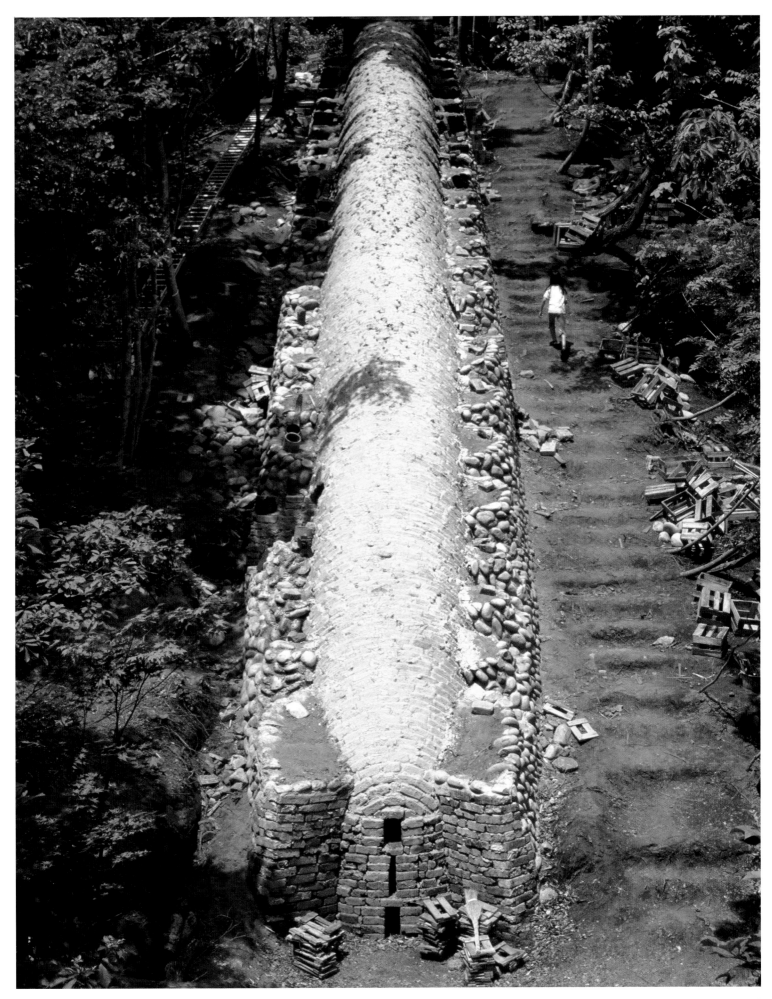

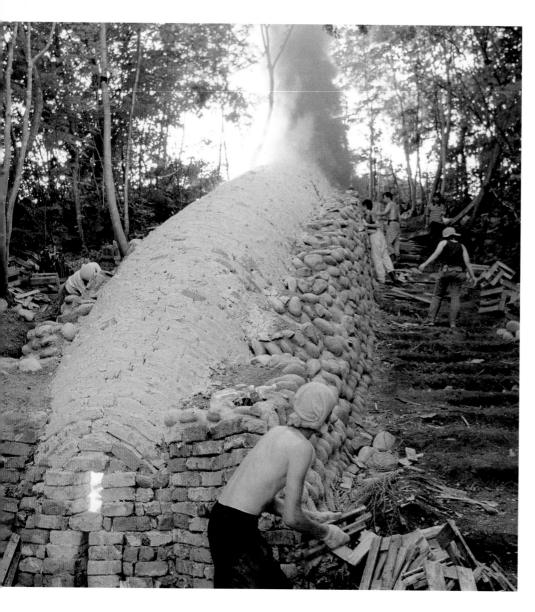

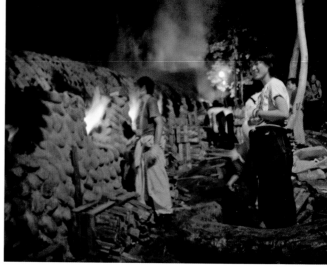

LEFT AND ABOVE: INITIAL FIRING, JULY 21, 2000

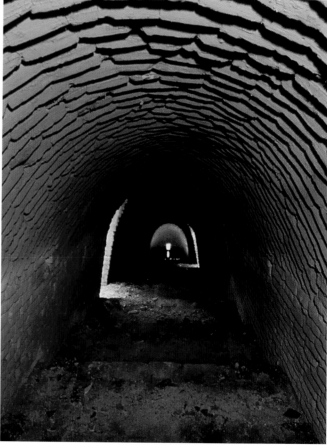

INTERIOR AFTER FIRING

EXHIBITIONS AT DMOCA

2000: *DMoCA (Dragon Museum of Contemporary Art): Everything Is Museum No. 1* for *Echigo-Tsumari Art Triennial 2000*

2003: *DMoCA 2: Pause, Inaugural Exhibition with Kiki Smith* for *Echigo-Tsumari Art Triennial 2003*

2006: *DMoCA 3: Range, Kōtarō Miyanaga* for *Echigo-Tsumari Art Triennial 2006*

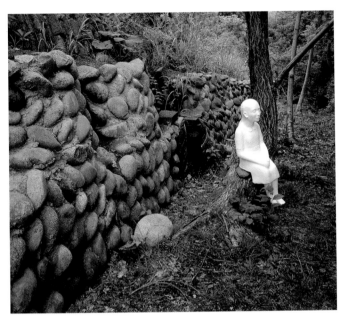

ABOVE AND RIGHT: KIKI SMITH, *PAUSE*, 2003. INSTALLATION WITH CERAMIC
SCULPTURES AND TREE TWIGS AND BRANCHES

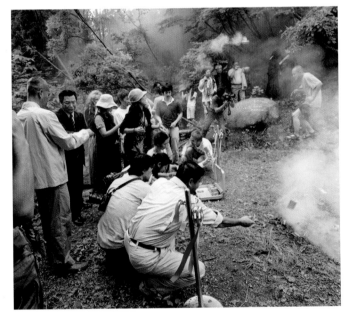

OPENING CEREMONY WITH FIRECRACKERS, JULY 19, 2003

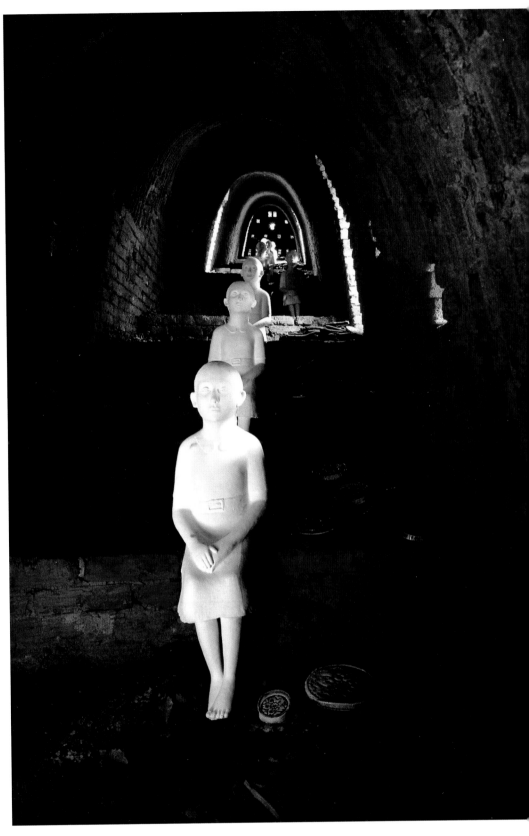

UMOCA (UNDER MUSEUM OF CONTEMPORARY ART): EVERYTHING IS MUSEUM NO. 2

桥下当代美术馆: 什么都是美术馆第二号

2001

PERMANENT MUSEUM CREATED IN **SEPTEMBER 2001 UNDER ST. FRANCIS BRIDGE, COLLE DI VAL D'ELSA, TUSCANY.** COMMISSIONED BY ASSOZIACIONE ARTE CONTINUA FOR *ARTE ALL'ARTE 6*. COLLECTION OF THE CITY OF COLLE DI VAL D'ELSA

In 2001, with UMoCA—the second of the museum franchise he has created under the rubric *Everything Is Museum*—Cai further articulated his vision: "It's a response to the various Guggenheim places around the world, to chains like McDonalds, Kentucky Fried Chicken, Starbucks and so on. My ambition is to overtake the Guggenheim with my own chain. . . . My MoCA series will serve the local community more and be more consumer friendly, always taking into consideration the local culture and history." Established in Colle di Val d'Elsa in Tuscany, in conjunction with *Arte all'Arte 6,* UMoCA is located on the dry riverbed under the arches of a fourteenth-century stone bridge that connects the town and a hillside monastery—hence, the name *Under Museum of Contemporary Art*. As architect, Cai selected the site and designed the museum logo, whose oversized neon letters incongruously illuminate the rustic landscape. As director, he set up museum facilities under ten arches, including the director's office, galleries for exhibitions and collections, and a café. As curator, he collaborated with the Taiwan-based critic Ni Tsai-Chin, who exchanged ideas with Cai about how to create a museum and also presented a mixed-media installation as the museum's inaugural exhibition. The role reversal between Ni and Cai added a provocative twist; Ni was a former director of the museum where Cai staged his explosion event *No Destruction, No Construction: Bombing the Taiwan Province Museum of Art* (1998, cat. no. 28). In 2005, in conjunction with *Arte all'Arte 10,* Cai curated UMoCA's second presentation, a solo exhibition by his studio director, the artist Jennifer Wen Ma, who installed wind pipes and hammocks under the old stone arches to create an environment of rest and contemplation for visitors. —RT

EXHIBITIONS AT UMOCA

2001: *Who Is the Happiest? UMoCA Inaugural Exhibition with Ni Tsai-Chin* for *Arte all'Arte 6*

2005: *Jennifer Wen Ma: Aeolian Garden* for *Arte all'Arte 10*

EXHIBITIONS ABOUT UMOCA

2001: *Exhibition of the Projects for Arte all'Arte 6,* Assoziacione Arte Continua, San Gimignano

UMOCA OPENING, 2001

NI TSAI-CHIN, *WHO IS THE HAPPIEST?*, 2001. FRAMED PAINTING REPRODUCTIONS AND PRINTED TEXTS. INSTALLATION VIEW AT UMOCA

JENNIFER WEN MA, *AEOLIAN GARDEN*, 2005. BRASS PIPES AND HAMMOCKS. INSTALLATION VIEW AT UMOCA

YUNG HO CHANG, *ONE DIVIDED BY TWO*, 2004. BUNKER STRUCTURE DIVIDED IN HALF. INSTALLATION VIEW AT THE CHANGLIAO REZONING DISTRICT

BMOCA (BUNKER MUSEUM OF CONTEMPORARY ART): EVERYTHING IS MUSEUM NO. 3
金门碉堡艺术馆：什么都是美术馆第三号
2004

PERMANENT MUSEUM OPENED IN **SEPTEMBER 2004**
ON KINMEN ISLAND, TAIWAN, SITED AT GUNINGTOU
CIHU GREAT BUNKER, NANSHAN FORTIFICATION,
TASHAN BATTERY, SHUITO VILLAGE, CHANGLIAO
REZONING DISTRICT, CULTURAL AFFAIRS BUREAU,
LINTSUO OLD-BATTLEFIELD ARMY BASE

With BMoCA, Cai's *Everything Is Museum* series
converged with the Cold War history of geopoliti-
cal conflicts across the Taiwan Strait. The "B" in
BMoCA stands for "bunker," some two thousand of
which dot Kinmen Island. The bunkers have been
used by Taiwanese forces to defend this and sur-
rounding islands from being seized by Mainland
China. Also known as Quemoy, the island lies just
offshore Fujian Province, Cai's home region, but it
has long been under Taiwan's control. Cai first
thought of using the then still active military bun-
kers as sites for art installations in 1991, when he
proposed to transform those found on either side
of the strait into "love hotels" as an antiwar ges-
ture in his Tokyo exhibition *Primeval Fireball: The
Project for Projects* (cat. no. 37). Ten years later,
9/11 prompted him to revisit the idea; this time,
he envisioned transforming the bunkers on
Kinmen Island into his third museum. The local
government, eager to promote tourism after the
island was opened up to direct travel from China
in 2002, was favorable toward Cai's idea of
BMoCA. Embodying his faith in art's power to
create a new symbolism, BMoCA was inaugurated
on the third anniversary of 9/11, with solo exhibi-
tions of eighteen artists and artists' groups both
from China and Taiwan. As curator, Cai further
iterated the concept of border crossing by select-
ing participants from diverse disciplines—such as
the curator Fei Dawei, the composer Tan Dun, and
the film director Tsai Ming-liang, among many
others—who created site-specific works in and
around former bunkers and related military sites.
Kinmen residents studied both local history and
contemporary art to serve as museum guides.
Over the six months during which *18 Solo
Exhibitions* took place, the number of visitors at
each exhibition ranged from 9,000 to over
106,000, with the overall total reaching some
880,000. As the first phase of his ambitious plan
to turn all of the island's military facilities into

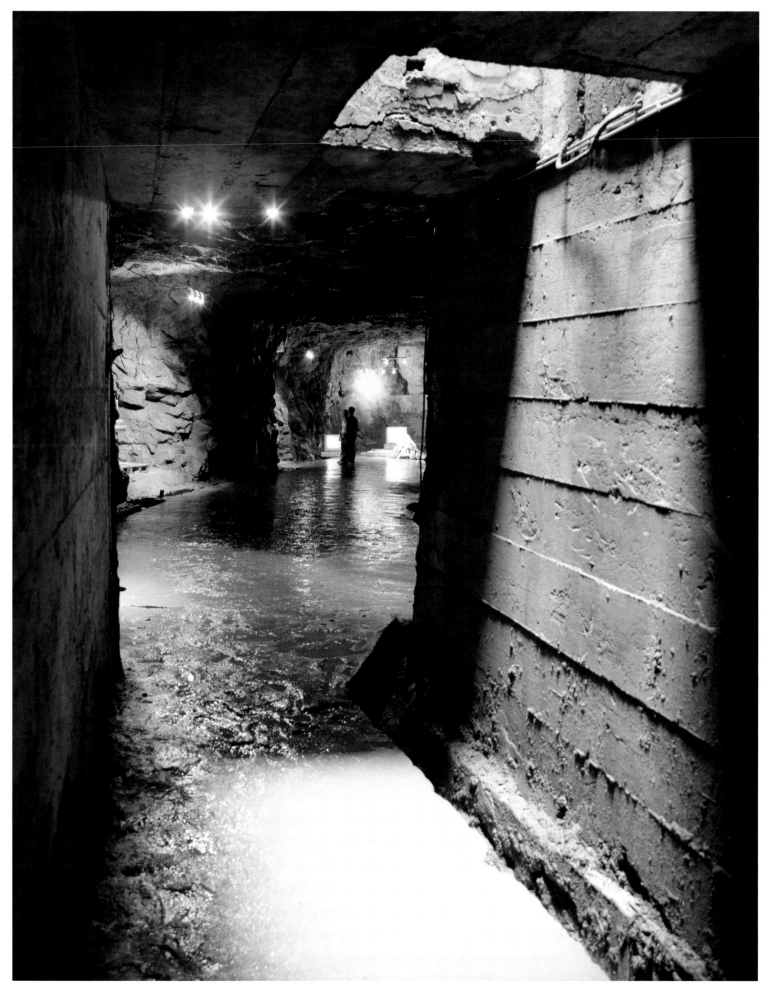

TAN DUN, *VISUAL MUSIC*, 2004. VIDEO, SOUND, AUDIO SPEAKERS, TV MONITORS, AND PIECES OF SMASHED PIANOS. INSTALLATION VIEW AT TASHAN BATTERY NO. 3 BUNKER

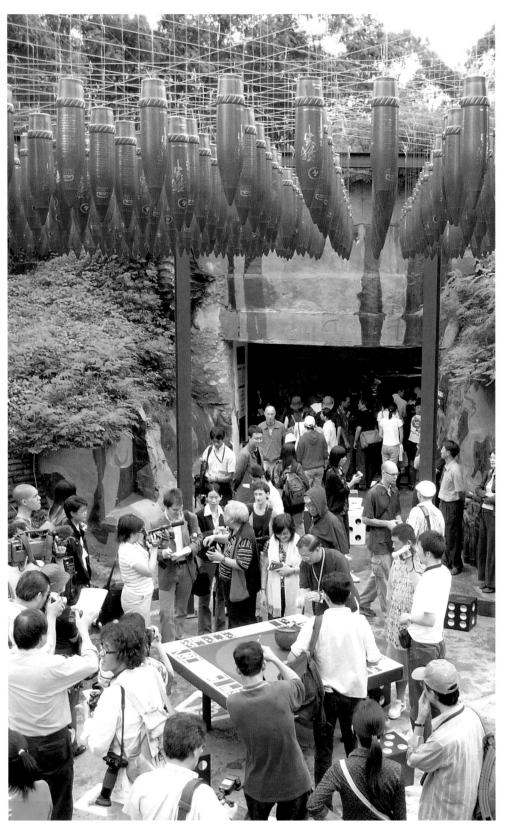

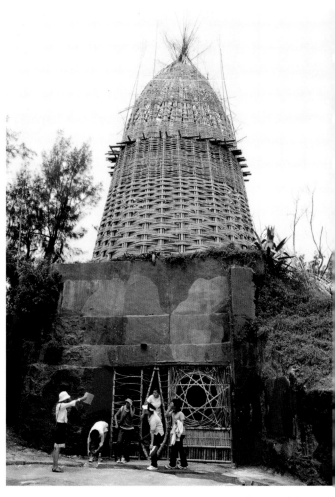

WANG WEN-CHIH, *DRAGON DARES TIGER LAIR*, 2004. BAMBOO AND RATTAN.
INSTALLATION VIEW AT NANSHAN FORTIFICATION NO. 2 BUNKER

LEE SHI-CHI STUDIO (LEE SHI-CHI AND TSAI CHI-RONG), *WAR BETS ON PEACE*, 2004. OUTDOOR CANOPY, SORGHUM LIQUOR
BOTTLES SHAPED LIKE ARTILLERY SHELLS, GAMBLING MACHINE, AND COMMEMORATIVE LIQUOR. INSTALLATION VIEW AT
NANSHAN FORTIFICATION NO. 1 BUNKER

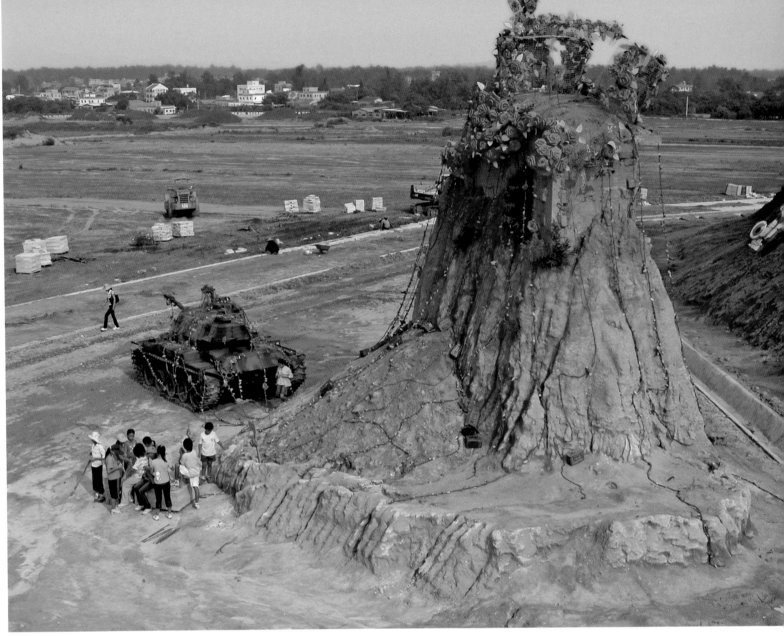

DUONIAN ELEMENTARY SCHOOL, *REGROWTH/OVERGROWTH*, 2004. PAPER ROSES, ROSE VINES, AND TANK. INSTALLATION VIEW AT CHANGLIAO REZONING DISTRICT

BMoCA, Cai also organized children's exhibitions. Fourteen groups, each selected from fourteen local schools, created original installations, many of which were informed by local history and culture.
—RT

EXHIBITIONS AT BMOCA

2004: *18 Solo Exhibitions*. The eighteen exhibitions were *Shen Yuan: Speaker Tea*, Guningtou Cihu Great Bunker; *Wang Jianwei: Soft Target*, Guningtou Cihu Great Bunker; *Lee Shi-chi Studio (Lee Shi-chi and Tsai Chi-rong): War Bets on Peace*, Nanshan Fortification No.1 Bunker; *Liu Xiaodong: Battlefield Sketches: The New Eighteen Arhats*, Nanshan Fortification Chungshan Classroom; *Wang Wen-chih: Dragon Dares Tiger Lair*, Nanshan Fortification No. 2 Bunker, Command Center, and surrounding areas; *Yao Chien: Listen! Who is Singing?*, Nanshan Fortification under the banyan tree and arsenal; *Yin Ling: Lovemaking for World Peace*, Nanshan Fortification No. 3 Bunker and Arsenal; *Ying Bo: Fei Ya! Fei Ya! (Flying)* and *Fusion*, Nahsan Fortification Arsenal and Blindage; *Da Lun Wei Art Squad (He Shi and Yan San): The Other Side of the Coast*, Tashan Battery No. 2 Bunker; *Tan Dun: Visual Music*, Tashan Battery No. 3 Bunker and Arsenal; *Su-mei Tse: Some Airing . . .* and *Yellow Mountain*, Tashan Battery No. 1 Bunker and Arsenal; *Tung Wang Wu: Surrender*, Tashan Battery No. 2 Bunker Arsenal; *Lee Mingwei: Shuito Legend*, Shuito Village; *Yung Ho Chang: One Divided by Two*, Changliao Rezoning District; *Fei Dawei: The Childrens' Bookstore Exchange Program*, Cultural Affairs Bureau; *Lin Hsing-yueh: Pyramid*, Cultural Affairs Bureau; *Tsai Ming-liang: Whitering Flower*, Lintsuo Old-Battlefield Army Base; and *Zeng Li: Fight Theatre*, Lintsuo Old-Battlefield Army Base

2004: *Kinmen Children's Bunker Museum of Art*, Changliao Rezoning District

EXHIBITIONS ABOUT BMOCA

2005: Documentation display *Can Buildings Curate*, Storefront for Art and Architecture, New York

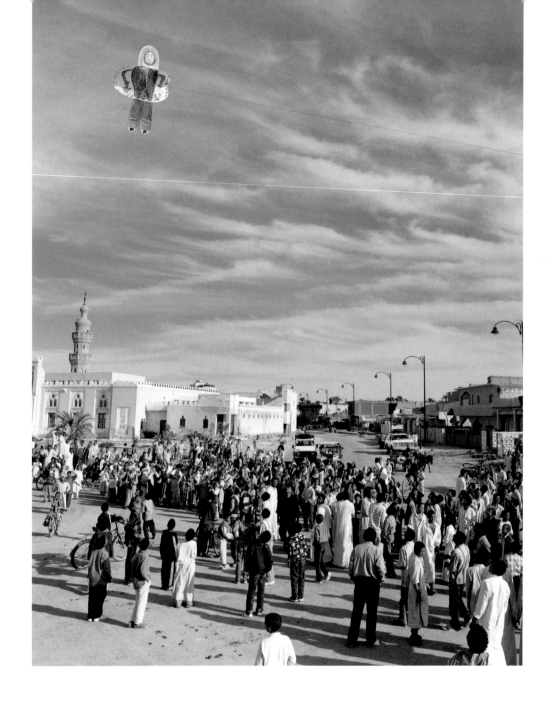

53

MAN, EAGLE, AND EYE IN THE SKY
天空中的人、鷹与眼睛：为埃及锡瓦作的风筝计划
2003

REALIZED **NOVEMBER 11–14, 2003**, **AT SIWA OASIS**, **EGYPTIAN SAHARA DESERT**. IN COLLABORATION WITH OVER 600 SCHOOLCHILDREN FROM 40 SCHOOLS THROUGHOUT THE GOVERNATE OF MARSA MATRUH. SILK AND BAMBOO HANDMADE KITES, AND PAINT. COMMISSIONED BY SIWA ART PROJECT, EGYPT

Created at Siwa Oasis, a remote town in the western Sahara, *Man, Eagle, and Eye in the Sky* best exemplifies the four most salient characteristics of Cai's social projects: his exploration of the symbolic power of art in a social context; his profound interest in local history and culture and astute incorporation of them into a project; his

active collaboration with the local people at all levels, from children to government officials; and his contribution, both cultural and economic, to the local community. The artist was invited to create an ephemeral land-based work by Siwa Art Project, an organization that promotes Siwa's cultural heritage internationally in an ecologically sensitive manner. Siwa's history and pristine environment inspired the artist to use kites as his medium. As indicated by its title, the project had three emblematic motifs. "Man" signifies humankind as an agent of history. "Eagle" refers to Alexander the Great, who traversed the Sahara Desert to receive an oracle in Siwa. And "eye in the sky" represents humankind's vision. The most significant, though intangible, ingredient of the project was the excitement it generated among the local population and the enthusiastic engagement

by over 600 schoolchildren, who participated in the painting workshop led by Cai and painted 300 kites brought from Weifang, China, the city that hosts the annual Weifang International Kite Festival. Some forty older boys helped fly the colorfully and imaginatively painted kites over the pristine desert and over the temple ruins and former strongholds for which Siwa is known. One hundred kites were used in an explosion event as a finale to the whole program. Cai found it gratifying to learn that a new custom has formed there, as people in Siwa have subsequently flown kites every year in late autumn, marking the anniversary of the project. The artist himself memorialized the project by creating a series of gunpowder drawings. —RT

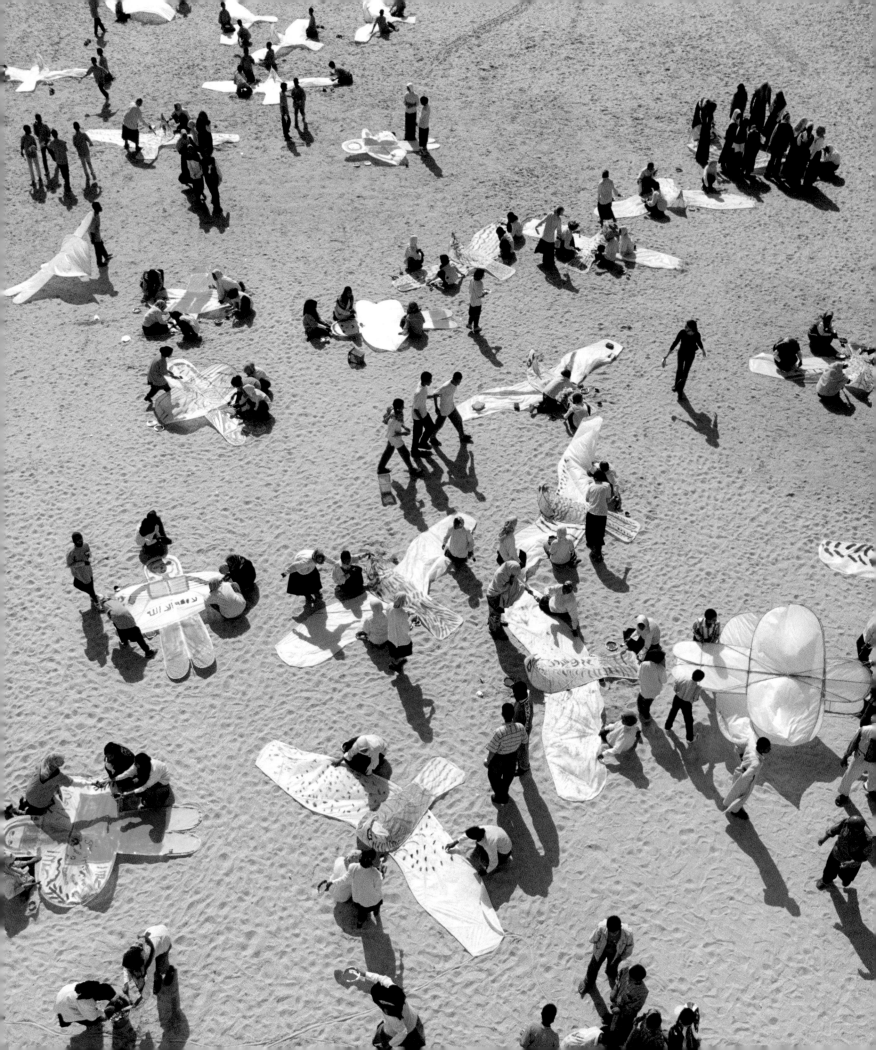

RELATED WORKS

2004: *Man, Eagle, and Eye in the Sky*. Gunpowder on
paper, mounted on wood as nine-panel folding screen, 230 x
698 cm overall. Collection of the artist
2004: *Man, Eagle, and Eye in the Sky: Eagles*. Gunpowder
on paper, mounted on wood as four-panel folding screen,
230 x 310 cm overall. Private collection
2004: *Man, Eagle, and Eye in the Sky: Eagles Watching
Man-Kite*. Gunpowder on paper, mounted on wood as six-
panel folding screen, 230 x 465 cm overall. Private collection
2004: *Man, Eagle, and Eye in the Sky: Eyes*. Gunpowder on
paper, mounted on wood as six-panel folding screen, 230 x
465 cm overall. Private collection
2004: *Man, Eagle, and Eye in the Sky: People*. Gunpowder
on paper, mounted on wood as eight-panel folding screen,
230 x 520 cm overall. Private collection
2004: *Man, Eagle, and Eye in the Sky: People Flying Eagle-
Kites*. Gunpowder on paper, mounted on wood as six-panel

folding screen, 230 x 465 cm overall. Private collection
2004: *Man, Eagle, and Eye in the Sky: People Flying Eye-
Kites*. Gunpowder on paper, mounted on wood as four-panel
folding screen, 230 x 310 cm overall. Private collection
2004: *Man, Eagle, and Eye in the Sky: People Flying Man-
Kite*. Gunpowder on paper, mounted on wood as four-panel
folding screen, 230 x 310 cm overall. Private collection
2004: *Man, Eagle, and Eye in the Sky: The Age of the Eagle*
(fig. 80)
2004: *Man, Eagle, and Eye in the Sky: Two Eagles* (fig. 81)

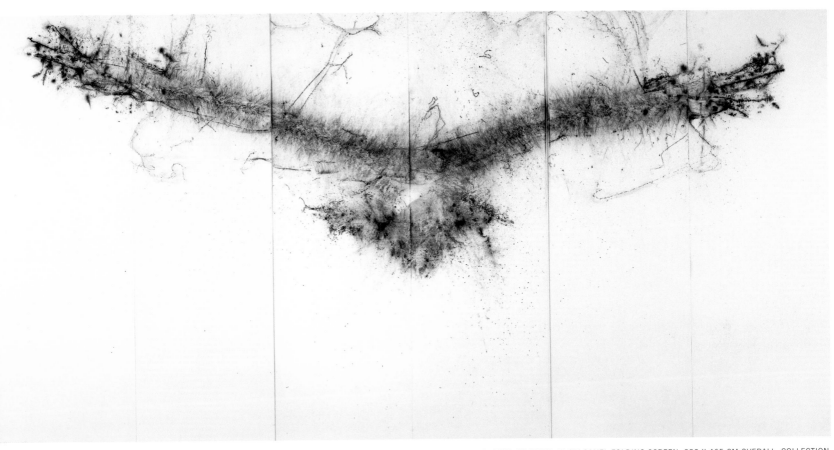

FIG. 80. *MAN, EAGLE, AND EYE IN THE SKY: THE AGE OF THE EAGLE*, 2004. GUNPOWDER ON PAPER, MOUNTED ON WOOD AS SIX-PANEL FOLDING SCREEN, 230 X 465 CM OVERALL. COLLECTION OF THE ARTIST

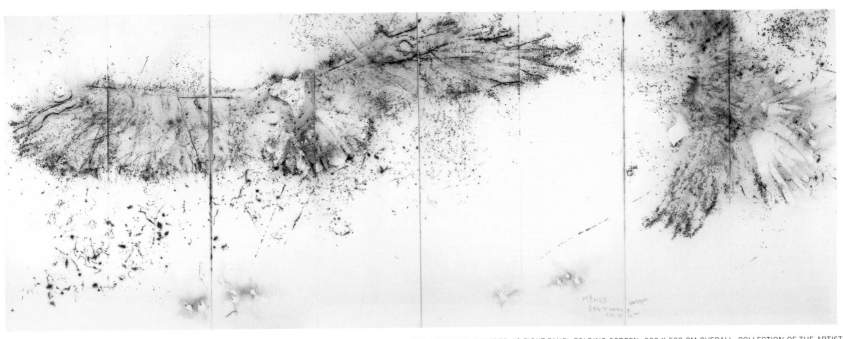

FIG. 81. *MAN, EAGLE, AND EYE IN THE SKY: TWO EAGLES*, 2004. GUNPOWDER ON PAPER, MOUNTED ON WOOD AS EIGHT-PANEL FOLDING SCREEN, 230 X 520 CM OVERALL. COLLECTION OF THE ARTIST

CLOUD GATE DANCE THEATRE OF TAIWAN'S REHEARSAL OF *WIND SHADOW*, SEPTEMBER 28–29, 2006,
AT CHIAYI PERFORMING ARTS CENTER AUDITORIUM

54
WIND SHADOW
风 · 影
2006

PREMIERED AT **NATIONAL THEATRE, TAIPEI,**
NOVEMBER 25, 2006, 7:45 PM, 90 MINUTES.
COLLABORATION WITH CLOUD GATE DANCE THEATRE
OF TAIWAN; CONCEPT AND VISUAL DIRECTION
CAI GUO-QIANG, CHOREOGRAPHY LIN HWAI-MIN

Cai majored in stage design at Shanghai Drama
Institute (also known as Shanghai Theatre
Academy) in 1981–85, and the modus operandi
he has developed as a visual artist is comparable
to that of a theater or film director. He has brought
together and directed diverse groups of people to
actualize his explosion events, installations, and
social projects. *Wind Shadow* offered him a rare
occasion to collaborate with a performing artist.

This collaboration with Lin Hwai-min, founder and
artistic director of Cloud Gate Dance Theatre of
Taiwan, began when Lin declined to participate in
Cai's project for the opening and closing ceremo-
nies of the Beijing 2008 Olympic Games and
instead invited him to provide the dance company
with the concept and visual direction for a stage
work. Their exchanges of ideas unfolded as Cai
played the role of self-acknowledged armchair

quarterback, presenting often outrageous concepts and images through ink drawings, e-mails, and occasional personal conversations. Cai and Lin focused on the themes of "wind" and "shadow." The artist conceived of this piece as "moving installation art," not just dancing. The staging is a study of motion in the monochromatic palette of black and white, light and shadow. In combination with choreographed lighting, use of mirrors, and

video projections, the dancing bodies create a variety of allusions to shadows and reflections. Props of fluttering and billowing kites, huge flags, and angel wings (on the dancers' backs) help visualize wind. Lin and Cai also collaborated on *Wind Shadow in the Air*, which was performed as a prelude to the premiere of *Wind Shadow* at the National Theatre in Taipei. For this piece, choreographed to music by Bach, a performer

with angel wings traversed the theater's roof, climbing up to the top ridge. The wings fluttered in the moonlight, catching the real wind blowing over the building. This collaboration rekindled Cai's interest in the human body as subject matter for his gunpowder drawings. —RT

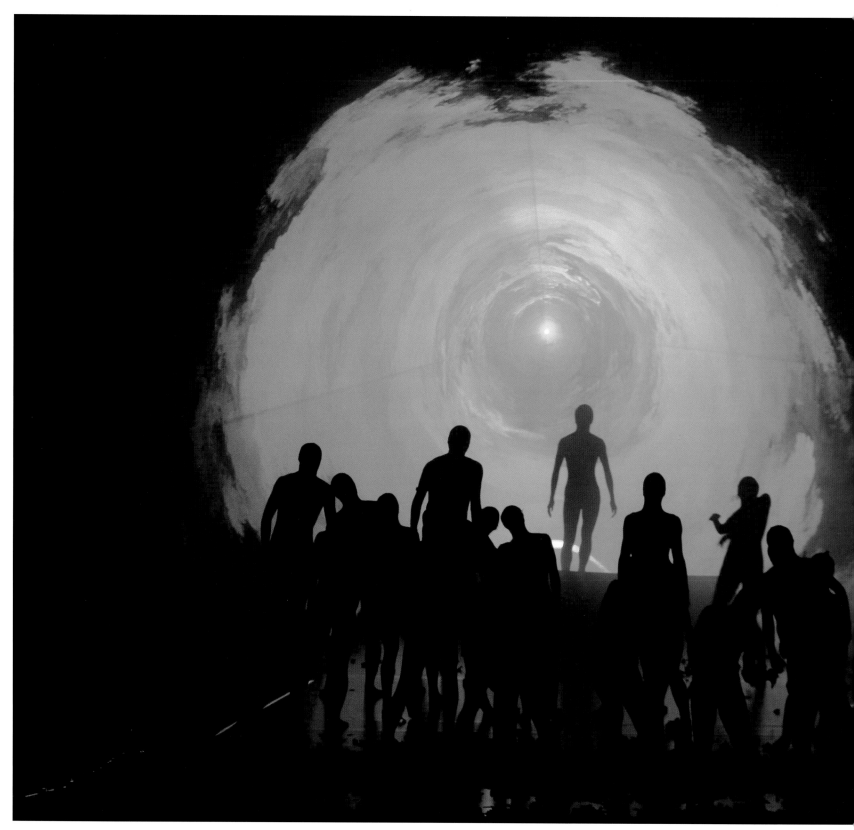

REHEARSAL OF *WIND SHADOW*, SEPTEMBER 28–29, 2006

FIG. 82. *DRAWING FOR WIND SHADOW*, 2006. INK ON PAPER, 27.4 X 37.5 CM.
COLLECTION OF THE ARTIST

FIG. 83. *DRAWING FOR WIND SHADOW*, 2006. INK ON PAPER, 27.4 X 37.6 CM.
COLLECTION OF THE ARTIST

VENUES TO DATE

2006: National Theatre, Taipei; Kaohsiung Cultural Center;
Chiayi Performing Arts Center

EXHIBITION HISTORY

2006: *Captured Wind Arrested Shadow: Cai Guo-Qiang
and Lin Hwai-min's Wind Shadow*, Eslite Gallery (Cherng
Piin), Taipei

RELATED WORKS

2006: *Drawings for Wind Shadow*. 111 works, ink on
paper, approximately 27.4 x 37.5 cm each. Collection of
the artist (see figs. 82 and 83)

2006: *Shadow of Dance*. Gunpowder on paper, 94 x 62 cm.
Private collection, Taipei

2006: *Shadow with Black Flags*. Gunpowder on paper,
400 x 600 cm. Private collection

2006: *Shadow with White Flags*. Gunpowder on paper,
400 x 600 cm. Collection of the artist

2006: *Shadows*. Gunpowder on paper, 300 x 400 cm.
Private collection

2006: *White Flags Black Flags*. Flags and two Taihu stones,
dimensions variable. Cloud Gate Dance Theatre of Taiwan
(flags) and collection of the artist (Taihu stones)

2006: *Wind Shadow in the Air*. Performance on roof of
National Theatre, Taipei, November 25, 2006, 6:45 PM,
24 minutes. Collaboration with Cloud Gate Dance Theatre
of Taiwan; concept and visual direction Cai Guo-Qiang,
choreography Lin Hwai-min

ANTHOLOGY

SELECTED BY PHILIP TINARI WITH REIKO TOMII

Cai Guo-Qiang's work over the last two decades has been interpreted in multiple ways. Discussions of Cai's technique, projects, and biography indicate much about the historical, geographical, and political contexts with which he has interacted. This anthology attempts to provide a mapping of the various viewpoints that have driven discourse about Cai over the course of his career thus far. The texts are divided into two basic sections: texts about, and texts by Cai. Both are arranged chronologically by year, and thus trace the artist's movements and developments within China, through Japan, to New York. The first section compiles texts by a wide range of authors and in a variety of formats. Included in the second section are statements by Cai, as well as excerpts from many of the numerous interviews he has given over the years. The aim throughout is to assemble the most significant texts through which Cai has come to be known, and to give a sense of the overlapping and sometimes competing ways in which he and his work are understood.

Original discrepancies in artwork titles have been retained. Annotations are editorial unless otherwise noted. Figure citations placed within brackets refer to illustrations in the anthology.

WRITINGS ON CAI GUO-QIANG

Sanda Haruo, "A Fierce Battle Between Two Matters," *Mainichi Newspaper* **(Japan), evening edition, Mar. 14, 1989. Originally published in Japanese, translated by Reiko Tomii.**

Today, a vast amount of information is exchanged, accumulated, and incessantly consumed. Art is no exception. One type of expression is quoted, and then this invites still further quotation. In this accelerating game of appropriation, the creation of something new becomes more difficult than ever. What can be done to sever this vicious cycle?

An exciting possibility is presented by . . . Cai Guo-Qiang, a second-generation artist of post-Cultural Revolution China. Cutting through the layers of quotation (especially that of art historical references), he descends to what can be called "primordial origin." Therein emerges the boundary between nature and non-nature; therein begins human creativity. Gunpowder, the material Cai works with, is symbolic of his path into this primordial origin.

His encounter with gunpowder, which was invented in his homeland some 1300 years ago, has made him aware of the dawn of human creativity—the history of civilization. He also discovered what can be called the "primal urge" toward expression in the dichotomy of creation and destruction inherent in this material. Gunpowder was his destiny, offering him a weapon to put the modern and contemporary art of the West that flooded post-Cultural Revolution China into perspective (or keep a critical distance from it) and arrive at an expression independent from it. . . .

In his new work, he replaced [canvas] with bands of Japanese paper reinforced by thin wood crosspieces. He had to destroy the institution of Western art, not only in terms of material (paint), but also in terms of painting support (canvas). Gunpowder . . . incinerates paper, another source of human civilization. . . .

Sanda Haruo is a cultural reporter for the nationwide daily Mainichi. *This article is the first critical and substantive review that Cai received in Japan. His solo exhibition at Gallery Kigoma, Kunitachi, in the outskirts of Tokyo followed his visit to Beijing, during which he gave a lecture at the exhibition* China/ Avant-Garde. *The exhibition also featured Cai's first installation work.*

Chiba Shigeo, "Fireworks at Mount St. Victoire: Chinese and Japanese Art," *Mainichi Newspaper* **(Japan), Sept. 10, 1990, evening edition, p. 6. Originally published in Japanese, translated by Reiko Tomii.**

. . . The present activities of the Chinese artists impressed me with their convincing efforts to express "art" free from the concept of "art" as formulated in either traditional Chinese or Western art.

Granted, the current state of Chinese art is chaotic because Chinese artists are trying, in a short period of time, to absorb the whole history of modern Western art all at once, from Impressionism to New Painting. Consequently, they practice any of these forms and styles of expression . . .

Although those first-class artists who participated in the *Chine demain pour hier* exhibition are not free from such chaos, they still asserted something very powerful in their art. Since my first visit to China [in 1988], I have been thinking about the origin of their power. Having visited China again [this year] and seen this exhibition in France, I came to realize that their strength derived from their aspiration to construct their "art" on an extraordinary scale . . . beyond the established norms, without trying to fit it into narrowly defined molds—be they that of traditional Chinese art or Western art.

For example, Cai Guo-Qiang, who uses gunpowder, initially proposed a large-scale project

in which he would lay gunpowder on Mount St. Victoire and create a line of fire rushing along the mountain. Due to the mountain fire last summer, anxious villagers opposed Cai's idea [and the artist opted for a project to create craters instead].

We, the Japanese, tend to think that this kind of project deviates too much from the framework of "art." Doesn't such a view expose the fact that Japanese art has merely managed to create something small and uninspiring, by either blindly following the Euro-American concept of painting . . . or hoping to refine given ideas, matters, or even their memories? Ultimately, this small art of Japan could never attain the extraordinary scale of the fireworks proposed for Mount St. Victoire.

At the time of this article, **Chiba Shigeo** *was curator at the National Museum of Modern Art, Tokyo, and the author of books including* A History of Deviations in Contemporary Art 1945–1985 *and* The Present Place of Art. *He currently teaches at Chūbu University, Aichi Prefecture. He was co-curator with Reiko Tomii of the Japanese section of the 1999 exhibition* Global Conceptualism: Points of Origin 1950s–1980s *at the Queens Museum of Art. This article is the only Japanese account of Cai's first major explosion event, realized at the exhibition* Chine demain pour hier, *curated by Fei Dawei in Pourrières, France in 1990. That exhibition marked the first exhibition of Chinese contemporary art by a Chinese curator in Europe, and can be seen as a coda to the* China/ Avant-Garde *exhibition in Beijing one year earlier.*

Serizawa Takashi, "Beyond Flash and Smoke," in *Cai Guo-Qiang. Primeval Fireball: The Project for Projects* **(Tokyo: P3 art and environment, 1991), unpaginated. Translation adapted by Reiko Tomii.**

In July 1990, P3 decided to have an exhibition of the art of Cai Guo-Qiang, regardless of the

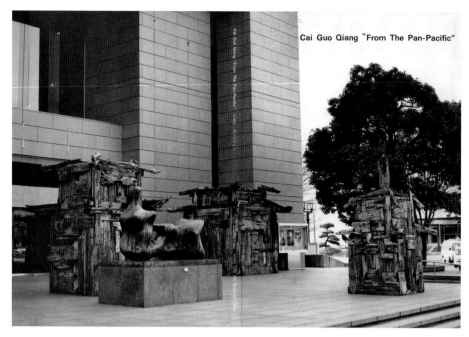

Cai Guo Qiang "From The Pan-Pacific"

FIG. 84. COVER OF *CAI GUO-QIANG: FROM THE PAN-PACIFIC*, EXH. CAT. (1994), SHOWING *SAN JŌ TOWER* (1994, CAT. NO. 38)

cost. That summer, after visiting Berlin . . . Takagishi Michiko and Itō Shinobu of P3 traveled to Aix-en-Province in southern France to see Cai's project of meteoric craters realized for the exhibition *Chine demain pour hier*. When they came home, their eyes were filled with enthusiasm. From their report, I gathered that instead of just watching, they had worked with him to help complete the project. Like farmers who till the earth in hope of rich harvest, they were engaged in the long, monotonous, and unending preparation work. As their expectations rose, the long awaited moment came. It felt like eternity, accompanied by a flash of light, explosive sounds, and gunpowder smoke. After a mere second, they had to go back to work, putting out the fire. The two unanimously reminisced: how gratifying it had been to help him. . . .

Their report made me realize that Cai's project had a far greater power to get people profoundly involved than I had ever imagined.

Subsequently, the relationship of P3 with Cai grew exponentially closer. I, myself was increasingly fascinated by him. I am afraid it may not be appropriate to say it in this way, but I think Cai Guo-Qiang has the talents of shaman. I don't want to tie his art particularly to his native country of China, or to the East (which naturally and fundamentally inform his

existence). Rather, we should discuss his art in terms of how it relates to the earth, the solar system, and the whole universe. I see in Cai a completely new type of shaman for the planetary age.

Serizawa Takashi is Director of P3 art and environment, an alternative space in Tokyo. The evolution of P3 and that of Cai's art were closely entwined from the beginning, as Serizawa and his enthusiastic staff members collaborated with Cai to develop his exhibitions and projects. This text eloquently captures the sense of excitement that Cai's art generated among his collaborators.

Kuroda Raiji, "The Future of Presenting 'Asian Art:' Thoughts on Asian Contemporary Art," *The Shin Bijutsu Shinbun* (Japan) 608, July 1, 1991. Originally published in Japanese, translated by Reiko Tomii.

. . .There are artists who transcend the symptoms of collage [uncritical hybridity], instantly nullify the notion of "cultural identity" [embraced as one of the theoretical pillars by the international art world], and invent their own art. They include Thai's genius, Thawan Duchanee, . . . Anish Kapoor, . . . and Cai Guo-Qiang. Cai's

projects constitute communication with the whole of humankind, the whole of history, no, the whole universe, through the use of the medium of gunpowder, a Chinese invention. His art is completely new; it starts from zero and transcends such stale issues as East versus West, tradition versus modernity, and high culture versus popular culture. In France [in the exhibition *Chine demain pour hier*], Chinese avant-garde artists presented work that effortlessly satisfied the Euro-American critical standard of "originality." Their work stunned me and completely changed my idea of Asian art. In fact, I was unfamiliar with these artists because no information was available from China's exhibition bureau, which was the main contact that Fukuoka [Art Museum] had in China. Thus, we were wrongly convinced that there was nothing but realist painting in China. . . .

Kuroda Raiji is an art historian and curator specializing in postwar Japanese and Asian art. Based in Fukuoka, he has been actively involved in research and exhibition activities at Fukuoka Art Museum and Fukuoka Asian Art Museum, his current affiliation. In this text, he self-critically examines the "illness" of modernism in Asia, which manifests itself in Asian contemporary art as the symptom of what he calls "collage," or mindless hybridity. Cai is included among the artists who transcend this illness.

Hirano Akihiko, "A Story Produced by Fire, Ocean and People," translated by Margaret E. Dutz, in *Cai Guo-Qiang: From the Pan-Pacific*, exh. cat. (Iwaki, Japan: Iwaki City Art Museum, 1994), pp. 12–17. [fig. 84]

. . . Certainly, Cai's art is unique when compared to other modern art. One cannot deny, either, the . . . [fame] his works have claimed, largely due to the fact that modern art is becoming "borderless." In a more literal sense, Cai is Chinese, and China has always been outside of . . . art limited by conventionality. This author believes, however, that there is a greater trend than ever to unify Chinese and Asian art and artists. If one tries to contain Cai within a modern artistic framework, his story becomes more important; attempting to cross art's limitation[s] is itself characteristic of modern thought. . . .

At the time of this article, Hirano Akihiko was assistant curator at the Iwaki City Art Museum, where major early projects by Cai including Returning Light: The Dragon Bone (Keel) *(in which locals worked with the artist to excavate a sunken ship from the waters of this coastal town) and* The Horizon from the Pan-Pacific: Project for Extraterrestrials No. 14 *(1994, cat. no. 22) were realized as part of this exhibition.*

Kurabayashi Yasushi, "What is 'Open System?'—To Identify It With Artists' Works," in *Mito Annual '94: Open System*, edited by Watanabe Seiichi and trans. by Media & Communications, Inc. (MAC), Miyatake Miki, and Miyatake Fumiyo, exh. cat. (Mito, Japan: Art Tower Mito Contemporary Art Center, 1994), pp. 58–69.

. . . One of Cai's most important viewpoints is the contrast between Western and Eastern cultures. The environment he was brought up in did not accept Western art as it was. Cai looks at Western culture from a foreigner's point of view and desires to transfer it. . . .

What is important is that Cai does not take the Western approach of dualism. Cultures and civilizations, along with goods and systems, were conceived by human minds that were alienated by nature. By understanding culture, human consciousness may offer an opportunity to look at nature and culture from a monistic perspective rather than the dual perspective of material and spirit. . . .

What impressed me most [of all of Cai's projects] was the plan for *The Vague Border at the Edge of Time/Space Project*. This is a project to create a world of confused time and space. . . . The plan . . . seemed to me . . . [very] important. . . . Without this plan, Cai's works might be regarded as an Asian version of Western land art. . . .

Explosive force above all transforms one substance into another through combustion. This is related to the idea of alchemy, exploring all the substances in the world. Alchemic thought, according to Jung (especially in his *Psychology and Alchemy*, 1944), is a philosophy that attempts a metamorphosis of matter and, at the same time, metamorphosis of the spirit.

Transforming or combining substances instantly in an explosion suggests transforming spirit in the blink of an eye. An explosion is a magical encounter of two different elements, and a process that encompasses the eternal transformation of matter. . . . The moment opens up at a point without time nor space, where visible and invisible, existence and non-existence, are connected, the spiritual, material and the cosmos synchronize, metamorphose, and become integrated. There seems to be an extinguishment of time, the explosion taking place both in an instant and in eternity. . . .

What happens if we compare similar factors in Cai's activities . . . [with] Western contemporary art? Beuys put all the traces of his activities into his works, and considered them to be "Social Sculpture," which form[s] people's consciousness. Regarding the issue of spirit and matter, Beuys might have been at a point that far exceeded the level of Western thought after going through the alchemic philosophy and thoughts of Rudolf Steiner. Cai's works are, in a sense, "Social Sculptures." Cai, however, strives to move beyond the subjective dualism of the West, that preoccupied Beuys, toward monism and acquire a wide perspective of civilization which both contains the self and allows the self to view itself from without.

Can he be compared with Christo, who implements socially large projects? He has recently strengthened his aesthetic approach and seems to be exploring the beauty of wrapping. Christo's works play a role in motivating people to participate in society, but they seem to come from the dualism of work versus audience. A wrapping piece always comes from outside and is installed. Cai wants to transform the 'place'

Another important factor is that Cai's ideas go beyond Western environmental studies, which are based on rational science, and further enter the comprehensive ecology involving the local specific ecosystem and the history of cultures. . . . He also hopes that in any area or environment where his works take place, many new stories inspired by his works will be generated, including the possibility of various dialogues. . . .

The Wall was created by the Han to exclude other ethnic groups and to fight for and fortify the regime's control. Cai's intention [in *Project to Extend the Great Wall of China by 10,000 Meters: Project for Extraterrestrials No. 10*](1993, cat. no. 21)] was to reuse and open the Wall, a fighting tool, to promote the progress of mankind. At the same time, explosions help emphasize man's desire for control and violence. . . .

Kurabayashi Yasushi is lecturer at Tokyo Zōkei University. This text was included in the catalogue for the Mito Annual '94 *exhibition for which Cai realized his project* Universal Design: Feng Shui Project for Mito: Chang Sheng.

Hasegawa Yūko, "New Order out of Chaos," in *Chaos: Cai Guo-Qiang*, exh. cat. (Tokyo and Osaka: Setagaya Art Museum and Nomart Art Editions Inc., 1994), unpaginated.

. . . Cai speaks of chaos as the only effective means for breaking out of the confusion of the present. At first, this . . . [statement] sounds paradoxical, but it supported by recent scientific theories. . . .

The present *Chaos* project is closely related to the 2000-year-old cultural objects being brought from mainland China for exhibition at Setagaya Art Museum. About Japan, Cai says: "The Chinese are closer to Westerners than the Japanese. I was interested to find many 'oriental' things still existing in Japan"

When visitors who have wandered among objects from 2200 years ago enter the "last room" created by Cai, they will be amazed at . . . [the] continuities and differences [between the China of the past and the present]. The flame reproducing the Great Wall built by the emperor has turned into a dragon on a screen. Living silkworms continue their mindless task of exuding silk thread. Silk embroidery reveals violent scenes from history. The viewers may be confused at first but will eventually realize how the process of history is drawn into the flow of nature and becomes one with the present.

Only the turbulent, boundless energy of a chaotic land makes this unification possible. Synthesizing ancient China and contemporary Japan . . . [through the concept of] chaos leads to an exchange between the spirits of both and opens up the possibility of a new order.

The "inhumanity" spoken of in Taoist thought is the idea that all things, including human beings, are one, and it points to a

disinterested level [of existence] beyond the human. Humanism, which focuses on human beings, is of little interest to Cai. No matter how much we may try to live at one with the forces of nature, human activity cannot escape the paradox of destroying or invading nature. . . . Cai considers ways of delaying the end as much as possible through wisdom and will power, that is, facing death as gently and calmly as possible.

"Contradiction, what is wrong with that?" asks Cai. He says this as a pure-hearted healer. If one searches for the pressure points of a tired art like searching for the pressure points of a living person, [then] "works of art can be made well like a person and prevented from becoming tired."

The state of chaos, neither monist nor dualist, created by Cai produces violent motions and vibrations between yin and yang. He reminds us of the angel who races at high speed through a special zone between heaven and earth, where eternity and the present exist without contradiction—a Taoist destroying and creating life.

At the time this was written, Hasegawa Yūko was curator of contemporary art at Setagaya Art Museum, Tokyo. She curated Cai's solo exhibition, Chaos, in 1995. In this catalogue, she articulates her thesis on the relationship of Taosim to Cai's art. She is currently Chief Curator at the Museum of Contemporary Art, Tokyo.

Sugawara Norio, "The Year in Art '94: Striking Rise of Asia: Cai Guo-Qiang Very Active, Decline of Euro-American 'Contemporary' [Art]," Yomiuri shinbun (Japan), Dec. 14, 1994, evening edition, p. 11. Originally published in Japanese, translated by Reiko Tomii.

. . . This year, there was no major exhibition comparable to the last year's Anselm Kiefer exhibition [at Sezon Museum of Modern Art, Tokyo]. However, regional museums asserted their presence with challenging projects. Especially notable are those focusing on Asia. They include two fall exhibitions: *Creativity in Asian Art Now* at Hiroshima City Museum and *The 4th Asian Art Show* at Fukuoka Art Museum,

both of which communicated the changing dynamism of Asian art. The Japan-based Chinese artist, Cai Guo-Qiang was arguably one of the busiest artists in the world this year, having had a solo exhibition at Iwaki City Art Museum (in March) and having been invited to various exhibitions and symposiums. It is not an exaggeration to say that his popularity exemplifies the rise of Asian art. . . .

Sugawara Norio is a cultural reporter for the nationwide daily Yomiuri, *who has also authored several volumes on Japanese and Western contemporary art. In this year-end review, Sugawara argues that the state of contemporary art can no longer be assessed simply by looking at it in Euro-American terms, and that Cai's popularity in Japan is symptomatic of this new reality.*

Yamawaki Kazuo, "Between Earth and the Heavens: At a Cross Road of the Civilization" in Between Earth and the Heavens: Aspects of Japanese Contemporary Art II, edited by Yamawaki Kazuo, trans. by Julia Cassem and Karen Miyagi, exh. cat. (Nagoya: Nagoya City Art Museum, 1996), pp. 7, 9, 11, 13, 15, 17, 19, 21, 23, 25.

. . . The Chinese artist Cai . . . was chosen for this exhibition [*Between Earth and the Heavens*] because of the tremendous stimulation he has afforded for the Japanese art world of the 90's. Contemporary Asian art has begun to attract attention in the past several years, but the fact that Cai has chosen Japan as the central base for his activities points to the important role it has to play in Asia in the contemporary art world. While contemporary Japanese art has tended to look to the West, Cai has plainly expressed oriental themes in his work producing work[s] that are explicitly Asian in origin [and] which differ in essence from those born of contemporary Western methodology. . . .

As we face the turning point in modern civilization, Cai inquires whether the neglected Orient can shoulder the responsibility for the civilization of the future. . . .

Nevertheless, the violence engendered by these explosions is also a key element of Cai's works. He sees this violence not as a method of killing but as a means by which life is renewed.

With an explosion, man instantaneously returns to nothingness and the infinitesimal experience of the "Big Bang" at the birth of the Universe. . . .

A creation of man, modern science has brought us environmental destruction and the nuclear bomb-achievements that have pushed us to the brink of extinction. By adopting the viewpoint of the extraterrestrial, [Cai] . . . brings Man face to face with the Creator and warns him of his foolishness. . . .

Also, when he presented *Project for Extraterrestrials—Fetus Movement II* [1992, cat. no. 20] at the Hann Münden military base in Germany, he tried to release nature into the base and thereby soften the martial aspects of the surroundings by bringing in water from a nearby river. In this way, today, Cai tries to revive traditional oriental philosophy and concepts which have been rejected by modern science. . . .

At a cross road of the civilization where Modern Western thinking has shown signs that it is rushing towards a dead end . . . Cai . . . manifested clearly the recovery of the relationship between art and life through the oriental way of thinking which has been discarded in modern time. This is why Cai's work has brought refreshing stimulation to the Japanese contemporary art world. In the accepted scheme of things, the West is advanced and . . . Asia lags behind. If this paradigm is transformed, then the opposite may become true. In this way, a lesson will be taught to us—a people dedicated to the West since the Meiji Period—by a neighbor from . . . [an] Asia that "lags behind". . . .

Furthermore, while Genghis Khan conquered the West,* in recent times the East has been conquered in the figurative sense by contemporary Western civilization. Yet as we witness the struggles of modern civilization, the question arises as to whether the Orient may or may not play a major role in world history once again. If this were to happen, would it lead the world, including the Orient, in a better direction? Cai's work hurls this question at us amidst the dangers and expectations surrounding oriental culture as it spreads beyond East and West.

* This part of the essay discusses the work *The Ark of Genghis Khan* (1996, see cat. no. 39).

Between Earth and the Heavens—Aspects of Contemporary Japanese Art II *is the sequel to* Seven Artists—Aspects of Japanese Contemporary Art. *Both exhibitions were designed to showcase various trends and artists in Japanese contemporary art, especially to a Western audience. The five artists chosen were not unified by any particular theme; instead they were chosen to highlight the diverse character of contemporary Japanese art.*

Jon Ippolito, "Cai Guo-Qiang," in *The Hugo Boss Prize 1996* (New York: Guggenheim Museum, 1996), pp. 51–59.

. . . While Cai's ceremonies are intended to heal the spirit, they are not sacred rituals. Their meaning derives not from religious objects but from the medicinal or therapeutic value they offer society. Cai doesn't pray for Venice, he does acupuncture on its walls. He doesn't offer lectures in Buddhist philosophy to visitors to his installations, but healing herbal teas. For their part, the people who live near Cai's installations often volunteer to set miles of cable afloat or to salvage hundreds of boards from a shipwreck rather than passively observe his events.

For Cai, a profoundly optimistic artist, there is no contradiction between dispensing medicines and detonating gunpowder. Although he grew up within earshot of bombs dropped by Taiwanese planes in their struggle with mainland China, he believes that aliens will interpret his explosions of gunpowder as friendly attempts at communication and that discharging his own gunpowder mushroom clouds near the Nevada Nuclear Test Site will remedy an injustice of the past. By incorporating into his work the immense and the tiny, the horrific and the healing, Cai aims to re-establish harmony in a world splintered into disconnected fragments of experience. Perhaps his most ambitious attempt to date is *Project for Extraterrestrials No. 9: Fetus Movement II* [cat. no. 20], performed in 1992 at a military base in Hannoversche-Münden, Germany. After diverting water from a nearby stream, Cai planted nine earthquake sensors in the island thus formed and attached an electrocardiograph and electroencephalograph to his own body. He then discharged ninety kilograms of explosives, setting off a sequence of detonations in concentric rings that radiated out from the center of the island to its circumference and back again. The scene left for viewers once the smoke had cleared is a fitting emblem for Cai's project: a man sitting alone on an island, the apparatus wired to his body recording his effort to link his heart and mind to the trembling earth below and to the vast, possibility-filled sky overhead.

At the time this was written, **Jon Ippolito** *was Assistant Curator of New Media Arts at the Guggenheim. He has taught in the New Media Department of the University of Maine since 2002. This text, which appeared in the first Hugo Boss Prize publication, accompanied the showing of Cai's installation* Cry Dragon/Cry Wolf: The Ark of Genghis Khan (cat. no. 39) *at the Guggenheim Museum SoHo.*

Geremie R. Barmé, "Draco volans est in coelo—Flying Dragon in the Sky," translated by Anneli Fuchs, Eva Lund, and Annette Mester, in *Cai Guo-Qiang: Flying Dragon in the Heavens*, exh. cat. (Humlebaek, Denmark: Louisiana Museum of Modern Art, 1997), unpaginated. [fig. 85]

. . . By alighting on the dragon for this installation, Cai Guo Qiang has chosen one of the stereotypical and ubiquitous motifs of *Chinoiserie*. Cai uses it to revisit both the cultural clichés of China and the apprehensive and exoticised perceptions of that country among Europeans. It is in the dragon-cliché that East–West can confront each other, in a mood of formulated recognition and formulaic self-assertion. . . .

The threat of the Chinese dragon has figured in the European mind for over a century. There has been a lingering fear of what will happen "when the dragon wakes." In recent years the English author David Wingrove has exploited this line of thought in his best-selling, multi-volume epic *Chung Kuo*. In this sci-fi tale Wingrove depicts a world in which the Chinese Han have overwhelmed the world and rewritten the history of mankind to blot out the existence of Western civilisation. According to . . . [this] account, the Roman Empire was extinguished in the first century A.D. by General Ban Chao of the Eastern Han Dynasty, and that defeat lead to an unbroken Han hegemony for over two millennia. . . . The emblem of the Han ruling house of the Seven is the (spurious) *Yuelong*, or Moon Dragon. . . .

In his recent work, Cai Guo Qiang has been playing, even dwelling on the image of the Oriental Dragon as shibboleth of the Western imagination. The dragon has become something of a self-fulfilling augury of change, threat, and difference, and Cai is relentless in his investigation of its looming presence. In late 1996, he exhibited an installation at the Guggenheim Museum gallery in SoHo, New York called *Cry Dragon/Cry Wolf: The Ark of Genghis Khan* [cat. no. 39]. His work consisted of a huge log raft that appeared to be held aloft by inflated sheepskins of the type used in fording rivers by the Mongols, rulers of the Yuan Dynasty (thirteenth century) that once held sway over much of Asia and parts of Europe. The Ark was seemingly powered by Toyota car motors running at full throttle, the unambiguous symbol of. . . Asian economic rise and technological thrust into Euro-America. The whole contraption was named the Ark of Genghis Khan, a menacing marriage of the Biblical Noah's far more benign boat with the mechanism of relentless expansion represented by the Golden Hordes. . . .

In "Draco volans est in coelo" Cai Guo Qiang releases his dragon over the Øresund between Denmark and Sweden. But what is the particular dragon he has chosen? The Chinese genus of *long* incorporates many species: "the Celestial Dragon *tianlong*, which protects and supports the mansions of the gods; the Spiritual Dragon *shenlong*, which produces wind and rain to benefit mankind; the Dragon of Hidden Treasures *fucanlong*, which mounts guard over the wealth concealed from the mortal eye; the Winged Dragon *yinglong*; the Horned Dragon *qiulong*; the Coiling Dragon *panlong*, which inhabits the waters; and the Yellow Dragon *huanglong*, which emerged from the River Luo to present the elements of writing to the legendary Emperor Fu Xi."*

This is a conundrum that spectators must resolve for themselves as they contemplate Cai Guo Qiang's fiery dragon in flight in the winter sky of northern Europe. As we recall the line from the *Book of Changes* from which this work takes its name, "draco volans est in coelo" (*fei long zai tian*) or "flying dragon in the sky," it

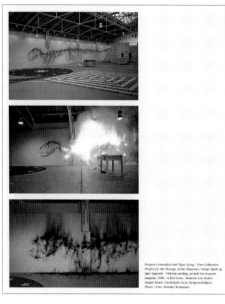

Dragon Concealed and Tiger Lying - True Collection, Project for the Storage of the Museum / Drage skjult og tiger liggende - Virkelig samling, projekt for museets magasin, 1996 -A Red Gate-, Museum van Hedendaagse Kunst, Citadelpark Gent, Belgium/Belgien. Photo / Foto: Miwako Wakimura.

Draco volans est in coelo - Flying Dragon in the Sky

BY GEREMIE R. BARMÉ [1]

China perhaps more so than most other great ancient civilisations is notably lacking in the monumental evidence of its historical and cultural longevity. Myth and symbol more than physical artefacts make up much of what is often presented as proof of its thousands of years of continuous civilisation.

Of course, the depredations of civil unrest, internecine strife and wilful vandalism have done much to demolish the remains of the rich array of Chinese achievement. The fragile nature of Chinese buildings too, many of them constructed in perishable wood and tile, has meant that few ancient structures or even their foundations have survived. Most of the renowned palaces, temples and houses are of recent provenance, at best the work of the energetic builders or re-builders of the last great dynasties, the Ming and Qing.

Surveying the legacy of the Chinese past it is easy to

be drawn to consider those famous lines by Shelley in -Ozymandias,- the poet's meditation on the fallen grandeur of Rameses II of Egypt :

And on the pedestal, these words appear:
My name is Ozymandias, King of Kings,
Look on my Works, ye Mighty, and despair!
Nothing beside remains. Round the decay
Of that colossal Wreck, boundless and bare
The lone and level sands stretch far away.

It is on a level stretch of sand surrounding the remains of another ancient civilisation that Cai Guo Qiang has so often sought a place for his own monumental, tantalising and wisely transient work.

Cai Guo Qiang has been making his artistic presence felt outside China for over a decade, having migrated to Japan in 1986. He quit the Mainland at a crucial juncture in the contemporary cultural history of that

FIG. 85. OPENING PAGES OF GEREMIE R. BARMÉ, "DRACO VOLANS EST IN COELO—FLYING DRAGON IN THE SKY" (1997), SHOWING PHOTOGRAPHS BY MIWAKO WAKIMURA OF *DRAGON CONCEALED AND TIGER LYING—TRUE COLLECTION, PROJECT FOR THE STORAGE OF THE MUSEUM* (1996), CITADELPARK, GHENT

would be well also to remember the reading for the last line of the hexagram *Qian* "The Creative," the *locus classicus* of Cai's work. It says, again in Latin translation, "draco transgressus est, est quod poeniteat" (*kang long you hui*) or "arrogant dragon will have cause to repent."

The ancient oracle warns against titanic aspirations that exceed one's true abilities, the perverse pursuit of which make it inevitable that a precipitous collapse will surely follow.[†] And it is at such a moment, at the point of soaring majesty, that Cai Guo Qiang's flying dragon, having achieved its own epiphany, explodes, self-immolates, and falls to earth.

[*] The footnote here reads: "C.A.S. Williams, *Outline of Chinese Symbolism and Art Motives: an alphabetical compendium of antique legends and beliefs, as reflected in the manners and customs of the Chinese*, Shanghai: Kelly and Walsh, 1941, p. 136."

[†] The footnote here reads: "The I Ching or Book of Changes, The Richard Wilhelm translation rendered into English by Cary F. Baynes, London: Routledge & Kegan Paul Ltd, 1970, pp. 9–10."

Geremie Barmé, Ph.D. is Professor of History in the Research School of Pacific and Asian Studies at the Australian National University. His unique view

of Contemporary Cultural Sinology is best glimpsed in his books In the Red: On Contemporary Chinese Culture *and* Shades of Mao: The Posthumous Cult of the Great Leader, *and in the documentary films that he has codirected:* The Gate of Heavenly Peace (*on the 1989 student movement) and* Morning Sun (*on the Cultural Revolution). This essay is one of very few non-art historical discussions of Cai by China scholars coming from other perspectives.*

Barry Schwabsky, "Tao and Physics: The Art of Cai Guo-Qiang," *Artforum International* **35, no. 10 (Summer 1997), p. 118–21, 155.**

. . . Cai . . . is meant to be seen as a "new discovery from ancient China." Though the specifically Chinese dimension of his work is undeniable, it occurs within an artistic framework that is to all appearances Western, familiar to anyone acquainted with the contemporary-art lineage that links Yves Klein and Joseph Beuys to *arte povera* to younger artists such as Kcho (with whom Cai shares an obsession with boats) or Matthew Barney (alongside whom he exhibited this fall in a show of Hugo Boss Prize nominees held at the SoHo Guggenheim). There is by now a multigenerational international vernacular of installation art that combines

showmanship with elusiveness and synthesizes the collective familiarity of the readymade with the suggestively idiosyncratic "atmosphere" of *bricolage*.

That Cai partakes of this international artistic lingua franca does not make him an epigone—it simply identifies the idiom within which he works. From an aesthetic viewpoint, in fact, Cai must be counted among its most fluent practitioners. . . . That we know so little about the immediate cultural situation in which an artist like Cai developed—his schooling, access to artistic developments abroad, his sense of a potential public, and so on—only increases our willingness to be entranced by his originality. Cai's work is fascinating precisely where it seduces, even deceives, only to reverse our expectations and challenge our habits of mind. Just as what is materially most ephemeral can prove monumental in scale, what begins as uncritical awe can often lead to productive skepticism. . . .

The hybridity of Cai's work goes deep enough to unsettle our sense that it can either emerge from or rejoin something with enough coherence to qualify as a "culture," Western or Chinese. Thus, if his installations at the Louisiana were presented alongside a trove of Chinese treasures to underwrite a notion of cultural identity, ready links between his art and national traditions were soon dissolved. If Cai chooses, as Geremie R. Barmé phrases it in his catalogue essay, "to trade on the history and mystery of his homeland," we should recognize that this "trade" takes the form of an exchange to which we viewers bring as much as the artist does, even if it has been orchestrated by Cai himself. . . .

When, in the large-scale gunpowder-burnt drawings (backlit by neon) in which Cai reflects on his *Projects for Extraterrestrials*, we notice the image of the atomic mushroom-cloud among the instances in which "light leaves the earth and flies out into the universe," we may wonder what "wisdom" does not carry its own particular poison within it. Even the extensive wall labels at the Louisiana tended to play slyly and almost imperceptibly with their own authority, vacillating between the persona of "curator" and that of "artist," their often rather ethnographic tone seeming to take liberties with the viewer's interpretive autonomy. ("This will

make the thoughts of the viewer fly out into the cosmos together with the light"—well, thank you!) As seductive as it is equivocal, Cai's work calls for an aesthetics of suspicion, yet suggests that skepticism may be difficult to sustain once you've got a dragon by the tail.

Barry Schwabsky is a poet and longtime contributor to Artforum International, *as well as the author of books including* The Widening Circle: The Consequences of Modernism in Contemporary Art. *This 1997* Artforum *profile represents the first feature-length treatment of Cai's oeuvre in a major American art magazine, coming shortly after his arrival in New York. Cai's solo exhibition at the Louisiana Museum of Modern Art in Humlebaek, Denmark was his first monographic exhibition in Europe.*

Holland Cotter, "Playing to Whoever In Distant Galaxies," *New York Times*, **Aug. 15, 1997, p. C24.**

. . . As in much of Mr. Cai's work, the primary message here [*Cultural Melting Bath: Project for the 20th Century* (1997, cat. no. 40) at the Queens Museum of Art] seems to be one of healing, psychic and social. The rocks have been configured according to Taoist principles to facilitate the flow of vital energy through the space. Herbal ingredients prescribed for a restorative bath are at hand near the tub. And the tub itself, communal in size, is a metaphor for the invigorating "melting pot"—which for some immigrants also proves to be a baptism by fire—that is New York City today.

Despite the wealth of resonant ideas it sparks, *Cultural Melting Bath* has some problems. Within the static environment of the gallery, Mr. Cai's mercurial, essentially gestural sensibility tends to stiffen up. And as is often true in assemblage-based installations, the work's discrete components never entirely gell visually, leaving a final product more rewarding to think about than to actually experience. . . .

Holland Cotter is an art critic for the New York Times. *This is the first of several pieces he has written on Cai. It is a review of Cai's project* Cultural Melting Bath: Project for the 20th Century *at the Queens Museum of Art.*

Huang Du, "Cai Quo-Qiang: From Mystery and Philosophy to Reality," *ArtAsiaPacific* **20 (Fall 1998), pp. 58–61.**

. . . It is obvious that artists apply cultural elements to their artistic expression, and Cai is no exception, creating through his art a third space that is neither purely eastern nor western. His art is a cultural strategy to give meaning to the conflict between traditional, cultural, spiritual, and material elements in modern society and culture. In other words, he harnesses paradox, namely the parallel hybridity of history and reality, spirit and phenomenon, sensitivity and rationality, to create dramatic visual effects. Cai resembles a cultural wizard predicting potential cultural power and the volatility of an ever-changing world. Like traditional Chinese landscape paintings, his works bring the audience into a mobile and inhabitable objective world. His art is an experiment that seeks to unite the viewer and the artwork in a cohesive whole, in the spirit of the aesthetics and language of modernity.

Cai transfers and transplants the traditional wisdom of the East to the context of the modern West and enthusiastically displays the force of nature. He develops the fundamental concepts of Chinese herbs, such as essence, balance and unity, and redefines *feng shui* to create a new, yet intangible, appreciation of life and art. This adoption of mystery and philosophy presents uncharted territory for art criticism in the East and West—a third space in the dichotomy. It is therefore impossible to capture the inherent complexity of Cai's art by viewing it in terms of an East/West logic. . . .

Huang Du is one of China's most active independent critics and curators. He was one of the curators of HyperDesign: The 2006 Shanghai Biennale, *and curator of the Chinese pavilion for the 2004 São Paolo Biennale. This article is typical of Chinese Mainland interpretations of Cai's work in the 1990s, in its concern with a dialogue between East and West.*

Hasegawa Yūko, "Circulating *Qi* **(Energy) of Mind and Intellect,"** translated by Reiko Tomii, in *Cai Guo-Qiang: I Am the Y2K Bug*, **edited by Gerald Matt, exh. cat. (Vienna: Kunsthalle Wien, 1999), pp. 8–18.**

. . . Cai accepts the contradiction that destruction and violence can be perceived as beautiful. His thinking is founded on Daoism (Taoism), the cornerstone of Chinese thought: each and every existence in this world—from humans to other living beings to lifeless beings—consists of *qi* (*ch'i*; invisible energy) and, according to Zhuangzi (Chuang Tzu), the true phase of being is chaos. . . .

To Cai, explosion is the simplest form of practicing *dao* (*tao*). . . . Practice of *dao* becomes possible by being one with the explosion itself. It is said that only the human mind can control *qi*. At such a time, the mind is one whole existence, embracing both the body and the spirit; . . . [this] can create a relative relationship, or vibration, not only with the intellect but also with *qi*. Controlled by *qi*, violence can become beauty. . . .

Dao is a philosophy of action. Today, our times and values are thrown into . . . turbulent change. For Daoists, who consider both themselves and the situations around them . . . [to be subject to constant change], no other time is as fitting as today to exert their power. What Cai the artist intends to do is to agitate and massage our . . . [rigid] thought[s], values, and soul[s].

It is logical that Cai emerged in the 1990s. As the theories of chaos and complex systems flourish in mathematics and science, as geopolitics become more intricate after the end of the Cold War, [and] as multiculturalism gathers momentum, [Cai] . . . knowingly names his own place "chaos" and invokes its name to the face of audiences everywhere. . . . He almost looks like a Don Quixote mounted on a dragon, who suddenly appeared in the race one lap behind (due to the Cold War), and ended up taking the lead. . . .

In this text, Hasegawa Yūko elaborates on her interpretation of Cai's art in relation to Taoism, especially regarding the two basic concepts of qi and tao.

Erik Eckholm, "Cultural Revolution, Chapter 2: Expatriate Artist Updates Maoist Icon and Angers Old Guard," *New York Times*, **Aug. 17, 2000, pp. E1, E6. [fig. 86]**

With a typically enigmatic installation [*Venice's Rent Collection Courtyard* (1999), cat. no. 42]

that won high honors at the most recent Venice Biennale, the expatriate Conceptual artist Cai Guo-Qiang has unexpectedly achieved every artist's dream: he has provoked a debate, long overdue, in his officially stifled native country about the meaning of art, originality, and the avant-garde. . . .

The debate began in earnest this spring when some of the original 1960s sculptors at the Sichuan Academy of Art in Chongqing announced plans to bring legal action against Mr. Cai and the Biennale for copyright infringement.

To outsiders accustomed to the role that appropriation plays in contemporary art, such a lawsuit may occupy a position between naive and absurd, especially since it involves a collectively produced work of public art made in an era when the very idea of intellectual property was spat upon.

But the ensuing debate has exposed the wildly different artistic sensibilities that coexist in China today, as well as the nationalistic

Cultural Revolution, Chapter 2

Expatriate Artist Updates Maoist Icon and Angers Old Guard

Continued on Page 6

FIG. 86. FIRST PAGE OF ERIK ECKHOLM, "CULTURAL REVOLUTION, CHAPTER 2: EXPATRIATE ARTIST UPDATES MAOIST ICON AND ANGERS OLD GUARD" (2000), SHOWING *VENICE'S RENT COLLECTION COUTRYARD* (1999, CAT. NO. 42).

resentment stirred by Chinese artists who succeed abroad. Most instructively, it has brought out defenders who are trying to explain just why a modern work like Mr. Cai's can carry a meaning different from its source. "This debate has become a work of performance art in itself," said Wang Mingxian, a Beijing art historian. Mr. Wang extols the visual power of the original tableau, but along with many Beijing intellectuals he appreciates Mr. Cai's use of it in a radically different time and place, calling the Venice project a provocative transformation. . . .

Erik Eckholm was Beijing bureau chief of the New York Times *from 1997 through 2003, covering culture in addition to economics and politics. The fact that his account of* Venice's Rent Collection Courtyard *controversy ran in a major American newspaper speaks to both the fervor with which the debate played out in China and the way in which the entire incident resonated with the larger discourses of socialism and capitalism in late 1990s China.*

Jonathan Napack, "Chinese artists may sue Venice Biennale: 1999 appropriation of a 1965 Socialist Realist work causes anger," *Art Newspaper* **11, no. 106, Sept. 1 2000, p. 3.**

. . . The original [*Rent Collection Courtyard*] still stands, oddly enough, in the courtyard of the real-life rent collector on whom the work was based.

That its clumsy modelling and crude, vicious caricature would ever inspire anything but satire seems difficult to believe now, but not only did China's government-controlled press extol it as "a revolution in the history of sculpture," but Harald Szeeman tried to include it, apparently unironically, in the 1972 Documenta in Kassel, Germany, which he curated.

The Academy has yet to announce in which jurisdiction they will file suit, and it is not really clear if they will actually follow through. It probably has at least the tacit support of a government tired of defending China's persistent violation of agreements on intellectual property. The real issue, however, is the increasing climate of xenophobia among Chinese intellectuals.

Resentment of émigrés has increased in tandem with resentment of Westerners. Cai,

who left China fourteen years ago, has been mocked in print as a "green card artist" and a "banana man"—yellow on the outside, white on the inside. Dao Zi, a teacher at the Sichuan Academy, calls Cai's work "postcolonial cultural imperialism" for portraying China as backward and despotic.

Part of the problem is that China's opening-up is actually fanning hatred of foreigners. As access to the outside grows so does awareness of China's backwardness. Many have also had bad experiences abroad, not only at the hands of rude visa officers, but also when the inadequacies of their education are shown up when they move to a competitive arena like New York or Paris.

That many have overcome these handicaps and achieved great success is seen less as a triumph than as an insult by the mediocrities who dominate China's cultural establishment. The attempts by the Shanghai city government, for example, to encourage the arts are being suffocated by apparatchiks squeezing work other than ink or oil painting out of the city's new art fair and biennial.

The paradox is that the "Chinese culture" trumpeted by the old guard was, of course, imported from the Soviet Union in the 1950s. It is these washed-up Western-style artists, not ink painters or calligraphers, who feel under threat.

Jonathan Napack (1967–2007) was a Hong Kong-based critic specializing in Asian contemporary art and was Asia Advisor to the international art fair Art Basel. *His rather sardonic treatment of the* Venice's Rent Collection Courtyard *controversy shows yet another direction in which this complex event was narrated.*

Fei Dawei, "Amateur Recklessness: On the Work of Cai Guo-Qiang," in *Cai Guo-Qiang* **(London: Thames & Hudson; Paris: Fondation Cartier pour l'art contemporain, 2000), pp. 7–14.**

. . . Cai's charisma lies in the difficulty we have in integrating his work into the context of contemporary art. Yet, at the same time, the inspiration his work brings to contemporary art deeply affects us. Cai ceaselessly changes his work method. These changes result from

relationships established between method and nature rather than the logic of art history. Nature is not an exterior world that opposes humankind, but a process in which the human being participates. Nature, in its entirety, does not vary quantitatively but it can spread through an unlimited number of forms. Artistic creation neither adds nor removes anything from nature. It simply puts peaceful eternity into question with the obvious disorder of the world of appearances. The instant an artist enters into a natural state through his creation, he becomes capable of going back and forth in time, straying from change to change. Each time, the artist can choose any entry point into nature he wants, integrating himself into the grand process. Art history is nothing more than footprints left behind by artists on its path. The goal of creation is not to get into art history but to get out of it. This approach to art-making is diametrically opposed to that of numerous artists today who try to bring about some change in art history by means of their work. It is not Cai's intention to stimulate this history. He keeps his distance from it.

Cai expresses himself in a manner that is disorderly, without internal logic, and always changing. At the same time, his work is often polysemic and multi-methodological. In order to construct it, he sometimes resorts to a poem, a narrative, to mining the lyricism of a sentiment or joke. He uses concepts without necessarily making conceptual art. Convening diverse and fluctuating methods, he looks for the profound disorder of the world, in the attempt to attain an organic, global vision of the universe that surpasses chaos. Here, the dialogue between humankind and the world is free, relaxed, and humorous. Through the fragments of shattered traditional forms, we can still get a sense of the human quest within the universe. In a way, Cai Guo-Qiang is more of a romantic artist full of poetry and free from all formal constraints. . . .

Art critic and curator Fei Dawei, an influential voice in China during the 1980s and then internationally after his emigration to Paris in the wake of 1989, is now artistic director of the Ullens Center for Contemporary Art in Beijing. This essay, from the first major monograph on Cai published to accompany his solo exhibition at the Fondation Cartier in Paris, celebrates the wide-ranging nature of Cai's practice with reference to a number of his projects throughout the 1990s.

Serizawa Takashi, "Going Beyond the Wall: Project to Extend the Great Wall of China by 10,000 Meters: Project for Extraterrestrials No. 10," in Dana Friis-Hansen, Octavio Zaya, and Serizawa Takashi, *Cai Guo-Qiang* (London: Phaidon Press Limited, 2002), pp. 107–10. Originally published in Cai Guo-Qiang, *Project for Extraterrestrials No. 10: Project to Add 10,000 Meters to the Great Wall of China* (Tokyo: Atelier Peyotl Co., Ltd. with P3 art and environment, 1994) as "At the End of a Certain Wall." [fig. 87]

On the day of the event we set out for the desert in the early morning. Different teams were given different tasks; they were lined up along the site like Chinese engineering brigades, who each specialize in one detail of a complicated construction. . . .

By evening, all the work was finally completed. Along with about forty thousand audience members, I waited for Cai, standing on a hill in the piercing cold wind, to light the fuse at the barrier station. Just before dusk, the fuse was ignited, accompanied by loud cheers. It burnt at about 14 meters per second, much more slowly than Cai's previous fuses; the space was so vast that the fire didn't have the compressed, explosive feeling usual in Cai's work. Instead, it slithered along the ground with dignity, like a gentle dragon. As the small bags of gunpowder exploded at intervals they created the effect of pulses of lightning. The fire ran across the desert as if it were a living thing, taking a full fifteen minutes to reach the end of the fuse before disappearing into the snowy mountains.

Here, Serizawa Takashi gives an evocative firsthand account of the grand-scale project Project to Extend the Great Wall of China by 10,000 Meters: Project for Extraterrestrials No. 10 *(cat. no. 21) on which his P3 art and environment and Cai collaborated.*

François Jullien, "The Great Image Has No Form: A Tribute to Cai Guo-Qiang," in

FIG. 87. COVER BY CAI GUO-QIANG FOR *PROJECT FOR EXTRATERRESTRIALS NO. 10: PROJECT TO ADD 10,000 METERS TO THE GREAT WALL OF CHINA*, ARTIST BOOK (1994)

Cai Guo-Qiang: An Arbitrary History, trans. by John Tittensor, John Doherty, and Frédérique Gautier, exh. cat. (Lyon: Musée d'Art Contemporain de Lyon; Milan: 5 Continents Editions srl, 2002), pp. 27–31. [fig. 88]

. . . One cannot help seeing, in the work of Cai Guo-Qiang, a synthesis of "the East and the West." Or at least one can quite logically look to this work for elements of dialogue between the two cultures. Cai himself tells us that the West liberated him; and we can clearly see what it was that he decided, at an early age, to break free from: an art of painting bamboo, flowers and rocks, generating variation between the empty and the full so as to bring out a "spiritual resemblance." This scholarly art, such as it has been handed down from master to disciple for more than a millennium, looked to his eyes like a straitjacket, ruling out any chance of inventiveness. At the same time, he imagined an atmospheric work that would unfold between Earth and Heaven; he dreamt of dragons uncoiling their undulating bodies between the clouds; and he invited geomancers to identify lifelines at ground level: so in fact he did not give up the idea of conceptualising

The Great Image Has No Form
A Tribute to Cai Guo-Qiang

François Jullien

Because he was born in a small town in Fukien, and spent his entire childhood in China while it was still relatively closed; because, as had already been the case for many Chinese modernists at the start of the 20th century, he began his discovery of "the West" still further east, in Japan; because he subsequently settled in New York, though he has been no less outspoken (to judge, at any rate, by the interviews I have read) in laying claim to the legacy of the Chinese tradition; one cannot help seeing, in the work of Cai Guo-Qiang, a synthesis of "the East and the West". Or at least one can quite logically look to this work for elements of dialogue between the two cultures. Cai himself tells us that the West liberated him; and we can clearly see what it was that he decided, at an early age, to break free from: an art of painting bamboo, flowers and rocks, generating variation between the empty and the full so as to bring out a "spiritual resemblance". This scholarly art, such as it has been handed down from master to disciple for more than a millenium, looked to his eyes like a straitjacket, ruling out any chance of inventiveness. At the same time,

he imagined an atmospheric work that would unfold between Earth and Heaven; he dreamt of dragons uncoiling their undulating bodies between the clouds; and he invited geomancers to identify lifelines at ground level: so in fact he did not give up the idea of conceptualising the real as vital energy rather than as being, or substance. He became attached, not to the idea of "nature" (as object) but to that of the "naturel" (as process); and as a result, he does not look at the work of art as representation (or anti-representation), but as phenomenon and proceeding. These three traits follow on logically from one another, and call our attention to what, for all our Foucault-inspired wariness of the notion, we can only call Chinese "tradition".

I must admit that for my part—with all the misgivings I feel about the cultural comparativism that is so much in vogue today, in the age of "globalisation"—I am not particularly drawn to the concepts that are meant to form a bridge between these cultures: cosmology, mysticism, intuition, etc. We might, after all, recall that such concepts come from the West, even if they are invoked on the fringes of our

27

FIG. 88. OPENING PAGES OF FRANÇOIS JULLIEN, "THE GREAT IMAGE HAS NO FORM: A TRIBUTE TO CAI GUO-QIANG" (2002), SHOWING *CULTURAL MELTING BATH: PROJECT FOR THE 20TH CENTURY* (1997, CAT. NO. 40)

the real as vital energy rather than as being, or substance. He became attached, not to the idea of "nature" (as object) but to that of the "naturel" (as process); and as a result, he does not look at the work of art as representation (or anti-representation), but as phenomenon and proceeding. These three traits follow on logically from one another, and call our attention to what, for all our Foucault-inspired wariness of the notion, we can only call Chinese "tradition."

I must admit that for my part—with all the misgivings I feel about the cultural comparativism that is so much in vogue today, in the age of "globalisation"—I am not particularly drawn to the concepts that are meant to form a bridge between these cultures: cosmology, mysticism, intuition, etc. We might, after all, recall that such concepts come from the West, even if they are invoked on the fringes of our rationalism as a way of going beyond it, or compensating for it. I would thus prefer to consider Cai Guo-Qiang's work by following the few lines of force I have just brought up, which I think can cast fresh light on the work: so that the real may be apprehended less from a perceptual point of view than in an *energetic* and respiratory mode; so that the natural may be envisaged less as an object ("nature," such as our

physics conceives it) than as a *fund of immanence*; and finally, so that art may be taken neither to *represent*, as in the classical West, nor as striving to break with representation, as in the modern West, because it is first and foremost bent on *abolishing any separation* between art and the natural. As we look at Cai Guo-Qiang's work let us remember that the two are traditionally brought together in Chinese by the same word, *xiang*, which means *both* "image" *and* "phenomenon." . . .

François Jullien is Professor at the Université Paris Diderot, Paris 7 and director at the Institut de la Pensée Contemporaine. His books include Detour and Access: Strategies of Meaning in China and Greece; The Propensity of Things: Toward a History of Efficacy in China; *and* In Praise of Blandness: Proceeding from Chinese Thought and Aesthetics. *In this essay, written to accompany Cai's solo show at the Musée d'Art Contemporain de Lyon, Jullien attempts to situate Cai's work within the twin contexts of Taoist thought and globalization discourse.*

Shu Kewen, "Cai Guo-Qiang's Explosions and Art Exhibitions," *Sanlian Lifeweek* (China) 6–7 (Feb. 2002), pp. 110–11.

Originally published in Chinese, translated by Philip Tinari.

Cai Guo-Qiang is like a household name in Shanghai . . . [partly] because Cai had designed the fireworks display that accompanied the opening of the APEC Summit in Shanghai [see cat. nos. 15.1–.14] in October 2001, bringing new fame and pride to the city. . . .

Cai Guo-Qiang says he is not a steadfast person, that he easily oscillates left and right, up and down. The key point for him is that art must be playful and that it must induce others to play along. Thus he is always able to find a way of playing that everyone can accept, that can generate different kinds of experiences. Sometimes it is provocative, as in his explosion project at a power station in Johannesburg. To begin, he only wanted to stage the explosion on an abandoned wall of a factory, but the city government asked whether it would not be more meaningful to set the explosion in a functioning power plant, and Cai immodestly accepted. Other times he is more gentle, for example when realizing his project "Horizon" [*The Horizon from the Pan-Pacific: Project for Extraterrestrials No. 14* (1994, cat. no. 22)] in Iwaki, local residents suggested that during the one minute of Cai's explosion, all those living along the coast should extinguish their lights in order to heighten the sense of silence and calm surrounding the work. Other times he manages to make people remember a spiritual disposition from an earlier time in their lives, such as *Rent Collection Courtyard*, or the Soviet Union of the 1950s . . .

Shu Kewen is one of China's leading cultural journalists and a longtime staff writer for Sanlian Lifeweek. *This article was among the first Chinese mass-media treatments of Cai, by then an internationally prominent artist, and was published around the time of the opening of his solo show at the Shanghai Art Museum.*

Eleanor Heartney, "Cai Guo-Qiang: Illuminating the New China," *Art in America* 5 (May 2002), pp. 92–97. [fig. 89]

. . . Despite [his] international recognition, the conference on Cai's work at the Shanghai Art

Museum revealed that, within China, questions persist about the validity of his work. The main difficulty expressed by some of the panelists and a number of audience members revolves around the issue of exoticism. Is Cai playing the China card? Is he merely a token who has succeeded by acquiescing to Western notions of Chineseness? Does his recourse to traditional symbolism mask a basic emptiness in his work?

This internal Chinese debate sheds light on the complex balancing act that non-Western artists must perform to find a place within the contemporary art world. In the conference, Cai's defenders included New York-based curator and art historian Gao Minglu, who noted that the artist began using traditional symbols and materials in his work long before his departure from China. Austin Museum of Art director Dana Friis-Hansen pointed out that Cai's work draws equally on Western developments—among them Land art, Process art and Conceptualism. . . .

But perhaps the best defense of the artist is his work itself. Cai was represented in the Shanghai Art Museum by five new installations that underscore the playful way he merges history, politics, traditional Chinese culture and ritual, and Western modes of artistic address. These pieces revealed how skillfully he designs each project to suggest different meanings to his diverse audiences, which here ranged from local patrons of the museum with a very limited exposure to either Western or avant-garde Chinese art, to the highly sophisticated art aficionados who gathered for the opening and conference. . . .

Cai's return to native ground has the peculiar effect of affirming both his Chineseness and the distance he has traveled from that sense of self. Like many of the most widely exhibited contemporary artists, he has joined the ranks of the art-world nomads for whom the idea of home is largely theoretical. For such an artist, the discomfort of exile is mitigated by the advantage of an external perspective. No longer a Chinese insider, yet not a Western native, Cai is able to reveal the unstable materials out of which such identities are constructed.

Eleanor Heartney is a contributing editor to Art in America *and the author of books including* Art & Today, Postmodernism (Movements in Modern Art), *and* Postmodern Heretics: Catholic Imagination in

Contemporary Art. *She is also President of AICA USA. This profile for* Art in America *related to Cai's Shanghai Art Museum solo show and featured on the cover of this issue, articulates, from the position of Cai's international practice, the importance of his budding career within China.*

Tatehata Akira, "A Tender, but Radical, Attempt: Cai Guo-Qiang's Tea House Project," in *Cai Guo-Qiang's CHADO Pavilion: Homage to Tenshin Okakura*, **trans. Stanley N. Anderson (Hakone-machi, Kanagawa-ken: The Hakone Open-Air Museum, 2002), unpaginated.**

. . . Tenshin Okakura's *Book of Tea* begins: "TEA began as a medicine and grew into a beverage The fifteenth century saw Japan ennoble it into a religion of aestheticism—Teaism." In its origins, tea was medicinal and thought of as a healing substance.

Tenshin also writes, "Teasim is a cult founded on the adoration of the beautiful among the sordid facts of everyday existence. It inculcates purity and harmony, the mystery of mutual charity, the romanticism of the social order." As Tenshin put it, the tea ceremony is a "tender attempt" to deal with the difficulties of life, so it was natural that Cai would be attracted to it. The elements of everyday life, ritual, mutual regard between people, and romanticism are all features of his own festive spaces. The gentle practice of harmonious communication found in the tea ceremony is a "medicine" that heals the cultural disease of absolute universalism or exclusive pluralism. . . .

I suspected that Cai would come up with one of his heroic projects, that he would produce a grand narrative that would radically change the appearance of the tea house. I thought that he would bring in unusual objects or dig holes in the garden, performing some sort of wild experiment that would test the permissible limits of the site.

What he actually did, however, was quite contrary to what I had expected. It was certainly a "tender attempt" at dealing with the tea house and the tea ceremony. Some observers might think that he didn't do anything at all. However he quietly repositioned and highlighted the cultural and historical meaning of the tea

house in terms of the meditative atmosphere pervading the place. He made no changes in the structure of the tea house itself. . . .

These slight interventions* seemed like nothing at all, but they were the result of a brilliant strategy conceived by the artist. The tea ceremony is a philosophy of communication. Cai saw that this communication is achieved through the spiritual tension of *ichigo ichie*, the single moment of an encounter never to be repeated, and he made the intelligent decision to rely on a faint light, a radical lack of intervention, to deal respectfully with the limited and stylized [a]esthetic world developed from this encounter. Like Cai's more spectacular projects, the "tender attempt" at enlivening Ungei was a great fiction supported by a powerful imagination that brings history into the present. It was a fitting application of another statement by Tenshin Okakura: "Would that we loved the ancients more and copied them less."

* The "slight interventions" referred to in this passage include: removing the paper windows and sliding doors from the tea pavilion; setting up two movie projectors in the pavilion's entrance and surrounding garden showing scenes of a tea ceremony; and installing multicolored stage lights which shone into the garden.

FIG. 89. COVER OF *ART IN AMERICA* (MAY 2002) SHOWING DETAIL OF *THIS IS CHINA—PEACEFUL CELEBRATION* (2001), DIGITAL RENDERING FROM PROPOSAL FOR *ASIA-PACIFIC ECONOMIC COOPERATION CITYSCAPE FIREWORKS* (2001, SEE CAT. NOS. 15.1–.14)

Por Lunar New Year, Cai Guo-Qiang sent a fireworks dragon across the Thames and to the top of the Tate Modern in London.

Public Art Both Violent and Gorgeous

By HOLLAND COTTER

I PRACTICALLY jumped out of my shoes when the Chinese-born artist Cai Guo-Qiang finished a drawing in a borrowed Long Island studio earlier this summer. I wasn't shocked because the results were fabulous but because the final touch involved gunpowder, a lighted fuse, a bang and an orange flash.

Tomorrow night, if all goes as planned, Mr. Cai will complete another drawing with explosives, but this one on a colossal scale in the sky over Central Park. The fireworks display, titled "Light Cycle," is to start at 7:40 from five points in the park between the Hacksher ball fields near 94th Street and the North Meadow at 98th Street, producing luminous pillars, a 1,000-foot halo over the Reservoir and a cascade of flares. The entire performance, months in preparation, should last about five minutes.

Mr. Cai — his full name is pronounced tsigh gwo chiang — is one of several artists from China who gained international attention during the 1990's, and one of the few who has mastered the momentum. He has been using gunpowder as an art medium for years. With it, in 1993, he created a six-mile-long "wall of fire" extending west from the end of the Great Wall of China in the Gobi Desert.

Cai Guo-Qiang, who uses gunpowder to paint the sky, brings his explosive art to Central Park.

In Hiroshima, Japan, in 1994, he attached packets of gunpowder to more than 100 helium balloons suspended in a spiral over the city. They were linked together by a fuse that ran down to a pill dug in the ground near the Atom Bomb memorial. The effect, when the fuse was lighted, was of fiery energy sucked into the earth, a mushroom cloud in reverse.

Last fall, for the inauguration of the Museum of Modern Art's temporary home in Queens, he designed a bridge of light that, for a few dazzling moments, arched over the East River. As magical as the image was, it had a somber aspect, as many of Mr. Cai's projects do. It referred to Sept. 11.

"I gave the city a rainbow, a symbol that comes after the storm," said Mr. Cai, who has lived in New York since 1995, in an e-mail message. Similar thinking underlies "Light Cycle." Commissioned by Creative Time, a nonprofit public-art agency, in cooperation with the city of New York and the Central Park Conservancy, the piece celebrates the park's 150th anniversary and is a metaphor for its seasonal cycles. At the same time, Mr. Cai also intends images of violent energy transformed into beauty to have a protective function for the city, to its "like amulets over the heart of Manhattan."

The Museum of Modern Art piece last year went off without a hitch.

Continued on Page 33

FIG. 90. FIRST PAGE OF HOLLAND COTTER, "PUBLIC ART BOTH VIOLENT AND GORGEOUS" (2003), SHOWING *YE GONG HAO LONG (MR. YE WHO LOVES DRAGONS): EXPLOSION PROJECT FOR TATE MODERN* (2003, CAT. NO. 31)

Tatehata Akira has been director of the National Museum of Art, Osaka since 2005. He was Japanese commissioner for the Venice Biennale in 1990 and 1993, and artistic director of the Yokohama Triennale in 2001. The Hakone Open-Air Museum is Japan's first modern sculpture garden, with significant collections of Pablo Picasso and Henry Moore.

Nanjō Fumio, "Cai Guo-Qiang: One Who Lays Bridges," in *Cai Guo-Qiang: An Arbitrary History*, trans. by John Tittensor, John Doherty, and Frédérique Gautier (Lyon: Musée d'Art Contemporain de Lyon; Milan: 5 Continents Editions srl, 2002), pp. 38–43.

. . . As Gaston Bachelard has observed, fire ignites human passions. The sound and flash of an explosion have an impressive effect. Fire excites people and can give them the feeling of having been present at a significant moment in history. That is why Cai's works that incorporate gunpowder can be said to have a monumental effect. Is it even appropriate to call his work contemporary art? Might it not be considered a kind of festival, as the Chinese government believed? If we do accept it as contemporary art, however, it cannot be assigned to any of the standard categories. These works tell a story of alchemy and create a mythology. Has contemporary art ever taken this form before? The fact that Cai's gunpowder works match no existing genre implies that he has forged an entirely new category. . . .

Free expression is the central concern of contemporary art. Finding ways to create, criticize, and realize one's personal vision is its *raison d'être*. Cai, a contemporary storyteller and alchemist, know this and lives by it. He walks the fine line of an art that could all too easily degenerate into entertainment on the one hand or magic tricks on the other. His art is the response of one Chinese artist to the dilemma of living within a global environment. This is an art of human life. The time has come to embark on a new journey into a global situation with one's local baggage in hand. Is this not the meaning of Cai's art?

*At the time of this article, **Nanjō Fumio** was an internationally active, independent curator. He has served as commissioner of the Japan Pavilion at the Venice Biennale (1997); commissioner of the Taipei Biennale (1998); co-curator of the 3rd Asia-Pacific Triennial of Contemporary Art, Brisbane (1999); artistic codirector of the Yokohama Triennale (2001); and artistic director of the Singapore Biennale (2006). He has been instrumental in bringing international attention to Cai's work, including it in the exhibtion TransCulture at the 1995 Venice Biennale. In 1996, he served as a juror for the Guggenheim Museum's Hugo Boss Prize, for which Cai was nominated. He has been Director of Mori Art Museum, Tokyo since 2006.*

Holland Cotter, "Public Art Both Violent and Gorgeous," *New York Times*, Sept. 14, 2003, Arts & Leisure, section 2, pp. 1, 33. [fig. 90]

. . . Charges of Orientalism,* of perpetuating "Eastern" stereotypes, have also been leveled at the gunpowder pieces. But Mr. Cai refers to his art as "supranational" and insists that it reflects his own past, which included an immersion in Western culture. "Seen from the Eastern perspective, I am actually quite Western," he says. "Since childhood my education has been based on dialectic training in Marxism."

At the same time, his attitude toward Western art, as toward virtually everything else, is elusive and contradictory. The first gunpowder-related piece he did in the United States, a photographic series titled *The Century With Mushroom Clouds: Project for the 20th Century* (1996, [cat. no. 26]), is a kind of mock-homage to the invasive, nature-altering 1970s earthworks of Robert Smithson and Michael Heizer, to whom he is sometimes compared. And a 1996 photograph of him igniting a hand-held explosive while facing the Statue of Liberty and the World Trade Center from across the Hudson can be read as a provocative take on the mercurial character of power, even to people to whom earth art means nothing.

What may be less accessible to a Western audience is the Asian side of the East-West equation in Mr. Cai's art, his Daoist Conceptualism. The volatile nature of gunpowder itself embodies a Daoist principle of cosmic energy sparked by the meeting of opposites: physically, minerals and fire; metaphysically, order and chaos, wholeness and fragmentation; nature and culture; creation and destruction, certainty and chance

Whether you take Mr. Cai as a showman or a philosopher, who would want to do without an artist who proposes turning the Grand Canyon into a terrestrial Milky Way? Or who, in 1999, came up with a project that called for everyone on earth to extinguish their lights for the second before and the second after the change of millennium, so that a strung-out planet could, however briefly, "eclipse into oblivion," and recoup some strength?

This is the stuff of a visionary, but unmystical art; complex in ideas, but tailored to a universal citizenry. In a world where politics, culture and nature are all unstable compounds, and everyone lives tensed in expectation of the next Big Bang, such art, like a throw of the I Ching, comes across as a judicious but exhilarating act of faith in the benignity of the unknown.

* This article discusses the work *Light Cycle: Explosion Project for Central Park* (2003, cat. no. 32).

Holland Cotter's extended New York Times *treatment of Cai's* Light Cycle: Explosion Project for Central Park *was the text through which Cai became a household name among the city's residents. While Cotter and the* New York Times *had been attentive to Cai's career as early as 1997, it was at this moment, after realizing several major explosion events in New York, including* Transient Rainbow *one year earlier, that Cai would emerge as a public persona in his adopted home.*

Calvin Tomkins, "Light Show: Rockets' Red Glare," *New Yorker* **79, no. 26, Sept. 15, 2003, Talk of the Town, p. 40.**

The Chinese may well have invented everything except the forward pass, but some of their most important inventions were accidental. Did you know, for example, that the Chinese characters for "gunpowder" translate literally as "fire medicine," because the alchemists who discovered it, in the eighth century A.D., were looking for a combination of minerals that would give their emperor eternal life? . . .

Sitting in his immaculate studio, at one end of a glass-topped table whose top had just been squeegeed and wiped dry on both sides by his wife, Hong Hong Wu, and a female assistant, Cai . . . projected an affable but ineffable reserve "When I came here, I was still travelling all around the world doing various exhibitions, so New York was more like a studio," Cai said. "I didn't have a sense of belonging to the city. But that changed after September 11th." He was in Italy at the time of the attack, working on a project, but his wife and daughter were here— his daughter's school is near the site of the World Trade Center—and afterward he felt differently about New York. "I felt tied to the city and to all the things that were happening here, and I had a strong urge to give back in some way," he said. . . .

"Everybody loves fireworks," Cai observed, "but you cannot tell one year of fireworks from the next. You watch, you have a good time, you clap, and no one remembers it." He continued, "One does not think of commissioned ceremonial works as art. I wonder why that is, and whether we could not explore that, to use

it as a challenge. The cultural climate is different now. For example, here in the city an explosion takes on much different significance since 9/11. Something used for destruction and terror can also be constructive, beautiful, and healing."

Calvin Tomkins is art critic for The New Yorker *and the author of many books including* Duchamp *and* Merchants and Masterpieces: The Story of the Metropolitan Museum of Art. *This* Talk of the Town *item and Holland Cotter's* New York Times *account above it are both pre-event accounts of Cai's 2003* Light Cycle: Explosion Project for Central Park *(cat. no. 32) which was slightly disrupted by poor weather.*

Theola S. Labbe and Ernesto Londono, "Fireworks Cause Deluge of Panicked Calls in D.C.," *Washington Post*, **Oct. 3, 2005, p. A1.**

Hundreds of Washington residents took cover in buildings, raced to outdoor balconies and made panicked calls to local police and fire departments Saturday night, unaware that the loud explosions they heard were from a fireworks display near the John F. Kennedy Center for the Performing Arts.

The noise, which sounded like machine-gun fire to some and like bombs or cannonballs to others, could be heard as far away as upper Northwest Washington and Falls Church.

D.C. fire department dispatchers were deluged with calls from worried residents for more than an hour, spokesman Alan Etter said. "They couldn't count the number of calls," Etter said. "They were swamped."

District emergency officials, aware of the scheduled fireworks display, nonetheless sent out firetrucks as a precaution in response to the numerous reports of noise, smoke, and haze, Etter said.

The seven-minute show, which launched the Kennedy Center's month-long Festival of China, was the creation of pyrotechnics designer Cai Guo-Qiang, who had referred to it as an "explosion event."

But in a region all too familiar with color-coded terror alerts—and not used to hearing fireworks on days other than the Fourth of July—the loud, unexplained noises in the night-time sky sowed fears of something far more ominous. . . .

Brooke Taylor, a 19-year-old George Washington University freshman, heard the disturbance from her dorm room. . . "Everyone in the dorms rushed to the halls to see what was going on," Taylor said. "We then went to the roof and saw gray smoke with a reddish taint. Someone was, like, 'Is that a nuke?' People were saying, 'Which way is the Pentagon?'"

Arlington resident Jim Pebley was online yesterday, reading his neighbors' complaints and comments. In the age of terrorism, he said, residents simply could not dismiss the sounds.

"I think everyone's a little jumpy right now, don't you?" Pebley said.

This report, by two Washington Post *staff writers, speaks to the new set of meanings Cai's explosion events have assumed in the wake of September 11, 2001, and to the power of these events to transcend the narrow realm of contemporary art and emerge into wider social conversations.*

David A. Ross, "Fear of Remembering," in *Cai Guo-Qiang: Transparent Monument* **(Milan: Edizioni Charta, 2006), pp. 10–13.**

. . . In the installation's title piece, *Transparent Monument*, 2006, [fig. 33] a simple glass sheet is mounted so as to stand freely in the middle of the space. Functioning as a framing device (we stand and look at the beauty of Central Park through the glass window as a framing device intended to focus our attention as a simple act of aesthetic willfulness) we are at once aware of our ability to look elsewhere, undirected and freely, and are led to a simple comparison. But then we catch sight of the disturbing image of the hyper-realistic sculptures of birds that have apparently flown into the glass and died from the impact. Cai has created a not-so-subtle metaphor for the danger of what is seemingly transparent (the act of framing and direction), and a signal that all is not well despite the abundance of beauty in which we find ourselves. . . .

Clear Sky Black Cloud [fig. 31] produces the punctuation that brings the work's text to a close. The work calls daily for a small, mournful black burst—one more directly associated with the martial use of firepower than the colorful and spectacular displays that we normally

associate with fireworks. As we watch the little cloud float out over the man-made natural beauty of Olmsted's great 19th-century masterpiece of landscape architecture, we are brought curiously and sadly back to ground. We remember what it was we've been repressing, we think about that which we have lost, that which is endangered, that which has been ruined or spoiled. Each cloud is a little prayer, an offering, an apology, and a reminder of our own evanescence. Each brave little black cloud reminds us of not only our won mortality (it is our daily one-gun salute), but of the fragility of the entire complex system of which we are but a small part. . . .

David A. Ross is former director of the San Francisco Museum of Modern Art, the Whitney Museum of American Art, and the Institute of Contemporary Art in Boston. This essay, written to accompany Cai's rooftop installation at the Metropolitan Museum of Art in 2006, situates this particular grouping of works by Cai within the fraught physical and historical setting of New York and Central Park.

Dan Cameron, "Blinded by the Light," in *Cai Guo-Qiang: Head On*, trans. by Burke Barrett and Dr. Stephen Richards (Frankfurt am Main: Deutsche Bank AG, 2006), pp. 19–24.

. . . One subject that Cai does not shy away from is war—or more particularly, the battle that ensues when one is fighting for one's own life. Since the use of gunpowder belongs almost entirely to the realms of the military and the theater, part of its fundamental attraction to the artist has been its capacity to convey the ferocity of the clash without incorporating any direct sign of blood, suffering, or death. The sheer frequency with which real and fictitious animals known for their ferocity are evoked in his art also ties him closely to the long tradition of military conquest evoked through art. Tigers, lions, and dragons—all frequent protagonists of Cai's art—are each invested with legendary quantities of strength, ferocity, and an uncanny ability to strike fear in the hearts of its foes. As often as not, such creatures are also experienced as part of more mutable, mythological forms—i.e., as kites, comets, warships—or else

they are riddled with arrows, a sign of mortal injury which also taps generously into the story of St. Sebastian. From the point of view of global politics, it is tempting but probably fruitless to engage in the game of identifying certain symbols as standing for America, and others for China. What is probably more to the point is that we live in an age when warfare and the open struggle among nations for power are as real and palatable as the rising and setting of the sun, and the artist's mission is in part to observe these struggles, and convey some sense of their meaning through artistic form. . . .

Dan Cameron was formerly curator at The New Museum in New York and director of the 2003 Istanbul Biennial. Cameron's text for a recent Cai exhibition in Berlin situates the symbology of Cai's recent works in the larger context of recent history.

WRITINGS BY AND INTERVIEWS WITH CAI GUO-QIANG

Cai Guo-Qiang, "An Important Tactic for Manifesting the Painter's Concept: A Preliminary Exploration into the Use of 'Light' in Expressing the Substance of an Artwork," *Art History and Theory* (China) 17 (1986), pp. 97–99. Originally published in Chinese, translated by Philip Tinari.

Different ways of handling light produce different artistic effects. Conversely, different conceptual positions require the production of techniques for handling light appropriate to their aims. By analyzing paintings from the perspective of how they deal with light, one can glimpse the development of all of Western art history. One must only pay attention to the distinctive methods for handling light that have arisen with each new artistic movement, and in the works of particular artists throughout Western art history, and one will discover how different understandings and applications of light are able to reveal the conceptual stances of various schools and artists.

This early text, dating to shortly after Cai completed his studies at the Shanghai Theatre Academy, is Cai's first published writing in a major art magazine. It explores the use of light throughout the history of Western art, foreshadowing the artist's use of explosions.

Cai Guo-Qiang with You Jindong, "Painting with Gunpowder," *Leonardo* 21, no. 3 (1988), pp. 251–54.

I like the hazard of working with gunpowder; it excites me. Depending on which ingredients I use, the gunpowder explodes at different speeds and with various noises and degrees of splendor. The unpredictable changes are fascinating. It was probably my love of the hazardous that led me to exploit this bizarre method of painting. . . .

My basic idea is that human beings are the children of our mother earth, or nature, or the universe . . . and in that sense we are all one with nature or the universe. While this seems a simple and obvious concept, it is one that modern people tend to forget. This is one reason I choose to wield natural materials in my paintings.

Additionally, individual power or capability is limited, and individual lives are short and weak compared to nature, which is strong and limitless. Therefore I borrow power from nature by using the 'skin' of the earth (soil) and other natural materials that are alive as we are alive, and I use this power to create effects that seem to me wondrous. I seek through my paintings a oneness of work, self, and nature as well as a fusion of humanity, history, and nature. . . .

All through these processes, the flares, heat, and noise that are produced and the relentless wantonness that they display usually distort the original workmanship and my initial design. Pigments and working materials may furl up explode, become puffy, scorched, or otherwise ruined, or be reduced to their original components: consequently, there is a furious wrangle between forces and materials. During this conflict of control versus counter-control, between fire and matter, I look for a live expression of the complicated interchanges between the evolving images and the original texture. In the burning aftermath during which the images undergo a series of transformations, I mold the formation of the images while the natural forces finish their work. . . .

Through my work, I explore my inherited culture and induce transformations into it. I hope to stir the spectators' imaginations sufficiently so that they will accompany me into the artistic scenery and historical settings. Being a proud son fostered on 5,000 years of culture, I am on the path of awakening and find myself in direct communion with my forefathers who, laying their mighty palms upon my shoulders, endow me with a sacred strength. In my works, history and my past experiences are incorporated together, merging into one. . . .

My vantage point is that of a common man living an everyday life in the present era. From this point of view, I observe and explore this kaleidoscopic world of ours. I do not seek to preach or to give advice; rather, I wish to make people think, to have them view current matters from the perspective of history and meditate upon history and life.

This exposition of the mechanics of "explosion painting" is one of the most direct texts Cai has published. It is notable for its early explanation of a technique that Cai continues to employ even today, and for the frank terms in which he articulates his own cultural identity.

Cai Guo-Qiang, Preface/Artist statement (August 10, 1993), in *Cai Guo-Qiang: From the Pan-Pacific.* exh. cat. (Iwaki, Japan: Iwaki City Art Museum, 1994), p. 86.

For the past several years I have been working with two concepts: gaze from the universe, and men addressing and conversing with the universe. I have mainly used gunpowder to express my ideas because I would like the movement caused by the explosion of my work to join and harmonize with the cosmic moment which has continued ever since the big ban[g]. The moment of explosion creates chaos in time and space. The universe comes near to us and the eternity is born. After the brief chaotic moment, the work disappears from our vision and flies away into . . . space with the speed of light to meet another audience. Life and art go beyond their limitations and infinitely expand themselves.

The effort to unite the universe in men with humanity in the universe is in agreement with . . . men's everlasting desire to return to the universe and look for compatriots. This task

which men are destined for, is all the more pressing in our age. The inclusion of the eyes of extraterrestrials into the project reflects the fundamental sense of crisis concerning the earth and . . . humankind. . . . I would like to place in[to] the overall picture of the universe the issues of the earth, humankind, the history of cultures, and the potential of contemporary art.

Indoor art basically originated from artists' interest in the inner world of human life. It [is] concern[ed] with the relationship between life and art, and the influences of art on life. . . . Outdoor art, on the other hand, seeks dialogues with the external universe. I would like to see these two kinds of art as organized circulation and balance of the inner and external universe. This requires a new methodology.

This text prefaces a group of twelve short project statements introducing Cai's major explosion events through 1994. All twelve were first published in the catalogue for this early solo show in Iwaki. While a number of the project statements have been consistently reprinted in other publications about the Projects for Extraterrestrials, *this concise manifesto has remained curiously absent.*

Cai Guo-Qiang, interview by Gao Minglu, "Traces of Gunpowder Explosions," *Dushu* **(China) 9 (1999), pp. 87–93. Originally published in Chinese, translated by Philip Tinari.**

GAO: *Borrowing Your Enemy's Arrows* [1998, cat. no. 41] was a very large work, and among your newest . . . [It] is not so obviously political [and its] image has not been widely circulated in the Western press. But the *New York Times* seems to believe that this work is anti-Western. When I first translated the title directly into English as "Straw Boat Borrows Arrows," the museum worried that the Western viewer would not understand, and changed the title to *Borrowing Your Enemy's Arrows.** With the addition of "enemy," it becomes sensitive. In China, the story of the "straw boat borrowing arrows" is more often seen as a kind of wisdom and a philosophical example of how yin and yang interact. When this story is placed in the context of the U.S. and China, it seems that the two countries become enemies, particularly in that article, which was written from a Cold War point of view.

Here I want to raise another point however: turning material from traditional culture into a source for art, particularly in the form of a concrete form like the straw boat, as a way of stimulating contemporary audiences—this seems like the most pressing task for installation art. Some people think that the few of you Chinese artists who are successful in the West are using your works to sell Eastern tradition, or just that you have Orientalist tendencies. This leads to yet another issue, namely that artistic success is not only a function of an artist's work itself, but of the strategy that underlies his conceptual practice. And "strategy" from a certain perspective might also be called "opportunism." As the Chinese artist who has had perhaps the most solo shows in Western museums, how do you consider this question of strategy?

CAI: Actually, I don't only use things from Chinese antiquity, but sometimes also things from other cultures, including the bible . . . I often use things from all cultures, not simply China's. . . . In appropriating historical stories and forms, two questions arise: first is whether these things are able to give rise to a productive tension within contemporary culture; second is whether they can be converted into contemporary language. For example, Westerners who never before knew the story of the "straw boat borrowing arrows" can still feel the pain of the boat pierced by so many arrows, at once battered and yet accomplished. People from any field whatsoever can sense this contradiction. This work tries to express the anguish of preserving one culture in the world of another, and perhaps also talks about how things learned from one's Other can eventually become one's own weapons. I used a Chinese flag in order to give the boat a sense of movement, and of course using another nation's flag—American or Japanese for example—would not have been natural

Previously, [there were often two reasons that] art coming from Eastern Europe, the Soviet Union, and other non-Western areas was appreciated in the West: first, it was seen as criticism of the artist's own culture or national system; second, it was seen as proving that the artist was studying diligently, seeking to catch up with contemporary Western artistic expression. But these modalities, which have become ingrained in the West, are starting to change. After the

Cold War, enthusiasm for non-Western cultures and multiculturalism has made it more difficult for the West to enact its whims, leading to a truly non-Western, multi-polar contemporary culture. Perhaps we are still in some ways the spring rolls at the banquet,† but if the spring rolls carry bacteria, they can ruin the entire party.

* *Gao Minglu* presented this work in his exhibition *Inside Out: New Chinese Art* which originated at P.S. 1 and the Asia Society in 1998, and was thus involved in the naming of a number of the works on display. The expression "straw boat borrows arrows" derives from a story about General Zhuge Liang who, during the Warring States Period, reputedly collected ammunition for his depleted army by launching unmanned rafts carrying bales of hay toward his enemy's position, later collecting and using the projectiles his opponents had shot at it.

† The reference is to curator and critic Li Xianting's notion of Chinese art as dispensable "spring rolls" at the banquet of the international art world.

Gao Minglu, Ph.D., a major voice in the critical conversation about contemporary art in 1980s China and one of the organizers of the China/Avant-Garde *exhibition in 1989, is professor of Art History at the University of Pittsburgh. He curated* Inside Out: New Chinese Art, *the first major group show of contemporary Chinese art in the United States shortly before conducting this interview with Cai.* Dushu *is China's leading academic monthly, roughly akin to* The New York Review of Books *in its interests and style.*

Cai Guo-Qiang, interview with Fei Dawei, "To Dare to Accomplish Nothing," in *Cai Guo-Qiang* **(London: Thames & Hudson; Paris: Fondation Cartier pour l'art contemporain 2000), pp. 117–35.**

FEI: . . . Do you think the freedom you gained in the course of [the ten years between 1990 and 2000] . . . has been the cause of . . . transformations [in your work]?

CAI: Today, I am certainly able to work in relative freedom. Financial freedom, a freedom drawn from opportunities that are given to me. When these are rare, freedom is limited. Freedom of choice regarding techniques must also be taken

into consideration. All these conditions create a relaxed atmosphere which I feel comfortable with and helps creativity. But there are also problems that come with this freedom. When I work I always feel as though I am swinging like a pendulum between Chinese and Western culture. Confronted with the times we live in, my cultural identity or my "subjective culture" must learn to respond quickly. Western artists also live with a similar dilemma—they must swing between formalism, conceptualism, and humanism, which go across the board of their history of modern art. When humanism and idealism occupy too great a place, or when social issues are the central preoccupation, the work of art loses its sublime form and no longer satisfies the pure aesthetic desire. The artist therefore turns to more formal concerns in an attempt to achieve something in artistic form. But after restricting himself to purity and the sublime for too long, perhaps the artist becomes incapable of returning to humanism and undergoes a loss of mythic inspiration. He does not dare to use colour since he has pushed purity so far that he has abandoned colour.

I too swing from one side to the other, but not in the same way. The West generates some questions that are not those of my "subjective culture." But I live here and have made the Western system and its "scene" my own, so I try to answer those questions. When I arrived in New York in the nineties, art critics touted me as the newest thing as far as performance was concerned. They put my work in the "bottleneck" which Western art was facing and said that my work broke through the conventions of performance and installation art. Before the eighties, artists were using their bodies to do performances. In the nineties, a group of artists including me started to create installations for the public to participate in. I had people drinking herbal teas, I set up a bathtub for people to have a soak in, I constructed a mini-golf course for people to play on. I also made a minimalist-type rug of pebbles and invited visitors to take off their shoes and walk on it to stimulate the acupuncture points on the soles of their feet. It is exactly the sort of work that is made for people to participate in, for making visitors' feet hurt so much that they remember it. It is an intentional imitation of English artist Richard Long's forms. Western art critics can locate my work

in their "bottleneck," and of course they can explain it by means of whatever "participative aesthetic" they want. . . .

This interview is among the most frank and extensive given by Cai in the early part of this decade. In it, he and Fei Dawei *converse as old friends who have made their careers in the same period and against the same backdrop of Western expatriation. They speak in depth about the dynamics of working in the West as a Chinese artist.*

Cai Guo-Qiang, interview with Huang Du, "Cultural Witchery, Alchemy, and 'Explosion'," *Avant-Garde Today* (China: Tianjin Academy of Social Sciences Publishing House) 9 (2000), pp. 43–65. Originally published in Chinese, translated by Philip Tinari.

HUANG: During your time in Japan, how did you consider your relationship to Japanese culture and art?

CAI: When I first assumed my place in the Japanese art scene, a debate occurred similar to the one in China as to whether I represented New Asian Conservatism or internationalism. Thus, in 1994, I staged large numbers of exhibitions in Tokyo, Hiroshima, Kyoto, and elsewhere, attracting a lot of attention and criticism. In the same year, Japan's largest newspaper, *Yomiuri*, titled its review of the year in art "Cai Quo-Qiang Very Active, Decline of Euro-American 'Contemporary' [Art]." In fact, the West was not in decline at all, but Japan's power in the West was, and so Japan's so-called "Cai Guo-Qiang phenomenon" was a form of neo-Orientalism, or the rise of an Asian Way. However, there was still an entertaining phenomenon whereby Nakamura Hideki, the Japanese curator who argues for an Asian path, never once organized an exhibition of mine. It was another kind of curator—those like Hasegawa Yūko and Nanjō Fumio, who oppose an eastern method and recognize only the West as the true stage and tastemaker in art—who constantly invited me to participate in exhibitions or organized my solo shows, and who selected specific artists for projects in the West. This is an extremely interesting contradiction. Even so, there are those curators who believe in furthering an Asian way, who see the

FIG. 91. COVER OF *AVANT-GARDE TODAY* (2000) SHOWING PERFORMANCE *STILL LIFE PAINTING* (2000) AT THE ART GALLERY OF NEW SOUTH WALES, FOR THE 2000 SYDNEY BIENNALE

need for an Asian parallel to every movement in Western modern art. For example, they would argue that installation art is not the sole province of the West, and then run all around East and Southeast Asia looking for examples, finally discovering the trucks that sell late-night snacks and believing that these express a distinctly Asian aesthetic of installation art.

This excerpt from an interview with the curator Huang Du, published alongside Cai's statement about Venice's Rent Collection Courtyard (cat. no. 42) and the Chinese version of Fei Dawei's article "Amateur Recklessness" is remarkable for the open assessment offered by Cai of his time in Japan.

Cai Guo-Qiang, "On *Venice's Rent Collection Courtyard*," *Avant-Garde Today* (China: Tianjin Academy of Social Sciences Publishing House) 9 (2000), pp. 75–78. Originally published in Chinese, translated by Philip Tinari. [fig. 91]

I have participated in three Venice Biennales in a row. In 1995 my *Bringing to Venice What Marco*

FIG. 92. COVER OF *TENDENCY QUARTERLY* 13 (2000) SHOWING *VENICE'S RENT COLLECTION COURTYARD*

Polo Forgot [cat. no. 48] was selected, in which I shipped over a boat from my native town of Quanzhou. On the day of the opening, the boat sailed down the Grand Canal toward the exhibition, like a UFO falling from the sky. The boat carried water, wood, metal, fire, and earth—five thousand bottles of Chinese medicine [that] were then placed into coin-op beverage machines for people to buy freely. That year marked the 700th anniversary of Marco Polo's journey from Quanzhou back to his hometown of Venice, as well as the 100th anniversary of the Biennale. . . . In 1997 it was my work *The Dragon Has Arrived! The Wolf Has Arrived!* which modified a work I did for the Museum of Contemporary Art in Tokyo in 1995 involving a wooden tower called *The Orient (San Jō Tower)* [cat. no. 38], pieced together from chunks of a sunken ship, the result of a dig that I conceived and organized. In Venice I turned the tower on its side and placed strong lights and fans inside the bottom of the tower, adding thirteen five-star Chinese flags so that the whole thing looked like a rocket taking off. This was a reaction to both the eight-year "War of Resistance" I had just completed in Japan and the international and Sino-American political circumstances I was newly facing in New York.

For the 1999 Venice Biennale, I prepared two proposals, one was rather easy and involved turning a Venetian gondola into a Roman warship. But curator Harald Szeeman and I decided instead to attempt to realize another more difficult project—*Venice's Rent Collection Courtyard* [cat. no. 42]. He knew that as someone accustomed to using "cultural readymades" in my work, I had long ago set my sights on the *Rent Collection Courtyard*. Szeeman himself in the 1970s thought of exhibiting the original *Rent Collection Courtyard*, a regret that many people know about. If that plan had been realized, *Venice's Rent Collection Courtyard* would have been able to convey its message more directly and powerfully in terms of concept and performance. For this reason, I could not but print a small pamphlet to publicize this classic work, mainly for the purpose of remedying the Western lack of understanding of this major work in Chinese socialism. The pamphlet used text and image to introduce the creative process behind the work of the original creators and its development. An objective look back at the political changes of that time continuously influenced the substance of this work—in addition to having gone through many reproductions and revisions, it also led us to emphasize the original creators' relationship to concepts such as the "readymade," "site-specific creation," and a number of other unplanned convergences with recent trends in the modern art of the Western world.

Cai's explanation of Venice's Rent Collection Courtyard *was published in this short-lived journal at the height of the copyright controversy that it provoked.*

Cai Guo-Qiang, "Wild Flights of Fancy," *Tendency Quarterly* **(Taiwan; Boston) 13 (2000), pp. 355–61. Originally published in** *Day Dreaming: Cai Guo-Qiang,* **trans. by Wu Chang-Jye, exh. cat. (Taipei: Eslite Gallery (Cherng Piin), 1998), pp. 4–17. [fig. 92]**

I lived in my hometown of Quanzhou for more than twenty years. It is on the opposite side of the Taiwan Strait. When I was a little boy, I used to indulge myself in wild flights of fancy. The more they forbade me to think, the more irresistible my impulse to dream was. Once I even thought of stowing away for Taiwan. (Maybe just for the sake of curiosity, for I had no definite purpose in my mind.) Now, though I have been to many countries and gone through customs many times, it still does not compare with the excitement and joy of being a stowaway. Several years ago, the international highways in Western Europe abolished their customs. I used my leisure time to drive from one country to another, risking being arrested. However, I got little from this illegal journey. One of the few impressions which still remains in my mind is that highway lights in Holland are far fewer than those in Belgium. In these years, I have produced a lot of supranational projects.

When I was in mainland China, I had nothing to do but think. Then I went to Japan with little money. At first, I continued to do nothing but think. Then I learned to speak Japanese and made friends with many people, including astrologists, seismographers, life scientists, fishermen, and divers. Of course, I also knew some gunpowder experts and the art community. I cooperated with them. And many of our projects have been realized. So, when I moved to America, I took many catalogues of my works with me. But I could hardly speak any English. Though there were translators to help me, most of the time I just watched and thought. . . .

I know little about the Oriental concepts of the universe or the Western physics of the universe. I have been obsessed with something faster than the speed of light, black holes, and especially extraterrestrials, with whom I have never been bored. I hope to be freed from the gravity of the earth, to detach myself far from the human world in order to think in a greater scale of time and space. Sometimes I dream of the Olympic Games on another planet.

This text serves as Cai's midcareer memoir and manifesto, as well as his first sustained instance of autobiography. In it, Cai articulates an artistic persona connected to, but somehow transcendent of the artist's own cultural and historical position.

Cai Guo-Qiang, interview with Jennifer Wen Ma, "I Wish It Never Happened," in *Cai Guo-Qiang: Inopportune* **(North Adams: Mass MoCA, 2005), pp. 54–69.**

MA: The simplicity of terrorists' means—like box cutters—relates to your work. For example, the video is simple and crude, made with three rented camera lenses and a simple rig that clamped the cameras in place. It was recorded in one night. A truck towed the car filled with kids' fireworks. It may be called low-tech.

CAI: The terrorists used knives, in a simple and primitive method, but they went through a lot of training and preparation, like learning civil aviation law. Many artists are like this. My work looks reckless but in fact it is somewhat contrary to that. Some people are good at doing complex things simply; some people are good at presenting simple things using complex, highly technical, detailed, and precise forms. My works are generally simple and easy, easy to participate in. This is related to my background; I grew up in a small city, you could say as an Asian peasant. My values, sense of dimension, degree of material treatment, [and] sense of weight and temperature, are all intimately connected to my background. . . .

MA: You often discuss methodology, in particular your use of Chinese traditions like Chinese medicine and feng-shui. In this case, I feel that you are responding to the methodologies of terrorism.

CAI: My work begins with things I observe and am interested in; this, then, gradually becomes the desire to produce a work. For example, I make explosions, so I pay attention to explosions. I can imagine the methods used and the mental state of the suicide bombers. In a crowd, the police make them raise their hands. As soon as their fingers separate, the positive or negative electrodes connect, detonation, a simple action. Before igniting an artwork, I am sometimes nervous, yet terrorists face death unflinchingly. Along with the sympathy we hold for the victims I also have compassion for the young men and women who commit the act. Artists can sympathize with the other possibility, present issues from someone else's point of view. The work of art comes into being because our society has this predicament. Artists do not pronounce it good or bad. . . .

*Artist **Jennifer Wen Ma** was manager of Cai Studio from 1999 through 2006. This sprawling interview*

published in the catalogue accompanying Cai's major installation Inopportune *at Mass MoCA in 2005 begins from, and consistently returns to the question of terrorism in Cai's work.*

Cai Guo-Qiang, Interview with Serizawa Takashi, "Like a small child building firecrackers," ARTiT (Tokyo) 11, vol. 4, no. 2 (Spring/Summer 2006), pp. 30–41. [fig. 93]

CAI: . . . In China, and for a while after moving to Japan, I was producing two-dimensional works that involved exploding gunpowder on paper and canvas, and looked much like abstract paintings. . . . And recently that's started to change a little again. You could say I'm returning to painting, and shifting towards something akin to representational painting. . . .

SERIZAWA: . . . you were saying that by using balls of gunpowder fitted with microchips you could control the explosions in both spatial and temporal terms, to achieve all sorts of effects. And now you say you're turning more to drawings as paintings, something quite separate from these gunpowder events. Why do you think this has occurred?

CAI: Well you know . . . Americans are very into studying such things. If I'm trying to produce a gunpowder drawing and say I want to create this effect, and I'd like this sort of explosive, they come up with all sorts of ideas. They mix all sorts of powders, like the cereal you eat for breakfast, and make up all these different kinds of explosive[s] (laughs). For example, if I say I want to show a human face, in a certain way using certain colors, they'll produce something that will let me do just that. . . . These days, the techniques required to express things in gunpowder drawings are relatively simple. Now you can depict anything, and easily. So limiting my gunpowder drawings to plans for events of that type would take all the excitement out of the work. . . . Before touching on the subject of art, let me say that China is changing with incredible speed. Before long the Chinese will have acquired American-style sensibilities to an even greater extent than the Japanese. And as the country becomes wealthier, the

FIG. 93. CAI GUO-QIANG ON COVER OF *ARTiT* (SPRING/SUMMER 2006), PHOTOGRAPH BY YAMAMOTO TETSUYA

government can no longer get away with acting arbitrarily. The leaders there now are smart, and they know this only too well.

SERIZAWA: In light of this, what then for art?

CAI: In the West, after 9.11 I expected artists would have more to say, but in the end they said very little. In broader terms, the major nations of the West and Asia, in other words the strong countries, are enjoying good economic conditions at present. At times like this, people are more interested in what's going on in their immediate surroundings, such as what work by whom sold for how much, and who was in what exhibition, than the future of the world. Talking about the times or issues faced by the world, big historic missions, starts to seem old-fashioned, uncool. Sure, the Chinese art scene is vibrant, and on the surface Chinese artists are a livelier lot than their generational counterparts in the West. Generally speaking that's not a bad thing, but as I always say to people, look behind it and you'll find China still has a long way to go in terms of the imagination needed to produce good art.

SERIZAWA: So what do you personally intend to do about that.

FIG. 94. COVER OF *YISHU: JOURNAL OF CONTEMPORARY CHINESE ART* (SPRING/MAY 2002) SHOWING *DREAMS* (2001), INSTALLATION VIEW AT SHANGHAI ART MUSEUM

CAI: I think it's down to education. . . . [Cai discusses various plans for the future.] Then in October I'm heading to a temple in Laos to become a monk. . . . A project that involves living with monks. . . . It's just such a thrill. When working on a piece, I feel like a small child building firecrackers (laughs). I always think, right this is it, I'm really going to blow them away this time! And sometimes I make the crackers too big and they don't burst (laughs).

In this interview, Serizawa Takashi, Cai's longtime collaborator in Japan, prompted the artist to explain the evolution of gunpowder drawing in terms of the different locations in which he has worked, and to reflect on the mission of a Chinese artist in a post-9/11 world.

Cai Guo-Qiang, "Master's Program in Contemporary Art Curriculum (Proposal) (March 2002)," *Yishu: Journal of Contemporary Chinese Art* (Taipei) 5, no. 3 (Sept. 2006), pp. 73–74. [fig. 94]

GOAL: To cultivate contemporary artists of excellence and to investigate an education system of contemporary art with Chinese characteristics.

CURRICULUM

FIRST YEAR (30 CREDITS)
Mandatory Courses required by the State Education Commission of China: English, Politics (Marxist–Leninism), Philosophy (including Modern Philosophy).

READING MATERIALS AND LECTURES
Histories of Chinese and World Art; Histories of Chinese and World Civilizations; Histories of Chinese Philosophies and Religions; Major Schools and Practices of Western Modern Art; History of the Development of Science and Technology; Modern Architecture; Design Theory; Modern Clothing Design; Landscape Design; Aesthetics of Calligraphy; Semiotics; Neuroscience and Psychological Studies; Science of Qi Gong (developing the potential energy of life); Music, Drama, and Dance Appreciation; Film Studies.

MAJOR COURSES
Materials and techniques: Computer skills (graphic design, 3D animation, Web design); Metalwork (forging, welding, casting); Resin work; Printing (silkscreen, woodcut, lithography, etching); Carpentry; Ceramics. *Students are required to take at least half of the above courses.*

Performance art: Stage Performance; Visual Art Performance; Audience Interactive Performance; Technological/Mechanical Performance (video, sound, music, etc.). *Students are required to take at least half of the above courses.*

Video and photography: Techniques; Analysis of masterpieces.

2D forms: Drawing; Drafting; Collage; Ink painting; Oil painting. *Students are required to take at least half of the above courses.*

3D forms: Installation; Sculpture; Environmental art; Public art. *Students are required to take at least half of the above courses.*

Project planning: Self-selected Theme; Assigned Theme; Appropriation and Re-making; Imitation. *Integrate into the course Major Schools and Practices of Western Modern Art.*

Exhibition: Open studio; Exhibition of student works.

SECOND YEAR (30 CREDITS)
Mandatory courses required by the State Education Commission of China: English, Politics (Marxist–Leninism), Philosophy (including modern philosophy); graduation work and dissertation.

READING MATERIALS AND LECTURES
Comparative study of Chinese and World Art Histories; Re-Writing Art History and its Objects; Art Criticism and Techniques; History of Aesthetics; History of Non-Western Modern Art; The Art System (Museums; Galleries; Foundations; Corporate Culture and Sponsorship); Survival Tactics and Business Management for Artists; Current Conditions and Prospects for Contemporary Art; Overview of International Biennials; Triennials, Art Fairs and their Problems; International Politics; History of International Relations; Current Conditions and Prospects of High Technology and Science; History of War and Military Strategy; Introduction to Advertising; Mass Media Studies; Life Sciences; Sexuality, Gender and Sex Orientation Studies (Feminism, Homosexuality, etc.); Mysticism and Astrology; Fengshui; Chinese Medicine; Mythology. *Students are required to take at least half of the above courses.*

MAJOR COURSES
Analysis of Artists and their Major Works
Practice and Self-Reflection in the Search
 for the New
Theory and Practice of Cultural Identity
Methodologies for Linking Theoretical
 Concepts and Forms of Expression
Field Work/Internships (International exhibitions, art museums, galleries, artist studios)

Exhibition: Two group shows (one by students/ teacher and one by students only); Exhibition of graduation work (including training of site inspection; fundraising; production and installation of work; promotion; publishing; documentation; and exhibition management.)

NOTES
- The first year emphasizes the study of history and theory and technical training.
- The second year emphasizes the practice of creative production and exhibition.
- The two curricula comprise a total of sixty credits; students who have not previously had any art training must supplement ten credits with foundation art courses.
- Reading materials are provided periodically; lectures are given once on each subject.
- Student facilities include small individual studios, a lecture room, and workshops.
- One or two famous artists will be invited to visit the studio and work each year.
- Students with permission may take courses from other departments.
- All projects and assignments must be presented to the class for critique and debate.
- For group and solo exhibitions, a public critique and debate must be held among students and individuals from the art community.

Teaching Method

The program aims to endow students with the power of self-discovery, the ability to understand the past, present, and future of contemporary art more fully, to gain greater creative power and concentration. This will allow them to create based on problems and questions, and to carry out self-examination and self-criticism.

This curriculum was originally prepared as Cai's participation in the Yan'an portion of The Long March: A Walking Visual Display, *a traveling experimental exhibition that moved along the path of the historical Long March curated by Lu Jie and Qiu Zhijie during the summer of 2002. It was ultimately presented at the Cai-initiated, Long March-organized "Yan'an Symposium on Art Education" in May 2006, and published in a special issue of* Yishu *edited by Philip Tinari and David Tung devoted to the proceedings of that symposium.*

Cai Guo-Qiang, selection from *Letters to a Young Artist* (New York: Darte Publishing, 2006), pp. 59–61.

Dear Young Artist:

. . . I'd say the most important thing is to grasp the quality of your own work before worrying about other things. I've lived in China, Japan, and the United States and had to start over twice as a young artist and once as a somewhat older artist.

In China, I worked as a stage designer for a theater troupe to support my life as an artist. I forged receipts so that I could get reimbursed by my employer for my own painting materials. When I left for Japan, I brought my paintings with me, which were works that took much exploration. On the one hand, I was determined to stop taking part-time jobs in order to support my art; on the other hand, I could not bear selling my precious paintings for a cheap price. Therefore, I painted popular Chinese landscapes to sell to Japanese collectors who love Chinese culture. These sold for little money, anywhere from $50 to a few hundred dollars. Later on, some of these paintings fetched a few thousand dollars. Concurrently, I continued doing what I considered my "real" work. People who were involved in contemporary art that saw this work and recognized its value encouraged me to keep on creating. I was fortunate that my work received attention and was exposed to a broader audience. . . .

Regarding your question of artistic integrity and commercial interest, they are not always in conflict with each other, though they can be. It is, in fact, a challenge for me still not to be led and confused by commercial ambition; more prominent artists and masters are also plagued with the question. But one's ability to survive will instinctively arise, and survival requires creativity.

I hope this is of help to you, as I hastily write these words on a plane back to New York. Without seeing your work it is hard to be more specific. Perhaps we can meet if time allows?

Yours,
Cai Guo-Qiang
New York

CHRONOLOGY

COMPILED BY SANDHINI PODDAR

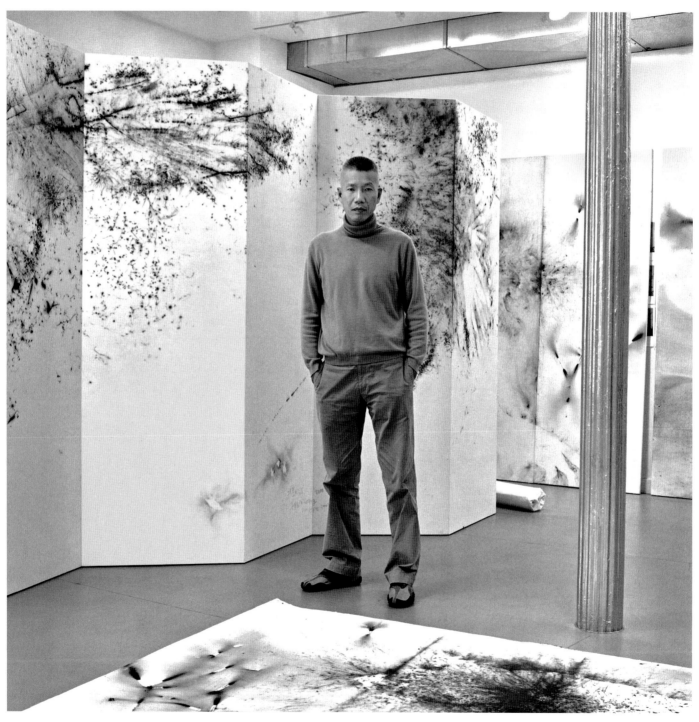

FIG. 95. CAI GUO-QIANG AT CAI STUDIO, NEW YORK, 2005

Highlighted in color within the chronology are statements by Cai Guo-Qiang that are taken from an interview conducted by Alexandra Munroe in May 2007 at Cai Studio in New York.

1957
Born Cai Guo-Qiang, December 8, in Quanzhou (fig. 96), located on the southeast coast of Fujian Province, China.

1971–79
Cai's father, Cai Ruiqin (fig. 97), manages the publications produced by the local Xinhua Bookstore and has access to imported publications by foreign authors, otherwise reserved for government officials. Because of his passionate interests in history, calligraphy, and painting he is an important influence on his son and has a great deal to do with Cai Guo-Qiang's exposure to traditional Chinese art during these formative years. Furthermore, the family's familiarity and relationship with local art and culture, including preeminent scholars, widens the intellectual scope of Cai's early education.

Throughout elementary and middle school, Cai actively participates in art and cultural propaganda troupes promoting Maoist ideology. He tries his hand at the violin, oil painting (figs. 98 and 99), and theatrical performances, and also acts in martial-art films in his early twenties (fig. 100).

"With the Cultural Revolution, people didn't go to school and participated in the revolution instead. I learned the art of propaganda. Xiaxiang (Down to the Countryside Movement) was a Maoist campaign that intended for intellectuals to go to the countryside to learn about farming and productivity and to be involved in national affairs through physical labor. I avoided Xiaxiang and passed the exam to join the municipal propaganda troupe, which was basically a theater troupe."

1976
Mao Zedong (1893–1976) dies, and with his death comes the end of the Cultural Revolution and the start of reforms.

"To us, Mao Zedong is the most influential person in the latter half of the twentieth century. He is the idol, God-like. His artistic talent, calligraphy, poetry, military strategies, philosophy, essays, and revolution movements deeply influenced my generation, despite the fact that later on we all started to question his ideologies.

The initial and most direct influence of Mao's ideology on my generation is the notion that "to revolt is justified" (zaofan youli); anything that disrupts the usual and consensual rule or law is considered good. Maoist theories and his influence on society coincided with my formative years—elementary school and adolescence—and seeped into my mentality, consciously and unconsciously."

FIG. 96. QUANZHOU

FIG. 97. CAI'S FATHER, CAI RUIQIN

FIG. 98. *UNTITLED (SEASIDE IN QUANZHOU)*, CA. 1975–85. OIL ON BOARD, 20 X 33 CM. COLLECTION OF THE ARTIST

FIG. 99. *UNTITLED (EAST LAKE, QUANZHOU)*, 1978. WATERCOLOR ON PAPER, 19.5 X 24 CM. COLLECTION OF THE ARTIST

1978

Cai meets his future wife, Hong Hong Wu (see fig. 130), who is a painter in Quanzhou.

1980

Cai studies calligraphy, painting, and stage design with Chen Yiting, who is a stage designer for the Quanzhou theater troupe and is a friend of Cai's father. Cai's work designing and painting stage sets for the troupe provides a strong foundation for what becomes an ongoing utilization of installation techniques. He also studies with Yang Zhenrong outside of the theater troupe. He continues to debate his father about Chinese art and culture. He rejects the study of traditional Chinese ink painting and calligraphy and substitutes these with oil painting, drawing and sculpture.

1981–85

"I experienced the military tensions between Mainland China and Taiwan because of the proximity of my hometown to Taiwan. [The shortest distance between Mainland China and Taiwan is 130 kilometers across the Taiwan Strait.] I have also experienced the economic opening of China and the establishment and reestablishment of universities, and that is how I could go to university. China opened up to allow students to go abroad for advanced degrees, which I also benefited from. The shift from a Marxist and Leninist chain of thought and the introduction of modern and contemporary Western philosophy to China through translated texts, provided an understanding on worldly developments."

Eager to broaden his horizons, Cai leaves Quanzhou to enter the department of stage design at the Shanghai Drama Institute (also known as the Shanghai Theatre Academy). He studies with one of the school's most important professors, Zhou Benyi, who had traveled to America to research Western stage design and to Russia to study the Stanislavsky method of theater training. With a new understanding of Western stage practices, and a heightened sense for theater, spatial arrangements, interactivity, and teamwork, Cai starts to deconstruct his traditional training, and to incorporate experimentation and spontaneity into a developing oeuvre.

Prior to graduating, Cai begins to think about going abroad. In the meantime, he is keen on finding his roots through travel, which motivates him to make self-funded summer trips to Xizang (Tibet), Xinjiang, and the Buddhist cave sites in Luoyang and Dunhuang in China. He wants to use his time before leaving the country to experience the splendor in traditional Chinese culture and in the natural landscape. Unlike some of his avant-garde contemporaries, who are more interested in overthrowing traditions and the system, Cai will assert his creativity using these foundations.

1984

Cai develops his first experiments working directly with gunpowder on canvas as a new artistic methodology. On one occasion, his grandmother uses burlap to smother one of his burning canvases, and serendipitously, this inspires Cai to use the same technique going forward. Gunpowder is a readily available material and Cai has access to several domestic firecracker-manufacturing businesses owned by family acquaintants. Initially, the artist is unfamiliar with the chemical makeup of gunpowder or how to control the explosions, but he persists in experimenting, creating violent explosions. The results are often disastrous.

FIG. 100. CAI ACTING IN THE MARTIAL-ARTS FILM *THE SPRING AND FALL OF A SMALL TOWN* (1978)

FIG. 101. CAI WORKING ON AN EARLY GUNPOWDER PAINTING, *UNTITLED* (1985), IN QUANZHOU

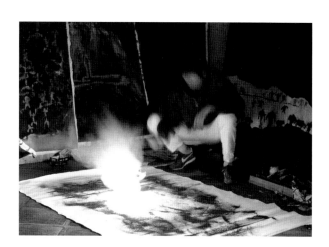

"My fixation on this material comes from something fundamental, in essence. I want to explore the dualistic relationship between the power of destruction and that of creation. Artists have always been attracted to and in awe of unpredictability, spontaneity, and uncontrollability. Sometimes, these qualities can be social or conceptual. But sometimes they are very physical, biological, and emotional. The act of making gunpowder drawings is connected to a twenty-year-long insistence on working two-dimensionally and to my childhood dream of becoming a painter."

1985

Cai curates and participates in his first group exhibition, *The Shanghai and Fujian Youth Modern Art Joint Exhibition*, at the Fuzhou City Museum in Fujian Province, with works by schoolmates and older artists from Quanzhou and Shanghai, including Chen Zhen, Hu Xiangcheng, and Zhang Jianjun. Because of the conservative atmosphere prevalent at the time of the exhibition, Cai exhibits paintings in a socialist-realist vein.

1986

With the help of Li Yihua, a friend who works at the National Palace Museum in Beijing's Forbidden City, Cai is able to realize his dream of studying overseas. He obtains a Japanese student visa, moves to Tokyo in December, and will remain in Japan until 1995. The artist brings a sizeable quantity of early gunpowder works with him. He enters a language school, where he studies for two years and occupies himself with a busy daily schedule. Cai's focus on mastering the Japanese language and making art, rather than looking for a job, make his early years in Japan financially unstable. He vividly remembers a beautifully painted landscape that he sold to a Tokyo classmate for seventy U.S. dollars at the start of school.

"While in China, I did not favor either side. I was not interested in mainstream art, which used itself in the service of politics. Neither did I fervently participate in the avant-garde movement to rebel against the system. Both groups employ an overbearing collective effort in employing art for social reform. When you observe my move from Quanzhou to Shanghai to Japan, a commonality develops. These were places, providing a source of individualism, where I could do the things that pleased me, that allowed me to indulge in my individuality."

1987–88

Cai is included in a group exhibition at the Tokyo Metropolitan Art Museum *55th Memorial Exhibition of Dokuritsu Art Association*. Also at this time, critic Takami Akihiko, who owns Gallery Kigoma in Kunitachi on the outskirts of Tokyo, invites Cai to participate in a solo exhibition.

Cai and Hong Hong Wu marry in Tokyo.

1989

Cai includes early gunpowder drawings in a second group show at the Tokyo Metropolitan Art Museum *16th International Modern Art AU Show*. For his second exhibition at Gallery Kigoma, *Explosions and Space Holes: Cai Guo-Qiang*, Cai creates his first mature installation *Space No. 1* (fig. 104). A review by Takami in *Bijutso Techō*, a popular art magazine in Japan, marks the first coverage of Cai's work in the established art press. NHK (Japan Broadcasting Corporation) commissions Cai to make new gunpowder drawings and he appears on the morning news.

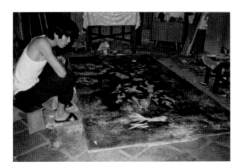

FIG. 102. CAI WORKING ON *SHADOW: PRAY FOR PROTECTION* (1985–86, CAT. NO. 3) IN QUANZHOU

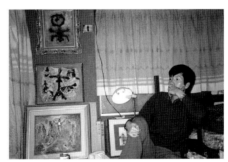

FIG.103. CAI AT HIS HOME IN JAPAN, 1986

FIG. 104. *SPACE NO. 1* (1989), INSTALLATION VIEW AT GALLERY KIGOMA, TOKYO, 1989

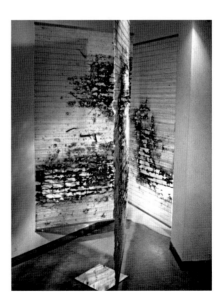

Curator Gao Minglu organizes *China/Avant-Garde* at the National Art Museum of China, which offers an unprecedented survey exhibition of avant-garde art in China. During a visit to Beijing, Cai delivers a lecture on Japanese contemporary art at the Central Academy of Fine Arts and tours *China/Avant-Garde* (fig. 105); he had, however, declined to contribute a work to the exhibition.

Cai attends the University of Tsukuba for two years as a nondegree research student under the tutelage of Kawaguchi Tatsuo, a conceptual sculptor who participates in the controversial exhibition *Magiciens de la Terre* at the Musée National d'Art Moderne, Centre Georges Pompidou, in Paris that year. Cai serves as the sculptor's production assistant and is deeply influenced by Kawaguchi's commitment to process.

Despite the early success of Cai's work with Japanese audiences, he spends considerable time alone watching television and reading. He develops an interest in modern Western astrophysics. Publications by the scientist Stephen Hawking (fig. 106) on cosmology, quantum gravity, and black holes are popular at this time, including the best-selling *A Brief History of Time: From the Big Bang to Black Holes* (1988). The artist commences his ongoing, iconic series *Projects for Extraterrestrials*, which aims at connecting the seen and unseen worlds and bridging communications among man, nature, and the cosmos. Cai also realizes his first large-scale explosion event, *Human Abode: Project for Extraterrestrials No. 1* (cat. no. 18), at the *89 Tama River Fussa Outdoor Art Exhibition* in Fussa, in the suburbs of Tokyo.

"At the moment of ignition, energy accumulates. There is an instant of suspension before the full explosion. It is a very blank and quiet moment. With gunpowder fuse, after you light it, you see the flame burn into the core and there is a moment of silence before a loud explosion. From this point of view, gunpowder drawings and outdoor explosions share this similar characteristic. Large-scale outdoor explosions bring connections to the cosmos, nature, society, glory, and heroic sensation, and this kind of allegorical excitement is incomparable. What the indoor work provides us with is a physical interaction, an intimacy, and the complexity of delicate emotions in a serene atmosphere, which is very different from the outdoor works."

The Tian'anmen Square protests of 1989 in Beijing have wide-sweeping effects domestically and internationally, leading to violence, civilian deaths, and arrests across China. Cai and Hong Hong Wu decide not to move back to China. The couple's first daughter, Cai Wen-You (see figs. 113 and 130), is born on December 14.

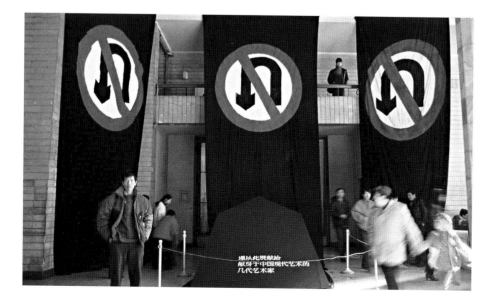

FIG. 105. CAI VISITING THE EXHIBITION *CHINA/AVANT-GARDE*, NATIONAL ART MUSEUM OF CHINA, 1989

FIG. 106. STEPHEN HAWKING AND CAI, 1990

1990

The Osaka Contemporary Art Center presents Cai's solo exhibition *Cai Guo-Qiang: Works 1988/89* (fig. 107), which includes remnants of the yurt used in the explosion event *Human Abode: Project for Extraterrestrials No. 1* and early gunpowder paintings.

Cai moves just outside Tokyo to Toride on the scenic Tonegawa River, the largest in Japan.

Cai travels to France to participate in *Chine demain pour hier* curated by Chinese critic Fei Dawei, with his explosion event *45.5 Meteorite Craters Made by Humans on Their 45.5. Hundred Million Year Old Planet: Project for Extraterrestrials No. 3* (cat. no. 19). This exhibition in Pourrières, Aix-en-Provence marks the first time Cai presents his work anywhere in the West. It is a turning point in the artist's career, bringing him to the attention of European critics and curators and exposing him to the Western art establishment. Takagishi Michiko and Itō Shinobu of P3 art and environment, an alternative gallery in Tokyo, travel to Aix-en-Provence to witness Cai's project and lay the groundwork for a working relationship with the artist.

1991

For the project *Earth SETI Base: Project for Extraterrestrials No. 0* (see fig. 108) to be realized on an island next to the port city of Kobe, Cai proposes to lease a piece of open land and leave it exposed as is. His intention is that residents of the region can inspect it day and night, searching for traces of extraterrestrials. Though unrealized, this concept predates the series *Projects for Extraterrestrials*, and hence it is numbered zero.

Following his introduction to the West, Cai embarks on a series of seven ambitious gunpowder drawings on paper mounted on wood as folding screens. These works are created with the enthusiastic support of P3 art and environment's director Serizawa Takashi and his staff for the installation *Primeval Fireball: The Project for Projects* (cat. no. 37) presented at the Tokyo gallery. This suite of drawings is a mature body of work that brings together drawing, gunpowder explosions, and installation, and spans Cai's interests in the origins of the universe and extraterrestrial life.

"When I lived in Japan, Japanese society was going through a time of self-reflection and self-examination. The Japanese wanted to achieve an internationalism and modernism. But in the end, they only retained the result of westernization. The Japanese executed quite a profound self-examination. Nevertheless, the Japanese problem became my problem. That is how the series *Projects for Extraterrestrials* came about. I was thinking, 'Would there be a way to go beyond the very narrow East and West comparison? Was there an even larger context or a broader approach?' This is the source of these concepts."

Tatsumi Masatoshi (see fig. 115) begins working with Cai and is the Technical Director of Cai Studio to the present day. Cai is considered by the Asian Cultural Council for a grant to come to the United States, but he is not selected at this time. The artist assists in the realization of *Exceptional Passage: China Avant-Garde Artists Exhibition* in Fukuoka, in southern Japan and realizes the explosion event *The Immensity of Heaven and Earth: Project for Extraterrestrials No. 11*.

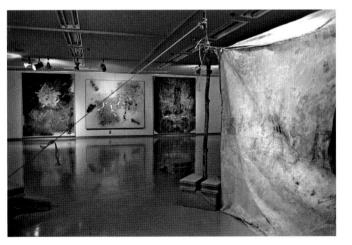

FIG. 107. INSTALLATION VIEW OF *CAI GUO-QIANG: WORKS 1988/89*, OSAKA CONTEMPORARY ART CENTER, 1990

FIG. 108. *EARTH SETI BASE: PROJECT FOR EXTRATERRESTRIALS NO. 0*, 1991. INK ON PAPER, 29.5 X 47 CM. PRIVATE COLLECTION

1992

Cai travels to Germany, where he realizes the explosion event *Fetus Movement II: Project for Extraterrestrials No. 9* (cat. no. 20) in Hannover- Münden as a participant in the exhibition *Encountering the Others: The Kassel International Art Exhibition.* This is the first and only time that the artist places his body directly within the physical area of the explosion event. The realization of the event at a military base attests to the artist's interest in using site specificity to manifest political commentary early on in his career.

1993

Cai receives grant for a residency in France at the Fondation Cartier pour l'art contemporain, Jouy-en-Josas (fig. 109). While there, he experiments with local herbs to make homemade perfume, mimicking the process of alchemy.

The monumental explosion event *Project to Extend the Great Wall of China by 10,000 Meters: Project for Extraterrestrials No. 10* (cat. no. 21), which is commissioned by P3 art and environment, Tokyo, is realized in the Gobi Desert in Jiayuguan, Gansu Province. Cai makes use of his considerable leadership skills to overcome significant bureaucratic and financial hurdles. To offset costs, for example, he works with a Japanese travel agency to organize a group of Japanese tourists, who pay to attend the event and are also mobilized, along with local volunteers, to help lay the fuse lines.

1993–94

Cai temporarily relocates to Iwaki, in Fukushima, on the northeastern coast of Japan, setting up a residence within the city's fishing community. He has chrysanthemums planted outside of his home (fig. 110), later using these flowers to make medicinal tea that is consumed as part of the interactive installation *Chrysanthemum Tea.* Takami Akihiko's father, who works in Iwaki, introduces Cai to Fujita Chūhei, a local gallery owner. Cai recruits local volunteers to help him create an installation for the solo exhibition *Cai Guo-Qiang: From the Pan-Pacific* at the Iwaki City Art Museum (fig. 111). Most of the

volunteers, led by Shiga Tadashige, have never visited the museum, but all of them show much-needed support for the artist, who reciprocates by donating a large section of art works included in *Cai Guo-Qiang: From the Pan-Pacific*. Cai realizes the explosion event *The Horizon from the Pan-Pacific: Project for Extraterrestrials No. 14* (1994, cat. no. 22) with the collaboration of Iwaki's residents, who also switch off their lights so that the explosion is more fully visible against the night sky. The artist's relationship with Iwaki, which continues to the present, is an early example of his collaborative methodology in realizing ambitious explosion events, installations, and social projects.

"I didn't have a very smooth start in Tokyo so I moved to Iwaki. This idea of using the countryside to surround the city is Mao Zedong's military strategy. Mobilizing the local population, motivating critics, creating a point of discussion—these are very fundamental methods. Having a very positive attitude at the most difficult of times is also important."

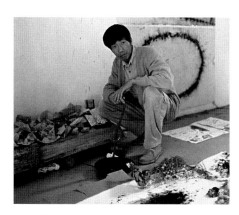

FIG. 109. CAI IN HIS STUDIO AT FONDATION CARTIER POUR L'ART CONTEMPORAIN, JOUY-EN-JOSAS, 1993

FIG. 110. PLANTING A CHRYSANTHEMUM GARDEN AT CAI'S RESIDENCE IN IWAKI, 1994

FIG. 111. POSTER FOR THE EXHIBITION *CAI GUO-QIANG: FROM THE PAN-PACIFIC*, 1994

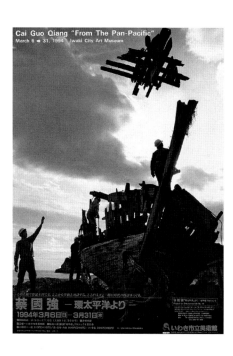

Hasegawa Yūko curates *Chaos: Cai Guo-Qiang* at the Setagaya Art Museum, Tokyo. The museum concurrently holds the exhibition *The Precious Artifacts of Ch'in*, which includes a collection of terra-cotta burial soldiers and horses. Cai digs a hole outside the exhibition gallery walls to create *Grave Robbing* (fig. 112), an installation that is made to resemble an excavation site. The project is a commentary on how human history has been partially constructed based on excavated materials from burial sites.

A headline in the year-end art review of *The Daily Yomiuri* newspaper on December 14, 1994 reads, "Cai Guo-Qiang—Very Active, Decline of Euro-American 'Contemporary' [Art]." The review is indicative of Cai's assimilation into the Japanese art world as he becomes the standard bearer of a new awareness within Japan of the importance of Asian art and its use as a relative index for the reassessment of Japanese contemporary art.

1995

A grant from the Asian Cultural Council (ACC) enables Cai to participate in a year-long residency as part of the P.S.1 Studio Program in New York as a representative of Japan.

"In 1995 I participated in an exhibition at the Museum of Contemporary Art in Tokyo, *Art in Japan Today 1985–1995*. I had a large installation in that show, and ACC approached me again. This time, they chose me because by then I had represented Japan in several international art exhibitions."

In September, Cai arrives in New York, where he continues to maintain a studio until the present day. At P.S.1 he develops the prototype for the small-scale explosions that make up *The Century with Mushroom Clouds: Project for the 20th Century* (cat. no. 26) in 1996. Cai's move to the United States initiates an emphatic shift in his oeuvre, as he starts to work consistently with political themes and cultural subject matter. This change is due in part to Cai's reaction to contemporaneous discussions on China's international ascendancy and the consequent fear expressed in the popular media in the West, as well as the artist's own marked perceptions of American foreign policy.

For the social project *Bringing to Venice What Marco Polo Forgot* (cat. no. 48), Cai receives the Benesse Prize, awarded in Japan by the Benesse Art Site, Naoshima, to emerging artists. This work is realized at the *46th Venice Biennale* as part of the exhibition *TransCulture*, which is jointly organized by the Japan Foundation and the Fukutake Science and Culture Foundation.

Cai is also the recipient of the Japan Cultural Design Prize, in recognition of his explosion events and vision as an artist.

1996

With the assistance of the Asian Cultural Council, Cai realizes *The Century with Mushroom Clouds: Project for the 20th Century* and has this series of small explosions documented in photographs. This project is realized in New York and at symbolic nuclear test and Land art sites in Nevada and Utah. These explosion events are especially resonant given the artist's belief in the vulnerability of the sites.

On the occasion of *The Second Asia-Pacific Triennial of Contemporary Art*, at the Queensland Art Gallery, Brisbane, Cai proposes the explosion event *Dragon or Rainbow Serpent: A Myth Gloried or Feared: Project for Extraterrestrials No. 28*. An accident at a local pyrotechnic company leaves the project unrealized, succinctly conveying the instability governing several of Cai's projects (see fig. 114).

FIG. 112. *GRAVE ROBBING*, 1994. REALIZED SEPTEMBER 1994 AT SETAGAYA ART MUSEUM, TOKYO, FOR THE EXHIBITION *CHAOS: CAI GUO-QIANG*. TRIGGERING DEVICE, LAMP, AND SHOVELS, 300 X 200 X 500 CM

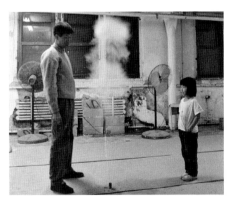

FIG. 113. CAI AND HIS DAUGHTER CAI WEN-YOU AT P.S.1, NEW YORK, 1995

FIG. 114. PRESS COVERAGE BY DAVID BRAY AND SEAN PARNELL, "EXPLOSION DESTROYS TRIENNIAL FIREWORKS," *COURIER-MAIL* (BRISBANE), SEPT. 26, 1996

Cai first realizes *Cry Dragon/Cry Wolf: The Ark of Genghis Khan* (cat. no. 39) at the Guggenheim Museum SoHo, New York, in the exhibition of works by the artists short listed for *The Hugo Boss Prize 1996*. This installation is the formal introduction of his work to the mainstream art world in the United States and also marks the beginning of an ongoing relationship between the artist and the Solomon R. Guggenheim Foundation.

1997

Cai Guo-Qiang: Flying Dragon in the Heavens, at the Louisiana Museum of Modern Art, Humlebaek, Denmark, which is the artist's first solo exhibition in a European museum, is followed a few months later by *Cai Guo-Qiang: Cultural Melting Bath: Projects for the 20th Century* at the Queens Museum of Art, New York, which is his first solo exhibition in an American museum. Cai's initial idea for an installation for the New York exhibition, to cut apart a United States torpedo boat, is unrealized, and instead he presents *Cultural Melting Bath: Projects for the 20th Century* (cat. no. 40).

Cai receives the first Oribe Award, part of the Oribe Project in Gifu Prefecture, Japan, in recognition of his concern about humanity, creativity, and exploration of new art forms.

A second project for the Guggenheim, the proposed installation *Foolish Man Moving the Mountain* conceived for *China: 5,000 Years: Innovation and Transformation in the Arts*, goes unrealized after it is decided not to include contemporary art in the exhibition.

Cai participates in the traveling exhibition *Cities on the Move* curated by Hans Ulrich Obrist and Hou Hanru.

1998

Eslite Gallery (Cherng Piin) in Taipei presents the solo exhibition *Daydreaming: Cai Guo-Qiang* (see fig. 115). The artist's fluency in Minnanese, a dialect used primarily by Taiwanese whose ancestors immigrated from China's Fujian Province, grants him acceptance in Taipei on an interpersonal level. *Daydreaming: Cai Guo-Qiang* immediately precedes the first Taipei Biennial *Site of Desire* curated by Nanjō Fumio, for which Cai erects *Advertising Castle*, a gigantic scaffolding of advertising billboards that shrouds the Taipei Fine Arts Museum. Combining irony with pragmatism, the billboards also serve as a means to attract funding for the project. Despite protests by members of the Taipei art community, the installation results in a consequent ban on the use of public buildings for corporate advertising. The explosion event *Golden Missile* (cat. no. 27), which shuts down the Taipei Songshan Airport for ten minutes, is another of Cai's contributions to the Biennial.

Cai participates in the survey exhibition *Inside Out: New Chinese Art* curated by Gao Minglu, which travels in the United States, Mexico, and Australia. The exhibition includes Cai's large installation *Borrowing Your Enemy's Arrows* (cat. no. 41). This work is later shown at The Museum of Modern Art in New York in 2000 as part of *Open Ends—MoMA 2000*, which brings critical acclaim for the artist from international curators.

At the invitation of Ni Tsai-Chin, Director of the Taiwan Province Museum of Art, Taichung, Cai stages an explosion event, *No Destruction, No Construction: Bombing the Taiwan Province Museum of Art* (cat. no. 28) during the museum's renovation. (The Taiwan Province Museum of Art is later renamed as the National Taiwan Museum of Fine Arts). Because of the political tensions between the two Chinas, the selection of an artist from Mainland China to "bomb" a Taiwanese museum provokes a controversy and eventually leads to the dismissal of Ni from his post.

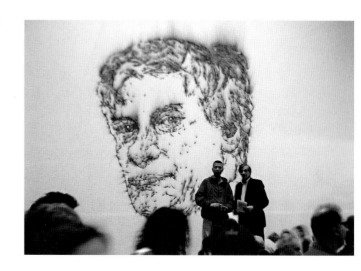

FIG. 115. CAI AND TATSUMI MASATOSHI WORKING ON GUNPOWDER DRAWINGS IN TAIWAN FOR THE EXHIBITION *DAYDREAMING: CAI GUO-QIANG*, 1998

FIG. 116. CAI AND JAN HOET IMMEDIATELY AFTER THE EXPLOSION EVENT *INHERITANCE: EXPLODING JAN HOET'S PORTRAIT*, REALIZED AT S.M.A.K., GHENT, MARCH 28, 2003

1999

For the explosion event *Firecrackers for the Opening of S.M.A.K.,* Cai explodes casino chips over the facade of S.M.A.K. (Stedelijk Museum voor Actuele Kunst) in Ghent. Cai and curator Jan Hoet, who invited him to create this work for the inauguration ceremony of S.M.A.K., begin an ongoing collaboration that includes nine exhibitions and explosion projects as of 2007 (see fig. 116).

Cai participates in the exhibition *Aperto Over All* curated by Harald Szeemann as part of the *48th Venice Biennale,* and is awarded the Golden Lion for his provocative installation *Venice's Rent Collection Courtyard* (cat. no. 42). This work sparks interest in Cai's use of the readymade but simultaneously raises issues of copyright infringement in China. The Sichuan Fine Arts Institute in Chongqing files charges against the artist but the case is ultimately dismissed by the courts.

An earthquake on September 21 in Chi-Chi, Nantou County, in the center of Taiwan kills over 2,400 people. Cai will commemorate this tragedy with the large gunpowder drawing *The Mark of 921* in 2000.

Cai travels to Brazil to participate in the *The Quiet in the Land* residency project in Salvador, Bahia, which is organized by curator France Morin. He works with juvenile delinquents from Bandaxé on two explosion events titled *Salute* (see fig. 117). The second explosion event is developed in July 2000 when Cai returns to Salvador to work with the children at the Casa de Cultura, Projeto Axé Social.

In response to the anxiety surrounding the coming of the new millennium, Cai develops the explosion event *Untitled (Last Supper)* for the Centraal Museum in Utrecht, Netherlands (see fig. 118). Cai's idea is to distribute small gunpowder fuses to residents and have them ignite these up their chimneys at dusk on the last day of 1999, and then sit down and have a "last supper." Owing to foggy conditions, the project cannot be fully realized as prevailing clouds prevent a clear viewing of the gunpowder smoke rising from the chimneys.

2000

The gunpowder drawing *The Mark of 921* is created on site at the National Taiwan Museum of Fine Arts, Taichung during the group exhibition *Gratitude* and immediately auctioned to benefit the victims of the September 21, 1999 earthquake.

Cai's ongoing interest in the concept and practice of geomantic energy principles leads to the project *How is Your Feng Shui? Year 2000 Project for Manhattan* (fig. 119), for which the artist offers feng shui remedies to visitors to the *2000 Whitney Biennial* at the Whitney Museum of American Art in New York.

"Feng shui often influences my installations. Even when the installation has nothing to do with feng shui, you can detect its governance in the way I place objects or how the elements in the work relate to one another. You can find it in the relationship these objects have with their surroundings, the attention to orientation, the treatment of the entrance space or the background, the creation of energy fields, and the relationship between the work and the audience or spectator. I consider the audience as part of the energy field and mobilize and manage the flow of energy. These are all the relationships and elements that I take into consideration in my work. The architecture and the building structures provide a foundation, just as a natural environment provides a city with a backdrop. Feng shui adds to the hardware; if you place things harmoniously according to the right energy, you can use that force to help your own force."

FIG. 117. CAI AND CHILDREN FROM BANDAXÉ WORKING ON THE DESIGN AND CONSTRUCTION OF CANONS FOR THE EXPLOSION EVENT *SALUTE* (1999), SALVADOR, BAHIA, 1999

FIG. 118. *THE LAST SUPPER*, 1999 (RECTO). DOUBLE-SIDED DRAWING: PEN ON PAPER (RECTO); FELT PEN ON PAPER (VERSO), 29.5 X 42 CM. COLLECTION OF THE ARTIST

FIG. 119. *HOW IS YOUR FENG SHUI? YEAR 2000 PROJECT FOR MANHATTAN* (2000), INSTALLATION VIEW AT THE WHITNEY MUSEUM OF AMERICAN ART, NEW YORK, 2000

At the *Biennale of Sydney 2000*, Cai presents *Still Life Performance* (fig. 120) in the Art Gallery of New South Wales. For this performance piece, local artists participate with him to create oil paintings of a nude model sitting on a horse in the gallery.

Cai's interests in site-specificity, museology, and working with local communities and histories lead him to initiate his creation of contemporary art museums, the *Everything Is Museum* series. The first, *DMoCA (Dragon Museum of Contemporary Art): Everything Is Museum No. 1* (cat. no. 50), is established in Niigata, Japan, as part of this year's Echigo-Tsumari Art Triennial. Acting as the curator, director, or architect of this and subsequent contemporary art museums, Cai intervenes in unusual, nonart sites to develop workable structures that serve as spaces for community involvement.

This is the first year in which Cai collaborates with Fireworks by Grucci, the pyrotechnic company led by Phil Grucci and based in Brookhaven, New York. Together, they realize the explosion event *Ascending a Staircase* (fig. 121) at the 69th Regiment Armory in New York as an homage to Marcel Duchamp's painting *Nude Descending a Staircase (No. 2)* (1912), which had been displayed at the armory in 1913.

2001

Named in the category of visual arts, Cai is a recipient of the CalArts/Alpert Award in the Arts, given by the Herb Alpert Foundation in collaboration with the California Institute of Arts Valencia. He is honored for his realized and theoretical projects.

Cai Guo-Qiang: Impression Oil Drawings, at the Charles H. Scott Gallery, Vancouver, is the only exhibition of the artist's oil paintings in recent years. He cites El Greco as a source of aesthetic inspiration for the works, which depict impressions and scenes from realized explosion events. A concurrent exhibition, *Cai Guo-Qiang: Performing Chinese Ink Painting* is held at the Contemporary Art Gallery and Dr. Sun Yat-Sen Classical Chinese Garden in Vancouver.

In Colle di Val d'Elsa, Tuscany, Cai creates *UMoCA (Under Museum of Contemporary Art): Everything Is Museum No. 2* (cat. no. 51) and curates *Who Is the Happiest? UMoCA Inaugural Exhibition with Ni Tsai-Chin*. The exhibition is held in conjunction with *Arte all'Arte 6*.

At the invitation of Harald Szeemann (see fig. 122), curator of the *49th Venice Biennial*, Cai realizes *Service for the Biennale!* as part of the main exhibition, *Plateau of Humankind*.

Serving as Artistic Director of the *Asia-Pacific Economic Cooperation Cityscape Fireworks* (see cat. nos. 15.1–.14), Cai conceives and orchestrates the largest explosion event in his career thus far, an approximately 20-minute-long extravaganza of fireworks realized along the Huangpu River in the heart of Shanghai. This event marks the first occasion for which the Chinese government invites a contemporary artist to participate in the execution of a state-sponsored event of such magnitude.

FIG. 120. PRESENTATION OF *STILL LIFE PERFORMANCE* AT ART GALLERY OF NEW SOUTH WALES, SYDNEY, 2000

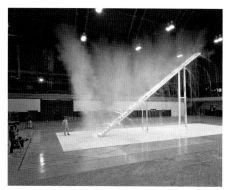

FIG. 121. *ASCENDING A STAIRCASE*, REALIZED AT 69TH REGIMENT ARMORY, NEW YORK, DECEMBER 1, 2000

FIG. 122. HARALD SZEEMANN AND CAI AT *SERVICE FOR THE BIENNALE!* DURING 2001 VENICE BIENNALE

"When large-scale explosions happen, the impact at the moment of the explosion creates a sense of momentary chaos. It distorts time, space, one's sense of existence and of those around you. It has an impact both biologically and spiritually. It creates a lot of possibilities and somehow also pauses time. It is a flash-like moment that also creates a sense of eternity. Sometimes, it makes time and space completely blank. Sometimes, it feels like time slows down."

The 9/11 attacks have a severe impact on international affairs. The tragedy, particularly the destruction of the twin towers of the World Trade Center in New York, where Cai is a resident, has a sustained influence on the development of his work hereafter.

2002

Cai's first solo exhibition in China is presented at the Shanghai Art Museum (fig. 123). Included as a show within the show, Cai curates the exhibition *Cai Guo-Qiang's Maksimov Collection* (fig. 21) to illustrate the influence of the Russian painter Konstantin Maksimov on Chinese art. The exhibition consists of 230 works from Cai's own collection of paintings by Maksimov, who came to Beijing to teach oil painting and between 1955 and 1957 helped establish Soviet socialist realism as the dominant academic style in China. Cai learned oil painting from the generation of artists who studied with the Russian. This portion of the exhibition then travels to Beijing and Shenzhen.

Created with the help of curator Lilian Tone, Cai's explosion event *Transient Rainbow* (cat. no. 30) for the opening of the Museum of Modern Art's temporary home in Queens, New York, is especially significant as the first pyrotechnic event permitted in the city since the terrorist attacks of 9/11, almost a year earlier. Realized June 29, this event also marks the first use of multicolor peony fireworks fitted with computer chips, developed by Fireworks by Grucci for Cai (fig. 124).

"My work *Transient Rainbow* showed people how to have courage and hope in the face of calamity. The city government and fire department both showed their support; they understood that one can't be beaten down by terrorism. In the end, to realize this project, the Coast Guard stopped water traffic, and air traffic was limited for a certain time. Needless to say, the police surrounded both banks of the East River."

FIG. 123. INSTALLATION VIEW OF OIL PAINTINGS IN *CAI GUO-QIANG*, SHANGHAI ART MUSEUM, 2002

FIG. 124. EXPLOSIVE MADE BY FIREWORKS BY GRUCCI FOR *TRANSIENT RAINBOW* (2002, CAT. NO. 30)

FIG. 125. *ETHEREAL FLOWERS*, REALIZED AT TRENTO CEMETERY, SEPTEMBER 6, 2002

The solo exhibition *Cai Guo-Qiang: Ethereal Flowers* is held at the Galleria Civica di Arte Contemporanea, Trento. Cai realizes *Ethereal Flowers* (fig. 125), a subtle, poetic explosion event set over the local cemetery.

2003

Cai curates *DMoCA (Dragon Museum of Contemporary Art) 2: Pause, Inaugural Exhibition with Kiki Smith* for *Echigo-Tsumari Art Triennial 2003* (see cat. no. 50).

Commissioned by Creative Time in conjunction with the City of New York and the Central Park Conservancy, Cai realizes *Light Cycle: Explosion Project for Central Park* (ca. no. 32) to commemorate the one-hundred-fiftieth anniversary of the creation of Central Park (see fig. 126). Inclement weather and a false terrorist scare in the park on the day of the event, September 15, hamper the full realization of Cai's vision. The Asia Society Museum in New York presents an exhibition of related gunpowder drawings.

Cai is commissioned by the Siwa Art Project, Egypt, to organize a social project at the Siwa Oasis in the western Sahara. He collaborates with local children and families to produce *Man, Eagle, and Eye in the Sky* (cat. no. 53), an interactive, community-based project that utilizes 300 Chinese kites that are painted and exploded.

Cai's studio practice, which has thus far been located within the artist's home, moves to an independent space in Manhattan's East Village (fig. 127). Cai's second daughter, Cai Wen-Hao (see fig. 130), is born on September 27.

2004

On March 11, terrorist bombs rip through four rush-hour trains in Madrid killing 191 civilians.

Cai creates *BMoCA (Bunker Museum of Contemporary Art): Everything Is Museum No. 3* (cat. no. 52) on Kinmen Island, Taiwan. Responding to the island's military history and the history of cross-straits tensions between Taiwan and Mainland China, he curates *18 Solo Exhibitions*, which includes contemporary artists from the two Chinas as well as overseas Chinese. Groups of local schoolchildren also create installations. All the art projects are realized at the island's ubiquitous bunkers and other abandoned military sites.

At the Miramar Air Show in California, one of the pilots of the show dies in a fatal crash just minutes before Cai's aerial work *Painting Chinese Landscape Painting*—referencing Chinese literati paintings of mountains and waterfalls—was to have been performed (see figs. 128 and 129). The piece, which is created in connection with an upcoming group exhibition at the San Diego Museum of Art, is realized the next day.

FIG. 126. MUNITIONS FOR *LIGHT CYCLE: EXPLOSION PROJECT FOR CENTRAL PARK* (2003, CAT. NO. 32)

FIG. 127. CAI STUDIO, NEW YORK

Massachusetts Museum of Contemporary Art (MASS MoCA) in North Adams presents the monumental room-sized installation *Inopportune: Stage One* (cat. no. 45)—consisting of a cascade of nine seemingly exploding cars and evoking terrorist car bombings—as part of the exhibition *Cai Guo-Qiang: Inopportune*. The work's subject matter is tied to Cai's consistent interest in culturally sensitive and politically charged themes since his move to the United States almost ten years earlier. The exhibition remains on view into fall 2005.

2005

Cai develops a new methodology for his explosion projects. *Black Rainbow: Explosion Project for Valencia* (cat. no. 34) is Cai's first explosion event realized in daylight and is a commentary on terror and communal anxiety with an offering of hope symbolized by a rainbow. The Spanish pyrotechnic company Pirofantasia develops black fireworks using biodegradable black pigments developed by Degussa in Rheinfeld, Germany, for this project.

The Ministry of Culture in China organizes its first official China Pavilion at the *51st Venice Biennale*. Fan Di'an is appointed commissioner, and Cai curates the exhibition *Virgin Garden: Emersion* (see fig. 131), further strengthening the artist's relationship with the city of Venice.

Cai Guo-Qiang: Inopportune is awarded the Best Monograph Show and Best Installation in a Museum by the United States branch of the International Association of Art Critics.

As part of *Arte all'Arte 10*, Cai curates *Jennifer Wen Ma: Aeolian Garden* (see cat. no. 51), a second solo exhibition at UMoCA in Colle di Val d'Elsa. Ma (see fig. 132) is Studio Director at Cai Studio at this time and instrumental to its development from 1999 to 2006.

Tornado: Explosion Project for the Festival of China (cat. no. 36) is realized for the John F. Kennedy Center for the Performing Arts in Washington, D.C.

2006

For the solo exhibition *Cai Guo-Qiang: Stage* held in the Tuscan countryside near the town of San Gimignano, Cai builds an empty stage—measuring 12 by 18 meters—identical to those used for contemporary outdoor concerts (fig. 133). The stage is brightly lit through the night providing a welcoming site for visitors to gather. At Galleria Continua in town, a 24-hour live video feed of the stage is projected onto a theater screen, providing the ongoing outdoor event with a parallel life. The installation inspires Cai to create a number of gunpowder drawings that reference traditional landscape motifs.

Cai collaborates with curator and critic Lu Jie and Beijing's Long March Foundation to initiate the *Yan'an Forum on Art Education*, which is conceived of as a forum to discuss the sociological basis of contemporary Chinese art education, based on Mao Zedong's legendary 1943 Yan'an speech.

"Chairman Mao talked about how artists should live among the laborers, farmers, and soldiers to learn from their experiences and reflect their own

FIG. 128. PRESS COVERAGE BY TONY PERRY, "PILOT KILLED IN CRASH AT MIRAMAR AIR SHOW," *LOS ANGELES TIMES*, OCT. 16, 2004

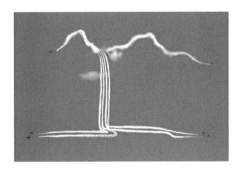

FIG. 129. COMPUTER RENDERING FOR *PAINTING CHINESE LANDSCAPE PAINTING* (2004)

FIG. 130. CAI AT HOME IN NEW YORK WITH HIS WIFE, HONG HONG WU, AND TWO DAUGHTERS, CAI WEN-HAO AND CAI WEN-YOU

time. His speech later on became the doctrine—the guideline for the development of art and literature in China—so Yan'an has this geographical and historical significance. When the Long March Project approached me, I paid homage to what Mao had done in the same place."

The exhibition *Cai Guo-Qiang on the Roof: Transparent Monument* at the Metropolitan Museum of Art in New York is on view for six months. In addition to the daily noon explosion of *Clear Sky Black Cloud* (fig. 31) above the museum, the exhibition includes three large-scale installations (see figs. 25, 33, and 132).

For the Deutsche Guggenheim in Berlin, Cai uses ninety-nine life-sized replicas of wolves and a glass wall to create *Head On* (cat. no. 47), a room-size installation that references the history of the city and addresses human fallibility.

"Japan inspired me to pay a lot of attention to the material and movement of the wolves, the spatial arrangements they form, and the speed and rhythm of their trajectory. All of these preserve a certain kind of aesthetic poetry and pureness. It is a kind of violent beauty. I also pay attention to how the installation reacts to space. Japan taught me to look at matters from a distance. It gave me the distance to look back on Eastern aesthetics. One pays attention to the wolves, the speed of the wolves going toward the wall, but you need the distance to actually make it art. You cannot just stand in front of something and convey certain ideas without this necessary distance or respect. We need to give the work enough space to stand on its own."

Cai provides the concept and visual direction for the multimedia performance *Wind Shadow* (cat. no. 54), a collaboration with the Cloud Gate Dance Theatre of Taiwan, which premieres at the National Theatre in Taipei.

2007

The installation *Inopportune: Stage One* (2004, cat. no. 45) is installed in the atrium of the new building of the Seattle Art Museum when it opens.

The solo exhibition *Light Passage: Cai Guo-Qiang & Shiseidō* at the Shiseidō Gallery, Tokyo, includes a retrospective of works created with the support and sponsorship of Shiseidō, as well as a suite of new gunpowder drawings based on the theme of the four seasons.

The Hiroshima City Culture Foundation awards Cai the 7th Hiroshima Art Prize awarded in recognition of his explosion events with healing messages. The award relates back to *The Earth Has Its Black Hole Too: Project for Extraterrestrials No. 16* from 1994 (cat. no. 24) and *The Century with Mushroom Clouds: Project for the 20th Century* from 1996. A solo exhibition of his work

FIG. 131. FARMER DU WENDA'S FLYING SAUCER AT THE CHINA PAVILION, 2005 VENICE BIENNALE

FIG. 132. CAI AND JENNIFER WEN MA IN FRONT OF *NONTRANSPARENT MONUMENT* (2006) AT THE METROPOLITAN MUSEUM OF ART, NEW YORK, 2006

FIG. 133. *STAGE*, SAN GIMIGNANO, TUSCANY, 2006

is scheduled for the Hiroshima City Museum of Contemporary Art in 2008.

Cai is currently a member of the creative team planning the opening and closing ceremonies for the Beijing 2008 Olympic Games (see fig. 134).

In collaboration with architect Norman Foster, Cai works on the development of *QMoCA (Quanzhou Museum of Contemporary Art): Everything Is Museum No. 4* (fig. 135), which is scheduled to open in the artist's hometown of Quanzhou in fall 2009. The international museum will employ the governing pedagogical principles of Chinese private schools and the tutor system; utilizing an open-ended, holistic approach to programming, and will support an interdisciplinary program of temporary exhibitions, artist residencies, and performances.

NOTE

The author wishes to thank Cai Guo-Qiang and Hong Hong Wu for their generosity in sharing personal stories, memories, and encounters. The compilation of this chronology would not have been possible without the assistance of Cai Studio and Lesley Ma in particular.

FIG. 134. ZHANG YIMOU (LEFT) AND CAI PREPARING FOR THE BEIJING 2008 OLYMPIC GAMES

FIG. 135. COMPUTER RENDERING OF *QMOCA (QUANZHOU MUSEUM OF CONTEMPORARY ART): EVERYTHING IS MUSEUM NO. 4*

SELECTED EXHIBITION HISTORY

COMPILED BY MARILUZ HOYOS

SOLO EXHIBITIONS

1987
Office of the Foreign Correspondents' Club of
Japan, Tokyo, *Cai Guo-Qiang's Painting*,
May 18–June 16.
Kigoma, Tokyo, *Cai Guo-Qiang: Gunpowder Art*,
Aug. 9–21.

1989
Kigoma, Tokyo, *Explosions and Space Holes:
Cai Guo-Qiang*, Mar. 5–17.

1990
Osaka Contemporary Art Center, *Cai Guo-Qiang:
Works 1988/89*, Feb. 5–10.

1991
P3 art and environment, Tokyo, *Primeval Fireball:
The Project for Projects*, Feb. 26–Apr. 20.
Exh. cat.

1992
IBM Kawasaki Gallery, *Wailing Wall: From the
Engine of Four Hundred Cars*, Oct. 15–26.

1993
Naoshima Contemporary Art Museum, (now
Benesse House), Naoshima, *Cai Guo-Qiang*,
Apr.–July.
P3 art and environment, Tokyo, *Long Mai:
The Dragon Meridian*, Jan. 22–Mar. 20.

1994
Gallery APA, Nagoya, *Cai Guo-Qiang: Calendar of
Life*, Jan. 7–30. Exh. cat.
Iwaki City Art Museum, Fukushima, *Cai Guo-Qiang:
From the Pan-Pacific*, Mar. 6–31. Exh. cat.
Tokyo Gallery, *Cai Guo-Qiang: Concerning Flame*,
May 9–28.
Setagaya Art Museum, Tokyo, *Chaos: Cai
Guo-Qiang*, Sept. 20–Nov. 3. Exh. cat.

1997
Louisiana Museum of Modern Art, Humlebaek,
Denmark, *Cai Guo-Qiang: Flying Dragon in the
Heavens*, Mar. 8–Apr. 27. Exh. cat.
Queens Museum of Art, New York, *Cai Guo-Qiang:
Cultural Melting Bath: Projects for the 20th
Century*, Aug. 1–Oct. 26. Exh. cat.

1998
Eslite Gallery (Cherng Piin), Taipei, *Day Dreaming:
Cai Guo-Qiang*, May 30–June 21. Exh. cat.

1999
Kunsthalle Wien, Vienna, *Cai Guo-Qiang: I Am the
Y2K Bug*, Nov. 4, 1999–Feb. 27, 2000. Exh. cat.

2000
Fondation Cartier pour l'art contemporain, Paris,
Cai Guo-Qiang, Apr. 5–May 28. Exh. cat.

2001
Contemporary Art Gallery, Vancouver, and Dr. Sun
Yat-Sen Classical Chinese Garden, Vancouver,
Cai Guo-Qiang: Performing Chinese Ink Painting,
July 28–Sept. 23.
Charles H. Scott Gallery, Vancouver, *Cai Guo-Qiang:
Impression Oil Drawings*, Aug. 3–Sept. 23.
Musée d'Art Contemporain de Lyon, *Cai Guo-Qiang:
An Arbitrary History*, Oct. 30, 2001–Jan. 6,
2002. Exh. cat. Traveled to S.M.A.K. (Stedelijk
Museum voor Actuele Kunst), Ghent,
Mar. 29–June 1, 2003.

2002
Shanghai Art Museum, *Cai Guo-Qiang*,
Feb. 1–Mar. 1. Exh. cat.
Hakone Open-Air Museum, *Cai Guo-Qiang's
CHADO Pavilion: Homage to Tenshin Okakura*,
May 25–Sept, 23. Exh. cat.
Galleria Civica di Arte Contemporanea, Trento,
Cai Guo-Qiang: Ethereal Flowers, Sept. 6–
Nov. 24. Exh. cat.

2003
Berkeley Art Museum, University of California,
Cai Guo-Qiang: For Your Pleasure Matrix 204,
Apr. 22–Aug. 3.
Asia Society Museum, New York, *Cai Guo-Qiang:
An Explosion Event: Light Cycle Over Central
Park*, Sept. 9–Dec. 14. Exh. cat.

2004
Arthur M. Sackler Gallery and Hirshhorn Museum
and Sculpture Garden, Smithsonian Institution,
Washington, D.C., *Cai Guo-Qiang: Traveler*,
Oct. 30, 2004–Apr. 24, 2005.
Massachusetts Museum of Contemporary Art, North
Adams, *Cai Guo-Qiang: Inopportune*,
Dec. 12, 2004–Oct. 30, 2005. Exh. cat.

2005
Institut Valencià d'Art Modern, *Cai Guo-Qiang:
On Black Fireworks*, May 20–June 12. Exh. cat.
Zacheta National Gallery of Art, Warsaw, *Cai
Guo-Qiang: Paradise*, June 17–Aug. 28.Exh. cat.
Fruitmarket Gallery, Edinburgh, *Cai Guo-Qiang: Life
Beneath the Shadow*, July 30–Sept. 25. Exh. cat.

2006
SITE Santa Fe (organized by the Massachusetts
Museum of Contemporary Art, North Adams),
Cai Guo-Qiang: Inopportune, Jan. 21–Mar. 26.
San Gimignano Mountain and Galleria Continua,
San Gimignano, *Cai Guo-Qiang: Stage*,
Mar. 25–Apr. 29.
Metropolitan Museum of Art, New York,
*Cai Guo-Qiang on the Roof: Transparent
Monument*, Apr. 25–Oct. 29. Exh. cat.
Shawinigan Space, National Gallery of Canada,
Quebec (organized in collaboration with the
Massachusetts Museum of Contemporary Art,
North Adams), *Cai Guo-Qiang: Long Scroll*,
June 10–Oct. 1. Exh. cat.
Deutsche Guggenheim, Berlin (organized by the
Deutsche Bank Collection), *Cai Guo-Qiang:
Head On*, Aug. 26–Oct. 15. Exh. cat.
Eslite Gallery (Cherng Piin), Taipei, *Captured Wind
Arrested Shadow: Cai Guo-Qiang and Lin Hwai-
min's Wind Shadow*, Nov. 22–Dec. 10. Exh. cat.

2007

Seattle Art Museum, *Cai Guo-Qiang: Inopportune: Stage One*, semi-permanent installation, opened May 5, 2007.

Shiseidō Gallery, Tokyo, *Light Passage: Cai Guo-Qiang & Shiseidō*, June 23–Aug. 12. Exh. cat.

GROUP EXHIBITIONS

1985

Quanzhou Art Gallery, *Cai Guo-Qiang and Hong Hong Wu: Paintings*, 1985.

Fuzhou City Museum, *The Shanghai and Fujian Youth Modern Art Joint Exhibition*, June 15–25.

1987

Tokyo Metropolitan Art Museum, *55th Memorial Exhibition of Dokuritsu Art Association*, 1987.

1989

Tokyo Metropolitan Art Museum, *16th International Modern Art AU Show*, 1989.

Fussa Minami Park and Kumagawa Shrine, Fussa, Tokyo, *89 Tama River Fussa Outdoor Art Exhibition*, Nov. 3–19. Exh. cat.

1990

Pourrières, Aix-en-Provence, *Chine demain pour hier*, July 7–31. Exh. cat.

Fukuoka City Hall and Nagahama Port, Fukuoka, *Museum City Tenjin '90: Circulation of Sensibility: Visual City, Functioning Art*, Sept. 17–Nov. 4. Exh. cat.

Ushimado, Okayama, *The 7th Japan Ushimado International Art Festival*, Nov. 2–4. Exh. cat.

1991

Tokyo Gallery, *Asian Wave: China*, Mar. 11–23.

Mitsubishi-jisho Artium and Kashii former train yard, Fukuoka (organized by Museum City Project, Fukuoka), *Exceptional Passage: Chinese Avant-Garde Artists Exhibition*, Aug. 29–Sept. 30, Exh. cat.

1992

Various sites, Hannover-Münden and Kassel, *Encountering the Others: The Kassel International Art Exhibition,* June. Exh. cat.

Museum of Modern Art, Saitama, *Looking for Tree of Life: A Journey to Asian Contemporary Art*, June 20–Aug. 2. Exh. cat.

Transformator–Verein zur Förderung aktueller Kunst, St. Veit/Glan, *Das Kunstwerk im Zeitalter seiner Telekommunizierbarkeit*, June 26. Exh. cat.

1993

Museum of Modern Art Oxford (now Modern Art Oxford), *Silent Energy*, June 27–Aug. 29. Exh. cat.

Shigaraki Ceramic Cultural Park, Shiga Prefecture, *Outdoor Workshop '93*, Oct. 21–31. Exh. cat.

1994

Shiseidō Gallery, Tokyo, *Promenade in Asia*, Jan. 26–Feb. 12. Exh. cat.

Kyoto City Hall (organized by the city of Kyoto), *Making New Kyoto '94*, Mar. 13–27.

Art Tower Mito Contemporary Art Center, *Mito Annual '94: Open System*, Apr. 2–May 29. Exh. cat.

Bath Festival Exhibition, *Well-Spring*, May 19–June 26. Exh. cat.

Hiroshima City Museum of Contemporary Art, *Creativity in Asian Art Now*, Sept. 18–Nov. 6. Exh. cat.

Kröller-Müller Museum, Otterlo, *Heart of Darkness*, Dec. 18, 1994–Mar. 27, 1995. Exh. cat.

1995

Electric Workshop, Johannesburg, *The Ever-Changing, Drifting Heat: The First Johannesburg Biennale*, Feb. 28–Apr. 30 Exh. cat.

Museum of Contemporary Art, Tokyo, *Art in Japan Today 1985–1995*, Mar. 19–May 21. Exh. cat.

Palazzo Giustinian Lolin, *TransCulture, 46th Venice Biennale*, June 11–Sept. 4. Exh. cat.

Watari Museum of Contemporary Art, Tokyo, *Ripple Across the Water*, Sept. 2–Oct. 1. Exh. cat.

Ho-Am Museum, Seoul, *Contemplation*, Sept. 26–Oct. 20. Exh. cat.

1996

P.S.1 The Institute for Contemporary Art. Off-site: 80 Lafayette Street, New York, *In the Ruins of the Twentieth Century. Twentieth Annual International Studio Artists Exhibition OFF-SITE*, May 3–31. Exh. cat.

Nagoya City Art Museum, *Between Earth and the Heavens: Aspects of Contemporary Japanese Art II*, June 15–Aug. 25. Exh. cat. Traveled to Rufino Tamayo Art Museum, Mexico City, Dec. 10, 1996–Mar. 9, 1997.

Queensland Art Gallery, South Brisbane, *The Second Asia-Pacific Triennial of Contemporary Art*, Sept. 27, 1996–Jan. 19, 1997. Exh. cat.

Pavilhão Ciccillo Matarazzo, Parque do Ibirapuera, São Paulo, *23rd Bienal Internacional de São Paulo: Universalis*, Oct. 6–Dec. 8. Exh. cat.

Museum of Modern Art, Saitama, *Origins and Myths of Fire: New Art from Japan, China and Korea*, Oct. 12–Dec. 8. Exh. cat.

Museum Van Hedendaagse Kunst Gent (now S.M.A.K. [Stedelijk Museum voor Actuele Kunst]), *de Rode Poort (The Red Gate)*, Nov. 9, 1996–Feb. 2, 1997. Exh. cat.

Guggenheim Museum SoHo, New York, *The Hugo Boss Prize 1996*, Nov. 20, 1996–Jan. 19, 1997. Exh. cat.

1997

Shiseidō Gallery, Tokyo, *Promenade in Asia II*, Jan. 17–Feb. 8. Exh. cat.

Museum of Contemporary Art, Chicago, *Performance Anxiety*, Apr. 17–July 6. Exh. cat. Traveled to Museum of Contemporary Art San Diego, Sept. 13–Nov. 30; SITE Santa Fe, Mar. 1–May 25, 1998.

Giardini di Castelo, Arsenale, Venice, *Future, Past, Present, 47th Venice Biennale*, June 15–Nov. 9. Exh. cat.

Various sites, Istanbul, *5th International Istanbul Biennial: On Life, Beauty, Translation, and Other Difficulties*, Oct. 5–Nov. 9. Exh. cat.

Secession, Exhibition Hall for Contemporary Art, Vienna, *Cities on the Move*, Nov. 26, 1997–Jan. 18, 1998. Exh. cat. Traveled to Museum of Contemporary Art, Bordeaux, June 4–30, 1998; P.S.1 Contemporary Art Center, New York, Oct. 18, 1998–Jan. 3, 1999; Museum of Contemporary Art Kiasma–Finnish National Gallery, Helsinki, June 11–Sept. 1, 1999; Louisiana Museum of Modern Art, Humlebaek, Denmark, Jan. 29–Apr. 21, 1999; Hayward Gallery, London, May 13–June 27, 1999.

1998

Moderna Museet, Stockholm, *Wounds: Between Democracy and Redemption in Contemporary Art*, Feb. 14–Apr. 19. Exh. cat.

Center for Curatorial Studies Art Museum, Bard College, Annandale-on-Hudson, New York, *Where Heaven and Earth Meet*, May 10–24.

Académie de France à Rome, Villa Médicis, Rome, *La Ville, le Jardin, la Mémoire: La Ville*, May 29–Aug. 30.

Taipei Fine Arts Museum, *Site of Desire: 1998 Taipei Biennial*, June 13–Sept. 6. Exh. cat.

Deste Foundation Centre for Contemporary Art, Athens, *Global Vision: New Art from the 90's Part II*, July 7–Sept. 26.

National Gallery of Canada, Ottawa, *Crossings*, Aug. 7–Nov. 1. Exh. cat.

P.S.1 Contemporary Art Center, New York and Asia Society, New York (organized by Asia Society and the San Francisco Museum of Modern Art), *Inside Out: New Chinese Art*, Sept. 15, 1998–Jan. 3, 1999. Exh. cat. Traveled to San Francisco

Museum of Modern Art and Asian Art Museum of San Francisco, Feb. 26–June 1, 1999; Museo de Arte Contemporáneo de Monterrery, July 9–Oct. 19, 1999; Tacoma Art Museum, Tacoma and Henry Art Gallery, Seattle, Nov. 11, 1999–Mar. 6, 2000; National Gallery of Australia, Canberra, June 3–Aug. 13, 2000.

Fondation Cartier pour l'art contemporain, Paris, *Issey Miyake Making Things*, Oct. 13, 1998–Jan. 17, 1999. Exh. cat. Traveled to ACE Gallery, New York, Nov. 13, 1999–Feb. 29, 2000; Museum of Contemporary Art, Tokyo, Apr. 29–Aug. 20, 2000.

Melbourne International Festival of the Arts, *Remanence*, Oct. 15–Nov. 1. Exh. cat.

1999

S.M.A.K. (Stedelijk Museum voor Actuele Kunst), Ghent, *De Opening*, May 9–Dec. 5. Exh. cat.

Académie de France à Rome, Villa Médicis, Rome, *La Ville, le Jardin, la Mémoire: La Memoire*, May 28–Aug. 29. Exh. cat.

Centraal Museum, Utrecht, *Panorama 2000: Art in Utrecht seen from the Dom Tower*, June 5–Oct. 3. Exh. cat.

Arsenale, Venice, *Aperto Over All, 48th Venice Biennale*, June 13–Nov. 7. Exh. cat.

SITE Santa Fe, *Looking for a Place: The Third International Biennial*, July 10–Dec. 31. Exh. cat.

Guggenheim Museum Bilbao, *International Currents in Contemporary Art*, July 24, 1999–Jan. 9, 2000.

Queensland Art Gallery, South Brisbane, *Beyond The Future: The Third Asia-Pacific Triennial of Contemporary Art*, Sept. 9, 1999–Jan. 26, 2000. Exh. cat.

Museum Ludwig Köln, Cologne, *Kunst-Welten im Dialog (Art-Worlds in Dialogue)*, Nov. 5, 1999–Mar. 19, 2000. Exh. cat.

Tel Aviv Museum of Art, *Hiriya in the Museum: Artists' and Architects' Proposals for Rehabilitation of the Site*, Nov. 17, 1999–Mar. 20, 2000. Exh. cat.

Kunstmuseum Bonn, *Zeitwenden*, Dec. 4, 1999–June 4, 2000. Exh. cat. Traveled to Museum Moderner Kunst Stiftung Ludwig Wein, Vienna, July 5–Oct. 1, 2000.

2000

Taiwan Museum of Art, Taichung, *Gratitude*, one day event and exhibition, Jan. 15, 2000.

Contemporary Arts Museum Houston, *Outbound: Passages from the 90's*, Mar. 4–May 7. Exh. cat.

Whitney Museum of American Art, New York, *2000 Biennial Exhibition*, Mar. 23–June 4. Exh. cat.

Fukuoka Asian Art Museum, *Pioneers of Chinese Contemporary Art*, Mar. 30–June 27.

S.M.A.K. (Stedelijk Museum voor Actuele Kunst), Ghent, *Over the Edges*, Apr. 1–June 30. Exh. cat.

Art Gallery of New South Wales, Sidney, *Biennale of Sydney 2000*, May 26–July 30. Exh. cat.

Koldo Mitxelena Kulturunea Erakustaret, Donostia-San Sebastian, *Erresistentziak / Resistencias (Acts of Resistance)*, June 15–Sept. 15. Exh. cat.

Art Basel, Messe Basel, *Art Unlimited, Art 31 Basel*, June 21–26. Exh. cat.

Académie de France à Rome, Villa Médicis, Rome, *La Ville, le Jardin, la Memoire: Le Jardin*, June 22–Sept. 24. Exh. cat.

Various sites between Nordhorn, Germany, and Zwolle, the Netherlands (organized by Städtische Galerie Nordhorn), *Kunstwegen*, public art project, official opening June 24, 2000. Exh. cat.

Musée d'Art Contemporain de Lyon, *Sharing Exoticisms. 5th Lyon Biennale d'art contemporain*, June 27–Sept. 17. Exh. cat.

Museu de Arte Moderna da Bahia, Salvador da Bahia, *The Quiet in the Land: Everyday Life, Contemporary Art and Project Axé*, July 7–Aug. 6. Exh. cat.

Tsunan Mountain Park, Niigata Prefecture, *Echigo-Tsumari Art Triennial 2000*, July 20–Sept. 10. Exh. cat.

De Oude Warandepark, Tilburg (organized by Fundament Foundation, Tilburg), *Lustwarande/Pleasure-Garden*, Aug. 19–Oct. 15.

Seoul Metropolitan Museum of Art, *Media City Seoul 2000*, Sept. 2–Oct. 31, 2000. Exh. cat.

Museum of Modern Art, New York, *Open Ends: MoMA 2000*, Sept. 28, 2000–Jan. 30, 2001. Exh. cat.

Shanghai Art Museum, *Shanghai Biennale 2000: Shanghai Spirit,* Nov. 6, 2000–Jan. 6, 2001. Exh. cat.

2001

Palazzo delle Papesse, Centro Arte Contemporanea, Siena (coproduced by Centro Culturale Candiani, Venice. Traveling Exhibition organized with Independent Curators International, New York), *The Gift: Generous Offerings, Threatening Hospitality*, June 2–Sept. 23. Exh. cat. Traveled to Centro Culturale Candiani, Venice, Oct. 14, 2001–Jan. 6, 2002; Scottsdale Museum of Contemporary Art, Arizona, Feb. 7–May 5, 2002; Bronx Museum of the Arts, New York, Nov. 27, 2002–Mar. 2, 2003; Mary and Leigh Block Museum of Art, Northwestern University, Evanston, Illinois,

Apr. 4–June 22, 2003; Art Gallery of Hamilton, Ontario, Aug. 9–Oct. 18, 2003.

Sonsbeek Park, Arnhem, *Sonsbeek 9: LocusFocus*, June 3–Sept. 23. Exh. cat.

Castello di Rivoli Museo d'Arte Contemporanea, Turin, *Form Follows Fiction*, Oct. 15, 2001–Jan. 27, 2002. Exh. cat.

Giardini di Castello, Arsenale, Venice, *Plateau of Humankind, 49th Venice Biennale*, June 10–Nov. 4. Exh. cat.

Various sites in Yokohama, *Yokohama 2001, International Triennale of Contemporary Art: Mega Wave: Towards a New Synthesis*, Sept. 2–Nov. 11. Exh. cat.

Associazione Arte Continua, San Gimignano, *Exhibition of the Projects for Arte all'Arte 6*, Sept. 15, 2001–Jan. 6, 2002, Part of *Arte all'Arte 6*.

Various sites in Tuscany (organized by Associazione Arte Continua), *Arte all'Arte 6*, Sept. 15, 2001–Jan. 6, 2002. Exh. cat.

2002

Museum der bildende Künste Leipzig, *Painting without Painting*, Jan. 30–Apr. 7. Exh. cat.

Apexart, New York, *Art that Heals*, Mar. 9–Apr. 6.

Various sites in Limerick (organized by Limerick City Gallery of Art), *EV+A 2002: Heroes + Holies*, Mar. 16–June 9. Exh. cat.

Fattoria di Celle, Santomato, Pistoia, Tuscany, (organized by Sistema Metropolitano d'Arte Contemporanea, Tuscany), *Magnete: artisti stranieri in Toscana 1945–2000 (Magnet: Foreign Artists in Tuscany 1945–2000)*, June 2–Sept. 30.

Gwangju Art Museum, South Korea, *Red Continent: Chinese Contemporary Art Exhibition*, June 3–29. Exh. cat.

Hyōgo Prefectural Museum of Art, Kōbe, *The Power of Art: The 2nd Inaugural Show of the Prefectural Museum of Art*, July 13–Aug. 25.

Obihiro Racetrack and Nishimaki Park, Obihiro, Hokkaidō (organized by P3 art and environment, Tokyo), *Tokachi International Contemporary Art Exhibition: Demeter*, July 13–Sept. 23. Exh. cat.

Royal Academy of Arts, London, *The Galleries Show*, Sept. 15–Oct. 12.

Cité Multimédia dans le Vieux-Montréal, *3e Biennale de Montréal*, Sept. 26–Nov. 3.

Guangdong Museum of Art, Guangzhou, *The First Guangzhou Triennial. Reinterpretation: A Decade of Experimental Chinese Art*, Nov. 18, 2002–Jan. 19, 2003.

Fondation Cartier pour l'art contemporain, Paris, *Ce Qui Arrive (Unknown Quantity)*, Nov. 29, 2002–Mar. 30, 2003. Exh. cat.

2003

Tate Modern and Tate Britain, London, *Tate & Egg Live 2003*, Jan.–Sept.

Institute of Contemporary Art, Boston, *Pulse, Art, Healing, and Transformation*, May 14–Aug. 31. Exh. cat.

Contemporary Arts Center, Cincinnati, *Somewhere Better Than This Place*, June 7–Nov. 9.

Centre national d'art et de culture Georges Pompidou, Paris, *Alors, la Chine?*, June 23–24. Exh. cat.

Tsunan Mountain Park, Niigata Prefecture, *Echigo-Tsumari Art Triennial 2003*, July 20–Sept. 7. Exh. cat.

Museum of Fine Arts, Houston, *The Heroic Century: The Museum of Modern Art's Masterpieces, 200 Paintings and Sculptures*, Sept. 21, 2003–Jan. 4, 2004. Exh. cat.

2004

Rovaniemi, Lapland, *The Snow Show: Harvested Ice*, Feb. 12–Mar. 31. Exh. cat.

Museum of Contemporary Art of Antwerp, (coorganized by the Guy & Myriam Ullens Foundation), *All Under Heaven*, Mar. 20–May 30. Exh. cat.

Pavilhão Ciccillo Matarazzo, Parque do Ibirapuera, São Paulo, *26th Bienal de São Paulo: Free Territory*, Sept. 25–Dec. 19.

San Diego Museum of Art, *Past in Reverse: Contemporary Art of East Asia*, Nov. 6, 2004–Mar. 6, 2005.

2005

Rose Art Museum, Brandeis University, Waltham, Mass., *DreamingNow*, Jan. 27–Apr. 24. Exh. cat.

Museum of Contemporary Art, Chicago, *Universal Experience: Art, Life, and the Tourist's Eye*, Feb. 12–June 5. Exh. cat.

Museum of Contemporary Art Taipei, *Trading Place: Contemporary Art Museum*, Apr. 2–May 22. Exh. cat.

MARTa Herford, Herford, Germany, *(my private) Heroes*, May 7–Aug. 21. Exh. cat.

Palais de Tokyo, Paris, *Translation*, June 23–Sept. 18.

Millennium Monument Art Museum, Beijing, *The Wall: Reshaping Contemporary Chinese Art*, July 22–Aug. 22. Traveled to University at Buffalo Art Galleries, Oct. 21, 2005–Jan. 29, 2006.

Various sites in Tuscany (organized by Associazione Arte Continua), *Arte all'Arte 10*, Sept. 1–Oct. 2. Exh. cat.

Storefront for Art and Architecture, New York, *Can Buildings Curate*, Sept. 13–Oct. 29.

John F. Kennedy Center for the Performing Arts, Washington, D.C., *The Kennedy Center Festival of China*, Oct. 1–31.

Sert Gallery, Carpenter Center for the Arts, and Harvard University Art Museums, Cambridge, *Quantum Grids*, Oct. 15, 2005–Apr. 16, 2006.

2006

Min Tai Yuan Museum, Quanzhou, *Min Tai Yuan Museum Collection (Inaugural Exhibition)*, open since May 14, 2006.

Musée d'Art Moderne Grand-Duc Jean, Luxembourg, *Opening Exhibition: Eldorado*, July 1–Nov. 20. Exh. cat.

Tsunan Mountain Park, Niigata Prefecture, *Echigo-Tsumari Art Triennial 2006*, July 31–Aug. 9.

Museum of Modern Art, New York, *Out of Time: A Contemporary View*, Aug. 30, 2006–Apr. 9, 2007.

China Institute Gallery, New York, *Shu: Reinventing Books in Contemporary Chinese Art*, Sept. 28, 2006–Feb. 24, 2007. Exh. cat. Traveled to Seattle Asian Art Museum, Aug. 9–Dec. 2, 2007.

Suzhou Museum, *Searching for Dreams in the Canals*, Oct. 6, 2006–Mar. 30, 2007.

2007

Metropolitan Museum of Art, New York, *Journeys: Mapping the Earth and Mind in Chinese Art*, Feb. 10–Aug. 26.

Andy Warhol Museum, Pittsburgh, *6 Billion Perps Held Hostage! Artists Address Global Warming*, Mar. 11–June 15.

Palazzo Fortuny, Venice, *Artempo: Where Time Becomes Art*, June 9–Oct. 7. Exh. cat.

EXPLOSION EVENTS AND OTHER EPHEMERAL PROJECTS

1989

Fussa Minami Park and Kumagawa Shrine, Tokyo, *Human Abode: Project for Extraterrestrials No. 1*, realized Nov. 11, commissioned by *89 Tama River Fussa Outdoor Art Exhibition* (see group exhibitions).

1990

Pourrières, Aix-en-Provence, *45.5 Meteorite Craters Made by Humans on Their 45.5 Hundred Million Year Old Planet: Project for Extraterrestrials No. 3*, realized July 7, commissioned by Les Domaines de l'art for the exhibition *Chine demain pour hier* (see group exhibitions).

Nagahama Port, Fukuoka, *I Am an Extraterrestrial: Project for Meeting with Tenjin (Heavenly Gods): Project for Extraterrestrials No. 4*, realized Oct. 6, commissioned by Museum City Tenjin, Fukuoka, for the exhibition *Museum City Tenjin '90: Circulation of Sensibility: Visual City, Functioning Art* (see group exhibitions).

Palace Plaza, Olive Mountain, Ushimado, Okayama, *Fetus Movement: Project for Extraterrestrials No. 5*, realized Nov. 3, commissioned by Japan Ushimado International Art Festival for *The 7th Japan Ushimado International Art Festival* (see group exhibitions).

1991

Kashii former train yard, Fukuoka, *The Immensity of Heaven and Earth: Project for Extraterrestrials No. 11*, realized Sept. 15, commissioned by Museum City Project, Fukuoka, for *Exceptional Passage: Chinese Avant-Garde Artists Exhibition* (see group exhibitions).

1992

Bundeswehr-Wasserübungsplatz military base, Hannover-Münden, *Fetus Movement II: Project for Extraterrestrials No. 9*, realized June 27, commissioned by the Kassel International Art Exhibition for *Encountering the Others: The Kassel International Art Exhibition*. Artist Book. (see group exhibitions).

1993

Gobi Desert, Jiayuguan, Gansu Province, *Project to Extend the Great Wall of China by 10,000 Meters: Project for Extraterrestrials No. 10*, realized Feb. 27, commissioned by P3 art and environment, Tokyo. Artist Book.

Angel Meadow Park, Oxford, *The Oxford Comet: Project for Extraterrestrials No. 17*, realized June 26, commissioned by the Museum of Modern Art Oxford (now Modern Art Oxford) for the exhibition *Silent Energy* (see group exhibitions).

Sun Plaza and Spring Square, Shigaraki Ceramic Cultural Park, *Buried Civilization: Field Firings*, realized Sept. 7–Oct. 20, commissioned by the Shigaraki Ceramic Cultural Park for *Outdoor Workshop '93* (see group exhibitions).

1994

Pacific Ocean, Offshore from Numanouchi to Yotsukura Beach, Iwaki, *The Horizon from the Pan-Pacific: Project for Extraterrestrials No. 14*, realized Mar. 7, commissioned by Iwaki City Art

Museum for the exhibition *Cai Guo-Qiang: From the Pan-Pacific* (see solo exhibitions).

Kyoto City Hall, *Project for Heiankyō 1,200th Anniversary: Celebration from Chang'an*, realized Mar. 13, commissioned by the city of Kyoto for the exhibition *Making New Kyoto '94* (see group exhibitions).

Hiroshima Central Park near the A-Bomb Dome, Hiroshima, *The Earth Has Its Black Hole Too: Project for Extraterrestrials No. 16*, realized Oct. 1, commissioned by Hiroshima City Museum of Contemporary Art for the exhibition *Creativity in Asian Art Now* (see group exhibitions).

Nationale Park De Hoge Veluwe, Otterlo, *Myth: Shooting the Suns: Project for Extraterrestrials No. 21*, realized Dec. 18, commissioned by the Kröller-Müller Museum, Otterlo for the exhibition *Heart of Darkness* (see group exhibitions).

1995

Tribune Hall, Johannesburg Power Station, *Restrained Violence: Rainbow: Project for Extraterrestrials No. 25*, realized Feb. 28, commissioned by the Johannesburg Biennale for *The Ever-Changing, Drifting Heat: The First Johannesburg Biennale* (see group exhibitions).

1996

Various sites in the United States: Nevada Test Site; Mormon Mesa, Overton, Nevada; the Great Salt Lake, Utah; and New York City, *The Century with Mushroom Clouds: Project for the 20th Century*, realized Feb. 13–Apr. 21.

Storage area, Museum Van Hedendaagse Kunst Gent (now S.M.A.K. [Stedelijk Museum voor Actuele Kunst]), Ghent, *Dragon Skeleton/Suture of the Wall: True Collection*, realized Nov. 9, commissioned by Museum Van Hedendaagse Kunst Gent.

1997

Louisiana Museum of Modern Art, Humlebaek, Denmark, *Flying Dragon in the Heavens: Project for Extraterrestrials No. 29*, realized Mar. 7, commissioned by the Louisiana Museum of Modern Art, Humlebaek for the exhibition *Cai Guo-Qiang: Flying Dragon in the Heavens* (see solo exhibitions).

1998

Ladugårdsland bay, Stockholm, between Museum of Modern Art and Vasa Museum, *Parting of the Sea: Project for Extraterrestrial No. 30*, realized Feb. 14, commissioned by Moderna Museet, Stockholm, for the exhibition *Wounds: Between*

Democracy and Redemption in Contemporary Art (see group exhibitions).

Taipei Fine Arts Museum, *Golden Missile*, realized June 13, commissioned by Taipei Fine Arts Museum for *Site of Desire: 1998 Taipei Biennial* (see group exhibitions).

Taiwan Province Museum of Art (now National Taiwan Museum of Fine Arts), Taichung, *No Destruction, No Construction: Bombing the Taiwan Province Museum of Art*, realized Aug. 21, commissioned by Taiwan Province Museum of Art. Book.

Fondation Cartier pour l'art contemporain, Paris, *Dragon: Explosion on Pleats Please Issey Miyake*, realized Oct. 5, commissioned by Fondation Cartier pour l'art contemporain for the exhibition *Issey Miyake Making Things* (see group exhibitions).

1999

S.M.A.K. (Stedelijk Museum voor Actuele Kunst), Ghent, *Firecrackers for the Opening of S.M.A.K.*, realized May 8, commissioned by S.M.A.K. for the opening events and exhibition *De Opening* (see group exhibitions).

Casa de Cultura, Projeto Axé Social, Salvador da Bahia, *Salute*, two explosion events in collaboration with children from Bandaxé, realized Aug. 18, 1999 and July 7, 2000, commissioned by The Quiet in the Land and the Museu de Arte Moderna da Bahia for the artist residence and exhibition *The Quiet in the Land: Everyday Life, Contemporary Art and Project Axé* (see group exhibitions).

2000

Académie de France à Rome, Villa Médicis, Rome, *Till by Blade, Sow by Fire*, realized June 29, commissioned by Académie de France à Rome for the exhibition *La Ville, le Jardin, la Mémoire: Le Jardin* (see group exhibitions).

De Oude Warandepark, Tilburg, *Fountain*, realized Aug. 19, commissioned by Fundament Foundation, Tilburg for the exhibition *Lustwarande/Pleasure-Garden* (see group exhibitions).

69th Regiment Armory, New York, *Ascending a Staircase*, realized Dec. 1, commissioned by NHK: Japan Broadcasting Corporation.

2001

Sonsbeek Park, Arnhem, *Picturesque Painteresque*, realized June 1, 2001, commissioned by Sonsbeek for *Sonsbeek 9: LocusFocus* (see group exhibitions).

The Bund, Huangpu River, and Oriental Pearl TV Tower, Shanghai, *Asia-Pacific Economic Cooperation Cityscape Fireworks*, realized Oct. 20, Commissioned by Asia-Pacific Economic Cooperation for the closing ceremonies of the 2001 APEC Conference.

2002

Zhejiang Library, Hangzhou, *Spider Web*, realized May 4, commissioned for the opening of the *2002 M Meeting*.

River Shannon at St. Johns Castle, Limerick, *Against the Current*, realized June 4, commissioned by Limerick City Gallery of Art, for the exhibition *EV+A 2002: Heroes + Holies* (see group exhibitions).

East River, from Manhattan to Queens, New York, *Transient Rainbow*, realized June 29, commissioned by the Museum of Modern Art, New York, for the opening of the Museum of Modern Art, Queens.

Hyōgo Harbor, Kōbe, *Blue Dragon*, realized July 13, commissioned by the Hyōgo Prefectural Museum of Art, Kōbe for *The Power of Art: The 2nd Inaugural Show of the Prefectural Museum of Art* (see group exhibitions). First attempted unsuccessfully in Brisbane in 1999, commissioned by Queensland Art Gallery for *The Future: The Third Asia-Pacific Triennial of Contemporary Art* (see group exhibitions).

Obihiro Racetrack, Obihiro, Hokkaidō, *Skybound UFO and Shrine*, realized Aug. 11, commissioned by P3 art and environment for *Tokachi International Contemporary Art Exhibition: Demeter* (see group exhibitions).

Trento Cemetery, *Ethereal Flowers*, realized Sept. 6, commissioned by Galleria Civica di Arte Contemporanea, Trento for the exhibition *Cai Guo-Qiang: Ethereal Flowers* (see solo exhibitions).

Royal Academy of Arts, London, *Money Net*, realized Sept. 12, commissioned by the Royal Academy of Arts for the exhibition *The Galleries Show* (see group exhibitions).

2003

Millenium Bridge and Tate Modern, London, *Ye Gong Hao Long (Mr.Ye Who Loves Dragons): Explosion Project for Tate Modern*, realized Jan. 31, commissioned by Tate Gallery as part of *Tate & Egg Live 2003* (see group exhibitions).

S.M.A.K. (Stedelijk Museum voor Actuele Kunst), Ghent, *Inheritance: Exploding Jan Hoet's Portrait*, realized Mar. 28, commissioned by

S.M.A.K. for the exhibition *Cai Guo-Qiang: An Arbitrary History* (see solo exhibitions).

Central Park, New York, *Light Cycle: Explosion Project for Central Park*, realized Sept. 15, commissioned by Creative Time in conjunction with the City of New York and the Central Park Conservancy for the 150th anniversary of the creation of Central Park.

Siwa Oasis, Egypt, *Man, Eagle, and Eye in the Sky*, realized Nov. 11–14, commissioned by Siwa Art Project, Egypt. Book.

2004

Rovaniemi, Lapland, *Caressing Zaha with Vodka*, realized Feb. 11, commissioned by The Snow Show for the exhibition *The Snow Show: Harvested Ice* (see group exhibitions).

Marine Corps Air Station, San Diego, *Painting Chinese Landscape Painting*, realized Oct. 16, commissioned by the San Diego Museum of Art for the *2004 Miramar Air Show* in conjunction with the exhibition *Past in Reverse* (see group exhibitions).

Lincoln Center, New York, *Red Star, Flying Saucer*, realized Nov. 10, 2004, commissioned for *Asian Cultural Council 40 Years*.

2005

Goebenstrasse, in front of MARTa Herford, Germany, *Auto-Destruct*, realized May 7, commissioned by MARTa Herford for the exhibition *(my private) Heroes* (see group exhibitions).

Old Turia Riverbed Park between Roal Bridge and Trinidad Bridge, Valencia, *Black Rainbow: Explosion Project for Valencia*, realized May 22, commissioned by Institut Valencià d'Art Modern for the exhibition *Cai Guo-Qiang: On Black Fireworks* (see solo exhibitions).

Zacheta National Gallery of Art, Warsaw, *Red Flag*, realized June 17, commissioned by Zacheta National Gallery of Art for the exhibition *Cai Guo-Qiang: Paradise* (see solo exhibitions).

Edinburgh Castle, *Black Rainbow: Explosion Project for Edinburgh*, realized July 29, commissioned by the Fruitmarket Gallery, Edinburgh, for the exhibition *Cai Guo-Qiang: Life Beneath the Shadow* (see solo exhibitions).

Potomac River, Washington, D.C., *Tornado: Explosion Project for the Festival of China*, realized Oct. 1, commissioned by the John F. Kennedy Center for the Performing Arts for *The Kennedy Center Festival of China*.

2006

Möckernstrasse/Stresemannstrasse, Berlin, *Illusion II: Explosion Project*, realized July 11, commissioned by Deutsche Guggenheim, Berlin for the exhibition *Cai Guo-Qiang: Head On* (see solo exhibitions).

Iris and B. Gerald Cantor Roof Garden, Metropolitan Museum of Art, New York, *Clear Sky Black Cloud*, realized Apr. 25–Oct. 29, commissioned by the Metropolitan Museum of Art for the exhibition *Cai Guo-Qiang on the Roof: Transparent Monument.* (see solo exhibitions).

Suzhou Museum, *Exploding Tower*, realized Oct. 8, commissioned by the Suzhou Museum for the inaugural exhibition *Searching for Dreams in the Canals* (see group exhibitions).

Taiwan, *Wind Shadow*, Premiered at the National Theatre, Taipei, Nov. 25, subsequent venues to date: Kaohsiung Cultural Center, and Chiayi Performing Arts, Taiwan, collaboration with Cloud Gate Dance Theatre of Taiwan.

PUBLIC ART

Mito Train Station, *Lion: Feng Shui Project for Mito: Chang Sheng*, realized May, 1994, commissioned by Art Tower Mito Contemporary Art Center for the exhibition *Mito Annual '94: Open System* (see group exhibitions).

Tōchō-ji Temple, Tokyo, *Eighteen Saints*, realized Dec. 1998, commissioned by Tōchō-ji Temple, Tokyo.

Hakataza Theatre, Hakata Riverain, Fukuoka, *Dragon Boat*, realized Feb. 1999, commissioned by Hakata Riverain, Fukuoka.

Oak Forest, Gramsbergen/Laar, Netherlands, *Skylight*, realized Sept. 1999, official opening June 2000, commisioned by Städtische Galerie Nordhorn, for the public art project *Kunstwegen* (see group exhibitions).

Dentsū Headquarters, Shiodome district, Tokyo, *Turtle Fountain*, realized Dec. 2002, commissioned by Dentsū.

Roppongi Hills, Mori Arts Center, Tokyo, *High Mountain Flowing Water: 3-D Landscape Painting*, realized Oct. 2003, commissioned by Mori Arts Center, Tokyo.

Bandai, Niigata, *Lighthouse*, realized Apr. 2003, commissioned by the city of Niigata.

Bronx Criminal Court, New York, *One Stone*, realized 2007, commissioned by the City of New York: Percent for Art Program Commission.

EXHIBITIONS CURATED BY CAI GUO-QIANG

2001

UMoCA (Under Museum of Contemporary Art), Colle di Val d'Elsa, *Who Is the Happiest? UMoCA Inaugural Exhibition with Ni Tsai-Chin* for *Arte all'Arte 6* (see group exhibitions).

2002

Shanghai Art Museum, *Cai Guo-Qiang's Maksimov Collection*, Feb. 1–Mar. 1. Part of *Cai Guo-Qiang* (see solo exhibitions).

Central Academy of Fine Arts, Beijing (organized by Fan Di'An and Wang Mingxian), *Cai Guo-Qiang's Maksimov Collection*, Apr. 28–May 9.

Gwanshanyue Art Museum, Shenzhen (organized by Fan Di'An and Wang Mingxian), *Cai Guo-Qiang's Maksimov Collection*, July 19–Aug. 18.

2003

DMoCA (Dragon Museum of Contemporary Art), Tsunan Mountain Park, Niigata Prefecture, *DMoCA 2: Pause, Inaugural Exhibition with Kiki Smith*. Exh. cat. Part of *Echigo-Tsumari Art Triennial 2003* (see group exhibitions).

2004

BMoCA (Bunker Museum of Contemporary Art), Kinmen Island, Taiwan, *18 Solo Exhibitions*, Sept. 11, 2004–Feb. 28, 2005. Exh. cat.

BMoCA (Bunker Museum of Contemporary Art), Kinmen Island, Taiwan, *Kinmen Children's Bunker Museum of Art*, Sept. 11, 2004–Feb. 28, 2005. Exh. cat.

2005

Venice Arsenale and Vergini Garden, Venice, *Virgin Garden: Emersion. China Pavilion at the 51st Venice Biennale*, June 12–Nov. 6.

UMoCA (Under Museum of Contemporary Art), Colle di Val d'Elsa, *Jennifer Wen Ma: Aeolian Garden*, Sept. 30, 2005–June 30, 2006. Exh. cat. Part of *Arte all'Arte 10* (see group exhibitions).

2006

DMoCA (Dragon Museum of Contemporary Art), Tsunan Mountain Park, Niigata Prefecture, *DMoCA 3: Range, Kōtarō Miyanaga*. Part of *Echigo-Tsumari Art Triennial 2006* (see group exhibitions).

SELECTED BIBLIOGRAPHY

COMPILED BY MICHELLE YUN

BY THE ARTIST

ARTIST BOOKS, WRITINGS, AND STATEMENTS

1986

"An Important Tactic for Manifesting the Painter's Concept: A Preliminary Exploration into the Use of 'Light' in Expressing the Substance of an Artwork." *Art History and Theory* (Beijing) 17 (Spring 1986), pp. 97–99. In Chinese.

1988

Cai Guo-Qiang with You Jindong. "Painting with Gunpowder." *Leonardo* (Cambridge, MA) 21, no. 3 (1988), pp. 251–54.

1989

Statements. In *Gunpowder Paintings of Cai Guo-Qiang*, pp. 1–2, 9, 17, 18, 42. Guilin: Lijang Publishing House, 1989. In Chinese and English.

Cai Guo-Qiang with Takami Akihiko. "From Beijing." *Bijutsu Techō* (Tokyo) 609 (May 1989), pp. 130–32. In Japanese.

1990

"Crateres de Meteorites." In *Art Chinoise 1990: Chine Demain Pour Hier*, p. 54. Exh. cat. Paris: Les Domaines de l'art et Editions Carte Segrete, 1990. In French.

1991

Statements. In *Cai Guo-Qiang. Primeval Fireball: The Project for Projects*, unpaginated. Exh. cat. Tokyo: P3 art and environment, 1991. In Japanese and English.

1992

Artist book. *Project for Extraterrestrials No. 9 "Fetus Movement II."* Osaka: Nomart Editions, Inc., 1992. With essays by the artist, Sakurai Kazuya, Tatsumi Masatoshi, Serizawa Takashi, and Kurabayashi Yasushi. In Japanese and English.

1994

Calendar of Life. Exh. cat. Nagoya: Gallery APA, 1994. In Japanese and English.

Project for Extraterrestrials No. 10: Project to Add 10,000 Meters to the Great Wall of China. Tokyo: Atelier Peyotl Col, Ltd. with P3 art and environment, 1994. With essays by the artist, Gao Fu, Moriyama Masamichi, Yamashita Rika, Serizawa Takashi, and Konno Yuichi. Includes English supplement by Serizawa Takashi. In Japanese and English.

"Commentary of Works." In *Chaos: Cai Guo-Qiang*, ed. Hasegawa Yūko, unpaginated. Exh. cat. Tokyo and Osaka: Setagaya Art Museum and Nomart Editions Inc., 1994. In Japanese and English.

"Project for Extraterrestrials No. 20: Raising a Ladder to the Earth." In *Well-Spring: Messages and Revelations by Contemporary Artists to Animate the Ancient City of Bath*, pp. 34–35. Exh. cat. Bath: Bath Festival Trust, 1994.

"Promenade." In *Promenade in Asia*, unpaginated. Exh. cat. Tokyo: Shiseidō Corporate Culture Department, 1994. In Japanese and English.

Statements. In *Cai Guo-Qiang: From the Pan-Pacific*, pp. 86, 90, 92, 96, 98, 100, 104, 108–9, 115, 120, 124, 126, 128. Exh. cat. Iwaki: Iwaki City Art Museum, 1994. In Japanese and English.

1996

Statement. In *de Rode Poort (The Red Gate)*, pp. 32, 155, 164. Exh. cat. Ghent: Museum van Hedendaagse Kunst Gent, 1996. In Dutch and English.

1997

"Heaven's Secrets." In *Promenade in Asia*, p. 50. Exh. cat. Tokyo: Shiseidō Corporate Culture Department, 1997. In Japanese and English.

"Placid Earth: A Project for the Meeting of Millennia." In *Unbuilt Roads: 107 Unrealized Projects*, eds. Hans Ulrich Obrist and Guy Tortosa, unpaginated. Ostfildern-Ruit: Hatje, 1997.

1998

"Wild Flights of Fancy." In *Day Dreaming: Cai Guo-Qiang*, pp. 4–17. Exh. cat. Taipei: Eslite Gallery (Cherng Piin), 1998. In Chinese and English.

1999

Artist book. *Venice's Rent Collection Courtyard*. Vancouver: Annie Wong Foundation, 1999.

"For Tatsumi and his Comrades—A Practical Dream." In *Dreams*, eds. Francesco Bonami and Hans Ulrich Obrist, p. 57. Rome: Fondazione Sandretto Re Rebaudengo, 1999.

2000

"In the Words of Cai Guo-Qiang. Slide lecture on June 20, 1998." In *Remain in Naoshima: Naoshima Contemporary Art Museum*, pp. 150–51. Kagawa Prefecture: Benesse House, 2000. In Japanese and English.

"On the Venice Rent Collection Courtyard." *Avant-Garde Today* (Tianjin) 9 (2000), pp. 75–78. In Chinese.

"Projects for Extraterrestrials." In *Cai Guo-Qiang*, ed. Fei Dawei, pp. 138–47. Exh. cat. London: Thames & Hudson and Paris: Fondation Cartier pour l'art contemporain, 2000. Editions in French and English.

2002

"Artist's Writings." In Dana Friis-Hansen, Octavio Zaya, and Serizawa Takashi, *Cai Guo-Qiang*, pp. 121–43. London: Phaidon Press Limited, 2002.

"Dragon Runs." In *Cai Guo-Qiang and Iwaki with His Drawing Works 1980–2002*, p. 8. Exh. cat. Iwaki: Cai Guo-Qiang Anthology Project, 2002. In Japanese and English.

Statement, in *EV+A 2002: Heroes + Holies*, pp. 76–77. Exh. cat. Limerick: EV+A, 2002.

"The Frankness of Collecting Maximov." In *Cai Guo-Qiang*, p. 40. Exh. cat. Shanghai: Shanghai Art Museum, 2002. In Chinese.

"To My Friends Beyond the Horizon." In *Cai Guo-Qiang and Iwaki with His Drawing Works 1980–2002*, pp. 112–13.

2003

Curatorial statement, in *Echigo-Tsumari Art Triennial*, p. 89. Exh. cat. Tokyo: Echigo-Tsumari Art Triennial, 2003. In Japanese and English.

2004

"Cai Guo-Qiang. Light Cycle: Explosion Project for Central Park." In *Cai Guo Qiang. Light Cycle: Explosion Project for Central Park*, unpaginated. Exh. cat. New York: Asia Society and Creative Time, 2004.

"Epilogue." In *Cai Guo Qiang. Light Cycle: Explosion Project for Central Park*, unpaginated.

"Feng Shui Master and Sheik." In *Cai Guo-Qiang: Man, Eagle and Eye in the Sky*, ed. Sharmini Pereira, pp. 92–93. London: Albion/Michael Hue-Williams Fine Art Ltd. 2004.

"Letter to the Children of Siwa." In *Cai Guo-Qiang: Man, Eagle and Eye in the Sky*, pp. 38–39.

"Tatsumi and His Ball." In *Cai Guo-Qiang: Man, Eagle and Eye in the Sky*, pp. 70–71.

Statement. In *The Snow Show*, pp. 24–25. Exh. cat. Rovaniemi: Rovaniemi Art Museum, 2004. In Finnish and English.

2005

Cai Guo-Qiang, ed. *Cai Guo-Qiang*. Taipei: Artist Publishing Co., 2005. With essays by Fei Dawei, Gao Minglu, Ni Tsai-chen, and Lilian Tone, and an interview with Jennifer Wen Ma. In Chinese.

"Dear Young Artist." *Art on Paper* (New York) 9, no. 6 (July/Aug. 2005), pp. 12, 40.

"Influence: Today and Tomorrow." *ArtAsiaPacific Almanac* (New York), no. 1 (2005–2006), p. 111.

"People's Republic of China: Virgin Garden: Emersion." In *51 International Art Exhibition: Participating Countries, Collateral Events*, pp. 106–9. Exh. cat. Venice: Fondazione La Biennale di Venezia, 2005. Editions in Italian and English.

2006

"A letter to friends in the media on the eve of the BMoCA opening." In *Bunker Museum of Contemporary Art, Kinmen Island: A Permanent Sanctuary for Art in a Demilitarized Zone*, p. 158. Exh. cat. Taipei: Kinmen County Government, 2006. Editions in Chinese and English.

"Curatorial Concept." In *Bunker Museum of Contemporary Art, Kinmen Island*, pp. 7–8.

"Excerpts from the curator speeches at the opening ceremony September 11, 2004." In *Bunker Museum of Contemporary Art, Kinmen Island*, pp. 159–61, 163.

"Master's Program in Contemporary Art Curriculum (Proposal)." Mar. 2002. *Yishu: Journal of Contemporary Chinese Art* (Taipei) 5, no. 3 (Sept. 2006), pp. 73–74.

"Speaking of Wind Talking of Shadow: Glimpsing the Basic Concept of *Wind Shadow* from Letters Exchanged Between Cai Guo-Qiang and Lin Hwai-min." In *Captured Wind Arrested Shadow: Cai Guo-Qiang and Lin Hwai-min's Wind Shadow*, pp. 97–104. Exh. cat. Taipei: Eslite Gallery (Cherng Piin), 2006. In Chinese and English.

Statement. In *Jennifer Wen Ma: Aeolian Garden*, pp. 18, 21. Exh. cat. San Gimignano and Siena: Associazione Arte Continua and Gli Ori, 2006. In Italian and English.

Statement. In *Cai Guo-Qiang*, unpaginated. Exh. cat. Warsaw: Zacheta National Gallery of Art, 2005. In Polish and English.

Statement. In Wu Hung. *Shu: Reinventing Books in Contemporary Chinese Art*, pp. 26–27. Exh. cat. New York: China Institute in America, 2006.

"Three More Sentences." In *Captured Wind Arrested Shadow*, pp. 15–17.

INTERVIEWS

1991

"Cai Guo-Qiang + P3." In *Cai Guo-Qiang. Primeval Fireball: The Project for Projects*, unpaginated. Exh. cat. Tokyo: P3 art and environment, 1991. In Japanese and English.

1992

Kobayashi Kenji. "Deeper, larger and farther." *Bijutsu Techō* (Tokyo) 649 (Jan. 1992), pp. 12–19. In Japanese.

1993

Konno Yuichi. "Cai Guo-Qiang: The palette of light that shoots the sky." *UR* (Tokyo) 7 (Mar. 1993), pp. 5–48. In Japanese.

Serizawa Takashi. "Interview with Cai Guo-Qiang." *Bijutsu Techō* (Tokyo) 671 (June 1993), pp. 121–28. In Japanese.

1996

Nakamura Keiko. "The Universalism and Individualism of Art." *Keiko Nakamura Interview Collection*, pp. 255–86. Tokyo: Seidosha, 1996. In Japanese.

Takeda Norihito and Takeda Masaaki. "Interview with Cai Guo-Qiang: The Internationalism of Art and the Position of Artists." *Sturm Literary Magazine* (Tokyo) 7 (1996), pp. 106–15. In Japanese.

1997

Jolles, Claudia. "Künstler sind wie Kung-Fu-Kämpfer." *Kunst-Bulletin* (Zurich) 4 (Apr. 1997), pp. 12–19. In German.

Lutfy, Carol. "Asian Artists in America: Cai Guo-Qiang." *Atelier International* (Tokyo) 834 (Mar.–Apr. 1997), pp. 84–91. In Japanese and English.

1998

Han, Dora. "Cai Guo-Qiang on 'Performance' in Art." *Dialogue* (Taipei) 18 (Sept. 1998), pp. 126–33. In Chinese.

1999

Gao Minglu. "Traces of Gunpowder Explosions." *Dushu* (Beijing) 9 (1999), pp. 87–93. In Chinese.

Matt, Gerald. "Gerald Matt in Conversation with Cai Guo-Qiang." In *Cai Guo-Qiang: I Am the Y2K Bug*, ed. Gerald Matt, pp. 50–57. Exh. cat. Vienna: Kunsthalle Wien, 1999. In German and English.

2000

Chiu, Melissa. "Off With A Bang: An Interview with Controversial Artist Cai Guo-Qiang." *Postwest* (Sydney) 17 (2000), pp. 28–31.

Fei Dawei. "To Dare to Accomplish Nothing. Fei Dawei Interviews Cai Guo-Qiang." In *Cai Guo-Qiang*, ed. Fei Dawei, pp. 117–35. Exh. cat. London: Thames & Hudson and Paris: Fondation Cartier pour l'art contemporain, 2000. Editions in French and English.

Huang Du. "Cultural Witchery, Alchemy, and 'Explosion'." *Avant-Garde Today* (Tianjin) 9 (2000), pp. 43–65. In Chinese.

Jouanno, Evelyne. "Cai Guo-Qiang: Between Heaven and Earth." *Flash Art* (Milan) 33, no. 214 (Nov.–Dec. 2000), pp. 66–68.

Ujica, Andrei. "A Conversaion: Cai Guo-Qiang and Andrei Ujica." In *Cai Guo-Qiang*, ed. Fei Dawei, pp. 81–88.

Wu Hung. "On 'Rent-collecting House': An Interview with Cai Guo-Qiang." *Sculpture* (Beijing) 21 (2000), pp. 8–11. In Chinese.

2001

Luo Rong. "Interview with Cai Guo-Qiang." *Design Trends* (Shanghai) 5/6 (Nov. 2001), pp. 115–27. In Chinese.

Sans, Jérôme. "Interview." In *Arte all'Arte: Arte Architettura Paesaggio*, pp. 54–56. Exh. cat. San Gimignano and Siena: Associazione Arte Continua and Gli Ori, 2001. In Italian and English.

2002

Demattè, Monica. "Half Empty, Half Full: A Conversation with Cai Guo-Qiang." In *Cai Guo-Qiang*, pp. 26–37. Exh. cat. Trento: Galleria Civica di Arte Contemporanea, 2002. In Italian and English.

Demattè, Monica. "The Art of Catching the Void." *Work* (Trento) 1, no. 3, (Oct.–Dec. 2002), pp. 14–15. In Italian and English.

Sans, Jérôme. "Light your fire." In *Cai Guo-Qiang: An Arbitrary History*, pp. 45–59. Exh. cat. Lyon: Musée d'Art Contemporain de Lyon and Milan: 5 Continents Editions srl, 2002. In French and English.

Zaya, Octavio. "Octavio Zaya in conversation with Cai Guo-Qiang." In Dana Friis-Hansen, Octavio Zaya, and Serizawa Takashi, *Cai Guo-Qiang*, pp. 6–35. London: Phaidon Press Limited, 2002.

2004

Chiu, Melissa. "Interview." In *Cai Guo Qiang. Light Cycle: Explosion Project for Central Park*, unpaginated. Exh. cat. New York: Asia Society and Creative Time, 2004.

2005

Caballero, David Rodríguez. "East-West-East." In *Cai Guo-Qiang: On Black Fireworks*, pp. 104–31. Exh. cat. Valencia: Institut Valencià d'Art Modern, 2005. In Spanish and English.

Goodbody, Bridgit. "No Introductions Necessary." *ArtAsiaPacific* (New York) 45 (Summer 2005), pp. 42–45.

Ma, Jennifer Wen. "I Wish it Never Happened." In *Cai Guo-Qiang: Inopportune*, pp. 54–69. Exh. cat. North Adams, Massachusetts: MASS MoCA, 2005.

McCoy, Michelle. "An Interview with Cai Guo-Qiang, Curator of the China Pavilion, Virgin Garden: Emersion." *Yishu: Journal of Contemporary Chinese Art* (Taipei) 4, no. 3 (Sept. 2005), pp. 36–38.

Tanguy, Sarah. "Conversation with Cai Guo-Qiang: Fire Medicine." *Sculpture* (Washington, D.C.) 24, no. 4 (May 2005), pp. 32–37.

2006

Goodbody, Bridget. "Outside Chance: Cai Guo-Qiang claims air rights at the Met." *Time Out New York* (New York) 553, May 4–10, 2006, p. 66.

Grigoteit, Ariane. "The River of Time: Of Lions, Wolves, and Dogs." *Visuell* (Frankfurt am Main) (2006), pp. 182–87. In German and English.

Huang Xiao-wei and Yi Pei-fang. "No Destruction, No Construction: Interview between Cai Guo-Qiang and Cai Kang-Yong." *INK Literary Monthly* (Taipei), 40 (Dec. 2006), pp. 22–49. In Chinese.

Lin Hwai-min. "Cai Guo-Qiang vs. Lin Hwai-min: The Chance Meeting and Formation of *Wind Shadow*." In *Captured Wind Arrested Shadow: Cai Guo-Qiang and Lin Hwai-min's Wind Shadow*, pp. 18–33. Exh. cat. Taipei: Eslite Gallery (Cherng Piin), 2006. In Chinese and English.

Maruta Nobuko. "Interview with Cai Guo-Qiang." *COOL Creators' Infinite Links* (New York) (2006), pp. 12–23. In Japanese and English.

Roundtable discussion. "Long March Yan'an Forum on Art Education." *Yishu: Journal of Contemporary Chinese Art* (Taipei) 5, no. 3 (Sept. 2006), pp. 18–60. Transcribed from Chinese to English by Philip Tinari, Fiona He, and Huong Trieu.

Shaughnessy, Jonathan. "Cai's Tour: An Interview with Cai Guo-Qiang about *Cai Guo-Qiang: Long Scroll*." In *Cai Guo-Qiang: Long Scroll*, pp. 48–79. Exh. cat. Ottawa: National Gallery of Canada, 2006.

Serizawa Takashi. "Like a Small Child Building Firecrackers: Interview with Cai Guo-Qiang." *ARTiT* (Tokyo) 11, vol. 4, no. 2 (Spring/Summer 2006), pp. 30–41. In Japanese and English.

2007

Grande, John K. "Shock and Awe: An Interview with Cai Guo-Qiang." *Yishu: Journal of Contemporary Chinese Art* (Taipei) 6, no. 1 (Mar. 2007), pp. 39–44.

Kakizaki Takao. "Light Passage: Interview with Cai Guo-Qiang." In *Light Passage: Cai Guo-Qiang & Shiseidō*, pp. 32–37. Exh. cat. Tokyo: Shiseidō Corporate Culture Department, 2007. In Japanese and English.

CURATED EXHIBITION CATALOGUES

2002

Cai Guo-Qiang's Maximov Collection. Beijing: Central Art Academy, 2002. With a statement by the artist and essays by Cao Qing Hui, Fan Di'An, and Wang Mingxian. In Chinese.

2003

Cai Guo-Qiang, ed. *Kiki Smith: Pause*. Tokyo: Dragon Museum of Contemporary Art, 2003. With essay by James Putnam. In Japanese and English.

2006

Bunker Museum of Contemporary Art, Kinmen Island: A Permanent Sanctuary for Art in a Demilitarized Zone. Taipei: Kinmen County Government, 2006. With essays by the artist, Chiang Bo-wei, Bridget Goodbody, Nan Fang-Shuo, Ni Tsai-Chin, and James Putnam. Editions in Chinese and English.

Captured Wind Arrested Shadow: Cai Guo-Qiang and Lin Hwai-min's Wind Shadow. Taipei: Eslite Gallery (Cherng Piin), 2006. With essays by the artist and Lin Hwai-min. In Chinese and English.

Jennifer Wen Ma: Aeolian Garden. San Gimignano and Siena: Associazione Arte Continua and Gli Ori, 2006. Statement by the artist and Jennifer Wen Ma. In Italian and English.

Kinmen Children's Bunker Museum of Art. Taipei: Kinmen County Government, 2006.

ABOUT THE ARTIST

MONOGRAPHIC EXHIBITION CATALOGUES

1991

Cai Guo-Qiang. Primeval Fireball: The Project for Projects. Tokyo: P3 art and environment, 1991. With statements by the artist and essays by Serizawa Takashi, Takami Akihiko, and Takagishi Michiko. In Japanese and English.

1994

Cai Guo-Qiang: From the Pan–Pacific. Iwaki: Iwaki City Art Museum, 1994. With statements by the artist and an essay by Hirano Akihiko. In Japanese and English.

Hasegawa Yūko, ed. *Chaos: Cai Guo-Qiang*. Tokyo and Osaka: Setagaya Art Museum and Nomart Editions Inc., 1994. With statements by the artist and essays by Chen Ri Sheng and Hasegawa Yūko. In Japanese and English.

1997

Cai Guo-Qiang. Cultural Melting Bath: Projects for the 20th Century. New York: Queens Museum of Art, 1997. With essays by Jane Farver and Reiko Tomii.

Cai Guo-Qiang: Flying Dragon in the Heavens. Humlebaek: Louisiana Museum of Modern Art, 1997. With essays by Geremie R. Barmé and Anneli Fuchs. In Danish and English.

1998

Day Dreaming: Cai Guo-Qiang. Taipei: Eslite Gallery (Cherng Piin), 1998. With essays by the artist and Tatsumi Masatoshi. In Chinese and English.

1999

Matt, Gerald, ed. *Cai Guo-Qiang: I Am the Y2K Bug*. Vienna: Kunsthalle Wien, 1999. With essays by Rosa Martínez, Michael Wenzel, and Hasegawa Yūko, and an interview with Gerald Matt. In German and English.

2000

Fei Dawei, ed. *Cai Guo-Qiang*. London: Thames & Hudson and Paris: Fondation Cartier pour l'art contemporain, 2000. With an essay by Fei Dawei and interviews with Fei Dawei and Andrei Ujica. Editions in French and English.

2002

Cai Guo-Qiang. Shanghai: Shanghai Art Museum, 2002. With essays by the artist, Hasegawa Yūko, Ni Tsai-Chin, Zhang Qin, and Zeng Qing Hui. In Chinese.

Cai Guo-Qiang and Iwaki with His Drawing Works 1980–2002. Iwaki: Cai Guo-Qiang Anthology Project, 2002. With statements by the artist. In Japanese and English.

Cai Guo-Qiang. Trento: Galleria Civica di Arte Contemporanea, 2002. With essays by Fabio Cavallucci, Hou Hanru, and Pier Luigi Tazzi, and an interview with Monica Demattè. In Italian and English.

Cai Guo-Qiang: An Arbitrary History. Lyon: Musée d'Art Contemporain de Lyon and Milan: 5 Continents Editions srl, 2002. With essays by Fei Dawei, François Jullien, Jan Hoet, Nanjō Fumio, Thierry Raspail, and Wang Mingxian, and an interview with Jérôme Sans. In French and English.

Cai Guo-Qiang's CHADO Pavilion: Homage to Tenshin Okakura. Hakone-machi, Kanagawa-ken: The Hakone Open-Air Museum, 2002. With essays by Matsumura Toshio and Tatehata Akira. In Japanese and English.

Cai Guo-Qiang: Day Dreaming. Shanghai: Yishu Shijie Magazine, 2002. In Chinese.

2003

Stringa, Nico. *Terrecotte Cinesi: Dalla 48th Biennale di Venezia*. Nove: Museo Civico della Ceramica, 2003. With essays by Francesca Dal Lago, Britta Erickson, Nico Stringa, Harald Szeemann, and Alessio Tasca. In Italian and English.

2004

Cai Guo Qiang. Light Cycle: Explosion Project for Central Park. New York: Asia Society and Creative Time, 2004. With essays by the artist, Melissa Chiu, and Peter Eleey.

2005

Cai Guo-Qiang: Life Beneath the Shadow. Edinburgh: The Fruitmarket Gallery, 2005. With essays by Fiona Bradley, Hasegawa Yūko, and James Robertson.

Cai Guo-Qiang: Inopportune. Wilmington: MASS MoCA, 2005. With essays by Laura Heon and Robert Pogue Harrison, and an interview with Jennifer Wen Ma.

Cai Guo-Qiang: On Black Fireworks. Valencià: Institut Valencià d'Art Modern, 2005. With essays by Consuelo Císcar Casabán, David Rodríguez Caballero, Lilian Tone, Vincente Valero, and Wu Hung and interview with David Rodríguez Caballero. In Spanish and English.

Cai Guo-Qiang. Warsaw: Zacheta National Gallery of Art, 2005. With statements by the artist and essays by Maria Brewinska and Jean-Luc Nancy. In Polish and English.

2006

Cai Guo-Qiang: Head On. Frankfurt am Main: Deutsche Bank AG, 2006. With essays by Dan Cameron, Ariane Grigoteit, Lao Zhu, and Nicholas Mirzoeff. Editions in German and English.

Cai Guo-Qiang: Long Scroll. Ottawa: National Gallery of Canada, 2006. With an essay and interview by Jonathan Shaughnessy.

Cai Guo-Qiang: Transparent Monument. Milan: Edizioni Charta, 2006. With an essay by David Ross.

2007

Higuchi Masaki and Iseki Yu, eds. *Light Passage: Cai Guo-Qiang & Shiseidō*. Tokyo: Shiseidō Corporate Culture Department, 2007. With essays by Fukuhara Yoshiharu, Kakizaki Takao, and Sugawara Norio, and an interview with Kakizaki Takao. In Japanese and English.

GROUP EXHIBITION CATALOGUES

1989

Tama-River Fussa Outdoor Sculpture Exhibition, unpaginated. Fussa: Tamagawa Fusa Yagi Bijutsu tenji mukyoku, 1989. In Japanese and English.

1990

Art Chinoise 1990: Chine demain pour hier, pp. 52–55. Paris: Les Domaines de l'art et Editions Carte Segrete, 1990. In French.

1992

Japan Ushimado International Art Festival, unpaginated. Ushimado: Ushimado International Art Festival, 1992. In Japanese and English.

1994

Watanabe Seiichi, ed. *Mito Annual '94: Open System*, pp. 42–48, 63–67, 72, 75–76. Mito: Art Tower Mito Contemporary Art Center, 1994. In Japanese and English.

Promenade in Asia, unpaginated. Tokyo: Shiseidō
 Corporate Culture Department, 1994. In Japanese
 and English.
*Well-Spring: Messages and Revelations by
 Contemporary Artists to Animate the Ancient
 City of Bath*, pp. 14–15, 34–35, 44. Bath: Bath
 Festival Trust, 1994.

1995

*Contemplation: '95 Joong-ang Biennial Special
 Exhibition*, pp. 74–75, 80–83, 150. Seoul:
 Ho-Am Art Museum, 1995. In Korean and English.
Art In Japan Today: 1985–95, pp. 48–53, 154–55.
 Tokyo: Museum of Contemporary Art, 1995.
 In Japanese and English.
Heart of Darkness, pp. 11, 15, 70–71, 84–97,
 201. Otterlo: Kröller-Müller Museum, 1997.
TransCulture: La Biennale di Venezia 1995, pp. 15,
 22–23, 72, 76–77, 99–104, 181. Tokyo: The
 Japan Foundation and Fukutake Science and
 Culture Foundation, 1995. In Japanese and
 English.

1996

*Between Earth and the Heavens: Aspects of
 Contemporary Japanese Art II*, ed. Yamawaki
 Kazuo, pp. 10–15, 26–28, 34–37, 59–62.
 Nagoya: Nagoya City Art Museum, 1996.
 Editions in Japanese, English, and Spanish.
de Rode Poort (The Red Gate), pp. 32–35, 155,
 164, 172–73. Ghent: Museum van Hedendaagse
 Kunst Gent, 1996. In Dutch and English.
The Hugo Boss Prize 1996, pp. 51–59. New
 York: Guggenheim Museum, 1996.
Michelsen, Anders and Octavio Zaya. *Interzones:
 A Work in Progress*, pp. 90–97. Copenhagen:
 Kunstforeningen Copenhagen, 1996.
*The Second Asia-Pacific Triennial of Contemporary
 Art*, pp. 36, 58–59, 128. Brisbane: Queensland
 Art Gallery, 1996.
Universalis: 23rd International Biennial São Paulo,
 pp. 230–35. São Paulo: Fundação Bienal de São
 Paulo, 1996. In Portuguese and English.

1997

Performance Anxiety, pp. 14, 38–41, 71, 79.
 Chicago: Museum of Contemporary Art, 1997.
Promenade in Asia, pp. 36–51. Tokyo: Shiseidō
 Corporate Culture Department, 1997. In
 Japanese and English.

1998

Elliott, David and Pier Luigi Tazzi, eds. *Wounds:
 Between Democracy and Redemption in
 Contemporary Art*, p. 134. Stockholm: Moderna
 Museet, 1998. In Swedish and English.
Gao Minglu, ed. *Inside Out: New Chinese Art*,
 pp. 13–14, 33–34, 71–72, 186–88. San
 Francisco: San Francisco Museum of Modern Art
 and New York: Asia Society Galleries, 1998.
Nemiroff, Diana, ed. *Crossings*, pp. 86–93, 188.
 Ottawa: National Gallery of Canada, 1998.
Palmer, Alice and Maudie Palmer. *Remanence*,
 pp. 16–17, 38. Melbourne: Melbourne
 International Festival of the Arts, Limited, 1998.
Site of Desire: 1998 Taipei Biennial, pp. 50–53,
 194, 204. Taipei: Taipei Fine Arts Museum,
 1998. In Chinese and English.

1999

*Beyond the Future: The Third Asia-Pacific
 Triennial of Contemporary Art*, pp. 196–97, 268.
 Brisbane: Queensland Art Gallery, 1999.
*Hiriya in the Museum: Artists' and Architects'
 Proposals for Rehabilitation of the Site*,
 pp. 110–15. Tel Aviv: Tel Aviv Museum of Art,
 1999. In Hebrew and English.
*Kunst Welten im Dialog von Gauguin zur Globalen
 Gegenwart*, pp. 390–93, 517, 560. Cologne:
 Museum Ludwig, Koln, 1999. In German.
*Panorama 2000: Art in Utrecht seen from the
 Dom tower*, pp. 36–39. Amsterdam: Centraal
 Museum, 1999. In Dutch and English.
Zeitwenden Ausblick, pp. 66–69. Cologne: Dumont
 and Kunstmuseum Bonn, 1999. In German.

2000

Issey Miyake: Making Things, pp. 52–53, 94–99,
 170. Paris: Fondation Cartier and Actes Sud,
 2000. Editions in French and Japanese.
Martínez, Rosa. *Looking for a Place*, pp. 32–33,
 46–47, 114, 121. Santa Fe: SITE Santa Fe, 2000.
Morin, France, ed. *The Quiet in the Land,
 Everyday Life, Contemporary Art and Projeto
 Axé*, pp. 100–5. Bahia: Museu de Arte Moderna
 da Bahia, 2000. In Portuguese and English.
Outbound: Passages from the 90's, pp. 28–33,
 110. Houston: Contemporary Arts Museum,
 Houston, 2000.
Over the Edges, pp. 54–57, 275–76. Ghent:
 Stedelijk Museum voor Actuele Kunst, 2000. In
 Flemish and English.
Varnedoe, Kirk, ed. *Modern Contemporary: Art at
 MoMA Since 1980*, pp. 484, 513, 550. New
 York: Museum of Modern Art, 2000.

Whitney Biennial: 2000 Biennial Exhibition,
 pp. 68–69, 232, 260. New York: Whitney
 Museum of American Art, 2000.

2001

Arte all'Arte: Arte Architettura Paesaggio,
 pp. 48–71. San Gimignano and Siena:
 Associazione Arte Continua and Gli Ori, 2001. In
 Italian and English.
Feuer, pp. 586–600. Bonn: Kunst und
 Ausstellungshalle der Bundesrepublik
 Deutschland GmbH, 2001. In German.
Sonsbeek 9: LocusFocus, pp. 28–30. Arnhem:
 Stichting Sonsbeek, 2001. In Dutch and English.
Ulmer, Sean. *Uncommon Threads: Contemporary
 Artists and Clothing*, pp. 12, 48. Ithaca: Herbert
 F. Johnson Museum of Art, 2001.

2002

EV+A 2002: Heroes + Holies, pp. 76–77.
 Limerick: EV+A, 2002.
*International Triennale of Contemporary Art:
 Yokohama 2001*, pp. 90, 164–65, 376, 390.
 Yokohama: The Organizing Committee for
 Yokohama Triennale, 2001. In Japanese and
 English.
Malerei ohne Malerei, pp. 92–97, 140–42. Leipzig:
 Museum der bildenden Künste, 2002.
 In German and English.
Morgan, Jessica, ed. *Pulse: Art, Healing and
 Transformation*, pp. 89–91. Göttingen: Steidl and
 Boston: Institute of Contemporary Art, 2003.
Paris-Pékin, pp. 66–67. Paris: Chinese Century and
 Ullens, 2002. In Chinese, French, and English.
*Tokachi International Contemporary Art Exhibition:
 Demeter*, pp. 33–40, 126, 158, 169, 179,
 187–88. Tokyo: Tokachi International
 Contemporary Art Exhibition Committee, 2002.
 In Japanese and English.
Wu Hung. *The First Guangzhou Triennial.
 Reinterpretation: A Decade of Experimental
 Chinese Art (1990–2000)*, pp. 404–5.
 Guangzhou: Guangdong Museum of Art, 2002.

2003

Alors, la Chine?, pp. 124, 398, 409, 446–47.
 Paris: Éditions du Centre Pompidou, 2003.
 Editions in French and English.
Echigo-Tsumari Art Triennial, pp. 89–90. Tokyo:
 Gendai Kikaku-shitsu, 2003. In Japanese
 and English.
*Somewhere Better Than This Place: Alternative
 Social Experience in the Spaces of Contemporary
 Art*, pp. 125–27, 211. Cincinnati:
 Contemporary Arts Center, 2003.

2004

Hug, Alfons, ed. *26th Bienal de São Paulo*, pp. 278–83, 317. São Paulo: Fundação Bienal de São Paulo, 2004. In Portuguese and English.

The Snow Show, pp. 22–29. Rovaniemi: Rovaniemi Art Museum, 2004. In Finnish and English.

2005

Arte all'Arte 2005: Arte Architettura Paesaggio, pp. 34–41. San Gimignano: Associazione Arte Continua. In Italian and English.

51 International Art Exhibition: Participating Countries, Collateral Events, pp. 106–9. Venice: Fondazione La Biennale di Venezia, 2005. Editions in Italian and English.

Platow, Raphaela. *Dreaming Now*, pp. 32–37, 72–73. Waltham: Rose Art Museum of Brandeis University, 2005.

Zhang Zhaohui. *Where Heaven and Earth Meet: Xu Bing and Cai Guo-Qiang*, pp. 10–15, 20–43, 51–53, 62–63. China: Timezone 8 Limited, 2005.

2006

Wu Hung. *Shu: Reinventing Books in Contemporary Chinese Art*, pp. 26–27. New York: China Institute in America, 2006.

2007

Artempo: Where Time Becomes Art, pp. 91, 99. Ghent: MER.Paper Kunsthalle, 2007.

BOOKS

1989

Gunpowder Paintings of Cai Guo-Qiang. Guilin: Lijang Publishing House, 1989. With statements by the artist. In Chinese and English.

1998

Goldberg. RoseLee. *Performance: Live Art Since 1960*, p. 60. New York: Harry N. Abrams, 1998.

Kastner, Jeffrey, ed. *Land and Environmental Art*, pp. 132, 247. London: Phaidon Press Limited, 1998.

1999

Ni Tsai-Chin. *No Destruction, No Construction: Bombing Taiwan Museum of Art*. Taichung: Taiwan Museum of Art, 1999. With statements by the artist and Ni Tsai-Chin. In Chinese and English.

2000

Asian Collection 50: From the Collection of the Fukuoka Asian Art Museum, pp. 40–41. Fukuoka: Fukuoka Asian Art Museum, 2000. In Japanese.

Fresh Cream: Contemporary Art in Culture, pp. 172–77. London: Phaidon Press Limited, 2000.

Remain in Naoshima: Naoshima Contemporary Art Museum, pp. 140–51, 238, 244–45, 249. Okayama-ken: Benesse House, 2000. In Japanese and English.

2001

Developing the Collection: Acquisitions 1999–2001, p. 51. Canberra: National Gallery of Australia, 2001.

2002

Dana Friis-Hansen, Octavio Zaya, and Serizawa Takashi. *Cai Guo-Qiang*. London: Phaidon Press Limited, 2002.

Hou Hanru. *On the Mid-Ground*, pp. 54–63, 64–73, 74–89, 92–101. Hong Kong: Timezone 8 Limited, 2002.

2003

Elderfield, John, ed. *Visions of Modern Art: Painting and Sculpture from The Museum of Modern Art*, pp. 2, 305–6. New York: Museum of Modern Art, 2003.

2004

MoMA Highlights: 350 Works from The Museum of Modern Art, New York, p. 362. New York: Museum of Modern Art, 2004.

Pereira, Sharmini, ed. *Cai Guo-Qiang: Man, Eagle and Eye in the Sky*. London: Albion/Michael Hue-Williams Fine Art Ltd. 2004. With essays by the artist, Jennifer Wen Ma, Sharmini Pereira, and James Putnam.

2005

Collection Art Contemporain, p. 98. Paris: Éditions du Centre Pompidou, 2007. In French.

Sollins, Marybeth, ed. *Art: 21. Art in the Twenty-First Century, 3*, pp. 46–57, 226, 230. New York: Art21, Inc. and Harry N. Abrams, Inc., 2005.

Vitamin D: New Perspectives in Drawing, pp. 48–49, 337. London: Phaidon Press Limited, 2005.

ARTICLES AND ESSAYS

1989

Sanda Haruo. "A Fierce Battle Between Two Matters." *Mainichi Newspaper* (Japan), Mar. 14, 1989, evening edition. In Japanese.

1990

Chiba Shigeo. "Fireworks at Mount St. Victoire: Chinese and Japanese Art." *Mainichi Newspaper* (Japan), Sept. 10, 1990, evening edition, p. 6. In Japanese.

Fei Dawei. "Art in *Chine demain pour hier*." *Yishujia* (Taipei) 184 (Sept. 1990), pp. 165–74. In Chinese.

1991

Kuroda Raiji. "The Future of Presenting 'Asian Art:' Thoughts on Asian Contemporary Art." *The Shin Bijutsu Shinbun* (Japan) 608, July 1, 1991. In Japanese.

Suzuki Soshi. "The Future Tense of Art: Launching of 21st Century Art: Cai Guo-Qiang, China's E.T.." *Bijutsu Techō* (Tokyo) 636 (Apr. 1991), pp. 202–14. In Japanese.

1993

Konno Yuichi. "Marching Towards the Light in the Sky: Cai Guo-Qiang." *UR* (Tokyo) 7 (Mar. 1993), pp. 5–32. In Japanese.

Wu Mali. "Explosion Art of Cai Guo-Qiang." *Yishujia* (Taipei) 215 (Apr. 1993), pp. 237–44. In Chinese.

1994

Friis-Hansen, Dana. "Cai Guo-Qiang at the Iwaki City Art Museum." *Art in America* (New York) 82, no. 11 (Nov. 1994), p. 144.

Sugawara Norio. "The Year in Art '94: Striking Rise of Asia: Cai Guo-Qiang Very Active, Decline of Euro-American 'Contemporary' [Art]." *Yomiuri shinbun* (Japan), Dec. 14, 1994, evening edition, p. 11. In Japanese.

1995

Kurabayashi Yasushi. "Cai Guo-Qiang: A Marvelous Chinese Alchemist." In *Listen to Contemporary Art: Music and Contemporary Art in the 20th Century*, pp. 209–41. Tokyo: Sky Door. In Japanese.

Poshyananda, Apinan. "From Hybrid Space to Alien Terrirory." In *TransCulture: La Biennale di Venezia 1995*, pp. 69–78. Exh. cat. Tokyo: The Japan Foundation and Fukutake Science and Culture Foundation, 1995.

Zhang Yuan-qian. "Order in Chaos: Cai Guo-Qiang, a Phenomenon in Japan." *Hsiung Shih Art Monthly* (Taipei) 296 (Oct. 1995), pp. 58–65. In Chinese.

1996

Cotter, Holland. "A SoHo Sampler: Short List for Prize." *New York Times*, Friday, Nov. 22, 1996, p. C26.

Serizawa Takashi. "Chia Yu Kuan." In *Moving on This Planet*, pp. 67–88. Tokyo: Iwanami Shoten, 1996. In Japanese.

Zaya, Octavio. "Cai Guo-Qiang." *Flash Art* (Milan) 29, no. 190 (Oct. 1996), p. 103.

1997

Cotter, Holland. "Playing to Whoever In Distant Galaxies." *New York Times*, Aug. 15, 1997, p. C24.

Gao Qian-hui. "The Ark of Genghis Khan: The Analysis of Cai Guo-Qiang's Art Methodology and Eastern Aesthetics." *Artists Magazine* (Taipei) 263 (Apr. 1997), pp. 322–29. In Chinese.

Johnson, Ken. "Eyes on the Prize." *Art in America* (New York) 85, no. 4 (Apr. 1997), pp. 41–45, 135.

Lufty, Carol. "Flame and Fortune." *Artnews* (New York) 96, no. 11 (Dec. 1997), pp. 144–47.

Schwabsky, Barry. "Tao and Physics: The Art of Cai Guo-Qiang." *Artforum International* (New York) 35, no. 10 (Summer 1997), pp. 118–21, 155.

Tokui Reiko. "Cai Guo-Qiang's Solo Exhibition: Cultural Melting Bath." *The Shin Bijutsu Shinbun* (Japan), Sep. 21, 1997, p. 1. In Japanese.

Wu Xiao-fang. "A Remedy for the Cultural Melting Bath: Cai Guo-Qiang's 'Cultural Melting Bath: Project for the 20th Century'." *Mountain Art* (Taipei) 91 (Oct. 1997), pp. 51–54. In Chinese.

Yu Hsiao-Hwei. "Cai Guo-Qiang Discusses Where the Budget Comes from, Where the Work Goes." *Cans Chinese Art News* (Taipei) (Nov. 1997), pp. 74–86, cover. In Chinese.

1998

Chang Bo-shun. "Ignition of Taiwan Province Museum of Art: Fire Dragon Climbing Dragon Columns." *United Daily News* (Taiwan) (Aug. 22, 1998), p. 5. In Chinese.

Cheng Nai-ming. "Powerful Explosion: Cai Guo-Qiang's art power." *Liberty Times*, May 28, 1998, p. 39. In Chinese.

Chian Li-an. "Explode One Second Into Eternity: Behind the Scene of Cai Guo-Qiang's Explosion Art." *Arts Circle Magazine* (Taipei) 3 (July 1998), pp. 12–15. In Chinese.

Goodman, Jonathan. "Cai Guo-Qiang." *ArtAsiaPacific* (Sydney) 18 (1998), p. 92.

Heartney, Eleanor. "Cai Guo-Qiang at the Queens Museum of Art." *Art in America* (New York) 86, no. 1 (Jan. 1998), p. 93.

Hsu Hui-Ling. "Taiwan Province Museum of Art Was Exploded Into Spectacular Beauty." *Central Daily News* (Taiwan), Aug. 22, 1998, p. 5. In Chinese.

Huang Bao-ping. "Taiwan Province Museum of Art: Explode Infinite Energy In 50 Seconds." *Min Shen News* (Taiwan), Aug. 22, 1998, p. 19. In Chinese.

Huang Du. "Cai Guo-Qiang: From Mystery and Philosophy to Reality." *ArtAsiaPacific* (Sydney) 20 (Fall 1998), pp. 58–61.

Kelmachter, Hélène. "Hervé Chandès presente Cai Guo-Qiang." *Connaissance des Arts* (Paris) 554 (Oct. 1998), pp. 78–79. In French.

Murdock, Robert. "The Explosive Drawings of Cai Guo-Qiang." *Drawing* (New York) 19, no. 4 (Summer 1998), pp. 127–29.

Nemiroff, Diana. "Crossings". In *Crossings*, ed. Diana Nemiroff, pp. 13–41. Exh. cat. Ottawa: National Gallery of Canada, 1998.

Tsai Mei-juan. "Stunningly, Cai Guo-Qiang Explodes His Work." *United Daily News* (Taiwan), May 22, 1998, p. 14. In Chinese.

Zheng Gong-xian. "Reverse Thinking of Two Events in Taiwanese Art World: Taipei Fine Arts Museum *Advertising Castle* and SuHo Paper Culture Museum." *Art of Collection* (Taipei) 72 (Sept. 1998), pp. 24–30. In Chinese.

1999

Gao Minglu. "Traces of Gunpowder Explosions." *Dushu* (Beijing) 246 (Sept. 1999), pp. 87–93. In Chinese.

Heartney, Eleanor. "Children of Mao and Coca-Cola." *Art in America* (New York) 87, no. 3 (Mar. 1999), pp. 42–47.

Hsu Wen-rwei. "Subject of Desire: The 1998 Taipei Biennial." *ArtAsiaPacific* (Sydney) 22 (1999), pp. 25–27.

Huang Qiang-fang. "Conversing with the Spirit of the Universe." *Art of Collection* (Taipei) 77 (Feb. 1999), pp. 172–77. In Chinese.

Madoff, Steven Henry. "All's Fair." *Artforum International* (New York) 38, no. 1 (Sept. 1999), pp. 145–55, 184, 190.

Takami Akihiko. "Cai Guo-Qiang." *Bijitsu Techō* (Tokyo) 768 (Mar. 1999), pp. 9–43, cover. In Japanese.

Thea, Carolee. "Prismatic Visions: An Interview with Rosa Martínez." *Sculpture* (Washington, D.C.) 18, no. 6 (July–Aug. 1999), pp. 32–37.

Vetrocq, Marcia E. "The Venice Biennale: Reformed, Renewed, Redeemed." *Art in America* (New York) 87, no. 9 (Sept. 1999), pp. 82–93.

Zaya, Octavio. "Cai Guo-Qiang." *Grand Street* (New York) 18, no. 3, 67 (Winter 1999), pp. 120–25, cover.

Zhang Chao-hui. "Where Heaven and Earth Meet: Cai Guo-Qiang and Xu Bing." *Jiangsu Art Monthly* (Jiangsu) 218 (Feb. 1999), pp. 11–14. In Chinese.

2000

Allen, Jane Ingram. "Participatory Works: Viewers as Co-Creators." *Sculpture* (Washington, D.C.) 19, no. 1 (Jan.–Feb. 2000), pp. 73–75.

Dal Lago, Francesca. "Open and Everywhere: Chinese artists at the Venice Biennale." *ArtAsiaPacific* (Sydney) 25 (2000), pp. 24–26.

Dal Lago, Francesca. "Chinese Art at the Venice Biennale: 1. The Virtual Reality of Chinese Contemporary Art." In *Chinese Art at the End of the Millennium: Chinese-Art.com 1998–1999*, ed. John Clark, pp. 158–66. Hong Kong: New Art Media Limited, 2000.

Demattè, Monica. "Chinese Art at the Venice Biennale 2. Chinese Art…It's dAPERTutto!" In *Chinese Art at the End of the Millennium*, pp. 167–74.

Ebony, David. "Who Owns 'The People's Art'?" *Art in America* (New York) 88, no. 10 (Oct. 2000), p. 51.

Eckholm, Erik. "Cultural Revolution, Chapter 2: Expatriate Artist Updates Maoist Icon and Angers Old Guard." *New York Times*, Aug. 17, 2000, pp. E1, E6.

Erickson, Britta. "Cai Guo-Qiang Takes the Rent Collection Courtyard from Cultural Revolution Model Sculpture to Winner of the 48th Venice Biennale International Award." In *Chinese Art at the End of the Millennium*, pp. 184–89.

He Wan-li. "From 'Fountain' to 'Venice Rent Collection Courtyard'." *Contemporary Artists* (Sichuan), 19 (Nov. 2000), pp. 32–34. In Chinese.

Hikosaka Naoyoshi. "History of Japanese Contemporary Art in the 1990s." *SAP (Saison Art Program)* (Tokyo) 2 (Jan. 2000), pp. 36–62. In Japanese.

Huang Du. "Cai Guo-Qiang." In *Chinese Art at the End of the Millennium*, pp. 182–3.

Morin, France. "The Quiet in the Land: Everyday Life, Contemporary Art, and Projeto Axé." *Art Journal* (New York) 59, no. 3 (Fall 2000), pp. 4–17.

Napack, Jonathan. "Chinese artists may sue Venice Biennale, 1999 appropriation of a 1965 Socialist Realist work causes anger." *Art Newspaper* (London), Sept. 1, 2000, p. 3.

Peng De. "Obsessed 'Venice Rent Collection Courtyard'." *Contemporary Artists* (Sichuan) 19 (Nov. 2000), pp. 30–31. In Chinese.

Wang Guan-yi. "Three Queries on the Work of 'Venice Rent-collecting House." *Sculpture* (Beijing) 21 (2000), pp. 6–7. In Chinese.

Wang Lin. "Comments on 'Venice Rent Collection Courtyard'." *Contemporary Artists* (Sichuan) 19 (Nov. 2000), pp. 28–29. In Chinese.

Wen Shan. "Old Problems, New Problems: Venice Rent Collection Courtyard." *Artscircle* (Shanghai) 151–52 (Sept.–Oct. 2000), pp. 79–83. In Chinese.

Zhang Zhi-ming. "Copyright Issues of Large Scale Sculpture 'Rent Collection Courtyard'." *Zhou Mo Zhuan Kan* (China), July 21, 2000, p. 8. In Chinese.

Zhou Jing-luo. "Explode Art on the Catwalk." *Huasheng Monthly* (Beijing) 61 (Apr. 2000), pp. 78–81. In Chinese.

2001

Erickson, Britta. "The Rent Collection Courtyard Breached Oversees: Sichuan Academy of Fine Arts Sues Venice Biennale." In *Chinese Art at the Crossroads: Between Past and Future, Between East and West*, ed. Wu Hung, pp. 52–55. Hong Kong: New Art Media Ltd., 2001.

Gao Minglu. "Cai Guo-Qiang." In *The Century's Utopia: The Trends of Contemporary Chinese Avant-Garde Art*, pp. 245–51. Taipei: Artist Publishing Co., 2001. In Chinese.

Garnett, Daisy. "How Is Your Feng Shui?" *Visuell* (Frankfurt am Main) (2001), pp. 17–20. In German and English.

In Zhi. "Cai Guo-Qiang: Play Art Well." *Art World* (Shanghai) 138 (Nov. 2001), pp. 8–15. In Chinese.

Li Xiangyang. "Cai Guo-Qing and Ni Tsai-Chin's Collaboration in Tuscany." *Art and Collection* (Taipei) 110 (Nov. 2001), pp. 168–69. In Chinese.

Lu Sheldon. "The Uses of China in Avant-Garde Art: Beyond Orientalism." In *China, Transnational Visuality, Global Postmodernity*, pp. 173–92. Stanford: Stanford University Press, 2001.

Tong, Jinghan. "Maksimov's Impact on the History of China Art." *Art China* (Shanghai) (Feb. 2002), pp. 66–71. In Chinese.

Zheng Huihua. "Two-sided Cai Guo-Qiang." *Art China* (Shanghai) 1 (Dec. 2001), pp. 76–79. In Chinese.

Zhu Qi. "We Are Too Sensitive When it Comes to Awards! Cai Guo-Qiang and the Copyright Infringement Problems Surrounding Venice's Rent Collection Courtyard." In *Chinese Art at the Crossroads*, pp. 56–65.

2002

Bartelik, Marek. "Cai Guo-Qiang: Shanghai Art Museum." *Artforum International* (New York) 40, no. 10 (Summer 2002), p. 189.

Berque, Augustin. "Pour que naquît ce paysage." In Charbonneaux, Anne-Marie and Norbert Hillaire. *Oeuvre et lieu*, pp. 18–34. Rotolito: Flammarion, 2002. In French.

Cavallucci, Fabio. "When Art Takes Part in Society." *Work* (Trento) 1, no. 3 (Oct.–Dec. 2002), pp. 11–13. In Italian and English.

Fei Dawei. "How to Write an Arbitrary History." *Art & Collection* (Taipei) 113 (Feb. 2002), pp. 59–61. In Chinese.

Gao Minglu. "Painting" Made by and for the Mythical: Cai Guo-Qiang's "Gunpowder Drawings." In *Malerei ohne Malerei,* pp. 92–97, 140–42. Exh. cat. Leipzig: Museum der bildenden Künste, 2002. In German.

Hasegawa Yūko. "Transcending the Time & Space, Roaring at the Universe." *Art & Collection* 113, pp. 46–52. In Japanese.

Heartney, Eleanor. "Cai Guo-Qiang: Illuminating the New China." *Art in America* (New York) 5 (May 2002), pp. 92–97, cover.

Ho Chun-rui. "Cai Guo-Qiang Creates Explosion Work 'Transient Rainbow' for MoMA." *Cans Chinese Art News* (Taipei) 57 (Aug. 2002), p. 16. In Chinese.

Huang Xiu-fang. "The Artist Using Land As His Stage: Cai Guo-Qiang." *People's China* (Tokyo) 592 (Oct. 2002), pp. 52–55. In Japanese.

Itoi Kay. "Making a Splash." *Newsweek* (New York) special edition (Fall–Winter 2002), pp. 76, 77.

———. "Hakone, Japan. Cai Guo-Qiang." *Sculpture* (Washington, D.C.) 21, no. 10 (Dec. 2002), p. 83.

Jhiratori Masao. "Cai Guo-Qiang: The Artist Who Uses the Universe as His Stage." In *Dreaming People*, pp. 90–100. Osaka: Eastern Publishing, 2002. In Japanese.

Jodidio, Philip. "Cai L'alchimiste." *Connaissance des Arts* (Paris) 590 (Jan. 2002), pp. 118–23. In French.

Katai Miki. "Cai Guo-Qiang's CHADO Pavilion." *PR Weekly* (Tokyo), May. 27, 2002, p. 194. In Japanese.

Leydier, Richard. "Cai Guo-Qiang." *ArtPress* (Paris) 275 (Jan. 2002), pp. 81–82. In French.

Lin Chien-hsiu. "Playful Sophistication: A Sketch of Cai's First Solo Show in China." *Art & Collection* 113, pp. 62–65. In Chinese.

Matsumura Toshio. "Cai Guo-Qiang's CHADO." *Open-Air* (Tokyo) (July 2002), pp. 2–7. In Japanese.

Ni Tsai-Chin. "Cai Guo-Qiang's Legend in Taiwan." *Art & Collection* 113, pp. 53–58. In Chinese.

Qing Ya-jun. "Counter-attack the Mainland China and Also Liberate Taiwan: Bunker Museum of Contemporary Art." *Art Today* (Taipei) 119 (Aug. 2002), pp. 72–75. In Chinese.

Reed, Arden. "'Living Well' on Naoshima." *Art in America* (New York) 9 (Sept. 2002), pp. 54–59.

Schench, Sabrina. "Two Offerings by Cai." *Work* 1, no. 3, pp. 8–10. In Italian and English.

Takashima, Miki. "Collaboration Takes Tea Ceremony Back to Its Roots." *The Daily Yomiuri* (Japan), Saturday, June 22, 2002, p. 13.

2003

Chou Dong-hsiao. "Amazement in the September Sky of New York." *Artists Magazine* (Taipei) 339 (Aug. 2003), pp. 102–5. In Chinese.

Cotter, Holland. "Public Art Both Violent and Gorgeous." *New York Times*, Sept. 14, 2003, Arts & Leisure, section 2, pp. 1, 33.

Fujimori Manami. "Cai Guo-Qiang." *Bijitsu Techō* (Tokyo) 833 (Apr. 2003), pp. 149–53. In Japanese.

Furukawa Mika. "Cai Guo-Qiang." *Bien* (Tokyo) 22 (Sept.–Oct. 2003), pp. 4–9. In Japanese.

Ho, Heather. "Cai Guo-Qiang's Fiddled Art and Amusing Life." *Chinese Art* (Beijing) 4, no. 33 (2003), pp. 14–27. In Chinese.

Hou Hanru. "Artistes Chinois, Diaspora et Art Global." In *Alors, la Chine?*, pp. 396–400. Exh. cat. Paris: Éditions du Centre Pompidou, 2003. In French.

Lavrador, Judicaël. "Art et Feux d'artifice: Étincelles Modernes." *Beaux Arts* (Paris) 225 (Feb. 2003), pp. 74–77. In French.

Pollack, Barbara. "Gunpowder Drawings: Cai Guo-Qiang." *Art on Paper* (New York) 8, no. 2 (Nov.–Dec. 2003), pp. 38–39.

Poshyananda, Apinan. "Cai Guo-Qiang." *ArtAsia-Pacific* (St. Leonards) 37 (Jan.–Feb.–Mar. 2003), p. 76.

Putnam, James. "The Way of the Dragon." *Contemporary* (London) 49 (2003), pp. 44–47.

Tomkins, Calvin. "Light Show: Rockets' Red Glare." *New Yorker* (New York) 79, no. 26, Sept. 15, 2003, Talk of the Town, p. 40.

Vanderbilt, Tom. "Playing with Fireworks: The Art of Cai Guo-Qiang." *Wall Street Journal*, Sept. 11, 2003, p. D10.

Zeng Hui-yan. "Explosion from the East to the West: Cai Guo-Qiang Plays Around the World." *World Journal*, Oct. 12–18, 2003, pp. 20–25, cover. In Chinese.

2004

Berwick, Carly. "Playing with Fire." *Artnews* (New York) 103, no. 10 (Nov. 2004), pp. 122–23.

Dawson, Jessica. "Cai Guo-Qiang's Ship Has Come In at Sackler." *Washington Post*, Nov. 14, 2004, p. N8.

Dean, Jason. "Bridging the Divide with Art." *Asian Wall Street Journal*, Sept. 13, 2004, p. A2.

Desai, Vishakha N. "Beyond the 'Authentic-Exotic:' Collecting Contemporary Asian Art in the Twenty-First Century." In *Collecting the New: Museums and Contemporary Art*, ed. Bruce Altshuler, pp. 103–14. Princeton: Princeton University Press, 2005.

Gao Chien-huei. "Cai Guo-Qiang." In *After Origin: Topic on Contemporary Chinese Art in New Age*, pp. 310–19. Taipei: Artist Publishing Co., 2004. In Chinese.

Goodman, Jonathan. "Cai Guo-Qiang An Explosion Event: Light Cycle Over Central Park at the Asia Society." *ArtAsiaPacific* (New York) 39 (Winter 2004), p. 84.

Lloyd, Ann Wilson. "Art That Goes Boom." *Smithsonian Magazine* (Washington, D.C.) 5, no. 8 (Nov. 2004), pp. 112–16.

Macleod, Helen. "Treasure Island: Subtracting the Art from Artillery on Taiwan's Remote, Wounded Outcrop." *New York Sun*, Oct. 1–3, 2004, p. 21.

Nichols, Matthew Guy. "Cai Guo-Qiang at Central Park & the Asia Society." *Art in America* (New York) 1 (Jan. 2004), p. 96.

Sayaka Yakushiji. "Blowing Away the Boundaries of Art and Politics." *Asahi Shimbun*, Oct. 9–10, 2004, p. 35.

Wang Zi-ren. "Cai Guo-Qiang: Explode the International Art World, Explode the Spectacular Art Life." *La Vie* (Taipei), Sept. 2004, pp. 114–27. In Chinese.

2005

Carrier, David. "Cai Guo-Qiang." *Artforum International* (New York) 43, no. 6 (Feb. 2005), pp. 176–77.

Glueck, Grace. "The Cars Aren't Really Exploding, but the Terrorist Metaphor Is." *New York Times*, Feb. 18, 2005, p. E39.

Jin Bo. "Oriental Touch to Venice Biennale." *China Daily*, June 11–12, 2005, p. 9. In Chinese.

Lefingwell, Edward. "The Extraterritorial Zone." *Art in America* (New York) 2 (Feb. 2005), pp. 48–55.

Pollack, Barbara. "Enter the Dragon: Cai Guo-Qiang Breathes New Fire Into Venice." *Modern Painters* (London) (June 2005), pp. 80–83.

Searle, Adrian. "Boom Town." *Guardian*, Aug. 2, 2005, G2, pp. 10–11

2006

Ma Yue-ling. "Wind. Shadow. Fire. Dance." *Common Wealth* (Taipei), Nov. 8, 2006, pp. 162–65. In Chinese.

Müller, Hans-Joachim. "Maler an der Lunte." *Die Zeit* (Berlin), Aug. 24, 2006, p. 38. In German.

Roberts, Claire. "China's Most Famous Ruin." In *The Great Wall of China*, eds. Geremie Barmé and Claire Roberts, pp. 16–25. Sydney: Powerhouse Publishing, 2006.

Pan Qing. "Ink in the Sky: Cai Guo-Qiang's 'Transparent Monument' at The Metropolitan Museum of Art." *Artco* (Taipei) 165 (June 2006), pp. 202–5. In Chinese.

Shinkawa Takashi. "Cai Guo-Qiang: A Groundbreaking Journey." *ARTiT* (Tokyo) 4, no. 2 (Spring–Summer 2006), pp. 42–47. In Japanese and English.

Vogel, Carol. "Inside Art: Up on the Roof, and Above." *New York Times*, Mar. 23, 2006, p. E28.

Wang Jia-ji. "Burning Medicine: Cai Guo-Qiang's explosion art." *INK Literary Monthly* (Taipei) 40 (Dec. 2006), pp. 50–56. In Chinese.

Zhao Li. "Encountering Cai Guo-Qiang." *INK Literary Monthly* 40, pp. 57–59. In Chinese.

Zhou Qian-yi. "Black Snow, Black Hole, Black Rainbow: Cai Guo-Qiang's 'Wind Shadow'." *Performing Arts Review* (Taipei) 167 (Nov. 2006), pp. 10–13. In Chinese.

2007

Tamashige Sachiko. "Cai Guo-Qiang." *Sō-en* (Tokyo) (Sept. 2007), pp. 122–25. In Japanese.

Taylor, Kate. "Poetic Explosions at the Guggenheim." *New York Sun*, Sept. 7–9, 2007, p. 14.

COPYRIGHT NOTICES AND PHOTO CREDITS

Photo credits are given in two groupings: by figure numbers and by page numbers. In general, inclusive page numbering indicates a single image that extends across two pages.

Figures 1, 2, 22, 116, 125: photos by Masatoshi Tatsumi, courtesy Cai Studio; 3: photo by Kristopher McKay; 4, 6, 17, 31, 33, 45, 64, 68, 76, 80, 111, 119, 121: photos by Hiro Ihara, courtesy Cai Studio; 5, 20, 21, 23, 41, 42, 58, 59, 96, 104, 107, 123, 124, 126: photos by Cai Guo-Qiang; 7: photo by Philippe Fuzeau, courtesy Galleria Continua, San Gimignano-Bejing; 8: photo by Chen Zhen, courtesy Galleria Continua, San Gimignano-Bejing; 9, 10: courtesy Tilton Gallery, NY; 11: photo by Yuji Suzuki, courtesy Cai Studio; 12: © Lee Ufan; 13, 14: © Endō Toshikatsu, photos by Tadasu Yamamoto, courtesy Shiraishi Contemporary Art Inc.; 15, 54, 112: photos by Masanobu Moriyama, courtesy Cai Studio; 16: photo © 2008 Museum of Fine Arts, Boston; 18: photo by Dieter Schwerdtle; 19: photo by Attilio Maranzano, courtesy Galerie Emmanuel Perrotin, Paris/Miami; 24: photo by Jung Kim, courtesy Cai Studio; 25: photo by Teresa Christiansen, courtesy the Metropolitan Museum of Art; 27, 72, 88: photos © Blaise Adilon; 28, 29, 30, 92, 122: photos by Elio Montanari, courtesy Cai Studio; 32, 53, 87, 89, 94, 97, 100, 105, 106, 114, 118, 128, 129: courtesy Cai Studio; 34: photo by Ken Tannenbaum, courtesy Marian Goodman Gallery, New York and Paris; 35: courtesy Marian Goodman Gallery, New York and Paris; 36, 101, 102, 103, 109, 113: photos by Hong Hong Wu, courtesy Cai Studio; 37: photo by Juan García Rosell © Institut Valencià d'Art Modern, IVAM,

Generalitat Valenciana, España, 2005; 38, 39: photos by Lesley Ma, courtesy Cai Studio; 40: photo by Stephen Robinson, courtesy the Fruitmarket Gallery, Edinburgh; 43, 44: photos by Gianfranco Gorgoni, courtesy James Cohan Gallery, New York; 46: photo by John Cliett © Dia Art Foundation; 47: photo by Wataru Kai 48, 49, 50, 51, 52, 55: photos © André Morin; 56, 60, 61, 75, 78, 82, 83: photos by David M. Heald; 57: courtesy Fireworks by Grucci; 62, 63: photos by Hagiwara Yoshihiro; 65: photo by Yasaki Yoshinaga; 66: photo by Chang Guan Ho; 67: photo by Masatoshi Tatsumi and Cai Guo-Qiang; 69: photo by Richard Kempton © The Fruitmarket Gallery; 70, 71: photos by Mitsumasa Fujitsuka; 73: photo by Dirk Pauwels/S.M.A.K.; 79: courtesy Imaging Department, photo © President and Fellows of Harvard College; 84: photo by Kazuo Ono © 1994 Iwaki City Art Museum; 85: photo by Miwako Wakimura © Louisiana Museum of Modern Art; 86, 90: © 2008 The New York Times. All rights reserved. Used by permission; 91: photo by Jenni Carter; 93: photo by Yamamoto Tetsuya; 95: photo by Donald Milne; 98, 99, 132: photos by Daxin Wu, courtesy Cai Studio; 108: photo by Chang Guan-Hao; 110: photo by Tadashige Shiga, courtesy Cai Studio; 115: photo by Yang Hai Guang, courtesy Cai Studio; 117: photo by France Morin, courtesy Cai Studio; 120: photo by Jennifer Wen Ma, courtesy Cai Studio; 127, 130: photos by Badeephol Inpirom, courtesy Cai Studio; 131: photo by Sun Yan, courtesy Cai Studio; 133: photo by Duccio Nacci, courtesy Galleria Continua, San Gimignano-Beijing; 134: photo by Lin Yi, courtesy Cai Studio; 135: courtesy Foster + Partners.

Pages 2: photo by Yamamoto Tadasu, courtesy Cai Studio; 78–79, 82, 83, 84–85, 87, 92 (top left), 95, 130 (first six), 152–53, 154 (both), 154–55: courtesy Cai Studio; 88–89, 100–101, 102–3, 104–5, 106–7, 108–9: photos © André Morin; 92 (drawing), 123, 124 (all), 125 (all), 187, 188–89, 201, 204–5, 218 (both), 219, 226–27, 238, 239: photos by Hiro Ihara, courtesy Cai Studio; 97: photo by Taiji Photography Studio, Taipei; 134, 135, 137: photos by Wataru Kai; 99: photo by Imamura

Kaoru; 112–13, 130 (event), 138–39, 140, 142–43, 144, 145, 148–49: photos by Masanobu Moriyama; 117, 118 (all), 119 (all), 120–21: photos by Shizhe Chen, courtesy Cai Studio; 127: photo © The Cleveland Museum of Art; 128–29, 150–51: photos by Kunio Oshima, courtesy Cai Studio; 136, 246–47, 248 (both): photos by Cai Guo-Qiang; 146 (both), 146–47: photos by Kazuo Ono, courtesy Cai Studio; 150: photo by Minoru Kimura, courtesy Cai Studio; 157, 159 (all), 162, 163, 164 (both), 165, 168–69 (all), 170–71, 172–73, 174, 175. 176, 176–77: photos by Hiro Ihara, courtesy Cai Studio; 160, 184, 185, 243, 244 (left and top right): photos by Masatoshi Tatsumi; 166–67: photo by Yasuaki Yoshinaga; 181, 182: photos by Juan García Rosell © Institut Valencià d'Art Modern, IVAM, Generalitat Valenciana, España, 2005; 192–93: photo by Yoshihiro Hagiwara; 195: photo by Norihiro Ueno, courtesy Cai Studio; 196, 197, 198–99, 230–31, 251, 254, 255: photos by Hiro Ihara; 206, 206–7, 208 (both), 208–9: photos by Elio Montanari, courtesy Cai Studio; 210, 211: photos © Blaise Adilon; 212: photo by Dirk Pauwels/S.M.A.K.; 215, 216, 217, 222–23: photos © National Gallery of Canada; 224: photo by Kevin Kennefick; 227, 229: photos by Mathias Schormann, Berlin; 234–35, 235, 236–37, 237 (both): photos by Yamamoto Tadasu, courtesy Cai Studio; 245 (top left and left): photos © S. Anzai; 249: photo by Ela Bialkowska, courtesy of Jennifer Wen Ma and Associazione Continua; 250: photo by Chang Kuo-chih; 258–59: photo by Liu Chen-hsiang; 260–61: courtesy Eslite Gallery (Cherng Piin).